[A]. I.

61. Longley, Misses C. and R. (452)+
62. " Bishop. (at Auckland) (451)+
63. Smith, Fanny. (with dog) (441)+
64. Bust of Madme. Ristori (420)+
65. " " Bianca. (426)+
66. Munro, A. Esq. (at work) (405)+
67. Twiss, Q. Esq. (229)+
68. "Rat-catcher's daughter." (351)+
69. "Two Bonnycastles." (352)+
70. "Artful Dodger." (350)+
71. "Country Fair." (353)+
72. Ottleys: group (475)+
73. Liddell, Harry. (383)+
74. " Ina (& black doll) (371)+
75. " Alice (profile) (355)+
76. " Edith (& book) (372)+

77. Dinsdale Church. (444)+
78. Sculp. Two children. (411)+
 (Ida Wilson & brother)
79. Bust of Ida Wilson. (409)+
80. "Tim." (344)+

81. Wood, Lisa. (271)+
82. Foster, R. (½ length) (284)+
83. Coates, Annie. (287)+
84. "Lovers' Walk" (2 views) (413, 414)+
85. Harington, Beatrice. (323)+ Margaret. (324)+
86. Statuette. "Hope." (424)+
87. Lushington, F., Esq. (307)+
88. Jelfs: group. (508)+
89. Joa Smith, (442½)+ Fanny Smith. (241 2/3)+ (269, 268)+
90. Kitchin, Rev. G.W., and first class. (394)+
91. Dodgson, W.L. and Dido. (278)+
92. Statue in clay - Misses Gladstone. (410)+
93. Liddell, Alice. (walking) (338)+
94. Wilcoxes: group. (460)+
95. Bust of Dante. (412)+
96. Harington, Margaret. (666)+ (549)+

LEWIS CARROLL

PHOTOGRAPHER

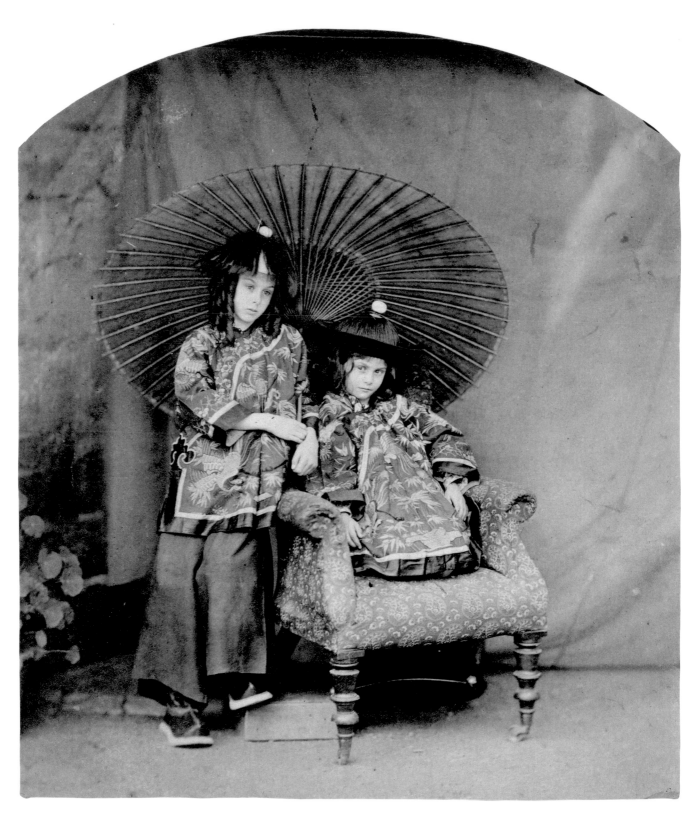

LEWIS CARROLL

PHOTOGRAPHER

THE PRINCETON UNIVERSITY LIBRARY ALBUMS

ROGER TAYLOR

EDWARD WAKELING

Introduction by Peter C. Bunnell

PRINCETON UNIVERSITY PRESS
Princeton and Oxford
PRINCETON UNIVERSITY LIBRARY

To the memory of Alexander D. Wainwright,
first curator of the Morris L. Parrish Collection—our friend and guide.

Front cover: *Alice Liddell*, July 1860. A(II): 53
Back cover: *Reginald Southey and Skeletons*, June 1857. A(I): 21
Frontispiece: *Lorina and Alice Liddell in Chinese Dress,*
spring 1860. A(II): 2
Endpapers: Dodgson's handwritten table of contents,
Album A(I), 1857–60

Published by Princeton University Press and
Princeton University Library

Princeton University Press, 41 William Street,
Princeton, New Jersey 08540
In the United Kingdom: Princeton University Press, 3 Market Place,
Woodstock, Oxfordshire OX20 1SY
www.pup.princeton.edu

Princeton University Library
1 Washington Road
Princeton, New Jersey 08544

Album A(I): 1, 3, 4b, 5, 6, 8a, 8b, 9a, 9b, 10, 11, 12, 13, 15, 16, 17, 18, 19a, 19b, 20, 22, 23, 28, 30, 31, 35, 37, 38, 39, 40, 41, 42a, 42b, 43, 45, 46, 47, 48, 49, 50, 51, 53, 54, 55, 57, 58, 59, 60, 61, 62, 63, 64, 65, 66, 67, 68, 69, 71, 72, 73, 76, 77, 78, 79, 80, 82, 83, 84a, 84b, 85a, 85b, 86, 87, 88, 89a, 90, 91, 92, 94, 95, and 96.

Album A(II): 4, 5, 6, 8, 9, 10, 13, 14, 15, 16, 17, 19, 21, 22, 24, 25, 26, 27, 29, 30, 31, 32, 34, 35, 36, 38, 39, 41, 42, 43, 44, 45, 47, 48, 49, 50, 51, 52, 54, 55, 57, 59, 61, 62, 63, 64, 66, 67, 68, 69, 71, 72, 74, 75, 78, 87, 88, 89, 90, 91, 93, 94, 95, 96, 97, 98, 99, 100, 101, 103, 104, 107, 108, 109, 110, 111, 112, 113, 115, 116, 117, 118, 121, 122, 124, 125, 126, 127, 128, 129, 130, 131, 132, 134, 135, and 136.

Album P(3): 6, 7, 8, 9, 10, 12, 13, 15, 16, 17, 18, 23, 24, 26, 28, 29, 30, 31, 32, 34, 36, 38, 40, 41, 43, 44, 50, 54, 55, 62, 63, 64, 66, 67, 71, 75, 79, 81, 83, 85, 88, 89, 90, 91, 92, 94, 95, 96, 99, and 100.

Album HH: 2, 3, 4, 5, 6, 7, 8, 9, 11, 14, 15, 16, 18, 19, 20, 21, 22, and 24.

Loose photographs L: 1, 3, 4, 5, 8, 12, 13, 20, 21, 26, 27, 28, 29, 30, 31, 37, 38, 39, 40, 41, 42, and 43.

Southey Albums: RS1: 1, 12, 20, 25, 27, 28, 30, and 40. RS2: 21 and 22. RS3: 33.

Printed and bound in Italy
1 3 5 7 9 10 8 6 4 2

Library of Congress Cataloging-in-Publication Data
Taylor, Roger, 1940–
 Lewis Carroll, photographer : the Princeton University Library albums / Roger Taylor, Edward Wakeling ; with an introduction by Peter C. Bunnell.
 p. cm.
 Includes bibliographical references.
 ISBN 0-691-07443-7
 1. Princeton University Library—Photograph collections.
2. Photograph collections—New Jersey—Princeton. 3. Parrish, Morris Longstreth, 1867–1944—Photograph collections.
4. Carroll, Lewis, 1832–1898. 5. Photography, Artistic.
I. Wakeling, Edward. II. Carroll, Lewis, 1832–1898. III. Title.

TR6.U6 P75 2002
779'.092—dc21

 2001036261

CONTENTS

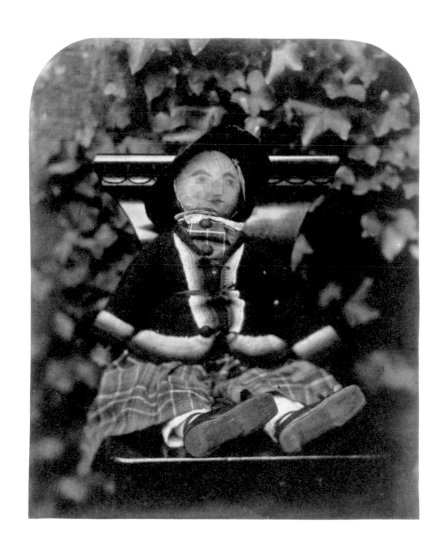

INTRODUCTION

PETER C. BUNNELL

This book marks the first comprehensive publication of the 407 photographs by Charles Lutwidge Dodgson—more familiarly known to his generations of admirers as Lewis Carroll—in the collection of the Princeton University Library. It is the largest collection of Dodgson's photographs anywhere, and this book offers the most extensive discussion and documentation of his pictures ever published. Though long known and appreciated by scholars—and, in the case of certain famous images, by devotees of Carroll—these photographs have never before been available to be studied all together.

Roger Taylor and Edward Wakeling have written the texts that follow, and no two authorities are more knowledgeable about Dodgson's photographic endeavors; the fact that Princeton has brought these major scholars together to create this book reflects the significance of its holdings and its commitment to making them better known. Roger Taylor, a British photographic historian and leading expert on the Victorian period, has written a book-length essay that addresses Dodgson's considerable body of photographs. In addition to surveying his photographic output and placing it into the context of his life and other work, Taylor presents new thinking and new evidence about Victorian image-making in general; about Dodgson's photographic contemporaries, from Julia Margaret Cameron to Oscar Gustav Rejlander; and about the practice of amateur, artistic, and commercial photography during the twenty-five years (1856–80) of Dodgson's enthusiastic involvement with the medium.

Taylor also vividly narrates Dodgson's struggles to master the complicated devices and demanding techniques of nineteenth-century photographic science and art. Dodgson's

Tim, the Dodgson Family Doll,
April 1858
Ripon, Yorkshire?
5 x 4 in. (12.6 x 10.3 cm)
A(I): 80

taking up of photography, the course of his learning with and from his friend Reginald Southey, his mastery of glass-plate negatives and albumen prints are all reported here, with new facts and exceptional insight into exactly why photography became so central to Dodgson's life. The fact that he was both a member of one particular level of society and an aspirant to another, and the new understanding of how he used photography to negotiate from one level to another, illuminates a life spent in some struggle for identity. Taylor casts light on the intricacies of class and achievement, of the individual and the family, and on how Dodgson's intelligence enabled him to emotionally master and come to terms with his complicated world.

Because the content of Dodgson's pictures provides a guide to his navigation through society, we must turn to Edward Wakeling for help in identifying his subjects and positioning his sitters within the environment they shared with Dodgson. A British Carroll scholar and former chairman of the Lewis Carroll Society, Wakeling has devoted years to the study of Dodgson's milieu. He has prepared the illustrated catalogue of the entire Princeton collection, providing detailed captions that describe the various subjects and identify the sitters, including their professions and family ancestries as well as their connections to Dodgson and to Victorian society. Wakeling's contributions, together with Taylor's exposition, take us far beyond the hitherto simplistic notion of Dodgson's infatuation with children to reveal the complete and true autobiography that he has left us in these pictures.

Among the most creative of Dodgson's photographic accomplishments are the albums of images he assembled. He created these for essentially three different purposes: "show" albums that he could exhibit to visitors and prospective sitters, albums that contained family portraits and photographs of close acquaintances, and finally, gift albums for friends. Princeton has four of Dodgson's albums, and the photographs in them are reproduced in the catalogue in album order, so that for the first time a reader without access to the originals will be able to experience the careful sequencing of photographs that is unique to each album and that reflects Dodgson's own intent for how these images should be seen.

In addition, Wakeling has painstakingly analyzed the artist's meticulous numbering system and undertaken his own extensive research to construct a chronological register of all the photographs (not just those at Princeton) that Dodgson is known to have made throughout his life; this list is unique and should become a basic reference tool for study of all Dodgson's photography. Until Wakeling constructed this invaluable register, the chronology of Dodgson's photographs was poorly understood and often misconstrued; by establishing the sequence of photographs, as well as through his detailed and thorough understanding of all things Carrollian, Wakeling provides an essential underpinning for this publication and for all future scholarship.

Building on this firm new foundation, Taylor has been able to write with conviction and authority about Dodgson's ambitions and development as a photographic artist. Together these authors worked their way through the myriad issues confronting them both, sharing information and ideas in a fruitful collaboration. Throughout their exchange, they have resisted speculation, instead basing their claims only on the evidence found in Dodgson's

Dodgson's Album (A[II])

pictures, letters, and diary entries—evidence that some of their predecessors may not have had access to and that others may have chosen to ignore because it contradicted their theories or preconceptions.

That a highly educated and sophisticated man like Charles Lutwidge Dodgson, or a re-markably imaginative writer named Lewis Carroll, would have had such a fascination with photography should not surprise us. In mid-nineteenth-century Britain the photographic im-age was thought to border on the miraculous, and it required a very special ability to inter-pret what it revealed. Experience played a considerable role in deciphering photography, as it did in decoding the aspects of Victorian society that exerted an equally strong fascination for Dodgson's restless intelligence and irrepressible humor. As evident in his now-famous tales of *Alice,* what Dodgson most desired was a world that made sense and, in terms of pictures, a world that would be what he called "a perfect likeness." For Dodgson, with his penchant for endeavors of the mind and the imagination, of language and of numbers, photog-raphy was one more complex realm to explore and conquer.

Dodgson wrote only briefly about the ideas behind photography, though he did make a characteristic remark that it was a "stupendous addition . . . to the powers of science"[1]— not surprising, given his interests in logic and mathematics. We can better appreciate the pre-vailing contemporary view of the medium by quoting another writer, A. Bisbee, who said of photography:

> It acts with a certainty and extent, to which the powers of human faculties are perfectly incompetent. Not only does it delineate every object presented to its operation, with perfection in proportions, perspective, and tint . . . but it delin-eates objects which the visual organs of man would overlook, or might not be able to perceive, with the same particularity, with the same nicety, that it depicts the most prominent feature . . . and thus may scenes of the deepest interest, be transcribed and conveyed to posterity, not as they appear to the imagination of the poet or painter, but as they actually are.[2]

In such real-life scenes, as in Dodgson's imaginary ones, he was in search of the ways we dis-close ourselves to others. In his hands, the camera became a tool for fixing the revelation of personality. The camera was understood to reveal more than the eye could see, and it gave Dodgson the instrument he needed to delve beneath surfaces into places of the deepest per-sonality and privacy (his goal even in face-to-face relationships). And just as language was a subject of Dodgson's writing, so photographs too were a way for him to gain insight into how the world looked and to what extent the world really was what it appeared to be. He saw that a photograph was ultimately a closed world, bound by its frame, a self-contained story —like his literary works—that begins and ends.

There are Dodgson photographs and negatives in several other public and private collections around the world. The most significant holding, after Princeton's, is that of the Helmut Gernsheim Collection in the Harry Ransom Humanities Research Center at the University of Texas at Austin, with over three hundred images, including four of Dodgson's own carefully constructed albums.[3] Another collection, including one major album, was formerly on deposit at Christ Church, Oxford. Originally the property of Alice Liddell (who inspired the *Alice* tales) and her family, it was auctioned in London in June 2001 and purchased by a private collector, who has put the pictures on display at Christ Church. Other institutions with significant holdings of individual prints and negatives include: The Alfred C. Berol Collection, Fales Library, New York University (54 works); National Museum of Photography, Film and Television, Bradford (44); National Portrait Gallery, London (30); Musée d'Orsay, Paris (27); The Rosenbach Foundation, Philadelphia (21); The Pierpont Morgan Library, New York (17); and The Royal Photographic Society, Bath (13).

Wakeling reports that after Dodgson's death in 1898, the sale of his effects mentions some thirty-four albums. Some of these have since been lost and others broken up; we can now account for perhaps only one third of them. Princeton has albums that cover the significant early years of Dodgson's photography up to the point when he began, in 1863, to use a studio in Oxford. Princeton also has an extensive collection of photographs from the later Christ Church studio period (beginning in 1872)—both in the Parrish Collection, which includes the Henry Holiday Album from that period, and in the library's other holdings of individual prints acquired over several years.

It is clear that the six years between 1857 and 1862 were the most active period of Dodgson's photographic career. By this time he had established his photographic style by exploring a range of subjects before settling more consistently on child portraiture. Albums A(I) and A(II) in the Princeton collection cover Dodgson's formative years and contain the most diverse subject matter of any of his albums. In addition to portraits, they encompass landscapes, still lifes, anatomical specimens, and narrative tableaux.

The later albums found elsewhere lack some of the creative spark that fired the first seven years of Dodgson's work. The exception to this observation is Album A(VI), in the Gernsheim Collection at the University of Texas. Unlike others in his A series, this is a small and intimate album, most likely his first and perhaps intended to be seen only by the Dodgson family and close friends. This album reveals just how quickly Dodgson was able to grasp and master the complexities of the process as well as compose exceptionally elegant images that markedly display his stylistic identity.

The vast majority of Princeton's Dodgson photographs came to the university in 1944 from the bequest of Morris L. Parrish. Born on November 5, 1867, Parrish was the son of a Burlington County, New Jersey, merchant who died four years after Parrish's birth. Parrish

entered Princeton University in 1884 but left before completion of his freshman year. He then entered business as a stockbroker in Philadelphia, eventually founding Parrish & Co. in 1900.

Parrish began to acquire his collection in 1913; his first mission was to complete a set of works by Dickens that his mother had given him. He moved on to collecting most of the great Victorian novelists, eventually building a library to house the collection at Dormy House, his home in Pine Valley, New Jersey. As a collector, he sought to gather all matter published by an author and to acquire works in the finest possible condition. In time, book collectors came to describe this pristine state as "Parrish condition." In the 1920s Parrish began to publish bibliographies of his collections, including two on his Lewis Carroll acquisitions.[4]

Parrish obtained three of the four albums he bequeathed to the university from Dodgson's sister, Louisa Fletcher Dodgson. In late December 1924, Parrish visited the sister at her home in Guildford and must have admired the photograph albums, for Louisa later inquired, "Would you care to have one of the volumes of 'Lewis Carroll's' photographs which you saw in my room? I could easily get Thorpe to value it."[5] Within days Parrish responded in the affirmative, the first of many expressions of interest in the months that followed.[6] Apparently, a dispute about rightful ownership of the volumes soon arose within the family, but Louisa assured Parrish, "As you know I think, I—personally—am *quite* willing for them to pass into your hands."[7]

Parrish continued to woo the family, sending the immense Daimler car he used while in England to bring Louisa's nieces to London to enjoy an evening at the theater. During his annual fall trip in 1926, Parrish must have visited with the family and persuaded them to sell, for Louisa wrote him, "We are having the photo albums now valued. My niece has them in London and has gone about them *today*."[8] The following March, Louisa indicated that the family had decided "to part with one or more of the books."[9] She then turned most of the negotiations over to her niece, F. Menella Dodgson. The niece sent Parrish a description of the contents and condition of three photograph albums that they had decided to sell at public auction, but not before allowing Parrish the opportunity to make a "private purchase." She noted that they would part with the albums only "if the price we can get for them really compensates us for their loss."[10] Parrish quickly replied that he did not like to bid at auction, but would be willing to pay £100 for Album A(II) or A(III).[11] Menella then sent Parrish a lengthy description of each album and Parrish elected to purchase Album A(II).[12]

Menella delivered the volume to Parrish in London in late October 1927. During that visit she raised the question of his interest in the other two albums and journal of Dodgson's visit to Russia in 1867.[13] Parrish offered another £100 for the remaining albums and the journal. With this offer came a new wrinkle in the negotiations. Menella indicated that the family would accept this bid "on the understanding that, if we are able to arrange for it, you are generously going to allow your collection to return to England."[14] The family suggested the Christ Church Library at Oxford as the place for the collection, but Parrish favored a separate shrine or building, either in Guildford or Oxford.[15] He apparently took up the matter of a "Lewis Carroll Memorial Building" in Oxford with Falconer Madan.[16] Later Parrish indi-

cated to Menella that he much preferred Oxford to Guildford, and that if a memorial were constructed in Oxford, his collection would be housed there.[17] One assumes that the Depression years and the war that followed put an end to the notion of a shrine to Carroll, thus saving the collection for Princeton.

When the two photograph albums and the Russian journal arrived in the United States in March 1928, Parrish was ecstatic, writing that he wanted to publish the journal privately.[18] Later Parrish sent the family an additional £100 because he believed the journal to be worth more than he had paid.[19]

Parrish obtained his other Dodgson photograph album (the Henry Holiday Album) after he published the catalogues for his collection.[20] In his first printed catalogue he lists fifteen of the library's loose photographs of the Hatch family and the accompanying Carroll correspondence relating to these photographs. The other loose photographs in the Parrish Library were later purchased for the collection by the Parrish Library curator, Alexander Wainwright.[21]

Parrish had begun negotiations with Princeton over the location of his collection as early as the 1930s. The university hoped to build a new library, and Parrish was willing to donate his collection to it if the new building contained a replica of his library at Dormy House. Yet even as late as 1940, Parrish wrote to the university president, Harold Dodds: "I excepted, as you will recall, the Carroll collection and I still wish to reserve this although it may be included."[22] Ultimately Parrish signed an agreement with the university in 1942 that committed "all the papers, books, manuscripts, prints, drawings, catalogs, furniture and other articles in the Library of Dormy House." The university for its part agreed to pay the salary of his librarian after Parrish's death and to house the collection in fireproof quarters in a room "conforming as closely as possible to the present floor plan" of the library in Dormy House.[23]

Following the death of Parrish on July 8, 1944, the university made arrangements to house the collection in the basement of Dickinson Hall, pending completion of the Firestone Library. Parrish's librarian, Elizabeth V. Miller, set about preparing an inventory for the estate but decided not to continue as curator of the collection after its transfer from Dormy House. Princeton University librarian Julian P. Boyd prepared a four-page memorandum on the proper wrapping, boxing, loading, and transporting of the books to Princeton and personally oversaw their transfer in November 1944.[24]

In 1946 the Parrish Library came under the curatorship of Alexander Wainwright, who over the years added thousands of imprints, manuscripts, and other materials to the collection, including most of the loose Dodgson photographs in it. The care of this collection became a labor of love for Wainwright over the next fifty-four years. He worked until the day before his death on January 5, 2000, on a seven-hundred-page catalogue of the collection, which has since been posted on the library's Web site.

During the 1990s Princeton alumnus Lloyd E. Cotsen purchased five albums said to have been arranged by Dodgson's friend and fellow photographer, Reginald Southey. Mr.

Cotsen recently donated them to the newly opened Cotsen Children's Library in the Firestone Library. At least three of the Southey albums contain photographs taken by Dodgson.

. . .

In considering Dodgson's photographs, we must avoid the temptation to see merely the who, where, and when. Dodgson purposefully chose notable men, women, and children to be his subjects, but the historical content of their depictions is not the reason to value his work. Nor should these photographs invite consideration only because of who made them. If this were all there was to it, Dodgson's work in photography would be no more than a curiosity. What has to be seen is the triumphant way he absorbed the medium into his larger conception of being and made its qualities manifest in terms of his own knowledge and deep emotional interpretation.

W. H. Auden, who admired Lewis Carroll and wrote about his work, said it this way: "The first criterion of success in any human activity, the necessary preliminary, whether to scientific discovery or to artistic vision, is intensity of attention or, less pompously, love."[25] No, it is not Dodgson's subjects that are important; what is important is the way he created a photograph, making its pictorial space an arena for interaction between ourselves and those depicted. In other words, it is his genius as a picture maker that must be appreciated. Lewis Carroll's writing has been read, and cherished, by generation upon generation. Charles Lutwidge Dodgson's photographs can now be seen to warrant a similar admiration and equal affection. It is hoped that this book will, as never before, capture and reveal the real looking-glass world that he created.

NOTES

1. Lewis Carroll, "Photography Extraordinary," in *Lewis Carroll: Photographer,* by Helmut Gernsheim (New York: Dover Publications, 1969), 112.

2. A. Bisbee, *The History and Practice of Daguerreotyping* (Dayton, Ohio: L. F. Claflin & Co., 1853), 19–20.

3. See Robert N. Taylor, *Lewis Carroll at Texas* (Austin: Harry Ransom Humanities Research Center, 1985).

4. Morris Longstreth Parrish, *A List of the Writings of Lewis Carroll [Charles L. Dodgson]: In the Library at Dormy House, Pine Valley, New Jersey, Collected by M. L. Parrish* ([New York]: Privately printed [by William Edwin Rudge], 1928) and Morris L. Parrish, *A Supplementary List of the Writings of Lewis Carroll in the Library at Dormy House, Pine Valley, New Jersey, Collected by M. L. Parrish* ([Philadelphia]: Privately printed [by Edward Stern & Company, Inc.], 1933).

5. Louisa Fletcher Dodgson to Morris L. Parrish, 8 January 1925, the Morris L. Parrish Collection of Victorian Novelists (C0171), Series IV, Parrish Correspondence, Box 9, Folder 8, Manuscripts Division, Department of Rare Books and Special Collections, Princeton University Library (hereafter cited as Parrish Mss.). In this same letter Louisa offers Parrish "the *negatives* (on glass) of some of my brother's photos." Apparently these did not interest Parrish since he did not respond to this offer and no negatives found their way into the Parrish holdings. All of the early letters between Parrish and Louisa mention only two albums. "Thorpe" refers to Mr. Thomas Thorpe of 109–110 High Street in Guildford, a bookseller. The firm, founded in 1883, also operated a shop at 93 St. Martin's Lane, London.

6. Parrish to Louisa Fletcher Dodgson, 23 January 1925, Parrish Mss.

7. Louisa Fletcher Dodgson to Parrish, 10 August 1925, Parrish Mss.

8. Louisa Fletcher Dodgson to Parrish, 10 December 1926, Parrish Mss.

9. Louisa Fletcher Dodgson to Parrish, 18 March 1927, Parrish Mss.

10. F. Menella Dodgson to Parrish, 5 June 1927, Parrish Mss.

11. Parrish to F. Menella Dodgson, 20 June 1927, Parrish Mss.

12. F. Menella Dodgson to Parrish, 7 July 1927, Parrish Mss.

13. F. Menella Dodgson to Parrish, 23 October 1927, Parrish Mss. The Russian journal was privately printed in an edition limited to sixty-six copies: C. L. Dodgson, *Tour in 1867: From the Original Manuscript in the Collection of M. L. Parrish, Esq., Pine Valley, New Jersey* (Philadelphia, 1928).

14. F. Menella Dodgson to Parrish, 17 November 1927, Parrish Mss. Menella asked that he send a letter confirming these conditions along with his check.

15. Parrish to F. Menella Dodgson, 28 November 1927, Parrish Mss. The family agreed to these terms, and on 1 March 1928, John and Edward Bumpus Ltd. shipped the albums and diaries to Philadelphia.

16. Parrish to F. Menella Dodgson, 16 March 1928, Parrish Mss. Falconer Madan (1851–1935) served as Bodley's Librarian, 1912–19, and published, with Sidney H. Williams, *A Handbook of the Literature of the Rev. C. L. Dodgson (Lewis Carroll)* (London: Humphrey Milford, Oxford University Press, 1931). Madan was a major Carroll collector who sold many items to Parrish. Between 1928 and 1937 Parrish carried on a frustrating correspondence with various officials at Christ Church who stubbornly refused to build a facility to house his collection. See Box 7, Folder 10, Parrish Mss.

17. Parrish to F. Menella Dodgson, 18 April 1928, Parrish Mss.

18. Parrish to F. Menella Dodgson, 16 March 1928, Parrish Mss.

19. F. Menella Dodgson to Parrish, 9 April 1928, Parrish Mss. Menella reported to Parrish on the Sotheby's sale of Mrs. Hargreaves's [Alice Liddell] photograph album on 3 April 1928, with the photograph album selling for £28 and a photo of Alice in a case going for £35. These prices suggest that Parrish had dealt fairly with the family in acquiring these albums.

20. The Holiday album is listed on an undated page from a catalogue published by the Rains Galleries, New York. We know that by 1942 this volume was in the Parrish library because Parrish mentions it in "Adventures in Reading and Collecting Victorian Fiction," *Princeton University Library Chronicle* 3, no. 2 (February 1942): 37. Edward Wakeling notes that the undated catalogue page for lot 91 describes this item as "A Photograph Album containing 24 photographs taken by Dodgson, with a list of the characters photographed, and his titles. Mounted in a 4to album, full morocco, gilt bands, gilt edges." There follows a transcription of the dedication to Henry Holiday.

21. Wainwright's guide to the Parrish Library states that twenty-seven photographs were added over the years. See http://libweb2.princeton.edu/rbsc2/parrish/Dodgson.index.pdf.

22. Parrish to Harold W. Dodds, 21 October 1940, Librarian's Records, Julian P. Boyd Series, "Morris L. Parrish Estate" file (hereafter cited as Parrish estate file), Princeton University Archives.

23. "Agreement between the Trustees of Princeton University and Morris L. Parrish," 24 June 1942, Parrish estate file.

24. "Instructions for Handling the Parrish Library," 31 October 1944, Parrish estate file.

25. W. H. Auden, in *Later Auden,* by Edward Mendelson (New York: Farrar, Straus and Giroux, 1999), 32.

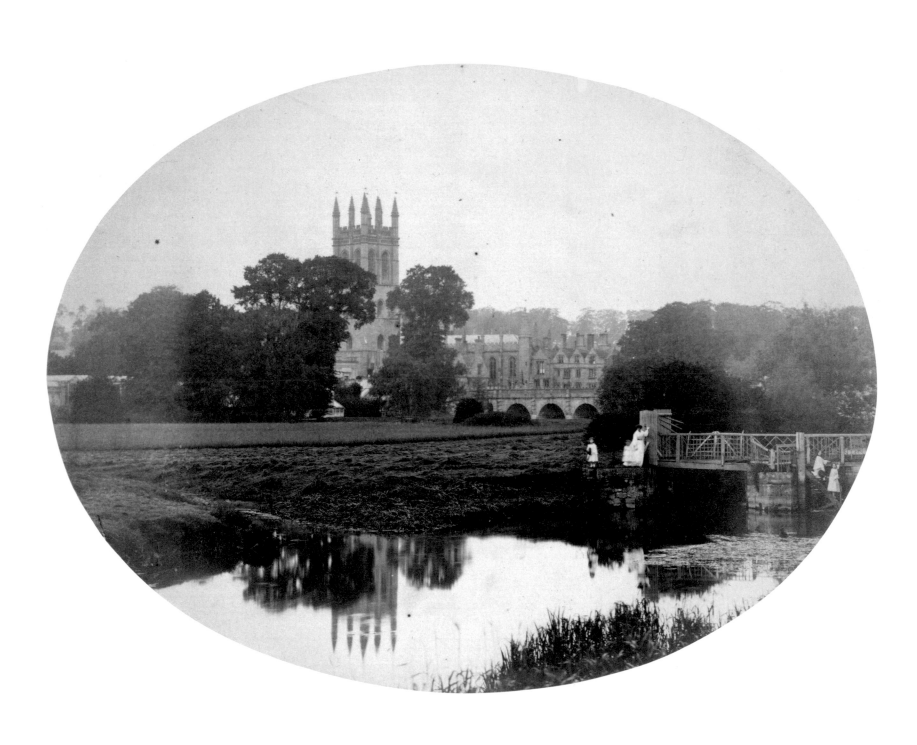

"ALL IN THE GOLDEN AFTERNOON"

THE PHOTOGRAPHS OF
CHARLES LUTWIDGE DODGSON

ROGER TAYLOR

All in the golden afternoon
Full leisurely we glide
For both our oars, with little skill,
By little arms are plied,
While little hands make vain pretence
Our wanderings to guide.
—from *Alice's Adventures in Wonderland*

When Charles Lutwidge Dodgson first took up photography in 1856, he was a young man of twenty-four; he had been recently appointed mathematics tutor at Christ Church and thought that the hobby would offer an "occupation" other "than [the] mere reading and writing" associated with collegiate life.[1] During the next twenty-five years, Dodgson photographed with an energy and enthusiasm that were quite exceptional, for few amateurs could point to an inventory of at least 2500 negatives, and of such distinguished sitters. The most important of these photographs Dodgson mounted into a sequence of albums, of which twelve have survived. The narrative and content of each album were carefully designed to reflect his artistic taste and technical proficiency. Although the albums range over every type of subject matter, portraiture predominates, with the largest percentage being of children; it is these, above all, on which Dodgson's reputation as a photographer now rests. His understanding and affection for children allowed him to create a relaxed and magical atmosphere in which photography was just one part of the proceedings, not the dominant purpose. His stories, riddles, and magic tricks created a rapport that allowed him to make some of the most sympathetic and compassionate portraits of children taken during the nineteenth century. This essay thus examines Charles Lutwidge Dodgson's achievements as an

Plate 1
Magdalen Tower,
summer 1861
Oxford
5⅝ x 7⅜ in.
(14.2 x 18.8 cm)
A(II): 24

amateur photographer within the context of his accomplishments as an Oxford don and as author of two of the most imaginative and enduring of all children's books, which he wrote under the celebrated pseudonym of Lewis Carroll.[2]

The essential facts of Charles Lutwidge Dodgson's early life are well known.[3] He was born on 27 January 1832 in Daresbury, a remote hamlet in the heart of the Cheshire countryside, where his father, Charles Dodgson, senior, eked out a meager living as a perpetual curate to the parish. Dodgson was the eldest son and the third child of a family that eventually grew to number eleven children. Although he had two older sisters, Dodgson was seen as the preferred child (in families above a certain position, it was the firstborn male who carried forward the good name). The attention of the Dodgson family focused far more on Charles than on his younger brothers or sisters. Throughout his life, he took his family responsibilities very seriously, providing for his sisters and helping with the education of others until his death.

Dodgson's attitude and actions were largely conditioned by the position of his family within society. Above all, it was respectable, with antecedents that could be traced back to well before the eighteenth century. Among its ranks were members of church and army, and it could lay claim to a bishop or two. By fulfilling their duty to the nation in this way, the Dodgsons conformed to a pattern that lay at the very heart of British nationhood. Their lineage, euphemistically referred to as "good breeding," assured them a place among the gentry. Neither aristocrats nor landowners, but with extensive family connections and a web of interconnecting friendships and affiliations, the Dodgsons belonged to the "good society" that so richly characterized Queen Victoria's reign.[4]

We see the benefits of this informal network at work during 1842. Charles Longley, the bishop of Ripon, an old friend of the family, rallied a number of local notables to lobby Prime Minister Robert Peel to ensure that Charles Dodgson, senior, was offered the recently vacated position of rector at Croft, North Yorkshire. The parish was in the gift of the Crown and provided an annual income of more than £1000, a significant increase over that at Daresbury. The lobbying was successful and the family moved to Croft in 1843. For the first time since their marriage in 1827, the Dodgsons were able to enjoy a standard of living more appropriate to their status. By any measure, they were financially well off, though not as rich as local landowners whose acres and mineral rights produced considerable incomes.[5]

Throughout his life, Dodgson was always acutely aware of his place within society, understanding implicitly the subtle nuances and gradations that marked the boundaries between different classes. He was taught to know his place and understood the importance of maintaining the good name of the family. Within his own class he was comfortable, even playful, but when dealing with individuals outside his class he could be obsequious, condescending, or patronizing, depending upon their station in life. In many ways Dodgson was a snob, distancing himself ruthlessly from the lower orders, yet behaving with extreme deference and compliance to those superior in status.

Following the move to Croft, the eleven-year-old Dodgson began his formal education. Up to this point he had been entirely taught by his parents at home, where a strict regime

of lessons, reading, and prayer was occasionally relieved with games. In Daresbury, parental teaching had been an economic necessity, but the marked improvement in circumstance at Croft dictated a more formal type of schooling, as a social necessity. By tradition, girls were educated at home, learning everything they needed for future life and happiness from their mothers. Boys, on the other hand, were sent away to schools to build their character and educate them for one of the three professions that underpinned British society: the Church, the army, and the law.

For Dodgson the pathway was clear. He was to follow his father's example and enter the Church. His upbringing and education were directed toward this outcome. First, he was sent to the local school in Richmond. There he came under the influence of Dr. James Tate, whose large family mirrored the Dodgson household and with whom Dodgson remained friendly for many years. It was in Richmond that those qualities and characteristics we now take as essential to Dodgson's personality were first reported. In a letter to the youth's parents, Tate told of the boy's "very uncommon share of genius" and how he would "not rest satisfied without the most exact solution of whatever appears to him obscure." The most telling comments were reserved for Dodgson's outstanding skill as a mathematician and his "love of precise argument, which seems to him natural."[6]

The geographic distance between the schools at Richmond and Rugby is not very great, but in all other respects the two places could not stand farther apart. By the early 1840s, under the auspicious headmastership of Thomas Arnold, Rugby had established a national reputation as a preeminent public school. With over five hundred boys living together, it was inevitable that bullying and "fagging" would become the means of establishing a hierarchy, a system that was immortalized by Thomas Hughes in *Tom Brown's Schooldays*.[7] When Dodgson moved to Rugby in January 1846, Arnold had been dead four years, but the fervent spirit of his convictions remained in evidence. Each day was structured by a pattern of worship, instruction in the classics, classical languages, French, mathematics, and scripture. Underpinning this academic curriculum was the belief that gentlemanly conduct, morality, and truth stood higher than intellectual achievement.

For Dodgson, always the intellectual, the experience of Rugby seems not to have been a happy one. He would have hated the bullying, the humbling initiation rituals, and the sense of inadequacy that every novice was made to endure. His academic prowess, hesitancy of speech, and dislike of contact sports would have marked him as a target for the more ruthless elements that terrorized the British public school system. A few years later he remarked in his usual elliptical way, "I cannot say that I looked back upon my life at a Public School with any sensations of pleasure, or that any earthly consideration would induce me to go through my three years again."[8]

The pathway to Oxford University was neither clearly defined nor open to everyone. Members of the aristocracy were admitted more by tradition and precedence than for individual academic achievement. For those lower down the social scale, however, such achievement was mandatory; it helped if there were also family connections. So it was with

Dodgson. His father was fondly remembered at Christ Church, where he had distinguished himself by attaining a double first in classics and mathematics. Dr. W. E. Jelf, one of the canons of Christ Church, neatly summarized this attitude: "I am sure I express the common feeling of all who remember you at Christ Church when I say we shall rejoice to see a son of yours worthy to tread in your footsteps."[9] The younger Dodgson matriculated at Christ Church on 23 May 1850, having sworn on bended knee to comply with the statutes of the university and signed his acceptance of the Thirty-nine Articles (the established creed of the Church of England). Upon matriculation, Dodgson became a member of a privileged minority, joining one of the oldest and most exclusive fraternities in Britain, where male fellowship and kinship added another layer to the elaborate social network that dominated nineteenth-century life. He became an "Oxford man."

When Dodgson returned to take up residence as a Christ Church scholar eight months later, on 24 January 1851, what kind of young man entered the college gateway? An early portrait taken at Christ Church (plate 2) reveals that he was good-looking, even slightly foppish, with his hair worn long down to his collar and severely parted on the left. His high-winged collar, black bow tie, and dark attire mark him a member of the university where conformity was everything. He could already parse a sentence in Latin or Greek, hold his own in French, and above all, understand the abstract conceptual framework of mathematics.

In addition to these academic talents, a strong sense of spirituality was at the very core of Dodgson's existence. His father had instilled a deep and enduring belief in the power and authority of God, before whom the young man felt accountable for every action, thought, and deed. For him, nothing remained invisible or hidden from the eyes of God. Even the most private thoughts and subconscious notions were accountable. Today, such religious feelings may seem strange, but during the nineteenth century they were widespread and deeply felt by a large majority of the population. These religious beliefs pervaded Dodgson's way of life, resulting in a straitlaced demeanor at odds with the playful personality we now celebrate. More familiar is the Dodgson who enjoyed fashioning stories, puzzles, and riddles to test the intellect and afford enjoyment. His letters are often full of fun and wry observations, and those to children are full of absurd but logical nonsense that reveals the high order of his creative intelligence.[10]

Perhaps the most important aspect of Dodgson's personality was his very real love of beauty, toward which he was drawn like a moth to a flame. He found beauty all around him: in paintings, sculpture, poetry, music, higher mathematics, and above all, in people. And like a moth, he circled dizzily around these attractions, committing his feelings and thoughts to his diary with a warmth and sincerity that belie the image he sometimes projected of a rather stern, inflexible, and unemotional man. It was this duality, this contrast between rigid formality and playful imagination, between mathematician and aesthete, between Oxford man and children's author, that was the creative polarity at the heart of Dodgson's life.

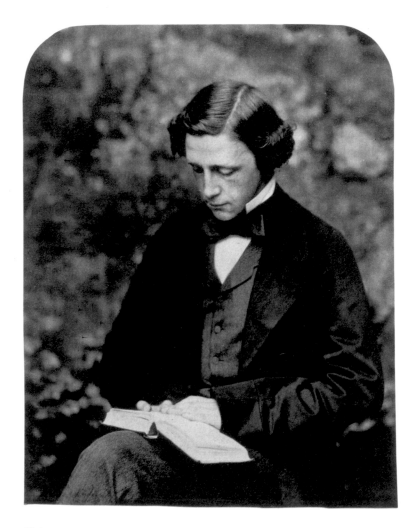

Plate 2
Charles L. Dodgson, 2 June 1857
Deanery garden, Christ Church, Oxford
4⅞ x 3⅞ in. (12.5 x 9.8 cm)
A(II): 70

The world that Dodgson entered as a Christ Church scholar in 1851 was effectively a closed society, still based largely on medieval precepts and attitudes and still wedded to its monastic past, unwilling, or even unable, to reform itself to meet the emerging needs of the nation.[11] The life of the university and the pace at which it operated sharply contrasted to the patterns of change elsewhere in Britain. Oxford was largely removed from the harsh realities of life that prevailed in the larger industrial towns and cities of the north, close to Dodgson's home, where iron and steel and cotton and wool drew folk together in increasing aggregations of poverty and disease. None of these shifting patterns greatly affected Oxford, which manufactured nothing other than graduates. Nonetheless, the influence of these students over the affairs of Church, State, and government remained disproportionately high in relation to their numbers, which were minute.[12]

THE EMERGENCE OF PHOTOGRAPHY

Photography had been developing almost exactly in step with the years of Dodgson's early life, and with equal vigor. The history of photography in Britain up to 1851 was characterized by the twin impulses of its two processes, the daguerreotype and the calotype. When photography was first outlined to the public in January 1839, the two competing systems were announced. They could not have been more different. Broadly speaking, if you used the daguerreotype, it would have been for commercial gain, and in the eyes of the world, you would have been a tradesman. If you used the calotype process, you were more likely to have been a member of "polite" society, where artistic sensibilities were more highly regarded than profit. This separation was as much a function of class, education, and social divisions as it was of the technical distinctions between the two processes.

The French process of Louis Jacques Mandé Daguerre used silver-plated sheets of copper made sensitive to light by complex chemistry. The process rendered images of exquisite beauty, refinement, and detail, each of which was unique and incapable of being multiplied. The process of William Henry Fox Talbot, on the other hand, used ordinary writing paper made chemically sensitive to light, which after exposure to light produced a negative, from which multiple prints could be made. Being paper, these negatives lacked the clear detail of the daguerreotype, giving a broader, more artistic effect that appealed to a different audience. Between 1839 and 1851 these two photographic processes—essentially different in form, aesthetic, and commercial application—battled for supremacy.[13]

In many ways, the characteristics of this struggle reflected the personalities of the inventors. Daguerre was an entrepreneur, a theatrical showman whose gaze invariably focused on commerce. Talbot, whose impeccable lineage as a member of the landed gentry gave him access to the highest levels of society, was a polymath with an interest in natural philosophy, etymology, botany, and higher mathematics. Had they met, Talbot would have been completely at ease in the company of Dodgson. Their shared interests and educational back-

ground would have transcended any social distinctions that might otherwise have kept them apart, for in every sense they were both perfect English gentlemen.

Daguerre's process quickly had a cultural and economic impact once it was applied to portraiture. The manner in which it rendered a likeness in exquisite and miniaturized detail caught the public's imagination. There was good money to be made in daguerreotyping, and within a decade of its introduction business entrepreneurs had established photographic studios throughout Britain. In the eyes of the public, a daguerreotypist was little more than a tradesman marketing the latest scientific novelty. However, unlike many other trades and professions of the nineteenth century, photography offered democratic access to every entrepreneur who could make the initial investment in a studio, a license to operate, a camera, and the necessary chemicals.[14]

Talbot's calotype process won its place higher up in society. The process was regarded not as a source of income but as an exciting new technology that could be applied to the scientific and cultural preoccupations of a class with curiosity, time, and money at their disposal. Very few members of the aristocracy took up photography, preferring more traditional country pursuits. Instead it was the landed classes, the gentry, and county families who explored photography with enthusiasm. Like the Dodgsons, they were interconnected through a network of relatives and friends with whom they exchanged news, ideas, and gossip. In many senses, they were tribal. They shared collective ideals and pursued common interests; above all, they strove to remain respectable. They spent extended periods in each other's company and when apart kept in touch through the new service of the "penny post."[15] Within this context amateur photography flourished vigorously, but only within highly localized groups.[16] Outside these intimate circles, within which information moved freely from family to family, there was little sense of belonging to a wider photographic community. At the same time, daguerreotypists were by and large secretive, describing even the slightest details of their working procedures only if they thought it might attract new business. As a result, the ideals and the cause of photography were rarely pursued with any sense of nationwide purpose.

Apart from one or two small displays, the first major exhibition at which photographs were shown was the Great Exhibition held in Hyde Park, London, during the summer months of 1851. The exhibition, now largely regarded as one of the pivotal events of the nineteenth century, brought together for the first time the raw materials, machinery, and finished products of the civilized world for public display.[17] The complexity of displaying several hundred thousand items of every type and description sent in by 1700 exhibitors from all quarters of the globe was resolved only by careful planning and a rigid system of classification that placed everything under four major headings and thirty subdivisions. British photography fell under two classes: Class 10, *Philosophical, Musical, Horological, and Surgical Instruments,* which occupied one of the upper galleries; and Class 30, *Sculpture, Models and Plastic Art, Mosaics, Enamels, Etc.,* which could be seen largely in the Fine Art Court. Elsewhere, photographs were displayed on the stands of individual nations, where they were integrated among the products of that country.[18]

This intellectual and physical separation of British photography into two classes and two locations reflected the distinction between trade and art, commerce and self-expression, the daguerreotype and the paper print. For example, the leading London portrait studios of Beard, Claudet, Kilburn, and Mayall dominated Class 10, whereas Class 30 encompassed salted-paper prints by Samuel Buckle, Hill & Adamson, Henry Harmer, and Ross & Thompson. When Queen Victoria remarked that she had seen both "daguerreotypes and photographs" at the Great Exhibition, she neatly summarized a distinction that was widely recognized.[19] However, just at the moment when the daguerreotype and calotype were being celebrated for their differences, a new and radically different photographic process was introduced at the Great Exhibition. This was Frederick Scott Archer's collodion process, which combined the sharpness of a daguerreotype with the reproductive qualities of the calotype process through exquisitely sharp and detailed glass-plate negatives.[20] Unlike the daguerreotype and calotype, which had been encumbered by patents, Archer gave the collodion process to the world free of all patent restrictions. Its appearance marked the dawn of the second era of photographic evolution.

The year 1851 proved to be critical for photography in ways that transcended the introduction of the collodion process. British photography as a whole had not been well represented at the Great Exhibition, with many eminent practitioners entirely absent. This can be attributed in part to the convoluted process by which exhibitors were nominated for inclusion and in part to the fragmented and isolated status of photographers, who remained divided by class, process, and aspiration. James Glaisher, the official reporter for the exhibition's photographic jury, later commented that although Britain generally led the field in experimentation, it was the Americans who made superior daguerreotypes and the French who surpassed everyone with their calotypes.[21] At a general level, the jury was disappointed at the rather narrow scope of photography, which they felt did little more than "please the eye and administer to personal feelings."[22] They asked that photography realize its full potential in the wider service of mankind and civilization by applying itself to the rich variety of opportunities that awaited its attention. In many respects they were correct in this judgment, as the progress of British photography had been hampered by restrictive patents, complacency, and the lack of any professional organization like those that benefited artists and scientists.

Spurred on by this sorry state of affairs, a group of amateur photographers came together during the early summer of 1852 with the idea of forming a photographic society in London to better promote the medium throughout Britain. They met at the offices of the *Art Journal*; its editor, Samuel Carter Hall, had championed the cause of photography from the outset.[23] Setting up a learned society was no easy matter and required the stamp of authority if things were to proceed beyond the planning stage. For this, they turned to the Society of Arts, whose role in the Great Exhibition revealed it to be an organization sympathetic to the needs of science, art, and industry.[24] Under the auspices of the Society of Arts a committee was established, which consisted of Frederick Berger, Roger Fenton, Peter Le Neve Foster, Peter Wickens Fry, Thomas Goodeve, Robert Hunt, Sir William Newton, Dr.

John Percy, and Professor Charles Wheatstone. This group of professional men from the arts and sciences, all amateur photographers, was given formal responsibility for establishing the Photographic Society.

Before them, however, lay Talbot's photographic patents. These were regarded as having hindered progress, and before any society could be formed, this web of restrictions had to be swept away.[25] The committee petitioned Talbot to relinquish his patent rights and sent Sir Charles Eastlake and Lord Rosse, respectively presidents of the Royal Academy and the Royal Society, to plead its case. Not wanting to stand in the way of progress, Talbot agreed to give up his patent rights, and the way toward the formation of the Photographic Society was now clear.[26] Such was the level of interest that nearly two hundred individuals had registered by December 1852 and eagerly awaited the outcome of the inaugural meeting.[27]

What better way to launch a photographic society than with an exhibition? Joseph Cundall, publisher and amateur photographer, proposed the idea to the Society of Arts in November 1852, suggesting it should open a month later, around mid-December.[28] As this was to be the first exhibition dedicated exclusively to photography and a showcase for British practitioners, it was planned on an ambitious scale. When it opened with a grand soirée on 22 December 1852, there were nearly 400 photographs closely hung around the walls.[29] To have drawn together an exhibition of this size and significance in a little under four weeks reveals how well committee members were able to prevail upon friends, colleagues, and dealers for the loan of prints.[30]

London had seen nothing like it. Many leading newspapers and periodicals reviewed the exhibition in glowing terms and wrote optimistically of photography's future. Such was the public interest that the dates of the exhibition were extended and photographs were added later.[31] Although this nearly doubled the size of the show, to 779 exhibits, not a single daguerreotype was included. In the words of Queen Victoria, every exhibit was a photograph.

The Photographic Society was inaugurated on 20 January 1853 at the Society of Arts. Sir Charles Eastlake was elected president; the vice presidents were Sir William Newton, Earl Somers, and Charles Wheatstone. Roger Fenton became honorary secretary, and twenty other professional gentlemen made up the council.[32] By placing such eminent men at its helm, the society had set its course away from commercialism and toward the calmer waters of artistic and scientific endeavor, thereby conforming to the objectives of every learned society in London. By excluding London's eminent daguerreotypists from the council, the society further separated amateur from professional practice.

Encouraged by the critical success of the photographic exhibition, the Society of Arts created a reduced version of eighty-three prints that toured to affiliated organizations throughout Britain during the closing months of 1853 and early 1854.[33] Photographs by Samuel Buckle, Joseph Cundall, Philip Delamotte, Roger Fenton, Sir William Newton, Hugh Owen, Benjamin Bracknell Turner, and other leading amateurs were seen as far north as Aberdeen and as far south as Ventnor in the Isle of Wight. They were shown in market towns and cities wherever there was a Mechanics Institute or literary, philosophical, or scientific society

willing to cover the cost of transport and provide an adequate room for the display. Late in 1854 the Society of Arts created two exhibitions of similar scale that toured to thirty-three other venues. By the close of that year, these exhibitions had been seen in fifty-one towns and cities throughout Britain.[34] For many of the rural market towns and smaller industrial centers, these photographs would have been among the first ever seen publicly, as photographic studios were only just becoming economically viable in towns of this size.

Even if the emergence of provincial photographic societies cannot be directly attributed to the influence of these touring exhibitions, it is surely no coincidence that fourteen societies were established by 1856 and just four years later the number had risen to thirty-two.[35] Just as the annual exhibition of the Photographic Society held in London became an important event around which the year revolved, so it was that many provincial societies organized their own exhibitions to promote photography within their region. In nearly all cases these exhibitions were created by open submission, and this encouraged many photographers to send their latest productions to such diverse centers of photographic activity as London, Birmingham, Dundee, Edinburgh, Glasgow, Macclesfield, Manchester, and Norwich.[36]

National and provincial newspapers invariably reviewed these exhibitions in glowing, and often uncritical, terms. But this seemed to matter little, as photography remained a fashionable novelty to the largely undiscriminating middle-class audience who were its patrons. During this same period, the burgeoning number of periodicals and magazines that became a feature of the Victorian period regularly began to include articles and reviews about the progress of photography. From 1850 onward the *Illustrated London News* acknowledged with increasing regularity its use of photography as the basis for its woodcuts. The portrait photographers whose work was credited became household names, and their studios flourished accordingly.[37]

Specialist journals dedicated to photography also began to appear. For the most part, these began life as official journals of photographic societies but quickly evolved to deal with issues of wider interest to the hapless photographer. The absolute beginner was well served by the numerous handbooks, manuals, and self-help pamphlets published in increasing numbers, and frequently in many editions,[38] as the market for photography began to develop. As instrument-makers, opticians, and chemists turned their attention toward photography, advertisements for cameras, lenses, apparatus, and every necessity ever required, or dreamed about, appeared with increasing frequency.

STARTING OUT, 1855–56

During the five years following the Great Exhibition, both Dodgson and photography grew to fuller maturity. By 1856 Dodgson was no longer a hesitant freshman anxious to prove himself but a graduate with first class honors in the Final Mathematical School. During the same five years, photography also graduated from its nascent state into a cultural force throughout

Britain, finding public expression through portrait studios, photographic societies, exhibitions, and numerous publications.

When Dodgson decided to take up photography in 1856, it was regarded as the very latest thing—a fashionable pastime that allowed gentlemen to demonstrate their interest in technology, chemistry, and optics as well as to reveal their artistic tendencies. Perhaps it was this symbiosis between science and art that initially attracted Dodgson, but more likely it was the conceptual framework of photography that appealed to his fertile imagination. Through the ground glass of his camera, the view of his world would have been turned upside down and laterally inverted. People hung upside down; the foreground took the place of sky; what lay to the right now appeared on the left. Change the focal length of the lens and large things became small. Shift the focus of the lens and solid objects dissolved until they disappeared from view.

In the deep yellow light of the darkroom, other magic was at work. The alchemy of developing solutions made images appear out of thin air, with the invisible becoming visible, the third dimension reduced to two. Watching the glass plate develop offered a conundrum of reversed tones where white became black and black, white. In the world of photography, the positive became negative and the negative, positive. The transient became permanent and the established, fugitive. Nothing was ever quite what it seemed. To the imagination of the man who was later to write *Alice's Adventures in Wonderland* and *Through the Looking-Glass and What Alice Found There,* all of this must have seemed infinitely appealing.

Although photography may have been attractive to Dodgson for these reasons, there was an even more profound reason he wished to become a photographer. It is clear that he enjoyed a highly developed visual sensibility. Throughout his life he was concerned with the appearance of things and in his diaries noted his response to particular scenes at the theater or works of art at the Royal Academy. When writing, especially for children, he filled his texts with a rich tapestry of images that have endured through countless generations. Given this sensibility, it is hardly surprising that Dodgson wanted to be recognized as an artist. From a very early age he sketched and drew. The family magazines he wrote as a boy at Croft are full of his thumbnail illustrations, which owe more to the comic works of Thomas Hood than to fine art.[39] These childish efforts reveal an early interest in combining narrative structure and pictorial expression, something to which he would return with photography. Later, he drew the illustrations for the manuscript version of *Alice's Adventures Under Ground* that he gave to Alice Liddell (plate 3) as a Christmas present in 1864.[40]

Despite the charm and appeal of these drawings, Dodgson realized his own short-comings as an artist and looked for other ways to express himself visually. It was the eminent artist and amateur photographer Sir William Newton who suggested "the Camera is by no means calculated to teach the principles of art; but to those who are already well-informed in this respect, and have had practical experience, it may be the means of considerable advancement."[41] Photography offered the perfect way forward and met a number of criteria important to Dodgson. It was not solely a medium of artistic expression, but also a scientifically

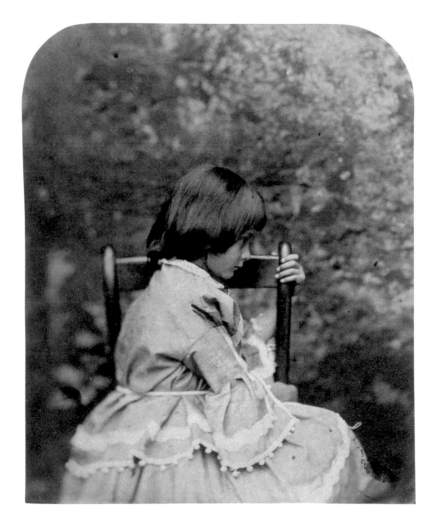

Plate 3
Alice Liddell, summer 1858
Deanery garden, Christ Church,
Oxford
5 x 4 in. (12.6 x 10.3 cm)
A(I): 75

complex business that required total mastery of each delicate stage of manipulation if it were to succeed. The discipline and order demanded by the process suited Dodgson's love of self-control and sense of purpose. Being the most fashionable hobby that a young man of his social class and education could pursue, it also gave him privileged access to individuals and situations that might otherwise have been denied him. For all these reasons, photography became critically important to the fulfillment of Dodgson's emotional needs and personal development.

The first of Dodgson's surviving diaries begins in January 1855, so we have no firm evidence that he had taken any prior interest in photography. But photography was all around him, making itself known in a variety of ways, and given his visual sensibilities, it seems unlikely that he remained insulated from it. He might well have seen the photographs during his visit in 1851 to the Great Exhibition, where he went as a reward for having successfully passed his first examinations at Oxford. Sadly, he failed to mention the photographs displayed in the Fine Art Court when writing to his sister about the many sculptures exhibited there.[42]

Only four years later, with the first diary, do we get some sense of Dodgson's interest in photography. It started in January with a visit to have his portrait taken by the local photographer in Ripon, Yorkshire. That proved not to be an auspicious start: Dodgson wryly noted in his diary that it took three failures to get a tolerably good likeness, which half his family pronounced "the best possible, and the other half the worst possible. . . ."[43] This one simple lesson taught him that photographs were neither universally appreciated nor readily achieved (especially during winter months when poor light made for lengthy exposures).

It has long been assumed that Dodgson's Uncle Skeffington, himself an amateur photographer, encouraged his nephew to take up photography. They certainly spent time together photographing the countryside around Croft during the summer months of 1855. Robert Skeffington Lutwidge, an unmarried brother of Dodgson's mother, was a barrister and commissioner in lunacy by profession and lived in London. An enthusiastic amateur, he joined the Photographic Society shortly after its founding, along with his friend and colleague Hugh Welch Diamond, superintendent of Surrey County asylum and an amateur photographer of distinction. Both were members of the Photographic Exchange Club, a group of like-minded amateurs who took it upon themselves to exchange photographs and technical details once a year. Uncle Skeffington's *Knole, Kent, in the Rain,* submitted to the annual exchange of prints of 1855–56, is a masterpiece of formal composition and technical competence.[44] But, like many other amateur photographers, Uncle Skeffington also found photography a frustrating pastime. Dodgson noted that the results from their time together photographing at Croft were "not very successful."[45] Undoubtedly Uncle Skeffington did help his young nephew to gain a better understanding of the complexities and joys of photography and presumably influenced Dodgson's decision to start the following year, but his role was less central than has been assumed.

A more likely candidate for that privilege was Reginald Southey, a friend and fellow student at Christ Church, who by 1855 was already a competent photographer. The first hint

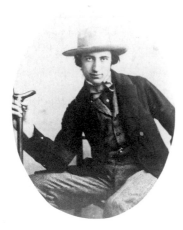

Plate 4
Reginald Southey (1835–1899)
Portrait Study of a Young Man, 1856
Christ Church, Oxford
4½ x 3⅝ in. (12.7 x 9.5 cm)
Cotsen Collection, Princeton
University Library, RS5: 32b

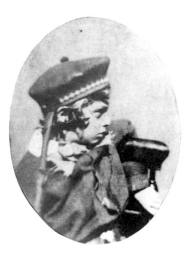

Plate 5
Reginald Southey (1835–1899)
Harry Liddell, 1856
Christ Church, Oxford
2⅞ x 2¼ in. (7.4 x 5.6 cm)
Cotsen Collection, Princeton
University Library, RS5: 32a

that Dodgson and Southey shared a common interest in photography comes in March 1855, when together they looked over Southey's most recent successes. One of these, a view of the Broad Walk taken from Southey's window, Dodgson thought "about the best amateur attempt that I have seen."[46] Although Reginald Southey was three years younger than Dodgson, having entered Christ Church in 1853, they struck up a friendship that seems to have been centered on their common interest in photography.[47] Southey and Dodgson came from similar social and educational backgrounds, and it is possible they might have known of each other through family connections before 1853. Southey's father, Henry Hubert Southey, was physician in ordinary to George IV, and physician extraordinary to Queen Adelaide, with his own practice in Harley Street, London. In 1833 Lord Brougham appointed him a physician in lunacy, a role in which he was likely to have known Dodgson's Uncle Skeffington.[48] Further polish was given to these already glittering social connections by Reginald's Uncle Robert, whose appointment to the post of poet laureate in 1813 had given formal recognition to "our only existing entire man of letters," as Byron called him.[49]

Reginald Southey has been referred to as little more than a "friend-in-photography" and "chum" who was conveniently on hand when Dodgson decided to take up photography in 1856.[50] But there is more to the friendship than that. Several of Southey's photograph albums, now at Princeton, show him as an extremely competent photographer. The earliest album, dated from 1855, is a typical compilation of the period. It contains over one hundred prints, the majority of them trimmed small into rectangles and ovals, many mounted three or four to a page. There is the usual mixture of subject matter, including topographic studies and copies of engravings, but portraits of family, friends, fellow students, and a dog predominate.

The composition and style of these portraits epitomize the vast majority of amateur work being produced at this time. Southey's prints are small, with the settings simplified to the point of austerity—in direct contrast to the more elaborate furnishings of the commercial portrait studio. For all their apparent shortcomings, these photographs represented a real achievement for Southey (see plates 4–7). Each diminutive print was regarded a minor success to be examined with the keenest admiration. As one leading commentator put it: "What indeed are nine-tenths of those facial maps called photographic portraits, but accurate landmarks and measurements for loving eyes and memories to deck with beauty and animate with expression, in perfect certainty, that the ground-plan is founded upon fact?"[51] One can well imagine the two young men eagerly discussing each new photograph, debating the artistic merits of posing and arranging the sitter, and deliberating over the latest chemical and optical improvements announced in the photographic press. Photography was clearly important to them both, and to keep abreast of the latest developments, they dedicated their wholehearted attention to its practice and progress.

Although he had yet to take up photography, Dodgson wrote a witty article about its application to literature for the periodical *Comic Times* during the summer vacation of 1855. With his characteristically fertile imagination, he suggested that the chemical principles of photography could be applied to literature in order to reduce "the art of novel-writing to the

merest mechanical labour." With the aid of a machine to focus mesmeric thoughts, the most transient of concepts could be transferred to the surface of specially prepared paper where, in the manner of a photographic negative, the simplest train of thought could be developed to different degrees of literary style. The literary style resulting from the gentlest development was the "milk-and-water School of Novels," which with further immersion, could be intensified to the "Matter-of-Fact School."[52] Development to Byronic intensity could be attempted, but only with extreme caution as it was known his fiery epithets would scorch and blister the paper. By suggesting that photography relied on the power of its chemistry for its ultimate effect, Dodgson was inverting his own beliefs for the sake of comic narrative. For him, successful photographs depended upon the conception of the artist and not the chemicals of the developing bath.

Had Dodgson wanted to take up photography during 1855, he would have been restrained from any significant expenditure by his modest income of around £50 per annum.[53] However, his appointment as full-time mathematics lecturer at Christ Church during the closing months of 1855 dramatically improved his financial circumstances. On New Year's Eve 1855 at Croft, he confided in his diary:

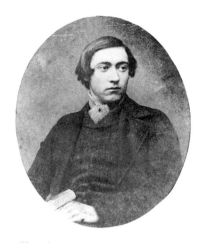

Plate 6
Reginald Southey (1835–1899)
Self-Portrait, 1856
Christ Church, Oxford
2¾ x 2⅜ in. (7.1 x 5.8 cm)
Cotsen Collection, Princeton
University Library, RS5: 32d

> I am sitting alone in my bedroom this last night of the old year, waiting for midnight. It has been the most eventful year of my life: I began it a poor bachelor student, with no definite plans or expectations; I end it a master and tutor in Ch. Ch., with an income of more than £300 a year, and the course of mathematical tuition marked out by God's providence for at least some years to come. Great mercies, great failings, time lost, talents misapplied—such has been the past year.[54]

For the first time in his life, Dodgson was well off. For a bachelor with all his creature comforts provided by the college, £300 represented a significant income that cleared the way for him to take up photography.

Shortly after returning to Oxford in January 1856, Dodgson wrote to his Uncle Skeffington asking him "to get me some photographic apparatus, as I want some occupation here [other] than mere reading and writing."[55] This request went unheeded, so we find Dodgson and Southey, two months later, heading along Caledonian Road in north London in search of Ottewill & Co., one of London's preeminent camera makers (plate 8). Attracted by the extremely fine workmanship and ingenious design of Ottewill's cameras, Dodgson took the plunge and spent £15 on an outfit.[56] In every sense, this was a significant purchase. Dodgson never rashly consigned himself to anything, and as this purchase exceeded what most families would have paid their cook annually, we see that he had committed himself to photography in a very serious way.[57]

With understandable enthusiasm, he tried out his camera as soon as it arrived on 1 May but soon discovered that the chemicals he had borrowed from Southey no longer

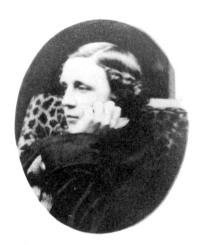

Plate 7
Reginald Southey (1835–1899)
Charles Lutwidge Dodgson, 1856
Christ Church, Oxford
2⅝ x 2¼ in. (6.7 x 5.5 cm)
Cotsen Collection, Princeton
University Library, RS5: 33c

Plate 8
Advertisement for Thomas
Ottewill's Photographic Apparatus
Journal of the Photographic Society,
21 December 1855

Plate 9
William Lake Price (1810–1896)
The Monk, wood engraving from
a photograph, 1856
Illustrated London News,
22 March 1856

worked. This was a predictable setback, as the complexities of photography were not easily mastered. The collodion process required that every plate be prepared for exposure on the spot. Each chemical had to be applied by hand with a manual dexterity and lightness of touch that came only with practice. The power of the light had to be judged and the exposure time calculated. The newly exposed plate had to be developed immediately before the chemicals hardened and spoiled. From start to finish the whole process was carefully choreographed so that nothing interrupted the flow and sequence, and like all choreography, it needed careful and frequent rehearsal if the outcome were to be successful.

Dodgson's decision to use the demanding collodion process throughout his photographic career was unequivocal. He used nothing else, despite the ready availability of alternative paper processes that were the preferred option of many amateurs, including his Uncle Skeffington. Dodgson sought accuracy and perfection in everything he attempted, whether it was photography, publishing, or poetry. He rejected, often to his financial cost, anything that failed to meet his own demanding standards.[58] This love of precision and exactitude probably affected his choice of collodion, as he preferred crisp focus and fine details in his photographs over the softer-working paper negative processes. This choice initially meant that he had to struggle with the manipulation and exposure of collodion before he was fully in control.

During the first two weeks in May, Dodgson and Southey experienced the trials and tribulations of photography, producing some successes but many failures.[59] Together they made portraits of colleagues and of each other. Their most instructive attempt was to photograph young Harry Liddell, who came to Southey's room, where they "had great difficulty in getting him to sit still long enough."[60] Three days later Dodgson went to see Harry's father, Dr. Henry Liddell, dean of Christ Church, taking the opportunity "to show him Harry's likeness and Southey's book of photographs: he asked me to stay luncheon [*sic*], and Mrs. Liddell proposed to bring over Harry again: Southey agreed to try him, and got one tolerable picture and several failures."[61] The lesson that showing photographs could effect a social entrée cannot have escaped Dodgson, and the advantages of presenting work in albums remained with him throughout his photographic years.

During the afternoon of 13 May 1856 Dodgson noted, "Southey spent a long time making up developing fluid for me, so that I am now ready to begin the art."[62] This date marks the start of Dodgson's independence as a photographer, although the decision about what to photograph still remained. We get an indication of what direction he might follow from an earlier visit he had made to the 1856 annual exhibition of the Photographic Society, where photographs of every style and application ranged around the walls. Landscapes and architectural studies taken throughout Britain and Europe dominated the exhibition. Photographing distant prospects, leafy glades, and crumbling ruins was the preferred option for the majority of amateurs. Armed with the latest guidebook and delivered to their destinations by the rapidly expanding railway network, photographers took their cumbersome equipment in

search of the picturesque. Each summer countless numbers of them pitched tripods and set up cameras in search of the perfect composition they hoped would be the center of attention at a forthcoming photographic exhibition.

Not so for Dodgson. Throughout his entire photographic career, he made only a limited number of topographic and architectural studies, and few are worthy of comment. His diary reveals that his preferences already lay with portraiture. During his visit to the exhibition he noted: "there was a very beautiful historical picture by Lake Price, called 'the scene in the tower,' taken from life. It is a capital idea for making up pictures. There is another, nearly as good, of the same kind, 'the confessional.' Some of the coloured portraits are exquisite—equal to the best enamel: one of the best portraits is Kean, in the character of Cardinal Wolsey."[63] The following day Dodgson made another visit, discovering another photograph by William Lake Price, entitled *The Monk* (plate 9), which he had overlooked previously. This study he thought "magnificent."[64] Given the wide range of work in the exhibition, Dodgson's response to the studies by Lake Price is significant, for they can be seen as early role models for his own aspirations, drawing together as they do themes of art, theatricality, and religious belief. That Dodgson's preferences accorded with the general taste of the day is reflected by the *Illustrated London News,* which devoted a full-page illustration to *The Monk,* drawing attention to its links with the work of the seventeenth-century Spanish painter Francisco Zurbarán.[65]

Life at Christ Church was regulated by a timetable that was as regular and immutable as the seasons. The "Long Vacation" of the summer months offered nineteen weeks of freedom and, in 1856, the opportunity for Dodgson to make his first photographic excursion. At the earliest opportunity, he packed up his new camera, chemicals, and paraphernalia and "went up to town" to stay with another uncle, Hassard Hume Dodgson in Putney, on the outskirts of London. For the next two weeks, he relaxed by going to the theater, the summer exhibitions at the Watercolour Society and the Royal Academy, visiting relatives and organizing an informal party for children when the weather turned wet.[66] During his time in Putney, it became clear that Dodgson had decided to concentrate upon portraiture as his chosen subject for photography. He photographed his various relatives, nieces and nephews, and their various friends. One of these portraits is of Alice Murdoch, who, along with her family, had come over specially to be photographed (plate 10). Dodgson posed little Alice uncomfortably on a chair with her legs tucked under her skirt, looking for all the world like a china doll. For an early attempt it is an adequate portrait, but the rigid pose and the emotional distance between Dodgson and his subject reveal the nervous hand of a beginner, ill at ease with posing a small child. Whatever we may now think of the photograph, it was clearly important to Dodgson. He composed a poem dedicated to Alice, which he meticulously inscribed opposite the portrait in the first of his personal albums:[67]

Plate 10
Alice Murdoch, 19 June 1856
Park Lodge, Putney
3⅞ x 3⅛ in. (10 x 7.8 cm)
Gernsheim Collection,
Harry Ransom Humanities
Research Center, University
of Texas at Austin

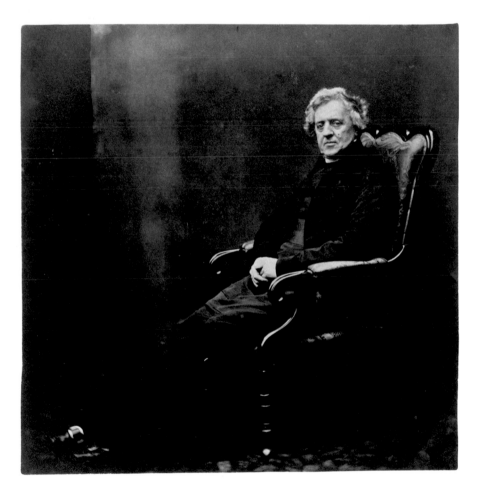

Plate 11
Archdeacon Charles Dodgson,
July 1856
Croft Rectory, Yorkshire
4⅝ x 4½ in. (11.8 x 11.5 cm)
Gernsheim Collection,
Harry Ransom Humanities
Research Center, University
of Texas at Austin

O child! O new born denison
Of life's great city! on thy head
The glory of the morn is shed
Like a celestial benison!

Such a response may seem strangely overembellished, but overt admiration and devotion to children was commonplace during the period.

Dodgson returned home to Croft the following week, and one can imagine the fuss and excitement when he showed off his new camera and demonstrated his newly acquired skills as a photographer. For a portrait of his father (plate 11), he created an outdoor studio by rigging up a black cloth as background and placing a chair and carpet as if the setting were indoors. Dressed entirely in clerical black, his father sits in a relaxed pose with his legs outstretched and his hands resting comfortably in his lap. His steady gaze is kindly and self-assured, revealing some of the affection between father and son.

For a more haunting portrait of three of his sisters (plate 12) taken the following year, Dodgson set himself the difficult challenge of photographing indoors. Here, in the drawing room of Croft Rectory, the high Georgian window is the sole source of illumination. The deep shadows and high-relief modeling created by this type of lighting are very effective. This appears to be a simple photograph, but it required Dodgson to be in precise control at each stage of the process. Collodion was an unforgiving medium for capturing such extremes of contrast and low levels of lighting. The standard advice was to expose for the shadows and develop for the highlights, but how was a beginner to gauge this with neither an exposure meter nor experience to guide him? It may have taken many attempts for Dodgson to get the exposure and development of this composition just right. But since he recognized the important link between concept and execution in picture making, he would have persevered to achieve perfection.[68] The resulting image of his sisters with their distant gazes and partial obscurity in deep shade suggests the sense of loss the family must have felt with the death of their mother five years earlier. This is a study not of happy family life but of grief and sadness, with each of the sisters set apart in emotional isolation. Contrast this image with his portrait of the Dodgson and Murdoch children taken during his earlier stay in Putney (plate 13). Here, the six girls are heaped together in close and affectionate proximity.

During the remaining weeks of his Long Vacation, Dodgson continued to photograph at every possible opportunity, concentrating mainly upon portraiture. He was rarely without his photographic paraphernalia wherever he traveled; even at this early date he wasted no time in demonstrating his newfound skills to friends and relatives, persuading them to sit for his camera. Photography was still very much a novelty, and Dodgson would have found a ready audience wherever he set up his camera. There were successes, but his photographs did not always turn out well and failure remained a constant frustration that he persevered to overcome. He used his nineteen weeks to good effect: by his own later reckoning he made over eighty negatives, which for his first summer's work was no mean achievement.

Plate 12
*Three Dodgson Sisters in the
Drawing Room, Croft Rectory,
July/August 1857*
Croft Rectory, Yorkshire
4⅞ x 5¼ in. (12.5 x 13.2 cm)
Gernsheim Collection,
Harry Ransom Humanities
Research Center, University
of Texas at Austin

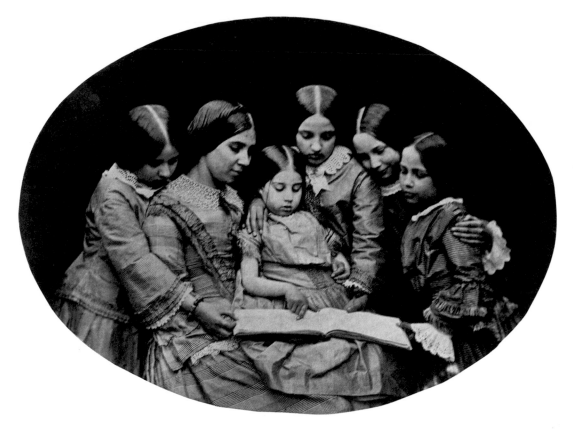

Plate 13
Dodgsons and Murdochs,
19 June 1856
Park Lodge, Putney
4 1/8 x 5 5/8 in. (10.4 x 14.2 cm)
Gernsheim Collection,
Harry Ransom Humanities
Research Center, University
of Texas at Austin

After returning to Oxford in October, Dodgson continued his photography by taking another series of portraits of Harry and Ina Liddell in the Deanery at Christ Church, where he had set up his photographic darkroom. His frequent visits to the Deanery seem not to have been welcomed by Mrs. Liddell, who decided that he could no longer photograph Harry and Ina until all the children could "be taken in a group." Dodgson recoiled from this slight reproach with characteristic sensitivity, resolving not to return until invited.[69] An invitation to dine at the Deanery came the following week; he and the Liddells spent part of the evening looking at an album of photographs by John Dillwyn Llewellyn brought by his son, who was also a dinner guest.[70]

At the close of each year, Dodgson was in the habit of confiding his most personal thoughts and feelings to his diary. He was critical of his every shortcoming and failure, usually blaming himself for inactivity and lack of purpose. Just before midnight on 31 December 1856 he looked back over the eventful past year with a characteristic candor that is worth quoting in detail for the insights it offers into his personality.

> Half past eleven: Now at the close of the Old Year, let me review the past and
> take counsel with myself for the future. I must with sorrow confess that my bad
> habits are almost unchanged. I am afraid that lately I have been even more

irregular than ever, and more averse to exertion: though the labour of last term has been nearly as heavy as at any period in my life, it has been forced on me by my position, rather than taken up voluntarily.

As to the future, I may lay down as absolute necessities, *Divinity Reading*, and *Mathematical Reading*. I trust to do something this Vacation, but most of the Long Vacation must be devoted to work, and I think my best plan will be to take lodgings wherever Price has his reading party and so get occasional help from him. On other subjects I think there is no use in making resolutions, (I hope to make good progress in Photography in the Easter Vacation: it is my one recreation, and I think should be done well).

I do trust most sincerely to amend myself in those respects in which the past year has exhibited the most grievous shortcomings, and I trust and pray that the most merciful God may aid me in this and all other good undertakings. Midnight is past: bless the New Year, oh heavenly Father, for thy dear Son Jesus Christ's sake![71]

Here is the conflict of emotions that was to dominate many aspects of Dodgson's life. He clearly enjoyed photographing but felt it had been at the expense of his academic studies. He resolved to confine it to the shorter Easter Vacation so that he might catch up with his reading. He took his responsibilities as a mathematics lecturer seriously and wished that he could overcome his "bad habits" of laziness and lack of will. This sense of failure and inadequacy was compounded by the ecclesiastical context of Christ Church, where every member was expected to devote significant time to worship and religious study, with the ultimate goal being full ordination as an Anglican priest. Despite his deep religious convictions, Dodgson felt he had "exhibited the most grievous shortcomings," which contributed to his lack of self-esteem and gave rise to fervent promises for the future. The feelings of doubt and failure that pervade this period of Dodgson's life seem to have provoked him into setting ever higher standards in everything he attempted, rejecting any result that did not meet his expectations.

These overarching attitudes and beliefs shaped Dodgson's attitude toward photography. From the outset it was clear that photography had the potential to become an important component of his life, even if he claimed it only as his "one recreation" (plate 14). Dodgson insisted that everything, even recreation, had to be done properly if progress were to be made. His considerable investment in an Ottewill camera, one of the most expensive on the market, shows he was unwilling to pay less and suffer inferior results, but the high expense of spoiled negatives soon made him conclude that it was "extravagant to attempt photographs, excepting when success is tolerably certain."[72] But whatever the expense or technical difficulty, it was photography's capacity to satisfy his artistic ambitions that mattered most, and what better way of showing his skills than through the pages of a carefully sequenced album.

Plate 14
Broad Walk with Figures,
Christ Church,
June 1857
Christ Church, Oxford
5¾ x 6½ in. (14.8 x 16.4 cm)
A(I): 40

Having seen how the albums of Southey and Llewellyn attracted attention and praise, Dodgson followed their example. As early as October 1856 he began the first of his own albums, which he used from the very outset to legitimize his photography by demonstrating his artistic abilities and technical competence.[73] These albums, of which there were to be several, became centrally important to Dodgson as the principal means of expressing himself as a photographic artist. He also thought that hand-colored photographs lifted photography into new realms of artistic expression by making them even more like paintings and considered the colored portraits he had seen at the Photographic Society exhibition "exquisite—equal to the best enamels."[74] By the end of the year he presented Mrs. Liddell with two colored portraits of the children.[75] For the next forty years, Dodgson regularly employed artists to color his presentation photographs.

THE EARLY YEARS, 1857–62

After this detailed look at the first two years of Dodgson's photographic initiation, there is no obvious way to divide the remaining twenty-three. In some years he was incredibly active, in others, less so. What determined his output is not always apparent, though his other commitments to writing, publishing, and academic life played an important part in setting the rhythm of his photographic endeavors. More evident are various differences in the style and appearance of his work that became apparent between 1857 and 1880. The first significant change appeared after 1863, when he took premises in Oxford to use as a photographic studio. The second change came with his move in 1872 from those premises into a purpose-built studio he had recently erected directly above his college rooms at Christ Church. There, in complete privacy, his photography moved into its final phase of development. His occupation of these two photographic studios has been used below to delineate the sections devoted to his middle and final years.

The six years between 1857 and 1862 were the most active period of Dodgson's photographic career, during which he added the better part of seven hundred new photographs to his inventory. These images trace his development from a hesitant beginner to a self-assured photographer who took every opportunity to experiment with framing and composition. His posing and arrangement of the figure became more self-assured as he began to grasp what was essential for good results. Although his subject matter is dominated by portraiture, he also photographed anatomical specimens, sculpture, paintings, and topographic views. This was the period that saw him produce some of his most celebrated photographs, the best known of which is Alice Liddell as *The Beggar Maid* (plate 44) of 1858. A pivotal year for Dodgson was 1860, when the British Association for the Advancement of Science held its annual meeting at Oxford University. This created new photographic opportunities that he was quick to realize. The period closed with Dodgson about to move into his new photographic studio on the premises of Richard Badcock, which he first began to use in 1863.[76]

When Dodgson took up photography in 1856, it was a period when young men of his education and economic status believed it fashionable to do so. Most of these new amateurs soon became disillusioned, overwhelmed by technical demands that lay beyond their capabilities. The editorial pages of photographic journals are strewn with their pleas for help. As with many other fashionable pastimes, the novelty soon wore off, and one suspects that many photographers quickly moved on to the more secure recreation of, say, collecting ferns and seaweed.

On another front, the world of commercial portrait photography had become a flourishing trade that continually sought to widen its audience with new forms of presentation and lower prices. The preferred format that came to dominate, especially after 1860, was the carte-de-visite. The relative low cost of this diminutive format prompted large numbers of middle-class sitters to be photographed for the first time. They were posed before studio settings that became increasingly elaborate and fussy until it became common practice for photographers to offer a choice of painted backdrops that ranged from rural idyll to heavy drapes with a stately column, in the belief that such settings met the social aspirations of their sitters. The customer's options were strictly limited to the choice of setting but not the pose, which increasingly conformed to well-defined conventions that had the camera set to a fixed distance and height from the sitter. Rather than rely on artistic sensibility, the pose was determined by the sitter's relationship to the props, on which the subject invariably leaned or drooped. Such overelaborate and formulaic carte-de-visite portraits (plates 15 and 16) were the very antithesis of everything that Dodgson strove to achieve in his own work.

When photographers began the wholesale publication of carte-de-visite portraits of eminent figures in Victorian life and culture, an entirely new and lucrative market opened up. Within a short time, likenesses of such notable figures as Queen Victoria and Prince Albert, William Gladstone, Michael Faraday, William Holman Hunt, and Alfred, Lord Tennyson, could be bought for a shilling each. Specially designed albums for the carte-de-visite became the proud possessions of many homes, their organization carefully structured to reflect the taste and political persuasion of the family. Although Dodgson's portraiture was diametrically opposed to the aesthetic sensibilities of the commercial carte-de-visite, he was nevertheless affected by their ubiquity. The organization and sequencing of his own photograph albums owe much to the prevailing structure of those carte-de-visite albums, which invariably began with portraits of the royal family and other distinguished heroes before moving to members of the immediate family. Dodgson also collected carte-de-visite portraits, buying "the whole set of the Royal Family" shortly after Mayall published them in 1860.[77] Over the years, he continued to collect cartes-de-visite, but only conceded to the popularity of the format when he began taking his own carte-de-visite-sized portraits in 1871.[78]

The spectacular growth of photography was achieved during a period when the dominance of amateur ideals was gradually being eroded by commercial values. Between 1857 and 1862 the council of the Photographic Society continued to exclude commercial photographers and lobbied to have this type of work kept out of their annual exhibitions.[79]

Plate 16
James Gordon
Carte-de-visite Portrait, c. 1860
4 x 2½ in. (10 x 6.3 cm)
The Art Museum, Princeton
University. Anonymous gift.
© 2001 Trustees of Princeton
University

Ultimately, their efforts proved futile as it became increasingly apparent that there was no justifiable distinction between an amateur selling prints as works of art and a commercial photographer selling his wares to the general public. Although the issue was thought to be ideological, it rested more on the confusion about the social and aesthetic status of photography, especially when practiced by an entrepreneurial (and likely uneducated) commercial photographer who could never be regarded as a fine artist. The denouement in this long-running conflict occurred when the commissioners of the 1862 International Exhibition, London, classified photography alongside machinery, rather than with the fine arts. The ensuing outcry forced the commissioners to grant British photography a separate department where photographs would be properly exhibited. But as this was tucked away up a flight of seventy stairs, their decision was not altogether magnanimous and the general regard for photography as one of the fine arts diminished correspondingly.[80]

The aspirations of the original band of enthusiastic amateurs who had established the Photographic Society evaporated by 1865, as power increasingly moved into the hands of trade and commerce. The novelty that had distinguished photography in its early years also gradually eroded as increasing numbers of people became familiar with the process of being photographed at one of the many studios that had sprung up around the country.[81] Given this background, it is hardly surprising that Dodgson never joined the ranks of the Photographic Society, or any other photographic society for that matter. No doubt aware of the growing conflict between artistic ideals and commercial imperatives, he chose to distance himself from these issues, realizing that the strength and authority of his own work lay in its individuality. To understand how this was achieved, we need to look more closely at Dodgson's working methods.

A number of elements influenced the outcome of Dodgson's photography: his choice of equipment and materials, his grasp of artistic principles, and his admiration of photographers he wished to emulate. His choice of the Ottewill camera in 1856 was a key factor in how he could photograph. Unlike the large and cumbersome equipment used by studio photographers, the compact design of the Ottewill made it extremely portable, allowing Dodgson to photograph wherever he chose. He acknowledged the design of the camera in his parody "Hiawatha's Photographing," where its complexity and construction are well described:

> From his shoulder Hiawatha
> Took the camera of rosewood,
> Made of sliding, folding rosewood;
> Neatly put it all together.
> In its case it lay compactly,
> Folded into nearly nothing;
> But he opened out the hinges,
> Pushed and pulled the joints and hinges,

Till it looked all squares and oblongs,
Like a complicated figure
In the Second Book of Euclid.[82]

The Ottewill camera was extremely adaptable, allowing Dodgson to take a variety of nega-
tive sizes from whole plate (6½ x 8½ in.) down to quarter plate (3¼ x 4¼ in.) without chang-
ing cameras.[83] At a time when making an enlargement was not a viable option, the size of
the print was entirely dictated by the size of the negative—large negatives gave large prints.
Large plates also required a long exposure; a smaller plate correspondingly less, and to a large
extent Dodgson's choice of negative size was dictated by these factors. Accordingly, he selected
small negatives for portraiture, especially of children, and larger sizes for inanimate subjects
such as the anatomical specimens where long exposure times were not a critical factor.

Dodgson's choice of lens was as important as the selection of his camera, for there
was little point in fitting poor-quality optics to a high-quality camera. Given his ambition to
achieve good results at the outset, he probably bought a lens designed and manufactured by
Andrew Ross, a leading optician and gold medal winner at the 1851 Great Exhibition, who
was also the main agent for the Ottewill camera.[84] His lenses were renowned for their optical
quality, which permitted short exposure times and minimized most of the usual aberrations
and distortions to give crisp definition, making them ideal for portraiture.

The most troublesome part of photography was its chemistry. There was little stan-
dardization between one manufacturing chemist and another. Adulterating chemicals with
cheap substitutes was commonplace. Even that most undistinguished of elements, water, was
unreliable and contaminated with every possible impurity. Consequently, photographers
fought a never-ending battle with their chemical baths as they attempted to achieve consis-
tent results. Dodgson bought his chemicals from reputable manufacturers whose products
were more likely to be pure and reliable. The higher prices involved in buying direct from
London would have been offset by the promise of consistent results.[85] Although he was always
judicious with money, Dodgson was not prepared to sacrifice quality in order to save a few
pence; photography was, after all, his major pastime and he believed it should be done well.

Reading Dodgson's diaries and letters, one senses a person for whom order and self-
discipline were essential. This is less evident when he was a young man, but in later years,
his bachelor existence as a college don became as methodical and regular as a timepiece. His
biographer tells us he was "a laborious worker, always disliking to break off from the pursuit
of any subject which interested him; apt to forget his meals and toil on for the best part of
the night, rather than stop short of the object he had in view."[86] He did everything system-
atically and with a strong sense of purpose that might now be considered obsessive. His every-
day life was filled with routine, nothing was left to chance, and everything had to be under
his control. He made endless lists as if his very preservation depended upon them, which in
an unconscious way, it did. From 1861 he began registering all his letters, both incoming and
outgoing, including a précis of their contents. It has been estimated that by the end of his life

he had registered well over fifty thousand letters, placing him among the most prolific correspondents of the period.[87]

Apply these traits to his photography and it is easy to understand that Dodgson's personality allowed him little choice but to be a careful and systematic worker in search of perfect results. Unlike those by many amateur photographers, Dodgson's collodion plates bear none of the telltale signs of sloppy or hasty work. From an early stage, he knew what he wanted to achieve and worked steadily toward its realization. Every aspect of his photography was perfected through trial and error, and once a skill was mastered it was never forgotten or hastily abandoned for a more fashionable approach or technique. At every stage his careful and deliberate control over every aspect of the procedure, from the camera to the collodion, rendered his photographs technically superior.

Dodgson seldom wrote expansively about photography in his diary. We get brief glimpses of his successes and failures with remarks about "photographing with very slender success."[88] We learn about whom he photographed and whether he thought them beautiful or striking. We read about his problems with the developing bath and about the faulty safelight that fogged his plates. He concentrated upon technical matters with never a word about photographic aesthetics or what kind of results he strove to achieve. As so often with Dodgson, we have to look elsewhere to get a bearing on his attitudes and values. In "Hiawatha's Photographing," his use of irony to describe a portrait session reveals by inversion (a very Carrollian trait) what he valued most about his own photography:

> First the Governor, the Father:
> He suggested velvet curtains
> looped about a massy pillar;
> And the corner of a table,
> Of a rosewood dining-table.
> He would hold a scroll of something,
> Hold it firmly in his left-hand;
> He would keep his right-hand buried
> (Like Napoleon) in his waistcoat;
> He would contemplate the distance
> With a look of pensive meaning,
> As of ducks that die in tempests.[89]

The pretentious wife fares little better, overadorned in jewels and satin, "far too gorgeous for an empress. / Gracefully she sat down sideways, / with a simper scarcely human, / holding in her hand a bouquet / rather larger than a cabbage." The plain daughter wanted to be taken with a look of "passive beauty," which consisted of squinting and drooping eyes and a "smile that went up sideways / to the corner of the nostrils."[90] Here, in order to make his point, Dodgson comically embellished the pretensions of those aspiring members of the

middle classes who sat for studio portraits. But through this satire he positioned himself at the opposite end of the photographic spectrum, where self-assurance, simplicity, beauty, and a lack of ostentation were hallmarks of his class; Dodgson was nothing if not a snob. These values carry through into his photographs, where neither velvet drapes, Napoleonic poses, bouquets, or unpleasant features intrude upon his compositions. Instead, Dodgson's sitters are distinguished, noble, handsome, or beautiful (plate 17), with never an anxious face to upset the countenance of his idealized world. They are his heroes, heroines, child friends, relatives (plate 18), and colleagues, all of whom belonged to his social circle, or the one to which he aspired.

Within this context, Dodgson felt it was crucially important that his results conform to well-established artistic principles, and he dedicated much of his spare time and energy to their study. During the course of 1857, his first full year of photography, he visited the exhibitions of the Society of British Artists, Modern Painters, Royal Academy, and the Photographic Society in London. During the Long Vacation, he visited the National Gallery, Edinburgh, and the *Art Treasures Exhibition,* Manchester. These visits were not hurried or superficial. Usually he spent the better part of the day looking at pictures, making careful notes in his diary, and often returning the following day for further reflection and analysis.[91] In Edinburgh, entranced by Noël Paton's *The Quarrel,* he counted every fairy in the painting, arriving at a total of 165.[92] On a more practical level, he "took hasty sketches on the margin of the Catalogue of several of the pictures, chiefly for the arrangement of hands, to help in grouping for photographs" during a visit to the Society of British Painters.[93] For more detailed study he "ordered various photographs, including some exquisite ones at Colnaghi's, of paintings in the Manchester Exhibition."[94]

During visits to the theater throughout the year, Dodgson often commented upon the visual effects of the production. At the Princess's Theatre he judged that the "scenic effects in *The Tempest* certainly surpass anything I ever saw there or elsewhere," and the graceful appearance of Kate Terry as Ariel was "one of the most beautiful living pictures I ever saw."[95] His visual acuity was so refined he could spot theatrical references in contemporary paintings, remarking that *Queen Katherine's Dream* by Henry Le Jeune, on show at the Royal Academy, was "clearly taken from the scene at the Princess'."[96] Even at Christ Church, where we think of him as concentrating upon mathematics and theology, art was all around him. During the course of that academic year he read Edward Young's book on the Pre-Raphaelites, met William Holman Hunt and William Collins in the Christ Church Common Room, and had long discussions "on Art, Ruskin, etc., etc." with his colleague and art theorist the Rev. Richard St. John Tyrwhitt.[97]

The range and scope of these activities throughout 1857 reveal the true extent of Dodgson's fascination with and commitment to art. His sophisticated visual sensibility drew him to images of every type, whether paintings, sculptures, drawings, photographs, or theatrical tableaux. It would have become clear to anyone that he was well educated and thoroughly conversant with all aspects of contemporary art, and he doubtless was pleased to be so regarded. It was within this broad context as art lover, critic, and connoisseur that he conceived

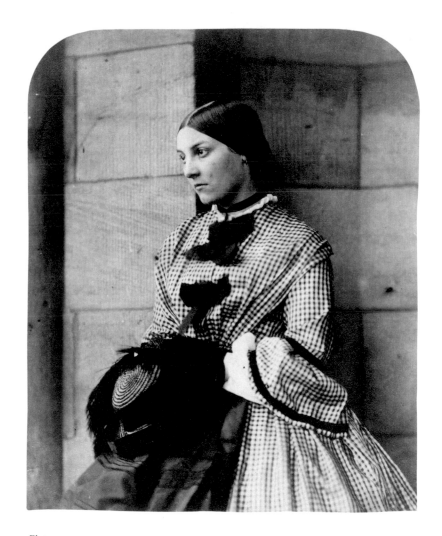

Plate 17
Miss Cole, summer/autumn 1859
Auckland Castle, Durham
5 x 4 in. (12.6 x 10.3 cm)
A(II): 31

his photography, which took its vocabulary from artistic conventions of posing, grouping, gesture, and expression. In this, he can be identified with that small group of British photographers who originally trained as artists.

One such artist-photographer was William Lake Price, whose work so inspired Dodgson during his visit to the 1856 Photographic Society exhibition (plate 9). In 1858 Price published *A Manual of Photographic Manipulation,* which was full of practical advice based on artistic principles and directed to "the progress of the student."[98] We cannot be certain Dodgson ever read Price's manual, but many of the recommendations correspond to what we know of Dodgson's preferred methods of working. Price goes into a lengthy discussion about the position of the camera in relation to the sitter: too close and its presence would be overbearing; too far away and intimacy would be lost. In many of his portraits Dodgson followed not only Prices's recommendations about judging the distance correctly (plate 20), but also his advice about setting the height of his camera level, above or below the eye line of his sitter. The height of the camera becomes especially apparent in Dodgson's photographs of young children, in which the camera is often brought down to their level or even occasionally looks up at them (A[II]: 122).

With the exception of groups, Dodgson rarely took standing figures, turning to this more habitually only in later years, after his move to the rooftop studio at Christ Church. He rarely photographed a sitter in close-up, no matter how interesting the physiognomy. The nearest he came are studies of his brother Wilfred and sister Margaret, where he filled the frame with head and shoulders (A[I]: 12 and 27). Paradoxically, these portraits have none of the intimacy and warmth of more distanced sitters. The range of work contained in the Princeton albums reveals that Dodgson frequently set his camera to give a three-quarter-length portrait, usually with the figure seated, the hands carefully placed to suggest repose. In this position, the figure is roughly pyramidal, with the base formed by the arms and legs, the apex by the head (plate 19). This composition became a favorite device for Dodgson, who used it to draw attention to the face of his sitter, which he sought to render in the sharpest focus and clearest detail.

Dodgson seldom used a headrest to help his sitter remain motionless during long exposures. These artificial restraints were widely employed by commercial studios, even though the discomfort of a metal brace against the neck did little to overcome the anxiety of the sitter. As Dodgson always sought a natural pose and relaxed expression, the regular use of a headrest was against his artistic principles, to be used only as a last resort when the odds of achieving success were stacked against him. In his complex arrangement of the three Liddell sisters for *Open Your Mouth and Shut Your Eyes* (plate 46), Dodgson did employ some sort of headrest to give extra support to Alice's head and upper body. It appears thrust through the back of the chair to the right of the composition and might be the upright bar from an artist's easel adapted to serve as a headrest. Dodgson used the same device for his portrait of Bessie Slatter, where it can be seen beneath the table, again thrust through the back of

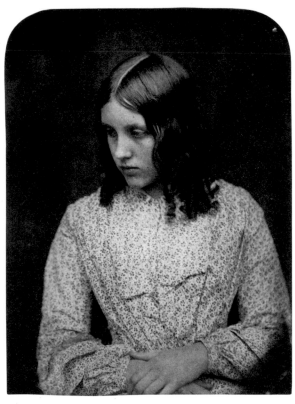

Plate 18
Margaret Dodgson, summer 1859
Croft Rectory, Yorkshire
4 x 3 in. (10.1 x 7.5 cm)
A(I): 18

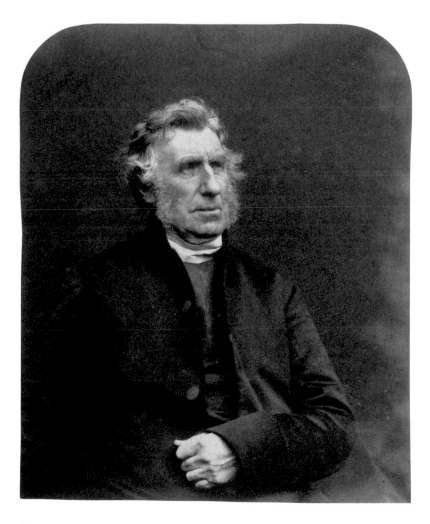

Plate 19
Dean Henry D. Erskine,
30 March 1858
Ripon, Yorkshire
5 x 4 in. (12.6 x 10.3 cm)
A(I): 38

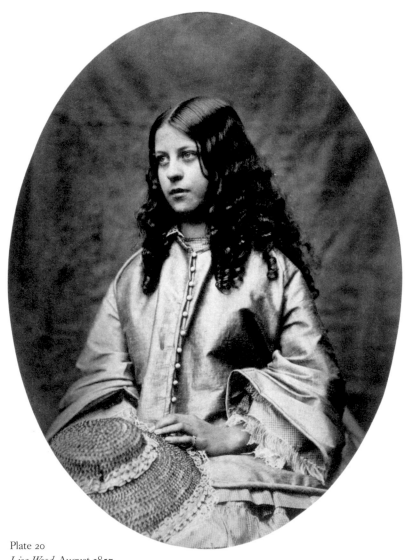

Plate 20
Lisa Wood, August 1857
Croft Rectory, Yorkshire?
5 ½ x 4 ⅛ in. (14 x 10.4 cm)
A(I): 81

Plate 21
Rev. Edward W. Whitaker,
September 1865
Croft Rectory, Yorkshire
4⅜ x 3⅜ in. (10.8 x 8.4 cm)
P(3): 40

a chair (A[II]: 50). Once, he forgot it was in the picture, where it appears out of focus in the background, giving some sense of its homemade construction (A[II]: 62). Only after his move into the Christ Church studio in 1872 did Dodgson buy a commercially made headrest of the type universally used in portrait studios.[99] This device allowed him to take photographs in the poor light of the winter months when exposure times would have increased to the point where the sitter could no longer keep motionless. But Dodgson did not like headrests, and in one of his portraits of Xie Kitchen with her violin, he disguised its presence with a rolled-up carpet at her feet (L: 33).

Expressive lighting played an important part in portraiture, and in an era when daylight was photography's only source of illumination, the position of the figure in relationship to the sun was critical. Price is quite specific about this and recommends placing the sitter to face "the quarter of the compass from N. W. -N., to N. E." where the "effect of light and shade on the sitter's face should be so gentle that the shadows are hardly defined." Anything harsher would appear "with dark and Carravagio-like effect, ill fitted for portraiture, and only permissible in heads of study."[100] Whether Dodgson followed Price's recommendation and had his sitters face northwest we shall never know, but looking through Dodgson's prints from this period, one is impressed by their consistent appearance and soft tonality. They are never harsh and unforgiving but always retain sufficient detail in both shadow and highlight areas, giving them a luminous quality that is a hallmark of his work.

When Dodgson worked outdoors he occasionally rigged up a plain cloth backdrop to create a clean and simple setting (plates 21 and 22). Under these circumstances the relation of the sitter to the light source was a matter of choice determined by the location of the backdrop. To soften the light Dodgson seems to have stretched a white muslin blind above the heads of his sitters to serve as a large diffuser. This can be seen in the Jelf family group portrait, where the blind hovers ethereally over the group (A[I]: 88). It is clear that Dodgson preferred this type of soft, expressive lighting whenever it could be arranged. In the studio he occupied at Badcock's Yard from 1863, he rigged up calico blinds to the overhead windows, as recommended by Price.[101] These could be drawn up or down and set at different angles according to circumstance and the effect required. Although these blinds are never revealed, in his portrait of the celebrated writer Charlotte Yonge (P[3]: 45), their existence is suggested. For the most part she is lit by a soft, diffuse, overhead light, but her right shoulder and elbow and the back of her dress are lit by directional sunlight whose shadows animate the overall composition. This effect was a matter of choice, not chance.

The first body of Dodgson's work that commands attention is a series of photographs of anatomical specimens made in June 1857 at the request of Dr. Henry Acland, Regius Professor of Medicine at Christ Church.[102] He commissioned the photographs (plate 23) in order

Plate 22
Harry Liddell, summer 1859
Twyford School, Hampshire
5 x 4 in. (12.6 x 10.2 cm)
A(I): 73

to have a visual record of the specimens before Christ Church loaned them to the new University Museum, then under construction. Such a commission appears entirely in keeping with the general level of support Christ Church seemed to offer Dodgson's photographic activity. Three months earlier, in February 1857, Dodgson had been told of a university fund for the encouragement of physical sciences, and "it was suggested in Common Room that my cultivating photography might entitle me, as a college tutor, to claim some of it."[103] The anatomical studies were a new departure for Dodgson, as he had never previously tackled a still-life subject.[104] Contrary to expectations, he chose to photograph these most inanimate of objects in bright, direct sunlight, something he never did when making portraits, when it would have been a definite advantage to have shorter exposure times. The crisp lighting defines the intricate and delicate bone structures with a precision that imitated medical and anatomical illustrations where every bone and joint is clearly delineated (plate 24). This group of twelve photographs seems straightforward and documentary in style, but one of them suggests Dodgson could not resist making a joke inspired by the colloquial saying that a foolish person had "a cod's head and shoulders."[105] This transforms Dodgson's juxtaposition of a fish head with a human skull into a dialogue about stupidity and aptitude, though in true Carrollian manner the placing of the skulls introduces ambiguity about which specimen enjoyed the higher intelligence (A[I]: 15).

Plate 24
Skeleton of Sunfish, June 1857
Anatomical Museum,
Christ Church, Oxford
6⅜ x 4⅞ in. (16 x 12.4 cm)
A(I): 22

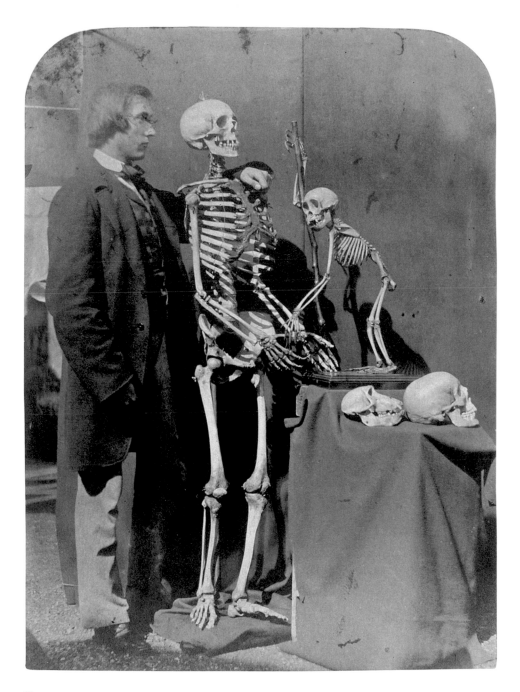

Plate 25
Reginald Southey and Skeletons,
June 1857
Anatomical Museum,
Christ Church, Oxford
6⅝ x 4⅞ in (16.9 x 12.5 cm)
A(I): 21

The most premeditated photograph relating to these anatomical studies shows Reginald Southey posed with skeletons and skulls (plate 25). Although superficially the image appears to belong to the main group, it would not have been part of Acland's commission but an image that arose out of the opportunity to use the skeletons while they were available. The exposure certainly seems to have been made under similar conditions, with a black cloth background and full sunlight that Dodgson has coming at an angle from behind his subjects. This seems quite deliberate, as it suggests that the two main characters, Southey and the human skeleton, have turned away from a setting sun to await with fixed gaze the arrival of a new dawn, while the monkey looks to the past. The image divides itself into two distinct components: that of Southey and the fully articulated skeletons, plus the two skulls set in profile below. The gesture of the monkey's hand on the forearm of the skeleton and that of Southey's arm resting on the shoulder of the human skeleton link the three figures in an evolutionary affinity. The gorilla and human skulls set out below, which have been arranged to show their exact profile, serve as indices of human development and mental capacity.

Given these interpretations, one might be tempted to assume that the photograph arose directly from the evolutionary debates that took place in Oxford during July 1860, but since the portrait was made in 1857, this cannot be the case. As the photograph coincided with Southey's graduation from Christ Church with first class honors in natural sciences, it could be regarded as a graduation portrait made by Dodgson of his close friend and photographic companion. Not content with the implicit meaning bound up in the compositional structure of the photograph, Dodgson added yet another layer of significance when he mounted a print in his album. On the facing page, he carefully inscribed four lines from Tennyson's "The Vision of Sin" as a reminder of mortality:

> You are bones, and what of that?
> Every face, however full,
> Padded round with flesh and fat,
> Is but modell'd on a skull.

During the years Dodgson spent at Christ Church the entire university was transformed from a medieval seminary whose main purpose had been to educate clergy for the Church of England into a teaching establishment more attuned to Victorian science. Central to these reforms was the proposal to build a University Museum that would become a center for scientific teaching, with lecture rooms and laboratories supported by an extensive teaching collection of geological and anatomical specimens (plate 26). The campaign to establish the museum was led by Dr. Acland and Dean Liddell, who together fought a series of protracted battles against entrenched attitudes that sought to hinder educational progress.[106] They eventually won their crusade for reform, and the foundation stone of the new museum was laid in 1855. The style and design of the building were matters of some consequence, as it had to announce its function through its architecture.

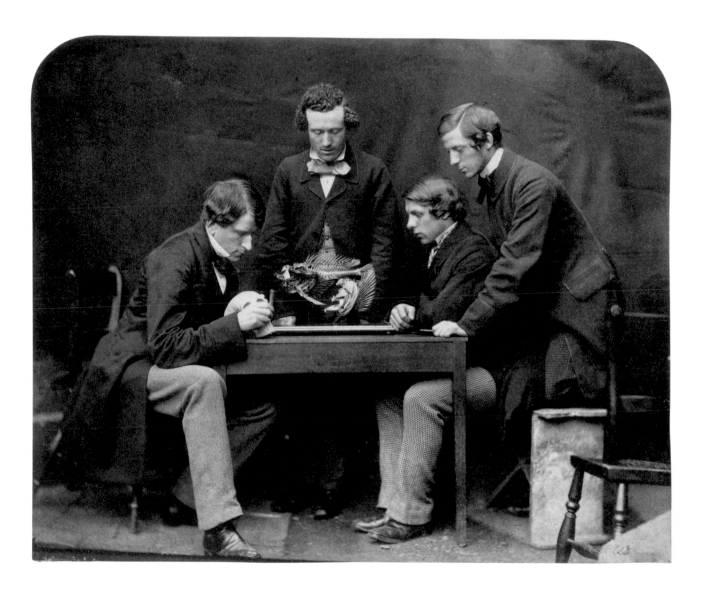

It is at this point that the relationship between the Pre-Raphaelite artists and Oxford University began, through the intervention of John Ruskin, the champion of modernity in art and lifelong friend of Acland. Responsibility for the building was given to Benjamin Woodward, who followed to the letter Ruskin's "belief in the power of Gothic architecture to adapt itself to all modern requirements." [107] Ruskin proved even more influential with the interior decoration of the building, as from the outset he had in mind "to get Millais and Rossetti to design flower and beast borders—crocodiles and various vermin" in a style that Acland liked. More to the point, Ruskin offered to pay for a good deal of this work himself. [108] His vision for the interior was realized by a whole team of Pre-Raphaelite artists and sculptors, including Edward Burne-Jones, Charles Collins, William Morris, Alexander Munro (who, like Ruskin, was a good friend of the Aclands), Valentine Prinsep, and John Stanhope. Dodgson noted meeting Hunt and Collins in Christ Church Common Room shortly after their arrival, but

this led to nothing.[109] He enjoyed more success with Stanhope, whose portrait marks Dodgson's first photographic contact with the Pre-Raphaelites.[110]

Both Acland and Liddell recognized the political and scientific importance of the new University Museum, and although it was only partially finished, they welcomed its use for the meeting of the British Association for the Advancement of Science in 1860. The association was a powerful and peculiarly British institution with a loose organizational structure but with a clearly defined set of objectives to raise the level of scientific understanding among the wider public. Its annual meetings were peripatetic, moving from city to city, wherever it felt they could be most effective. At a time when all branches of science were in the ascendancy and not yet fragmented into constituencies, these annual meetings were widely reported as events of national importance, drawing together some of the finest intellects and scientific minds of the period.

Every aspect of natural science was allotted its proper time and space within the restricted timetable of the meeting, which was made viable only by running parallel "tracks" each day, with mathematicians in one lecture room and geologists in another.[111] The subject matter covered during each meeting ranged far and wide—frequently reaching, in true Victorian manner, into regions of arcane detail—but in every instance it was expected to add to the sum total of human understanding. The Oxford meeting proved no exception: during the course of the week 27 June to 4 July 1860 the audience considered such divergent topics as "On the Magnetism of Certain Indian Granites" and "On the British Teredines, or Ship-Worms." The lecture entitled "On the Intellectual Development of Europe, Considered with Reference to the Views of Mr. Darwin, and Others, That the Progression of Organisms Is Determined by Law," given by Professor John Draper of New York, seemed innocent enough, but the recent publication of Darwin's radical views on natural selection and evolutionary theory alerted members of both the established church and the science community to the significance of this lecture. On the appointed day, an "immense audience" of over seven hundred packed themselves into the library of the New Museum, eager to listen to Draper's lecture and witness the lively argument that was bound to follow between Bishop Wilberforce and Professor Huxley. The ensuing debate has gone down in history as a defining moment that saw the evolutionists successfully argue their case against the fundamental beliefs of the established Church.[112] This baptism by controversy may not have been what Acland and Liddell had in mind, but it clearly identified the role of the New Museum within the university.[113]

We know from the evidence of signatures and dates in the Princeton albums that Dodgson made portraits every day of the meeting, with the exception of Sunday. He created a makeshift studio with fabric walls to create a neutral space, free of confusing background detail, in which to pose his eminent sitters. This studio is likely to have been in the Deanery garden, adjacent to the house, where he would have set up his darkroom and prepared his fickle chemicals with meticulous care. The meeting offered Dodgson an unequaled opportunity to photograph some of the most important figures of Victorian theology, science, and

art, so he could not afford any mistakes. Perhaps a little overawed by the singularity of the opportunity, Dodgson adopted an overriding style to ensure consistent results. He positioned his camera to give a three-quarter-length portrait with the sitter in full or near profile (A[II]: 28, 41, 45). The gaze of the scientists and clerics is fixed either upon a distant point, upon a book, or in that of Rev. Henry Tristram, upon an animal skull he gently holds (A[II]: 29). In the portraits of Bishop Samuel Wilberforce (A[II]: 7) and Professor Michael Faraday (A[II]: 18), this distant look is meant to act as an index of their intelligence, whereas the fixed expression of the bishop of Lincoln makes him look distinctly stubborn and uncomfortable (A[II]: 11). When Dodgson allowed the sitter to look directly at the camera, as he did with Rev. Herbert Randolph, the portrait loses its cool detachment to become an intimate and affectionate study of an elderly man (plate 27).

For his portraits of the Pre-Raphaelites William Holman Hunt and Thomas Woolner, Dodgson adopted an approach more in keeping with the radical spirit of these two artists. Both are full-length portraits in which the sitter directly encounters the camera. Hunt's pose is self-confident and relaxed, completely at ease with his setting and the narrative suggestions of brushes and easel (plate 28). By contrast, Woolner's pose is distinctly uneasy as he perches on the edge of a table in a manner that throws his body off balance (plate 29). Even the steadying gesture of the right arm across his knee is unconvincing and creates additional tensions with the suggestion of a clenched fist. His penetrating gaze adds to these compositional elements to create an unsettling and powerful portrait indicative of Woolner's complex personality. One of the last portraits Dodgson made that week is of Benjamin Woodward, architect of the University Museum, for which the studio setting was abandoned in favor of something more informal (A[II]: 51). Woodward, terminally ill with tuberculosis (he died eleven months later), sits uncomfortably on a chair brought into the garden, his figure strangely hunched within an ill-fitting suit, his look resigned and forlorn.[114] Very few of Dodgson's portraits from the British Association meeting rise above the level of ordinary competence. They owe more to the reputation of the sitter than to any photographic originality. The portraits of Hunt and Woolner begin to suggest Dodgson was capable of better things. The most intimate and revealing portrait is that of Woodward, whose sadness and resignation still touch us today.

Victorian hero worship led to ever-increasing desire for portraits of famous and distinguished people. This desire was satisfied by the new technologies of printing and photography that made it possible to mass-produce portraits at ever-decreasing cost. In addition, the illustrated newspapers and periodicals of the period boosted their circulation with the regular inclusion of portraits of every type of prominent person. Each week the *Illustrated London News*, for example, carried woodcuts accompanied by articles that drew attention to the achievements of statesmen and opera singers, titled nobility, actresses, the clergy, and heroes of the Crimean War.[115]

Plate 27
Rev. Herbert Randolph, 3 July 1860
Christ Church, Oxford
4⅞ x 3⅞ in. (12.5 x 9.8 cm)
A(II): 42

Plate 28
William Holman Hunt, 30 June 1860
Christ Church, Oxford
6⅝ x 5⅛ in. (16.9 x 12.9 cm)
A(II): 23

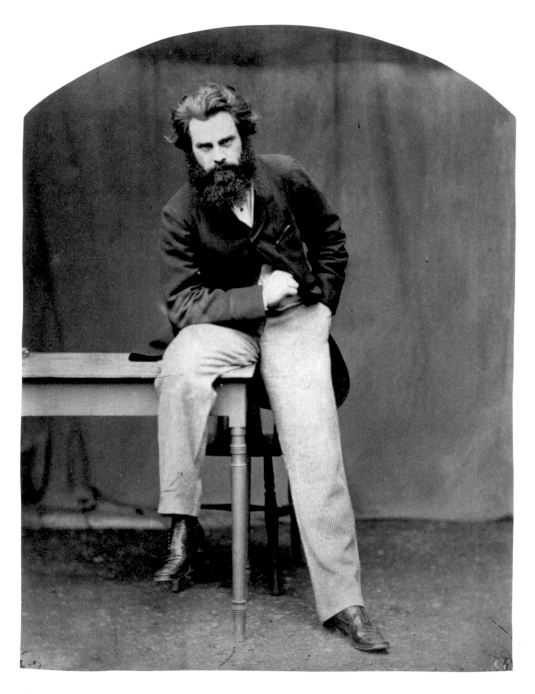

Plate 29
Thomas Woolner, 2 July 1860
Christ Church, Oxford
6⅝ x 5⅛ in. (16.8 x 12.9 cm)
A(II): 38

PHOTOGRAPHS.

I.

PORTRAITS, Size, 6 by 5.

Anderson, C., Esq.
Andrews, Rev. S., M.A., Ch. Ch., Master at Radley School.
Baker, Rev. J., M.A., Chaplain of Winchester College.
Barnes, Rev. R., M.A., Ch. Ch.
Bayne, Rev. T. V., M.A., do.
Benson, Rev. R. M., M.A., Ch. Ch., Perpetual Curate of Cowley, Oxon.
Bolstor, Rev. J., M.A., Prebendary of Cork, Incumbent of Killaspugmullane, Glanmire. 1860
Bosanquet, S. C., Esq., M.A., Ch. Ch.
Chamberlain, Rev. T., M.A., Ch. Ch., Vicar of St. Thomas', Oxford.
Clerke, Ven. C., D.D., Archdeacon of Oxford.
Colley, R. H., Esq., B.A., Ch. Ch.
Collyns, H. M., Esq., M.A., do.
Coombe, T., Esq., University Press, Oxford. 1860
Corfe, C. W., Esq., D. Mus., Organist of Ch. Ch. 1860
Dickin, G. A., Twyford School.
Dindorf, W., Esq., Professor of Greek. 1860
Dodgson, Ven. C., M.A., Archdeacon of Richmond, Yorkshire.
Dodgson, C. L., Esq., M.A., Ch. Ch.
Dodgson, W. L., Esq., do.
Dodgson, E. H., Twyford School.
Dodgson, J. H., do.
Enniskillen, Earl of, (Full-face). 1860
——————— (Side-face). 1860
Erskine, Hon. and Very Rev. H. D., M.A., late Dean of Ripon. (Re-photographed from print.)
Faraday, C. W., Esq., Professor of Chemistry. 1860
Faussett, R., Esq. (now Rev.), M.A., Ch. Ch.
Gordon, Rev. O., B.D., do. 1858 1860

Group containing
 H. Longley, Esq., Ch. Ch.,
 R. Harington, Esq., do.
 S. Joyce, Esq., do.
 C. Lane, Esq., do.
Group containing
 E. H. Dodgson, Twyford School.
 C. Turner, do.
Group containing
 J. Park Harrison, Esq., M.A., Ch. Ch.
 M. J. Park Harrison, R.N. do. 1860
Harding, C., Esq.
Harrison, C., Whitburn, Sunderland.
Hart, J., Esq., Master at Twyford School.

Hill, Rev. E., M.A., Ch. Ch., Rector of Sheering, Essex. 1860
Hussey, Rev. W. L., M.A., Ch. Ch., Vicar of Kirkham, Lancashire.
Ingram, H., Esq., M.A., Ch. Ch.
Jacobson, Rev. W., D.D., Canon of Ch. Ch.
Jelf, Rev. G. E., M.A., Ch. Ch.
Johnson, Rev. F. P., M.A., do.
Joyce, Rev. H., do. (Looking up) 1860
Joyce, Rev. F. H., M.A., do. (Looking down.) 1860
Kitchin, Rev. G. W., M.A., Ch.Ch., Head Master of Twyford School.
Ley, Rev. J., M.A., Ch. Ch., Vicar of Staverton.
Liddon, Rev.H. P., M.A.,Ch.Ch., Vice-Principal of St. Edmund Hall, Oxford.
Lipscombe, ——, Esq.
Longley, Right Rev. C. T.,D.D., Bishop of Ripon. (Now Archbishop of York.)
 (Full length.) 1857
 (Half length.) 1857
——————(As Bishop of Durham.) (Half length.) 1859
Malet, C. D. E., Twyford School.
Marshall, Rev. G.,M.A.,Ch. Ch., Vicar of Pirton.
Marsham, Hon. R., M.A., Ch. Ch.
Mayor, Rev. R., M.A., Master at Rugby School. 1860
Melhuish, ——, Radley School. 1860
Müller, Max., Esq., Christ Church.
Murchison, Sir R., Bart. 1860
Orde, ——, Esq.
Oswald, Rev. H. M., M.A., Ch. Ch., Curate of Alnwick, Northumberland. 1860
Ouseley, Rev. Sir F. A. Gore., Bart., M.A., Ch. Ch., Professor of Music, Oxford.
Petherick, J., Esq. 1860
Pickard, Rev. H. A., M.A., Ch. Ch.
Price, Rev. B., M.A., Pemb. Coll., Professor of Natural Philosophy, Oxford.
Prout, Rev. T., Ch. Ch.
Ramsay, J. H., Esq., do.
Randolph, Rev. H., M.A., Ch. Ch., Vicar of Marcham. 1860
Ranken, Rev. W. H., M.A., C. C. C. 1860
Rich, Rev. J., M.A., Ch. Ch., Curate of Newtimber, Sussex.
Robertson, W., Demonstrator of Anatomy in the Museum, Ch. Ch. 1859 1860

Rowley, Rev. R., M.A., Christ Church. 1859 1860

Dodgson published a list of his own photographs shortly after his successes at the British Association meeting (plate 30). Of the 137 photographs he listed, 104 are portraits, the remainder being topographic views, studies of Munro's sculpture, and anatomical specimens. Highly selective, the list includes only subjects that Dodgson thought belonged properly in the public domain. Portraits of Christ Church men and those taken at the British Association meeting dominate the list, though some clerical friends are also included. Portraits at Twyford School (plate 31) are also included through its links with Oxford and with the Rev. George Kitchin, himself a Christ Church man and colleague of Dodgson's. No portraits of female relatives, friends, or their children appear, as Dodgson regarded these as entirely personal; to have included them would have been a breach of etiquette.

The true purpose of the list remains something of an enigma, but it is reasonable to assume Dodgson was trying to place his work at the gallery of James Ryman—gilder, printseller, and publisher with premises on the High Street, Oxford—perhaps to recoup some of his photographic expenses.[116] The identity and status of the sitters would have been held in higher regard than Dodgson's own name, and he wisely chose to retain his anonymity. Similarly, he chose not to include the prices of his prints on the list, as their inclusion would have reduced the scheme to the level of trade, something we can be certain Dodgson was anxious to avoid.

Dodgson was not above a little hero worship himself, and undoubtedly this influenced the course of his photography, especially in later years when he actively sought out celebrated artists and authors in order to take their portraits. During these early years of 1857–62, one personality above all others captured Dodgson's imagination. This was Alfred, Lord Tennyson, one of the most prolific and accomplished of Victorian poets, who became widely popular following his appointment as poet laureate in 1850. Drawing heavily upon the human conditions of religious faith, madness, and troubled sexuality, he touched the hearts of countless individuals, from Prince Albert and Queen Victoria to the ranks of the emergent middle classes. It is hard now to appreciate how loudly Tennyson's verses resonated throughout the nation. Each new book was eagerly awaited, selling in large numbers as soon as it appeared. When *Idylls of the King* was published in 1859, an estimated ten thousand copies sold within the first week.[117] Following his appointment as poet laureate, Tennyson was quickly cast in the role of a cultural icon, national hero, and cult figure, whose flowing beard and shoulder-length hair became symbols of poetic idealism. In this role, he was constantly in demand and pursued by admirers eager to meet the great man. Dodgson belonged to this band of devotees, reading *Maud* from start to finish on the day it arrived.[118] If there was one

Plate 31
Five Twyford Schoolboys,
summer 1859
Twyford School, Hampshire
5⅜ x 5⅝ in. (13.6 x 14.2 cm)
A(I): 48

personality he wished to photograph more than any other, it was Tennyson. But Tennyson was anxious to maintain his privacy and relied on his wife to deal with all unwanted correspondence and impudent callers. Two quite separate incidents allowed Dodgson to penetrate these layers of self-protection and get closer to his objective.

Reginald Southey provided the first of these. During a visit to Freshwater, on the Isle of Wight, during April 1857, Southey photographed the children of both Alfred Tennyson and Julia Margaret Cameron (plates 32 and 33). By any measure, the portraits are not great triumphs of photographic art, but they raise interesting possibilities about Southey's friendship with Mrs. Cameron, as the sitting seems to have taken place at her house rather than at Tennyson's home, Farringford. It is conceivable that she, or her husband, knew Southey's father in London, either socially or professionally, and welcomed Southey's proposal to photograph the children.[119] He was, after all, just the kind of young man she took under her protective wing: well educated and with impeccable literary connections.

Plate 32
Reginald Southey (1835–1899)
Hallam and Lionel Tennyson, 1857
Freshwater, Isle of Wight
3⅜ x 5⅜ in. (8.4 x 13.7 cm)
Cotsen Collection,
Princeton University Library,
RS5: 37

Plate 33
Reginald Southey (1835–1899)
Charles and Harry Cameron, 1857
Freshwater, Isle of Wight
3⅜ x 5⅜ in. (8.4 x 13.7 cm)
Cotsen Collection,
Princeton University Library,
RS5: 34

Southey seems not to have known the Tennysons, but since he was the nephew of a former poet laureate, the usual social etiquette of photographing their children only with prior permission would have been readily set aside. It caused no anxiety to the ever-protective Emily Tennyson, who noted in her journal: "Mrs. Cameron & Julia to tea with Mrs. Prinsep. We hear that Mr. Southey has been photographing the children." Six days later she wrote: "Mr. Reginald Southey's photograph of the boys arrives. One can trace some likeness to Hallam in that of Hallam, little ruffian tho' he may be. Lionel comes out still less distinctly but one is grateful." [120] In his note of thanks for the prints, Tennyson extended an invitation to Southey, saying, "I wish you had come up here when you were at Freshwater. As it is I look forward to the pleasure of making your acquaintance at some future time." [121] Even if they did not know Southey personally, it is quite clear from the tone of these notes that the Tennysons knew of his position in society.

What Julia Margaret Cameron thought of Southey's photographs of her two boys remains unknown, but as this is the first recorded occasion of her involvement with photography, the relationship between Southey and her later decision to take up photography could be of importance. [122] Did he excite her interest in the expressive potential of the medium? Was he the fictional photographer Hexham, who steals the heart of the heroine in Anne Thackeray's novel *From an Island,* published in 1877? Did Southey first explain the inner workings of photography to Cameron as he had for Dodgson? These tantalizing possibilities potentially cast Southey as the photographic muse to two of Britain's most eminent nineteenth-century portrait photographers.

Some months later, when staying at Croft during the Long Vacation of 1857, an opportunity presented itself that drew Dodgson closer to Tennyson. On 18 August, "A party came down from the Castle to be photographed, consisting of Mrs. Otter, W. Chaytor, and a Mrs. Weld and her little girl Agnes Grace; the last being the principal object. Mrs. Weld is sister-in-law to Alfred Tennyson (I presume sister of Mrs. Tennyson), and I was much interested in talking about him with one who knew him so well." [123] No doubt wanting to establish his indirect link to the great man, Dodgson had Mrs. Weld identify the Tennyson boys in Southey's photograph. They discussed Tennyson's interest in learning to photograph and the imminent publication of his latest poem.

The "principal object" of Dodgson's attention, though, was Agnes Weld, who was "very striking and attractive, and will certainly make a beautiful photograph." [124] Dodgson photographed Agnes three times, twice in a conventional pose beautifully attired as a little lady of some social standing, with lace at her throat and cuffs (A[II]: 72 and plate 51). For the third, Agnes is dressed in clothes more appropriate to childhood (plate 34). Her simple white dress is covered with a hooded cape: her stockings and buttoned boots suggest she is about to make a journey. In one hand she carries a basket of food partially covered by a napkin, the other pulls the cape around her. Her transformation into *Little Red Riding-Hood* is complete. Without a forest readily to hand, Dodgson posed Agnes against a wall of densely textured ivy that provides a contrast to the smooth fabric of her cloak. She peers apprehensively toward

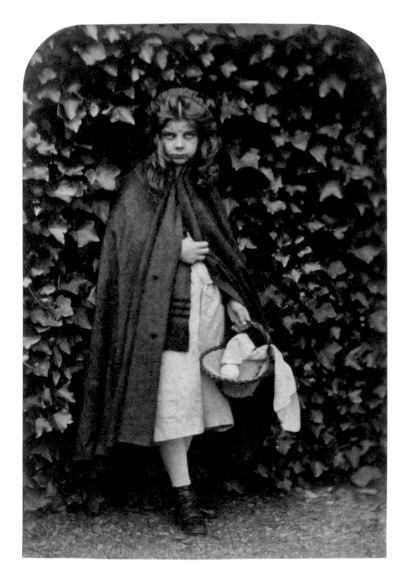

Plate 34
*Agnes Weld as "Little Red
Riding-Hood,"* 18 August 1857
Croft Rectory, Yorkshire
5 ⅜ x 3 ¾ in. (13.8 x 9.6 cm)
A(I): 24

the camera from under the protective cover of her cloak, looking uncomfortable with the role she is playing. Dodgson sent copies of the photographs to Tennyson through Mrs. Weld and was delighted to learn his hero thought "the portrait indeed a gem." [125] Perhaps encouraged by this remark, Dodgson followed Southey's example and submitted *Little Red Riding-Hood* along with three unidentified portraits to the Fifth Annual Exhibition of the Photographic Society, where they were exhibited under the name of C. L. Dodgson. [126] He never repeated the experience.

The month after Dodgson photographed Agnes Weld, he returned to the Lake District for a holiday. When he learned that Tennyson was in the area, he took the initiative and paid a call, sending in his visiting card to Mrs. Tennyson "adding underneath the name in pencil 'Artist of Agnes Grace' and 'Little Red Riding-hood.'" [127] On the strength of this introduction he was made welcome and stayed nearly an hour, meeting both Lionel and Hallam, whom he thought "the most beautiful boys in the world." [128] One can imagine the name of Reginald Southey entering into the conversation, where it would have been used as a component in the social glue that helped society feel sufficiently comfortable in establishing rapport with strangers. Whichever way the conversation ran, Dodgson came away with permission to photograph Hallam and Lionel, the promise of an autograph, and the faint hope that "Tennyson himself might sit." [129]

The formalities over, Dodgson made no fewer than three separate visits to Monk Coniston Park, Ambleside—the holiday home of James Marshall, a Leeds industrialist, from whom the Tennysons had taken accommodation at Tent Lodge. He seems to have been somewhat surprised by his first encounter with his hero: "a strange shaggy-looking man entered, his hair, moustache and beard looked wild and neglected." [130] Dodgson was nevertheless received warmly by Tennyson, who made arrangements with Mrs. Marshall for Dodgson to set up his photographic paraphernalia. Tennyson was regularly pestered to sit for his portrait by commercial carte-de-visite photographers anxious to capitalize on his celebrity and increase sales, but he sat for very few. For Dodgson, Tennyson sat in a high-backed chair with his hands firmly thrust under his knees, wearing his dark morning coat, loose-collared shirt, and wide-brimmed hat that was so much a part of his visual identity (A[I]: 26). He looks uncomfortable and unable to relax in front of the camera. With his hero before him at last, Dodgson probably felt incapable of intervening to ask for a more relaxed and natural pose. The rapport that Dodgson almost invariably established with his sitters is totally absent, reducing the portrait to the level of mere description. The Tennysons also felt the portrait to be a failure and wrote to Dodgson asking him to destroy all copies of the photograph except those he had made for himself, the family album at Croft, and for Southey. [131]

Of all the photographs Dodgson made during his visits to Monk Coniston Park, his portrait of Tennyson and Hallam in the company of the Marshall family is the most remarkable (plate 35). Tennyson sits upon a daybed set beneath a tall window, with little Hallam snuggled into his protective lap. To one side sit the Marshalls, their daughter Julia seated on the floor between the legs of her parents, her face turned in perfect profile. Dodgson's use of

Plate 35
Tennysons and Marshalls,
29 September 1857
Monk Coniston Park, Ambleside
5¼ x 5⅝ in. (13.1 x 14.3 cm)
A(I): 34

Plate 36
James G. Marshall and Julia,
28 September 1857
Monk Coniston Park, Ambleside
5⅜ x 4⅜ in. (13.7 x 11.3 cm)
A(II): 66

light and the structure of his composition break the established photographic conventions of the day. The photograph is dominated by a series of verticals created by the window frame, shutter, and drapes. These alternating bands of light and dark establish a rhythmic flow across the upper part of the image that begins and ends with bands of darkness to contain the composition. At the center of the picture the dark frame of the window coincides with the back of the daybed, effectively dividing the picture into two distinct parts; that of the Tennysons and that of the Marshalls.

This division is reinforced by differences in pose. Tennyson sits hunched on the daybed, with his arms protectively wrapped around Hallam and his knees drawn up as if to shield the boy from the camera. From the dark shadow of his face Tennyson's eye glints warily at the camera, watchful and mistrusting. This is a cameo portrait of a father protecting his son from a world he knows to be wicked and threatening. The Marshalls adopted an altogether different set of poses. True to the image of a Victorian industrialist, James Marshall sits bolt upright, his face set with an unyielding expression. His wife, her head slightly bowed as if in thought, leans upon her husband, his arm around her. Seated at their feet, their daughter Julia is sheltered from the world on both sides by the impressive barrier of her father and the skirts of her mother. Here we have two expressions of parental affection: the one loving but hermetic, the other cool and unresponsive. We sense this emotional distance in another portrait of Marshall and Julia made on the same occasion (plate 36). Again Marshall sits as impassively as a statue, seemingly incapable of responding to his daughter's affectionate gesture. In these two photographs, Dodgson moved past the immediate subject matter of Tennyson and Marshall to direct attention to relationships between children and their parents.

Dodgson seems to have understood how heavily the weight of adult responsibility pressed down upon young children, and he responded by taking them into his world and into his confidence in a way that was remarkable for the period. In Dodgson's social class, the daily life of children was narrowly circumscribed by numerous conventions willingly enforced by parent, nursemaid, and governess. Within this protected environment, childhood was often a prolonged and sometimes tedious affair, with girls often not reaching puberty until the age of fourteen or fifteen.[132] Articles in the popular press advised concerned parents how to impart the moral values of truth, sincerity, charity, and religious belief to their children from an early age. Books written especially for children reinforced these values through word and picture with tales of virtue, forbearance, and obedience. Although Dodgson laid great store by these values, he understood that the boundless imagination of children created a world intellectually separate from that of adults, and he regarded nurture of that invented life as essential to their proper emotional development. His two *Alice* books are based upon a series of adventures that take place in a realm beyond the confines of nurseries and schoolrooms. His ability to enter this fictive world endeared him to families who welcomed him into their homes for the diversion and entertainment he gave their children.

Throughout his adult life Dodgson found himself consistently rewarded by the friendship of children, especially younger children before they went through what he called that

"awkward age of transition."[133] Ever since his death there has been wild speculation about his relationship with those children, and with little girls in particular. It has been suggested he was unhealthily fixated upon little girls and shy and ill at ease in the company of adults. This combination has now firmly established him as a pedophile in the public imagination, although there is not a shred of evidence to support the claim. His oft-quoted remark "I am fond of children (except boys)" was, in all probability, meant as a joke, but it has been removed from its original context and repeatedly cited to underline his supposed preference for the company of little girls.[134] Undoubtedly he did prefer the company of some children to others, but it was not a preference based exclusively on gender.

In Dodgson's scheme of things, all children were not equally attractive; their appeal was determined, to some extent, by the combination of their physical appearance, personality, and position in society. He found himself attracted to children whose beauty was expressive

or striking, and in general, these children belonged to his social class. We rarely find Dodgson drawn toward those working-class waifs or orphans who conformed to another stereotype of Victorian childhood beauty. It has often been suggested that Dodgson was shy, inhibited by a slight hesitancy of speech, and it was this that led him to prefer the company of children. In fact, his diaries and correspondence reveal a busy round of social engagements; he spent many happy days staying with families (plate 37), calling upon others, and corresponding regularly with a whole range of individuals.

These were not the actions of a shy and withdrawn person, but instead reveal Dodgson's need to get away from the all-male company of the Oxford Common Room and enjoy the more balanced company of families blessed with children. His many friends and colleagues found nothing odd about his wide circle of affectionate friendships with children. They would have known that his position at Christ Church was conditional upon remaining unmarried and that this enforced celibacy was a matter of economic fact, not of choice.[135] None of his brothers or sisters started families until the 1870s, but Dodgson created a surrogate family of his own through his close friendships with relatives and friends (plate 38). The unmarried reverend gentleman seems unusual today, but during the Victorian period he was more common and conformed to the well-known type of the bachelor friend to the family, warmly welcomed at all times.

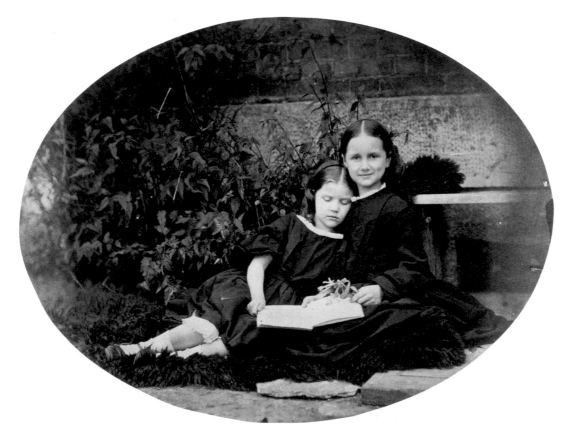

Plate 38
Ethel and Lilian Brodie, 21 June 1861
Oxford
4¾ x 6⅜ in. (12.2 x 16.3 cm)
A(II): 83

Following Dodgson's death in 1898, reminiscences by his many "child-friends," as he called them, began to appear in the press. Without exception, they recalled with fondness and affection his avuncular role, with never a hint of anxiety about the nature of their relationship. When Stuart Dodgson Collingwood, his first biographer, devoted the last two chapters of his book to Dodgson's friendships with children, he did so in the firm belief that they exhibited "a very important and distinct side of his nature" that was both "beautiful" and based upon love.[136] When this theme was repeated many years later by Helmut Gernsheim in his book about Dodgson's photography, it reinforced the emerging contemporary view that such deep and affectionate relationships camouflaged an unhealthy fixation.[137] Although the facts of Dodgson's sexuality, motivation, and emotional needs are lost forever, his undiminished popularity as a children's author has played its part in transforming him from a benign and celibate academic into the perfect stalking-horse for prevailing anxieties about the welfare and safety of children. Dodgson's current baseless reputation as pedophile tells us more about the state of our society than it does about his own character.

A helpful way to approach this troublesome subject is by looking briefly at the Victorian attitude toward children, which was shaped by the fact that premature death was an ever-present fear for every family throughout the country during Dodgson's lifetime. Outbreaks of cholera, typhoid, and influenza reached epidemic proportions and carried away large sections of the population with alarming regularity. No one was spared from the specter of sudden death. Disease was not limited to the poor and undernourished, but they suffered its greatest toll, since few could afford the luxury of a doctor. Within Dodgson's social circle, avoidance was the first line of defense. When scarlet fever broke out in Oxford, Dr. Acland ordered the Liddell children (plate 39) to Lowestoft in the hope they might escape the disfiguring disease.[138] Sanitary reform and wholesale improvements in public health slowly began to improve life expectancy, which rose from forty years in 1850 to fifty-two for males and fifty-five for females by 1911–12.[139]

The great disgrace of the period was the appallingly high rate of infant mortality. For much of the century it has been estimated that in England well over ten thousand infants died each year before reaching their first birthday, and the scandal of these premature deaths has been called "the massacre of the innocents."[140] Faced with ever-present death and disease, society attempted to rationalize the widespread distress by turning to God for explanation, solace, and guidance. In a popular handbook on motherhood, the author, herself a woman, offered these words of advice to a bereaved mother: "Remember that you have been instrumental in bringing into existence a being who will live *for ever* in celestial glory."[141] As a counterpoint to the pervasive grief, themes of childhood innocence and vulnerability became increasingly popular with novelists, poets, artists, and sculptors.[142]

Dodgson's photographs of children fit squarely within this context, given shape by his deep religious conviction, love of beauty, and highly developed artistic sensibility. He revered children for their loveliness and grace, sincerely believing that they were pure, innocent beings, untouched by the sins and troubles of the world. These feelings of reverence are

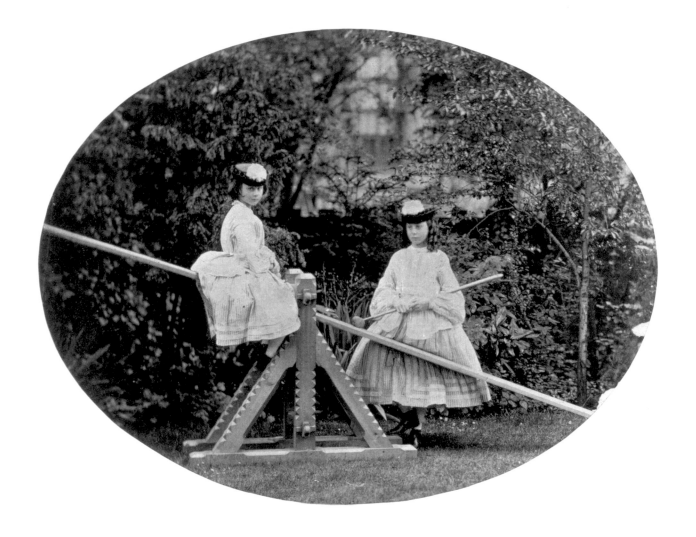

perfectly expressed in the stanza he composed to Alice Murdoch (plate 10) in which he referred to her as a celestial blessing. In 1856, when that photograph was made, childhood was considered a blessed state of grace that few survived into adulthood. As time went by and public health began to improve marginally, childhood began to be regarded rather differently. By the last quarter of the century, the focus had switched from the vulnerability of children to their beauty and innocence. This type of subject matter became popular with artists of the Aesthetic Movement and found its perfect expression in the works of Kate Greenaway, Ralph Caldecott, Walter Crane, and William Stephen Coleman (a friend and a formative influence upon Dodgson's later photography).

If the cultural sensibilities of the period served as a general guide for Dodgson, then his friendship with Alexander Munro, the Pre-Raphaelite sculptor, provided a role model.[143] When Mrs. Acland invited Dodgson to show his photographs to Munro in February 1858 she likely knew that the two young men shared the same enthusiasm for art and photography, but she could not have foreseen the train of events that arose from their meeting.[144]

Plate 39
Alice and Lorina Liddell in "See-Saw,"
May/June 1860
Deanery garden, Christ Church, Oxford
4¾ x 6⅜ in. (12.3 x 16.3 cm)
A(II): 105

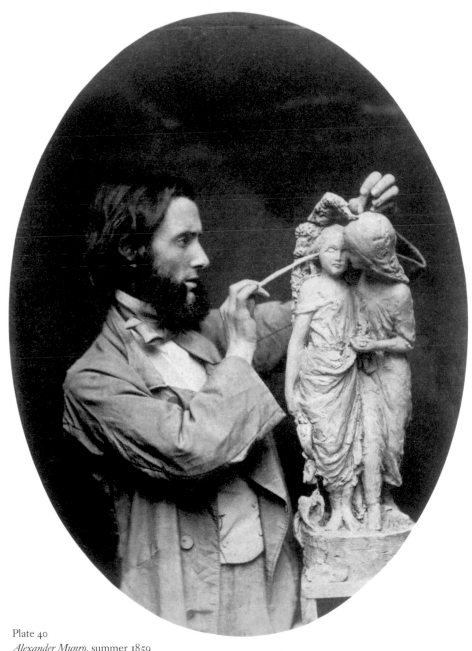

Plate 40
Alexander Munro, summer 1859
6 Upper Belgrave Place, Pimlico
6½ x 4¾ in. (16.4 x 12.1 cm)
A(I): 66

When Dodgson called on Munro two months later, he was warmly received and noted in his diary:

> He showed us over his studio, containing, among many half-finished designs, four statues which are going to the Academy tomorrow. He has a large collection of photographs, many from his own sculpture; one he gave me, a duplicate of an exquisite picture by [Henry Peach] Robinson in the Photographic Exhibition this year, it is called Juliet, and is an imitation (taken from the life) of Leslie's picture. He gave me carte-blanche to photograph anything and everything in his studio, when I come to town in June, whether he is there or not. It is a tempting inducement to take my camera there, especially if (as he seems to think not unlikely) there is any chance of getting a sitting from the original of "Juliet."[145]

This visit marked the beginning of a long friendship that brought Dodgson into intimate contact with the Pre-Raphaelite circle through Munro's introductions to Arthur Hughes, Tom Taylor, the Rossettis, and Val Prinsep. They in their turn effected further entrées, extending Dodgson's access in a series of ever-widening artistic circles.[146] Over the years Dodgson paid many visits to Munro's studio, where he photographed a number of preparatory models and finished works as well as a portrait of Munro at work on his *Measurement by Foxglove* of 1859 (plate 40, A[I]: 92). Munro and Dodgson shared similar ideals in their use of children as subjects. For much of his working life Munro took themes of childhood innocence and insecurity as the frequent subject of his sculptures. That instrument of popular taste, the *Illustrated London News,* consistently praised Munro for the sentiment of his subject matter and the skill of his execution, thus helping ensure his widespread popularity for the better part of twenty years.[147]

When Munro exhibited *The Sisters* (A[I]: 78) at the Royal Academy in 1857, one reviewer drew attention to the sentiments it evoked, suggesting "the grace and loveliness of its childlike forms . . . the upturned head of the younger child shone full and bright with sympathetic hopefulness, and the inclined head of its elder sister acquired a deeper shade of pensiveness, bowed down, as it almost seemed to be, by delicate health . . . a young sorrow more sweet and tender than the feverish joys of later life."[148] The clothing used by Munro in such sculptures was invariably nothing more than a simple shift, which was meant to signify innocence and purity. Victorian sculptors relied heavily on classical references, frequently adopting the form of dress popular in Greek antiquity; such costumes were considered neither immoral nor impure, even though they revealed the underlying form of figure and limbs.[149]

Mary Thornycroft, who undertook a number of commissions for Queen Victoria, made a statue of Princess Helena as "Peace" (plate 41) that shows the young princess as "an embodiment of the purity and modesty of nature with the purity and modesty of Art-treatment."[150] The artistic tastes of Queen Victoria were widely known, not just through articles and engravings of work she commissioned in the *Art Journal,* but also through her

Plate 41
Mary Thornycroft
Princess Helena as "Peace"
The Art Journal, November 1861

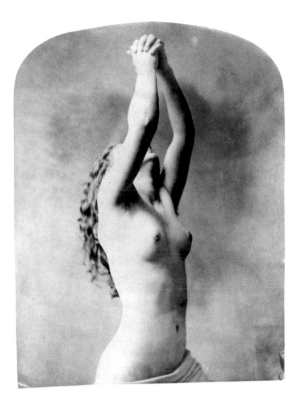

Plate 42
Oscar Gustav Rejlander
(1813–1875)
"Too Late," c. 1856
7⅜ x 5¾ in. (19.4 x 14.5 cm)
The Art Museum,
Princeton University.
Anonymous Fund.
© 2001 Trustees of
Princeton University

visits with Prince Albert to many of the annual exhibitions of painting, sculpture, and photography held in London. She and Albert attended the very first exhibition of the Photographic Society, in January 1854, where their praise for the photographs and the advances made by the art were widely reported in the press.[151] This royal patronage was immensely important to the status of photography and helped foster its progress during its formative years. When the royal family bought photographs as a result of their visits to the annual exhibitions of the Photographic Society, certain types and genres of photography were given greater legitimacy.

One photographer greatly admired by both Queen Victoria and Prince Albert was Oscar Gustav Rejlander, whose studies they bought for their personal collection. Rejlander exerted a significant influence upon Dodgson's photography for many years, representing an ideal role model —that of an artist expressing himself through photography. A Swede, Rejlander trained initially as a portrait painter in Rome before finally settling in Wolverhampton, from where he submitted a painting that was exhibited at the Royal Academy in 1848.[152] When photography emerged during the early 1850s, Rejlander took it up with enthusiasm and great technical skill. He earned his living as a portrait photographer and established his reputation by exhibiting "studies from life." He first came to wider notice during 1855 with the twelve studies he submitted to the annual exhibition of the Photographic Society.[153] His work enjoyed general acclaim among photographers for having brought artistic credibility to photography, though many artists roundly criticized his presumption.

In style and sentiment, Rejlander's work relied heavily upon the popular genre paintings that featured narrative content and moral implications and were eagerly awaited by art lovers each season. Rejlander's photographs quickly established themselves as central attractions of the London exhibition season. Like the successful genre painter William Powell Frith, Rejlander selected his subject matter, models, and titles with great care so that each would add another layer of meaning to his compositions. Many of his studies were presented as diptychs or triptychs, often displayed within a single frame. His diptychs—epitomized by *Marriage, Before and After*—tended to rely on contrasting situations where the intent was to offer a clear social message to the audience. The triptychs offered similar meanings but told through a structured narrative sequence, as with *His Country's Hope; Pride; Care.* The other works for which Rejlander became well known were his figure studies (plate 42), which were based on the academic traditions that had been a central part of his artistic training.

Rejlander's compositional tour de force was *The Two Ways of Life,* or *Hope in Repentance,* first exhibited at the 1857 *Art Treasures Exhibition,* Manchester, to a mixture of critical acclaim, derision, and denouncement. This large-scale and complex study remains the most ambitious and technically accomplished photograph of the nineteenth century.[154] Hearing of the undertaking, Prince Albert invited Rejlander to Buckingham Palace so that he could

view *The Two Ways of Life* before it was submitted to the exhibition. Clearly, neither Prince Albert nor Queen Victoria was offended by Rejlander's inclusion of nude figures, as they ordered three copies, reputedly one for each of Prince Albert's dressing rooms at Windsor, Osborne, and Balmoral.[155] Although Dodgson does not mention this photograph in his diary, he is unlikely to have overlooked such a monumental work during his two-day visit to the exhibition. He would have found the sentiment, execution, and technical accomplishment of the work entirely to his taste.

Dodgson bought examples of Rejlander's work from the 1857 Photographic Society exhibition that he admired, "especially one of two children, called 'Non Angeli, sed Angeli'" (plate 43).[156] This study of two cherubic infants was taken directly from Raphael's *Sistine Madonna,* an iconic image that became extremely popular with the Victorians, who were just "rediscovering" Raphael's work.[157] Dodgson remained a keen admirer of Rejlander, buying additional examples of his work in order to study his technique for composition and the grouping of figures. He called upon Rejlander in London, was photographed by him, and spent time looking "over a great number of prints and negatives, some of which were very beautiful."[158] When setting up his first photographic studio in Badcock's Yard, he turned to Rejlander for practical advice.[159]

Of all the photographers familiar to Dodgson, Rejlander had the most evident influence. This became apparent in a number of ways. We see it in his genre studies when the composition and title combine to create a narrative, usually with a moral imperative such as in *Little Red Riding-Hood* (plate 34) and *Open Your Mouth and Shut Your Eyes* (plate 46). It is less obvious but still present in Dodgson's photographs of children dressed in fancy costumes and theatrical outfits (plates 67 and 68), all of which are modeled on Rejlander's genre studies, where telling a story was the main purpose. We also see references to Rejlander in Dodgson's use of opposing pairs such as those of Alexandra, or "Xie," Kitchin in Chinese costume with slippers and hat on, and slippers and hat off, entitled *On Duty* (plate 66) and *Off Duty* (P[3]: 106). More significantly, Dodgson required Rejlander's success to sanction his own artistic aspirations. No other photographer offered such an ideal role model—someone whose artistic integrity remained assured despite the evident artifice of his studies. Rejlander was the exemplar on whom Dodgson modeled much of his photography, and he provides us today with a framework for understanding Dodgson's work.

Of all the child studies by Dodgson, his portrait of Alice Liddell as *The Beggar Maid* (plate 44), taken in 1858, has caused the most intense speculation. Viewed through the

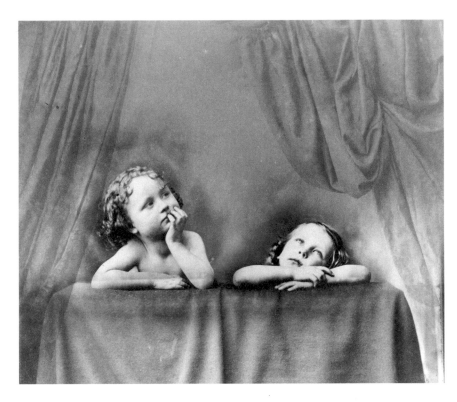

Plate 43
Oscar Gustav Rejlander
(1813–1875)
"Non Angeli, sed Angeli," c. 1856
Wolverhampton
8⅛ x 10⅜ in. (20.5 x 26.3 cm)
The Art Museum,
Princeton University.
David H. McAlpin Fund.
© 2001 Trustees of
Princeton University

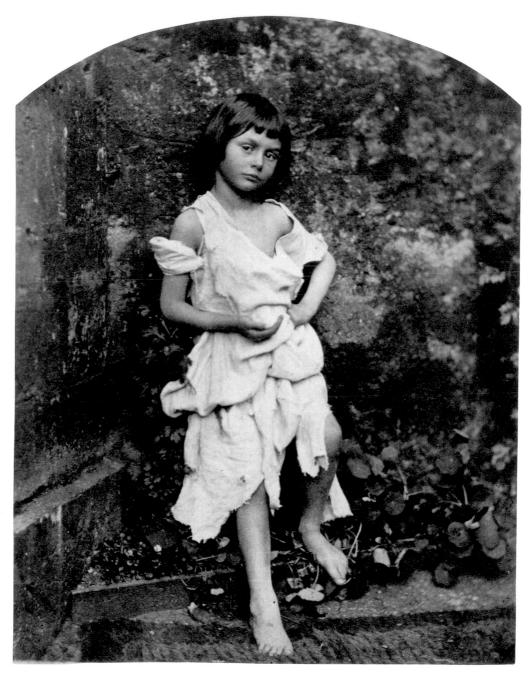

Plate 44
Alice Liddell as "The Beggar Maid,"
summer 1858
Deanery garden, Christ Church,
Oxford
6⅝ x 5⅛ in. (16.8 x 13 cm)
RS2: 15

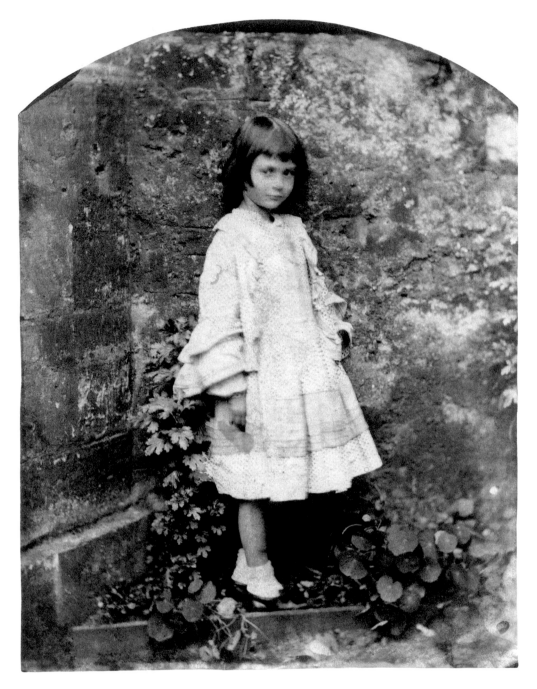

Plate 45
*Alice Liddell Dressed in Her Best
Outfit,* summer 1858
Deanery garden, Christ Church,
Oxford
6⅝ x 5⅛ in. (17 x 13 cm)
Liddell album, Christ Church,
Oxford

prism of modern anxiety about child welfare, this portrait may seem exploitative. To some, the direct, knowing gaze of Alice combines in a telling way with naked limb, cupped hand, and exposed nipple to create a sexually charged image. But to view the photograph from this perspective would be to misunderstand Dodgson's intentions. The notoriety of the photograph ensures that it is invariably displayed alone, removed from its original context. But, like Rejlander's genre studies, the photograph was most probably meant to be seen as one of a pair, with the other showing little Alice, then aged six, dressed in her best outfit, complete with white ankle socks and black leather shoes (plate 45). Since both studies seem to have been taken on the same occasion and in exactly the same setting, it is reasonable to surmise that Dodgson originally conceived the pair to be seen as two sides of the same subject, to contrast a demure young woman of good breeding and deportment with a ragged beggar girl whose knowing look and wayward stance were purposely contrived to tempt alms from the pocket. It is a diptych suggestive of class distinction, as well as a fall from grace and a rise to redemption. The narrative possibilities provided by the two images would have appealed to Dodgson more than any societal connotations, for as we know from his writings, he loved to create complex structures with hidden meanings. He loved puzzles, riddles, and word games, inventing a large number of his own in which hidden meanings and internal messages played an important part.[160] As he might have put it, nothing was quite as it seemed.

In his portrait of Alice Liddell (front cover) of July 1860, he alluded to other meanings by including a fern alongside Alice. In the Victorian period, the language of flowers was highly developed and widely understood. In this complex and codified rhetoric, flowers and plants stood for a wide range of human emotions, allowing individuals to send concealed messages.[161] As with etiquette and good manners, this language depended upon subtlety and nuance where every slight variation held meaning. A rosebud stripped of its thorns indicated "There is everything to hope for" and stripped of its leaves announced "There is everything to fear."[162] This form of language was as artificial as the phrenological skill of diagnosing character from the bumps of the head, but it served real emotional needs and consequently was extremely popular. Dodgson's inclusion of the fern is unlikely to have been purely decorative: in the language of flowers this plant signified sincerity, which is one of a child's greatest virtues.

On the same occasion this portrait was made, Dodgson photographed all three Liddell sisters together (plate 46), with Edith sitting demurely on a table holding a plate of cherries as Ina tempts Alice with fruit that she dangles above her upturned mouth. It is a skillful composition, as it braces Alice's hand against Ina's to hold everything motionless for the exposure. The tableau was based upon the children's nursery rhyme saying "Open your mouth, shut your eyes and see what Providence will send you." This type of subject matter and the sentiments it expressed remained popular throughout the Victorian period. As early as 1839 William Mulready had used the same title and subject matter for a painting he exhibited at the Royal Academy.[163] Rejlander repeated the motif with a study of the same title that he exhibited in Birmingham in 1857.[164] This was the likely model for Dodgson's tableau.

Plate 46
Edith, Lorina, and Alice Liddell in "Open Your Mouth and Shut Your Eyes," July 1860
Deanery garden, Christ Church, Oxford
7½ x 6⅞ in. (19.1 x 17.5 cm)
A(II): 60

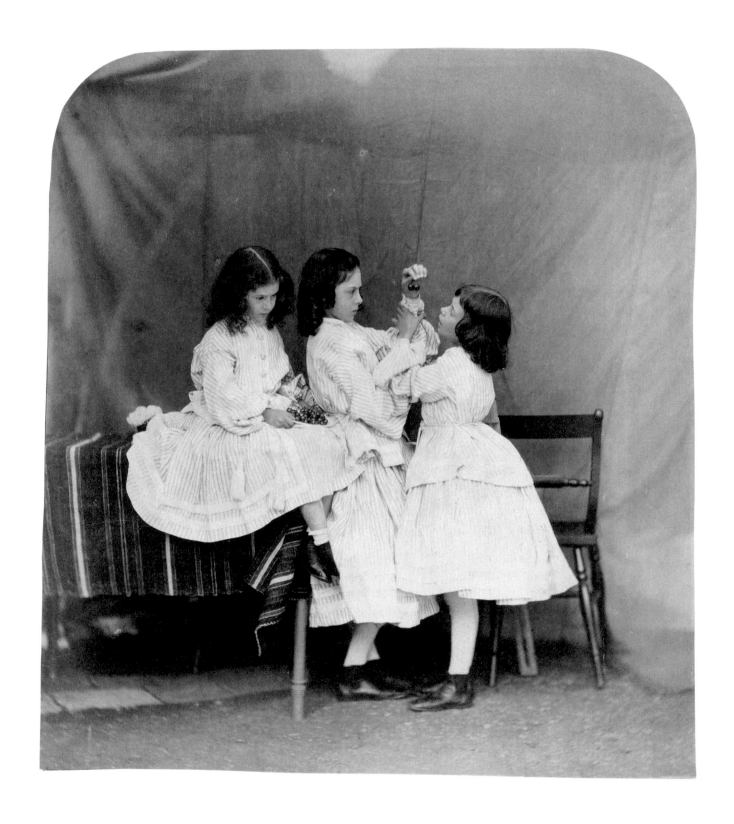

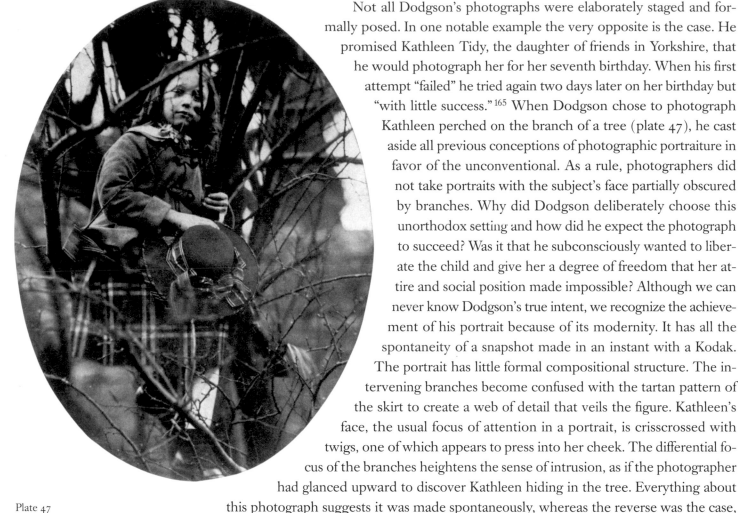

Not all Dodgson's photographs were elaborately staged and formally posed. In one notable example the very opposite is the case. He promised Kathleen Tidy, the daughter of friends in Yorkshire, that he would photograph her for her seventh birthday. When his first attempt "failed" he tried again two days later on her birthday but "with little success."[165] When Dodgson chose to photograph Kathleen perched on the branch of a tree (plate 47), he cast aside all previous conceptions of photographic portraiture in favor of the unconventional. As a rule, photographers did not take portraits with the subject's face partially obscured by branches. Why did Dodgson deliberately choose this unorthodox setting and how did he expect the photograph to succeed? Was it that he subconsciously wanted to liberate the child and give her a degree of freedom that her attire and social position made impossible? Although we can never know Dodgson's true intent, we recognize the achievement of his portrait because of its modernity. It has all the spontaneity of a snapshot made in an instant with a Kodak. The portrait has little formal compositional structure. The intervening branches become confused with the tartan pattern of the skirt to create a web of detail that veils the figure. Kathleen's face, the usual focus of attention in a portrait, is crisscrossed with twigs, one of which appears to press into her cheek. The differential focus of the branches heightens the sense of intrusion, as if the photographer had glanced upward to discover Kathleen hiding in the tree. Everything about this photograph suggests it was made spontaneously, whereas the reverse was the case, with Dodgson struggling to create a successful image. But to Dodgson, the mathematician with a profound love of logic, the most logical thing for him to do was be illogical.

Dodgson's commitment to photography sets his work apart from the more modest output by the majority of his contemporaries, many of whom were limited either by the expense of the materials or the lack of opportunity. Dodgson was especially fortunate in having sufficient disposable income and free time from Christ Church to devote to his hobby. Unlike many amateurs of the period, he chose not to show each season's new work at the many photographic exhibitions available to him. But he did not restrict work solely to his family and immediate social circle. Instead, he chose to create a series of albums that, from the very outset, became his principal means of demonstrating to the wider world his photographic skills. These albums, first begun in 1856, fall into three distinct types, each addressing a different audience. The principal sequence of albums, which he later named his "A" sequence, were his show albums and intended for general circulation. The second type were albums he made exclusively for his family. The third type were prepared as special gifts for

Plate 47
Kathleen Tidy, 1 April 1858?
Ripon, Yorkshire
5 x 3 ⅝ in. (12.6 x 9.4 cm)
A(I): 44

friends like the Weld family and Henry Holiday. At Princeton University, there are examples of all three types. The albums known as A(I) and A(II) trace Dodgson's progress as a photographer up to the end of 1862, with album A(III), now at the University of Texas in Austin, continuing the sequence. As Edward Wakeling has discovered, Dodgson devoted himself to organizing and numbering the whole of his photographic inventory during the summer of 1875, when the albums formed part of the exercise. The sequence Dodgson gave his albums is not chronological; album A(VI) is the earliest, dating from his first year of photography.

What are we to read into Dodgson's sequence? When he reviewed his albums, Dodgson must have regarded albums A(I) and A(II) as being the most important and numbered them accordingly. Together they cover the period between 1857 and 1862, with the photographs in A(I) predating those in A(II). But this overarching chronology does not apply to the internal sequencing of the photographs, which have been arranged to reflect the range and variety of Dodgson's skills: a photographic curriculum vitæ.

The rhythm and pace given by the sequencing of the photographs was crucially important to the way they would be seen, and careful thought went into how this should be achieved. It was essential the viewer encounter something new and fresh with each turn of the page. Album A(I) starts with a portrait of Dodgson's father, followed by one of the family at home (plate 48), before moving to a study of the Broad Walk at Christ Church, portraits

Plate 48
Edwin Dodgson and "The New Book,"
July/August 1857
Croft Rectory, Yorkshire
4¾ x 6⅜ in. (12.3 x 16.3 cm)
A(I): 2

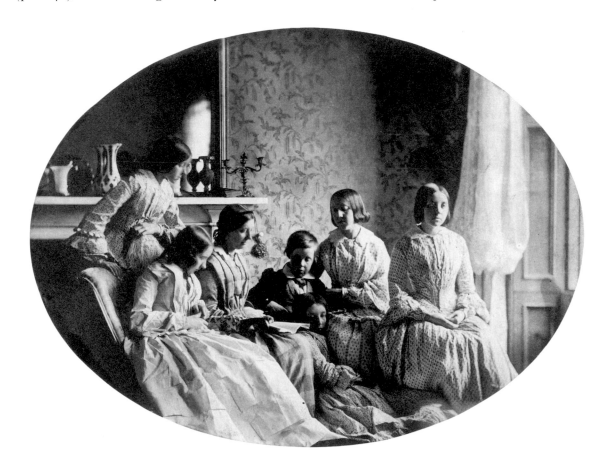

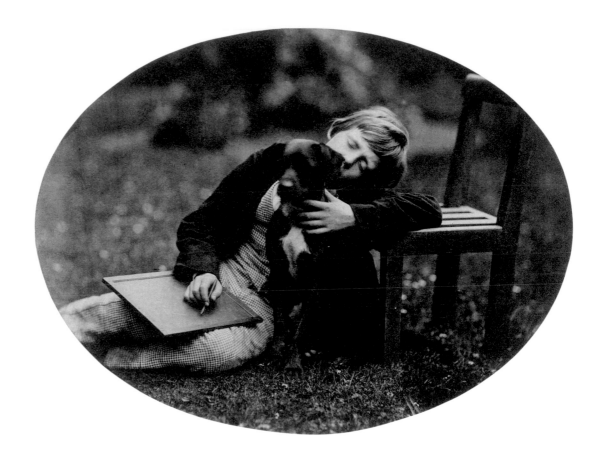

Plate 49
*Edwin Dodgson as "The Young
Mathematician,"* July/August 1857
Croft Rectory, Yorkshire
4⅛ x 5⅜ in. (10.5 x 13.8 cm)
A(I): 6

of the Liddell girls, an anatomical specimen, a narrative study entitled *The Young Mathematician* (plate 49), and a clerical colleague, before returning to the cycle with portraits of the two Smith girls. In this way, brief narratives were implied to tell of Dodgson's background, education, tastes, and accomplishments. Dodgson knew how he wanted his sequencing to appear from the outset and planned accordingly. We know he left blank pages in the albums to be filled later with photographs appropriate to the sequence. When this was not possible, it seems that Dodgson was not above removing pages and inserting others to help establish a proper sense of order.[166]

The size and shape of each photograph were also carefully planned. There are very few simple rectangular prints, as Dodgson preferred rounded top corners. Some he trimmed into ovals (plate 50), others he gave a semicircular top that arches over the composition to contain the image in a dramatic way. Whatever his choice of shape, he was meticulously precise when trimming each print; there are no ragged edges or misalignments to spoil the effect. These print formats are so uniform that one wonders if Dodgson had a number of templates to give him absolute consistency. (That would be entirely in keeping with his character and with the aspirations he had for his albums.)

This exactness was carried still further when Dodgson mounted his prints. Rather than trust his judgment, he drew a set of registration marks in fine pencil to locate each print with

absolute accuracy. He applied the same technique to position any title or poem accompanying the photographs. On the page opposite his portrait of Agnes Weld (plate 51), for example, he laid out a complex grid of lines to contain seven stanzas by F. T. Palgrave. Into this matrix he inscribed each line, taking care to form each letter and line to mimic type on a printed page.

The final element to complete the layout of the page was the signature of his sitter. The Victorians were avid collectors of autographs, writing to celebrities solely to elicit a reply with a signature. These they mounted in albums, often beneath cartes-de-visite, where they added significance and interest to each portrait. Dodgson was no exception, but in the case of his albums he took the concept one stage further by having the sitter sign and date the album page, thus lending authority to the testimony of the portrait. But his insistence on this approach was the cause of some difficulties, as it meant Dodgson needed to have the albums at hand whenever he photographed, otherwise a follow-up visit was required to get the necessary signatures.[167]

Occasionally, signatures appear without a photograph, suggesting the intended portrait did not meet Dodgson's exacting standards for inclusion. Dodgson tried repeatedly to

Plate 50
Professor Robert Gandell and Florence,
10 July 1862
Iffley Rectory, Oxford
4¾ x 6⅜ in. (12.3 x 16.3 cm)
A(II): 96

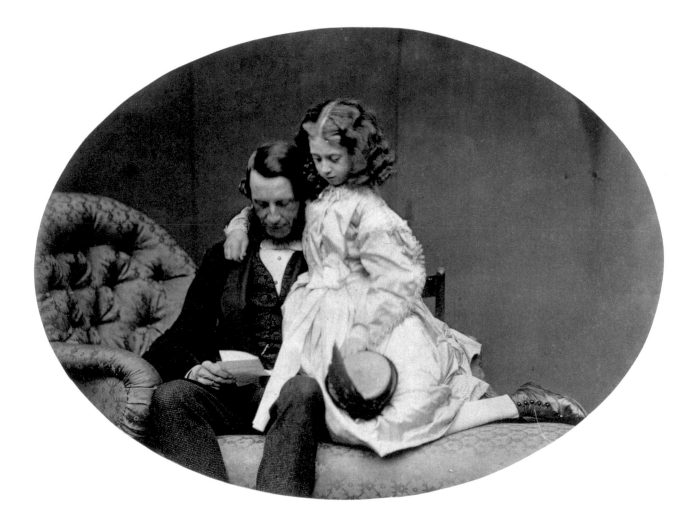

TO AGNES GRACE .

——O fair the blossom on the bough
 With twilight Childhood falling : —
And fair the golden Autumn fruit
 The bloom of youth recalling !

Between our childhood and our age
 The heats of summer tremble:
Defeated Love and Hopes unheard
 Upon the waste assemble .

And thoughts of earlier promise flown
 Or still delaying sadden : —
O long the flower must fade , before
 The fruit our eyes may gladden .

Yet, dear one , in thy smiles we see
 The strength that will sustain thee ,
Till Childhood's happy peace once more
 And blithesomeness regain thee .

——We promise kisses , soon repaid ,
 Within our arms to win thee :
We gaze on azure eyes , that tell
 The depths of Heaven within thee .

We bless thee , darling , as thou art ,
 Our foolish fancy stilling : —
The loving promise of thy youth
 We trust to Love's fulfilling .

We bless the smiles of rising day
 That shame our blind regretting :
We know each grace that gilds the dawn
 Will glorify the setting .

 F . T . Palgrave .

Plate 51
Agnes Weld, with accompanying
stanza by F. T. Palgrave,
18 August 1857
Croft Rectory, Yorkshire
4 x 3 in. (10.1 x 7.5 cm)
A(I): 25

get the Prince of Wales to sit for a portrait during the latter's years as an undergraduate at Oxford. He planned to have the portrait as the opening image of his new album A(II), where it would have greatly enhanced Dodgson's reputation. Initially, the prince agreed, signing and dating the page in anticipation of being photographed, but to Dodgson's great dismay he later withdrew, as "he was utterly weary of being photographed, having been so often victimised."[168] Although Dodgson thought this "hardly sufficient excuse for not keeping his promise," he nevertheless retained the page with its royal autograph, no doubt feeling a royal signature was better than nothing.[169]

Getting signatures from his younger sitters proved less of a problem (plate 52), though getting them to sign in the right place on the page sometimes proved difficult, especially when the child could barely write. To overcome these complications Dodgson drew pencil lines to guide the sitter's immature hand. When he photographed Dymphna Ellis and her sisters in 1865, he forgot to get their signatures and posted the album (A[III]) to them with the following instructions. "So will you please turn 2 or 3 pages on after 'Mary Millais,' and then sign your name in the same place in the page as she did, only about half an inch lower down, and then get Mary, Bertha, and Katie to do the same thing in the following three pages."[170] A few days later when the album had arrived safely back at Croft, Dodgson wrote to thank Dymphna saying "*your* signature made the book 'above £10 in value' and that it 'ought to

Florence Hilda Bainbridge

Plate 52
Florence Bainbridge, summer 1860
Whitby, Yorkshire
5⅜ x 4½ in. (13.8 x 11.4 cm)
A(II): 102

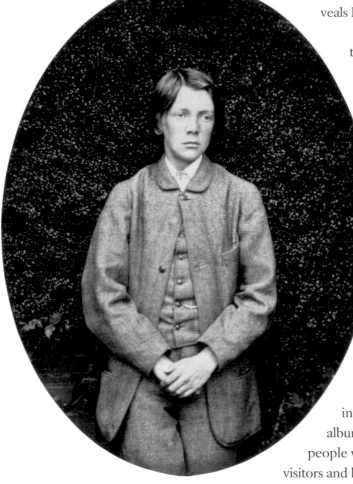

have been registered.'" [171] Clearly a joke to please the child, but one that reveals Dodgson's attitude to the autographs he so painstakingly collected.

Dodgson invested significant time, thought, and effort into the preparation of his show albums, as they were his principal means of reaching a wider audience. Each album was, in effect, a photographic exhibition of his most important work bound between covers. They were fundamentally different from the commercially produced carte-de-visite albums that were, by this time, commonplace in many homes. Dodgson's albums were larger and bound in black leather, a little like a family Bible. Significantly larger than a carte-de-visite, his prints offered greater variety and diversity than those by most photographic studios (plate 53). It would have been immediately apparent to anyone looking at the albums that they had been assembled by someone who thought highly of his work and cared about how it was presented.

The surviving group of six "A" albums constitutes an integrated statement of Dodgson's artistic concepts and intent, the embodiment of his aspirations as a photographer. They played a critical part in establishing his reputation and encouraging new sitters. Throughout the twenty-five years he was involved with photography, the manner in which he used these albums remained consistent. He would send, or leave, his albums with people who expressed any interest in his work. He would show them to visitors and he took them with him wherever he traveled. Through his albums he was rewarded with approval and additional sittings.

Plate 53
Aubrey Taylor, 5 September 1862
East Sheen, London
5⅜ x 4 in. (13.8 x 10.3 cm)
A(II): 124

THE MIDDLE YEARS, 1868–71

This nine-year period in Dodgson's life was characterized mainly by his use of a photographic studio for the first time and his major expeditions into London to photograph some of the most illustrious figures of his day. It was during these years that he matured fully into a confident, self-assured photographer, adding the better part of twelve hundred photographs to his register. Many of these are among his most accomplished and of his most eminent sitters. But to look at this period solely through his photographic activity ignores the significance of these years in terms of Dodgson's professional, literary, and emotional development. During these years he published, under his pseudonym Lewis Carroll, *Wonderland* (1865), *Phantasmagoria* (1869), and *Looking-Glass* (1871). Under his own name he published no fewer than ten works on mathematics: determinants, algebraic formulas, and Euclidean geometry. By

1865, his teaching commitments at Christ Church had increased to the point where they "were getting too much for one" with "about 70 men to look after."[172]

He was no doubt busy and preoccupied, but the outward rhythm and events of Dodgson's life seem ordinary enough for an Oxford don. His biographer Morton N. Cohen describes him as "reticent Victorian, inbred Oxonian, upright cleric, rational mathematician — conservative, formal, controlled" and goes on to suggest that "conventions were the very motors of his life."[173] Dodgson's diaries reveal a very different story: beneath the surface, complex doubts and anxieties began to plague Dodgson with increasing intensity. Throughout this period, prayers and entreaties increasingly filled his diary, where they served to remind him of his sloth, temptation, sin, and worthlessness. During the late 1860s his invocations to the Almighty reached a crescendo before subsiding to record the more steady rhythm of daily life. On 6 March 1864 he implored: "I pray to Thee, oh God, for thy dear Son's sake, help me to live Thee. Help me overcome temptation: help me live as in Thy sight: help me to remember the coming hour of death. For of myself I am utterly weak, and vile and selfish. Lord I believe that Thou canst do all things: oh deliver me from the chains of sin. For Christ's sake. Amen." A week later he returned to the entry, adding "Amen, amen" in reinforcement of his earlier entreaty.

Often Dodgson's prayers are no more than a statement of his deeply felt religious commitment and constant prayer. To Cohen, however, the pattern of these invocations suggests that they were linked to Dodgson's repressed sexual feelings. Cohen reasons that "Chastity, the supreme virtue, was not enough; a clear conscience required not only abstinence, certainly for a bachelor, but an absence of desire, a mind free of sexual fantasies, however involuntary. What we see today as natural human impulses violated both religious faith and social morality."[174] Cohen and others further suggest Dodgson's crisis was prompted by his rejection by the Liddell family in 1863, following a sustained and happy period of informal friendship with Alice and her sisters.[175] What lies behind this suggestion is that Dodgson had repressed sexual feelings for an eleven-year-old girl and that once he was rejected, his "focus turned elsewhere, to other children, both for aesthetic and emotional satisfaction."[176] Rather than Dodgson being rejected by the Liddells, as Cohen suggests, the friendship cooled but nevertheless remained in place, with Dodgson continuing to give inscribed copies of his books to the family and photographing Alice and Lorina. The rejection theory has been put forward by Cohen and others as it neatly fits the idea that Dodgson's proposal of marriage to Alice was rebuffed. There is not a shred of evidence to suggest that such a proposal was ever made. In later life, Dodgson liked to draw and photograph very young girls in the nude, and this too has been offered to corroborate his subconscious inclinations. This chain of supposition begins with Dodgson's presumed rejection by the Liddells, is carried forward through his multiple friendships with little girls, and culminates with his nude photography. This tenuous progression has now labeled him a pedophile.

The demons that plagued Dodgson's dreams and "wakeful hours" will forever remain anonymous. Perhaps his nights were troubled by thoughts of more mature women, as Karoline Leach has suggested.[177] Perhaps his disquiet reflected nothing more sinister than the

conflict of his natural desires with the enforced celibacy of Christ Church. The problem now lies in one's interpretation of just what Dodgson meant when he raised the specters of "sin," "temptation," and "evil" in his diaries. In our prurient, post-Freudian world, it is too easy to conclude that his anxieties arose from sexual urges. However, reading those very same words against the background of mid-nineteenth-century theology and the anxieties it raised casts an altogether different light on Dodgson's entreaties.

The historian Walter Houghton describes the psychological burden imposed by the Puritan dogmas on most of society throughout the Victorian period. "Conscientious souls who tried to achieve a life of absolute purity and self-denial might experience an almost daily sense of failure, distressing in itself and frightening in its implications."[178] Sin, temptation, and evil read through the prism of theological anxiety take on entirely different meanings that readily account for Dodgson's feelings of failure. By committing himself to prayer, he was able to renounce previous wrongdoings and entrust himself to a new and better life in the sight of God.

When Dodgson's name was put forward for a studentship at Christ Church in 1852, acceptance was conditional upon his proceeding to full holy orders. He took deacon's orders in December 1861 and under normal circumstances would have proceeded to priest's orders shortly after. But his sense of worthlessness and inadequacy before God made him feel that to do so would have been inappropriate and hypocritical. He turned to Dean Liddell for advice, suggesting that his studentship was "lay" rather than "clerical." Liddell did not agree, proposing to refer the matter to the Electors (the governing body of Christ Church), but then reconsidered and decided to take the matter no further. His decision left Dodgson with his studentship intact and under no obligation to proceed to holy orders.

Although this must have come as a relief, Dodgson's conscience told him that by turning away from full ordination, he had failed in his duty to his father and Dr. Pusey, his sponsor at Christ Church.[179] Perhaps this explains why he continued to read for ordination long after the dean told him that he no longer needed to do so. An entry in 1868 reveals a glimpse of his true feelings: "To have entered into Holy Orders seems a desecration, with my undisciplined and worldly affections. Help me, dear Lord, to put away self and to give my will wholly to Thee."[180] One should not confuse Dodgson's doubts about proceeding to holy orders with the strength of his religious belief, which remained steadfast. If the personal crisis about taking holy orders was the primary cause of his entreaties to God—and there is nothing to suggest otherwise—then it undermines the claim that he was a pedophile by revealing that he suffered from an inner conflict of religious duty rather than a predatory and frustrated sexuality.

Between 1863 and 1872, portrait photography became increasingly widespread throughout Great Britain. There was a ready market for portraits among the flourishing middle classes, whose disposable income was increasingly spent on the very latest consumer products. During this period, as photography moved from exclusivity to ubiquity, following new formats and fashions in portraiture became essential to a photographer's economic survival. The main "innovation" of the period was the cabinet portrait, a larger, more substantial version

of the carte-de-visite format that was introduced during the late 1860s when every photographer hoped "these pictures will become a rage" and bring new customers to their business.[181]

By 1870 the number of portrait studios in central London had risen to new levels, with over 250 listed in the post office directory.[182] A well-established hierarchy had Elliot & Fry, Hills & Saunders, and other eminent photographers leading the profession, where they served the aristocracy and upper classes of the West End. Middle-ranking photographers had studios scattered throughout the suburbs, where they drew clientele from the rapidly expanding population. At the lowest end of the market were photographers whose fortunes were as transient as their addresses. They knew enough about photography to make a negative and print, but little else mattered. Except for individuals on the very brink of poverty, portraiture was now sufficiently cheap for everyone to be photographed at least once, frequently in celebration of some special occasion.[183]

The commercial supremacy of portraiture had been given impetus by the annual exhibitions of the Photographic Society, which from 1860 onward dedicated increasing space to portraits submitted by leading studios. As the Photographic Society slowly edged toward commercialism, its former authority all but evaporated and more than once it faced bankruptcy.[184] Dodgson would have been aware of the changes within the "profession" and appalled by the photographers who falsely claimed the title of "Professor" and "By Appointment" to attract new customers.[185] The claims of countless photographers to be "artists" devalued the word *artist* to such an extent that it convinced many amateur photographers like Dodgson to remain steadfastly fixed to their original ideals.

His diary entry for 22 April 1863 is the first indication that Dodgson was looking for premises to use as his photographic studio. "Then called at Badcock's to see if his yard will do for photographing. I think myself it will, but have written to ask Mr. Rejlander to come over and give advice about it." In 1863 Richard Badcock was listed as being an upholsterer and appraiser with premises at 105 St. Aldates, just across the road from Christ Church. We have no plans of Badcock's Yard to help reconstruct the likely dimensions and aspect of Dodgson's studio, though one sees from the evidence of his photographs that it was a pretty simple affair. As a minimum, it would have had two rooms, one being the darkroom where negatives could be prepared, processed, and washed. The other would have been set up as the studio, with enough room for both sitter and camera without being cramped. The orientation of the building was a primary consideration, for the direction of the sitter in relation to the sun was critical to the success or failure of a portrait. Working indoors offered many advantages, but it also meant that the lighting had to be carefully controlled according to the time of day and prevailing weather. The usual way to achieve this was by deploying a carefully arranged series of blinds and white reflectors. Exposure times in the studio were invariably longer than outdoors, largely because even the clearest glass had a greenish tinge that reduced the power of the light.

Two months after making his initial inquiry of Badcock, the studio was ready, and on 18 June 1863 Dodgson took his first photograph of the year there, of Mrs. Wethered. He

noted he used "Horne & Thornethwaite's [*sic*] collodion, and iron developer"—a combination of emulsion and chemistry that reduced the exposure time to compensate for the reduced light in the studio. Having made no photographs during the first six months of the year, he found that the studio provided a great impulse that had him hard at work with his camera during the next month, before he left Oxford for the Long Vacation. By mid-July he reported: "I have taken many photographs lately, among others the Brodies, the Donkins, and the Rowdens; two of the Brodies and two of the Donkins were 'ghost' pictures and seem to have succeeded very fairly. I have had some (of Kitchin and his dog) printed, and have come to the conclusion that the background is much too light at present."[186] The next mention of the studio is in November, when Dodgson photographed Crown Prince Frederick of Denmark, then an undergraduate at Christ Church and friend of the Kitchin family.

> A memorable day. Kitchin called about half-past 11 to say he would bring the Prince to be photographed at half-past 12 (he had consented some time ago to sit). Went over to Badcock's and had everything ready when they arrived. They stayed about half an hour, and I took two negatives of him, a 6x5 half-length, and a 10x8 full-length. In the intervals he looked over my photographs that are mounted on cards, and he also signed his name in my album, saying as he did so that it was the *first* time he had used his new title. (He is now Crown-Prince, the news of the death of the old king having come on *Monday*). He conversed pleasantly and sensibly, and is evidently a much brighter specimen of royalty than his brother-in-law.[187]

Dodgson compounded the problems of low November light by choosing such large negative formats, which required longer exposure times. By way of compensation he took the figure full-length, with his camera set farther away than usual, so that any slight movement would be less detectable. The prince seems to have held steady with one hand at his midriff, the other lightly resting on the table. His academic robe and mortarboard complete the ensemble to create a statuesque pose that is entirely without animation or personality (P[3]: 3). In terms of rank, this was Dodgson's most eminent sitter, and little wonder he began a new album, A(III), with the hope of the prince's portrait and signature. It would make up for his earlier disappointment with the Prince of Wales (hence the dig about the brother-in-law). Once more, fate intervened: the negative did not meet Dodgson's expectations, being underexposed and poorly lit. Consequently, the first page in album A(III) also lacks a photograph, and the prince's signature is the only testimony of their meeting.[188]

On the evidence of the photographic register and diary entries, Dodgson seems to have taken about 350 photographs at the studio in Badcock's Yard during the nine years he retained it. Of those, only a third seem to have been preserved, either in his albums or as a handful of loose prints. The majority of these prints are in album A(III), now at the Univer-

sity of Texas at Austin. One can understand why Dodgson would have been attracted to the idea of a studio in the first place. It gave him a place of his own, which he could call "his studio" and where he could work as an "artist." It was somewhere he could leave his camera, apparatus, and chemicals ready for immediate use. Most important, it gave him a permanent headquarters for his photography away from the restrained world of Christ Church—a sanctuary to which he could retreat. We get a glimpse of his feelings about the new studio in one of his heart-rending invocations on 28 June 1864.

> The first half of 1864 is drawing to an end. Oh holy and merciful God, grant for Christ's sake that the second half may be spent more as in Thy sight—that it may not be sullied with the sins that have clouded these six months, and so much of my life hitherto. Help me for Christ's sake. Amen. I write this in my photographic studio, with the earnest hope that from this may date, by God's blessing, the commencement of a new and better life.[189]

It would be facile to suggest Dodgson's Badcock's Yard photographs are as bleak as this judgment of his character. However, very few of the portraits made at the studio are notable, the majority being competent exercises in photography rather than perceptive studies of interesting sitters. All conform to prevailing notions of photographic practice. It is as if, being in a studio for the first time, Dodgson became less assured, not knowing how to make best use of the place. Paradoxically, he seems to have been encumbered by the opportunities presented by his studio and liberated by the restrictions of photographing under difficult circumstances in the homes of his friends, when he would rise to the challenge by making some of his most engaging and significant portraits. His studio portraits of Professor Acland (A[II]: 94) and Professor Donkin (A[II]: 91), for example, are uncomfortable essays in studio portraiture. The lighting from the overhead skylight is both flat and unbecoming, expressing neither the form nor the character of either face. The unfortunate effect of the light background is evident here, with both figures eclipsed by the large, featureless expanse of studio wall that dominates the composition.

An exception to the general dullness is the portrait of Rev. Thomas Barker with his daughter, May, taken on 6 June 1864 (plate 54). "Before I was drest [*sic*] Barker arrived with his eldest child, May, whom I had begged he would bring over to be photographed. Took three pictures of her. One, with him, looks first rate."[190] The photograph was taken in one corner of the studio, where an open window gives significance and structure to the overall composition and its potential meaning. Without it, Barker's pose would have been impossible. As it is, his eyes barely reach above the lintel where he rests his head and peers outside. His daughter, May, stands on the chair, resting her weight upon his back and her hand upon his shoulder. Her right hand lightly touches the wall above her father's head. Her steady gaze at the camera is both knowing and completely trusting. It is a sunny day, and the light streams through the skylight to cast its shadow on Barker's legs and forearm.

Plate 54
Rev. Thomas Barker and May,
6 June 1864
Badcock's Yard, Oxford
8 x 6 in. (20.4 x 15.3 cm)
Gernsheim Collection,
Harry Ransom Humanities
Research Center, University
of Texas at Austin

What meaning did the photograph suggest to Dodgson? Clearly, he recognized something in the picture when he called it "first rate." The overall effect is unsettling and quite unlike any other photograph Dodgson ever took. Central to the feeling of displacement is the diametric tension between the two figures. The father looks hesitantly over the threshold of the window, his arm outstretched in support, as if fearful of what he might discover. He carries the burden of his daughter on his back, both literally and metaphorically. Standing protectively behind her father, May rests a comforting hand upon his shoulder, suggesting that she is aware of the responsibility he bears. But unlike her father, she looks not to the future but toward the present, where the camera makes its exposure.

In the summer of 1870, toward the end of Dodgson's time at the studio and several years after his close and affectionate relationship with the family had cooled, Mrs. Liddell paid an unexpected call. "This morning an almost equally wonderful thing occurred: Mrs. Liddell brought Ina and Alice to be photographed . . . first visiting my rooms, and then the studio." [191] It was almost exactly five years since Dodgson had seen his "little favourites," Ina and Alice. On that earlier occasion he had noted, "Alice seems changed a good deal, and hardly for the better, probably going through the usual awkward stage of transition." [192] Here she was before his camera again, now a young woman of eighteen (plate 55). What a profoundly different person from the girl of six he had photographed in 1858 as she acted out the part of a beggar maid (plate 44). The evanescent spirit of childhood had evaporated, and Alice's eyes are filled with overwhelming sadness as she looks past the camera to some distant point. The warmth and happiness of a friendship that had altered the course of Dodgson's life and filled it with such joy are long past, and he used this opportunity to say farewell with a portrait that is both poignant and affectionate. This was his last photograph of Alice.

Plate 55
Alice Liddell, 25 June 1870
Badcock's Yard, Oxford
5⅝ x 4 in. (14.1 x 10.3 cm)
Private collection,
Christ Church, Oxford

The studio photographs from Badcock's Yard account for a little more than thirty percent of Dodgson's registered output for the period. The remainder, amounting to over five hundred subjects, were made away from Oxford, either in London, Yorkshire, or the Isle of Wight. With the start of each Long Vacation, Dodgson would pack his bags and photographic apparatus at the first opportunity and head off to stay with family, friends, or relatives, where he would establish himself and get to work with his camera. These trips, which usually took place between early July and mid-October, allowed several weeks for photographing to his heart's content.

Dodgson spent the whole summer of 1864 photographing and traveling. The experiences of these three months are typical for their range and diversity. Dodgson's diary for that period reveals something of his social life, photographic *modus operandi,* and personality. Lambeth Palace was the official London residence of Charles Longley, Archbishop of

Canterbury, primate of the Church of England, and old friend of the Dodgson family. Being directly opposite the Houses of Parliament on the south bank of the Thames made Lambeth Palace a convenient and prestigious address for Dodgson's visitors. The Old Hummums in Covent Garden was his preferred hotel. The diary extracts below have been selected and lightly edited to give a taste of Dodgson's photographic activities.

1 JULY Left Oxford by the 2.20 for London. First called at Thomas' to leave the photographic machinery, then to the Old Hummums to leave the other luggage: then to Thurloe Square and dined and spent the evening with Uncle Skeffington.

2 JULY Called at Thomas' and arranged about the new camera etc. Then to Lambeth Palace, where I settled that I would bring over the apparatus on Monday morning. Then to the German Reed's afternoon entertainment—the Egyptian piece "The Pyramid," "The Bard and his Birthday," and Parry's "Mrs. Roseleaf at the sea-side"—the latter was far the best thing of the entertainment.

4 JULY Took the camera etc., from Thomas' to Lambeth Palace, but only succeeded in getting one picture done before lunch, a half-length of Rosamond. As I was going away after lunch I met Mrs. Balfour of Roker, who happens to be in London with her children, and we at once arranged for her to bring them tomorrow. . . .

5 JULY Lambeth again. Took a small picture of Mrs. H. Longley, and a full length of Little Walter Bourke. (The Longleys were away at a wedding). Also took Dr. Gatty, who accidentally called, and Georgie and Ella Balfour, separately and together. . . .

6 JULY Took pictures of the Longley party. Called on Mr. Denman at the Temple. (Uncle Hassard had spoken to him about taking a photograph of Grace.) He gave me a note to Mrs. Denman, and I called on her, and arranged for their coming on Friday.

7 JULY Took pictures of Lord Dalkeith's [*sic*, Lord Darnley] children, Ivo (5) and Alice (3). Also of Mr. Parnell's, Victor, Madeline, Loui, Leila (Elizabeth) and Mabel, and a full-length of the Archbishop. . . .

8 JULY On reaching Lambeth I found Mrs. Denman and her three children, Edith (9), Arthur (6), and Grace (5). Mrs. Johnson arrived soon afterwards with three boys, . . . and a little girl Edith. They could not stay long, and I had only time to do the eldest boy and the little girl. Mrs. Denman also was obliged to go about 1, but she left the children, whom I went on photographing till about 3, and then took them home and stayed some while with them. Edith showed me the clay

model of a statue of herself taken about 4 years ago by Marochetti. I remember seeing it in the Royal Academy, and asking Marochetti if it was possible to get an opportunity of photographing it. . . . Heard today from Lady A. Stanley—no sitting to be had of the Princess Beatrice: she does not mention the photographs, from which I conclude that the Queen did not keep any.

9 JULY Mr. Westmacott sent four of his children to Lambeth, Beatrice, Amy, Antoinette, and Constance, of all of whom I got good pictures. Most of the Longleys left about 2. Henry and his wife remained, and I took a picture of them together. About 5 I went to the Westmacotts to get signatures in my album—dined at their tea, and remained till nearly 9.

11 JULY Took pictures of Mrs. Gilliatt and children, and a Mrs. Randall, a friend of hers. Also a little niece of the porter at the gate, Maria White by name, who sat capitally. . . .

12 JULY Took photos of Mr. Westmacott, Mr. Darvall, and Miss Irene MacDonald, alone, and with Mary. . . .

13 JULY Did not photograph. Took three boxes of negatives to Messrs. Cundall's place, 19 Bedford Place, Kensington, and went over all the negatives there, putting some back into their places, and re-numbering others.

14 JULY Called on Tom Taylor at his office, but he had not come. I left for him a photograph of the nun, and one of "When May was young," and asked for an introduction to Mr. Watts. (I have got no answer from Mrs. Cameron to my request for one). Called on Andrews, and settled to photograph him tomorrow. Also to the Deanery, Westminster, and asked the Dean to send back my photographs, and offered to photograph Lady A. Stanley and her little niece if they can come tomorrow morning. Then called on Mr. Munro, and lunched there. He kindly gave me a note of introduction to Mr. Valentine Prinsep. (5 Courtland Place, Kensington). I called there and saw both him and Mr. Martineau, who lodges in the same house. I saw many pictures of Mr. Prinsep's, the one he is now working at is from *The Rape of the Lock,* where the lady is walking out of the room in a huff. . . . Mr. Prinsep gave me, at my request, a note of introduction to Mr. Watts, armed with which I at last found my way to "Little Holland House." *He* also was at home, and received me most kindly, and showed me a room full of pictures, including Tennyson, Henry Taylor, and Garibaldi, and also his studio. . . . He showed me a large photograph (negative) by Mrs. Cameron, of Mrs. Watts in "Choosing," and nearly promised to come, with her, on Saturday, to be photographed. Mr. Martineau will probably come on that day also.

What do we understand of Dodgson and his world from these entries? First, we see that practically every day was devoted to photography. With Lambeth Palace as his base, Dodgson found no shortage of sitters willing to be photographed. Some he invited, but others, perhaps hearing he was in town, offered themselves for portraits, sometimes materializing— like Cheshire cats—without prior warning. His portraiture was not at all limited to children, as often claimed, but was well balanced with adults. Even the unfortunate Dr. Gatty, who called "accidentally," ends up before the camera. Dodgson emerges from his account as a social animal, comfortable with everyone he encounters, from the Archbishop of Canterbury to the niece of the porter at Lambeth Palace. People enjoyed his company and welcomed him into their homes; he often stayed for meals and entertained the children.

Dodgson used his contacts within society to advance his cause. Lady Stanley, wife of Dean Stanley, was a lady-in-waiting to Queen Victoria. Through her, Dodgson sought permission to photograph Princess Beatrice, then aged seven, sending examples of his photographs in support of his application. At this level of society, an introduction, usually by note or letter, was the only acceptable means of extending one's circle of contacts. Without it a person was either not "received" or was told the person on whom they called was not "at home." Armed with the appropriate introductions, Dodgson was warmly received, as his education, interests, and social standing as an Oxford don made him desirable company. Dodgson's social acceptance was essential to his success as a photographer, for without personal entrée to such diverse and remarkable sitters, his efforts would have been doomed.

Like many other amateur photographers, Dodgson used the services of a photographic printer who could be trusted to fulfill orders promptly and to the highest possible standard. We have seen that during the course of two weeks Dodgson made sufficient negatives to fill three boxes, which he took to Messrs. Cundall and Downes for printing.[193] Joseph Cundall ran one of a number of establishments in London that did photographic printing on a commercial basis for those, like Dodgson, who could afford to leave this demanding, time-consuming craft in professional hands.[194] By 1864 Dodgson had made over fourteen hundred collodion negatives though not all might have survived. This heavy, bulky collection could not be stored in his confined quarters at Christ Church, so he sent most of the negatives to Cundall's, where they were readily available for printing on demand. This arrangement suited Dodgson well, and during the 1870s, following the demise of Cundall's, he similarly used the eminent portrait photographers Hills & Saunders in Oxford, whose studio was in Cornmarket Street adjacent to Christ Church. Also around this time, he entrusted special commissions to the photographers Robinson and Cherrill, of Tunbridge Wells. The first of these, in 1874, was for two colored photographic enamels of Xie Kitchin; the company specialized in this technique.[195]

After his hectic spell of photography in London during July of 1864 Dodgson felt he had "enough of town" and decided to try a vacation on the Isle of Wight.[196] He took with him a "carpet bag full of photographs" to show Tennyson or Julia Margaret Cameron, with whom he had been in recent correspondence.[197] During a visit that June to the Photographic Society exhibition he had first seen Cameron's "large heads taken out of focus" and found he

"did *not* admire" them at all. Unlike Dodgson, she went in close with her camera, frequently filling the frame with the head of her sitter. At such close quarters, she found it difficult to control her focus and keep the sitter motionless. In addition, her handling of the collodion process was slapdash, with fingerprints and smudges commonplace. This was the first time Cameron had exhibited, and although critics judged her work bold and distinctive, they ultimately felt she failed to achieve the desirable qualities of sharpness and detail.[198] Little wonder that photographs thought to be "dreadfully opposed to photographic conventionalities"[199] were anathema to Dodgson, whose love of detail and precision lay at the very heart of his practice (plate 56).

When the two met on the morning of 28 July, Cameron "begged" Dodgson to bring over his photographs that evening, after which he reported to his sister, "Mrs. Cameron and I had a mutual exhibition of photographs. Hers are all taken purposely out of focus—some are very picturesque—some merely hideous. However she talks of them all as if they were triumphs in art. She wished she could have had some of *my* subjects to take *out* of focus— and *I* expressed an analogous wish with regard to some of *her* subjects" (in other words, *in* focus).[200] Both were amateur photographers, and both regarded themselves as artists: Dodgson, with his pristine and very detailed photographs with never a blemish to detract from their perfection; Cameron, with photographs that echoed her extravagant personality. But beneath the differences in style and technique, Dodgson and Cameron shared many ideals that stemmed from their deep love of art, religion, and literature. He would have been attracted by her personality and her social position within the "Holland House" set and surely admired her generous and independent spirit. Throughout his life, Dodgson bought the work of photographers he especially appreciated, referring to the prints for analysis and inspiration. His album called "Professional and Other Photographs," now at the University of Texas, offers a representative selection of work by his favorite photographers. Not surprisingly, Rejlander figures significantly and Cameron hardly at all. A photographer for whom Dodgson had great regard and whose work he readily bought was Clementina, Lady Hawarden. He was so taken with her pictures at the 1864 Photographic Society exhibition that he sought out her stand at a bazaar held for the benefit of female artists at the Kensington Museum, where he bought a group of prints. When Dodgson discovered that Lord Hawarden had been an old pupil of his father's, he arranged to return the following day to have Lady Hawarden photograph Mary and Irene MacDonald in her studio at the bazaar.[201]

Among Dodgson's closest friends in the 1860s were the MacDonalds, who lived in north London. George MacDonald was professor of English at Bedford College but better known for his fairy stories and other fantasies for children. Dodgson first met the MacDonald children at Munro's studio in 1860, where Greville was the model for the statue *Boy with the Dolphin,* now in Hyde Park, London. Visits to their home soon followed, and the family readily accepted Dodgson as a close and welcome friend. He was clearly at home there and on one memorable occasion made a group portrait of Mrs. MacDonald and four of the children in which he uncharacteristically placed himself at its center as if he were part of the family—

Plate 56
Julia Margaret Cameron
(1815–1879)
Sir J. F. W. Herschel, 1867
8⅜ x 6⅛ in. (21.3 x 15.6 cm)
Private collection

which in many respects he probably was (plate 57). It was the MacDonalds who suggested that Dodgson publish *Alice's Adventures Under Ground*.[202]

During late July 1863, Dodgson spent an intensive few days photographing the MacDonalds, their friends, and sundry other children, adding over thirty new subjects to his inventory.[203] This group of photographs shows just how varied and imaginative Dodgson could be when completely familiar with his subjects and they with him. In the course of the week he employed a range of different photographic strategies to achieve what he wanted. He showed George MacDonald at work, concentrating deeply on his writing (plate 58). What appears at first to be a simple profile portrait is, in fact, filled with a latent tension that animates the space between MacDonald's eyes and his pen, creating a triangulation that symbolizes his mental powers as an author. The composition would have collapsed if he had looked at the camera. The portrait of Nelly MacDonald, a niece, relies equally upon the direction of her gaze (A[II]: 87). Her devotional attitude and uplifted eyes remove all sense of tension. As in Lake Price's *The Monk* (plate 9), the real subject of the photograph lies well beyond the frame, in heaven.

Just as God watches over Nelly, so George MacDonald and his son, Ronald, watch over the sleeping form of Mary (plate 59). For the second time within a month, Dodgson resorted to photographic manipulation to achieve his desired effect. His "ghost" pictures of the Donkins (see p. 76), involved making two separate exposures on a single plate, giving the figures a slightly transparent and supernatural appearance. Here the effect was achieved by making two separate negatives and combining the prints into a single composition. In this, Dodgson followed the example of Rejlander and Henry Peach Robinson, whose complex collages were regularly exhibited at the Photographic Society in London. To Victorian sensibilities sleep was a state of grace that brought one closer to God. In that world of ever-present vulnerabilities, there was little to distinguish sleep from death; they were two sides of the same state—one in this world, the other in heaven. Christina Rossetti, one of Dodgson's heroines, touched on the subject in her poem "After Death" (1848): "He leaned above me, thinking that I slept / And could not hear him; and as he turned away / Came a deep silence, and I knew he wept."[204]

Very young children were especially admired asleep, when their serene expressions conveyed angelic innocence. (This admiration of childhood innocence remains just as potent today.) The motif of the sleeping child was popular with photographers from the outset, for it served a practical purpose by keeping children motionless during the long exposures. David Octavius Hill and Robert Adamson used the idea in several of their portraits from the 1840s—most notably in that of Elizabeth Logan, a portrait that prefigures Dodgson's attempts over twenty years later.[205] The pose was not new to Dodgson, who had already used it in the portraits of his brother Edwin (plate 49) and of Alice Liddell (A[II]: 37). In the composite portrait of Mary he took the idea a stage further by including MacDonald with his son, Ronald. Together they adopt the role of watchful guardians looking to the safety of the family.

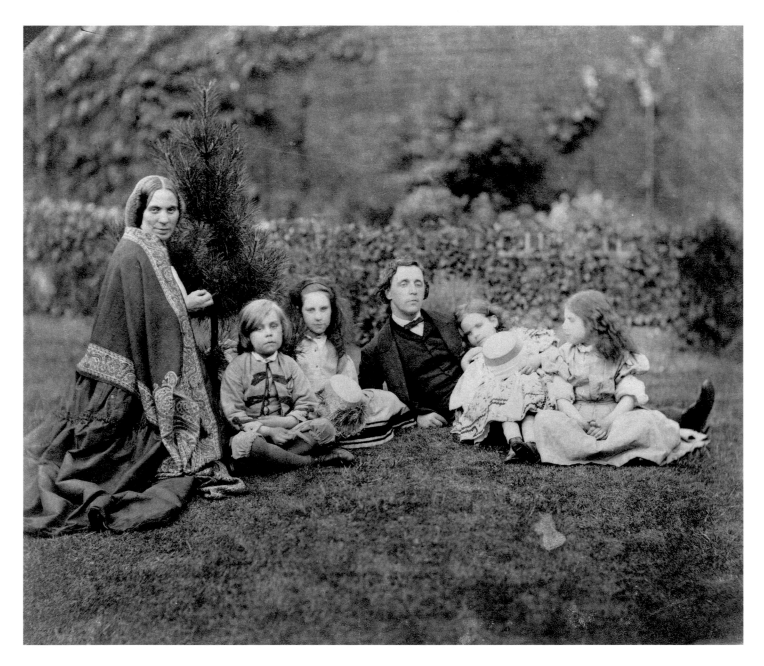

Plate 57
Mrs. MacDonald and Children, with
Charles Dodgson, 25–31 July 1863
Elm Lodge, Hampstead
6⅞ x 9½ in. (17.5 x 24.2 cm)
Scottish National Portrait Gallery,
Edinburgh

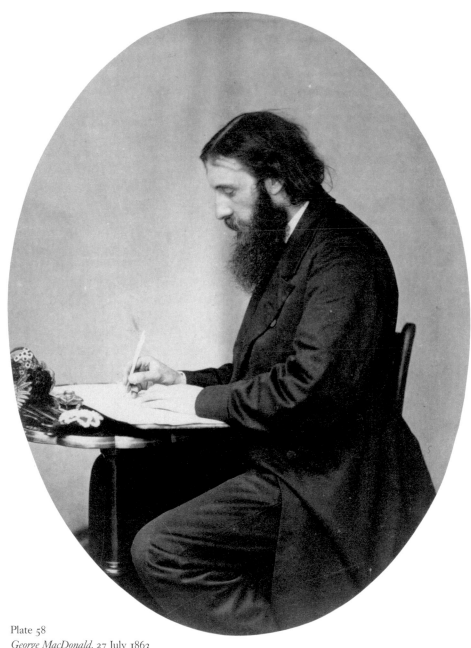

Plate 58
George MacDonald, 27 July 1863
Elm Lodge, Hampstead
6½ x 4¾ in. (16.4 x 12.2 cm)
A(II): 59

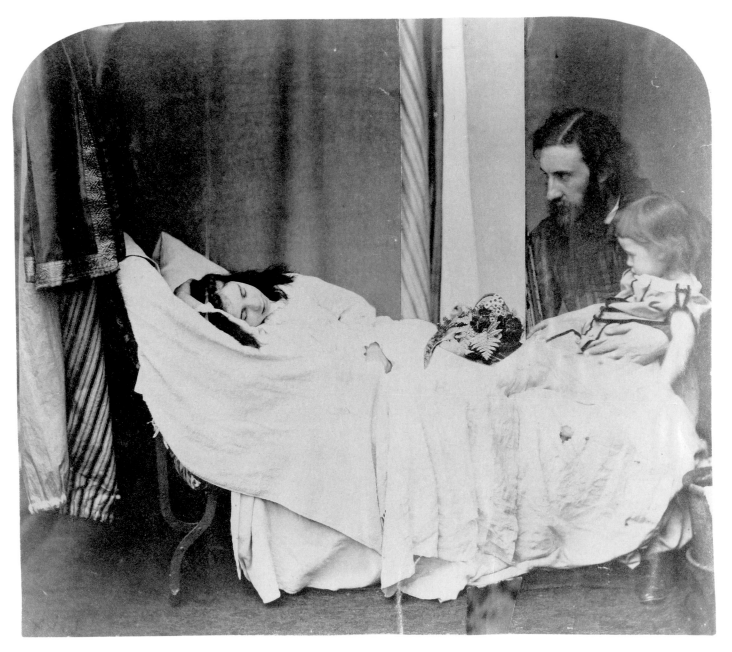

Plate 59
George MacDonald with Mary and Ronald, 25–31 July 1863
Elm Lodge, Hampstead
6⅜ x 7¼ in. (15.9 x 18.2 cm)
Scottish National Portrait Gallery, Edinburgh

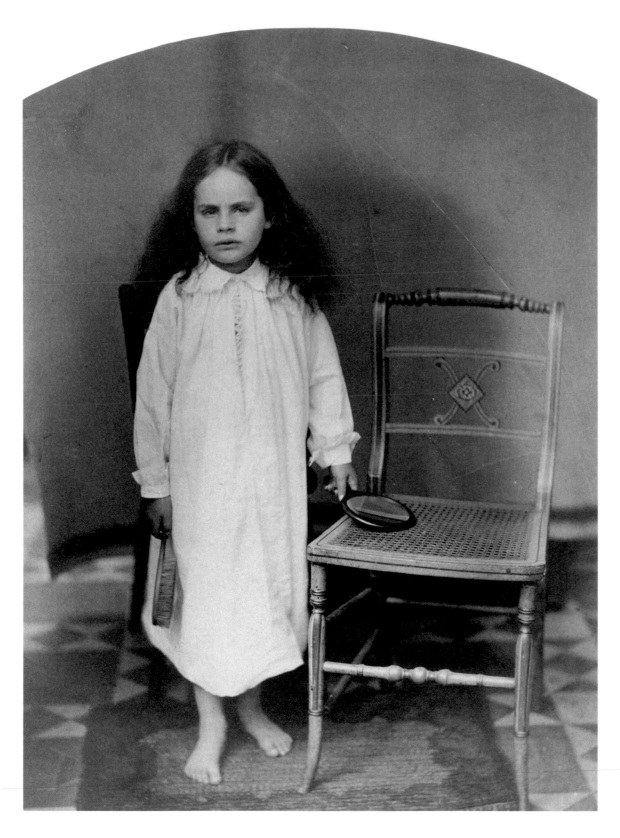

Plate 60
*Irene MacDonald in "It Won't Come
Smooth,"* 25–31 July 1863
Elm Lodge, Hampstead
8⅛ x 6 in. (20.5 x 15.3 cm)
Gernsheim Collection,
Harry Ransom Humanities
Research Center, University
of Texas at Austin

Another narrative is suggested by a pairing of two photographs of Irene Mac-Donald. The first pictures young Irene, aged six, standing barefooted in her night-dress, her hair in disarray (plate 60). In one hand she holds a hairbrush, in the other a mirror, and she looks imploringly at the camera. Knowing what misery young children experienced each morning when trying to dress their hair, Dodgson entitled the photograph *"It Won't Come Smooth."* In another photograph Irene is now fully dressed, with her hair neatly brushed and tied up with a ribbon (plate 61). Although they are not presented as a be-fore-and-after pair, the implicit meaning would have been clear to both Dodgson and Irene. There has been much speculation about the mean-ing of another portrait of Irene, clad in a disheveled dress, in which she reclines upon richly textured fabrics and cushions (plate 62). Her bare limbs and languid expression strike a discordant note with contemporary viewers alert to the erotic incongruity of a six-year-old posing as an adult. However, the MacDonalds had recently returned from Algeria, and so this setting and pose, with its overtones of harem life, was more likely to have been suggested by the parents than by Dodgson.[206]

Among the visitors who came to the MacDonalds that photography-filled week were Flora and Mary Rankin and Margaret Campbell. Of the three girls, Dodgson considered Flora "the only one of the three particularly worth taking" and set up his largest camera to take her portrait.[207] Again, he could not resist the opportunity to make a pair of images that draws upon our emotional response to the contrasting states of repose and joy. In the first (A[II]: 113) Flora looks directly at the camera with a calm, steady expression, and her open and trusting gaze holds our attention. In the second (plate 63) she again looks directly at the camera, but here it is her luminous smile that captures our whole-hearted attention. This is a picture of a radiantly happy young girl, utterly self-confident be-fore Dodgson's camera. The technical ability necessary to capture such a fleeting expression was considerable, and this picture reveals that Dodgson had learned how effective the com-bination of Horne & Thornthwaite's collodion and iron developer was in reducing exposure times.[208] He recognized what he had achieved in capturing the spontaneity of Flora's smile, and some years later he sent a print to Charles Darwin after reading his book *The Expression of the Emotions in Man and Animals,* published in 1872.[209] The book was illustrated, in part, with photographs of expressions and gestures taken by Rejlander especially for the book. Other photographers also contributed to it, notably Herr Kindermann of Hamburg and Dr. Wallich of London, who had also photographed a smiling girl. Dodgson knew Dr. Wallich and had been photographed by him in April 1866, so he may have been encouraged to send Darwin his photograph of Flora's engaging smile.

Dodgson's use of the studio in Badcock's Yard, which remained a constant factor in his photographic activities throughout this middle period, allowed him to photograph when-ever an opportunity arose, albeit sporadically. The rewarding years of 1863–66 brought him

Plate 61
Irene MacDonald, 25–31 July 1863
Elm Lodge, Hampstead
3⅞ x 3 in. (10 x 7.5 cm)
Gernsheim Collection,
Harry Ransom Humanities
Research Center, University
of Texas at Austin

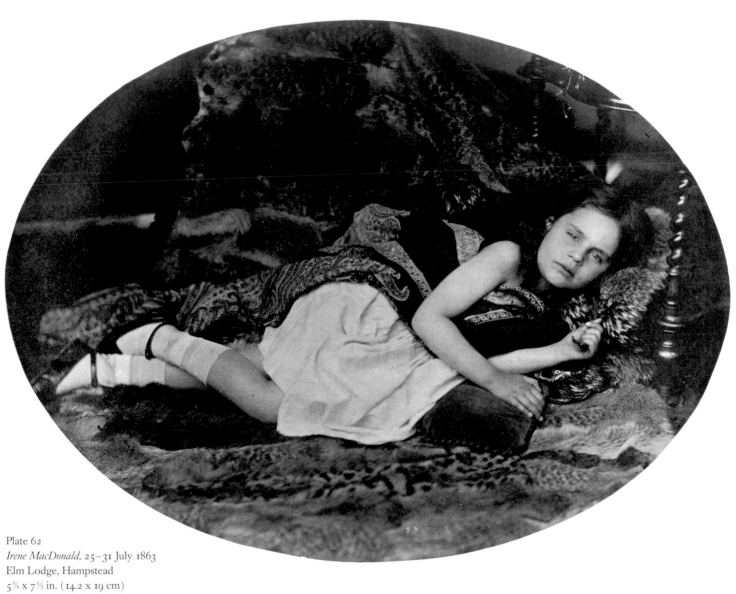

Plate 62
Irene MacDonald, 25–31 July 1863
Elm Lodge, Hampstead
5⅝ x 7½ in. (14.2 x 19 cm)
Gernsheim Collection,
Harry Ransom Humanities
Research Center, University
of Texas at Austin

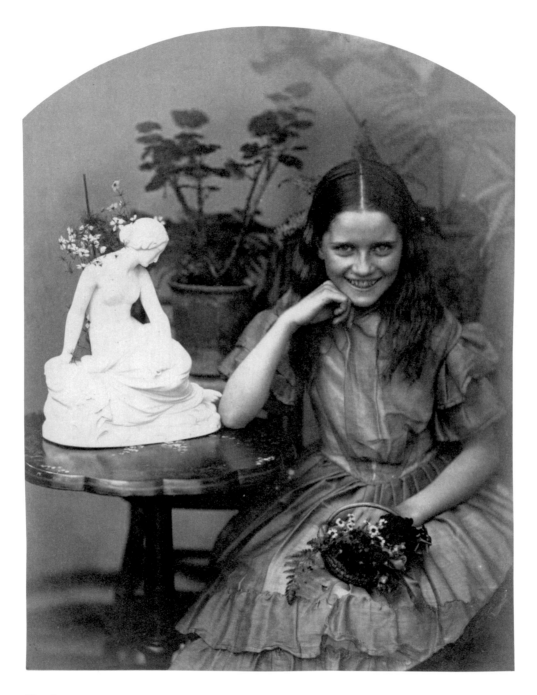

Plate 63
Flora Rankin in "No Lessons Today,"
25–31 July 1863
Elm Lodge, Hampstead
6⅝ x 5⅛ in. (17 x 12.9 cm)
A(II): 81

into intimate contact with Pre-Raphaelite artists and leading literary, scientific, and theatrical figures of the day. During the Long Vacations, Dodgson met and photographed such eminent people as the Rossetti family, John Everett Millais (plate 64), Arthur Hughes, James Westmacott, James Sant, Tom Taylor, Henry Taylor (A[II]: 123), Aubrey de Vere (A[II]: 85), Charlotte Yonge (P[3]: 45), John Phillips, George Peabody, and Benjamin Terry and his entire family.

This pattern of busily photographing during the Long Vacation would doubtless have continued during the summer of 1867 if Dodgson had not agreed to accompany his friend Henry P. Liddon to Russia. The anticipation of a long and arduous trip across Europe prompted Dodgson to leave his camera and paraphernalia at Christ Church. The following June, when he would ordinarily have returned to photography, his father died unexpectedly, leaving Dodgson to assume full responsibility for his brothers and sisters. In future years, the long months of summer were no longer dedicated to photography; instead, Dodgson alternated between Christ Church and Guildford, where he had leased a house for his family following their enforced departure from Croft Rectory.

These profound changes are reflected in Dodgson's diaries. Up to 21 June, the day his father died, he set down his thoughts, observations, fears, and prayers in a daily record. Immediately after his father's death he wrote nothing for six weeks, and then his diaries seem never to have assumed the same importance again, as there are frequent gaps of several weeks between entries. Life took on new meaning for Dodgson as he came to terms with the loss of his father and his new responsibilities as head of the family. The rhythm of his life began to slow, with less frequent visits to London and the theater. The passion and energy that had driven his photography for fifteen years began to diminish, so that by 1871 he took hardly any photographs at all. This middle period closed in December 1871, with Dodgson about to face his fortieth birthday and his life running at a different pace.

Plate 64
John Everett Millais, 21 July 1865
7 Cromwell Place, London
5 x 3¾ in. (12.7 x 9.5 cm)
P(3): 53

THE FINAL YEARS, 1872–80

This final period of Dodgson's photography opens on 17 March 1872 with a note in his diary: "Yesterday I took my first photo in the new studio, Julia Arnold: I had her and Ethel with me for about three hours."[210] This entry marks the phase of photography in the rooftop studio that the college authorities had allowed Dodgson to build above his new suite of rooms at Christ Church. The rooms had become vacant during the summer of 1868, and Dodgson was

fortunate to secure them, as they were among the best in Christ Church and far larger than anything he had previously occupied. In all, there were ten rooms on two floors, and from the upper floor there was easy access to the roof. Part of their attraction, apart from the additional space, was the hope he might be able to build a new studio. "There seems a bare possibility of my erecting a photographing room on the top, accessible from the rooms which would be indeed a luxury, and as I am paying £6 a year rent for my present one, I should soon save a great deal of the outlay."[211]

Dodgson moved into the rooms on 30 October 1868, and for the next few years pursued the possibility of having an adjacent studio. It took the better part of four years for the college authorities to agree and for Dodgson to have the studio built, but by October 1871 it was finished.[212] A small and windowless room, on the stairs and close to the studio, was converted into a darkroom where he could prepare and develop his collodion plates. By October 1871 everything was ready.[213] For the next eight years this studio and darkroom lay at the center of Dodgson's photographic activities, and he rarely took his cameras elsewhere —the most notable exception being his visit to the home of the artist Henry Holiday in July 1875.

The new studio encouraged Dodgson to photograph much sooner in the year, often as early as March, but more usually April or May, when the light had improved. He would continue to photograph well into October, but rarely beyond that date. He did most of his photography now in spring and autumn, rather than during the Long Vacation. His summers were spent at the fashionable seaside resort of Eastbourne, where, from 1877, he dedicated this part of the year to working on forthcoming publications.[214] For summer relaxation, he spent time walking, sketching, and making new child-friends at every opportunity, but never once took his camera with him. Photography remained important to Dodgson, but now it was confined more or less to his Christ Church studio.

By the time Dodgson moved into his new rooms, he had made and accumulated the better part of two thousand negatives, and for the first time he was able to bring them all together under his direct care rather than leave them with commercial printers. With the negatives and darkroom readily at hand, Dodgson was able to print again, something he seems not to have done regularly since the very early days.[215] He could set out his printing frames on the roof of Christ Church to expose them for several hours, safe in the knowledge he could hurry upstairs from time to time to see how they were progressing.[216] On one occasion he prided himself for having photographed, printed, and mounted the finished results within a matter of three days, saying, "It is the quickest piece of photography I have done."[217]

Dodgson dedicated himself to reviewing his entire photographic output during the summer of 1875, when he reorganized his entire stock of negatives, prints, and albums into one consistent and coherent sequence with everything registered and numbered retrospectively back to 1856. After two more weeks spent going through all the negatives, he knew exactly what prints had to be made to complete his files.[218] During the course of this review, he discovered that many of his best negatives had been ruined by dampness from being shut

up tightly in wooden storage boxes.[219] Three years later Dodgson moved the negative cupboard from his sitting room to the spare bedroom upstairs in order "to escape the damp." The move prompted yet another review and sorting of negatives.[220] For Dodgson, this final phase in his Christ Church studio was as much about the organization and presentation of his past as it was to do with making new photographs.

The new suite of rooms allowed Dodgson to receive and entertain guests more easily than before, and his diaries reveal a constant stream of mothers and children who either called socially or came to be photographed. For the children, these visits were filled with magical delights. A regular visitor was Beatrice Hatch, whom Dodgson first photographed in July 1873. She later recalled her visits and described the comfortable sitting room with its red sofa and walls lined with bookcases with cupboards beneath. These cupboards held "musical boxes of different colours and different tunes, the dear old woolly bear that walked when he was wound up, toys, picture books and packets of photographs of other children who had also enjoyed these mornings of bliss."[221] There were also Indian shawls, Chinese costumes, beggars' rags, and other theatrical properties, which the children used to dress up. And there was music, with Dodgson solemnly turning the handle of his "orguinette," raising and lowering its lid to modulate the sound, and enjoying every note of "Santa Lucia," with which he invariably started his concerts.[222]

Upstairs in the darkroom, favored children stood beside Dodgson "while he poured the contents of several little, strong-smelling bottles on to the glass picture of yourself that looked so funny with its black face."[223] To Alice Liddell, recalling an even earlier time, such fun and games made "being photographed . . . a joy to us and not a penance as it is to most children."[224] For her "the darkroom was so mysterious, and we felt any adventure might happen there! There were all the joys of preparation, anticipation, and realisation, besides the feeling that we were assisting at some secret rite usually reserved for grown-ups!"[225] This kind of entertainment was extended to Dodgson's summer holidays at Eastbourne, where he took an assortment of toys, puzzles, and games to capture the attention of the children he met there.

Seeking the friendship of children—in Oxford, Eastbourne, and elsewhere—became a distinguishing feature of Dodgson's life in the years following his father's death. As an author of children's books, Dodgson (or should we say Lewis Carroll?) consistently surrounded himself with the company of children, in order to better know the workings of their imagination and their fears. During this latter phase of his life, it is clear that he also needed the company of children to retain his sense of equilibrium and direction. This became especially apparent during his visits to Eastbourne, where he would actively seek out children to befriend and tally up his score at the end of each holiday. In 1877, for example, he noted, "My child-friends, during this seaside visit, have been far more numerous than in any former year" and went on to list the names of twenty-six children belonging to eleven families. Nine more children were also listed "but hardly as friends."[226]

Nothing gave Dodgson greater pleasure than to have a child as a companion whenever this was practicable. In London he would "borrow" a child to accompany him to the

theater, having first checked whether the play was in good taste and unlikely to offend innocent sensibilities.[227] In Eastbourne he would borrow children and take them either on trips in a rowing boat or to the aquarium in Brighton.[228] His diary entries make clear that he greatly enjoyed the company of these children and took complete responsibility for their physical and moral welfare. Their parents were no doubt grateful that this reverend Oxford don took such a benign interest in their daughters, for once having met him, they knew him to be correct in every aspect of behavior and social etiquette.

Having spent five weeks in Margate with his sisters during the summer of 1870, Dodgson concluded that the people he met there were pleasant, though "very few turned out to be above the commercial class, the one drawback of Margate society."[229] As a resort, Eastbourne was higher up the social scale than Margate, and Dodgson chose it for his summer holidays because he knew he would meet families of his own class whose children he expected to be educated *and* graceful. He disliked what he considered the coarse features of working-class children and was attracted to children who conformed to his ideals of beauty, but he would encourage the friendship only if the child proved to be alert and intelligent. These preferences could now be regarded as suspect had not Dodgson been equally fascinated by the company of mature women. Many were married women and the mothers of the children he befriended. Some were single women, others widows. Again, the tone of his diary suggests his interest in them was entirely platonic, inspired by their intellectual and social qualities rather than by any other motivation.

The image we have from Dodgson's diaries and letters of this period is not of a shy and retiring man handicapped by a stammer. Rather, it is of someone outwardly genial and sociable, enjoying invitations and a wide circle of friends ranging from the highest levels of society to families he met on the promenade at Eastbourne. At heart he was a social creature who loved nothing more than the company of others, whatever their gender, age, or marital status. He actively sought friendship and fellowship (among his own kind) as a counterbalance to his otherwise solitary existence at Christ Church in the exclusively male company of dons and undergraduates. His deep sense of loss following the death of his father was heightened by an inner sense of isolation resulting from his enforced bachelorhood. The governing body of Christ Church overturned the rule of celibacy only in 1878, but by then it was too late; Dodgson was forty-six years old and deeply set in his ways.[230]

Despite his sociability, Dodgson nevertheless remained a troubled man, fearful of his unconscious thoughts. By day, he was in absolute control of every action, thought, and deed. He left nothing to chance; every aspect of his self-possessed behavior was endowed with a charm and grace appropriate to his position as an Oxford don and reverend gentleman. But the nights posed special problems. To avoid surrendering control to the world of dreams, Dodgson kept himself awake by solving complex mathematical problems in his head. In his introduction to *Pillow Problems Thought Out During Sleepless Nights* (1893), he recommends the book to readers who might find comfort in solving a mathematical problem "while lying awake at night" troubled by some thought "which no effort of will is able to banish."[231] We

cannot know what thoughts and anxieties kept Dodgson awake until the early hours, for (unlike some other Victorian diarists) he never hinted at what passed through his mind as he lay awake in bed. The central issue is not whether Dodgson had erotic fantasies—and it would be unusual for any adult male not to have them—but whether these fantasies manifested themselves during his waking hours and, if so, what he did to control or sublimate them.

During the eight years Dodgson used his Christ Church studio, it is estimated that he took sixty to eighty photographs each year. In comparison with earlier years, and given the ideal circumstances of his new studio, this number is remarkably low. Some years he barely photographed at all. For instance, in 1877 he started the year full of good intent, noting he "had the studio etc., dusted and mixed some chemicals, as I hope to do some photographs here this month."[232] But little followed these initial preparations, and during the year he seems to have made only twelve photographs, the majority of which were taken on 16 and 20 June, immediately after the studio was prepared for active use. Making new photographs had become less important to Dodgson than organizing and caring for his photographs from earlier years. In 1875 he was willing to dedicate three weeks of solid and complex work to renumbering his entire photographic output from the previous nineteen years, but found only two days for taking photographs in 1877. The new photographs he did take fall into three distinct categories. There were straightforward portraits; portraits of children "dressed up" and frequently with staged settings and props; and photographs of young children "sans habillement." Most of his new photographs were of children, and of these, the majority were of young girls.

Of all the young girls Dodgson photographed, his favorite model was undoubtedly Alexandra, or Xie (as she was better known), Kitchin. He photographed her more often and in a wider variety of poses and costumes than any other person, and so she, above all others, has come to epitomize this period in the Christ Church studio. Her father, George William Kitchin, was four years older than Dodgson and a Christ Church man, having graduated brilliantly with first class honors in both mathematics and classics.[233] They shared many common interests, including a love of art, and their friendship continued after Kitchin was appointed headmaster of Twyford School, Hampshire, in 1855, with Dodgson paying visits in 1857 and 1859, the latter with his camera. Kitchin returned to Christ Church in 1861 and two years later married Maud Alice Taylor, the second daughter of Bridges Taylor, British consul to Denmark. As a young girl in Denmark she had become a friend of Alexandra, daughter of Prince and Princess Christian of Schleswig-Holstein-Sonderburg-Glucksburg; the young princess was destined to marry the Prince of Wales in 1863. Alexandra Kitchin was born in 1864 and named for the Princess of Wales in honor of the friendship. It is clear from Dodgson's diaries and surviving correspondence that his friendship with the Kitchins was especially close and unconstrained. It was Kitchin who arranged to bring Prince Frederick of Denmark to be photographed by Dodgson in 1863, and in later years it was to Maud Kitchin that Dodgson turned for moral support and guidance when dealing with rumor and gossip directed against him.

The portraits Dodgson took of Xie are unique among his entire output, as she was the only person he photographed from childhood, aged five, through adolescence, aged sixteen. Wakeling's comprehensive register of Dodgson's photographs identifies almost fifty portraits of Xie, with the first taken in 1869 and the last in 1880. The 1869 portrait, made when Dodgson still kept his studio in Badcock's Yard, shows Xie reclining barefoot upon his massive sofa (L: 2). Supported somewhat uncomfortably by a single cushion, she looks directly toward the camera with all the innocence of a child unfamiliar with the processes of photography. The device of sofa, cushion, and propped-up child was Dodgson's standard pose when he could think of nothing more original. He repeated it three years later when Xie was first photographed in the Christ Church studio (plate 65). Despite the similarity of pose, she is no longer an infant propped up by cushions, but a young girl of eight with fancy stockings and shoes, her hair adorned by a ribbon. Understandably, Dodgson found her a most attractive subject: she had already matured into a classically beautiful young girl with clear, fine features. Her gaze toward the camera now looks more assured and at ease.

In every portrait of Xie it is her gaze that holds our attention. When she looks to the camera, she does so with a directness, sincerity, and openness that reveal how comfortable and relaxed she was in Dodgson's company. She understood the practical limitations imposed by photography and happily colluded with Dodgson to help achieve his ambition of making interesting and artistic compositions. In 1873, for example, she was photographed repeatedly—in Indian shawls on 19 April, "in winter dress (Danish), in red petticoat, and in Greek dress" on 14 May. On 12 June she was photographed "with spade and bucket, in bed, and in Greek dress" (L: 6) and on 14 July in "Chinese dress (two positions)."[234] Of this group, the best-known images are the last, which are a diptych of opposing images that have Xie as an "on duty" (plate 66) and "off duty" (P[3]: 106) Chinese merchant. Dodgson clearly went to some trouble to locate six authentic-looking tea-chests as well as a full Chinese outfit, complete with shoes and hat, of the correct size to fit Xie. What prompted the photographs remains a mystery, but more than likely it was a theatrical or literary reference that now eludes us.

Dodgson's favorite image from the 1873 series was of Xie dressed for a Danish winter (plate 67). Given the family connections, the idea for the photograph most likely came from Xie's parents, and the picture may have been intended as a gift to Princess Alexandra. Writing to Mrs. Kitchin in August 1873, Dodgson hoped the "coloured portrait of Xie (as Dane) worthy of being offered to the Princess of Wales," adding as an aside, "you might send it 'from the Artist,' if you think it etiquette to do so."[235] A few days later he wrote again, asking Mrs. Kitchin if she could suggest any improvements to the coloring of copies he was having done for himself and the Kitchins. His own list of suggested improvements tells us something about Xie, whose complexion he indicated should not be "fair and colourless" and whose hair should be "brown, tipped with gold."[236] In January 1874 he ordered two photographic enamels of this image from Robinson and Cherrill of Tunbridge Wells, one of which he gave to Mrs. Kitchin.[237]

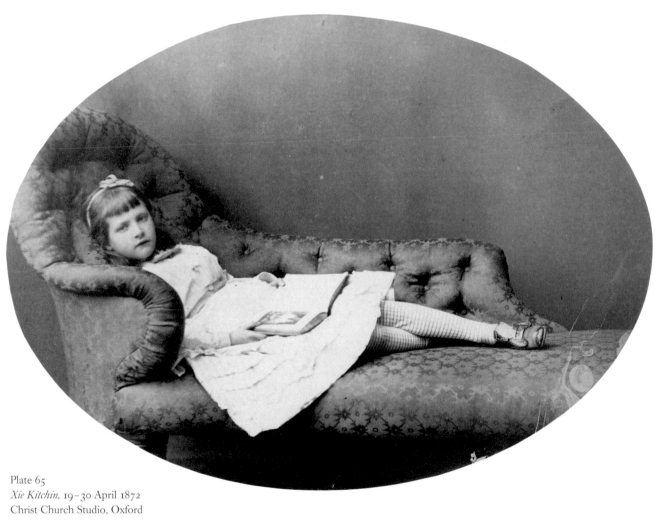

Plate 65
Xie Kitchin, 19–30 April 1872
Christ Church Studio, Oxford
4¾ x 6½ in. (12.3 x 16.6 cm)
P(3): 99

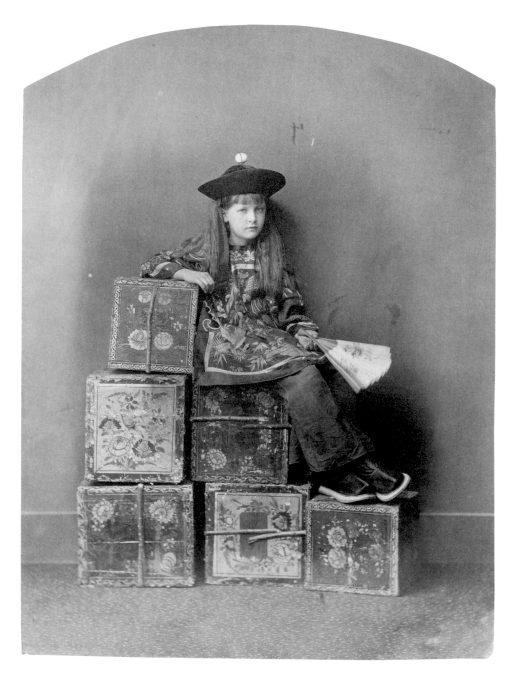

Plate 66
Xie Kitchin as "Tea-Merchant"
(On Duty), 14 July 1873
Christ Church Studio, Oxford
6⅝ x 5 in. (16.7 x 12.7 cm)
P(3): 105

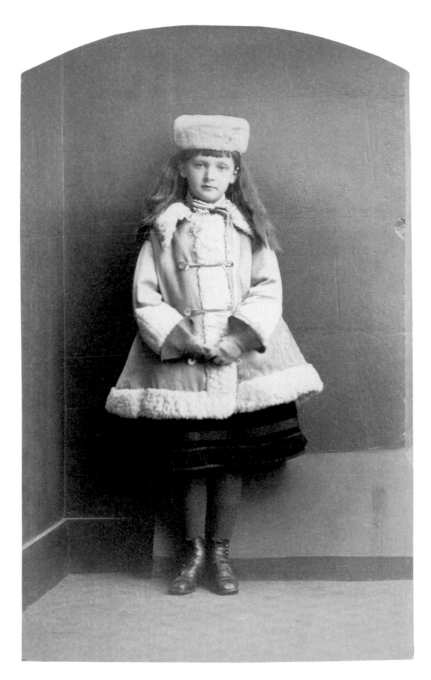

Plate 67
Xie Kitchin as "Dane," 14 May 1873
Christ Church Studio, Oxford
6⅝ x 4⅛ in. (16.8 x 10.4 cm)
P(3): 101

The most elaborate of Dodgson's costume studies dates from June 1875 and involved not just Xie but also her three younger brothers in a set piece entitled "St. George and the Dragon" (plate 68). This is the most telling of all Dodgson's set pieces because it shows how well he understood the minds of children, who didn't care a jot about strict adherence to reality as long as the essence of the idea was carried out with vigor and enthusiasm. The image of St. George (Britain's patron saint) impaling the serpentine dragon with his lance was deeply embedded in the national consciousness as a symbol of good triumphing over evil.[238] What fun it must have been for the Kitchin children to play out the characters of this drama, gathering together the necessary props and costumes. What matter if the proud charger was a rocking horse, the dragon a leopard-skin rug, the crowns silver paper, and the sword too long to lift? With these wonderful improvisations and exaggerations, Dodgson draws us into the world of childhood imagination. In this awkward and curious photograph we recognize the pantomime being played out before the camera and recall with fondness the childish games of our own youth. Dodgson tapped deep into collective memories with this image and in so doing created something entirely unique and memorable that sets this photograph closer to his literature than to his artistic ambitions.

St. George and the Dragon also marked the beginning of Xie's gradual departure from childhood into adolescence. After this date, Dodgson's photographs of her became more formal, treating Xie as a diminutive adult rather than a grown-up child. His photographs of her as Penelope Boothby, a character from Oliver Goldsmith's *Vicar of Wakefield,* show her as an actress, a young Ellen Terry, if you will, rather than as a child dressing up for fun. Here Xie projected herself into the role of a fully grown woman, and through the act of being photographed perhaps caught a glimmering of what this persona might be like (L: 22, 23).

During his last four years of photographing, Dodgson frequently posed Xie with her violin. A study from 1876 shows her with the violin held to her chin, the tip of her bow resting on the studio wall to keep it from moving. There is an uneasy relationship between Xie and her violin: the instrument is slightly too large, making it appear as if it might escape her control at any moment (L: 24). By 1880, however, she revealed herself to have become a violinist (L: 43). The instrument is now tucked firmly under her chin and her head tilted sideways, in the manner of a true professional. Her bowing arm is arrested at the very moment it was about to begin its downward sweep and the tune begin. How things have altered in the course of four years! The sway of Xie's pose suggests her emergence into womanhood even more definitively than it does her skills with the violin. Her dress is now that of an adult, with its soft velvet styled to reveal her narrow waist and the swell of her hips. With her transition from childhood now complete, how appropriate that this portrait should be the last Dodgson made of Xie, taken just weeks before he also made his transition away from photography — the pastime that had rewarded him constantly for twenty-five years.

When Dodgson began photography during the closing years of the 1850s, it was possible to photograph naked children in the name of art and show the results at the annual exhibitions

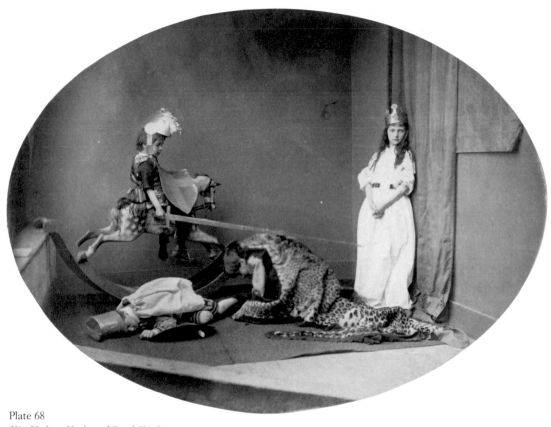

Plate 68
Xie, Herbert, Hugh, and Brook Kitchin
in "St. George and the Dragon,"
26 June 1875
Christ Church Studio, Oxford
4 ⅛ x 5 ½ in. (10.5 x 14 cm)
P(3): 108

of the Photographic Society and elsewhere. Many of Rejlander's compositions, for example, relied upon his being able to include naked children without fear of censure, and he was often praised for his allusions to classical art and biblical themes. We have also seen that his use of nudes in the *Two Ways of Life* caused little affront when exhibited in Manchester and London. Because Prince Albert and Queen Victoria both regarded this type of nudity in art as perfectly acceptable and bought Rejlander's work without hesitation, they legitimized this genre of photography.[239] During the 1850s printsellers, booksellers, and stationers in London were importing "academic" nude studies by French photographers in response to the demand of artists who found life models too expensive.[240] Rejlander's *Studies of the Anatomy of the Arm* and other life studies exhibited during the late 1850s were his way of responding to this market (plate 42).[241]

But attitudes toward this type of study slowly began to change. When Rejlander exhibited a retrospective group of his work, which included some nudes, at the Dublin International Exhibition of 1865, it was felt that two of his pictures were "indecent and should not have been submitted."[242] Three years later the photographic press called for a stop to the "custom of exhibiting . . . portraits of the most notorious courtesans of the day amongst the royal family, the bishops, the prime ministers and other celebrated personages."[243] Anxieties about the links between photography, immorality, and the theater began to emerge with reports of photographs of "brazen burlesque pages, lolling opera dancers and small female notorieties—notorious for immodesty on the stage rather than for dramatic capacity."[244] As increasing numbers of photographers began to exploit the growing market for cartes-de-visite, it was inevitable that the morality of their choice and presentation of certain subjects would be called into doubt.

Questions about the morality of the photographic nude were posed. "If it be right and proper to exhibit in public the statue of a nude female, on what grounds is it indecent to exhibit a photograph of the same female in a similar state of undress."[245] The debate went further by asking, "how much is to be hidden, how much concealed" and "where is the horizontal line on the human leg above which is perdition, below which all is pure?"[246] Unlike the theater, over which the lord chamberlain held considerable powers of censorship, photography remained largely unregulated, allowing unscrupulous photographers to test the limits of decency under the disguise of art. Gradually, though, the boundaries of censorship were defined, largely through the untiring efforts of the Society for the Suppression of Vice, which began to work closely with the police to bring cases of indecent photography before the courts.

The unflinching resistance to all forms of immorality reflected the fears of the middle classes about the moral welfare of their children, who were endangered (or so it was suggested) by the rising tide of immorality that threatened to engulf the nation. All representations of the naked human form were decried, but especially photography, which had "largely stimulated and aided the production of immoral pictures"; by 1871, 150,000 such photographs were reported to have been destroyed.[247] Vigilante groups from the Society for the Suppression

Plate 69
Arthur Burdett Frost (1851–1928)
Stunning Cantab, illustration from
"Hiawatha's Photographing,"
Firestone Library,
Princeton University

of Vice toured London's streets in search of what they considered indecent pictures displayed in shop windows. They bought prints from unsuspecting dealers and used them to secure prosecutions. Swept along by the rising tide of national opinion, the courts handed down severe sentences. Even in cases where an element of doubt remained, a sentence of two years hard labor plus the destruction of stock and a fine of £50 were considered appropriate.[248] As the courts attempted to define what was lawful, errors of judgment about what constituted an indecent picture were inevitable. One zealous magistrate ordered the destruction of reproductions of "well-known works of art—*Leda and the Swan, Perseus and Andromeda, The Greek Slave, &c.*" because he thought that "the works were indecent."[249] If the legendary Mrs. Grundy stood as a metaphor for public opinion, then the Society for the Suppression of Vice served as her prosecuting council.[250]

Dodgson was fully aware of these issues and knew that society had become increasingly sensitive about the fundamental differences between high art and photographic art.[251] A camera in the hands of a commercial operator could reveal a woman with almost clinical accuracy, whereas it was widely recognized that "no artist worthy of the name has ever painted a naked woman with the unreserved imitation of detail given by the indecent photograph of a woman."[252] The previously acclaimed virtues of photographic verisimilitude now became its own worst enemy by revealing the human form in scandalous detail. That such photographs could be circulated for personal gain and gratification was regarded as sordid and disgraceful.

Paradoxically, just as photography began to be censored, the taste in popular art moved in exactly the opposite direction, with images of prepubescent girls establishing themselves as a favorite subject matter in children's literature and the burgeoning market for greeting cards. When British art began to look to the Orient for inspiration during the late 1860s, the tenets of the Pre-Raphaelites gave way to the idealization of beauty that became known as the Aesthetic Movement. This new approach became widely influential, reaching into many aspects of everyday life. Peacocks, parasols, lilies, sunflowers, and oriental blue-and-white china—all of which became icons of the Aesthetic Movement—were eagerly taken up by architects, fabric and furniture designers, and ceramic manufacturers. One of Dodgson's illustrators, Arthur Burdett Frost, used this symbolism in his drawing of the "Stunning-Cantab" for a new printing of "Hiawatha's Photographing" (plate 69), when he showed a young man striking a theatrical pose in deep contemplation of a lily. Behind him stands a screen boldly patterned with sunflowers.

The idealization of beauty reached its most populist and commercial level through the illustrations of Walter Crane, Ralph Caldecott, and Kate Greenaway, whose popular books were all woven around sentimental ideals associated with the innocence of childhood. Greenaway took the Georgian period as her setting, allowing her children to act out adult roles in the safety of the past. Another artist, William Stephen Coleman, conjured up an equally

THE OLD AND THE NEW.

Christmas (New Style). "WE ARE THE MODERN CHRISTMAS CARDS—WE ARE! WE ARE! WE ARE!"

Plate 70
Linley Sambourne
The Old and the New,
cartoon from *Punch,*
24 December 1881, 290

untainted and idyllic world where partially clothed prepubescent girls were represented as unself-conscious children of nature, happy to be naked in the perpetual sunlight of his imagination. As the art director of the Minton Art Pottery Studio, London, Coleman designed a variety of ceramic wares heavily influenced by the Aesthetic Movement. His work reached an even wider audience through his designs for Christmas, Easter, and birthday cards published by Thomas de la Rue during the closing years of the 1870s. The public responded enthusiastically to Coleman's overtly sentimental rendering of childhood innocence, despite the erotic overtones of budding breasts and dimpled buttocks.[253] This style of greeting card became so popular it was copied by numerous imitators and was parodied by the satirical magazine *Punch,* which suggested that naked girls might be thoroughly modern but they posed a real threat to the traditional image of Christmas (plate 70).[254] The triumph of these greeting cards was that they established naked young girls as acceptable subject matter without bringing a blush to the cheeks of the ever-vigilant Mrs. Grundy; had these same subjects been photographed, it would have been a very different matter.[255]

By the time Dodgson moved into his new Christ Church studio in 1872, the moral crusade against any form of nudity in photography was well established. No matter how innocent and sincere his intentions, he realized that his requests to make nude studies were "unconventional notions of Art" that placed all concerned at risk.[256] But when images of prepubescent girls began to gain acceptance within mainstream popular culture, Dodgson, believing he would now be less open to censure, was encouraged to renew his interest in the genre.

Of the many artists and illustrators whose work found its way into the greeting-card market, Dodgson especially admired Emily Gertrude Thomson, whose drawings of naked children and fairies conformed exactly with his own interests and sentiments. Although Thomson was not in the same league as Coleman, she was nevertheless a highly competent and successful artist, having trained at the Manchester School of Art and exhibited on several occasions. When Dodgson saw a set of her cards that had been published for the Christmas season of 1878, he wrote to her publishers asking whether he might meet with her to discuss their shared interests in art, technique, and the importance of working from life models.[257] Their meeting in June 1879 began a friendship that lasted until Dodgson's death in 1898. This friendship was based upon their mutual appreciation of the naked form of the prepubescent child as the most perfect means to express the innocence of childhood. Both knew these sentiments could be expressed in art without fear of recrimination, and Dodgson's friendship with Thomson no doubt made him feel more comfortable about nude photography. This was crucially important to Dodgson, as he wanted nothing more than to photograph free of moral censure, remaining, as another artist lady-friend put it, in "the pink of propriety."[258]

Because Dodgson's nude photographs have been the subject of more intense speculation and ill-formed judgment than any other aspect of his entire photographic œuvre, it is crucially important to establish some clear facts before going on to judge the work itself. Edward Wakeling's meticulous register of Dodgson's photographs reveals that prior to 1875, well after his move to the Christ Church studio, there were two occasions on which nude studies of young girls were *definitely* taken. The first was of Beatrice Latham in May 1867. She and her mother came to the Badcock's Yard studio, where Dodgson took a number of portraits of them together before photographing Beatrice "sans habillement," as he modestly put it.[259] The next occasion was in October 1869 at the house of the Haydon family in Guildford, where he made a great number of portraits, including two of a very young Ethel Haydon "undraped." All the photographs that day were taken in the garden, so the nude sittings must have been kept short, given the season.[260] When Dodgson photographed Ethel and Beatrice Hatch in July 1873, he discovered that Beatrice was "entirely indifferent as to dress."[261] He photographed her "seated in a crouching attitude, with one hand to her chin" and considered the result a "gem" that he was unlikely to repeat.[262]

In October 1876 Dodgson devoted four days to photographing Lily Gray. Bad chemicals in the developer spoiled the first photographs, but this was quickly remedied, and Dodgson made more studies of Lily who, he remarked, was "so perfectly simple and unconscious that it is a matter of entire indifference to her whether she is taken in full dress or nothing."[263]

Three years elapsed before Dodgson made his next series of nude studies, which took place in a number of sessions between 17 and 29 July 1879. The first was of Ada Smith, the favorite child-model of Sir Frederick Leighton. She came down from London with Emily Gertrude Thomson expressly to be photographed by Dodgson, with Thomson in attendance helping arrange the poses.[264] There is some doubt whether these photographs were nude studies, though given Smith's profession as an artist's model it seems more likely than not.

The next few days were filled with visits from Mrs. Henderson, whose daughters Annie and Frances were "ready for any amount of undress and seemed delighted to run about naked."[265] They went to the studio on four separate occasions during the next seven days.[266] On one occasion, Frances went to the studio without her mother, with Thomson acting as chaperone, and was photographed "lying on the sofa in her favourite dress of 'nothing.'"[267] A few days later, it was the turn of Annie, who Dodgson photographed "lying on a blanket, naked as usual."[268] That same afternoon "Mrs. Hatch came with Beatrice, Ethel, and Evelyn. I photographed all three: Evelyn naked—a kind of photo I have often done lately."[269] With this wry observation, Dodgson ended his photography for the year, setting off for his summer holidays in Eastbourne a few days later. His final series of nude studies was made the following year, 1880, when Annie and Frances Henderson were photographed once more in their favorite state of "nothing to wear."[270]

This, then, is the sum total of Dodgson's nude photography: an activity limited to eight sessions spread over thirteen years involving the children of six families (excluding Ada Smith, whose profession as a life model places her in a somewhat different category). It is not the record of a habitual voyeur, pornographer, or pedophile, but the response of an overtly sentimental bachelor to the innocent beauty and grace of childhood.[271] Whether this type of photography was Dodgson's way of satisfying or sublimating his sexual desires can never be known and will always remain fruitless speculation. Certainly the fear that this might be the case never troubled the families involved, and we can be certain that any whiff of impropriety would have been keenly scented.

Dodgson was always concerned about the nature of his requests to make nude studies, knowing that what he asked posed a threat to the reputation of the families concerned. He took every precaution to ensure confidentiality, knowing that if prints fell into the wrong hands they could be misinterpreted; as he was now printing his own negatives again, he was able to guarantee control over every stage of the process. Writing to Mrs. Chataway about photographs he had just taken of Gertrude in her bathing drawers, he revealed his sensitivity when he asked permission to show the prints to friends. "My own idea would be to put them among others I have done of the same kind (some in less dress), and then they would only be shown on exceptional occasions and to exceptional friends."[272] In another letter he tells the Chataways the negative of Gertrude "is locked up safe, where no printer can get at it; and it is entered on a list 'to be erased,' as a direction to my Executors, when the negatives come into their possession."[273] Prints he made from these negatives he stored in envelopes marked "to be burned unopened."[274] Through such elaborate arrangements he sought

to protect the reputations of the families and children involved rather than conceal his own actions, for he knew his motives to be above reproach.

Because of these precautions, only four nude studies have survived, and even these are not photographs in the strict sense of the word. Three of them have been heavily over-painted in oils and the fourth is a watercolor sketch based on a photograph. The technique of applying color to photographs began with daguerreotype portraits, in which it was used to soften the metallic glare and make the appearance of the sitter more lifelike. Subsequently, coloring was used to raise the status of the photograph to that of a painting and was called by one artist "elaborating upon photographic foundations."[275] This description applies perfectly to the overpainted portrait of Evelyn Hatch (plate 71); here the artist took the central figure and elaborated every detail of the setting and background to create a riverbank and gypsy encampment. The technique used to color the figure is soft, transparent, and suggestive of photography, but the remainder is oil color densely applied in a painterly fashion that contrasts strangely with the appearance of the figure. Evelyn is portrayed as the unself-conscious child of nature, a free-spirited gypsy child, to whom nakedness was of little concern, free to scamper back to the safety of the tent at a moment's notice.

The whole confection owes much to popular taste and the Coleman school of artistic sentiment, but it also had to meet Dodgson's own exacting standards. We have to remind ourselves that Dodgson always regarded himself as an artist and that his nude studies were an extension of that ambition. In a letter to one parent, he explained, "If I did not believe I could take such pictures without any lower motive than a pure love of Art, I would not ask it."[276] His aspiration was to create a nude study that would be regarded as a work of art and not be out of place in the drawing room of the most respectable home.[277]

Ironically, it was Dodgson's ambitions as a photographic artist that ultimately contributed to his giving up photography after July 1880.[278] By that date, rumors were freely circulating among university wives about Dodgson's photographic activities in the rooftop studio. These, they felt certain, lay beyond the bounds of propriety. Much of this gossip stemmed from a single incident earlier in the year. Dodgson had been looking after "Atty" Owen and her younger brother in his rooms until their father, Sidney Owen, Tutor and Reader in Modern Law at Christ Church, came to collect them. Dodgson's diary mentions that Atty did not look fourteen, and that, "having kissed her at parting, I learned (from Owen) that she is seventeen, I was astonished, but I don't think either of us was much displeased at the mistake having been made!"[279] Nevertheless, aware he had transgressed socially, he wrote immediately to Atty's mother, Mary Ellen Owen, with a letter of mock apology. But Mrs. Owen was not to be placated, perhaps feeling that Dodgson's kiss indicated a more serious and sinister flaw in his character. Dodgson was at a loss to know how to make amends, writing, "I really don't know *what* would result from a chance meeting. I think I should cross the road if I saw them coming, and so avoid the difficulty."[280]

The matter was never resolved, and the rumors and gossip continued unchecked during the next few months. Almost inevitably the issue of the kiss became conflated with

Dodgson's photographic activities. Dodgson clearly knew about the gossip, for after making his nude studies of the Henderson girls in May 1880, he wrote to his old friend and confidante Maud Kitchin asking for her help. "If Mrs. Grundy should mention the matter to you, please make all the excuses for me that you can think of."[281] Despite his best efforts to quiet the wagging tongues, rumors condemning Dodgson's photography of "*other* peoples children" continued to circulate, with Mary Ellen Owen named as the chief culprit.[282] Although he knew himself to be blameless, Dodgson would have recognized how hurtful such gossip would be to the families of his sitters. Always exquisitely sensitive to social niceties, Dodgson sought to limit further damage by setting aside his photography until the gossip died away. His biographer Morton N. Cohen summarizes it perfectly: "The decision to abandon photography was . . . neither instantaneous nor deliberate. It seems to have evolved naturally. Eight days after he took his last photograph, he left for Eastbourne. Photography was out of the question while he was there: Eastbourne time was for writing. On his return to Oxford in the autumn, the pressures of academic life made him forgo photography until good weather and bright sunshine returned."[283]

And so it was that Dodgson drifted into photographic retirement. Occasionally he thought about taking a nude study,[284] but somehow he never got around to it, and little by little his darkroom days were over. But this did not mean that Dodgson abandoned all interest in photography, for right up to his death in January 1898 he continued much as before, showing his albums, meeting photographers, commissioning photographs, and ordering reprints from existing negatives.

Had Dodgson decided to give up photography in 1876, following his review of his entire photographic output, his reputation would have stood higher than it does today, since his œuvre would have excluded the later nude studies that have done so much to bring his motives into question. What are we to make of the long span of Dodgson's photography now that it has more fully entered the public domain with this publication? Very few amateurs from Dodgson's period consistently photographed for so many years (twenty-five, in his case) with little more reward than personal recognition as an artist and an extended series of friendships to sustain them. Many gave up early on, defeated by the changing context of photography. For others, it was the expense that finally overwhelmed them, forcing them to sell their equipment and switch to less costly pastimes. Others simply lost their motivation. But for Dodgson none of these things held true. His chosen isolation from the world of photographic societies and exhibitions served him well, insulating him from the disillusionment that helped drive so many of the second generation of photographers into early retirement during the 1860s. As an Oxford university tutor he enjoyed a more than adequate income and a comfortable lifestyle, cushioned by the privileges of Christ Church. He could well afford his hobby, and once the royalties of his *Alice* books began to pour in, the cost of photography was no longer an issue. In his search for photographic perfection he could easily afford the best equipment and materials available.

During the course of Dodgson's twenty-five years as a photographer, it is hardly surprising that his involvement with photography ebbed and flowed in response to his circumstances and other commitments. But there was never a real crisis about how he was to move forward to the next season and the next body of work. His concentration on portraiture ensured that he would never be short of material so long as he could get out and about to meet new and interesting families and their children. Concentrating largely, though not exclusively, on children as sitters enabled him to regenerate his enthusiasm with each new discovery. To him, children were magical, a gift from God that gave meaning and purpose to his life as a bachelor, reverend gentleman, and children's author. Their enjoyment of his company reaffirmed his sense of humanity and kept the vital spark of his creativity very much alive as part of his daily life. Only weeks before his death on 14 January 1898 he was still meeting children, sketching with Gertrude Thomson, and sitting up until 4 A.M. trying to solve a mathematical problem that had been sent him. Charles Lutwidge Dodgson was no ordinary man. He was a polymath of remarkable talent whose legacy still enriches our lives through his literature and this extraordinary body of photographs.

NOTES

1. Charles Lutwidge Dodgson, *Diary*, 22 January 1856. In 1969 the executors of Dodgson's estate deposited his surviving manuscript diaries at the British Library (though four volumes have been lost). In all, these span the period January 1855 to December 1897. The Lewis Carroll Society has published five of these volumes in their original and unabridged form, and my colleague and coauthor, Edward Wakeling, has edited these with great care and attention to detail: Edward Wakeling, ed., vols. 1–5, *Lewis Carroll's Diaries* (Luton, UK: Lewis Carroll Society, 1993–99). For consistency, citations to the diaries will not distinguish between their unpublished and published form, but refer only to the date and year of each entry as above. I am deeply indebted to Wakeling for the generous access he gave me to his complete transcription of Carroll's diaries and for his collegial support throughout the writing of this manuscript. Without his eagle eye many errors of fact and interpretation would have littered my text.

2. The pseudonym is a Latinized form of Charles Lutwidge, which Dodgson reversed to create the name Lewis Carroll.

3. The field of Carroll studies and scholarship has been greatly advanced by the tireless and invaluable work of Professor Morton N. Cohen, to whom I acknowledge a debt of gratitude for the two books that have richly informed my own research. These are Morton N. Cohen, ed., with the assistance of Roger L. Green, *The Letters of Lewis Carroll*, 2 vols. (New York: Oxford University Press, 1979), and Morton N. Cohen, *Lewis Carroll* (London: Macmillan, 1995). In the preface of *Letters* there is a biographical chronology and a Dodgson family tree.

4. During the mid-nineteenth century the upper levels of society were defined as "good society" into which families of all classes and ranks could belong, provided they had the essential requirements of good breeding, education, cultivated taste, moral character, good manners, and so forth. The less fortunate were grouped into three classes: "low society," characterized by unrestrained familiarity; "vulgar society," by pretension; and "dangerous society," whose members were the stuff of Dickensian novels. See Anon., *The Habits of Good Society: A Handbook of Etiquette* (London: James Hogg and Sons, 1859).

5. The estimated annual income of Sir William Chaytor, Croft's most notable landowner, was more than £4000. During the 1860s, the annual salary of a private secretary in the Foreign Office was £150, on which a family could run a comfortable household with servants. This makes the £1000 income offered Charles Dodgson, senior, seem very generous indeed. See John Bateman, *The Great Landowners of Great Britain and Ireland* (1883; reprint, Leicester: Leicester University Press, 1971), 85, and Henry White, *A Guide to the Civil Service* (London: F. Warne & Co, 1868), 92.

6. Cohen, *Lewis Carroll*, 15.

7. An Old Boy, pseud., Thomas Hughes, *Tom Brown's Schooldays* (London: Macmillan, 1857). This book drew widespread attention to the problems associated with bullying and fagging within the British public school system. The system was not universally condemned, as it would be today, but rather seen as being the English method of creating gentlemen.

8. Dodgson, in Stuart Dodgson Collingwood, *The Life and Letters of Lewis Carroll* (London: T. Fisher Unwin, 1898), 30.

9. Ibid., 46

10. For three examples see Cohen and Green, *Letters,* 14 November 1864, 30 January 1868, and 29 April 1868.

11. A commission to inquire into the "state, studies, discipline and revenues" of the university was appointed in 1850 and reported its findings in 1852. Its recommendations were passed as Acts of Parliament in 1854 and 1856. See Benjamin Vincent, *Haydn's Dictionary of Dates,* 23rd ed. (London: Ward, Lock & Co., 1904), 908; see also Cohen, *Lewis Carroll,* 29–55

12. A quick survey of *Crockford's Clerical Directory for 1865* (1865; reprint, Edinburgh: Peter Bell, 1995) reveals that of the 20,500 clerics listed, the majority took holy orders at Oxford or Cambridge University. Ordination at one of these two universities ensured that candidates were offered the better livings when these became available.

13. Every history of photography carries its own account of the struggle for priority that accompanied Daguerre's and Talbot's announcements in January 1839. A thorough and accurate account that traces history from Talbot's position is given by Larry J. Schaaf, *Out of the Shadows* (New Haven, Conn., and London: Yale University Press, 1992) and Schaaf, *The Photographic Art of William Henry Fox Talbot* (Princeton, N.J.: Princeton University Press, 2000).

14. There is no comprehensive study of the rise of provincial daguerreotype studios in Britain. The best source of information is the periodical *History of Photography,* which, since its appearance in 1977, has published a number of articles about the early years of the daguerreotype, the legal battles to retain patent control, and the emergence of photography within provincial towns.

15. Talbot's own extended circle of relatives and friends is one such example. His surviving correspondence numbers approximately 10,000 letters with some 1200 different correspondents. Further details can be found on www.foxtalbot.arts.gla.ac.uk (personal communication from Prof. Larry Schaaf, 18 April 1999). Dodgson was an even more prolific correspondent, sending an estimated 50,000 letters during his lifetime.

16. Among the centers of activity that have been identified thus far are Aberdeen, Birmingham, Edinburgh, Glasgow, Liverpool, London, Manchester, Norwich, Oxford, and Swansea, where amateur groups flourished independent of commercial practice. For one such grouping see Vanda Morton, *Oxford Rebels: The Life and Friends of Nevil Story Maskelyne, 1823–1911* (Gloucester: Alan Sutton, 1987).

17. The history, organization, and cultural impact of the Great Exhibition are discussed by John R. Davis, *The Great Exhibition* (Stroud, UK: Sutton Publishing, 1999), and Jeffrey A. Auerbach, *The Great Exhibition of 1851* (New Haven, Conn., and London: Yale University Press, 1999).

18. *Official and Descriptive Catalogue to The Great Exhibition of the Works of Industry of All Nations,* 3 vols. (London: Spicer Brothers, 1851).

19. C. R. Fay, *Palace of Industry* (Cambridge, UK: Cambridge University Press, 1951), 53.

20. The opticians and philosophical instrument-makers Horne, Thornthwaite & Wood showed examples of the collodion process among their cameras and photographic apparatus ("Photography at the Palace of Glass," *Athenaeum* 1233 [14 June 1851], 632). Fallon Horne communicated the working details of the process to Robert Hunt, who included them in his article "On the Applications of Science to the Fine and Useful Arts: Photography—Recent Improvements," *Art Journal,* 1 July 1851, 188–90.

21. James Glaisher, *Lectures on the Results of the Great Exhibition of 1851, Delivered before the Society of Arts, Manufactures, and Commerce* (London: Society of Arts, 1853), 149–80.

22. *Reports by the Juries* (London: Royal Commission, 1852), 279.

23. *Art Journal,* 1 September 1852, 270–71.

24. Derek Hudson and Kenneth W. Luckhurst, *The Royal Society of Arts 1754–1954* (London: John Murray, 1954), 187–205.

25. The controversy surrounding Talbot's patents and the role it played in delaying the formation of the Photographic Society is part of the wider story of patents. In the wake of the Great Exhibition, there was a groundswell of public opinion against the whole patent system, with Charles Dickens throwing his weight behind the populist cause for its reform (Charles Dickens, "Patent Wrongs," *Household Words,* 7 May 1853, 229–34). For a broader picture see James Harrison, "Bennett Woodcroft at the Society of Arts: Reform of the Society and of the Patent System," *Journal of the Royal Society of Arts,* March 1980, 231.

26. Talbot's reluctance to relinquish his photographic patents was based on the loyalty he felt toward Henneman, whose business interests he was anxious to protect. In the case of the Photographic Society it is apparent there was hostility on both sides. In a private note to Robert Hunt, Talbot wrote, "I assure you that I have the best wishes for the formation of a prosperous society, but it appears to me that there is not much *reciprocity of feeling*" (W. H. F. Talbot to Robert Hunt, 24 March 1852, Royal Photographic Society, RPS 1279/T2). I am grateful to Larry Schaaf for this reference.

27. Anon., "Photographic Society," *Journal of the Society of Arts,* 31 December 1852, 76.

28. *Minutes of Council,* 17 November 1852, 127, Papers of Society of Arts.

29. The first edition of the exhibition catalogue lists 397 titles: *A Catalogue of an Exhibition of Recent Specimens of Photography,* 1st ed. (London: Society of Arts, 1852). The acknowledgment given to Messrs. Elkington for the loan of the fine collection of gold and silver plate exhibited at the opening suggests the soirée was a grand affair (Anon., "Exhibition of Recent Specimens of Photography," *Journal of the Society of Arts,* 24 December 1852, 53). For a brief account and illustration of the soirée see Anon., "Photography," *Illustrated London News,* 1 January 1853, 12–13.

30. Although Joseph Cundall proposed the exhibition, the organization of loans and the arrangements for the exhibition fell to his business associate, Phillip Delamotte, and to Roger Fenton (*Journal of the Society of Arts,* 31 December 1852, 63). During this period photographic exhibition catalogues invariably cited the title of the work, the name of the photographer, the process used to make the negative, and the name of the exhibitor/lender. This last category reveals whether an exhibit was lent by the photographer, or by dealers such as Cundall, Baillière and Gambart, who represented French photographers in London, or by an individual owner from a private collection. The 1852 exhibition drew heavily on loans from dealers and private individuals.

31. The exhibition was intended originally to stay open for only one week (*Journal of the Society of Arts,* 24 December 1852, 53). The new closing date of 29 January 1853 was announced in *Journal of the Society of Arts,* 19 January 1853, 100. Photographs were added by the end of December 1852. A mention in the *Athenaeum* 1314 (1 January 1853), 23, refers to the larger body of work. A second edition of the catalogue was published to include these new exhibits: *A Catalogue of an Exhibition of Recent Specimens of Photography,* 2nd ed. (London: Society of Arts, 1852).

32. Details of the inaugural meeting, the rules of the society, and election of members to council are given in the "Introductory Address," *Journal of the Photographic Society* 1, 3 March 1853, 1–5.

33. The touring exhibition of photographs was offered to those institutions that recently had come into union with the Society of Arts. This extension of the franchise and influence of the society began in 1852, when it agreed to invite literary, philosophical, and mechanics' institutes throughout the country to join a scheme whereby they could share privileges otherwise beyond their reach (*The Society of Arts: Weekly Proceedings,* 20 March 1852 and 17 July 1852).

34. A notice inviting institutions to apply for the photographic exhibition was published in *Journal of the Society of Arts,* 5 August 1853, 449. Details of the route of the 1853–54 tours were published in *Journal of the Society of Arts,* 16 September 1853, 522, and 24 March 1854, 319.

35. The best account of the emergence of these photographic societies is by Jens Jaeger, "Photographic Societies in Britain in the 19th Century," *Darkness and Light* (Oslo: Proceedings of the ESHP Symposium, 1994), 133–40.

36. Between 1851 and 1865 photographic exhibitions flourished widely throughout Britain. These were larger scale and more widely distributed throughout Britain than has been generally recognized. I have traced 47 exhibition catalogues, which list more than 20,000 individual titles submitted by over 1,400 photographers.

37. From the outset, the *Illustrated London News,* a weekly newspaper with woodcut illustrations, acknowledged its use of photographs as the basis for its engravings. Portraits by Mayall, Kilburn, Watkins, and other photographers were used increasingly after 1850 (W. H. Smith, "Photography and the *Illustrated London News,*" *Photographic Journal,* May 1942, 183–85; November 1942, 363–69). From the date of the photographic exhibition at the Society of Arts, December 1852, the paper gave increasingly detailed coverage of the latest developments in photography. For a study

of this periodical see Peter W. Sinnema, *Dynamics of the Pictured Page, Representing the Nation in the* Illustrated London News (Aldershot, UK: Ashgate Publishing, 1998).

38. Between 1853 and 1860 four influential photographic journals were established. They reported the activities of all the major photographic societies, published lectures given at meetings, reviewed exhibitions, gave correspondents the space to air their views, announced forthcoming events and exhibitions, and addressed pertinent photographic issues. For full bibliographic details of photographic periodicals and other literature see Helmut Gernsheim, *Incunabula of British Photographic Literature* (London: Scolar Press, 1984).

39. The works of Thomas Hood contained comic drawings, prose, and poetry and were issued as *The Comic Annual* (London: Colburn, 1836–42). A collection of these annuals was later issued as *Hood's Own: Laughter from Year to Year* (London: Moxon, 1861). Hood's work offers many interesting precedents for the interpretation of Dodgson's literary and artistic output.

40. For the complex story surrounding the publication of *Alice's Adventures in Wonderland* see Cohen, *Lewis Carroll,* 123–45.

41. Newton, in Cuthbert Bede [pseud. Rev. E. Bradley], *Photographic Pleasures* (London: T. Mc'Lean, 1855), 33.

42. Cohen and Green, *Letters,* 5 July 1851, 17.

43. *Diary,* 10 January 1855.

44. Grace Seiberling and Caroline Bloor, *Amateurs, Photography, and the Mid-Victorian Imagination* (Chicago: University of Chicago Press, 1986), plate 34. The workings and membership of the Photographic Exchange Club are fully explained in this detailed study.

45. *Diary,* 8 September 1855.

46. *Diary,* 1 March 1855.

47. Southey was awarded a first class degree in natural science in 1857. He took the degree of D. Med. in 1866, following his medical studies at St. Bartholomew's Hospital, where he later practiced as a physician (Norman Moore, *The History of St. Bartholomew's Hospital* [London: C. Arthur Pearson, 1918], 2: 575).

48. Frederic Boase, *Modern English Biography* (1892; reprint, 6 vols., London: Frank Cass, 1966), 3: 675.

49. Quoted by Lynda Pratt in a letter to the *Times Literary Supplement,* 21 July 2000, 17.

50. Cohen, *Lewis Carroll,* 60 and 150.

51. Lady Elizabeth Eastlake, "Photography," *Quarterly Review* 101, nn. 201, 465.

52. Lewis Carroll, "Photography Extraordinary," *Comic Times,* 3 November 1855, reprinted in *The Complete Works of Lewis Carroll* (London: Nonesuch Press, 1939), 1109–13.

53. *Diary,* 25 April 1855.

54. Dodgson, in Collingwood, *Life and Letters,* 64. This quote is taken from Collingwood, as the diary pages for September to December 1855 are now missing.

55. *Diary,* 22 January 1856.

56. *Diary,* 18 March 1856.

57. The wages of a cook in London during the 1860s were reckoned to range between £14/14/0 and £31/10/0 per annum. These rates are set out in *The Book of the Household* (London: London Printing and Publishing Company, n.d., c. 1862–63), where rates for all types of domestic servant, indoor and outdoor, liveried and ordinary, are tabulated.

58. When Dodgson canceled the first printing of *Alice's Adventures in Wonderland* following Tenniel's objections to the printed quality of the illustrations, it personally cost him £600 to reprint the edition (Cohen, *Lewis Carroll,* 129–30).

59. *Diary,* 8, 10, and 13 May 1856.

60. *Diary,* 10 May 1856.

61. *Diary,* 13 May 1856.

62. Ibid.

63. *Diary,* 16 January 1856. Although Dodgson does not make it clear, the photograph of Charles Kean as Wolsey was also by William Lake Price (*Exhibition of Photographs and Daguerreotypes, Third Year* [London: Photographic Society, 1856]), exhibit 135.

64. *Diary,* 17 January 1856.

65. *Illustrated London News,* 22 March 1856, 309.

66. *Diary,* 7–20 June 1856.

67. Robert N. Taylor, *Lewis Carroll at Texas* (Austin: University of Texas at Austin, 1985), 187.

68. Dodgson drew a distinction between concept and execution when criticizing the Princess Royal's watercolor paintings on exhibition in Oxford (*Diary,* 7 May 1856).

69. *Diary,* 14 November 1856.

70. *Diary,* 19 November 1856. John Talbot Dillwyn Llewellyn was an undergraduate of Christ Church between 1854 and 1858. His father, John Dillwyn Llewellyn, was a leading amateur photographer and founding member of the Photographic Society. Richard Morris, in *Penllergare: A Victorian Paradise* (Llandeilo, UK: Friends of Penllergare, 1999), gives a clear sense of the family's social standing and interests in natural history, gardening, and the culture of orchids.

71. *Diary,* 31 December 1856.

72. *Diary,* 5 November 1856.

73. *Diary,* 22 October 1856. The first mention of Dodgson's "book of photographs" occurred when he showed it to Harry and Lorina Liddell. In November he sought permission from Dr. Acland to photograph his children, having been told by Southey that they were a beautiful family. Following Dr. Acland's consent, Dodgson sent his book of photographs to Mrs. Acland (*Diary,* 3, 5, and 17 November 1856).

74. *Diary,* 16 January 1856.

75. *Diary,* 3 December 1856.

76. Dutton, Allen & Co. *Directory & Gazetteer of the Counties of Oxon & Berks and Bucks* (Manchester: Dutton, Allen & Co., 1863), 131, lists Richard Badcock, 105 St. Aldate Street, upholsterer and appraiser. This places the Badcock's premises across the road from Christ Church. Berks. and Bucks. are abbreviations for Berkshire and Buckinghamshire.

77. Cohen and Green, *Letters,* 18 December 1860, 44. *The Royal Album* of cartes-de-visite portraits of the royal family was reviewed in *Athenaeum* 1712 (18 August 1860), 230. This was the first occasion Queen Victoria allowed photographs of

herself and family to be commercially published and widely distributed.

78. The carte-de-visite was a photographic format, typically 3⅝ x 2¼ in. (9.5 x 5.7 cm), and mounted onto a slightly larger card. Commercial photographers used both sides of the cards to advertise their name, address, and artistic status. Specially designed carte-de-visite cameras made it possible to take four, six, or eight different exposures upon a single plate, thereby keeping time and material costs to a minimum. However, these specialized cameras were not obligatory, as any camera of the appropriate size could be used. Once the fashion took hold, it was not uncommon for photographers like Dodgson to have earlier work rephotographed, or reduced, to the carte-de-visite format so their prints accorded with the taste of the day and fit readily into the albums of the period. The first reference to Dodgson's using the carte-de-visite format comes with "Mrs. Hussey called in the morning, and I took a carte of Bessie" (*Diary,* 16 June 1871). A detailed study of the carte-de-visite in Britain has yet to be written, but the outstanding study by Elizabeth Anne McCauley, *A. A. E. Disderi and the Carte-de-Visite Portrait Photograph* (New Haven, Conn., and London: Yale University Press, 1985), explores the rise of the format in Paris.

79. At the first annual general meeting of the Photographic Society a motion was proposed that "all persons practising photography professionally with a view to profit . . . be disqualified from holding office in the Council . . ." (*Journal of the Photographic Society* 1 [21 February 1854], 166). This caused a heated debate as members asked, "Where could the line be drawn between the professional photographer making and *selling his pictures for profit,* and the *amateur* who *sold* his pictures?" When no answer was forthcoming, Roger Fenton, Peter le Neve Foster, and Alfred Rosling, all amateur photographers who sold prints, promptly resigned their seats on the council, only to be reinstated later when the motion was rescinded on a vote. The whole affair was reported at length in *The Builder* 12 (11 February 1854), 73. The same journal firmly believed that "if the trade once got a footing in the council, the ruin of the society was inevitable." In 1858 the council once more attempted to limit the incursion of commerce into the annual exhibition by introducing the rule "that no photographs will be admitted that have been exposed in shop windows or otherwise publicly exhibited in this country" (*Journal of the Photographic Society* 5 [21 August 1858], 1). This rule was later relaxed and never reinstated (*Athenaeum* 1625 [18 December 1858], 803). The following year the council, now in retreat, introduced additional rules for the submission of prints for exhibition. These tended to be more ambiguous than usual; nevertheless, their overall thrust was to exclude the work of photographers who retouched or colored their work (*Journal of the Photographic Society* 6 [15 November 1859], 71).

80. The best summary is given in *Photographic Notes* 7 (15 August 1862), 201. For the full version of this long-running and complex issue, see the correspondence and editorial columns of *British Journal of Photography* and *Photographic News,* for the period January–August 1862.

81. The post office directories for London list 10 photographic studios in 1850, 72 in 1856, and 198 in 1863. These figures relate only to the central London postal districts of W1, WC1, and N1; see Michael Pritchard, *A Directory of London Photographers 1841–1908* (Watford, UK: PhotoResearch, 1994), 19. I am grateful to Michael Pritchard for the additional information he provided. Elsewhere, the number of photographic studios steadily grew to 51 in Liverpool, 29 in Manchester, 38 in Glasgow, and 33 in Edinburgh (*Photographic News,* 27 February 1863, 102).

82. Lewis Carroll, "Hiawatha's Photographing," in *Phantasmagoria* (London: Macmillan and Co., 1869), reprinted in *Complete Works of Lewis Carroll,* 768–72.

83. The holder, or dark slide, which held the collodion plate in the Ottewill camera could be fitted with a series of internal frames to reduce its size from whole plate (6½ x 8½ in.) to quarter plate (3¼ x 4¼ in.). The ground-glass screen on which the image was composed was marked correspondingly.

84. *Athenaeum* 1525 (17 January 1857), 93. An advertisement by Andrew Ross cites the 1851 Jurors' Report commending the quality of his portrait lens. As early as 1853, Ottewill named Ross as his agent (*Journal of the Photographic Society,* 21 December 1853, 141).

85. We know from his diary that Dodgson bought chemicals from Richard Thomas and from Horne & Thornthwaite, two leading photographic chemists (*Diary,* 1 June 1856, 18 June 1863). Richard Thomas advertised widely during the 1850s, regularly placing half-page advertisements in the *Journal of the Photographic Society.*

86. Cohen, *Lewis Carroll,* 290.

87. There is an unresolved debate about how many letters Dodgson registered. For my authority I quote the figure proposed by Edward Wakeling, who, in a comprehensive study of the subject, has arrived at an estimated figure of 50,000 letters written by Dodgson (personal communication, 1 December 1999). See also n. 15 above.

88. *Diary,* 26 June 1857.

89. *Complete Works of Lewis Carroll,* 769.

90. Ibid.

91. At the British Institution, Dodgson made "hasty sketches in the margin of the Catalogue . . . , chiefly for the arrangement of hands, to help in grouping for photographs" (*Diary,* 22 and 23 April, 1 and 2 July, 14 and 15 October, and 20 December 1857, respectively.

92. *Diary,* 12 September 1857.

93. *Diary,* 22 April 1857.

94. *Diary,* 21 December 1857. Paul and Dominic Colnaghi were among the leading printsellers with premises in Pall Mall, London. In common with many printsellers, they began selling photographs during the 1850s.

95. *Diary,* 3 July 1857.

96. *Diary,* 1 July 1857. Dodgson had earlier seen *Henry VIII* at the Princess's Theatre on 22 June 1855 when he was moved to confide in his diary, "I never enjoyed anything so much in my life

before: and never felt so inclined to shed a tear at anything fictitious, save perhaps at that poetical gem of Dickens, the death of little Paul."

97. *Diary,* 2 April, 13 June, and 17 March 1857, respectively. Rev. Richard St. John Tyrwhitt, *A Handbook of Pictorial Art* (Oxford: Clarendon Press, 1868). When the Science and Art Department of the Committee of Council on Education selected this as their prize book for attainment at art schools, it was both widely read and became the standard book to give prizewinners.

98. William Lake Price, *A Manual of Photographic Manipulation* (London: John Churchill, 1858). The sale catalogue of Dodgson's personal effects, held in Oxford, May 1898, lists a number of photographic books and manuals, but not that by Price (Jeffrey Stern, *Lewis Carroll Bibliophile* [Luton, UK: White Stone Publishing, 1997]).

99. First mention of the headrest comes in a letter to Mrs. Chataway in December 1876. "I have got a regular head-rest now, and need not use the wall to rest the head against" (Cohen and Green, *Letters,* 264).

100. Price, *Photographic Manipulation,* 149.

101. Ibid., 61.

102. Dodgson mentions being taken to see the specimens at the end of May (*Diary,* 26 May 1857).

103. *Diary,* 5 February 1857. Although Dodgson seems not to have benefited from this fund, his interest in photography seems to have been supported by members of the Common Room. See also *Diary,* 23 and 24 February 1857.

104. Dodgson had, however, photographed paintings; see 84–86 in Edward Wakeling's comprehensive register.

105. Eric Partridge, *The Routledge Dictionary of Historical Slang* (London: Routledge & Keagan Paul, 1973), 198.

106. J. B. Atlay (*Sir Henry Wentworth Acland, Bart.* [London: Smith Elder & Co, 1903]) gives full details of Acland's struggle to found the University Museum and of his relationship with Ruskin and the Pre-Raphaelite artists employed in its decoration.

107. Atlay, *Henry Wentworth Acland,* 215.

108. Ibid., 214.

109. *Diaries,* 13 June 1857.

110. The portrait of John Roddam Spencer Stanhope is in Dodgson's Album A(VII) at Christ Church, Oxford. Spencer Stanhope was a Christ Church man, and Dodgson made this photograph as part of the college records.

111. O. J. R. Howarth, *The British Association for the Advancement of Science: A Retrospect 1831–1931* (London: By the Association, 1931). This gives a concise yet thorough account of the history of the association, with details on the organization and management of the annual meetings.

112. There are several reports of the 1860 British Association Oxford meeting. The most objective account, which also covers Prof. Draper's lecture, is given by *Athenaeum* 1706 (7 July 1860), 18–32 and (14 July 1860), 59–69. For a spirited explanation of the context and significance of Darwin's evolutionary theory and its impact upon the Victorian psyche, see Adrian Desmond and James Moore, *Darwin* (London: Michael Joseph, 1991).

113. I am grateful to Kevin Moore for sharing his pioneering work in establishing the link between some of Dodgson's portraits and the meeting of the British Association. His unpublished paper is "Charles Dodgson's Anatomical Photographs: Their Creation and Reception" (Princeton University, 1996).

114. Woodward died in Lyons on 11 May 1861, en route to the south of France, where he had hoped to recuperate. Boase, *Modern English Biography,* 6: 948.

115. Richard D. Altick, *The English Common Reader* (Chicago: University of Chicago Press, 1957), 392. The widespread circulation of the *Illustrated London News,* estimated to be 123,000 in 1853–54, made it an influential and powerful cultural force in creating an index of national heroes and heroines and doubtless helped pave the way for the commercial success of published cartes-de-visite.

116. *M. Billing's Directory and Gazetteer of the Counties of Berks. and Oxon.* (Birmingham, UK: M. Billing, 1854) has James Ryman at 24 and 25 High Street, Oxford. Having taken several photographs of Quintin Twiss in theatrical costume, Dodgson notes that "I intend trying these at Ryman's, as well as the anatomical pictures, to see if I can in any way make photography pay its own expenses" (*Diary,* 15 June 1857). The distinction between amateur and commercial photographers offering their photographs for sale was still imprecise, but the inclusion of both Dodgson's name and the prices of prints would have identified him as having commercial, rather than artistic, imperatives. (Berks. and Oxon. are abbreviations for Berkshire and Oxfordshire.)

117. Altick, *English Common Reader,* 387.

118. *Diary,* 14 August 1855.

119. Mrs. Cameron's friend Sir Henry Taylor, whom she often photographed, had known Robert Southey since 1823; he belonged to the latter's intimate circle of friends and was one of his most frequent correspondents. It is therefore possible that Mrs. Cameron knew Reginald Southey through this connection (Jack Simmons, *Southey* [London: Collins, 1945], 180).

120. R. J. Hutchings and B. Hinton, eds., *The Farringford Journal of Emily Tennyson 1853–1864* (Newport, UK: Isle of Wight County Press, 1986), 56. The entries are dated 18 and 24 April 1857, respectively. Mrs. Tennyson thought her son Hallam looked a little like their old friend Arthur Hallam, to whom her husband dedicated *In Memoriam.* Southey's portraits of the Tennyson and Cameron boys are here reproduced for the first time.

121. C. Y. Lang and E. F. Shannon, eds., *Letters of Alfred, Lord Tennyson* (Oxford: Clarendon Press, 1987), 171.

122. It has always been assumed that Oscar Gustav Rejlander, who photographed the Tennysons at Farringford in May 1863, had first introduced Mrs. Cameron to photography (Hutchings and Hinton, *Farringford Journal,* 116).

123. *Diary,* 18 August 1857.

124. Ibid.

125. *Diary,* 2 September 1857.

126. *Exhibition of Photographs and Daguerreotypes at the South Kensington Museum* (London: For the Photographic Society, 1858), exhibit

174. Southey also submitted two prints, one of which, exhibit 141, was *Freshwater Bay, Isle of Wight*; a print of this is in his album now at Princeton.

127. *Diary,* 18 September 1857.

128. Ibid.

129. Ibid.

130. *Diary,* 22 September 1857.

131. *Diary,* 3 December 1857. It would have been in Dodgson's nature to follow Tennyson's request to the letter and destroy all extra prints and perhaps even the negative itself, leaving extant only those mentioned. To temper these instructions Mrs. Tennyson sent a copy of Mayall's recent photograph of her husband to Dodgson. In his 1949 biography Helmut Gernsheim incorrectly ascribes the Mayall portrait to Dodgson, creating a misunderstanding that continues to this day.

132. During the nineteenth century girls did not reach puberty until they were at least thirteen, and often as late as sixteen. See Spencer Thomson, *Dictionary of Domestic Medicine and Household Surgery* (London: Groombridge and Sons, 1852), 344.

133. *Diary,* 11 May 1865.

134. Cohen and Green, *Letters,* 351.

135. Dodgson's father had to leave his post at Oxford University when he fell in love and married. He took a very poorly paid post as perpetual curate at Daresbury, Cheshire, where Charles was born. The memory of living on a modest income must have remained with the family long after they moved to Croft. The object lesson was quite clear. See Cohen, *Lewis Carroll,* 3–27.

136. Collingwood, *Life and Letters,* 297.

137. Helmut Gernsheim, *Lewis Carroll, Photographer* (London: Max Parrish & Co, 1949).

138. *Diary,* 23 February 1857. Alice Liddell's older brother, James Arthur Charles Liddell, had died of scarlet fever on 27 November 1853, a devastating loss to the family. See *Lewis Carroll's Alice,* auction catalogue (London: Sotheby's, 6 June 2001), 35.

139. Figures quoted by Pat Jalland, *Death in the Victorian Family* (Oxford: Oxford University Press, 1996), 143.

140. Anthony S. Wohl, *Endangered Lives: Public Health in Victorian Britain* (London: J. M. Dent, 1983), 10–11.

141. Mrs. J. Bakewell, *The Mother's Practical Guide* (London: John Snow, 1862), 238. Many families expressed their sense of reconciliation to the will of God on the headstone of the family grave. One such, for sixteen-year-old Mary Foulds, runs: "Short has been my life, / But long will be my rest, / God took me in early days, / Because he thought it best." Three siblings who died in infancy joined her in death (19 June 1864, Lumb Valley Congregational Church, Yorkshire).

142. The Victorian period is crowded with images of childhood, from Academy painting and sculpture to Grimm's fairy tales and moral stories of every kind. The catalogue of the exhibition *Childhood* (London: Sotheby's, 1988) gives a real sense of this diversity and multiplicity.

143. For a study of Munro's work see Katherine Macdonald, "Alexander Munro: Pre-Raphaelite Associate," in *Pre-Raphaelite Sculpture: Nature and Imagination in British Sculpture 1848–1914,* ed. Benedict Read and Joanna Barnes, exh. cat. (London: Henry Moore Foundation, 1991), 46–65. I am especially grateful to Katherine Macdonald for the generous access she gave me to the papers of her grandfather, Alexander Munro.

144. *Diary,* 22 February 1858.

145. *Diary,* 16 April 1858. Although this is Dodgson's first mention of Henry Peach Robinson, it was not until 1874 that he made direct contact with him, in Tunbridge Wells. They subsequently became good friends. Charles Robert Leslie, a painter of historical genre scenes, frequently exhibited at the Royal Academy.

146. The social etiquette of effecting introductions was carefully prescribed. For details of how the system worked and the limits placed upon it, see *Habits of Good Society,* 290–99. For dates of Carroll's first meeting with these people, see *Diaries,* 21 July 1863, 30 September 1863, and 14 July 1864.

147. Between 1853 and 1869 *Illustrated London News* regularly featured Munro's latest work with a woodcut illustration and accompanying article. For the illustration of *Measurement by Foxglove* see *Illustrated London News,* 18 June 1859, 599.

148. *Illustrated London News,* 10 October 1857, 364. For an engraving of a similar work by Munro see *The Sister and Brother, Art Journal,* 1 July 1857, 216.

149. For examples of the dress of angels, see Mrs. Anna Jameson, *Sacred and Legendary Art* (London: Longman, Brown, Green, and Longmans, 1850), 23–56. The book enjoyed widespread popularity by drawing together the themes of religious belief and artistic expression.

150. *Art Journal,* 1 November 1861, 344. The following month the *Art Journal* also carried an engraving of Princess Louise as "Plenty" by Mrs. Thornycroft, in which the young princess is also attired in classical costume and footwear.

151. *Journal of the Photographic Society,* 21 January 1854, 154.

152. Algernon Graves, *A Dictionary of Artists* (Bath: Kingsmead Reprints, 1970), 231.

153. *Exhibition of Photographs and Daguerreotypes, Second Year* (London: Photographic Society, 1855).

154. For Rejlander's detailed account of the conception and execution of *The Two Ways of Life,* see *Journal of the Photographic Society,* 21 April 1858, 191–97.

155. Privy Purse Accounts, Royal Archives, PP 2/24/8012, August 1857.

156. *Diary,* 22 January 1857.

157. Frances Dimond, "Prince Albert and the Application of Photography," in Frances Dimond and Roger Taylor, *Crown and Camera: Photography, The Royal Family and Photography, 1842–1910* (London: Viking, 1987), 45–49. This chapter covers Prince Albert's use of photography to establish a catalogue raisonné of the work of Raphael, an artist whom he fervently admired. Prince Albert bought a copy of *Non Angeli, sed Angeli* for his own photographic collection.

158. *Diary,* 28 March 1863.

159. *Diary,* 22 April 1863.

160. Jean Gattégno, "Inventions and Games," trans. Rosemary Sheed, *Lewis Carroll: Fragments of a Looking Glass* (New York: Thomas Y.

Crowell Co., 1976), 103–13. It has been estimated that during his lifetime Dodgson invented at least one hundred new puzzles and games that he intended to publish as "Alice's Puzzle Book," an idea that, sadly, never came to fruition. I am grateful to my coauthor for this information.

161. For a general survey see Nicolette Scourse, *The Victorians and Their Flowers* (London: Croom Helm, 1983).

162. Robert Tyas, *The Language of Flowers* (London: George Routledge & Sons, 1869), x.

163. Ronald Parkinson, *Victoria & Albert Museum: Catalogue of British Oil Paintings 1820–1860* (London: HMSO, 1990), 202.

164. *Catalogue of the First Annual Exhibition* (Birmingham, UK: Birmingham Photographic Society, 1857), exhibit 379. This was one of forty items exhibited by Rejlander.

165. *Diary,* 1 April 1857.

166. I am grateful to Scott Husby, of the Firestone Library, for details of his conservation work on Album A(I), which drew attention to changes in the pagination of the album. However, the question remains whether it was Dodgson or members of his family who removed or inserted pages after his death.

167. *Diary,* 9 July 1864: "About 5 I went to the Westmacotts to get signatures in my album—dined at their tea, and remained till nearly 9."

168. Cohen and Green, *Letters,* 45.

169. Ibid.

170. Ibid., 76.

171. Ibid.

172. *Diary,* 28 October, 1865.

173. Cohen, *Lewis Carroll,* 198.

174. Ibid., 221.

175. For a detailed account of Dodgson's ongoing relationship with the Liddell family after 1864, see Wakeling's footnote, *Diary,* 18 May 1867.

176. Cohen, *Lewis Carroll,* 226.

177. Karoline Leach (*In the Shadow of the Dreamchild* [London: Peter Owen, 1999]) proposes that Dodgson may have had an affair with Alice's mother, Mrs. Liddell, a claim I believe to be incredible given the acute differences in their circumstance. However, Leach is more convincing in her argument that Dodgson enjoyed the company of women of all ages, and not just that of children.

178. Walter Houghton, *The Victorian Frame of Mind 1830–1870* (New Haven, Conn., and London: Yale University Press, 1957), 62.

179. In later life Dodgson wrote about this episode to his young cousin and godson, William Wilcox, when he discussed his doubts about not taking Holy Orders and offered an explanation that justified his decision (Cohen and Green, *Letters,* 602).

180. *Diary,* 14 April 1868.

181. Valentine Blanchard, "Cabinet Portraits," *British Journal of Photography,* 11 September 1868, 437.

182. Pritchard, *Directory,* 19.

183. For a detailed discussion of the social range and application of studio portraiture see Andrew Wynter, "Cartes-de-Visite," *British Journal of Photography,* 12 March 1869, 125–26, and 25 March 1869, 148–50.

184. The balance of accounts presented each February at the annual general meeting of the Photographic Society reveals the parlous and perilous state of the finances, which frequently went into deficit, largely through losses incurred by the annual exhibitions. Reports of these meetings are found each year in the February issues of the *Journal of the Photographic Society.* During the 1860s there were frequent calls to reform the management of the society.

185. Photographers were assured there were no laws to prevent them from adopting the title of professor, but they were warned it would only degrade them and not deceive the public ("Titles in Connection with Photography," *British Journal of Photography,* 21 August 1868, 406). A more serious problem existed with the false assertions made by numerous photographers throughout Britain that they were "Photographers to Her Majesty." The abuse was brought under control only by the Patents, Designs, and Trade Marks Act of 1883. See Dimond and Taylor, *Crown and Camera,* 211.

186. *Diary,* 13 July 1863.

187. *Diary,* 18 November 1863.

188. Although Dodgson thought the photograph was not good enough to be included in his "show" album, he nevertheless included a print in one of his family albums (P[3]: 3).

189. *Diary,* 28 June 1864.

190. *Diary,* 6 June 1864.

191. *Diary,* 25 June 1870.

192. *Diary,* 11 May 1865.

193. Thomas Sutton wrote about his visit to the printing establishment of Messrs. Cundall and Downes, at Kensington in 1860, commenting upon the excellent quality of their prints: "The whites of the picture are preserved perfectly pure and free from yellowness; and the shadows are a warm chestnut black, of the greatest possible vigour and transparency" (*Photographic Notes* 5, no. 103 [15 July 1860], 185).

194. Cundall, already well established as a publisher of children's books, entered photography in 1852, when, in partnership with Phillip Delamotte, he set up the Photographic Institution on Bond Street. They operated a portrait studio, held exhibitions, sold prints by leading British and French photographers, and published photographic portfolios and handbooks. Cundall also kept premises in Kensington for photographic printing, away from the sulphurous smog of central London. See Ruari McLean, *Joseph Cundall: A Victorian Publisher* (Pinner, UK: Private Libraries Association, 1976).

195. *Diary,* 14 January 1874. For illustrations of this type of photoceramics see Margaret F. Harker, *Henry Peach Robinson* (Oxford: Basil Blackwell, 1988), plates 39, 40.

196. *Diary,* 22 July 1864.

197. *Diary,* 20 July 1864.

198. For a detailed review of the Photographic Exhibition, see *Photographic News,* 3 June 1864, onward.

199. *Photographic Notes* 9, 1 July 1864, 171.

200. Cohen and Green, *Letters,* 66.

201. *Diary,* 23, 24, and 25 June 1864.

202. *Diary,* 9 May 1863.

203. Dodgson photographed at the MacDonald's from 24 July to 31 July 1863. According to the sequence of the images he later registered, it seems likely he took over thirty photographs during the course of the week (*Diary,* 24 and 31 July 1863).

204. Christina Rossetti, "After Death," in *The Victorians,* ed. Geoffrey Grigson (London: Routledge & Keagan Paul, 1950), 55.

205. Colin Ford and Roy Strong, *An Early Victorian Album* (New York: Alfred A. Knopf, 1976), 282.

206. For a succinct biography of MacDonald, see Humphrey Carpenter and Mari Prichard, *The Oxford Companion to Children's Literature* (Oxford: Oxford University Press, 1984), 328. MacDonald went to Algeria to recuperate his health in the warm climate. The trip was paid for by Lady Byron, who greatly admired his work.

207. *Diary,* 31 July 1863.

208. As early as 1859, the photographer George Washington Wilson had used a proto-sulphate of iron developer to reduce exposure times. He applied the technique to stereoscopy to take the first "instantaneous" views of street traffic in Britain. As there were no shutters to regulate exposure times, he removed and replaced his lens cap with a deft flick of the wrist to give about one-tenth of a second exposure. See Roger Taylor, *George Washington Wilson* (Aberdeen, UK: Aberdeen University Press, 1981), 72–74.

209. *Diary,* 26 December 1872. Darwin's book had been published earlier that year and used Rejlander's photographs as illustrations, none of which expressed joy as successfully as Dodgson's photograph of Flora Rankin. See Charles Darwin, *The Expression of the Emotions in Man and Animals* (London: John Murray, 1872), 202.

210. *Diary,* 17 March 1872.

211. *Diary,* 21 June 1868.

212. *Diary,* 1 November 1871.

213. For a detailed description of Dodgson's accommodation see Edward Wakeling, "Lewis Carroll's Rooms at Christ Church," *Jabberwocky* 12, no. 3 (Summer 1983), 51–61. A sketch-plan of the rooms showing their layout and the position of the studio is included.

214. After 1877, most of Dodgson's books were written partly, or wholly, at Eastbourne.

215. The *Diary* entry for 19 July 1856 is the last recorded instance of Dodgson's printing photographs.

216. Beatrice Hatch, "Lewis Carroll," *Strand Magazine,* April 1898, 412–23. In her reminiscences of childhood visits to Dodgson's rooms, Hatch tells of "excursions to the roof of the college, which was easily accessible from the windows of the studio."

217. *Diary,* 23 October 1876.

218. *Diary,* 11–12 August 1875.

219. Prolonged damp causes the collodion film to frill and lift away from its glass support. It is irreversible. Among Dodgson's negatives one casualty seems to have been that of Alice Liddell as *The "Beggar Maid,"* where a piece of the collodion lifted away from the region of Alice's left knee, creating a black patch in every print that was made subsequently. See A(II): 65.

220. *Diary,* 5, 8, 13, and 15 July 1878.

221. Hatch, "Lewis Carroll," 419.

222. Ibid., 421. Unlike a barrel organ, Dodgson's orguinette, or organette, used circular perforated cards to play the tunes in the manner of a polyphone.

223. Ibid., 419.

224. Alice Liddell, "Alice's Recollections of Carrollian Days," *Cornhill Magazine,* July 1932, 6.

225. Ibid.

226. *Diary,* 27 September 1877.

227. *Diary,* 20 July 1871: "in future I will not take any children to a London theatre without first ascertaining that the pieces acted are objectionable."

228. *Diary,* 27 September and 7 October 1880.

229. *Diary,* 10 October 1870.

230. *Diary,* 17 May 1878.

231. Quoted in Cohen, *Lewis Carroll,* 198.

232. *Diary,* 15 June 1877.

233. For an account of Dodgson's friendship with the Kitchin family see Morton N. Cohen, *Lewis Carroll and the Kitchins* (New York: Argosy Bookstore, 1980). This reprints many important letters from Dodgson to Mrs. Kitchin that are not to be found in Cohen, *Letters.*

234. *Diary,* 14 May, 17 May, 12 June, and 14 July 1873.

235. Cohen, *Carroll and the Kitchins,* 11.

236. Ibid., 13.

237. *Diary,* 14 January 1874. A working description of photographic enameling is given in W. W. Abney, *Instruction in Photography,* 5th ed. (London: Piper & Carter, 1882), 266–72.

238. According to legend, St. George was a prince of Cappadocia whose greatest feat was to slay a dragon and save the life of the king's daughter (*The Encyclopædia Britannica,* 11th ed. Cambridge, UK: Cambridge University Press, 1911), 11: 736.

239. For a brief essay on Prince Albert's taste and patronage see Frank Davis, *Victorian Patrons of the Arts* (London: Country Life, 1963), 20–25; also for an illustration of a male nude study by William Mulready given to Queen Victoria in 1853.

240. The use of academic life models by painters is covered by Aaron Scharf, *Art and Photography* (London: Allen Lane, 1968). For a wide selection of these academic studies see *After Daguerre, Masterworks of French Photography (1848–1900) from the Bibliothèque Nationale,* exh. cat. (New York: Metropolitan Museum of Art, 1980). Prince Albert bought examples of French academic studies by F. J. Moulin. These are preserved in the "Calotype" albums at the Royal Archives, Windsor Castle.

241. *Exhibition of Photographs at the Mechanic's Institution,* exh. cat. (Manchester: Manchester Photographic Society, 1857), exhibits 446, 450.

242. "The Dublin Exhibition—Photographic Department," *Photographic Journal,* 15 August 1865, 123–27.

243. "Photographic Nuisances," *British Journal of Photography,* 11 December 1868, 597.

244. "Alleged Immorality of Photographers," *British Journal of Photography,* 1 January 1869, 5.

245. "The Morality of the Nude," *British Journal of Photography,* 5 February 1869, 65.

246. Ibid.

247. "Indecent Photographs," *British Journal of Photography*, 3 February 1871, 57.

248. The case of Henry Evans was widely reported for the severe sentence he received for trading in obscene photographs. This resulted in a petition for clemency being presented to the Home Secretary. See "Indecent Photographs: Severe Sentence," *British Journal of Photography*, 25 March 1870, 141, and 22 July 1870, 346.

249. "Charge of Selling Indecent photographs," *British Journal of Photography*, 3 August 1877, 371.

250. The *Shorter Oxford English Dictionary* (Oxford: Oxford University Press, 1983) describes Mrs. Grundy as "The surname of an imaginary personage . . . proverbially referred to as a personification of the tyranny of social opinion in matters of conventional propriety." She first makes her appearance in Thomas Morton's comic-drama *Speed the Plough*, 1798.

251. Dodgson's letters to Mrs. J. Chataway in 1876 reveal his awareness of public opinion (Cohen, *Letters*, 261–63).

252. "Morality of the Nude," note 246.

253. The cards were highly colored, and invariably issued in sets of three and given fanciful names like *Eastern Damsels, Nymphs of the Grove,* and *Girlish Delights*. A complete listing of William and Rebecca Coleman's designs for De la Rue is given by George Buday, *The History of the Christmas Card* (London: Spring Books, 1954), 219–20. For the most comprehensive range of illustrations by several artists working in this genre see Graham Ovenden, *Nymphets and Fairies* (London: Academy Editions, 1976).

254. *Punch*, 24 December 1881, 290. In an accompanying poem, Father Christmas asks: "Why what do you call this here modern fad, / Sending gimcrack cards by dozens, dauby, glaring, good and bad, / Nymphs—and what not? Why, between you, you drive friends, and Postmen mad."

255. This legitimacy was achieved, in part, through a series of annual competitions intended to discover the best designs for the coming season. These events were organized by the publishers and staged at prestigious galleries in London; leading artists, such as John Everett Millais, judged the work and awarded the winners large cash prizes. One company put up a total of £5000 in prize money, no doubt hoping it would recoup this outlay from sales of the prizewinning designs. The history of the market for Christmas cards and competitive exhibitions is given by Gleeson White, "Christmas Cards and the Chief Designers," *Studio*, extra number, December 1894.

256. Cohen, *Letters*, 262.

257. Ibid., 321–23.

258. Edith Letitia Shute, "Lewis Carroll as Artist," *Cornhill Magazine*, November 1932, 559–62.

259. *Diary*, 21 May 1867.

260. *Diary*, 9 October 1869.

261. Dodgson's diary entry for 29 July 1873 makes only an oblique reference to photographing Beatrice in "primitive costume," a phrase which, at best, offers an ambiguous meaning about her attire. He made more photographs of Beatrice the following day

(*Diary*, 29 and 30 July 1873). The truth became clear some years later when Dodgson photographed Lily Gray in the nude and records, "I have had none such since Beatrice Hatch, July 30/73" (*Diary*, 20 October 1876).

262. Cohen, *Letters*, 272–73.

263. *Diary*, 20 October 1876.

264. *Diary*, 17 July 1879.

265. *Diary*, 18 July 1879.

266. *Diary*, 18, 21, 25, and 29 July 1879.

267. *Diary*, 21 July 1879.

268. *Diary*, 29 July 1879.

269. Ibid.

270. *Diary*, 29 May 1880.

271. For a reasoned and thorough discussion of Dodgson's relationship to children and how this related to his love of theater and contemporary painting, see Hugues Lebailly, "C. L. Dodgson and the Victorian Cult of the Child," *The Carrollian*, Autumn 1999, 3–31.

272. Cohen, *Letters*, 261.

273. Ibid., 262. In his "Directions regarding my funeral &c" Dodgson instructed his executors to "Please erase the following negatives: I would not like (for the families sake) the possibility of their getting into other hands. They are best erased by soaking in a solution of washing soda" (Anne Anninger and Julie Melby, *Salts of Silver, Toned with Gold*, exh. cat. [Boston: Houghton Library, Harvard University Press, 1999], 119).

274. Cohen, *Letters*, 435.

275. Royal Archives, Windsor Castle, Privy Purse Accounts, Invoice from Edward Henry Corbould, PP2/17/6670. To make his photographs appear even more artistic and socially acceptable, Dodgson paid Anne Lydia Bond of Southsea to color several of his studies, which he then presented to the parents of his sitters. Miss Bond was highly regarded as an artist, having undertaken commissions for Queen Victoria and illustrated a number of books. Following her death in 1881 Dodgson lamented that "the colouring-power has fallen off . . ." (Cohen, *Letters*, 431).

276. Cohen, *Letters*, 338.

277. In a letter to Mrs. Mayhew, Dodgson writes, "I need hardly say that the pictures should be such as you might if you liked frame and hang up in your drawing-room" (Cohen, *Letters*, 338).

278. *Diary*, 15 July 1880, is the last entry in which Dodgson mentions taking a photograph.

279. *Diary*, 5 February 1880.

280. Cohen, *Carroll and the Kitchins*, 30. Mary Ellen Owen was the eldest daughter of Henry Sewell, the first premier of New Zealand.

281. Ibid., 39.

282. Ibid., 43. Dodgson writing to Maud Kitchin tells her that "Ladies tell me 'people' condemn those photographs in strong language: and when I enquire more particularly, I find that 'people' means Mrs. Sidney Owen! It is sad."

283. Cohen, *Lewis Carroll*, 172.

284. Cohen and Green, *Letters*, 385.

CHRONOLOGY

EDWARD WAKELING

1832 27 January—Charles Lutwidge Dodgson is born at the Parsonage, Daresbury, Cheshire, England, the eldest son and third child of Charles Dodgson, perpetual curate of Daresbury, and Frances Jane, née Lutwidge.

1844–45 Attends Richmond School, Yorkshire.

1846–49 Attends Rugby School.

1850 23 May—matriculates at Christ Church, Oxford.

1851 24 January—takes up residence at Christ Church, Oxford. 26 January—his mother dies.

1852–98 Becomes a "Student" of Christ Church (equivalent to a fellow), Oxford.

1854 Receives B.A., First Class Honors in Mathematics, Second Class in Classics.

1855 February–becomes sub-librarian of Christ Church Library; May—receives Bostock Scholarship; October—becomes lecturer in mathematics; 3 November—his *Photography Extraordinary* is published in *Comic Times*.

1856 1 May—begins taking photographs with his new Ottewill camera.

1857 5 February—receives M.A.; December—"Hiawatha's Photographing" is published in *The Train*.

1860 *A Photographer's Day Out* is published in aid of the South Shields Mechanics' Institute.

1861 22 December—ordained deacon of the Church of England.

1862 4 July—tells the story of Alice's adventures to the Liddell sisters on a boat trip from Oxford to Godstow; begins the manuscript of *Alice's Adventures Under Ground* soon thereafter.

1863 18 June—rents space in Badcock's Yard, Oxford, for a photography studio.

1865 July—*Alice's Adventures in Wonderland* is published under the pseudonym Lewis Carroll but immediately withdrawn; December—it is reissued with improved print quality for the illustrations.

1867 July–September—journeys through Europe to Russia with Henry P. Liddon; October—*An Elementary Treatise on Determinants* is published.

1868 21 June—his father dies; September—his siblings move to "The Chestnuts," Guildford.

1869 *Phantasmagoria* is published.

1871 11 October—construction of the photographic studio on the roof above his rooms in Tom Quad, Christ Church, is completed; December—*Through the Looking-Glass* is published.

1872 17 March—uses new studio for the first time.

1876 1 April—*The Hunting of the Snark* is published.

1880 15 July—takes his last photograph.

1881 Takes early retirement from his lectureship in mathematics.

1882 December—becomes curator of the Common Room at Christ Church.

1885 *A Tangled Tale* is published.

1886 Facsimile of *Alice's Adventures Under Ground* is published.

1887 *The Game of Logic* is published.

1889 *Sylvie and Bruno* is published.

1890 *The Nursery "Alice"* is published.

1892 Resigns as curator of the Common Room.

1893 *Sylvie and Bruno Concluded* is published.

1896 *Symbolic Logic: Part 1* is published.

1898 14 January—dies at Guildford and is buried there; *Three Sunsets and Other Poems* is published later that month.

CATALOGUE OF THE PRINCETON UNIVERSITY LIBRARY ALBUMS

EDWARD WAKELING

Charles Lutwidge Dodgson ("Lewis Carroll" to the world) took up his photographic hobby in 1856. From the outset, he assembled albums of his photographic work. These became "show" albums that he could exhibit to visitors or take with him on his travels to encourage prospective "sitters" and friends. The photographs in the albums are not chronologically arranged. They are carefully selected to show the range and diversity of his photographic art. The position and juxtaposition of photographs in the albums were important. When assembling an album, Dodgson left spaces between the mounted photographs that he filled subsequently with later images. In some of the surviving albums, these gaps remain. The general approach was one of variety and contrast. Portraits of the famous were mixed with his photographs of family, friends, and colleagues. Landscapes were interspersed with still-life images. Tableaux photographs based on literature were placed next to pictures inspired by works of art. And all were combined with various compositions of his own creation.

At the dispersal of Dodgson's effects following his death in 1898, the sale catalogue listed thirty-four photographic albums, but not all of these contained exclusively his own photographs.[1] He collected the work of other eminent photographers of his day, including Oscar Rejlander, Julia Margaret Cameron, and Lady Clementina Hawarden. At least twelve of these albums have survived (four are in the Firestone Library, Princeton University, in the Morris L. Parrish Collection), and other contemporaneous albums not assembled by Dodgson but containing examples of his work exist in various collections around the world.

Dodgson's handwritten table of contents, Album A(I), 1857–60

In addition to his numerous photographic albums, Dodgson also created sets of his best images to show and give to friends and potential sitters. These as well as many loose prints of his photographic output have also survived, now in private and institutional collections.

At some stage in his photographic career, Dodgson decided to number his show albums, using the capital letter A followed by a Roman numeral. Again, the order is not chronological; for example, Album A(VI) contains many of his earliest photographs. Other albums containing family portraits and photographs of close acquaintances were left unnumbered. A few albums were specifically prepared as gifts for friends. Princeton has examples of each type. The following list is my census of surviving albums assembled by Dodgson, showing their current locations.

Album A(I)	Princeton University (Morris L. Parrish Collection)
Album A(II)	Princeton University (Morris L. Parrish Collection)
Album A(III)	University of Texas (Helmut Gernsheim Collection)
Album A(VI)	University of Texas (Helmut Gernsheim Collection)
Album A(VII)	Christ Church, Oxford University
Album A(X)	University of Texas (Helmut Gernsheim Collection)
Canon Rich Album	National Portrait Gallery, London
Dodgson Family Album	Princeton University (Morris L. Parrish Collection) —called Album P(3)
Dodgson Family Album	University of Texas (Helmut Gernsheim Collection)
Miss Dodgson Album	New York University Library (Alfred C. Berol Collection)
Henry Holiday Album	Princeton University (Morris L. Parrish Collection)
Weld Album	University of Texas (Helmut Gernsheim Collection)

Other contemporary albums containing examples of Dodgson's photographs, some of which he wholly or partly assembled:

Arthur C. Madan Album	whereabouts unknown
Bosworth Album, 1867	presentation album, whereabouts unknown; included in the G. P. Dutton & Company, London, catalogue dated 1914, no. 15
Common Room Album	Christ Church, Oxford University (Senior Common Room)
Henry B. Crichton Album	date unknown, whereabouts unknown; sold by Sotheby's, London, 1 November 1977, lot 273
Hassard Dodgson Albums	two albums, Royal Photographic Society, Bath
Liddell Albums	Christ Church Library, Oxford University

Kitchin Family Album	Jon Lindseth Collection
Salisbury Albums	six albums and notebooks, Hatfield House, Hertfordshire
Reginald Southey Albums	three of five albums, Princeton University (Cotsen Collection)

Some of the missing albums have undoubtedly been split up and the individual photographs dispersed. Others may remain still to be discovered. Most of the surviving albums exclusively assembled by Dodgson contain his handwritten index of photographs. He often sought the signature of the sitter either at the time the photograph was taken or, in some cases, at a later date. In a few of the albums Dodgson included poems, sometimes of his own invention, to complement the photographs. He saw his photography as an artistic activity that combined easily with other literary and aesthetic achievements.

Dodgson's highly developed imagination and creative spirit were matched by his need to have structured order in his life. He surrounded himself with files and registers that enabled him to keep track of his work and achievements. He was a frequent maker of lists. These had two functions—as a record of what he had already achieved and as a resolution of things to come. The latter, despite his good intentions, was often not fulfilled. Dodgson's journal recorded lists of books he intended to read or tasks he intended to undertake, but the cold light of day often saw these quickly shelved or forgotten.

Dodgson kept a diary in a series of journal notebooks, probably from his undergraduate years at Christ Church, Oxford, until his death. The diary filled thirteen notebooks, of which four are now missing; there are ten missing pages from those that survive. They give a very clear account of his photographic activities, listing the sitters, places where the photographs were taken, and the mode of the photograph—for example, sometimes the size of the plate used, whether it was a group photograph, or whether dressing-up costumes were used. Not every photographic session was recorded, and some are recorded for which no photographs have yet been found.

For some reason Dodgson's photographic output was not properly registered until 1875. Some of the surviving glass-plate negatives show signs of an early numbering system, occasionally with subsequent amendments. These numbers come in two varieties: some with an oval drawn around the number and some without, occasionally with one number crossed out and another substituted. The numbers that survive either on glass plates or visible as a mirror image on prints do not seem to fit any pattern. Dodgson's bouts of renumbering may account for the lack of systematic order in these assigned numbers. For example, he noted on 13 July 1864: "Took three boxes of negatives to Messrs. Cundall's place, 19 Bedford Place, Kensington, and went over all the negatives there, putting some back into their places, and re-numbering others."[2]

Many of the individual photographs that survive as mounted cabinet cards, cartes-de-visite, or untrimmed prints contain a number on the back in the top right corner. I have spent many years collecting details of these numbers and including them in a database.

I assumed at first that they had been written on the photographs around the time the prints were made. They are, without doubt, chronologically assigned. However, all are written in violet ink, even those marked on photographs in the early albums. Warren Weaver was the first to analyze Dodgson's use of various colored inks, and he discovered that violet ink was not used until October 1870, at least fifteen years after Dodgson began photographing.[3] Hence I have come to the conclusion that the "image numbers" (as I now call them) were assigned retrospectively. This theory is supported by entries in Dodgson's journals and by a handwritten note in Album A(VI).

About a third of Dodgson's photographic output survives today. I estimate that he took about three thousand pictures between 1856 and 1880, when he gave up his hobby. This is based upon the evidence given in his journals, letters, albums, and the numbering system he finally adopted in 1875. After taking photographs for over twenty years, Dodgson set himself the extraordinary task of compiling a register of all the photographs he had taken up to that time, recording details of the prints and assigning each photograph a unique number in chronological order. The process took a number of weeks of unstinting effort and concentration to complete.

Dodgson spent some days in July 1875 at the home of the artist Henry Holiday, taking photographs. On 16 July he recorded, "Photo writing all day," which probably meant that he was preparing the album he would subsequently give to his host. At the end of that month he noted, "The week has gone in registering and arranging photos, at about 10 hours work per day." So began his endeavor to track his photographic output back to its start in May 1856. He gave a more detailed account of his activities in an entry dated 7/8 August 1875 (probably written in the early hours of Sunday morning):

> Another week has gone exactly like the last, in photographic registering etc., and going through and destroying old letters. I have now got the alphabetical index of negatives arranged and nearly complete, written up the chronological register nearly to date, numbered, by it, all unmounted prints and mounted cartes and cabinets, and arranged them, numbered nearly all mounted in albums, and entered in the register references to them, and gone through all the 4¼ x 3¼ and 6 x 5 negatives by means of the register, erasing some, finding places for others, and making out an order for new prints to be done by Hills and Saunders. I find I must adopt some plan to keep the negatives from *damp*: shut-up boxes have ruined many of my best. I think of having all the lids removed, and the sides of the boxes, and the panels of the cupboard, pierced with holes. The remaining photo business is to go through the 7¼ x 6¼, 8½ x 6½, and 10 x 8 negatives, to select some more cabinets for "show" bundles, and a bundle of "show" cartes, to mount on larger cards some of the new prints, also for show. The mounting prints in albums I leave for the winter. I hope to get all done this week.[4]

This activity continued for several more days. On 10 August 1875, he wrote, "I have now gone through the 7¼ x 6¼, and 8½ x 6½ negatives," and on 11/12 August, "I have now gone through all the negatives, and copied into a little book the order for prints, the largest I have ever given. . . . Several of the negative boxes have now been turned into upright crates, and seem to answer very well." And on 17 August, "Mounted 2 photographs and other photo business," with "ditto" for the following day. So, all in all, Dodgson probably spent three weeks sorting out his photographs and preparing his photographic register.

Here we have clear evidence that Dodgson was assembling a register of his photographs, from his albums, from his collection of glass-plate negatives, and also from a quantity of loose prints. In addition, he was preparing an alphabetical register of his glass-plate negatives. It was not an easy task. He noted that he was not successful in numbering all the photographs in his albums, and we see evidence of his checking and cross-checking in the indexes, with tally marks and then an assigned image number in violet ink. Some of the image numbers were changed once he found that he had assigned a number to the wrong image (usually of the same sitter photographed on more than one occasion). At the end of the index in Album A(VI), Dodgson noted (also in violet ink) "ref. en. 30/7/75," which shows the outcome of his image-numbering activity ("ref. en. 30/7/75" is probably a partly Latin abbreviation that translates into "reference as at 30 July 1875").

The question that came to my mind was how Dodgson began this retrospective task. My view is that he tried to estimate the number of photographs taken up to August 1875 so that he had some idea of the range his numbering system would encompass. The photographs taken during his visit to the home of Henry Holiday have numbers around 2360 and 2370 assigned to them, which leads me to believe that Dodgson reckoned on 2400 prints taken up to this time.[5] With a sense of range determined, Dodgson was able to work backward from that moment in time and forward from his earliest photographs, giving numbers to each print. The scheme was bound to result in errors. Whatever records he had to hand would have been insufficient to allow him complete accuracy in this retrospective assignment. And errors were made. Similar photographs taken at the same time were found at some later stage in the process and these ended up with intermediate numbers, such as halves or thirds, assigned to them. Dodgson could not remember when some photographs had been taken, and these received no number, as shown by the incomplete assignment of numbers in his albums. The cabinet cards, cartes, and untrimmed prints had numbers added on the back in the top right corner, a system that Dodgson used from then on. Many photographs had already been given away to his sitters and their families. These, of course, bear no image numbers, but Dodgson was still giving copies of his photographs to friends, so some of the earlier prints do include image numbers prior to 2400.

There are references to photographs by number in some letters that Dodgson received before 1875. For example, in an undated letter with Dodgson's correspondence number 2013 (which dates it in 1865), George MacDonald asks: "Please send four of 181 of Irene. . . ." This no doubt refers to a glass-plate negative number; it certainly does not fit the image-number

system adopted from 1875. The earliest reference to photographs by image numbers in correspondence sent by Dodgson appears in his letter to E. Gertrude Thomson dated 24 January 1879, in which five numbers are used as reference to particular photographs.[6]

Dodgson's new approach to numbering his photographs, adopted in 1875, helps to explain why a complete year is missing from this system. This was an oversight by Dodgson. Between July 1864 and July 1865 this numbering system is missing and an alternative system is applied. I think that Dodgson found the omission at some later date and was forced to use a different method of numbering. He adopted the letter P (for photograph, perhaps) followed by numbers assigned in order. The highest number I have found is P91, indicating that approximately one hundred photographs were probably not assigned numbers using Dodgson's 1875 system.

In 1876 we get further evidence of this retrospective activity. Dodgson wrote: "Spent 4 hours over family album, in making up index, selecting new photographs etc., and mounted a few of the new ones." This is, most likely, Album P(3), which has some early photographs with image numbers less than 200, as well as a cross section of his photographic output over the next twenty years and a group with numbers in the range 2300 to 2320 (clearly the "new ones").

Sadly, Dodgson's comprehensive register of photographs has not survived. It was probably among the many other significant papers that have since been lost and possibly destroyed. Likewise, the alphabetical index of negatives is also missing, presumed lost. However, the image numbers that do survive make it possible to reconstruct the register as it might have been. In some cases, diary entries help date images, and from this a range of possible image numbers can be assigned. In the register that follows the catalogue, I present the reconstructed photographic list of all the photographs taken by Dodgson that have so far come to light. As time goes by, this list will be amended as more examples of Dodgson's photographs are discovered.

The last recorded image number, only recently discovered, is from a photograph of Evelyn Hatch taken in June 1880; it is numbered 2662. Dodgson gave up photography that year, and the last recorded photograph that he took is noted in his journal for 15 July: "Spent morning in printing. Gertrude and Gerida Drage came at 3, and I spent two hours in photographing them: then toning, fixing etc. till 7."

Dodgson employed the wet collodion process, which required that all his glass plates be developed at the time the photographs were taken. He probably had three different cameras, producing glass plates of varying sizes. Positive prints were prepared from the glass plates at a later time, with several prints often being made from the same negative. All prints from the same glass-plate negative were subsequently assigned the same image number. He used a number of different photographic printers to make prints from his negatives, a task he gave to professionals from an early stage in his photographic career. During the latter years of his photographic activity, he returned to making his own prints.

Dodgson's output varied from year to year, his most prolific year being 1863, when he took an estimated 250 or more pictures. On 16 June 1880 he wrote, "Spent several hours in preparing a catalogue in which to enter all 'prints on hand.'" He continued this task the following day. Another casualty of time, this catalogue is now missing. The reconstructed register includes all known photographs taken by Dodgson and provides an alternative to the missing registers, lists, and catalogues that he prepared. The reconstructed register makes it possible to date newly discovered photographs more accurately, as long as the image number is known.

In the catalogue that follows, each photograph in the Princeton albums is reproduced in album order, accompanied by the following information:

CATALOGUE NUMBER

A unique number indicating the album and page number. For example, A(I): 1 is the photograph on page 1 of Album A(I). Dodgson assigned the album numbers A(I) and A(II). The unnumbered album at Princeton University Library is now called P(3). Princeton University Library has also assigned the name HH for the Henry Holiday Album and RS1, RS2, and RS3 for three of the Reginald Southey albums. The letter L indicates a loose print. The page number (following the colon) has been assigned by the Princeton University Library. If more than one photograph appears on a page, each is indicated by alphabetical letters assigned from left to right; for example, A(I): 4a is the photograph on the left side of page 4 in Album A(I).

TITLE AND DATE TAKEN

Since many of these photographs had no title given by Dodgson, nor did he always identify them, I have given a title and a date. If the photograph is a portrait, I have identified the sitter wherever possible. In some cases, the photograph is a place, or skeleton, or reproduction of a painting or sculpture. In such cases I have supplied a simple title. Dates are given to each photograph, if known, using diary entries and inscriptions. As far as possible, the actual day when the photograph was taken is specified. Dodgson's diaries between 1858 and 1860 are missing, which has made it more difficult to date the photographs taken during this period.

DODGSON'S INDEX TITLE

I have indicated [in brackets] the title Dodgson gave to the image in his index to the album.

IMAGE NUMBER

Dodgson's own 1875 numbering system is used. If the image number is not known, I provide a range in which the number is very likely to fit. Photographs taken between July 1864 and July 1865 have Dodgson's alternative numbering system prefixed with the letter P. A question mark after an image number means that it has not been verified from actual prints or album indexes. This is nevertheless very likely to be the number Dodgson assigned, based on evidence such as close similarity to a photograph known to have been taken at the same time.

PLACE

The place where the photograph was taken is given, if known. In some cases I have been able to determine the place by using Dodgson's own location at the time (known from his diaries) or from identifiable characteristics of the setting. A question mark after the place name indicates that I have some doubts about the exact location. Some of the principal locations are:

2 FITZROY SQUARE, LONDON: home of the artist James Sant and his family.

5 MARLBOROUGH ROAD, ST. JOHN'S WOOD: London home of the artist Henry Holiday in 1870.

6 UPPER BELGRAVE PLACE, PIMLICO: London studio of the sculptor Alexander Munro.

7 CROMWELL PLACE, LONDON: home of the artist John Millais and his family.

12 EARL'S TERRACE, KENSINGTON: London home of George MacDonald and his family in October 1863.

16 CHEYNE WALK, CHELSEA: London home of the Rossetti family.

29 TEWRY STREET, WINCHESTER: home of James Thresher and his family.

92 STANHOPE STREET, LONDON: home of the Terry family.

ANATOMICAL MUSEUM, CHRIST CHURCH, OXFORD: occupied the lower floor of the Lee Building, now part of the Senior Common Room at Christ Church, Oxford. The photographs were probably taken just outside this building. There have been many alterations during the intervening years, making it difficult to be absolutely certain of the exact location.

AUCKLAND CASTLE, DURHAM: residence of the Bishop of Durham.

BADCOCK'S YARD, OXFORD: a rented building that Dodgson used for his photography from 18 June 1863 until he acquired his own studio within Christ Church in 1872.

CHRIST CHURCH STUDIO, OXFORD: Dodgson's photographic studio, erected on the roof above his rooms in Tom Quad, Christ Church, and first used by him on 17 March 1872.

CROFT RECTORY, YORKSHIRE: home of the Dodgson family from 1843 to 1868. It is now The Old Rectory, Croft-on-Tees, County Durham; the County boundary has been changed.

EAST SHEEN, LONDON: home of (Sir) Henry Taylor and his family.

ELM LODGE, HAMPSTEAD: London home of George MacDonald and his family in July 1863. The house was in Heath Street and actually belonged to Mrs. MacDonald's father.

FARRINGFORD, ISLE OF WIGHT: home of Alfred Tennyson and his family.

MONK CONISTON PARK, AMBLESIDE: owned by James Garth Marshall, a rich industrialist who owned other property in this part of the Lake District; one such building, Tent Lodge, was made available to Alfred Tennyson and his family in 1857.

OAK TREE HOUSE, HAMPSTEAD: London home of Henry Holiday and his family in 1875.

PARK LODGE, PUTNEY (sometimes called The Old House): London home of Dodgson's Uncle Hassard Dodgson and family.

THE RETREAT, HAMMERSMITH: London home of George MacDonald and his family in 1870.

WANDSWORTH, LONDON: home of the dramatist Tom Taylor and his family.

WHITBURN, TYNE AND WEAR: home of Dodgson's Wilcox cousins.

ORIGINAL INSCRIPTION

The photographs have a variety of inscriptions, some of which postdate Dodgson's time. Those in his hand are included, and the position of the inscription, either recto or verso on loose prints, is indicated. Some other inscriptions are given if they help to verify identifications. In Dodgson's albums, many of his sitters provided a signature and occasionally a date (indicating either the day the photograph was taken or the day the inscription was added). These are transcribed, and the location of the inscription is given only if it is not centered immediately below the print.

IMAGE SIZE

The height and width of the print, in inches and centimeters, are provided. The various shapes in which Dodgson trimmed his photographs will be evident from the reproductions.

NARRATIVE CAPTION

The caption provides additional details — mainly background information about the sitters or the circumstances of the photographs being taken. For portraits I have given, in the first instance, the birth and death dates of the sitter(s), if known. Where a diary entry is relevant to the photograph, it is included. If a photograph appears more than once in the albums, a cross-reference is made to the first image.

The Princeton albums are examples of the three distinct forms and purposes that Dodgson gave to his albums of photographs. The first, Album A(I), is a show album carefully arranged by Dodgson to exhibit the range of his photographic output with images ranging in date from 1857 to 1860. This album reveals Dodgson's early photographic career. The second, Album A(II), is also a show album demonstrating Dodgson's development as a photographer. The earliest photograph is dated 1859 and the latest, 1863. These two albums were frequently the subject of evening entertainments when Dodgson showed them to visitors and friends. The third album was unnumbered but is here given the name P(3). This is an album mainly for photographs of particular interest to the Dodgson family. It is a record of friends and family, and of places known to the family. Some Victorian celebrities are also included. The fourth album is a presentation album specially prepared by Dodgson to give to his friend, Henry Holiday, in gratitude for allowing Dodgson to use the Holiday home as a photographic venue for a week in July 1875. All the photographs in the album, many supplemented by quotations from poems, were taken during Dodgson's visit. He added the following inscription: "To Henry Holiday, in memory of a pleasant week spent with him in the Summer of 1875, this collection of amateur Photographs, taken during that visit, is presented by his sincere Friend, C. L. Dodgson." The remaining albums were compiled by other hands and include examples

of Dodgson's photographic opus. Reginald Southey was a photographer in his own right, and five of his albums are now part of the Lloyd Cotsen bequest to Princeton University. Southey included some of Dodgson's best and earliest photographs in his albums. A portrait of Dodgson was included in an album of scraps, mainly press-cuttings with *Alice* themes, collected by a contemporary, Rev. Arthur Henry Austen Leigh, fellow of St. John's College, Oxford. Finally, a number of loose prints completes the collection of Dodgson photographs at Princeton.

NOTES

1. See Jeffrey Stern, *Lewis Carroll, Bibliophile* (Luton, England: White Stone Publishing, 1997), 10–11.
2. Edward Wakeling, ed., *Lewis Carroll's Diaries,* vol. 4 (Luton, England: Lewis Carroll Society, 1997), 332.
3. Warren Weaver, "Ink (and Pen) Used by Lewis Carroll," *Jabberwocky: The Journal of the Lewis Carroll Society* 4 (Winter 1975): 3–4.
4. All diary entries and subsequent quotes are from the unpublished manuscript of Dodgson's journals and are printed by kind permission of the Trustees of the C. L. Dodgson Estate.
5. The number is significant. He might have estimated 2500 pictures, but 2400 is more in keeping with his particular interest in numbers; "24" is the reverse of "42" and this was Dodgson's favorite number. See Edward Wakeling, "What I Tell You Forty-Two Times Is True," *Jabberwocky: The Journal of the Lewis Carroll Society* 6 (Autumn 1977): 101–6; and Wakeling, "Further Findings about the Number Forty-Two," *Jabberwocky* 17 (Winter/Spring 1988): 11–13.
6. See Morton N. Cohen and Roger L. Green, eds., *The Letters of Lewis Carroll* (London: Macmillan, 1979), 327.

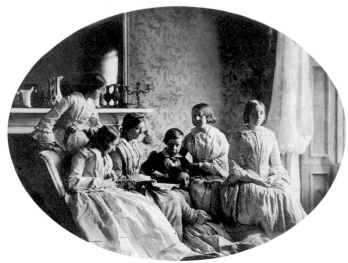

A(I): 1
Archdeacon Charles Dodgson, summer 1859
[Dodgson, Archdeacon]
427–439
Croft Rectory, Yorkshire
Inscribed below right: *C. Dodgson*
4 x 3 in. (10.1 x 7.5 cm)
Archdeacon Charles Dodgson (1800–1868), Dodgson's father, was initially perpetual curate of Daresbury, Cheshire (Dodgson's birthplace), but was promoted to the more lucrative Crown living at Croft, Yorkshire, in 1843. He was appointed a residentiary canon of Ripon in 1852 and became archdeacon of Richmond in 1854.

A(I): 2
Edwin Dodgson and "The New Book," July/August 1857
["The new book"]
248
Croft Rectory, Yorkshire
No inscription
4¾ x 6⅜ in. (12.3 x 16.3 cm)
Six of Dodgson's sisters share a new book with the youngest member of the family, Edwin Heron Dodgson (1846–1918). The photograph was taken in the drawing room at Croft Rectory, the Dodgsons' family home from 1843 to 1868.

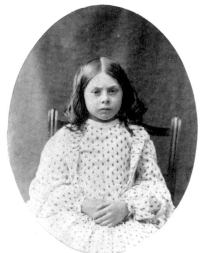

A(I): 3
Broad Walk, Christ Church, spring 1857
[Broad Walk]
173
Christ Church, Oxford
No inscription
5¼ x 6⅜ in. (13.1 x 17.1 cm)
The Broad Walk at Christ Church, situated at the college end of Christ Church Meadow, was lined with elm and plane trees. To be seen walking or riding here on a Sunday was essential to establish social status in Victorian times.

A(I): 4a
Lorina Liddell, 2 June 1857
[Ina Liddell]
194
Deanery garden, Christ Church, Oxford
No inscription
3⅞ x 3 in. (10 x 7.6 cm)
Lorina Charlotte Liddell (1849–1930), known as "Lina" or "Ina," was the older sister of Alice. Dodgson immortalized Lorina in *Alice's Adventures in Wonderland* as the Lory in "The Pool of Tears" and Elsie (or LC: Lorina Charlotte), one of the children in the treacle well in "A Mad Tea-Party."

A(I): 4b
Alice Liddell, 2 June 1857
[Alice Liddell]
195
Deanery garden, Christ Church, Oxford
No inscription
3⅞ x 3 in. (10 x 7.6 cm)
Alice Pleasance Liddell (1852–1934) was the second daughter of the dean of Christ Church, Henry George Liddell (1811–1898), and his wife, Lorina. She was Dodgson's inspiration for the two *Alice* books that grew out of a storytelling session during a boat trip on 4 July 1862.

A(I): 5
Skeleton of Brown Kiwi, June 1857
[Apteryx]
218
Anatomical Museum, Christ Church, Oxford
No inscription
5⅜ x 4¾ in. (13.8 x 12.2 cm)
Dodgson, with the help of his Christ Church colleague Reginald Southey (1835–1899), made a photographic record of the skeletons in the Anatomical Museum prior to their being transferred to the new University Museum, which opened in 1860. Some skeletons survive to this day, still labeled "Christ Church Collection."

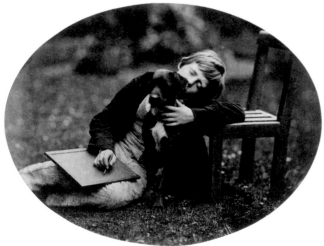

A(I): 6
Edwin Dodgson as "The Young Mathematician," July/August 1857
["Young Mathematician"]
251
Croft Rectory, Yorkshire
No inscription
4⅛ x 5⅜ in. (10.5 x 13.8 cm)
Edwin Dodgson, here with the family dog Dido, has fallen asleep at his studies. At Twyford School, Hampshire, he studied mathematics and later became a missionary, representing the Society for the Propagation of the Gospel; he served in Zanzibar and on the island of Tristan Da Cunha.

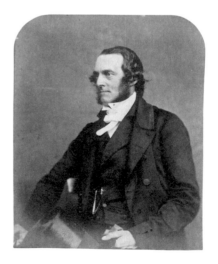

A(I): 7
Rev. John W. Smith, 4 August 1857
[Smith, Rev. W.]
256
Dinsdale Rectory, Yorkshire
No inscription
4⅞ x 4 in. (12.5 x 10.2 cm)
Rev. John William Smith (1811–1897), rector of Dinsdale from 1851 to 1859, was well acquainted with the Dodgsons at Croft. Visits between the two families were frequent.

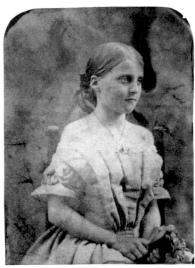

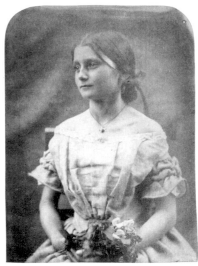

A(I): 8a
Anne Smith, 4 August 1857
[Anne Smith]
269
Dinsdale Rectory, Yorkshire
No inscription
4 x 3 in. (10.1 x 7.5 cm)
Anne Grey Smith (b. 1848) was the fourth and youngest daughter of the Rev. John and Maria Smith. On 3 August 1857 Dodgson wrote: "Went over to Dinsdale . . . for two days to visit the Smiths, arriving for dinner. They are very pleasant and uniformly kind people."

A(I): 8b
Fanny Smith, 4 August 1857
[Fanny Smith]
269½
Dinsdale Rectory, Yorkshire
No inscription
4 x 3 in. (10.1 x 7.5 cm)
Fanny Grey Smith (1847–1874) was the third daughter of the Rev. John and Maria Smith. On the second of Dodgson's two days with the Smiths at Dinsdale, 4 August 1857, he noted that he was "principally photographing."

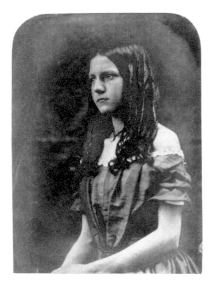

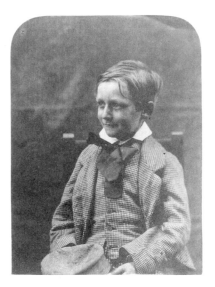

A(I): 9a
Maria Smith, 4 August 1857
[Maria Smith]
264
Dinsdale Rectory, Yorkshire
No inscription
4 x 3 in. (10.1 x 7.5 cm)
Maria Grey Smith (b. 1843) was the Smiths' eldest daughter.

A(I): 9b
William Smith, 4 August 1857
[Willie Smith]
265
Dinsdale Rectory, Yorkshire
No inscription
4 x 3 in. (10.1 x 7.5 cm)
William "Willie" Arthur Grey Smith (b. 1850) was the Smiths' only son.

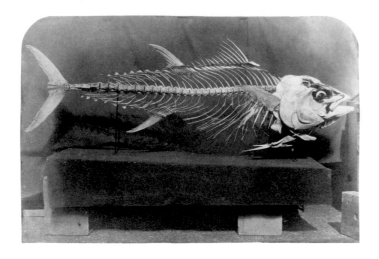

A(I): 10
Skeleton of Tunny-fish (Blue-fin Tuna), June 1857
[Thunny (side-view)]
206
Anatomical Museum, Christ Church, Oxford
Pasted printed sheet on facing page: *In a congregation to be holden on Saturday, the 31st instant, at Two o'Clock, the following form of Statute will be promulgated.* [signed] *F. Junius, / Vice-Can. / University Catacombs, / Nov. 3, 1860.* [followed by a Latin ode beginning] *Thunnus quem vides . . .*
4¼ x 6¾ in. (10.7 x 17.3 cm)
Dodgson noted on 26 May 1857: "Dr. Acland called . . . and afterwards took me to see the skeleton of his tunny-fish in the Anatomy schools which he wants me to photograph." Henry Wentworth Acland (1815–1900) was professor of medicine at Oxford. The following month Dodgson and Southey made a photographic record of the skeletal specimens in the Anatomical Museum.

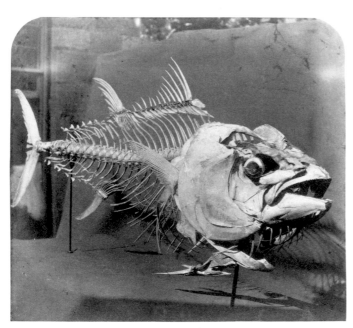

A(I): 11
Skeleton of Tunny-fish, June 1857
[Thunny (foreshortened)]
208
Anatomical Museum, Christ Church, Oxford
No inscription
5⅜ x 6 in. (13.8 x 15.3 cm)
Acland's tunny-fish (the blue-fin tuna: *thunnus thynnus*) was caught by fishermen off the island of Madeira and brought back to Oxford for dissection in 1847. The assembled skeleton, about 4.9 feet (1.5 meters) in length, survives to this day in the University Museum.

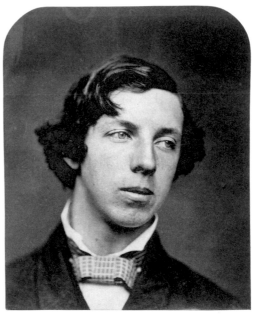

A(I): 12
Wilfred Dodgson, summer 1859
[Dodgson, W. L. (head)]
427–439
Croft Rectory, Yorkshire
No inscription
4⅞ x 4 in. (12.5 x 10.2 cm)
Dodgson's second brother, Wilfred Longley Dodgson (1838–1914), graduated at Christ Church, Oxford, in 1860. He was renowned as a good sportsman and an excellent shot. He married his childhood sweetheart, Alice Jane Donkin (1851–1929), and they had nine children. In later life he was land agent at Lord Boyne's estates in Shropshire.

A(I): 13
Anne, Maria, Joanna, and Fanny Smith (left to right),
4 August 1857
[Smith—4 girls]
270
Dinsdale Rectory, Yorkshire
No inscription
4⅛ x 5⅜ in. (10.4 x 13.8 cm)
Dodgson recorded his opinion of the Smith family in his diary entry
for 3 August 1857, noting that the children were "much what one might
expect from their free country life, strong, active, handsome, and with
a strong aversion to books." The sisters were Maria (A[I]: 9a), Joanna
Grey (1845–1932), Fanny (A[I]: 8b), and Anne (A[I]: 8a).

A(I): 14
Broad Walk, Christ Church, June 1857
[Broad Walk (from window)]
212
Christ Church, Oxford
No inscription
5⅜ x 7 in. (14.6 x 17.8 cm)
This view of the Broad Walk was probably taken from Southey's window
in Fell's Building. Neither the building nor the trees survive today. Fell's
Building gave way to Meadow Buildings in the 1860s, and the trees were
destroyed by Dutch elm disease in the 1970s.

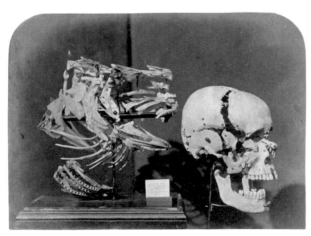

A(I): 15
Skeleton of Cod's Head and Shoulders with Human Skull,
June 1857
[Cod's head and skull]
210
Anatomical Museum, Christ Church, Oxford
No inscription
4⅝ x 6½ in. (12 x 16.5 cm)
Dodgson noted on 16 June 1857: "Took . . . 6 anatomical pictures to
Ryman's." He intended to generate income to help pay for his photo-
graphic activities, an expensive pastime in his day. Ryman's was a gallery
in Oxford that sold works of art and photographs.

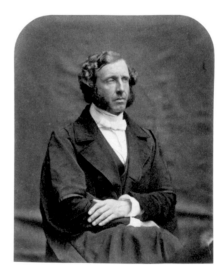

A(I): 16
Rev. Alexander R. Webster, June 1857
[Webster, Rev. A. R.]
236
Christ Church, Oxford
No inscription
4⅞ x 4 in. (12.5 x 10.3 cm)
Rev. Alexander Rhind Webster (1816–1890?), M.A., St. Mary Hall,
Oxford, was curate at Crosthwaite, near Keswick, Cumberland. He had
been curate to Archdeacon Dodgson at Croft before moving in July 1855.
Webster ran a school for students preparing for university entrance, and
two of Dodgson's brothers studied with him for a time.

A(I): 17
Magdalen Tower, Magdalen College, Oxford, March 1858
[Magdalen Tower (from Ch. Ch.)]
321
Oxford
No inscription
5⅜ x 6¼ in. (13.7 x 15.7 cm)
A distant view of Magdalen Tower photographed from Christ Church.

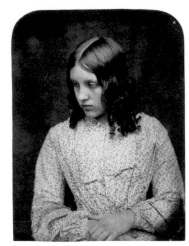

A(I): 18
Margaret Dodgson, summer 1859
[Dodgson, M. A. A.]
427–439
Croft Rectory, Yorkshire
No inscription
4 x 3 in. (10.1 x 7.5 cm)
Margaret "Maggie" Anne Ashley Dodgson (1841–1915), the sixth of Dodgson's seven sisters, remained unmarried and lived in the family home with her other five unmarried sisters. For a time she helped in the local school at Croft as a teacher.

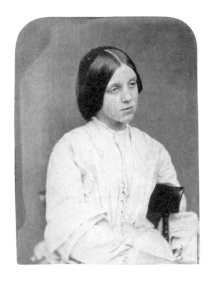

A(I): 19a
Henrietta Dodgson, summer 1859
[Dodgson, Henrietta]
427–439
Croft Rectory, Yorkshire
No inscription
4 x 3 in. (10.1 x 7.5 cm)
Henrietta was the youngest of Dodgson's seven sisters. She remained unmarried and lived in the family home at Croft and then, following the death of Archdeacon Dodgson, at "The Chestnuts" in Guildford. Eventually, she moved to Brighton, where she lived for the rest of her life with her maid, Annie, and several cats.

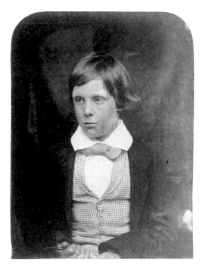

A(I): 19b
Edwin Dodgson, summer 1859
[Dodgson, Edwin]
427–439
Croft Rectory, Yorkshire
No inscription
4 x 3 in. (10.1 x 7.5 cm)
Edwin was the youngest of Dodgson's three brothers. This photograph was taken when he was thirteen, then a pupil at Twyford School, Hampshire.

A(I): 20
Sixteenth-Century Venetian Drawing at Christ Church Library,
November 1857?
[Picture (Ch. Ch. Library)]
311
Christ Church Library, Oxford
No inscription
2⅝ x 4⅜ in. (6.6 x 11.3 cm)
This drawing in brown ink on a red-grounded paper from Christ Church
Library (now in the Picture Gallery) is by a follower of Giorgione (1477?–
1510) and is titled *Pair of Lovers Playing Music in a Landscape* (Guise be-
quest). Dodgson wrote on 9 November 1857: "Dr. Heurtley called to ask
me to take a photograph of a drawing in the Library, for some one in Italy."

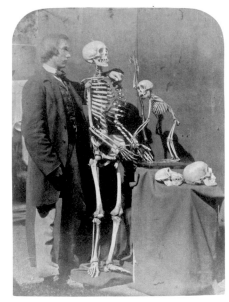

A(I): 21
Reginald Southey and Skeletons, June 1857
[Southey, R. and skeletons]
219
Anatomical Museum, Christ Church, Oxford
Inscribed on facing page: *You are bones, and what of that? / Every face,*
however full, / Padded round with flesh and fat, / Is but modell'd on a skull.
[from Tennyson's "The Vision of Sin" (1842)]
6⅝ x 4⅞ in. (16.9 x 12.5 cm)
Southey was a Christ Church graduate scientist who became a physician
at St. Bartholomew's Hospital and lecturer at the College of Physicians.
A lifelong friend of Dodgson, he was also his photographic teacher and
guide. This photograph probably celebrates his graduation at Oxford.

A(I): 22
Skeleton of Sunfish, June 1857
[Sun-fish]
215
Anatomical Museum, Christ Church, Oxford
Inscribed on facing page: *Slowly upward, wavering, gleaming / Like a white*
moon in the water, / Rose the Ugadwash, the sun-fish, / Seized the line of Hia-
watha, / Swung with all his weight upon it, / Made a whirlpool in the water, /
Whirled the birch-canoe in circles, / Round and round in gurgling eddies, / Till
the circles in the water / Reached the far-off sandy beaches, / Till the water-flags
and rushes / Nodded on the distant margins. [from Longfellow's "The Song
of Hiawatha" (1855)]
6⅜ x 4⅞ in. (16 x 12.4 cm)
Dodgson appears to have confused two species of sunfish. One is a fresh-
water fish that is referred to in Longfellow's "The Song of Hiawatha"
(quoted in the accompanying inscription). The other is a sea fish, as here
in this skeletal specimen.

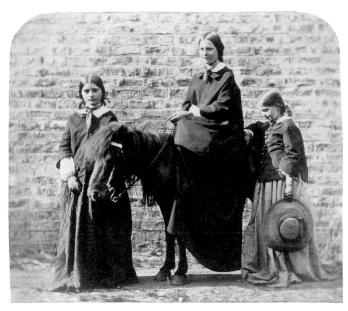

A(I): 23
Fanny, Maria, and Anne Smith with Their Pony, 4 August 1857
[Smiths, 3 with pony]
255
Dinsdale Rectory, Yorkshire
No inscription
5½ x 6⅜ in. (14 x 16.1 cm)
The sisters are (left to right) Fanny, Maria (seated on their pony), and
Anne.

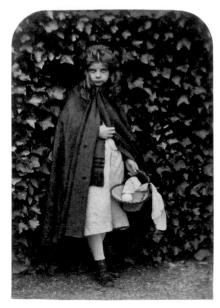

A(I): 24
Agnes Weld as "Little Red Riding-Hood," 18 August 1857
[Weld, Agnes. "Red Riding-hood"]
275
Croft Rectory, Yorkshire
Inscribed on facing page: *Into the wood—the dark, dark wood—/ Forth went
the happy Child; / And, in it's* [sic] *stillest solitude, / Talked to herself, and
smiled; / And closer drew the scarlet Hood / About her ringlets wild. // And now
at last she threads the maze, / And now she need not fear; / Frowning, she meets
the sudden blaze / Of noonlight falling clear; / Nor trembles she, nor turns, nor
stays, / Although the Wolf be near.* [original poem by Dodgson]
5⅜ x 3¾ in. (13.8 x 9.6 cm)
Agnes Grace Weld (1849–1915), a niece of Alfred Tennyson (her
mother, Anne Weld née Sellwood, was Tennyson's sister-in-law), was
photographed as "Little Red Riding-Hood" in one of Dodgson's earliest
"costume" pictures. It was exhibited at the Fifth Annual Exhibition of the
Photographic Society, London, 1858.

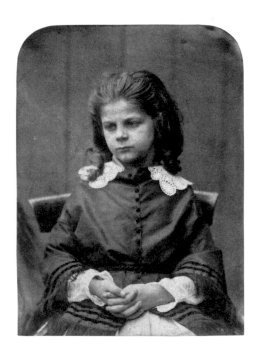

A(I): 25
Agnes Weld, 18 August 1857
[Weld, Agnes]
273
Croft Rectory, Yorkshire
Seven stanzas inscribed on facing page, beginning with: *O fair the blossom
on the bough / With twilight Childhood falling: / And fair the golden Autumn
fruit / The bloom of youth recalling!* [and ending with:] *We bless the smiles
of rising day / That shame our blind regretting: / We know each grace that gilds
the dawn / Will glorify the setting. / F. T. Palgrave.*
4 x 3 in. (10.1 x 7.5 cm)
Dodgson wrote: "She hardly merits one by actual beauty, though her face
is very striking and attractive, and will certainly make a beautiful photo-
graph. I think of sending a print of her, through Mrs. Weld, for Tennyson's
acceptance." Dodgson's photographs of Agnes became his introduction to
the poet laureate.

A(I): 26
Alfred Tennyson, 28 September 1857
[Tennyson, A.]
306
Monk Coniston Park, Ambleside
Signature below right of print: *A. Tennyson*; inscribed on facing page: *The poet in a golden clime was born, / With golden stars above; / Dower'd with the hate of hate, the scorn of scorn, / The love of love.* [from Tennyson's "The Poet" (1829)]
5 x 4 in. (12.6 x 10.2 cm)
Alfred, Lord Tennyson (1809–1892), poet laureate, was greatly admired by Dodgson. In 1857 Tennyson was residing in the Lake District, and Dodgson was keen to meet him and take his photograph. Dodgson succeeded on both counts. He wrote on 28 September: "I got pictures of Mr. and Mrs. Tennyson." Dodgson recorded on 3 December 1857: "Yesterday I heard from Mrs. Tennyson . . . begging me to destroy her picture, and all of his except those for myself, the Croft Album, and Southey," making this a rare photograph of Tennyson by Dodgson.

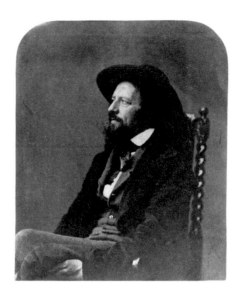

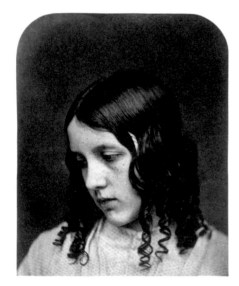

A(I): 27
Margaret Dodgson, summer 1859
[Dodgson, M. A. A. (head)]
427–439
Croft Rectory, Yorkshire
No inscription
5 x 4 in. (12.6 x 10.3 cm)
This close-up photograph of Dodgson's sister, Margaret, was probably taken at the same time as A(I): 18.

A(I): 28
Skeleton of an Anteater, June 1857
[Anteater]
203
Anatomical Museum, Christ Church, Oxford
No inscription
4⅜ x 6⅞ in. (10.9 x 17.5 cm)
One of the series of photographs made of the anatomical specimens before their transfer to the new University Museum in 1860.

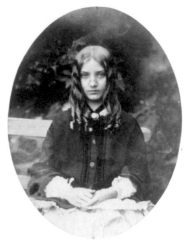

A(I): 29
Mary and Charlotte Webster with Margaret Gatey,
25 September 1857
[Websters and M. Gatey]
300
Crosthwaite, near Keswick
No inscription
3⅜ x 6¾ in. (8.7 x 17.3 cm)
Mary Elizabeth (b. 1849) and Charlotte Augusta (b. 1847), two daughters
of Rev. Alexander Webster, were joined in this photograph by Margaret
Gatey (dates unknown). Dodgson wrote: "Spent the day again in photo-
graphing . . . and I got promising negatives of Mrs. Webster, Charlotte,
Mary, and their friend Margaret Gatey, together and in groups."

A(I): 30
Margaret Gatey, 25 September 1857
[Gatey, Margaret (full face)]
298
Crosthwaite, near Keswick
No inscription
5 x 3⅝ in. (12.6 x 9.4 cm)
Margaret Gatey is photographed alone in this portrait, looking straight at
the camera and the photographer. Dodgson found willing subjects in the
Websters and Margaret, and "in order to do these I put off going till the
morning," he wrote.

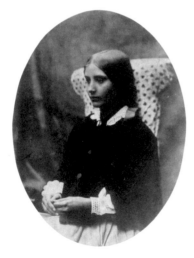

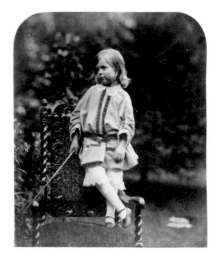

A(I): 31
Margaret Gatey, 25 September 1857
[Gatey, Margaret (3/4 face)]
299
Crosthwaite, near Keswick
No inscription
5 x 3⅝ in. (12.6 x 9.5 cm)
Little is known about Margaret Gatey apart from her friendship with the
Webster sisters.

A(I): 32
Hallam Tennyson, 28 September 1857
[Tennyson, Hallam]
305
Monk Coniston Park, Ambleside
Signature below right of print: *Hallam Tennyson*
5⅜ x 4½ in. (13.8 x 11.5 cm)
Hallam Tennyson (1852–1928), the poet laureate's eldest son, was
educated at Marlborough and Cambridge but did not take his degree.
He left to become his father's companion and secretary. Hallam was
devoted to both his parents and wrote his father's biography soon after
Tennyson's death.

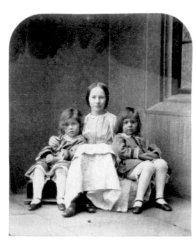

A(I): 33
Hallam and Lionel Tennyson with Julia Marshall,
28 September 1857
[Tennysons and J. Marshall]
309
Monk Coniston Park, Ambleside
Signed below left: *Lionel Tennyson*; inscribed below right, added after the
photograph was taken: *Hallam Tennyson / April 19th 1862*
5 x 4 in. (12.6 x 10.3 cm)
Dodgson noted in his diary for 28 September 1857 that he had taken
"a group of Hallam, Lionel, and Mr. Marshall's little girl Julia." Lionel
(1854–1886) was Hallam's younger brother, and Julia Marshall (1845–
1907) was the daughter of James Garth Marshall (1802–1873), the owner
of Monk Coniston Park.

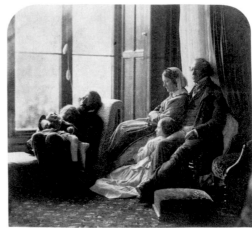

A(I): 34
Tennysons and Marshalls, 29 September 1857
[Tennysons and Marshalls (indoors)]
310
Monk Coniston Park, Ambleside
No inscription
5¼ x 5⅝ in. (13.1 x 14.3 cm)
This interior photograph shows Hallam Tennyson on his father's lap, Mr.
and Mrs. James Marshall, and their daughter Julia, taken at Monk Coniston
Park, the Marshalls' Lake District home.

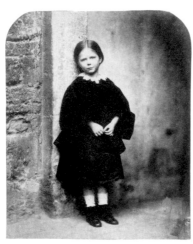

A(I): 35
Mary Lott, spring 1857
[Lott, Mary]
171
Christ Church, Oxford
No inscription
5 x 4 in. (12.6 x 10.3 cm)
"Dined with the Sub. Dean, and met . . . Mr. and Mrs. Lott," Dodgson
wrote on 12 February 1857. A few days later he received a note asking
"if I will some day take a picture of Mrs. Lott's three little children." Mary
Elizabeth Lott (b. 1855?) was the daughter of Rev. Frederick Edwin Lott
(1813–1869), vicar of Bampton Lew, and his wife, Elizabeth (b. 1817).

A(I): 36
Archdeacon Charles Dodgson, May 1860
[Dodgson, Archdeacon (reading)]
554
Croft Rectory, Yorkshire
No inscription
5⅜ x 4⅜ in. (13.4 x 11.1 cm)
Archdeacon Dodgson, now a widower, was a very able man who took a
double first at Oxford University in mathematics and classics. He translated
"Tertullian" in 1838 for the theological series *The Oxford Library of Fathers*
and published several sermons.

A(I): 37
Bust of Robert Hussey by Alexander Munro, March 1858
[Bust of Prof. Hussey]
328
Christ Church, Oxford
No inscription
5½ x 5½ in. (14 x 14 cm)
Dodgson wrote on 9 November 1857: "Dr. Heurtley called to ask me to take a photograph of . . . the bust of the late Dr. Hussey, but the weather is hopeless at present." Robert Hussey (1803–1856) was the first professor of ecclesiastical history at Christ Church, Oxford. Alexander Munro (1825–1871) was a sculptor with Oxford associations.

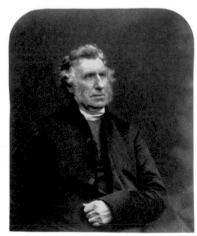

A(I): 38
Dean Henry D. Erskine, 30 March 1858
[Erskine, Dean]
333
Ripon, Yorkshire
Signed as the dean of Ripon, below right of print: *H. D. Erskine Dec: Rip. 1858*
5 x 4 in. (12.6 x 10.3 cm)
From 27 March until 12 April 1858, Dodgson was at Ripon, where his father was a residentiary canon for the first thirteen weeks of each year. The Very Rev. Henry David Erskine (1786–1859), dean of Ripon, was photographed during this time. Dodgson was well acquainted with the dean and his family.

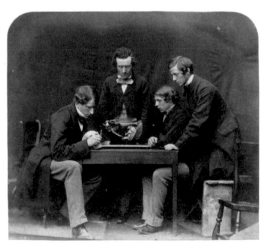

A(I): 39
Anatomy Lesson with Dr. George Rolleston, June 1857
[Rolleston, Dr. and group]
205
Anatomical Museum, Christ Church, Oxford
No inscription
5¾ x 6½ in. (14.8 x 16.5 cm)
Dr. George Rolleston (1829–1881), professor of human and comparative anatomy at Oxford, with William Robertson (dates unknown), demonstrator of anatomy, and two students, Augustus Vernon Harcourt (1835–1919) and Heywood Smith (b. 1838).

A(I): 40
Broad Walk with Figures, Christ Church, June 1857
[Broad Walk with figures]
213
Christ Church, Oxford
No inscription
5¾ x 6½ in. (14.8 x 16.4 cm)
This view of the Broad Walk at Christ Church with four undergraduates in the foreground was taken from a window in rooms occupied by Southey. The building in which the rooms were situated was removed in the 1860s to make way for a new accommodation block called Meadow Buildings.

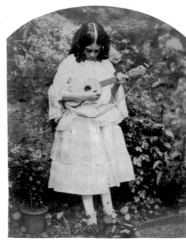

A(I): 41
Salmon-Leap, Dinsdale, summer 1859
[Salmon-leap, Dinsdale]
443
Dinsdale weir, River Tees, Yorkshire
No inscription
4⅞ x 6⅜ in. (12.4 x 16.3 cm)
The salmon-leap at Dinsdale weir and mill near Darlington was taken during a visit to Rev. John W. Smith, rector of Dinsdale, and his family in 1859. Unfortunately, Dodgson's diaries are missing for this period, so the date of the visit cannot be confirmed.

A(I): 42a
Lorina Liddell with Guitar, spring 1860
[Ina & machête]
546
Deanery garden, Christ Church, Oxford
No inscription
6⅜ x 5⅛ in. (16.8 x 13 cm)
The Liddell sisters enjoyed the musical entertainment featured in the Deanery as part of the social life of Christ Church. Lorina and her sisters were talented musically; they played instruments and were accomplished singers.

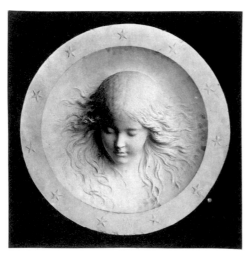

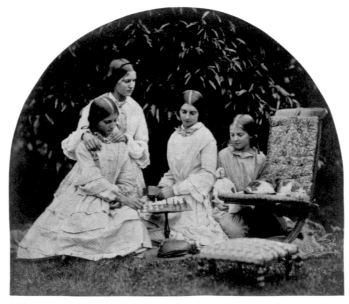

A(I): 42b
Marble Medallion Portrait of Agnes Gladstone by Alexander Munro, summer 1859
[Medallion, A. Gladstone]
425
6 Upper Belgrave Place, Pimlico
No inscription
4⅞ x 4⅞ in. (12.5 x 12.4 cm)
This high-relief medallion of Agnes Gladstone (1842–1931) was sculpted in 1854. Agnes was the second child and first daughter of the eminent politician William Ewart Gladstone (1809–1898), M.A., Christ Church, and later prime minister. She became Mrs. Wickham, wife of the head-master of Wellington College.

A(I): 43
Fanny, Maria, Joanna, and Anne Smith, summer 1859
[Smiths (chess)]
442
Dinsdale Rectory, Yorkshire
No inscription
5⅜ x 6⅜ in. (13.7 x 16.1 cm)
Four Smith sisters (left to right), Fanny, Maria, Joanna, and Anne, playing chess. The family cat joins the composition.

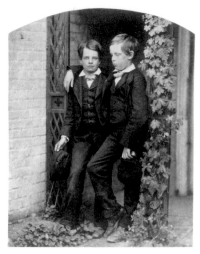

A(I): 44

Kathleen Tidy, 1 April 1858?

[Tidy, Kathleen (in tree)]

341

Ripon, Yorkshire

Signature on pasted-down slip, below right: *Kathleen H. Tidy*; inscribed on opposite page: *out fishing yesterday*

5 x 3⅝ in. (12.6 x 9.4 cm)

Kathleen H. Tidy (b. 1851) photographed in a tree at Ripon, probably on her seventh birthday. Her father was Thomas Holmes Tidy (1809–1874), a lieutenant colonel (later major general) with the 14th Buckinghamshire Foot Regiment from 1854.

A(I): 45

Edwin Dodgson and C. Turner, summer 1859

[Dodgson, E. H. and C. Turner]

380

Twyford School, Hampshire

Inscribed below left: *C. Turner*; and below right: *E. H. Dodgson*

5⅜ x 4 in. (13.5 x 10.3 cm)

Dodgson's schoolboy brother, Edwin, together with a fellow pupil, C. Turner, at Twyford School. No details about C. Turner are known.

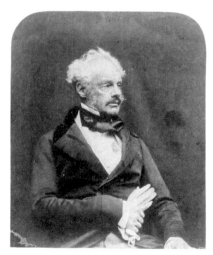

A(I): 46

Richmond Friary, spring 1860

[Richmond Friary (lower part)]

479

Richmond, Yorkshire

No inscription

6½ x 5⅝ in. (16.6 x 14.5 cm)

This view of Richmond Friary shows the lower part of the Friary Tower, photographed during Dodgson's tour of places associated with his childhood and youth in the spring of 1860. He attended school at Richmond, Yorkshire, from the age of twelve until he went to Rugby School in 1846.

A(I): 47

Captain William S. Smith, 31 March 1858

[Smith, Captain]

337

Ripon, Yorkshire

Inscribed below right of print: *Wm. Slayter Smith*

5⅜ x 4½ in. (13.8 x 11.5 cm)

Captain William Slayter Smith (1792–1865) served in the Peninsular War (13th Regiment of Light Dragoons) and at Waterloo (10th Royal Hussars). He retired from active army service in 1819 but from 1822 to 1864 was captain and adjutant of the Yorkshire Regiment of Hussar Yeomanry. He married Sarah Bradney née Bockett in 1818.

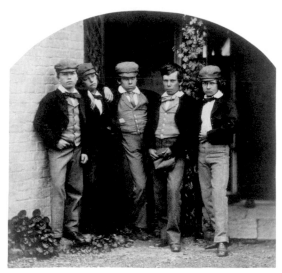

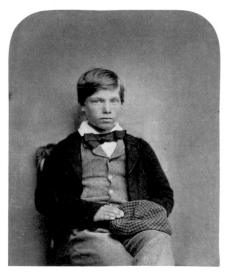

A(I): 48
Five Twyford Schoolboys, summer 1859
[5 Twyford boys]
392
Twyford School, Hampshire
Spaced beneath print: *Clement D. E. Malet / Ralph Clutton / John Henry
Clutton / F. G. Richardson / John St. J. Frederick*
5⅜ x 5⅝ in. (13.6 x 14.2 cm)
These five schoolboys attended Twyford School in preparation for public
school and university. They are (left to right): Clement Drake Elton Malet
(1845–1930), Frederick George Richardson (b. 1844), John Henry Clutton
(b. 1846), Ralph William Clutton (b. 1846), and John St. John Frederick
(1846–1907).

A(I): 49
Clement D. E. Malet, summer 1859
[Malet, C. D. E.]
400
Twyford School, Hampshire
Inscribed below right of print, set upon pencil guide mark: *Clement D. E.
Malet*
4⅞ x 4 in. (12.5 x 10.2 cm)
Clement was the son of Eliza and William Malet, vicar of Ardeley, Hert-
fordshire. Clement went on to study at Pembroke College, Oxford, and
was ordained deacon in 1872 and priest in 1873. Dodgson described him
as "a remarkably nice-looking and gentlemanly boy."

A(I): 50
PHOTOGRAPH MISSING FROM ALBUM
Dido, the Dodgson Family Dog, August 1857
279?
Croft Rectory, Yorkshire
No inscription

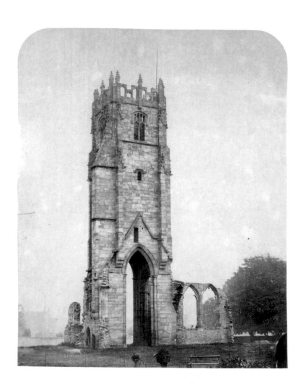

A(I): 51
Richmond Friary, spring 1860
[Richmond Friary]
480
Richmond, Yorkshire
No inscription
6⅝ x 5⅜ in. (17.1 x 13.7 cm)
Richmond Friary, Yorkshire, photographed during the Easter vacation
in 1860, when Dodgson toured places associated with his early life. See
A(I): 46.

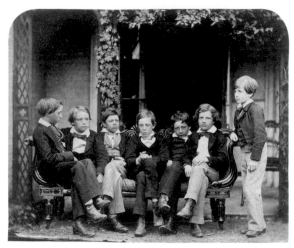

A(I): 52
Seven Twyford Schoolboys, summer 1859
[Group, 7 Twyford boys]
393
Twyford School, Hampshire
Spaced beneath print: *James H. Dodgson / F. G. Richardson / A. Gordon /*
E. H. Dodgson / C. Fosbery / John St. J. Frederick / A. Heathcote
5⅜ x 6½ in. (13.8 x 16.6 cm)
A group of younger boys at Twyford School (left to right): James Hume
Dodgson (1845–1912), Frederick George Richardson (b. 1844),
A. Gordon (dates unknown), Edwin (Dodgson's brother), Charles Fosbery
(b. 1846), John St. John Frederick (1846–1907), and Albert Heathcote
(b. 1848). James (A[I]: 60) was Dodgson's cousin.

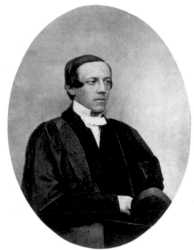

A(I): 53
Rev. Alfred F. Smith, summer 1859
[Smith, Rev. A. F.]
381
Twyford School, Hampshire
Inscribed below right: *Alfred F. Smith*
5 x 3¾ in. (12.7 x 9.5 cm)
Rev. Alfred Fowler Smith (1831–1891) was a schoolmaster at Twyford, the
only surviving son of Alfred Smith, surgeon at Ripon. He was educated at
Pembroke College, Cambridge, and later gained an honorary doctorate of
divinity at the College of William and Mary in the United States (1885).
He was also the curate at Twyford and later headmaster of Thetford
Grammar School.

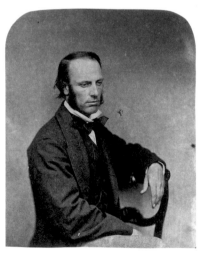

A(I): 54
John Hart, summer 1859
[Hart, J. Esq.]
382
Twyford School, Hampshire
Inscribed in ink, below right: *John Hart*
5 x 4 in. (12.6 x 10.3 cm)
John Hart (dates unknown), schoolmaster at Twyford.

A(I): 55
Robert Foster, August 1857
[Foster, R. (full-length)]
285
Croft Rectory, Yorkshire
No inscription
6⅝ x 5 in. (16.9 x 12.8 cm)
Robert Foster (1798–1877) was the gardener employed by Archdeacon
Dodgson, responsible for the extensive rectory gardens. He lived at
Hurworth Place, Croft.

A(I): 56
Lorina, Alice, and Edith Liddell, summer 1858
[Ina, Alice, and Edith (on sofa)]
374
Deanery garden, Christ Church, Oxford
Inscribed in ink, below center of print: *Lorina Charlotte Liddell / Edith Mary Liddell / Alice Pleasance Liddell*
4⅜ x 6⅜ in. (11.1 x 16.1 cm)
Lorina, Alice, and their younger sister, Edith Mary (1854–1876)—the first three daughters of Dean Liddell—were photographed on a sofa in the Deanery garden with a blanket as backdrop.

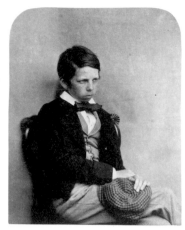

A(I): 57
George A. Dicken, summer 1859
[Dicken, G. A.]
399
Twyford School, Hampshire
Inscribed in ink, below right of print: *George A. Dicken*
4⅞ x 3⅞ in. (12.5 x 9.9 cm)
George Alldersey Dicken (1843–1867), son of Rev. A. Dicken, of Norton, Bury St. Edmunds, was a pupil at Twyford School. He continued his education at Marlborough College and then attended St. Peter's College, Cambridge, where he took his B.A. in 1866. The cause of his death the following year is not known.

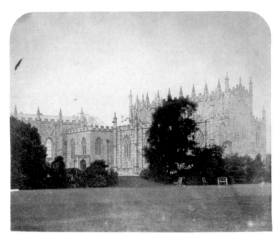

A(I): 58
Chapel at Auckland Castle, summer/autumn 1859
[Chapel, Auckland Castle]
455
Auckland Castle, Durham
No inscription
5⅜ x 6½ in. (13.8 x 16.6 cm)
Auckland Castle is the home of the bishop of Durham, situated at Bishop Auckland, about fifteen miles northwest of Croft. Charles Thomas Longley (1794–1868) was bishop of Durham in 1859. Dodgson visited Auckland Castle on a number of occasions, and his story "The Legend of Scotland," which features one of the dungeons at the castle, was written for Bishop Longley's family.

A(I): 59
Mr. and Mrs. Henry Hobson and Family, summer 1860
[Hobson, H., and family]
281½
Croft Rectory, Yorkshire
No inscription
5⅝ x 6½ in. (14.5 x 16.6 cm)
Henry Hobson (1819–1873) was the schoolmaster at the Croft National School. Soon after arriving at Croft in 1843, Archdeacon Dodgson established a fund to build the new school and his family helped to raise the capital for the building. Hobson is photographed with his wife, Sarah (1823–1877), and daughters, Sarah (b. 1852), Eliza (b. 1855), and Lydia (b. 1858). Dodgson probably assigned an image number that does not fit the chronology of this photograph.

A(I): 60
James Dodgson, summer 1859
[Dodgson, J. H.]
398
Twyford School, Hampshire
Inscribed in ink, below right of print: *James Hume Dodgson*
5 x 3 ⅝ in. (12.7 x 9.3 cm)
James Hume Dodgson (1845–1912) was Dodgson's cousin, son of his
Uncle Hassard Dodgson. Photographed here as a pupil at Twyford School,
he was known in later life as Hume. He assumed the responsibility as head
of family after the death of his father in 1884, his two older brothers having
emigrated to Australia. Later he married Elizabeth Ada Mary Smyth.

A(I): 61
Caroline and Rosamond Longley, summer/autumn 1859
[Longley, Misses C. and R.]
452
Auckland Castle, Durham
No inscription
5 ⅜ x 4 ½ in. (13.8 x 11.4 cm)
Two of Bishop Longley's daughters, Caroline Georgiana (1843–1867) and
Rosamond Esther Harriet (1844–1936), photographed in the grounds of
the bishop's residence, Auckland Castle.

A(I): 62
Bishop Charles T. Longley, summer/autumn 1859
[Longley, Bishop (at Auckland)]
451
Auckland Castle, Durham
Inscribed in ink, signing as the bishop of Durham, below right of print:
C. T. Dunelm
5 ½ x 4 ½ in. (13.9 x 11.5 cm)
Charles Longley, bishop of Durham from 1856, later Archbishop of
Canterbury, photographed at Auckland Castle. He graduated at Christ
Church in 1815, becoming a tutor and examiner in classics from 1825
to 1828, during which time he enjoyed a friendly relationship with
Dodgson's father.

A(I): 63
Fanny Smith and Dog, summer 1859
[Smith, Fanny (with dog)]
441
Dinsdale Rectory, Yorkshire
No inscription
3 ½ x 4 ⅜ in. (8.9 x 11.3 cm)
Fanny Smith, daughter of Rev. John W. Smith, rector of Dinsdale, with the
family dog.

A(I): 64
Bust of Madame Adelaide Ristori by Alexander Munro,
summer 1859
[Bust of Mad^me. Ristori]
420
6 Upper Belgrave Place, Pimlico
No inscription
6⅝ x 5⅛ in. (17 x 13 cm)
Dodgson wrote on 16 April 1858: "[Munro] . . . gave me carte-blanche
to photograph anything and everything in his studio, when I come to town
in June." The expedition in June does not appear to have happened, but a
series of photographs was taken in 1859, 1860, and 1863. Munro's sculpture
of Madame Adelaide Ristori, the marchioness del Griglio, was exhibited at
the Royal Academy in 1858.

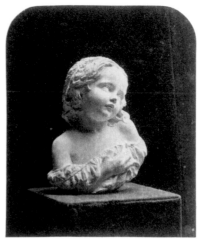

A(I): 65
Bust of Bianca by Alexander Munro, summer 1859
[Bust of Bianca]
426
6 Upper Belgrave Place, Pimlico
Inscribed in ink, on pasted down slip: *Bianca*
5 x 4 in. (12.7 x 10.3 cm)
The bust of Bianca, the young daughter of Madame Adelaide Ristori,
marchioness del Griglio, was exhibited with the bust of her mother at the
Royal Academy in 1858.

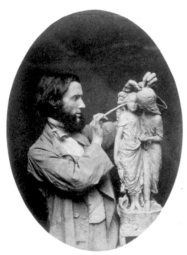

A(I): 66
Alexander Munro, summer 1859
[Munro, A. Esq. (at work)]
405
6 Upper Belgrave Place, Pimlico
No inscription
6½ x 4¾ in. (16.4 x 12.1 cm)
Alexander Munro, the son of a stonemason, was a portrait sculptor. He
exhibited at the Royal Academy from 1849, regularly contributing for the
rest of his life. Here he is working on *Measurement by Foxglove*; see A(I): 92.

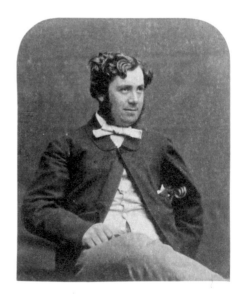

A(I): 67
Quintin Twiss, 15 June 1857
[Twiss, Q. Esq.]
229
Christ Church, Oxford
No inscription
4⅞ x 4 in. (12.5 x 10.2 cm)
Quintin William Francis Twiss (1835–1900), an undergraduate at Christ
Church who took his B.A. at the end of 1857, was a renowned amateur
actor. He became a clerk to the Treasury. Dodgson photographed him
in various theatrical costumes and roles, but this photograph shows him
in ordinary dress.

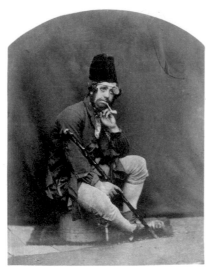

A(I): 68
Quintin Twiss in "The Rat-Catcher's Daughter," summer 1858
["Rat-catcher's daughter"]
351
Deanery garden, Christ Church, Oxford
No inscription
6⅝ x 5⅛ in. (17 x 13 cm)
Dodgson was an avid theater-goer and probably saw the verse mime by
Harold E. Priestley upon which this photograph is based. Quintin Twiss
takes the role of the "Rat-catcher."

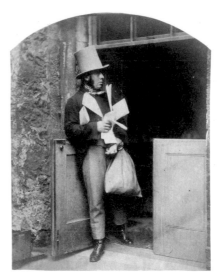

A(I): 69
Quintin Twiss in "The Two Bonnycastles," summer 1858
["Two Bonnycastles"]
352
Deanery garden, Christ Church, Oxford
No inscription
6⅝ x 5⅛ in. (17 x 13 cm)
Quintin Twiss photographed in a scene from John Maddison Morton's
farce "The Two Bonnycastles."

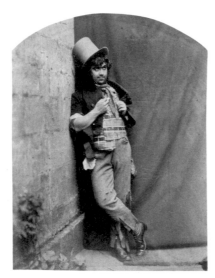

A(I): 70
Quintin Twiss as the "Artful Dodger," summer 1858
["Artful Dodger"]
350
Deanery garden, Christ Church, Oxford
No inscription
6⅝ x 5⅛ in. (17 x 13 cm)
Quintin Twiss photographed as the "Artful Dodger" in Charles Dickens's
Oliver Twist.

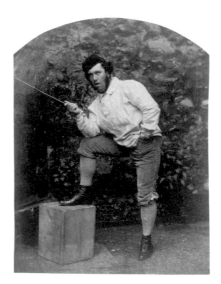

A(I): 71
Quintin Twiss in "The Country Fair," summer 1858
["Country Fair"]
353
Deanery garden, Christ Church, Oxford
No inscription
6⅝ x 5⅛ in. (17 x 13 cm)
Published in 1854, *The Country Fair; or Rural Sports and Rural Rambles* is the
theme of this photograph.

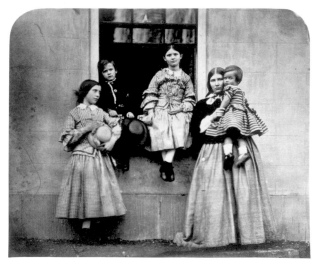

A(I): 72
Ottley Family Group, spring 1860
[Ottleys: group]
475
Richmond, Yorkshire
No inscription
5⅜ x 6½ in. (13.8 x 16.6 cm)
Lawrence Ottley (1808–1861) was rector of Richmond and canon of
Ripon. His wife, Elizabeth (1817–1902), was a sister of the bishop of
Ripon. They had sixteen children, four of whom died young. The surviving
children and their ages in 1860 are: Sarah (24), Emily (22), Alice (20),
Lawrence (17), John (15), Georgiana (13), Agnes (11), Henry (10),
Edward (8), Robert (4), Charles (2) and Herbert (1), five of whom
are pictured here.

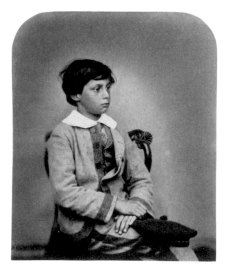

A(I): 73
Harry Liddell, summer 1859
[Liddell, Harry]
383
Twyford School, Hampshire
Inscribed in ink, below right of print: *Edward Henry Liddell*
5 x 4 in. (12.6 x 10.2 cm)
Edward Henry "Harry" Liddell (1847–1911), Alice's older brother, taken as
a pupil at Twyford School. Dodgson attempted to teach Harry arithmetic
prior to attending this school, but he was more successful in teaching him
to row a boat.

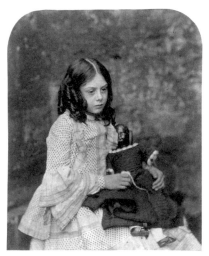

A(I): 74
Lorina Liddell with Black Doll, summer 1858
[Liddell, Ina (& black doll)]
371
Deanery garden, Christ Church, Oxford
Inscribed in ink, below right of print: *Lorina Charlotte Liddell*
5 x 4 in. (12.6 x 10.3 cm)
Lorina Liddell photographed with her black doll.

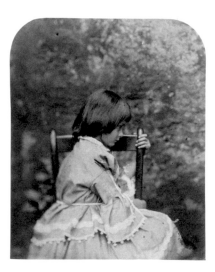

A(I): 75
Alice Liddell, summer 1858
[Liddell, Alice (profile)]
355
Deanery garden, Christ Church, Oxford
Inscribed in ink, below right of print: *Alice Pleasance Liddell*
5 x 4 in. (12.6 x 10.3 cm)
One of Dodgson's best photographs of Alice Liddell, age six.

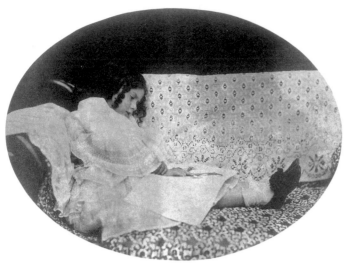

A(I): 76
Edith Liddell, summer 1858
[Liddell, Edith (& book)]
372
Deanery garden, Christ Church, Oxford
Inscribed in ink, below right of print: *Edith Mary Liddell*
4¾ x 6⅜ in. (12.3 x 16.3 cm)
Another picture of Edith Liddell in a similar pose on the same sofa, taken two years later, reveals a less contented child; see A(II): 56.

A(I): 77
Dinsdale Church, summer 1859
[Dinsdale Church]
444
Dinsdale, Yorkshire
No inscription
5⅜ x 6½ in. (13.8 x 16.6 cm)
Dinsdale Church, near Darlington, in the parish of Rev. John W. Smith. Dodgson visited the Smiths from time to time and photographed all the family.

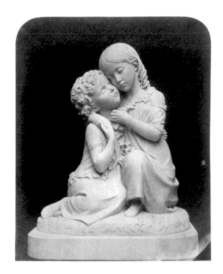

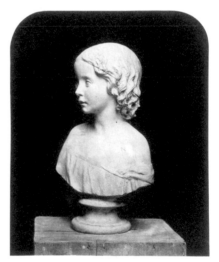

A(I): 78
The Sisters (Ida Wilson and Her Sister), Sculpture by Alexander Munro, summer 1859
[Sculp. Two children (Ida Wilson & brother {*sic*})]
411
6 Upper Belgrave Place, Pimlico
No inscription
6⅞ x 5⅝ in. (17.4 x 14.2 cm)
Munro's sculptures, many commissioned by notable people, were well executed but sentimental in composition, as in this study of the Wilson children. *The Sisters* was shown at the Royal Academy in 1857 and at the British Institution Exhibition in 1858.

A(I): 79
Bust of Ida Wilson by Alexander Munro, summer 1859
[Bust of Ida Wilson]
409
6 Upper Belgrave Place, Pimlico
No inscription
5 x 4 in. (12.6 x 10.3 cm)
The photograph against a dark background of Munro's bust of Ida Wilson is particularly effective in highlighting the contours of the sculpture.

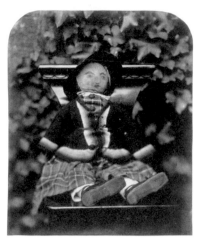

A(I): 80
Tim, the Dodgson Family Doll, April 1858
["Tim"]
344
Ripon, Yorkshire?
No inscription
5 x 4 in. (12.6 x 10.3 cm)
This unusual photograph of the Dodgson family doll named "Tim" was probably taken at Ripon during the family's residence there while the archdeacon undertook his duties as canon of the cathedral. There are no details known about the family doll apart from this photograph, taken when most of the Dodgson children were beyond the age of enjoying its company. The fact that it is a male doll is perhaps surprising.

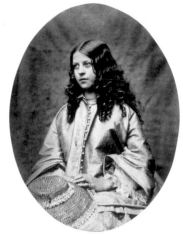

A(I): 81
Lisa Wood, August 1857
[Wood, Lisa]
271
Croft Rectory, Yorkshire?
Inscribed in ink, below right of print: *Lisa Wood. Jan.*
5 ½ x 4 ⅛ in. (14 x 10.4 cm)
Theresa "Lisa" Henrietta Charlotte Wood (b. 1844?), photographed possibly during a visit to Croft Rectory with her family. Her father, Edward Wood (1796–1874), was perpetual curate at Skelton on Ure, near Ripon, and was well known to the archdeacon. Dodgson and his father visited the Woods at Skelton on 14 January 1858, and it was on this occasion that Lisa signed her name in Dodgson's album.

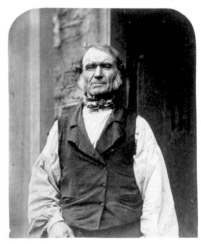

A(I): 82
Robert Foster, August 1857
[Foster, R. (1/2 length)]
284
Croft Rectory, Yorkshire
No inscription
5 ⅜ x 4 ½ in. (13.7 x 11.4 cm)
See A(I): 55

A(I): 83
Annie Coates, August 1857
[Coates, Annie]
287
Croft Rectory, Yorkshire
No inscription
5 ⅜ x 4 ½ in. (13.8 x 11.4 cm)
Annie Coates (dates unknown) was the daughter of William and Isabella Coates, poulterer and grocer at Croft. Dodgson taught Annie's brother, James, some algebra in July 1855 so that he could prepare for a pupil-teachership.

A(I): 84a
Lovers' Walk, Sculpture by Alexander Munro (back view),
summer 1859
["Lovers' Walk" (2 views)]
413
6 Upper Belgrave Place, Pimlico
No inscription
6⅝ x 5⅛ in. (16.8 x 12.9 cm)
A preliminary study for Munro's sculpture *Lover's Walk* was exhibited at
the Royal Academy in 1855. Munro completed this marble statue and
displayed it at the British Institution Exhibition in 1860, after Dodgson had
taken these two views. He clearly wanted to record as much of this sculp-
ture as possible. The back view, with arms entwined, shows a particularly
binding emotional relationship between the two figures.

A(I): 84b
Lovers' Walk, Sculpture by Alexander Munro (front view),
summer 1859
["Lovers' Walk" (2 views)]
414
6 Upper Belgrave Place, Pimlico
No inscription
6⅝ x 5⅛ in. (16.8 x 12.9 cm)
These lovers are in medieval costume, conjuring up a time, much admired
by the Victorians, when chivalry and romance were essential elements
of life.

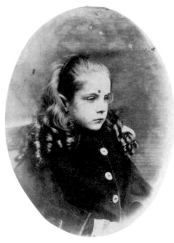

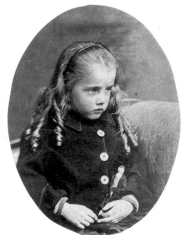

A(I): 85a
Beatrice Harington, 26 March 1858
[Harington, Beatrice]
323
Christ Church, Oxford
Inscribed in ink, below left of print: *Beatrice*
3½ x 3 in. (8.8 x 7.6 cm)
Dodgson noted on 26 March: "Mrs. Harington brought her children, and
I took several successful pictures." Dr. Richard Harington (1800–1853),
principal of Brasenose College, and his wife, Mary, had three children:
Robert "Bob" (1851–1855), Beatrice Cecilia (b. 1852?), and Alice Margaret
(1854?–1901), the latter born after the death of her father.

A(I): 85b
Margaret Harington, 26 March 1858
[Harington, Margaret]
324
Christ Church, Oxford
No inscription
3⅜ x 2⅝ in. (8.7 x 6.5 cm)
Dodgson wrote on 26 January 1858: "Called at Mrs. Harington's lodgings.
. . . She has two nice little girls, Beatrice and Margaret, 5 and 3 years old,
whose photographs I have undertaken to try when the weather is warm
enough"; and on 25 March 1858: "Called on Mrs. Harington, to ask her to
bring over the children tomorrow to be photographed."

A(I): 86
Hope, Sculpture by Alexander Munro, summer 1859
[Statuette, "Hope"]
424
6 Upper Belgrave Place, Pimlico
No inscription
6⅜ x 5⅛ in. (16.9 x 12.9 cm)
This statuette shows the Victorian taste for emotions embodied in a physical representation. Henry Holiday used the same image for Hope when illustrating Dodgson's epic nonsense poem, *The Hunting of the Snark* (1876).

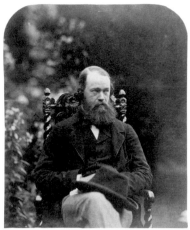

A(I): 87
Franklin Lushington, 28 September 1857
[Lushington, F. Esq.]
307
Monk Coniston Park, Ambleside
No inscription
4⅞ x 4 in. (12.5 x 10.2 cm)
Franklin Lushington (1823–1901) was a great friend of Edward Lear and became the sole executor of Lear's estate. His friendship with Alfred Tennyson grew out of his brother's marriage; Edmund Law Lushington (1811–1893) married Cecilia Tennyson, Alfred Tennyson's sister, in 1842.

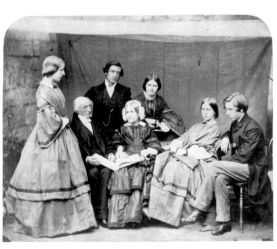

A(I): 88
Professor and Mrs. Jelf and Family, spring 1860
[Jelfs: group]
508
Christ Church, Oxford
No inscription
5⅜ x 6½ in. (13.8 x 16.6 cm)
Rev. Dr. Richard William Jelf (1798–1871), M.A., Christ Church, became a fellow of Oriel College in 1825 and was classics examiner in 1844. At the time of this photograph he was principal of King's College, London. In his role as a canon of Christ Church he also kept a house in Oxford. His wife was Emmy, Countess Schlippenbach.

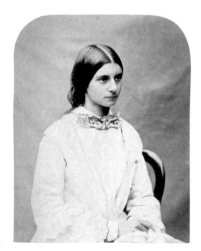

A(I): 89a
Joanna Smith, summer 1859
[Joa Smith]
442½
Dinsdale Rectory, Yorkshire
No inscription
4¼ x 3⅜ in. (10.7 x 8.3 cm)
Joanna Smith, second daughter of Rev. John W. Smith of Dinsdale (see also A[I]: 13).

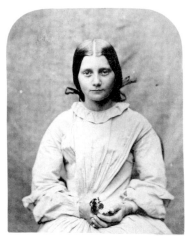

A(I): 89b
Fanny Smith, summer 1859
[Fanny Smith]
441 ⅔
Dinsdale Rectory, Yorkshire
No inscription
4 ¼ x 3 ⅜ in. (10.7 x 8.3 cm)
Fanny Smith, third daughter of Rev. John W. Smith of Dinsdale
(see also A[I]: 8b).

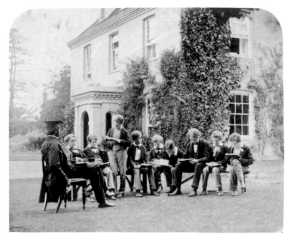

A(I): 90
Rev. George W. Kitchin and the Twyford School First Class,
summer 1859
[Kitchin, Rev. G. W., and first class]
394
Twyford School, Hampshire
No inscription
5 ⅜ x 6 ⅝ in. (13.8 x 16.7 cm)
George William Kitchin (1827–1912), M.A., Christ Church, was a tutor
for a short time before becoming headmaster of the preparatory school
at Twyford, Hampshire; in 1861 he returned to Oxford to become censor
of Christ Church. He is photographed with the first class (younger pupils)
at Twyford School.

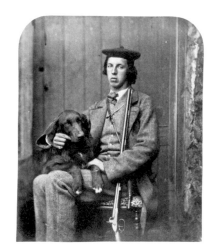

A(I): 91
Wilfred Dodgson and Dido, August 1857
[Dodgson, W. L. and Dido]
278
Croft Rectory, Yorkshire
No inscription
5 ⅜ x 4 ½ in. (13.8 x 11.4 cm)
This photograph was taken when Wilfred was nineteen. Dido was
Wilfred's gun-dog and faithful companion (see also A[I]: 12).

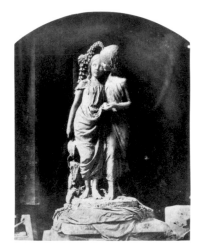

A(I): 92
Measurement by Foxglove, Sculpture by Alexander Munro,
summer 1859
[Statue in clay. Misses Gladstone {*sic*}]
410
6 Upper Belgrave Place, Pimlico
No inscription
6 ⅜ x 5 ⅛ in. (16.3 x 13 cm)
This sculpture shows Edith and Emily, the daughters of the Rt. Hon.
Gathorne Hardy (1814–1906), under-secretary at the Home Office.
Munro's sculpture was exhibited at the Royal Academy in June 1859.

A(I): 93
PHOTOGRAPH MISSING FROM ALBUM
Alice Liddell, spring 1860
[Liddell, Alice (walking)]
538
Deanery garden, Christ Church, Oxford
No inscription

A(I): 94
Wilcox Family Group, summer/autumn 1859
[Wilcoxes: group]
460
Whitburn, Tyne and Wear
No inscription
5⅜ x 6½ in. (13.8 x 16.6 cm)
The Wilcoxes of Whitburn, near Sunderland, were Dodgson's cousins—
the children of Uncle William (1801–1872) and Aunt Mary Anne Wilcox
(1812–1870). The photograph shows nine of the fourteen children (five
sons and four daughters); the last child, Dora, was born a few days after
this picture was taken. Also in the group are two other cousins, probably
children of William's brother, George Hume Wilcox (1796–1853), and
his wife, Jane. They had eleven children.

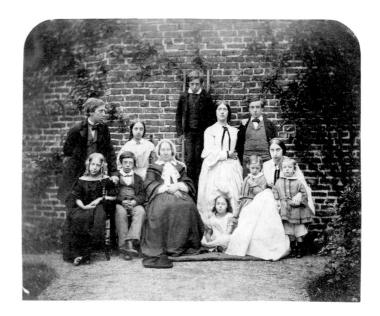

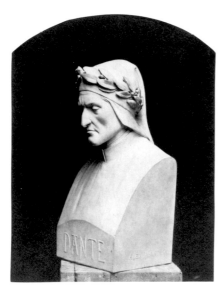

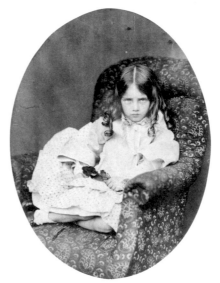

A(I): 95
Bust of Dante by Alexander Munro, summer 1859
[Bust of Dante]
412
6 Upper Belgrave Place, Pimlico
No inscription
6⅝ x 5⅛ in. (16.9 x 12.9 cm)
Munro's bust of the Italian poet Dante Alighieri (1265–1321) was
exhibited at the Royal Academy in 1856.

A(I): 96
Margaret Harington, spring 1860
[Harington, Margaret]
549
Christ Church, Oxford
No inscription
5½ x 4⅛ in. (14 x 10.4 cm)
After the death of her husband in 1853, Dodgson befriended Mrs. Haring-
ton and her two daughters. He photographed Margaret Harington in 1858
(A[I]: 85b), but this picture was taken at a later date, possibly during the
spring of 1860.

A(II): 1
PHOTOGRAPH MISSING FROM ALBUM
Prince of Wales
Inscribed in ink, below right corner of page: *Arthur A. Edward V, Frewen Hall, Oxford, December 13th 1860*
Dodgson, an ardent admirer of the royal family, received a promise that the Prince of Wales would sit for his photograph. The prince eventually declined, but he did add his signature in Dodgson's album by way of compensation.

A(II): 2
Lorina and Alice Liddell in Chinese Dress, spring 1860
[L., and A. Liddell in Chinese dress]
540
Deanery garden, Christ Church, Oxford
Inscribed in ink, left and right of print: signatures in fanciful Chinese characters in Dodgson's hand
5⅞ x 5⅛ in. (15.1 x 12.9) cm
The Victorian interest in the Orient is demonstrated in this photograph of Lorina and Alice Liddell. The genuine Chinese costumes were probably borrowed from one of the Oxford museums. Dodgson's invention of mock-Chinese names for his sitters (see page ii) is a humorous touch.

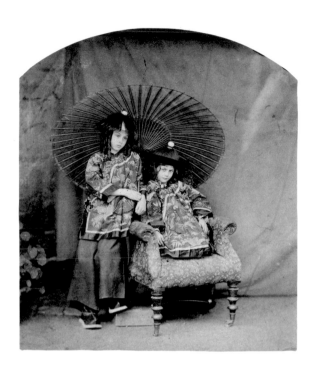

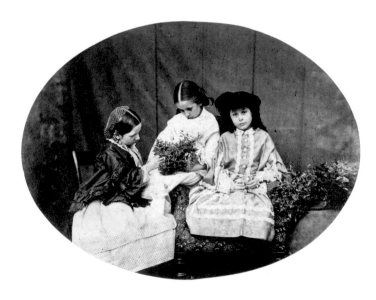

A(II): 3
PHOTOGRAPH MISSING FROM ALBUM
Daresbury Parsonage, spring 1860
[Daresbury Parsonage]
486
Daresbury, Cheshire
See P(3): 1.

A(II): 4
Alice Emily Donkin, Sarah Acland, and Lorina Liddell, spring 1860
[A. E. Donkin, S. A. Acland, and L. C. Liddell]
548
Deanery garden, Christ Church, Oxford
Inscribed in ink, with pencil guidelines for signatures barely visible:
Alice E. Donkin / Sarah Angelina / Lorina Charlotte Liddell
4¾ x 6⅜ in. (12.2 x 16.2 cm)
Alice Emily (b. 1850) was the daughter of William F. Donkin, professor of astronomy at Oxford. Sarah Angelina (1849–1930) was the daughter of Dr. Acland, professor of medicine. Lorina was the eldest daughter of Dean Liddell. Sarah Acland became a distinguished photographer in her own right and, among other distinctions, went on to become a Fellow of the Royal Photographic Society.

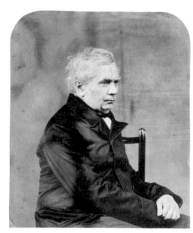

A(II): 5
Professor K. Wilhelm Dindorf, 26 June 1860
[Professor W. Dindorf]
569
Christ Church, Oxford
Inscribed in ink, below right of print: *Prof. William Dindorf / June 26, 1860*
5⅜ x 4½ in. (13.7 x 11.4 cm)
Karl Wilhelm Dindorf (1802–1883), professor of Greek, was attending
the thirtieth meeting of the British Association for the Advancement of
Science being held at the new Oxford University Museum during June
and July 1860. Dodgson took the opportunity of getting him, and many
other participants, to sit for a photograph.

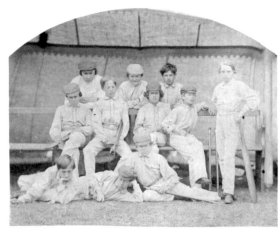

A(II): 6
Twyford School Cricket Eleven, summer 1859
[Twyford Eleven]
384
Twyford School, Hampshire
No inscription
4⅛ x 5⅛ in. (10.5 x 12.9 cm)
The "Twyford Eleven," members of the school cricket team, photo-
graphed on the veranda at Twyford School. Harry Liddell, a keen
cricketer, attended Twyford, and he may be among the group, possibly
back row far right.

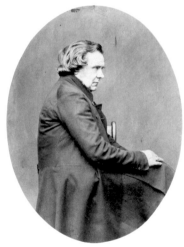

A(II): 7
Bishop Samuel Wilberforce, 28 June 1860
[Bishop of Oxford]
571
Christ Church, Oxford
Inscribed in ink, signing as bishop of Oxford: *S Oxon. June 28 1860*
6⅜ x 4¾ in. (16.2 x 12.1 cm)
Samuel Wilberforce (1805–1873), bishop of Oxford, was leading the
debate against the theory of evolution being promoted by Thomas Huxley
on behalf of Charles Darwin at the British Association's annual meeting.
Wilberforce ordained Dodgson as deacon of the Church of England in
December 1861.

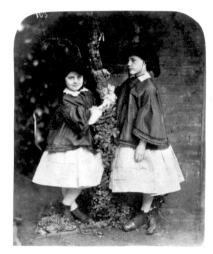

A(II): 8
F. and M. Benson, spring 1860
[F., and M. Benson]
523
Oxford?
No inscription
5⅜ x 4⅜ in. (13.8 x 11.3 cm)
This photograph of two girls, known only as F. and M. Benson, was
taken during the spring of 1860, probably at Oxford. Dodgson's diaries
for this time are missing, so it is not possible to be certain about the date
and location. Possibly the children were relatives of Rev. Richard Meux
Benson, perpetual curate of Cowley, Oxford.

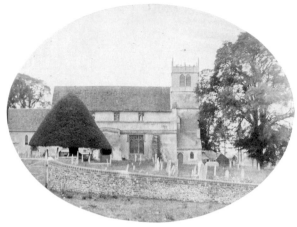

A(II): 9
Twyford Church, summer 1859
[Twyford Church]
387
Twyford, Hampshire
No inscription
4¾ x 6⅜ in. (12.3 x 16.3 cm)
Dodgson made at least two visits to Twyford, principally to visit the school
where his friend and former colleague, George Kitchin, was headmaster.
A visit in December 1857 is recorded in his diary, but it is unlikely he took
any photographs at this time. This photograph of Twyford Church was
more likely taken during his visit in the summer of 1859, but this cannot be
confirmed since his diary is missing.

A(II): 10
Benjamin Woodward, 4 July 1860
[B. Woodward, Esq.]
599
Christ Church, Oxford
No inscription
6⅝ x 5⅛ in. (16.9 x 12.9 cm)
Benjamin Woodward (1816–1861) was the architect of the new Gothic-
style Oxford University Museum, originally proposed by Dr. Acland in
1849 and strongly supported by John Ruskin. Tennyson described the
building, completed in 1860, as "perfectly indecent." Woodward, who
was in serious ill health, died the following year.

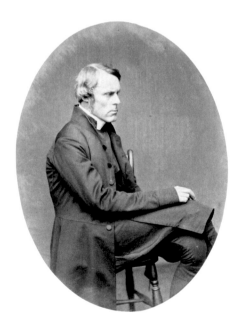

A(II): 11
Bishop John Jackson, 28 June 1860
[Bishop of Lincoln]
572
Christ Church, Oxford
Inscribed in ink, signing as bishop of Lincoln, below right of print:
John Lincoln / Jun 28, 1860
6½ x 4¾ in. (16.4 x 12.2 cm)
John Jackson (1811–1885), bishop of Lincoln (later bishop of London),
was educated at Pembroke College, Oxford, taking his first class honors
degree in 1833 at the same time as Dean Liddell. Jackson wrote to Dodg-
son on 28 September 1860: "I am very much obliged for the photographs
I have just received. I think the Bishop of Oxford and the Archdeacon
excellent: but I cannot, of course, judge of my own profile" (MS. Dodgson
Family Collection).

A(II): 12
PHOTOGRAPH MISSING FROM ALBUM
Whitby, summer 1860
[Whitby]
630½
Whitby, Yorkshire
See P(3): 15.

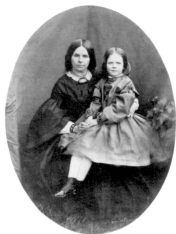

A(II): 13
Mrs. Letitia Barry and Louisa, summer 1860
[Mrs. Barry and Loui]
623
Whitby, Yorkshire
No inscription
5½ x 4⅛ in. (14 x 10.4 cm)
Mrs. Letitia Anna Barry (1824–1911) and her daughter, Louisa "Loui"
Dorothy (b. 1852), were photographed during Dodgson's visit to Whitby
in 1860. Mrs. Barry was the widow of Rev. John Barry (1819–1856), who
had been rector of Great Smeaton, Yorkshire, from 1848 until his death.
Archdeacon Dodgson officiated at Barry's funeral.

A(II): 14
Walton Hall, Near Warrington, spring 1860
[Walton Hall]
493
Walton Hall, near Warrington, Cheshire
No inscription
5⅜ x 6½ in. (13.7 x 16.6 cm)
Walton Hall, the seat of the Greenall family, is not far from Dodgson's
birthplace at Daresbury, and he photographed it during his pilgrimage
to the places of his youth in the spring of 1860. The building survives;
part of it is a museum open to the public.

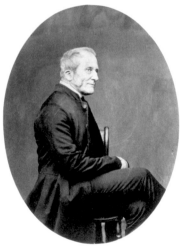

A(II): 15
Archdeacon James Randall, 28 June 1860
[Ven. Archdeacon Randall]
573
Christ Church, Oxford
Inscribed in ink, below right of print: *James Randall / Archdeacon of Berks. /
28 June, 1860*
6⅜ x 4¾ in. (16.3 x 12.2 cm)
The Ven. Archdeacon James Randall (1790–1878?), M.A., Trinity College,
Oxford, was a fellow at his college, and later chaplain to the bishop of
Oxford (1846) before becoming archdeacon of Berkshire in 1855.

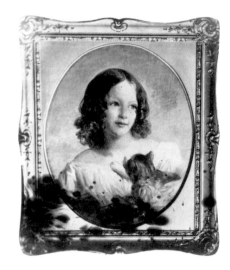

A(II): 16
Oil Painting of Rosamond Longley, summer/autumn 1859
[Oil-painting of R. Longley]
457
Auckland Castle, Durham
No inscription
4⅞ x 4⅜ in. (12.5 x 10.8 cm)
Dodgson photographed the oil painting of Rosamond Longley, daughter
of Bishop Longley, at the Bishop's Palace; see A(I): 61.

A(II): 17
Bust of Giuseppe Mazzini by Alexander Munro, summer 1859
[Bust of Mazzini]
418
6 Upper Belgrave Place, Pimlico
No inscription
6⅝ x 5⅛ in. (16.7 x 12.9 cm)
Munro's bust of Giuseppe Mazzini (1805–1872), Italian patriot and agitator who was forced to reside for a time in London, was photographed by Dodgson at the sculptor's studio. Munro was friendly with Mazzini during the latter's London sojourn, and this bust was made in March 1857.

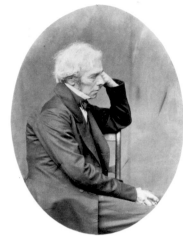

A(II): 18
Professor Michael Faraday, 30 June 1860
[Professor Faraday]
574
Christ Church, Oxford
Inscribed in ink below print: *M Faraday 30 June 1860*
5½ x 4 in. (13.9 x 10.3 cm)
Professor Michael Faraday (1791–1867), scientist and former vice-president of the British Association (1854), was photographed during the time he attended the association's meeting.

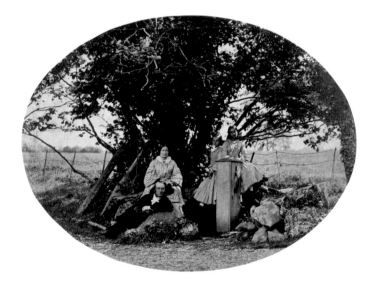

A(II): 19
Dinsdale Rectory Garden, summer 1859
[Dinsdale Rectory garden]
444½
Dinsdale Rectory, Yorkshire
No inscription
4¾ x 6⅜ in. (12.2 x 16.3 cm)
The four figures are possibly the rector, Rev. John W. Smith, his wife, and two of his four daughters, Maria, Joanna, Fanny, and Anne Smith; see A(I): 7, 8a, 8b, 9a, and 13.

A(II): 20
PHOTOGRAPH MISSING FROM ALBUM
Alice Liddell, May or June 1860
[Alice P. Liddell and wreath]
561
Deanery garden, Christ Church, Oxford
Inscribed on facing page in ink: *There's many a black black eye, they say, but none so bright as mine; / There's Margaret and Mary, there's Kate and Caroline: / But none so fair as little Alice in all the land they say, / So I'm to be Queen o' the May, mother, I'm to be Queen o' the May.*
This portrait of Alice Liddell wearing a wreath of flowers survives elsewhere (P[3]: 5) but is missing from this album. The verse is probably an original composition by Dodgson.

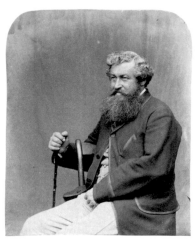

A(II): 21
John Petherick, 29 June 1860
[J. Petherick, Esq.]
577
Christ Church, Oxford
Inscribed in ink, below right of print: *John Petherick June 29th 1860*
5⅜ x 4⅜ in. (13.8 x 11.3 cm)
John Petherick (d. 1882) is recorded in the Foreign Office List (1914) as a former British consul. Otherwise, few details are known about him. He was no doubt attending the British Association meeting at this time.

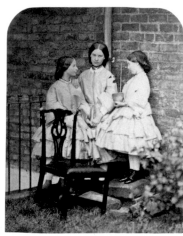

A(II): 22
Florence, Agnes, and Laura Bainbridge, summer 1860
[F., C., and L. Bainbridge]
628
Whitby, Yorkshire
No inscription
4⅞ x 3⅞ in. (12.5 x 9.8 cm)
Florence Hilda (b. 1847), Agnes Constance (b. 1850), and Laura (b. 1854) were the daughters of Henry and Mary Bainbridge. Dodgson became friendly with the family during the Oxford University mathematics summer school spent at Whitby in 1854, and he visited them in later years whenever he was back at Whitby.

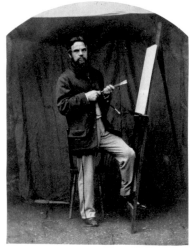

A(II): 23
William Holman Hunt, 30 June 1860
[W. Holman Hunt, Esq.]
576
Christ Church, Oxford
Inscribed in ink underneath print at right, *W. Holman Hunt June 30/60*
6⅝ x 5⅛ in. (16.9 x 12.9 cm)
William Holman Hunt (1827–1910), artist and founding member of the Pre-Raphaelite Brotherhood in 1848, photographed during the British Association meeting.

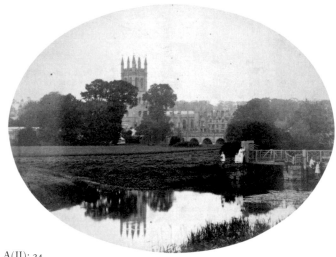

A(II): 24
Magdalen Tower, summer 1861
[Magdalen Tower]
721
Oxford
No inscription
5⅝ x 7⅜ in. (14.2 x 18.8 cm)
The landscape with Magdalen Tower photographed from Christ Church includes some children and a woman holding a small child. Dodgson probably knew these people, since they cooperated with his composition and remained motionless while the photograph was taken.

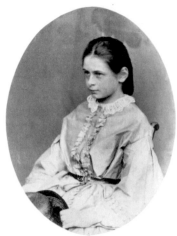

A(II): 25
Miss Fellowes, May/June 1860
[Miss Fellows (*sic*)]
562
Deanery garden, Christ Church, Oxford
No inscription
5½ x 4⅛ in. (14 x 10.4 cm)
Miss Fellowes, possibly Pleasance Susan (b. 1846?), a cousin of the Liddell sisters.

A(II): 26
Canon John A. Bolster, 30 June 1860
[Rev. Canon Bolster]
578
Christ Church, Oxford
Inscribed in ink, below right of print: *John A. Bolster / Prebry Cork / June 30 —1860*
5½ x 4⅛ in. (13.9 x 10.4 cm)
Rev. Canon John Abraham Bolster (dates unknown), prebendary of Cork, incumbent of Killaspugmallane, Glanmire, photographed at the British Association meeting. He was educated at Trinity College, Dublin, taking his degree in 1826, but was incorporated "ad eundem" (with existing qualifications) into Oxford University in 1853.

A(II): 27
Twyford Schoolhouse, summer 1859
[Twyford school-house]
389
Twyford School, Hampshire
No inscription
4¼ x 5⅛ in. (10.6 x 13 cm)
Twyford Schoolhouse showing the headmaster, George Kitchin, and three of his pupils in the doorway; see A(I): 90.

A(II): 28
Thomas Combe, 30 June 1860?
[T. Combe, Esq.]
606
Christ Church, Oxford
Inscribed in ink, below right of print: *Th. Combe / 30 June 60*
5⅜ x 4½ in. (13.8 x 11.4 cm)
Thomas Combe (1797–1872), printer to Oxford University and director of the Clarendon Press, was an enthusiastic supporter and collector of the Pre-Raphaelite artists' pictures. Holman Hunt's *Light of the World* was painted at Combe's home in Oxford and later purchased by him. Dodgson became a frequent visitor to Combe's home to see his collection of pictures.

A(II): 29

Rev. Henry B. Tristram, 2 July 1860

[H. B. Tristram, Esq.]

580

Christ Church, Oxford

Inscribed in ink, below right corner of print: *H.ʸ B. Tristram. / Castle Eden. / 2 July 1860*

4⅞ x 4 in. (12.5 x 10.3 cm)

Rev. Henry Baker Tristram (1822–1906), M.A., rector of Castle Eden, Durham, went on to become a canon of Durham Cathedral. Evidence suggests that he was tutor to two of Dodgson's brothers, Skeffington and Wilfred, before they went to university. He traveled in Palestine during 1863–64 and wrote a number of books about his journeys.

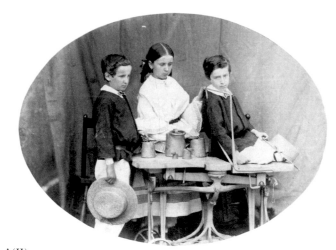

A(II): 30

Sarah, Henry, and Theodore Acland, July 1860

[Aclands and scales]

608

Deanery garden, Christ Church, Oxford

No inscription

4¾ x 6⅜ in. (12.3 x 16.3 cm)

Sarah Acland with two of her brothers, Henry Dyke (1850–1936) and Theodore Dyke (1851–1931), with a set of weighing scales. They were the children of Dr. Acland and his wife, Sarah; see A(II): 4.

A(II): 31

Miss Cole, summer/autumn 1859

[Miss Cole]

454

Auckland Castle, Durham

No inscription

5 x 4 in. (12.6 x 10.3 cm)

Miss Cole, for whom no details are known, was probably related to the third earl of Enniskillen, William Willoughby Cole (1807–1886). The earl was photographed by Dodgson (A[II]: 41). She was clearly linked with Bishop Longley and his family since she was photographed at his residence.

A(II): 32

Rev. Henry Gough, autumn 1860

[Mr. Gough]

668

Christ Church, Oxford

No inscription

5½ x 4⅛ in. (13.9 x 10.4 cm)

Rev. Henry Gough (1812–1862), M.A., Queen's College, Oxford, was a fellow at his college from 1846 to 1856. He became rector of Charlton-on-Otmoor in 1855 and served until his death in 1862.

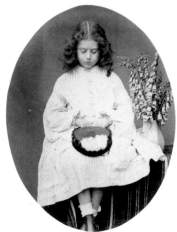

A(II): 33
Edith Liddell, July 1860
[Edith M. Liddell]
616
Deanery garden, Christ Church, Oxford
Inscribed in ink, below right of print, signature set between parallel pencil guidelines to give proper consistent height to lower-case letters: *Edith Mary Liddell*
5½ x 4⅜ in. (14 x 11 cm)
Edith Liddell is perched on a table with a spray of foxgloves. This photograph is a pair to Dodgson's picture of Alice with ferns, taken at the same time, with Alice seated on the same table (A[II]: 53).

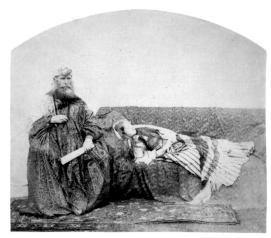

A(II): 34
Col. Skeffington Poole and Daughter, 1–11 September 1862
["The Sultan's Daughter"]
865
Park Lodge, Putney
No inscription
6⅛ x 7 in. (15.5 x 17.7 cm)
Dodgson's uncle, Colonel Skeffington Poole (1803–1876), plays the part of the sultan, and one of his daughters, either Margaret "Meta" Frances (b. 1842) or Alice Henrietta (b. 1844), plays "The Sultan's Daughter." Col. Poole served with the Honourable East India Company (HEIC) for thirty years. In 1840 he married Isabella Hume (1812–1873), sister of the wife of Dodgson's Uncle Hassard.

A(II): 35
Richmond Church, spring 1860
[Richmond Church]
478
Richmond, Yorkshire
No inscription
5⅜ x 6¾ in. (13.5 x 17.2 cm)
See A(I): 46.

A(II): 36
C. Orde, summer 1859
[C. Orde, Esq.]
431
Croft, Yorkshire?
No inscription
5⅜ x 4⅛ in. (13.8 x 10.4 cm)
There were two Orde brothers at Durham School. Henry Paulett Shafto Orde (b. 1838) and William Jocelyn Shafto Orde (1836–1871). Both were school friends of Gordon Salmon (b. 1833), who was, at this time, curate at Croft. One of them may have been visiting Croft Rectory. Dodgson was uncertain about Orde's first name and omitted it in his *List of Photographs* (1860).

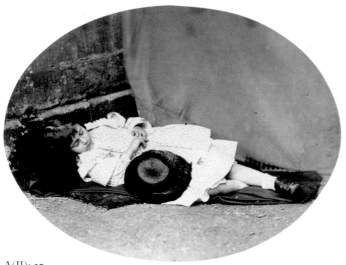

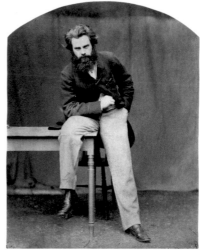

A(II): 37
Alice Liddell, spring 1860
[Alice P. Liddell (asleep)]
537
Deanery garden, Christ Church, Oxford
Inscribed in ink, below print: *Alice Pleasance Liddell*
3⅝ x 4⅞ in. (9.4 x 12.5 cm)
Alice Liddell is lying on a blanket in the Deanery garden feigning sleep.
She enjoyed the process of having her photograph taken, unlike her sisters.
As a result, there are more solo pictures of her than of other members of
her family.

A(II): 38
Thomas Woolner, 2 July 1860
[T. Woolner, Esq: Sculptor]
584
Christ Church, Oxford
Inscribed in ink, below right of print: *Thomas Woolner / July 2. 1860*
6⅝ x 5⅛ in. (16.8 x 12.9 cm)
Thomas Woolner (1825–1892), sculptor, gave Dodgson advice about the
publication of *Alice's Adventures in Wonderland,* encouraging him to find
a professional artist to illustrate the book. In Woolner's opinion, Dodgson's
own attempts to draw on wood were deficient. Dodgson took Woolner's
advice and commissioned John Tenniel to be his illustrator.

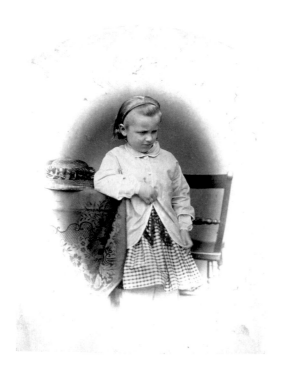

A(II): 39
Mary Bowlby, July 1860
[Mary Bowlby]
609
Deanery garden, Christ Church, Oxford
No inscription
6⅝ x 5⅛ in. (16.8 x 12.9 cm)
Mary Bowlby (b. 1854) was the eldest daughter of Henry Bond Bowlby
(b. 1824), M.A., Wadham College, Oxford, perpetual curate of Oldbury,
Worcestershire.

A(II): 40
PHOTOGRAPH MISSING FROM ALBUM
Daresbury Parsonage, spring 1860
[Daresbury Parsonage (distant)]
488
Daresbury, Cheshire
Dodgson's photograph of Daresbury Parsonage taken from the end of
Morphany Lane, Daresbury, Cheshire, survives elsewhere (P[3]: 19).

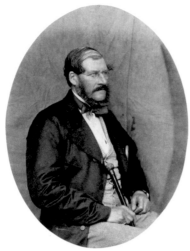

A(II): 41
Earl of Enniskillen, 3 July 1860
[Lord Enniskillen]
588
Christ Church, Oxford
Inscribed in ink, below right of print: *Enniskillen / July 3rd 1860*
5 ½ x 4 ⅛ in. (13.9 x 10.4 cm)
William Willoughby Cole, third earl of Enniskillen (1807–1886), was attending the British Association meeting. He was a former vice-president of the association (1852).

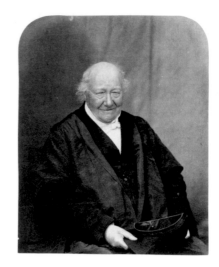

A(II): 42
Rev. Herbert Randolph, 3 July 1860
[Rev. H. Randolph]
589
Christ Church, Oxford
Inscribed in ink, below right of print: *Herbert Randolph MA / Late Student of Christ Church, Oxford / now / Vicar of Marcham with Garford, Berks. / July 3rd / 1860*
4 ⅞ x 3 ⅞ in. (12.5 x 9.8 cm)
Rev. Herbert Randolph (1789–1875), M.A., Christ Church, Oxford, was vicar of Marcham, Berkshire, from 1819. He was attending the British Association meeting.

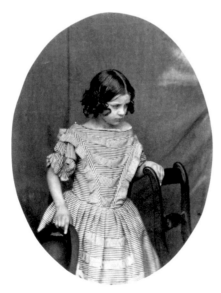

A(II): 43
Blencoe Brooks, July 1860
[Blencoe Brooks]
604
Christ Church, Oxford
No inscription
5 ½ x 4 ⅛ in. (13.9 x 10.4 cm)
No details of Blencoe Brooks are known. She was possibly the daughter of a clergyman visiting Oxford for the British Association meeting.

A(II): 44
Deanery Garden, May/June 1860
[Ch. Ch. Deanery]
564
Deanery garden, Christ Church, Oxford
No inscription
6 ⅝ x 8 in. (16.8 x 20.2 cm)
Seated on a grassy bank in front of the Deanery, the three Liddell sisters hold croquet mallets with croquet balls at their feet. Croquet was to feature in *Alice's Adventures in Wonderland,* but the croquet mallets became flamingos and the croquet balls, hedgehogs.

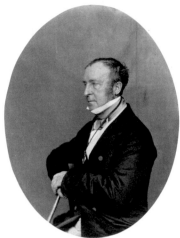

A(II): 45
Sir Roderick I. Murchison, 4 July 1860
[Sir R. I. Murchison]
596
Christ Church, Oxford
Inscribed in ink, below right of print: *Rod I. Murchison / July 4 1860*
5½ x 4⅛ in. (13.9 x 10.4 cm)
Sir Roderick Impey Murchison (1792–1871), geologist, was attending the British Association meeting. He was a former vice-president of the association (1856 and 1859).

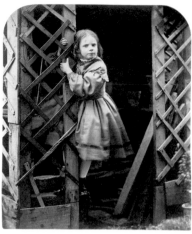

A(II): 46
Louisa Barry, summer 1860
[Louisa Barry]
622
Whitby, Yorkshire
Inscribed in ink, on pasted-down slip set between guidelines for signature:
Louisa D. Barry
5⅜ x 4½ in. (13.8 x 11.4 cm)
Louisa Barry, daughter of one of Dodgson's Whitby friends; see A(II): 13.

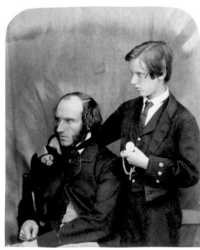

A(II): 47
James Park Harrison and His Son, Matthew J. Harrison,
5 July 1860
[J. Park Harrison, Esq. and son]
601
Christ Church, Oxford
Inscribed in ink, below right of print: *J. Park Harrison / M. J. Harrison R.N. / July 5th 1860*
5⅜ x 4½ in. (13.8 x 11.4 cm)
James Park Harrison (1817–1901), M.A., Christ Church, and his son, Matthew (b. 1847), were attending the British Association meeting. A renowned architect, archaeologist, and church restorer, James Park Harrison reassembled the broken shrine to Saint Frideswide in Oxford Cathedral. Matthew pursued a career in the Royal Navy, becoming lieutenant and coastguard inspector at Sheppey, Kent.

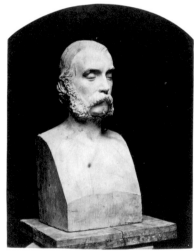

A(II): 48
Bust of Saffi by Alexander Munro, summer 1859
[Bust of Saffi]
417
6 Upper Belgrave Place, Pimlico
No inscription
6⅜ x 5⅛ in. (16.9 x 12.9 cm)
This sculpture of Aurelio Saffi was made by Alexander Munro in the late 1850s.

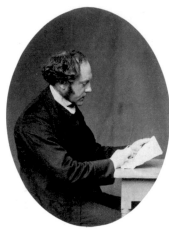

A(II): 49
Rev. John Slatter, 2 July 1860
[Rev. J. Slatter]
582
Christ Church, Oxford
Inscribed in ink, below right of print: *John Slatter / Dec͏ʳ 15. 1860*
5½ x 4¾ in. (13.9 x 12.3 cm)
Rev. John Slatter (1817–1899), M.A., Lincoln College, Oxford, lived at Rose Hill, near Oxford, and was perpetual curate at Sandford-on-Thames from 1852 to 1861. Later he became vicar of Streatley, Reading. The signature was added on a visit to the Slatters in December 1860. Dodgson was a frequent visitor and family friend.

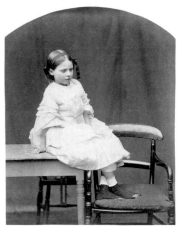

A(II): 50
Bessie Slatter, 2 July 1860
[Bessie Slatter. 1860]
583
Christ Church, Oxford
Inscribed in ink, below right of print: *Bessie Slatter / Dec: 15. 1860*
6⅝ x 5⅛ in. (16.8 x 12.9 cm)
Elizabeth "Bessie" Ann Slatter (b. 1854), daughter of Rev. John Slatter, remained a lifelong friend of Dodgson, receiving inscribed copies of his published books.

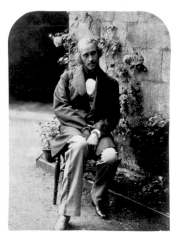

A(II): 51
Benjamin Woodward, 4 July 1860
[B. Woodward, Esq: Architect]
598
Christ Church, Oxford
Inscribed in ink, below right of print: *Benjm. Woodward / July 4 1860*
5⅜ x 4 in. (13.8 x 10.3 cm)
Benjamin Woodward, partner in the Dublin firm of Deane and Woodward, architects of the University Museum, Oxford, built between 1855 and 1860; see A(II): 10.

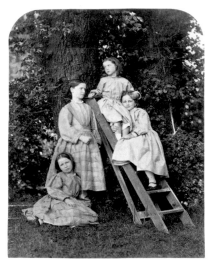

A(II): 52
Margaret, Mary, Lilian, and Ethel Brodie, 21 June 1861
[Brodies and step-ladder]
710
Oxford
No inscription
4⅞ x 3⅞ in. (12.5 x 9.9 cm)
Margaret Anne (b. 1850) standing, Mary Isabel (b. 1858) positioned above, Lilian (1853–1916) below on ladder, and Ethel (1856–1926) on grass were four of the five daughters of Sir Benjamin Collins Brodie (1817–1880), Waynflete Professor of Chemistry, and his wife, Philothea. The missing second daughter was Ida Philothea (1852–1917). A son, Benjamin Vincent Sellons (1862–1938), was born the following year.

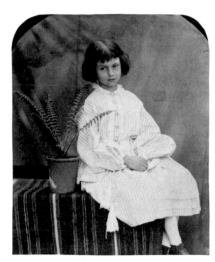

A(II): 53
Alice Liddell, July 1860
[Alice P. Liddell and fern]
613
Deanery garden, Christ Church, Oxford
Inscribed in ink, below right of print: *Alice*
5⅜ x 4½ in. (13.8 x 11.4 cm)
Part of this photograph of Alice Liddell with ferns was used on the last page of the manuscript *Alice's Adventures Under Ground,* presented to Alice as a Christmas gift in 1864. A small oval close-up of Alice's face was cut out and pasted over a sketch of Alice made by Dodgson, probably indicating that he was not satisfied with his own drawing.

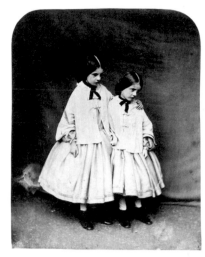

A(II): 54
Beatrice and Margaret Harington, autumn 1860
[B., and M. Harington]
667
Christ Church, Oxford
Inscribed in ink, below left and right of print: *Beatrice C. Harington / Alice M. Harington / Dec 20/60*
8⅝ x 6⅞ in. (22 x 17.5 cm)
Beatrice and Margaret Harington; see A(I): 85a and 85b.

A(II): 55
Rev. Robert B. Mayor, 30 June 1860
[Rev. R. Mayor]
579
Christ Church, Oxford
No inscription
5⅜ x 4½ in. (13.8 x 11.4 cm)
When Rev. Robert Bickersteth Mayor (1820–1898) was a master at Rugby School he taught Dodgson mathematics. In a letter to Archdeacon Dodgson, while his son was attending Rugby School, Mayor wrote: "I have not had a more promising boy at his age since I came to Rugby."

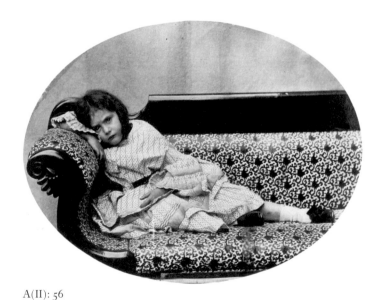

A(II): 56
Edith Liddell, spring 1860
[Edith M. Liddell (on sofa)]
543
Deanery garden, Christ Church, Oxford
Inscribed in ink, below right of print: *Edith Mary Liddell. Dec 19. 1860*
4⅛ x 5 in. (10.5 x 12.7 cm)
Two photographs of Edith Liddell were taken on this sofa, two years apart; see A(I): 76.

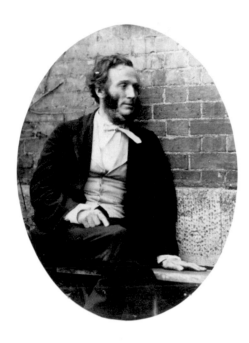

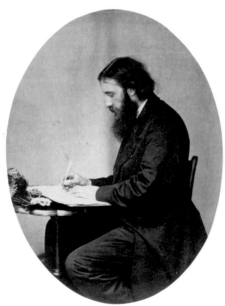

A(II): 57
Professor Benjamin C. Brodie, 21 June 1861
[Professor Brodie]
704
Oxford
Inscribed in ink, below right of print: *B.C. Brodie / December 9 1861*
5½ x 4⅛ in. (14 x 10.4 cm)
Professor Benjamin Collins Brodie; see A(II): 52.

A(II): 58
PHOTOGRAPH MISSING FROM ALBUM
Statuette of Annie Rogers, June 1861?
[Annie Rogers (statuette) (crossed out)]
678–733
Annie Mary Ann Henley Rogers (1856–1937) was the daughter of
Professor James Edwin Thorold Rogers (1822–1890), Drummond
Professor of Political Economy at Oxford.

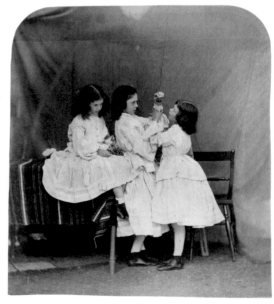

A(II): 59
George MacDonald, 27 July 1863
[MacDonald, G. Esq. (writing)]
1003
Elm Lodge, Hampstead
Inscribed in ink, below print, address on left, name and date on right:
George MacDonald / July 27, 1863 / Elm Lodge, Hampstead
6½ x 4¾ in. (16.4 x 12.2 cm)
George MacDonald (1824–1905), novelist and poet, suffered a slight
speech hesitation, a complaint shared by Dodgson. They met in Hastings
while consulting the same speech therapist and became great friends.
Dodgson's friendship with the MacDonald family continued for many
years, and he was a frequent visitor to their various homes.

A(II): 60
Edith, Lorina, and Alice Liddell in "Open Your Mouth and
Shut Your Eyes," July 1860
["Open your mouth, and shut your eyes."]
611
Deanery garden, Christ Church, Oxford
Inscribed in ink, below print: *"Open your mouth, & shut your eyes"—Lorina,
Alice, Edith*
7½ x 6⅞ in. (19.1 x 17.5 cm)
Edith, Lorina, and Alice Liddell (left to right) eating cherries. Alice holds
Lorina's wrist to help steady the arm holding the cherries.

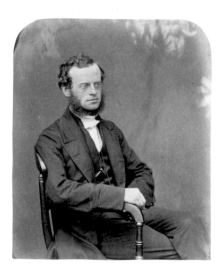

A(II): 61
Rev. William H. Ranken, 2 or 3 July 1860
[Rev. W. H. Ranken]
585
Christ Church, Oxford
No inscription
5⅜ x 4½ in. (13.8 x 11.4 cm)
Rev. William Henry Ranken (1832–1920), M.A., Corpus Christi College, Oxford, was with Dodgson at the university mathematics summer school at Whitby in 1854 preparing for their finals. They remained good friends. Ranken became a fellow at Corpus Christi College from 1862 to 1869 and was also vicar of Sandford-on-Thames.

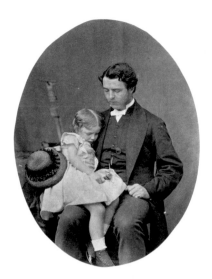

A(II): 62
Rev. Robert I. Salmon and Frances Bowlby, July 1860
[Rev. R. Salmon and F. Bowlby]
610
Deanery garden, Christ Church, Oxford
No inscription
5½ x 4⅛ in. (14 x 10.4 cm)
Rev. Robert Ingham Salmon (b. 1835), M.A., Exeter College, Oxford, held various curacies between 1861 and 1875 and was curate at Croft for a time. Eleanora Frances Bowlby (b. 1858) was the daughter of Henry Bowlby and the sister of Mary.

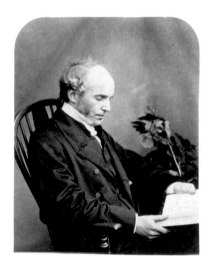

A(II): 63
Rev. William Keane, summer 1860
[Rev. W. Keane]
624
Whitby, Yorkshire
Inscribed in ink, below right of print: *Wm. Keane / 1860*
4⅞ x 3⅞ in. (12.5 x 9.8 cm)
Rev. William Keane (1818–1873), M.A., Emmanuel College, Cambridge, was perpetual curate, and later rector, of St. Mary's, Whitby. Dodgson met the Keane family during his various visits to Whitby. Keane traveled widely and was for a time canon of St. Paul's Cathedral, Calcutta, and assistant secretary to the Missionary Society, before settling at Whitby.

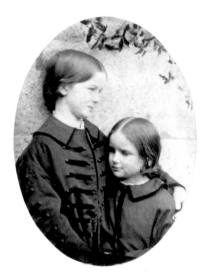

A(II): 64
Margaret and Lilian Brodie, autumn 1860
[M., and L. Brodie. 1860]
676
Oxford
Inscribed in ink, below left and right of print: *Margaret Anne Brodie / Lilian Brodie / Dec: 20 1860*
5⅞ x 4⅜ in. (15.1 x 11.1 cm)
Margaret and Lilian Brodie; see A(II): 52.

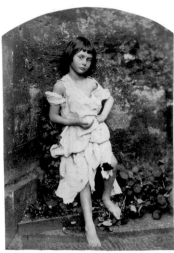

A(II): 65
Alice Liddell as "The Beggar-Maid," summer 1858
["The Beggar-Maid"]
354
Deanery garden, Christ Church, Oxford
No inscription
6⅝ x 4⅝ in. (16.8 x 11.6 cm)
Dodgson's most famous photograph of Alice Liddell as "The Beggar-Maid" is in sharp contrast to his paired picture of Alice posed in a similar position, taken on the same day, in her finest dress (see plate 45). Beggar children were commonplace in major cities during the Victorian era and were the cause of great concern to social reformers.

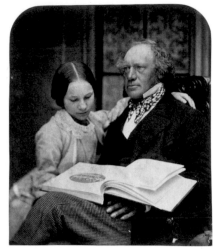

A(II): 66
James G. Marshall and Julia, 28 September 1857
[J. Marshall, Esq. and daughter]
308
Monk Coniston Park, Ambleside
No inscription
5⅜ x 4⅜ in. (13.7 x 11.3 cm)
James Garth Marshall (1802–1873), the rich industrialist of Headingley House, Leeds, and Monk Coniston Park, Ambleside, with his daughter, Julia Mary Garth Marshall (1845–1907). Marshall also owned Tent Lodge, about a mile away from Monk Coniston Park, which he lent to the Tennysons during their stay in the Lake District in 1857.

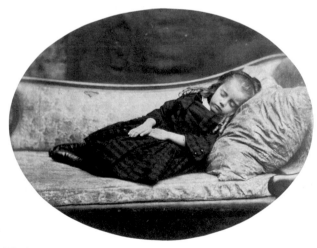

A(II): 67
Margaret Harington, 26 March 1858
[Margaret Harington (on sofa)]
326
Christ Church, Oxford
Inscribed in ink, below right of print: *Alice Margaret Harington*
4⅜ x 5⅞ in. (11.2 x 14.9 cm)
Dodgson wrote on 25 March 1858: "Called on Mrs. Harington, to ask her to bring over the children tomorrow to be photographed," the children being Beatrice and Margaret. He noted the following day: "Mrs. Harington brought her children, and I took several successful pictures"; see A(I): 85a and 85b.

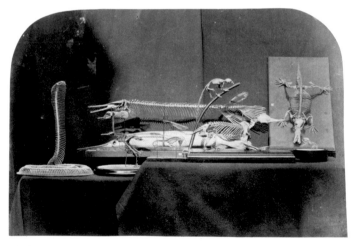

A(II): 68
Skeletons of Fish, Etc., June 1857
[Skeletons of fish, &c.]
221
Anatomical Museum, Christ Church, Oxford
No inscription
3⅝ x 5½ in. (9.3 x 13.9 cm)
Dodgson recorded that these skeletons were prepared from fish (probably pike) caught in the River Cherwell, which runs along one of the boundaries of Christ Church meadow. Other skeletons in this arrangement include a cobra and possibly a squirrel.

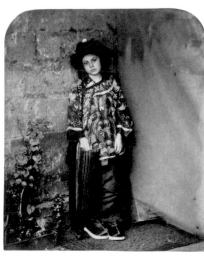

A(II): 69
Lorina Liddell, spring 1860
[L. C. Liddell in Chinese dress]
539
Deanery garden, Christ Church, Oxford
Inscribed in ink, right of print: signature in mock Chinese characters in
Dodgson's hand
5⅜ x 4½ in. (13.7 x 11.4 cm)
Lorina is dressed in an original Chinese costume probably borrowed from
one of the Oxford Museums. Dodgson added an accompanying mock
Chinese inscription similar to the two he concocted for A(II): 2.

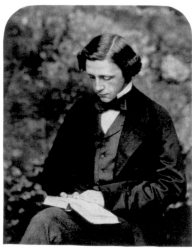

A(II): 70
Charles L. Dodgson, 2 June 1857
[C. L. Dodgson]
235
Deanery garden, Christ Church, Oxford
No inscription
4⅞ x 3⅞ in. (12.5 x 9.8 cm)
Dodgson was assisted in this self-portrait by Lorina Liddell. He noted
in his journal for 2 June 1857: "To try the lens, I took a picture of myself,
for which Ina took off the cap, and of course considered it all her doing!"

A(II): 71
Mary MacDonald, 25–31 July 1863
[Mary MacDonald]
1025
Elm Lodge, Hampstead
Inscribed in ink, below right of print: *Mary Josephine MacDonald*
4⅛ x 5⅜ in. (10.5 x 13.8 cm)
Dodgson spent a week at the home of the MacDonalds taking photo-
graphs every day, including this one of Mary Josephine MacDonald
(1853–1878) asleep. Mary was the second of George MacDonald's
eleven children.

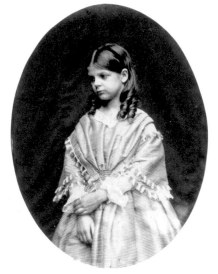

A(II): 72
Agnes Weld, 18 August 1857
[Agnes G. Weld]
274?
Croft Rectory, Yorkshire
Inscribed in ink, below right of print: *Agnes Grace Weld*
5½ x 4⅛ in. (14 x 10.4 cm)
"A party came down from the Castle to be photographed, consisting of . . .
Mrs. Weld and her little girl Agnes Grace; the last being the principal
object. Mrs. Weld is sister-in-law to Alfred Tennyson (I presume sister
of Mrs. Tennyson)," wrote Dodgson on 18 August 1857. The "principal
object" was Agnes Grace Weld (1849–1915).

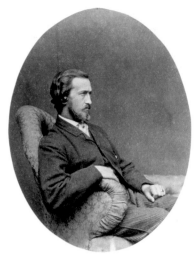

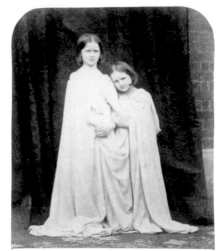

A(II): 73
Rev. Francis H. Atkinson, 29 June 1862
[F. H. Atkinson, Esq.]
751
Christ Church, Oxford
Inscribed in ink, below right of print: *F. H. Atkinson / June 29. 1862*
5½ x 4⅛ in. (14 x 10.4 cm)
Francis Home Atkinson (1840–1901), M.A., Caius College, Cambridge, of Morland Hall, Westmorland, became a private tutor to the Tennyson children. In 1880, he was made curate of St. Paul's, Jersey, and later All Souls, Jersey.

A(II): 74
Margaret and Lilian Brodie, 21 June 1861
[Μαργαρίς Λείρινη (Greek inscription for "Margaret and Lilian")]
716
Oxford
Inscribed in ink, below left and right of print: inscription Μαργαρίς Λείρινη
5⅜ x 4½ in. (13.8 x 11.4 cm)
Two of the Brodie sisters (A[II]: 52), Margaret and Lilian, with their names written by Dodgson as a caption in Greek. In the picture, Dodgson imitates Greek sculpture in the use of flowing white material draped around the children.

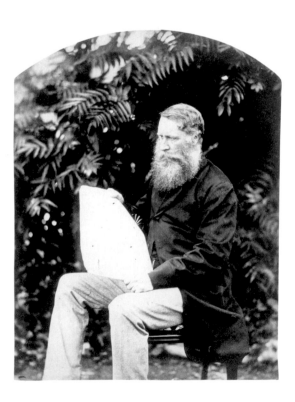

A(II): 75
Colonel Skeffington Poole, 1–11 September 1862
[Colonel Poole]
866
Park Lodge, Putney
Inscribed in ink, below right of print: *Skeffington Poole / Colonel / 11th September 1862*
6⅝ x 5⅛ in. (17.0 x 12.9 cm)
Colonel Skeffington Poole and his wife, Isabella, lived for many years in India, and some of their children were born there. The Poole family left India in 1851, and they were frequent visitors of the Hassard Dodgsons at Park Lodge, Putney; see A(II): 34. The date is a mystery since, according to his diaries, Dodgson went to Croft on 9 September.

A(II): 76
PHOTOGRAPH MISSING FROM ALBUM
Irene MacDonald, 25–31 July 1863?
[Irene MacDonald (crossed out)]
996?
Irene MacDonald (b. 1857) was the fourth daughter of George MacDonald. Dodgson took a number of photographs of her, many of which survive in other albums and in private collections.

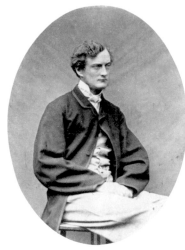

A(II): 77
Sir Michael E. Hicks Beach, 3 July 1862
[Sir M. Hicks Beach]
761
Christ Church, Oxford
Inscribed in ink, below right of print: *M. E. Hicks Beach / July 3rd 1862*
6½ x 4¾ in. (16.4 x 12.2 cm)
The Right Hon. Sir Michael Edward Hicks Beach (1837–1916) was the ninth baronet, succeeding his father in 1854. He was educated at Christ Church, gaining a first class degree in law and modern history in 1858, and went on to have a distinguished political career.

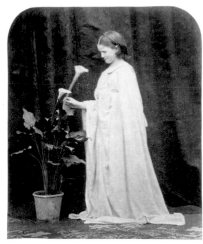

A(II): 78
Margaret Brodie, 21 June 1861
[Margaret Brodie, (picking flowers)]
715
Oxford
Inscribed in ink, below right of print: *Margaret Anne Brodie. June 21/61*
5⅜ x 4½ in. (13.8 x 11.4 cm)
This photograph of Margaret Brodie was obviously taken at the same time as Dodgson's picture of her and her sister Lilian dressed in Greek classical drapery (A[II]: 74).

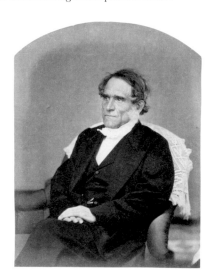

A(II): 79
Rev. Frederick D. Maurice, 27 July 1863
[Rev. F. D. Maurice]
1002
Elm Lodge, Hampstead
Inscribed in ink, below right of print: *Frederick D. Maurice / July 27. 1863*
6⅝ x 5 in. (16.9 x 12.8 cm)
Rev. Frederick Denison Maurice (1805–1872), founder and first principal of the Working Men's College, London (1854), was also perpetual curate at St. Peter's, Vere Street (1860–66), attended by the MacDonald family, and occasionally by Dodgson. "Photographing all day. Mr. Maurice came to luncheon and sat for his picture, which seems good," Dodgson recorded in his journal that day.

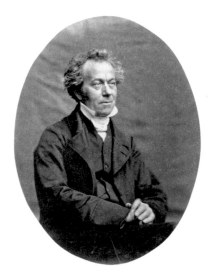

A(II): 80
Professor William Jacobson, June 1857
[Rev. Dr. Jacobson]
239
Christ Church, Oxford
No inscription
5⅜ x 4⅛ in. (13.8 x 10.4 cm)
Rev. Dr. William Jacobson (1804–1884), D.D., Lincoln College, Oxford, was elected a canon of Christ Church and served in this role between 1848 and 1865; throughout this time he was also Regius professor of divinity at Oxford. He went on to become bishop of Chester (1865).

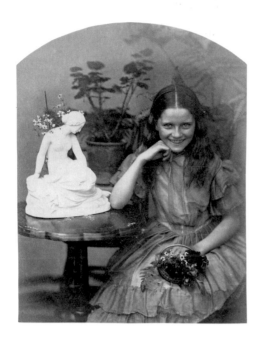

A(II): 81
Flora Rankin in "No Lessons Today," 25–31 July 1863
["No lessons today."]
1017
Elm Lodge, Hampstead
Inscribed in ink, below center of print: *Flora Rankin*
6⅝ x 5⅛ in. (17 x 12.9 cm)
On 31 July 1863 Dodgson recorded: "Took a few more photographs. I have now done all the MacDonalds . . . and three children whom they brought in, Flora and Mary Rankin, and Margaret Campbell. Flora was the only one of the three particularly worth taking." In 1872 Dodgson sent a copy of this photograph to Charles Darwin for his book *The Expression of Emotions,* but the photograph was not used.

A(II): 82
PHOTOGRAPH MISSING FROM ALBUM

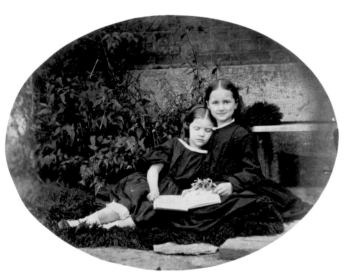

A(II): 83
Ethel and Lilian Brodie, 21 June 1861
[Ethel and Lilian Brodie]
709
Oxford
Inscribed in ink to left and right of print: *ETHEL BRODIE / Lilian Brodie June 21/61*
4¾ x 6⅜ in. (12.2 x 16.3 cm)
Ethel and Lilian Brodie (left to right), comfortably resting on a black sheepskin rug; see A(II): 52.

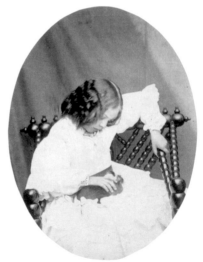

A(II): 84
Bessie Slatter with Guinea Pig, spring 1862
[Bessie Slatter (and guinea-pig)]
736
Christ Church, Oxford
No inscription
5 x 3⅝ in. (12.7 x 9.4 cm)
Bessie Slatter, daughter of Rev. John Slatter, with her pet guinea pig; see A(II): 50.

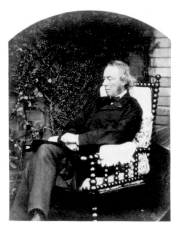

A(II): 85
Aubrey de Vere, 5 September 1862
[Aubrey De Vere, Esq.]
880
East Sheen, London
Inscribed in ink, below right of print: *Aubrey de Vere Sept. 5th 1862*
6⅝ x 5⅛ in. (17 x 12.9 cm)
Aubrey Thomas de Vere (1814–1902) was a poet much influenced by Coleridge and Wordsworth, friend of Tennyson, and brother-in-law of (Sir) Henry Taylor (1800–1886). Dodgson, on a visit to the Taylors on 3 September 1862, wrote: "I found Mr. Taylor walking in the garden with Mr. Aubrey De Vere, another poet. . . . Settled to take over my camera on Friday."

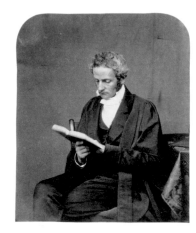

A(II): 86
Professor Arthur P. Stanley, 4 July 1860
[Rev. Dr. Stanley]
597
Christ Church, Oxford
Inscribed in ink, below print, center for signature and right for date: *Arthur P. Stanley / Nov. 16. 1862*
5⅜ x 4½ in. (13.8 x 11.4 cm)
Rev. Arthur Penrhyn Stanley (1815–1881) was a former Rugby School teacher and tutor at Balliol College who made a name for himself preaching radical sermons at Oxford in the late 1840s. He was a lifelong friend of Dean Liddell. In 1856 he became a canon of Christ Church and Regius Professor of Ecclesiastical History. In 1863 he was created dean of Westminster.

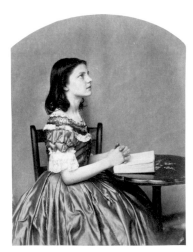

A(II): 87
Nelly MacDonald, 25–31 July 1863
[Nelly MacDonald]
1005
Elm Lodge, Hampstead
No inscription
6⅝ x 5⅛ in. (17 x 12.9 cm)
On 31 July 1863, during a photographic expedition to the home of the MacDonalds, Dodgson wrote: "Took a few more photographs. I have now done all the MacDonalds, their niece Nelly, Mr. Maurice, and three children whom they brought in. . . ." Nelly MacDonald may be praying, an unusual pose for Dodgson to photograph.

A(II): 88
Lilian, Margaret, Ida, and Ethel Brodie, 21 June 1861
[Brodies (on grass-plot)]
718
Oxford
Inscribed in ink, spaced beneath print: *Lilian / Margaret / Ida / ETHEL*
6⅛ x 7⅝ in. (15.6 x 19.5 cm)
The figures of the Brodie sisters (left to right: Lilian, Margaret, Ida, and Ethel) form a triangular composition that Dodgson sets within an oval as if it were a geometric drawing; see A(II): 52. Ethel, the youngest, printed her name; the others signed their names in the normal way.

A(II): 89
Charlotte Dodgson, 1–11 September 1862
[Charlotte M. Dodgson]
850
Park Lodge, Putney
Inscribed in ink, below right of print: *Charlotte Mary Dodgson / Sept*. *11th 1862*
5 x 3⅝ in. (12.6 x 9.4 cm)
Charlotte Mary Dodgson (b. 1839) was the second daughter of Dodgson's Uncle Hassard and Aunt Caroline. She was one of ten cousins who lived at Park Lodge, Putney.

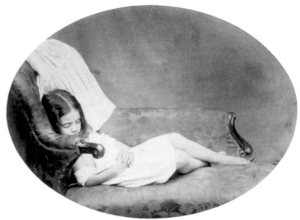

A(II): 90
Annie Rogers, June 1861
[Annie Rogers (on sofa)]
734 (but probably around 698)
Christ Church, Oxford
Inscribed in ink, pasted-down slip below right: *Annie*
4¾ x 6½ in. (12.2 x 16.4 cm)
Dodgson photographed Annie Rogers several times, sometimes in dramatic costume scenes or in petticoats and underslips tied with tasseled cords. He gave this photograph the image number 734, yet it is obvious that it was taken at the same time as 698 (A[II]: 100). A print of this image in the Rogers family collection is dated June 1861, indicating that Dodgson probably made an error in assigning this image number.

A(II): 91
Professor William F. Donkin, 4–13 July 1863
[Professor Donkin]
980
Badcock's Yard, Oxford
Inscribed in ink, below right of print: *W. F. Donkin / July 22. 1863*
6⅝ x 5⅛ in. (16.8 x 12.9 cm)
Professor William Fishburn Donkin (1814–1869), M.A., University College, Oxford, was a lecturer in mathematics before becoming Savilian professor of astronomy at Oxford in 1842. He was the father of Alice Emily Donkin (photographed by Dodgson). His niece was Alice Jane Donkin who married Dodgson's brother Wilfred.

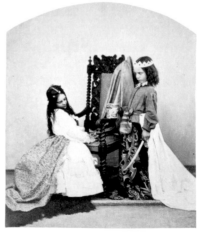

A(II): 92
Annie Rogers and Mary Jackson in "Fair Rosamond,"
3 July 1863
["Fair Rosamond"]
974
Badcock's Yard, Oxford
No inscription
8⅛ x 6⅝ in. (20.7 x 17.1 cm)
"Fair Rosamond" with Annie Rogers as Queen Eleanor (on right) and Mary Jackson as the "Fair Rosamond." Annie was the daughter of Professor James Rogers, and Mary (b. 1854?) was the daughter of Dr. Robert Jackson, physician at Oxford. Dodgson wrote: "Mrs. Rogers brought Annie to be photographed, and also (at my request) Mrs. Jackson's little girl, Mary. Mrs. Jackson came also. I got some splendid photographs of both children."

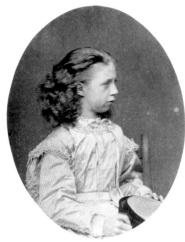

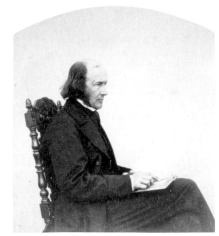

A(II): 93
Florence Gandell, 10 July 1862
[Florence Gandell]
766
Iffley Rectory, Oxford
Inscribed in ink, below right of print: *Florence Gandell / July 10th 1862*
3⅞ x 3 in. (9.9 x 7.6 cm)
Dodgson wrote on 10 July 1862: "Took photographs of Mr. Gandell and two of his children, Florence and Shomberg. . . ." Florence Gandell (dates unknown) was the daughter of Robert Gandell (1818–1887).

A(II): 94
Professor Henry W. Acland, 1–20 July 1863
[Dr. Acland]
957
Badcock's Yard, Oxford
Inscribed in ink, centered below print: *Henry W. Acland / July 21. 1863*
6⅝ x 5⅞ in. (17 x 15.1 cm)
Dr. Henry W. Acland, M.A., Christ Church, was Regius Professor of Medicine and honorary physician to the Prince of Wales. In 1845 he was Lee's Reader in Anatomy. He was also Dean Liddell's doctor, giving him medical advice and accompanying him on a trip to Madeira for the sake of the dean's health in 1857, and again to Switzerland in 1865. He was knighted in 1884.

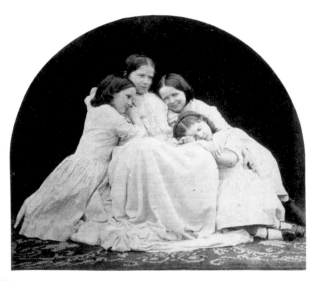

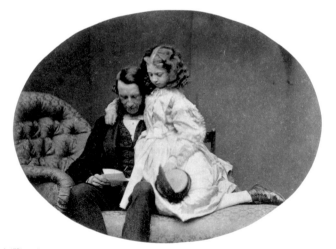

A(II): 95
Lilian, Margaret, Ida, and Ethel Brodie, 21 June 1861
[Brodies and curtain]
719
Oxford
No inscription
5⅞ x 6⅞ in. (15 x 17.6 cm)
The figures of the Brodie sisters (left to right: Lilian, Margaret, Ida, and Ethel) form a triangular composition, allowing Dodgson to trim the print with a semicircular top. See A(II): 52.

A(II): 96
Professor Robert Gandell and Florence, 10 July 1862
[Rev. R. Gandell and Florence]
769
Iffley Rectory, Oxford
Inscribed in ink, below right of print: *R. Gandell / Florence Gandell / July 10. 1862*
4¾ x 6⅜ in. (12.3 x 16.3 cm)
Professor Robert Gandell (1818–1887), M.A., Queen's College, Oxford, and his daughter, Florence (A[II]: 93). Gandell was a tutor at Magdalen Hall from 1848 until 1872, chaplain of Corpus Christi College from 1852 until 1877, Laudian Professor of Arabic from 1861, and later became canon of Wells Cathedral (1880).

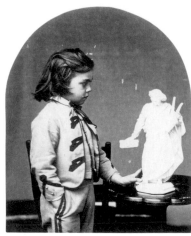

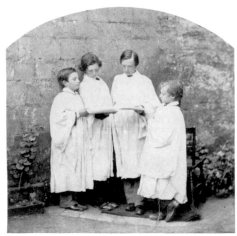

A(II): 97

Greville MacDonald, 25–31 July 1863

[Greville MacDonald]

1029

Elm Lodge, Hampstead

Inscribed in ink, below right of print: *Greville M. MacDonald*

4¾ x 3⅞ in. (12.1 x 9.9 cm)

Greville Matheson MacDonald (1856–1944) was the eldest son of George and Louisa MacDonald. He was Alexander Munro's model for the sculpture *Boy with Dolphin,* which now stands in Hyde Park. It was Greville who, after hearing the manuscript version of *Alice's Adventures* read to him by his mother, suggested that there should be 60,000 copies of the book. This may have encouraged Dodgson to publish the story.

A(II): 98

Choristers at Christ Church, spring 1860

[Choristers, Ch. Ch.]

494–568

Christ Church, Oxford

No inscription

5⅛ x 5⅛ in. (13 x 12.9 cm)

Four choristers from the Cathedral choir at Christ Church.

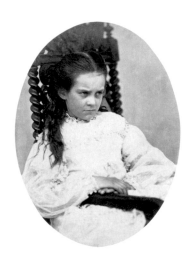

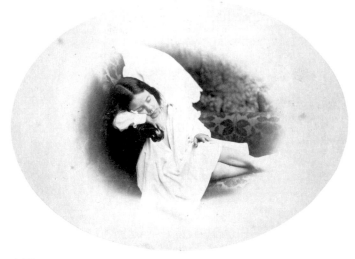

A(II): 99

Mary Jackson, 3 July 1863

[Mary Jackson]

969

Badcock's Yard, Oxford

Inscribed in ink, below right of print: *Mary L. Jackson*

5½ x 4 in. (13.9 x 10.3 cm)

Mary Jackson, daughter of Dr. Robert Jackson, G.P.; see A(II): 92.

A(II): 100

Annie Rogers, June 1861

[Annie Rogers]

698

Christ Church, Oxford

No inscription

5⅝ x 7½ in. (14.2 x 19 cm)

Annie Rogers, asleep. She became an avid supporter of women's education and championed the cause for establishing a university for women (also supported by Dodgson).

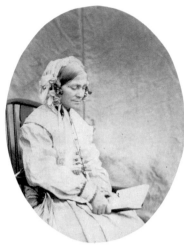

A(II): 101
Mrs. Hunton, summer 1860
[Mrs. Hunton]
630
Whitby, Yorkshire
No inscription
6¾ x 3⅜ in. (17.3 x 8.6 cm)
Mrs. Hunton (dates unknown) was Dodgson's landlady at 5 East Terrace, Whitby, when he attended the university mathematical summer school there, organized by Professor Bartholomew Price in preparation for the mathematics finals in 1854. Dodgson came at the top of the honors list that autumn.

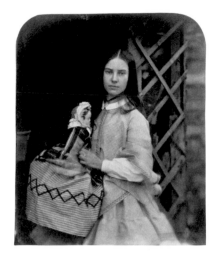

A(II): 102
Florence Bainbridge, summer 1860
[Florence Bainbridge]
627
Whitby, Yorkshire
Inscribed in ink, pasted-down slip below right of print: *Florence Hilda Bainbridge*
5⅜ x 4½ in. (13.8 x 11.4 cm)
Florence Bainbridge, aged thirteen, is seen leaning against a trellis, holding a doll; see A(II): 22. She was the daughter of Dodgson's Whitby friends, Henry and Mary Bainbridge.

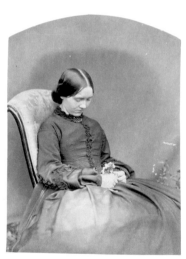

A(II): 103
Lucy Tate, 20 August 1863
[Miss L. Tate]
1050
Croft Rectory, Yorkshire
No inscription
8⅛ x 6 in. (20.5 x 15.2 cm)
Lucy Hutchinson Tate (1842–1873) was the daughter of James Tate, headmaster of Richmond School. Dodgson attended this school from 1844 to 1846 before going on to Rugby School. He resided in the headmaster's house and became friendly with the whole family.

A(II): 104
Rev. Charles R. Conybeare, 30 June 1862
[Rev. C. Conybeare]
752
Christ Church, Oxford
No inscription
4⅞ x 3¾ in. (12.5 x 9.7 cm)
On 1 July 1862 Dodgson noted in his diary that he had been photographing a number of university people over the last few days, including Conybeare. Charles Ranken Conybeare (1821–1885), M.A., Christ Church, became vicar of Pyrton, Oxfordshire, from 1852 to 1857, and then vicar of Itchin Stoke, Hampshire, for the rest of his life.

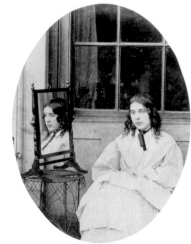

A(II): 105
Alice and Lorina Liddell in "See-Saw," May/June 1860
["See-Saw"]
563
Deanery garden, Christ Church, Oxford
Inscribed in ink, below left and right of print: *Alice Pleasance Liddell /
Lorina Charlotte Liddell*
4¾ x 6⅜ in. (12.3 x 16.3 cm)
Alice and Lorina Liddell in the Deanery Garden, with the third sister,
Edith, in the foreground. However, she was cut out of this print as a result
of Dodgson's cropping it in the shape of an oval.

A(II): 106
Margaret Dodgson in "Reflection," September 1862
["Reflection"]
897
Croft Rectory, Yorkshire
No inscription
5⅞ x 4⅜ in. (15.1 x 11.2 cm)
Dodgson's sister, Margaret, aged nineteen, normally wore her hair tied
back, but she reveals her ringlets in this portrait, which includes a perfect
reflection in a mirror strategically placed beside her; see A(I): 18.

A(II): 107
Mrs. Elizabeth Rumsey and Leila, 10 – 14 July 1862
[Mrs. Rumsey and child]
785
Iffley Rectory, Oxford
Inscribed in ink, below right of print: *E. Rumsey / L. Rumsey*
4¾ x 3⅞ in. (12.1 x 9.9 cm)
Elizabeth Rumsey (b. 1826?) with her daughter, Elizabeth Cornelia
"Leila" (b. 1859). Dodgson wrote on 10 June 1862: "Went over to Iffley
Rectory to arrange about coming there to photograph. Settled that the
Rumseys should go over there when I go." However, from the age of Leila,
this photograph may have been taken on 12 June 1868, when Dodgson
recorded: "Photographed Mrs. Rumsey with Leila." In this case, Dodgson's
image number is incorrect.

A(II): 108
Barmby Moor, 8 October 1862
[Barmby Moor]
933
Barmby Moor, Yorkshire
No inscription
6½ x 7⅞ in. (16.4 x 20.1 cm)
Barmby Moor was the home of Edward and Mary Donkin and their five
children. He was a land agent. His brother was William F. Donkin, Savilian
professor of astronomy at Oxford. The eldest daughter, Alice Jane, married
Dodgson's brother, Wilfred, in August 1871. "Took pictures of some of the
children, and the house," Dodgson wrote on 8 October 1862 while visiting
the Donkins.

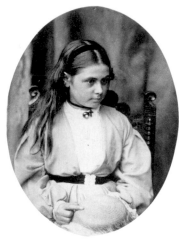

A(II): 109
Constance Powell, 26–29 August 1863
[Constance M. Powell]
1076
Whitby, Yorkshire
Inscribed in ink, pasted-down slip: *Constance Mary Powell*
5½ x 4⅛ in. (13.9 x 10.4 cm)
Constance Mary Powell (dates unknown) was taking a holiday at Whitby with her uncle and aunt at the time this photograph was taken. The Powells originated from Sharow, near Ripon, and were acquainted with the Dodgsons through the archdeacon's connections with Ripon Cathedral. Dodgson's diary records that the photograph was taken at the home of Rev. William Keane.

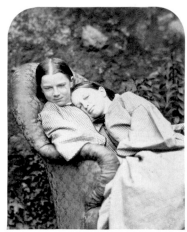

A(II): 110
Margaret and Ida Brodie, 2 August 1862
[Margaret and Ida Brodie]
792
Christ Church, Oxford
Inscribed in ink, below left and right of print: *Margaret Anne Brodie / Ida Brodie / Aug 2 1862*
4⅞ x 3⅞ in. (12.5 x 9.9 cm)
On 2 August 1862 Dodgson wrote: "Mrs. Brodie brought her children over to be photographed in the morning: she went back soon after 12, leaving Margaret, Ida, and Lily to be photographed." See A(II): 52.

A(II): 111
Winteringham Church, 8–11 September 1863
[Winteringham Church]
1087
Winteringham, Lincolnshire
No inscription
6½ x 8 in. (16.5 x 20.2 cm)
Dodgson and his sister Fanny visited friends at Winteringham, Lincolnshire, from 4 until 11 September 1863. He recorded: "During our stay at Winteringham I have taken photographs of Mr. and Mrs. Read, and Mr. Mitchell, of the church and the rectory, and of several of the schoolchildren, and a child of Mr. Wood, vicar of a neighbouring church."

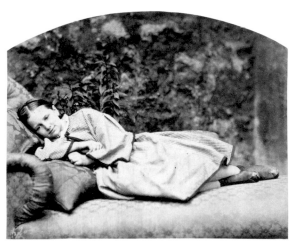

A(II): 112
Lilian Brodie, 2 August 1862
[Lilian Brodie]
793
Christ Church, Oxford
Inscribed in ink, below right of print: *Lilian Brodie / Aug: 2. 1862*
4⅝ x 6 in. (12 x 15.2 cm)
Lilian Brodie; see A(II): 52.

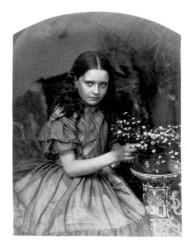

A(II): 113
Flora Rankin, 25–31 July 1863
["Flora"]
1016
Elm Lodge, Hampstead
No inscription
6⅝ x 4⅞ in. (16.7 x 12.5 cm)
Flora Rankin; see A(II): 81.

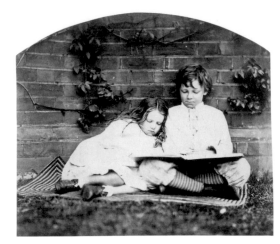

A(II): 114
Harry and Una Taylor, 5 September 1862
[Harry and Una Taylor]
884
East Sheen, London
Inscribed in ink, below left and center of print: *Una / Harry Taylor*
6⅛ x 6⅞ in. (15.5 x 17.6 cm)
Harry Ashworth Taylor (1854–1907) and Una Mary Ashworth Taylor (1857–1922), son and daughter of (Sir) Henry Taylor (1800–1886). Dodgson noted two days before the photograph was taken: "The whole party were at home, Una as delightful as ever." Dodgson first met the Taylor children in April 1862 on the beach at the Isle of Wight.

A(II): 115
Rev. Henry J. Ellison, 23 August 1862
[Rev. H. Ellison]
833
South Bank, Malvern
Inscribed in ink, below right of print: *Henry J Ellison / August 23. 1862*
5½ x 4⅛ in. (14 x 10.4 cm)
"Have been photographing the Ellisons daily," Dodgson wrote on 23 August 1862. Rev. Henry John Ellison (1813–1899), M.A., Trinity College, Cambridge, was vicar of New Windsor, Berkshire. The family was taking a holiday at Malvern. Coincidentally, Dodgson was also at Malvern consulting the university's moderator for mathematics.

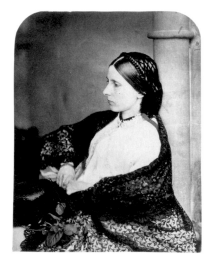

A(II): 116
Mrs. Mary Ellison, 23 August 1862
[Mrs. Ellison]
835
South Bank, Malvern
Inscribed in ink, below right of print: *Mary D. Ellison / Augt. 23. 1862*
4⅞ x 3⅞ in. (12.5 x 9.8 cm)
Dodgson, having heard from an old friend that the Ellison children were very beautiful, wrote to Mary Dorothy Ellison (1832–1870), wife of Rev. Henry J. Ellison, asking permission to photograph them. On 9 August 1862 he recorded in his diary: "Mrs. Ellison had written to say she was quite willing to have the children photographed."

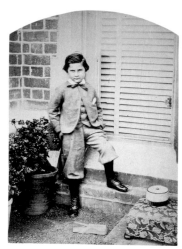

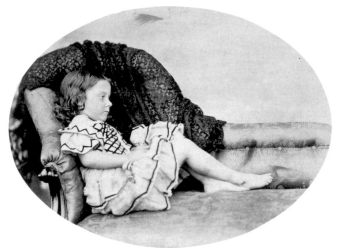

A(II): 117
Johnnie Ellison, 23 August 1862
[Johnnie Ellison]
817
South Bank, Malvern
Inscribed in ink, below center-right of print: *John Henry J. Ellison*
8⅛ x 6 in. (20.7 x 15.2 cm)
John "Johnnie" Henry Joshua Ellison (b. 1855) in a confident mood. Later he attended Merton College, Oxford, taking his degree in 1878, and then went on to become vicar of St. Gabriel's, Pimlico (1885).

A(II): 118
Constance Ellison, 23 August 1862
[Constance Ellison]
824
South Bank, Malvern
Inscribed in ink, below center of print: *Constance Ellison*
4¾ x 6⅜ in. (12.3 x 16.3 cm)
Constance Margaret Ellison (b. 1856), eldest daughter of Henry and Mary Ellison. She married George Rodney Eden (1853–1940), who became bishop of Wakefield (1897).

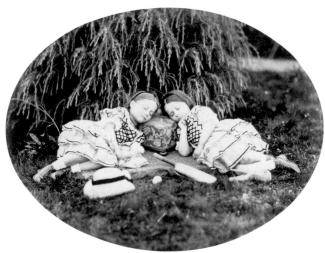

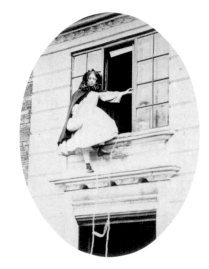

A(II): 119
Constance and Mary Ellison in "Tired of Play," 23 August 1862
["Tired of play"]
830
South Bank, Malvern
No inscription
4¾ x 6⅜ in. (12.3 x 16.3 cm)
Constance, with her sister, Mary Beatrice (b. 1857), daughters of Henry and Mary Ellison, relaxing after an exhausting game with bat and ball.

A(II): 120
Alice Jane Donkin in "The Elopement," 9 October 1862
["The Elopement"]
929
Barmby Moor, Yorkshire
Inscribed in ink, below center-right: *Alice Jane Donkin*
6⅜ x 4¾ in. (16.3 x 12.2 cm)
On 9 October 1862 Dodgson wrote: "Photographing most of the day. Took a composition-picture, 'the elopement,' Alice getting out of her bedroom window, with a rope-ladder. . . ." Alice Jane Donkin (1851–1929) was already romantically linked with Dodgson's brother Wilfred, and they eventually married on 9 August 1871.

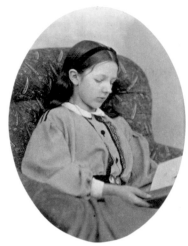

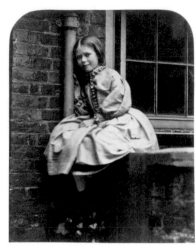

A(II): 121
Alice Emily Donkin, 3 July 1863
[Alice Donkin (Oxford)]
966
Badcock's Yard, Oxford
Inscribed in ink, below right of print: *Alice Emily Donkin*
5⅜ x 4 in. (13.8 x 10.3 cm)
Alice Emily Donkin was a cousin of Alice Jane Donkin. Her father was professor of astronomy at Oxford. See A(II): 4.

A(II): 122
Mary Lott, 27 June 1862
[Mary Lott (on wall)]
746
Christ Church, Oxford
Inscribed in ink, on pasted-down slip, below right of print: *Mary Elizabeth Lott / June 27th 1862*
5⅛ x 3⅞ in. (13 x 10 cm)
Dodgson listed in his diary the photographs he took at the end of June 1862, including Mary Elizabeth Lott. She was the daughter of Rev. Frederick Edwin Lott and his wife, Elizabeth. Dodgson first met the family in February 1857. See A(I): 35.

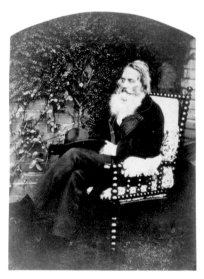

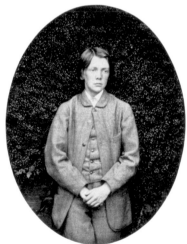

A(II): 123
Sir Henry Taylor, 5 September 1862
[Henry Taylor, Esq.]
881
East Sheen, London
Inscribed in ink, below right of print: *H. Taylor / East Sheen / 5th Sept 1862*
8⅛ x 5⅞ in. (20.5 x 15.1 cm)
(Sir) Henry Taylor (1800–1886) was author of plays, poetry, and articles on literary subjects. He wrote for the *London Magazine* and the *Quarterly Review*. He was married to Theodosia, daughter of Baron Monteagle, and they had five children; Aubrey, Eleanor, Ida, Harry, and Una, all photographed by Dodgson.

A(II): 124
Aubrey Taylor, 5 September 1862
[Aubrey Taylor, Esq.]
876
East Sheen, London
Inscribed in ink, below right of print: *Aubrey Taylor / East Sheen / 5th September 1862*
5⅜ x 4 in. (13.8 x 10.3 cm)
Aubrey Ashworth Taylor (1845–1876), eldest son of Theodosia and Henry Taylor (A[II]: 123).

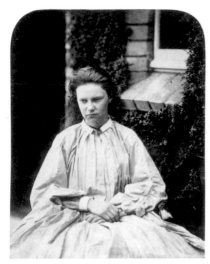

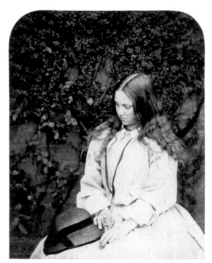

A(II): 125
Eleanor Taylor, 5 September 1862
[Miss Taylor]
878
East Sheen, London
Inscribed in ink, below center of print: *Eleanor Taylor*
4⅞ x 3⅞ in. (12.5 x 9.9 cm)
Eleanor Emma Ashworth Taylor (1847–1911), eldest daughter of
Theodosia and Henry Taylor (A[II]: 123).

A(II): 126
Ida Taylor, 5 September 1862
[Ida Taylor]
879
East Sheen, London
Inscribed in ink, below left of print: *Ida Taylor*
4⅞ x 3⅞ in. (12.5 x 9.9 cm)
Ida Alice Ashworth Taylor (1850–1929), second daughter of Theodosia
and Henry Taylor (A[II]: 123).

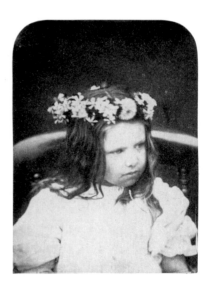

A(II): 127
Harry Taylor, 5 September 1862
[Harry Taylor]
883
East Sheen, London
Inscribed in ink, below center of print: *Harry Taylor*
8⅛ x 5⅞ in. (20.5 x 15.1 cm)
Harry Ashworth Taylor (1854–1907), second son of Theodosia and
Henry Taylor (A[II]: 123).

A(II): 128
Una Taylor, 6 September 1862
[Una Taylor]
886
East Sheen, London
Inscribed in ink, below right of print: *Una Taylor*
4 x 2⅞ in. (10.1 x 7.4 cm)
Una Mary Ashworth Taylor (1857–1922), youngest daughter of Theodosia
and Henry Taylor (A[II]: 123). On 6 September 1862 Dodgson wrote:
"Took, among others . . . a beautiful small one of Una in a wreath."

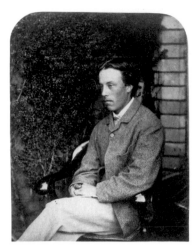

A(II): 129
Ewen Cameron, 6 September 1862
[Ewen Cameron, Esq.]
888
East Sheen, London
Inscribed in ink, below right of print: *Ewen Hay Cameron / East Sheen*
4⅞ x 3¾ in. (12.5 x 9.7 cm)
Ewen Wrottesley Hay Cameron (1843–1888), second son of Charles Hay Cameron (1795–1880) and his photographer-wife Julia Margaret (1815–1879). Dodgson met Mrs. Cameron on the Isle of Wight in April 1862; she gave him a photograph of Tennyson, and he gave her a copy of his edition of *Index to 'In Memoriam'* (1862).

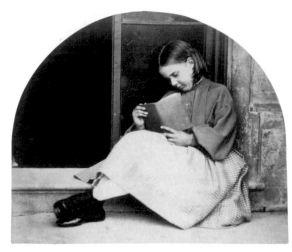

A(II): 130
Laura Dodgson, 1–11 September 1862
[Laura Dodgson]
859
Park Lodge, Putney
Inscribed in ink, below center of print: *Laura Dodgson*
5⅜ x 6⅜ in. (13.7 x 16.1 cm)
Laura Elizabeth Dodgson (1853–1882), youngest daughter of Dodgson's Uncle Hassard and Aunt Caroline.

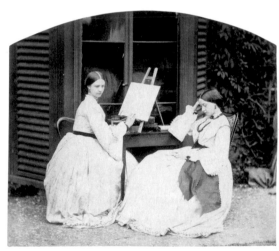

A(II): 131
Alice and Meta Poole, 1–11 September 1862
[The Misses Poole]
864
Park Lodge, Putney
Inscribed in ink, below left and right of print: *Alice H. Poole / Meta F. Poole / September 11th 1862*
5¼ x 5⅞ in. (13.2 x 15.1 cm)
Alice and Meta Poole, two of Dodgson's cousins, engaged in artistic and handicraft activities during their stay with the Hassard Dodgsons at Putney; see A(II): 34.

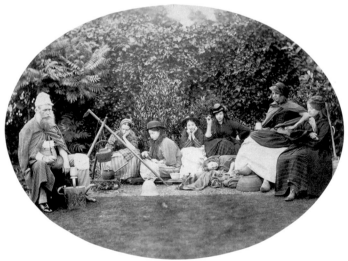

A(II): 132
Dodgsons and Pooles in "I Zingari," 8 September 1862
["I Zingari"]
892
Park Lodge, Putney
Inscribed in ink, placed corresponding to figures: *Saving Widby / Esther Witney / Abel Witney / Meg Witney / Dolly Widby / Lucheuch Pinfold / Limpetty Widby / Boston Pinfold*
5⅝ x 7⅜ in. (14.2 x 18.9 cm)
A mock gypsy camp consisting of Pooles and Dodgsons. Inscriptions give their fictitious names, Dodgson probably having had a hand in their invention. Dodgson noted on 8 September 1862: "Took pictures of 'the sleeping beauty,' 'a gipsy camp' etc."

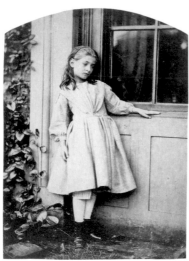

A(II): 133
Gertrude Dykes, September 1862
[Gertrude Dykes (full-length)]
904
Croft Rectory, Yorkshire
No inscription
8⅛ x 5⅞ in. (20.5 x 15.1 cm)
Gertrude Kingston Dykes (b. 1854), daughter of the theologian and
hymn-tune composer, John Bacchus Dykes (1823–1876). Dodgson
wrote on 7 October 1862: "I have taken several good photographs at
Croft, including Dr. Dykes' children, Mary, Ernest, Gertrude, and Caroline.
The two youngest, Ethel and Mabel, I did not take"; see P(3): 77.

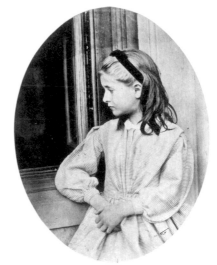

A(II): 134
Gertrude Dykes, September 1862
[Gertrude Dykes (½)]
902
Croft Rectory, Yorkshire
Inscribed in ink, below right of print: *Gertrude Dykes*
3⅞ x 3 in. (10 x 7.6 cm)
Gertrude Dykes leaning against the windowsill at Croft Rectory; see A(II):
133.

A(II): 135
PHOTOGRAPH MISSING FROM ALBUM
Family Group, Putney, 1–11 September 1862
[Family group, Putney]
891
Park Lodge, Putney
Hassard and Caroline Dodgson were photographed with six of their
children, seated in the garden of their Putney home. A copy of this
photograph was included in P(3): 73.

A(II): 136
Bishop Robert Bickersteth, 24 September 1862
[Bishop of Ripon]
912
Croft Rectory, Yorkshire
Inscribed in ink, signing as the bishop of Ripon, below right of print:
R. Ripon / Sept. 24. 1862
4⅞ x 3⅞ in. (12.5 x 9.8 cm)
Robert Bickersteth (1816–1884), D.D., Queen's College, Cambridge,
became a residentiary canon of Salisbury in 1854. He was appointed
bishop of Ripon in 1857 and remained so until his death in April 1884.
He was photographed on a visit to Archdeacon Dodgson at Croft.

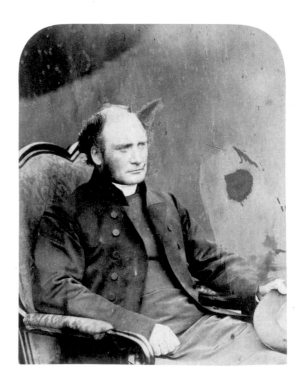

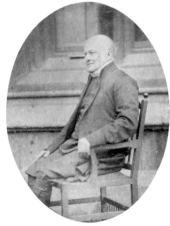

P(3): frontispiece
Archbishop Charles T. Longley, 7 July 1864
[Archbishop Longley]
1304
Lambeth Palace, London
Inscribed in ink, signing as Archbishop of Canterbury, below center of print: *C. T. Cantuar: / Nov*. *18. 1864*
6½ x 4¾ in. (16.4 x 12.2 cm)
Charles T. Longley, Archbishop of Canterbury (A[I]: 62). Dodgson wrote on 7 July 1864: "Took pictures of . . . a full-length of the Archbishop."

P(3): 1
Daresbury Parsonage, spring 1860
[Daresbury Parsonage]
486
Daresbury, Cheshire
Legend in violet ink, below center of print: *Daresbury Parsonage*, over pencil erasure of same title
5½ x 6⅛ in. (13.9 x 15.6 cm)
Dodgson's photograph of his birthplace, Daresbury Parsonage, Cheshire, photographed during an expedition in spring 1860 when he visited the places of his youth with his camera.

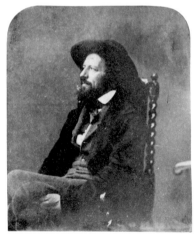

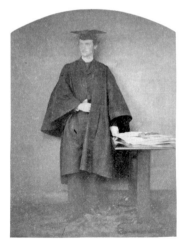

P(3): 2
Alfred Tennyson, 28 September 1857
[A. Tennyson, Esq.]
306
Monk Coniston Park, Ambleside
Pencil inscription partially erased; legend in violet ink, below center of print: *Alfred Tennyson*
5⅜ x 4½ in. (13.8 x 11.4 cm)
Duplicate of A(I): 26.

P(3): 3
Frederick, Crown Prince of Denmark, Standing, 18 November 1863
[Prince of Denmark]
1197
Badcock's Yard, Oxford
Pencil inscription partially erased; legend in violet ink, below center of print: *Crown Prince of Denmark*
8⅛ x 6 in. (20.6 x 15.2 cm)
Crown Prince Frederick of Denmark (1843–1912) was an undergraduate at Christ Church in 1863. Prince Frederick's brother-in-law was the Prince of Wales, later Edward VII. The crown prince's career at Oxford was interrupted by the outbreak of war between Denmark and Prussia on the Schleswig-Holstein problem.

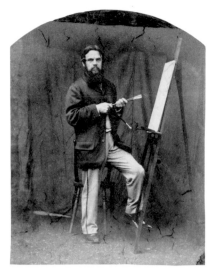

P(3): 4
William Holman Hunt, 30 June 1860
[Holman Hunt, Esq.]
576
Christ Church, Oxford
Inscribed in ink, below and to right of print: *W. Holman Hunt /*
October 8 / 61
6⅝ x 5⅛ in. (17 x 12.9 cm)
Duplicate of A(II): 23.

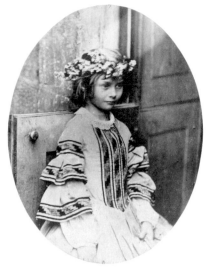

P(3): 5
Alice Liddell as "Queen of the May," May/June 1860
[Alice P. Liddell (in wreath)]
561
Deanery garden, Christ Church, Oxford
Legend in violet ink, below center: *Alice Liddell, / daughter of the Dean*
of Ch. Ch., written over pencil erasure
5 x 3¾ in. (12.8 x 9.6 cm)
This photograph was intended for A(II): 20 but is missing from that
album.

P(3): 6
Broad Walk, Christ Church, spring 1857
[Broad Walk, Ch. Ch.]
173
Christ Church, Oxford
Legend in violet ink, below center: *Broad Walk, Ch. Ch.,* written over pencil
erasure
5½ x 6⅝ in. (13.9 x 16.7 cm)
Duplicate of A(I): 3.

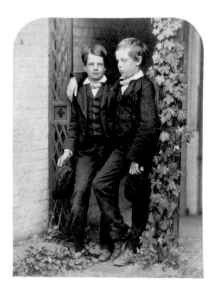

P(3): 7
Edwin Dodgson and C. Turner, summer 1859
[E. H. Dodgson and C. Turner]
380
Twyford School, Hampshire
Legend in violet ink, below center: *C. Turner and E. H. Dodgson /*
at Twyford School, written over pencil erasure
5⅜ x 3⅞ in. (13.4 x 9.9 cm)
Duplicate of A(I): 45.

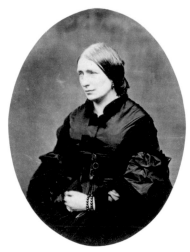

P(3): 8

Harriet, Caroline, or Anne Erskine, 30 March 1858

[Miss Erskine]

335

Ripon, Yorkshire

Legend in violet ink, below center: *Miss Erskine, / daughter of the Dean of Ripon,* written over pencil erasure

5⅝ x 4⅛ in. (14.1 x 10.5 cm)

Miss Erskine was one of the daughters of the Very Rev. Henry David Erskine, Dean of Ripon. Dodgson wrote on 29 March 1858: "Called at the Deanery with Fanny, and arranged for the party there coming tomorrow to be photographed"; and the following day: "Began with the Dean and the Misses Erskine." The dean's three unmarried daughters at this time were Harriet Frances (b. 1814), Caroline Stuart (1818–1890), and Anne Agnes (1825–1912).

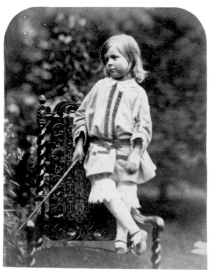

P(3): 9

Wilfred Dodgson and Dido, August 1857

[W. L. Dodgson and Dido]

278

Croft Rectory, Yorkshire

Legend in violet ink, below center: *W. L. Dodgson / and Dido,* written over pencil erasure

5 x 3⅞ in. (12.6 x 9.9 cm)

Duplicate of A(I): 91.

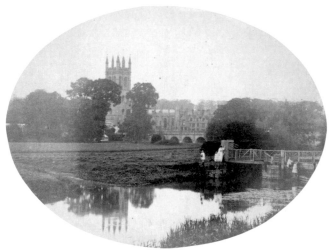

P(3): 10

Magdalen Tower, summer 1861

[Magdalen Tower]

721

Oxford

Legend in violet ink, below center: *Magdalen Tower, Oxford,* written over pencil erasure

5⅝ x 7½ in. (14.2 x 19 cm)

Duplicate of A(II): 24.

P(3): 11

Hallam Tennyson, 28 September 1857

[Hallam Tennyson]

305

Monk Coniston Park, Ambleside

Legend in violet ink, below center: *Hallam Tennyson,* written over partial pencil erasure

4⅞ x 3⅞ in. (12.5 x 9.9 cm)

Duplicate of A(I): 32.

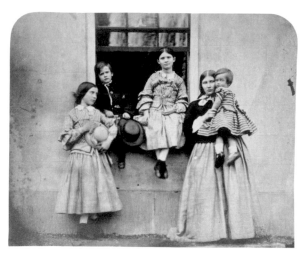

P(3): 12
Ottley Family Group, spring 1860
[Ottleys (group)]
475
Richmond, Yorkshire
Legend in violet ink, below center: *Children of Rev. L. Ottley; Richmond,*
written over pencil erasure
5⅜ x 6⅝ in. (13.7 x 16.7 cm)
Duplicate of A(I): 72.

P(3): 13
Rev. William Keane, summer 1860
[Rev. W. Keane (in Indian hat)]
626
Whitby, Yorkshire
Legend in violet ink, below center: *Rev. W. Keane, Whitby,* written over
pencil erasure below right
5⅜ x 4½ in. (13.8 x 11.5 cm)
See A(II): 63. The Indian hat stems from 1846, when Rev. William Keane
was canon of St. Paul's Cathedral, Calcutta.

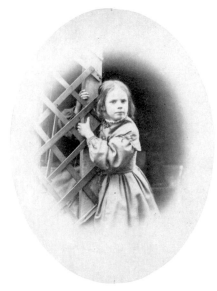

P(3): 14
Louisa Barry, summer 1860
[Louisa Barry]
622
Whitby, Yorkshire
Legend in violet ink, below center: *Louie Barry,* written over pencil erasure
5 x 3¾ in. (12.7 x 9.5 cm)
Duplicate of A(II): 46.

P(3): 15
Whitby, summer 1860
[Whitby]
630½
Whitby, Yorkshire
Legend in violet ink, below center: *Whitby,* written over partial pencil
erasure
4¾ x 6⅜ in. (12.3 x 16.3 cm)
This is the photograph missing from A(II): 12. Dodgson was a frequent
visitor to Whitby from 1854 until his last recorded visit in August 1871.

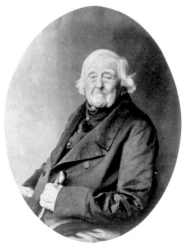

P(3): 16
Robert Bamlett, summer 1859
[Mr. Bamlet (*sic*)]
450
Croft Rectory, Yorkshire
Legend in violet ink, below center: *Mr. Bamlet* (sic), *farmer, Croft,* written over pencil erasure of *farmer near Croft* below center
5⅝ x 4¼ in. (14.2 x 10.6 cm)
Robert Bamlett (1772–1863), first of three generations to farm Oxen Le Fields, near Croft, part of the Milbanke Estates. He was born at East Cowton, North Yorkshire, and married Jane Barker (d. 1820) in 1803. They had seven children.

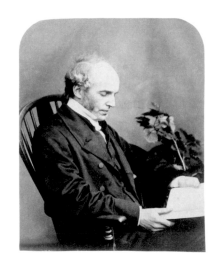

P(3): 17
Rev. William Keane, summer 1860
[Rev. W. Keane]
624
Whitby, Yorkshire
Legend in violet ink, below center: *Rev. W. Keane, Whitby,* written over partial pencil erasure of *Keane, vicar of Whitby* below right
4⅞ x 3⅞ in. (12.5 x 9.9 cm)
Duplicate of A(II): 63.

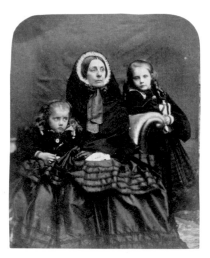

P(3): 18
Mrs. Mary Harington with Beatrice and Margaret, 26 March 1858
[Mrs. Harington and children]
325
Christ Church, Oxford
Legend in violet ink, below center: *Mrs. Harington and children,* written over partial pencil erasure of *Mrs. Harington and children, Oxford*
5⅜ x 4½ in. (13.8 x 11.4 cm)
Mrs. Mary Harington, widow of Rev. Richard Harington, Principal of Brasenose College, Oxford, with her two daughters, Beatrice and Margaret; see A(I): 85a and 85b.

P(3): 19
Daresbury Parsonage, spring 1860
[Daresbury Parsonage (distant)]
488
Daresbury, Cheshire
Legend in violet ink, below center: *Daresbury Parsonage,* written over pencil erasure
4¾ x 6½ in. (12.3 x 16.4 cm)
This photograph of Dodgson's birthplace, missing from A(II): 40, shows the view of the parsonage from the end of Morphany Lane, Daresbury.

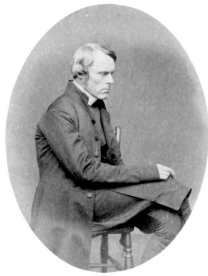

P(3): 20
Bishop John Jackson, 28 June 1860
[Bishop of Lincoln]
572
Christ Church, Oxford
Legend in violet ink, below center: *Bishop of Lincoln (Jackson)*, written over
pencil erasure
6⅜ x 4¾ in. (16.3 x 12.3 cm)
Duplicate of A(II): 11.

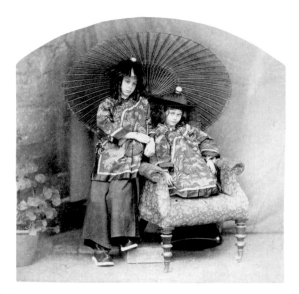

P(3): 21
Lorina and Alice Liddell in Chinese Dress, spring 1860
[Liddells in Chinese dress]
540
Deanery garden, Christ Church, Oxford
Legend in violet ink, below center: *Lorina and Alice Liddell, / daughters of
the Dean of Ch. Ch.*, written over pencil erasure
5⅛ x 5¼ in. (13 x 13.1 cm)
Duplicate of A(II): 2.

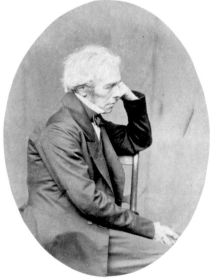

P(3): 22
Professor Michael Faraday, 30 June 1860
[Professor Faraday]
574
Christ Church, Oxford
Legend in violet ink, below center: *Professor Faraday,* written over pencil
inscription *Professor Faraday* partially erased
5½ x 4⅛ in. (14 x 10.5 cm)
Duplicate of A(II): 18.

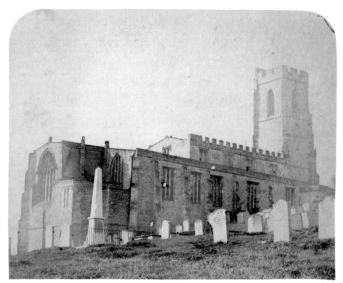

P(3): 23
Richmond Church, spring 1860
[Richmond Church]
478
Richmond, Yorkshire
Legend in violet ink, below center: *Richmond Church, Yorkshire,* written
over pencil inscription *Richmond Church, Yorks* partially erased and over-
written below right
5⅜ x 6⅝ in. (13.8 x 16.7 cm)
Dodgson photographed Richmond Church as part of his pilgrimage to
places of his youth during the Easter vacation of 1860; see also A(I): 46.

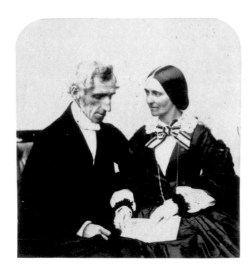

P(3): 24
Rev. Richard and Mrs. Mary Greenall, spring 1860
[Rev. R. and Mrs. Greenall]
492
Daresbury, Cheshire
Legend in violet ink, below center: *Rev. R. and Mrs. Greenall,* written over pencil erasure
4 x 3¾ in. (10.3 x 9.5 cm)
Rev. Richard Greenall (b. 1830), M.A., Brasenose College, Oxford, and his wife, Mary (b. 1835), lived at Stretton, near Warrington, where he was perpetual curate from 1831. Greenall was the author of a number of religious books. His uncle was Sir Gilbert Greenall of Walton Hall, near Daresbury.

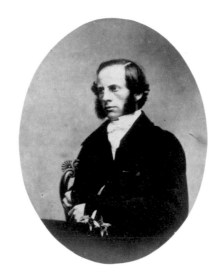

P(3): 25
Rev. George W. Kitchin, summer 1859
[Rev. G. W. Kitchin]
395
Twyford School, Hampshire
Legend in violet ink, below center: *Rev. G. W. Kitchin, / Head Master of Twyford School,* written over pencil erasure (partially legible) *Mr. E. Dodgson was there*
5 x 3¾ in. (12.6 x 9.5 cm)
Rev. George W. Kitchin, headmaster of Twyford School; see A(I): 90.

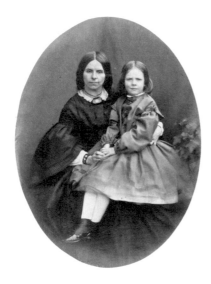

P(3): 26
Mrs. Letitia Barry and Louisa, summer 1860
[Mrs. Barry and Loui]
623
Whitby, Yorkshire
Legend in violet ink, below center: *Mrs. Barry and Louie,* written over pencil erasure
5 x 3¾ in. (12.6 x 9.5 cm)
Duplicate of A(II): 13.

P(3): 27
Broad Walk, Christ Church, June 1857
[Ch. Ch. Meadow]
212
Christ Church, Oxford
Legend in violet ink, below center: *End of Broad Walk, Ch. Ch.,* written over pencil erasure
5⅜ x 6⅝ in. (13.7 x 16.8 cm)
Duplicate of A(I): 14.

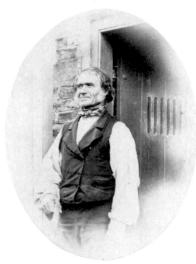

P(3): 28
Robert Foster, August 1857
[R. Foster]
285
Croft Rectory, Yorkshire
Legend in violet ink, below center: *Robert Foster, / gardener at Croft Rectory,* written over pencil erasure
3⅞ x 3 in. (10 x 7.6 cm)
Duplicate of A(I): 55.

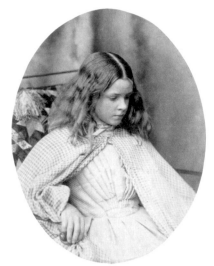

P(3): 29
Louisa Barry, 26–29 August 1863
[Loui Barry]
1072
Whitby, Yorkshire
Legend in violet ink, below center: *Louie Barry,* written over pencil erasure
5½ x 4⅛ in. (14 x 10.5 cm)
Dodgson was at Whitby from 25 August until 4 September 1863, photographing between 26 and 29 August. He noted: "I took my camera to Mr. Keane's, and there photographed all his party, as well as Mrs. Barry's three, Johnnie, Loui, and Emily, and Miss Anna Powell and Constance, and Miss Goode"; see A(II): 13.

P(3): 30
Lucy Tate, 20 August 1863
[Lucy Tate]
1050
Croft Rectory, Yorkshire
Legend in violet ink, below center: *Lucy Tate,* written over pencil erasure, partially legible *Miss L. Tate* below right
6⅝ x 5⅛ in. (16.8 x 13 cm)
Duplicate of A(II): 103.

P(3): 31
Bishop Robert Bickersteth, 24 September 1862
[Bishop Bickersteth]
912
Croft Rectory, Yorkshire
Inscribed in ink, signing as the bishop of Ripon, below right of print: *R. Ripon / Sept. 24. 1862*
4⅞ x 3⅞ in. (12.4 x 9.8 cm)
Duplicate of A(II): 136.

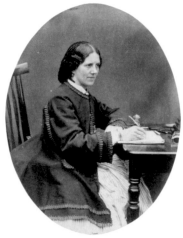

P(3): 32
Minnie Anderson, 20–25 August 1863
[Miss Anderson]
1054
Croft Rectory, Yorkshire
Legend in violet ink, below center: *Miss Anderson, Bedale,* inscription
partially erased below right: *Miss Anderson, Bedale*
5½ x 4⅛ in. (13.9 x 10.5 cm)
Dodgson wrote on 18 August 1863: "Miss Minnie Anderson arrived for
a few days visit." Maria "Minnie" Katherine Anderson (1846–1889) was
the youngest daughter of Rev. Richard Anderson of The Grange, Bedale,
North Yorkshire. She married Walter Moseley (1832–1887) of Buildwas
in September 1864.

P(3): 33
Angus Douglas, 7 October 1863
["The Milkman's Boy." (Angus Douglas)]
1137
16 Cheyne Walk, Chelsea
Legend in violet ink, below center: *Angus Douglas (model to D. G. Rossetti),*
written over pencil erasure
4⅞ x 3⅞ in. (12.5 x 9.9 cm)
Dodgson spent four days at the home of the artist Dante Gabriel Rossetti,
from 6 to 9 October 1863. One of his photographic subjects was Angus
Douglas, a model used by Rossetti, described by Dodgson as "a very fine
curly-headed boy."

P(3): 34
Medora, from an engraving, summer/autumn 1859
["Medora"]
462
Whitburn, Tyne and Wear
Legend in violet ink, below center: *"Medora,"* pencil inscription partially
erased below right: *Medora from a picture*
6⅜ x 4⅞ in. (16.3 x 12.5 cm)
This engraving of a painting entitled *Medora* was probably photographed
at Whitburn, home of Dodgson's Wilcox cousins. Dodgson's diaries are
missing for this period, and the date of the photograph is not clear.

P(3): 35
Agnes Hughes, 12 October 1863
[Agnes Hughes]
1173
12 Earl's Terrace, Kensington
Legend in violet ink, below center: *Agnes Hughes,* pencil inscription
partially erased, below right: *Agnes Hughes daughter of the painter*
4¾ x 4½ in. (12.2 x 11.5 cm)
Agnes Hughes (1859–1945), photographed here as an Indian girl, was the
daughter of the artist Arthur Hughes (1830–1915) and his wife, Tryphena.
Agnes later studied art under her father. She married John Henry White
(later Hale-White), a railway-design engineer, in 1891. They had one child,
Cecily, in 1895.

P(3): 36
Mrs. Louisa Read, 8–11 September 1863
[Miss Erskine (Mrs. Read)]
1083
Winteringham, Lincolnshire
Legend in violet ink, below center: *Mrs. Reed* (sic) *(late) / daughter of Dean Erskine,* written over pencil erasure, largely illegible, only *Ripon* evident
4⅞ x 3⅞ in. (12.5 x 10 cm)
Louisa Lucy Rudston Read (1816–1865) was formerly Miss Erskine, daughter of the Dean of Ripon. She married Rev. Thomas Frederick Rudston Read (1811–1892), the rector of Winteringham, Lincolnshire, in 1845. Dodgson wrote on 11 September 1863: "During our stay at Winteringham I have taken photographs of Mr. and Mrs. Read."

P(3): 37
William Edward and Fanny Wilcox, 19–29 September 1864
[W. E. and F. Wilcox]
P91
Whitburn, Tyne and Wear
Legend in violet ink, below center: *William and Fanny Wilcox,* written over pencil erasure, partially legible
4⅝ x 3⅞ in. (12 x 9.9 cm)
Dodgson was at Whitburn from 19 to 29 September 1864; he wrote on 2 October 1864: "I have omitted all account of my visit to Whitburn. I went on the 19th of September, and was housed by William and Fanny at their little house. During my stay, I took a good many photographs." William Edward (1835–1876) and Fanny (1832–1919) Wilcox were his cousins.

P(3): 38
PHOTOGRAPH MISSING FROM ALBUM
Anna C. Powell, 26–29 August 1863
[Miss Powell (Mrs. Cameron)]
1075
Whitby, Yorkshire
Inscribed in ink below right: *Anna C. Powell*
See P(3): 29, for Dodgson's diary entry where he recorded this photograph of Miss Anna Catherine Powell (1841–1911). She married Commander Orford Somerville Cameron in 1870.

P(3): 39
BLANK PAGE

P(3): 40
Rev. Edward W. Whitaker, September 1865
[Rev. E. W. Whitaker]
1408 ⅔
Croft Rectory, Yorkshire
Inscribed in ink, below right of print: *E. Wright Whitaker / Student of Ch: Ch: / 1865*
4⅜ x 3⅜ in. (10.8 x 8.4 cm)
Rev. Edward Wright Whitaker (1840–1881), M.A., Christ Church, Oxford, became Archdeacon Dodgson's curate at Croft in March 1865. Later he became rector of Stanton-by-Bridge (1868). Whitaker and his wife, Cecilia, had one son, Hugh (b. 1870).

P(3): 41
Rev. Robert I. Salmon, summer 1859
[Rev. G. Salmon (*sic*)]

445

Croft Rectory, Yorkshire

Legend in violet ink, below center: *Rev. R. Salmon, / curate at Croft*, pencil inscription partially erased below right: *Mr. Salmon*

4⅞ x 3⅞ in. (12.5 x 9.9 cm)

Robert Ingham Salmon (b. 1835), curate at Croft; see A(II): 62 for a photograph of Robert Salmon with a little girl.

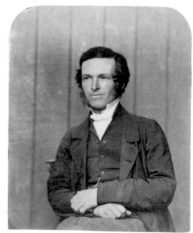

P(3): 42
Rev. James Baker, August 1857
[Rev. J. Baker]

282

Croft Rectory, Yorkshire

Legend in violet ink, below center: *Rev. J. Baker, / curate at Croft*, pencil inscription partially erased below right: *Mr. Baker*

4⅞ x 3⅞ in. (12.5 x 9.9 cm)

Rev. James Baker (1825–1897), M.A., University College, Oxford, was ordained in 1853 and became curate at Great Milton, Oxfordshire, from 1852 to 1854, and then curate at Croft, Yorkshire, until 1858. He was then appointed chaplain of Winchester College, becoming rector of St. Swithin, Winchester, the following year. In 1885 he was chaplain at Hampshire County Hospital.

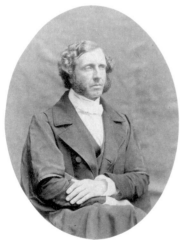

P(3): 43
Rev. Alexander R. Webster, June 1857
[Rev. A. R. Webster]

236

Christ Church, Oxford

Legend in violet ink, below center: *Rev. A. R. Webster, / curate at Croft*, pencil inscription partially erased below right: *Mr. Webster*

5 x 3¾ in. (12.7 x 9.5 cm)

Duplicate of A(I): 16.

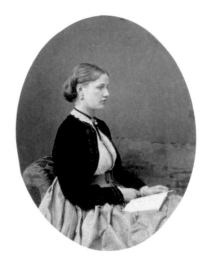

P(3): 44
Mary Allen, June 1866
[Miss Allen (Mrs. Blore)]

1490

Badcock's Yard, Oxford

Legend in violet ink, below center: *Miss Allen / (now Mrs. Blore)*, pencil inscription partially erased below right: *Miss Allen*

3⅞ x 3 in. (9.9 x 7.6 cm)

Dodgson noted the engagement of Mary Allen (b. 1843), daughter of Thomas and Mary Allen of Headington, Oxford, to George John Blore (1835–1916) on 24 June 1867. Blore, formerly one of Dodgson's mathematics students, was then reading divinity at Christ Church.

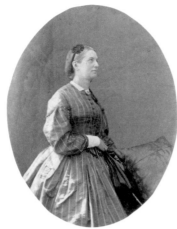

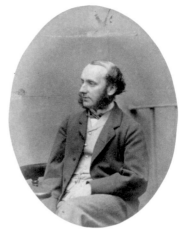

P(3): 45
Charlotte Yonge, 4 May 1866
[Miss C. Yonge]
1452
Badcock's Yard, Oxford
Legend in violet ink, below center: *Miss Yonge,* pencil inscription partially erased below right: *Miss Yonge (Authoress)*
3⅞ x 3 in. (9.9 x 7.6 cm)
Dodgson wrote on 3 May 1866: "Lunched at Prof. Price's to meet Miss Yonge and her mother. It was a pleasure I had long hoped for, and I was very much pleased with her cheerful and easy manner, the sort of person one knows in a few minutes as well as many in as many years. They kindly consented to visit the 'studio' tomorrow." Charlotte Mary Yonge (1823–1901), the author, was visiting Oxford with her mother.

P(3): 46
James Sant, 24 July 1866
[J. Sant, Esq.]
1513
2 Fitzroy Square, London
Legend in violet ink, below center: *J. Sant (Artist),* pencil inscription partially erased below right: *Mr. Sant Artist*
5 x 3¾ in. (12.6 x 9.5 cm)
Dodgson much admired the artist James Sant (1820–1916), whose work he had seen exhibited at the Royal Academy. Sant was appointed portrait painter to Queen Victoria in 1872. He married Eliza Thomson (1833–1907) in 1851. They had six children: Mary Edith (b. 1852), Minnie Lilla (b. 1854), Sarah Fanny Constance (b. 1856), Ada (b. 1859), James "Jimmie or Jemmy" (b. 1862), and Mowbray Lees (b. 1863).

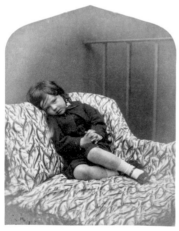

P(3): 47
Jemmy Sant, 26 July 1866
[Jemmy Sant]
1523
2 Fitzroy Square, London
Legend in violet ink, below center: *James, son of J. Sant,* pencil inscription partially erased below right: *Jemmy Sant*
5 x 3⅞ in. (12.8 x 10 cm)
"Took Jimmie (aged 4), and the baby, and two large ones—a group of the four girls, the eldest two playing backgammon—and Mr. Sant at his easel with Constance standing as model," wrote Dodgson on 26 July 1866. See also P(3): 46.

P(3): 48
Chess-Players, August 1866
[Chess-players]
No image number; possibly not by Dodgson
Redcar, Yorkshire
Legend in violet ink, below center: *Group of Chess-Players*
3½ x 5⅛ in. (8.9 x 13 cm)
This group of chess-players and observers is in a pose uncharacteristic of Dodgson, making it difficult to be sure whether he took the photograph. However, he was in Redcar at the time, as his diary for 10 August 1866 recorded: "Spent a good deal of the day watching the 'Chess Tourney.'" The main tournament, organized by the North Yorkshire and Durham Chess Association, was won by Cecil de Vere, aged twenty-one. De Vere is possibly the tall figure in the back row (eighth from left).

P(3): 49
St. Lawrence, 1866?
[The St. Lawrence]
No image number; probably not by Dodgson
Location unknown
Legend in unknown hand
5¼ x 6⅞ in. (13.3 x 17.6 cm)
The following photograph, P(3): 50, shows Dodgson's cousin Harry Wilcox, captain of the *St. Lawrence*. Wilcox probably gave the photograph to Dodgson for the family album. Dodgson did not record visiting the ship or taking this photograph.

P(3): 50
Captain Harry G. Wilcox, 7 July 1866
[Cap. H. G. Wilcox]
1496
Badcock's Yard, Oxford
Signature cropped by page trim; inscribed in ink, below right:
H. G. Wilcox / Captain of St. Lawrence, written over pencil *Henry Wilcox* partially erased
3⅞ x 3 in. (9.9 x 7.6 cm)
Capt. Henry "Harry" George Wilcox (1839–1907) was the son of Dodgson's Uncle William and Aunt Mary Wilcox. At the age of fifteen, Harry sailed for Calcutta on the *Hotspur* as midshipman. In 1859 he was second-mate on the *Blenheim,* his sixth voyage to Calcutta. Harry rose in the ranks to become captain and was also commissioned as sub-lieutenant in the Royal Navy Reserve. When he retired from the sea, he became chief emigration officer for the board of trade at Liverpool.

P(3): 51
Joanna Pollock, 30 July 1866
[Joa Pollock]
1544
2 Fitzroy Square, London
Legend in violet ink, below center: *Joa Pollock,* pencil inscription partially erased below right: *Joa Pollock*
5⅛ x 4 in. (12.9 x 10.1 cm)
(Sir) Charles Edward Pollock (1823–1897), judge in the High Court and last baron of the Court of Exchequer, was married three times. By his second marriage to Georgina née Archibald (d. 1864) he had two children; Joanna de Morlôt (1863–1949) and Charles Stewart (b. 1864). His third wife was Amy Menella Dodgson (1842–1922), third daughter of Dodgson's Uncle Hassard. Dodgson wrote on 30 July 1866: "Took photographs of little Joanna Pollock, Miss Ward, and Beatrice."

P(3): 52
Alice Emily and Alice Jane Donkin, 14 May 1866
[Two Alices]
1455
Badcock's Yard, Oxford
Legend in violet ink, below center: *Two Alices (Donkin),* pencil inscription
partially erased below right: *Miss A. & A. Donkin*
5 x 4 in. (12.8 x 10.1 cm)
"Prof. Donkin (A[II]: 91) and the two Alices came to be photographed:
I got good pictures of all three" wrote Dodgson on 14 May 1866. Alice
Emily Donkin (A[II]: 4) and Alice Jane Donkin (A[II]: 120) were cousins.

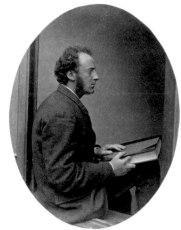

P(3): 53
John Everett Millais, 21 July 1865
[J. E. Millais, Esq.]
1366
7 Cromwell Place, London
Legend in violet ink, below center: *J. E. Millais (Artist),* pencil inscription
partially erased below right: *Mr. Millais*
5 x 3¾ in. (12.7 x 9.5 cm)
John Everett Millais (1829–1896), artist, together with William Holman
Hunt and Dante Gabriel Rossetti founded the Pre-Raphaelite movement.
Dodgson first met the Millais family in April 1864. On 21 July 1865 he
wrote: "Finished photographing at the Millais', by taking beautiful nega-
tives of Mr. M. and Mary, and a family group. . . ."

P(3): 54
Walter Bourke, 5 July 1864
[Walter Bourke]
1291
Lambeth Palace, London
Legend in violet ink, below center: *Walter, / son of Hon. and Rev.
R. Bourke, / and grandson of Abp. Longley,* pencil inscription partially
erased and written over: *Walter Bourke Grandson of Archbishop Longley*
5½ x 4⅛ in. (13.9 x 10.5 cm)
Walter Longley Bourke (1859–1939) was the son of the Hon. Rev. George
Wingfield Bourke (1829–1903) and his wife, Mary Henrietta née Longley
(1837?–1906), and also grandson of the Archbishop of Canterbury.
Dodgson recorded on 5 July 1864: "Lambeth again. Took a small picture
of Mrs. H. Longley, and a full length of little Walter Bourke. . . ."

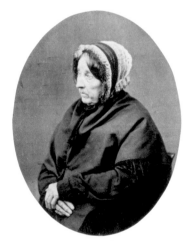

P(3): 55
Mrs. Mary Foster, August 1857
[Mrs. Foster]
286
Croft Rectory, Yorkshire
Legend in violet ink, below center: *Mrs. Foster,* pencil inscription partially
erased below right: *Mrs. Foster*
5 x 3¾ in. (12.7 x 9.5 cm)
Mary Foster (1798–1871), wife of Robert Foster, gardener at Croft
Rectory.

P(3): 56
BLANK PAGE

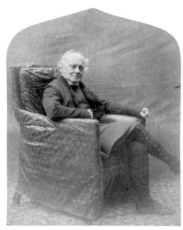

P(3): 57
Bishop Charles T. Longley, October 1856
[Bishop Longley]
128
Hilda Terrace, Whitby
Legend in violet ink, below center: *Bishop of Ripon (Longley)*, written over partial erasure of pencil inscription . . . *then Bishop of Ripon* but rest illegible
5⅛ x 4 in. (12.9 x 10.2 cm)
Charles Longley was photographed many times by Dodgson, here as bishop of Ripon; see A(I): 62.

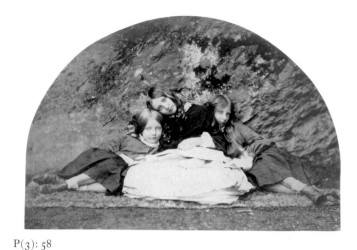

P(3): 58
Mary and Charlotte Webster with Margaret Gatey,
25 September 1857
[C. and M. Webster & M. Gatey]
300
Crosthwaite, near Keswick
Legend in violet ink, below center: *Mary Webster, Margaret Gatey, / and Charlotte Webster*, written over partially erased pencil inscription *The Misses Webster and a friend, daughters of Mr. Webster, curate of Croft*
4⅜ x 6½ in. (11.2 x 16.4 cm)
Duplicate of A(I): 29.

P(3): 59
BLANK PAGE

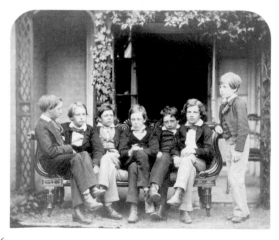

P(3): 60
Seven Twyford Schoolboys, summer 1859
[Edwin & Twyford boys]
393
Twyford School, Hampshire
Legend in violet ink, below center: *Boys at Twyford School / (E. H. Dodgson in centre)*, written over pencil erasure
5⅜ x 6⅝ in. (13.8 x 16.8 cm)
Duplicate of A(I): 52.

P(3): 61
BLANK PAGE

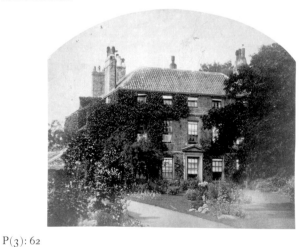

P(3): 62
Croft Rectory, July 1856
[Croft Rectory]
64
Croft Rectory, Yorkshire
Legend in violet ink, below center: *Croft Rectory,* written over pencil erasure
5⅜ x 6⅛ in. (13.7 x 15.6 cm)
Dodgson was at Croft from 20 June to 7 July 1856 making short trips to Dinsdale and Richmond. He returned to Croft on 12 July and remained there until 12 August 1856. This photograph was taken sometime during these periods at the Dodgson family home.

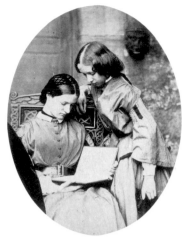

P(3): 63
Caroline and Rosamond Longley, summer/autumn 1859
[C. and R. Longley]
452
Auckland Castle, Durham
Legend in violet ink, below center: *Caroline and Rosamond, / daughters of Bishop Longley,* written over pencil erasure
5½ x 4⅛ in. (14 x 10.5 cm)
Duplicate of A(I): 61.

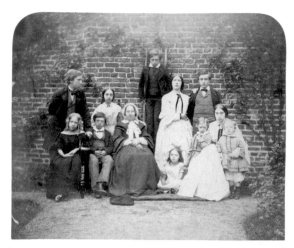

P(3): 64
Wilcox Family Group, summer/autumn 1859
[Group of Wilcoxes]
460
Whitburn, Tyne and Wear
Legend in violet ink, below center: *Mrs. Wilcox, with five sons, four daughters, / a niece and a nephew,* written over pencil erasure
5½ x 6½ in. (13.9 x 16.6 cm)
Duplicate of A(I): 94.

P(3): 65
BLANK PAGE

P(3): 66
Phoebe Irwin (Bostock), spring 1860
[Phoebe Bostock]
491
Daresbury, Cheshire
Legend in violet ink, below center: *Phoebe Irwin (formerly a / servant at Daresbury)*
5 x 3⅞ in. (12.7 x 9.9 cm)
Phoebe Bostock née Thomas, later Irwin (b. 1812), formerly a servant at Daresbury, was born in Wales. She married Joseph Bostock in Daresbury on 7 May 1840, and they had a daughter in 1842. Later she married James Irwin at Runcorn in 1851. Dodgson photographed her during his pilgrimage to places of his youth during the Easter vacation in 1860.

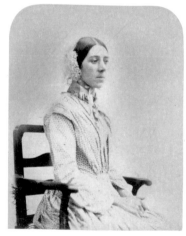

P(3): 67
Mary Houghton, spring 1860
[Mary Houghton]
490
Daresbury, Cheshire
Legend in violet ink, below center: *Mary Houghton (formerly a / servant at Daresbury),* written over pencil erasure
5 x 3⅞ in. (12.7 x 9.9 cm)
Mary Houghton née Cliff (b. 1822), formerly a servant at Daresbury Parsonage, but at the time of this photograph she was married and living in the village of Daresbury. Dodgson photographed her during his pilgrimage to places of his youth in 1860.

P(3): 68
BLANK PAGE

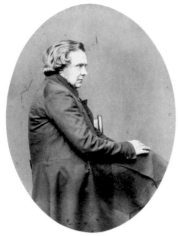

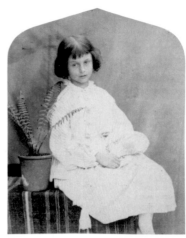

P(3): 69
Bishop Samuel Wilberforce, 28 June 1860
[Bishop Wilberforce]
571
Christ Church, Oxford
Legend in violet ink, below center: *Bishop of Oxford / (Wilberforce)*, written over pencil erasure
6½ x 4¾ in. (16.6 x 12.3 cm)
Duplicate of A(II): 7.

P(3): 70
Alice Liddell, July 1860
[Alice Liddell (fern)]
613
Deanery garden, Christ Church, Oxford
Legend in violet ink, below center: *Alice Liddell,* written over pencil erasure visible as *Miss Alice Liddell*
5⅛ x 4 in. (13 x 10.1 cm)
Duplicate of A(II): 53.

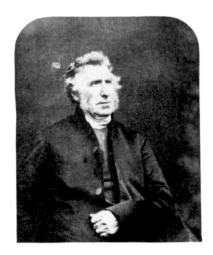

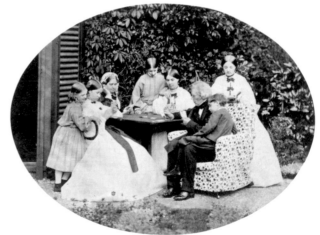

P(3): 71
Dean Henry D. Erskine, autumn 1860
[Dean Erskine]
663
Croft Rectory, Yorkshire
5⅝ x 4⅝ in. (14.1 x 12 cm)
See A(I): 38, but this is a re-photographed picture of image number 333 including the dean's signature.

P(3): 72
BLANK PAGE

P(3): 73
Uncle Hassard Dodgson and Family, 1–11 September 1862
[Putney group (whist)]
863
Park Lodge, Putney
Legend in violet ink, below center: *H. H. Dodgson and family,* written over pencil erasure
4⅞ x 6⅜ in. (12.4 x 16.3 cm)
Dodgson's Uncle Hassard and Aunt Caroline with six of their ten children playing whist; one son died in infancy. The children here are Louis Henry (b. 1850) on Hassard's lap, and the five daughters: Lucy Caroline (b. 1836), Charlotte Mary (b. 1839), Amy Menella (1842–1922), Menella Frances (b. 1848), and Laura Elizabeth (b. 1853).

P(3): 74
BLANK PAGE

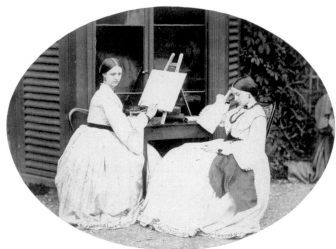

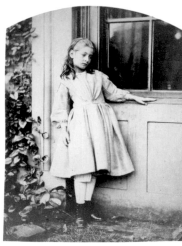

P(3): 75
Alice and Meta Poole, 1–11 September 1862
[Meta and Alice Poole]
864
Park Lodge, Putney
Legend in violet ink, below center: *Meta and Alice Poole,* written over pencil erasure
4¾ x 6⅜ in. (12.3 x 16.3 cm)
Duplicate of A(II): 131.

P(3): 76
Gertrude Dykes, September 1862
[Gertrude Dykes]
904
Croft Rectory, Yorkshire
Legend in violet ink, below center: *Gertrude, daughter of Rev. Dr. Dykes,* written over partial pencil erasure
8 x 6⅛ in. (20.2 x 15.5 cm)
Duplicate of A(II): 133.

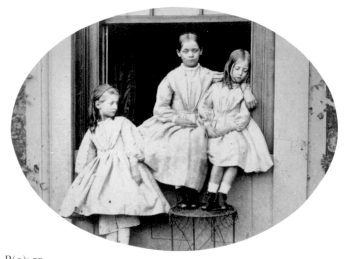

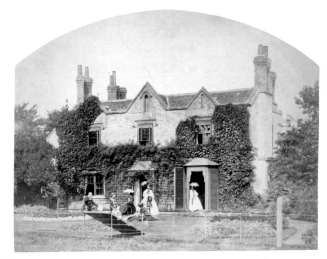

P(3): 77
Gertrude, Mary, and Caroline Dykes, September 1862
[Group of Dykeses]
907
Croft Rectory, Yorkshire
Legend in violet ink, below center: *Children of Rev. Dr. Dykes,* written over partial pencil erasure: *The Miss Dykes*
5⅝ x 7½ in. (14.2 x 19 cm)
Gertrude (left) with Mary (b. 1852) and Caroline Sybil (b. 1856), daughters of Dr. John Bacchus Dykes and his wife, Susannah; see A(II): 133.

P(3): 78
BLANK PAGE

P(3): 79
Old House, Putney, 1–11 September 1862
[Putney House]
868
Park Lodge, Putney
Legend in violet ink, below center: *Residence of H. H. Dodgson, Putney,* written over partial pencil erasure: *House of Mr. and Mrs. H. Dodgson, Putney*
6⅜ x 8 in. (16.1 x 20.4 cm)
Park Lodge, or "The Old House" at Putney, home of Dodgson's Uncle Hassard, including (left to right) Aunt Caroline, Hal Poole, Col. Skeffington Poole, Amy, Menella (seated), Meta Poole, Laura and Alice Poole (seated), Lucy and Charlotte; see also A(II): 34 and P(3): 73.

P(3): 80
BLANK PAGE

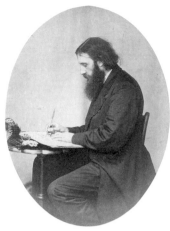

P(3): 81
George MacDonald, 27 July 1863
[G. MacDonald, Esq.]
1003
Elm Lodge, Hampstead
Legend in violet ink, below center: *George MacDonald,* written over partial pencil erasure: *Mr. George MacDonald (Author)*
6½ x 4¾ in. (16.4 x 12.3 cm)
Duplicate of A(II): 59.

P(3): 82
BLANK PAGE

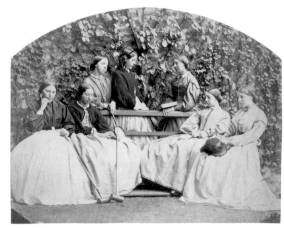

P(3): 83
Dodgson Sisters, 20–25 August 1863
[Seven Sisters]
1058
Croft Rectory, Yorkshire
Legend in violet ink, below center: *The Misses Dodgson, Croft Rectory,* written over pencil erasure partially legible which reads . . . *in Croft Rectory Garden*
6½ x 8 in. (16.4 x 20.2 cm)
Dodgson's seven sisters with croquet equipment. Individuals are not identified, but it is likely that they are (left to right): Mary, Caroline, Frances, Henrietta, Elizabeth, Margaret, and Louisa.

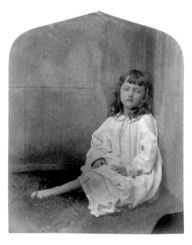

P(3): 84
Mary Millais in "Waking," 21 July 1865
[Mary Millais]
1369
7 Cromwell Place, London
Legend in violet ink, below center: *Mary Millais,* written over partial pencil erasure: *Mary Millais*
5 x 4 in. (12.8 x 10.2 cm)
Mary Hunt Millais (1860–1944), daughter of John Everett Millais, in a photograph that Dodgson later entitled "Waking." Millais commenced a painting of Mary in July 1865 that he called "Waking," but it is not clear who had the first inspiration.

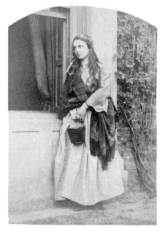

P(3): 85
Mrs. Eliza Fawcett (Rose Wood) as "Jeannie Campbell," September 1865
[Miss R. Wood]
1405
Croft Rectory, Yorkshire
Legend in violet ink, below center: *Miss Wood, Hollin Hall, / Ripon (now Mrs. Fawcett),* written over pencil erasure
6⅝ x 4½ in. (16.7 x 11.4 cm)
Dodgson first met Eliza Rose Wood (b. 1843) of Hollin Hall, Ripon, in January 1856, when she was thirteen. She married Lt. Col. Rowland Hill Fawcett (d. 1914) on 12 August 1865. Dodgson wrote on 5 September 1865: "Miss Rose Wood and Ada Leigh arrived . . . ," but he does not specifically mention taking this photograph on that day.

P(3): 86, 87
BLANK PAGES

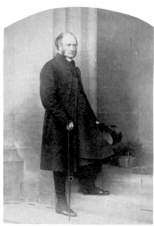

P(3): 88
Bishop Robert Bickersteth, 7 September 1865
[Bishop Bickersteth]
1426
Bishop's Palace, Ripon
Legend in violet ink, below center: *Bishop of Ripon (Bickersteth),* written over pencil erasure
7⅛ x 4⅞ in. (18 x 12.5 cm)
Robert Bickersteth, bishop of Ripon, standing on the steps of the Bishop's Palace at Ripon. In September 1865, Dodgson made a visit to Ripon, and on 7 September he wrote: "Spent most of the day in photographing, and got good pictures of the Bishop . . . "; see A(II): 136.

P(3): 89
Bishop's Palace, Ripon, 9 September 1865
[The Palace, Ripon]
1445
Bishop's Palace, Ripon
Legend in violet ink, below center: *Bishop's Palace and Chapel, / Ripon,* written over pencil erasure
5⅝ x 7⅜ in. (14.4 x 18.9 cm)
On 9 September 1865, the last day of Dodgson's visit to Ripon, he wrote: "Took some pictures in the morning, including one of the Palace. Returned to Croft." The chapel (on the right) in the Bishop's Palace has a memorial window dedicated to Dodgson's father, the archdeacon.

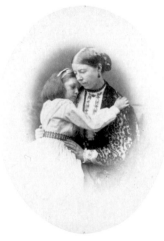

P(3): 90
Catharine Lloyd and Katie Brine, 16 June 1866
[Miss Lloyd & Katie Brine]
1487
Badcock's Yard, Oxford
Legend in violet ink, below center: *Miss Lloyd, and / her godchild Kate Brine, Oxford,* written over pencil erasure
4⅜ x 3⅜ in. (11.3 x 8.6 cm)
Catharine Eliza Lloyd (1824–1898) photographed with her godchild, Catherine "Katie" Gram Brine (b. 1860). Catherine, daughter of Charles Lloyd (1784–1829), bishop of Oxford, was a close friend of Dodgson for many years. Katie was the daughter of James Gram Brine (1819–1901), rector of All Saints, Chardstock, Dorset, and his wife, Mary Amelia (b. 1834), who was the youngest daughter of Dr. Edward Bouverie Pusey (1800–1882), Regius Professor of Hebrew at Oxford.

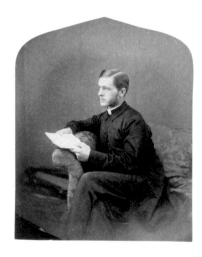

P(3): 91
Rev. George E. Jelf, July 1866
[Rev. G. E. Jelf]
1495
Badcock's Yard, Oxford
Legend in violet ink, below center: *Rev. G. E. Jelf,* written over partial pencil erasure: *Mr. G. Jelph* [sic] *son of Canon Jelph (late) at Oxford*
5½ x 4 in. (13.9 x 10.2 cm)
Rev. George Edward Jelf (1834–1908), M.A., Christ Church, Oxford, held various curacies between 1858 and 1868 before becoming vicar of Saffron Walden in 1874. He was made an honorary canon of St. Albans in 1878 and canon of Rochester in 1880. Dodgson listed his photographic subjects during the first week of July 1866, including George Jelf.

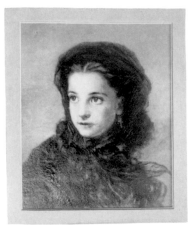

P(3): 92
"Minnie Morton," 11–23 July 1866
["Minnie Morton"]
1503
Badcock's Yard, Oxford
Legend in violet ink, below center: *Picture by Mrs. Anderson*
4⅜ x 3½ in. (10.8 x 9 cm)
The works of Sophie Anderson (1823–1903) were much admired by
Dodgson. In June 1864 he purchased his first picture from her, "Minnie
Morton," the subject of this photograph. Dodgson later discovered that
Florence Braithwaite (b. 1852), the daughter of a friend, probably sat
for this portrait. Later he asked Sophie Anderson to make a copy of this
picture so that he could give it to his sister Mary as a wedding gift in 1869.

P(3): 93
BLANK PAGE

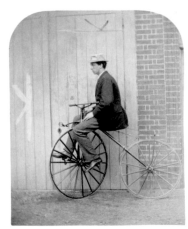

P(3): 94
Wilfred Dodgson, 4–17 September 1869
[W. L. Dodgson (bicycle)]
1754
Chestnuts, Guildford, Surrey
Legend in violet ink, below center: *W. L. Dodgson,* written over partial
pencil erasure: *Mr. Wilfred Dodgson*
4¼ x 3⅜ in. (10.6 x 8.5 cm)
After the death of Archdeacon Dodgson in 1868, the family moved to
Guildford. Wilfred Dodgson is seen with a bone-shaker bicycle resting
against the outbuildings of The Chestnuts, the new family home.

P(3): 95
May Haydon, 6 October 1869
[May Haydon]
1852
Guildford, Surrey
Legend in violet ink, below center: *May Haydon,* written over partial pencil
erasure: *Miss May Haydon of Guildford*
4⅜ x 3⅜ in. (11.3 x 8.6 cm)
The Haydon family lived next door to the Dodgsons at Guildford. "Had
my camera in the Haydons' garden most of the morning, and took several
good pictures," wrote Dodgson on 6 October 1869. Among the pictures he
took was this photograph of Mary "May" Eleanor Haydon (1862–1944).

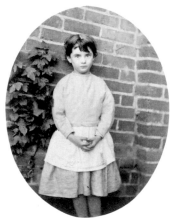

P(3): 96
Edith Haydon, 6 October 1869
[Edith Haydon]
1854
Guildford, Surrey
Legend in violet ink, below center: *Edith Haydon,* written over partial
pencil erasure: *Miss Edith Haydon*
4⅜ x 3⅜ in. (11.2 x 8.7 cm)
Edith Georgiana Haydon (b. 1863), taken at the same time as the previous
photograph, P(3): 95. Her parents were Dodsworth Haydon (b. 1829),
a banker at Guildford, and his wife, Eleanor Georgiana née Dudding
(b. 1839).

P(3): 97
BLANK PAGE

P(3): 98
Lord Salisbury and His Sons, James and William Cecil,
23 June 1870
[Lord Salisbury & boys]
1870
Badcock's Yard, Oxford
Legend in violet ink, below center: *Lord Salisbury, and eldest two sons,*
written over pencil erasure
4¼ x 3⅜ in. (10.6 x 8.4 cm)
Robert Cecil, Lord Salisbury (1830–1903), was installed as chancellor
of Oxford University on 21 June 1870. Two days later "Lord Salisbury
and party came, and I took negatives of him, alone, and with the two little
boys in the dresses they wore as his train bearers," recorded Dodgson.
The two sons of Lord Salisbury were James (1861–1947) and William
(1863–1936).

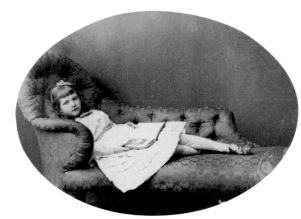

P(3): 99
Xie Kitchin, 19–30 April 1872
[Xie Kitchin on sofa]
2012
Christ Church Studio, Oxford
Legend in violet ink, below center: *Xie Kitchin,* written over partial pencil
erasure: *Miss Kitchin*
4¾ x 6½ in. (12.3 x 16.6 cm)
Alexandra "Xie" Rhoda Kitchin (1864–1925) was the daughter of
George W. Kitchin and his wife, Alice Maud née Taylor (1844?–1930).
Xie was named after Alexandra, Princess of Wales, childhood friend
of her mother's. She was Dodgson's favorite photographic subject, and
he took many pictures of her over a period of more than ten years.

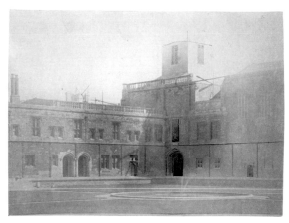

P(3): 100
The New Belfry, Christ Church, April 1873
[The New Belfry]
2120
Christ Church, Oxford
Legend in violet ink, below center: *The New Belfrey* [sic], *Ch. Ch. Oxford,*
written over pencil erasure
5⅝ x 7½ in. (14.1 x 19 cm)
The New Belfry at Christ Church was an ugly wooden structure built
above the staircase into Hall. Dodgson wrote a satirical pamphlet about
this eyesore, which he likened to a "Tea-Chest." He also attacked two
other architectural features seen in this photograph: the new entrance
(double-doorway) into the cathedral (the "Tunnel") and the cutaway
parapet between the belfry and Hall (the "Trench").

P(3): 101
Xie Kitchin as "Dane," 14 May 1873
[Xie Kitchin (Danish)]
2132
Christ Church Studio, Oxford
Legend in violet ink, below center: *Xie Kitchin,* written over partial pencil
erasure: *Miss Kitchin*
6⅝ x 4⅛ in. (16.8 x 10.4 cm)
"Photographed Xie in winter dress (Danish), in red petticoat, and in Greek
dress," Dodgson noted on 14 May 1873. His picture of Xie as "Dane" was
a particular favorite; he had many copies printed and often gave it as a gift
to friends. Alice Emily Donkin was later inspired to use the photograph for
her painting *Waiting to Skate,* which Dodgson hung in his rooms at Christ
Church.

P(3): 102
BLANK PAGE

P(3): 103
Rev. Edward F. Sampson, June 1875
[Rev. E. F. Sampson]
2314
Christ Church Studio, Oxford
Legend in violet ink, below center: *Rev. E. F. Sampson,* written over partial pencil erasure: *Mr. Sampson Mathematical Lecturer at Oxford*
5 x 4 in. (12.8 x 10.3 cm)
Rev. Edward Francis "Frank" Sampson (1848–1918), M.A., St. John's College, Oxford, became a senior student at Christ Church in 1869 and was appointed mathematics tutor and lecturer in 1870 to assist Dodgson in his duties. When Dodgson retired in 1881, Sampson took over as senior lecturer in mathematics.

P(3): 104
BLANK PAGE

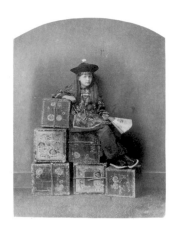

P(3): 105
Xie Kitchin as "Tea-Merchant" (On Duty), 14 July 1873
["Tea-merchant." (on duty)]
2155
Christ Church Studio, Oxford
Legend in violet ink, below center: *Xie Kitchin,* written over partial pencil erasure: *Miss Kitchin*
6⅝ x 5 in. (16.7 x 12.7 cm)
This photograph and the next in this album form a pair. Xie Kitchin is dressed as a Chinese "tea-merchant" sitting on tea chests, with fan in hand. On 14 July 1873 Dodgson wrote: "Took Xie in Chinese dress (two positions)." In this pose, Dodgson described her as "on duty."

P(3): 106
Xie Kitchin as "Tea-Merchant" (Off Duty), 14 July 1873
["Tea-merchant." (off duty)]
2156
Christ Church Studio, Oxford
Legend in violet ink, below center: *Xie Kitchin,* written over partial pencil erasure: *Miss Kitchin*
6⅝ x 4⅞ in. (16.8 x 12.5 cm)
Xie Kitchin is "off duty" as "tea-merchant" in this photograph, without hat and leaning against the tea chests in a relaxed manner. Unfortunately, there are signs of cropping marks on this photograph, added by persons unknown. The photograph has been reproduced countless times.

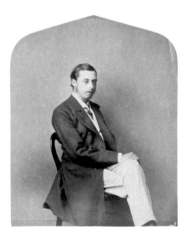

P(3): 107
Prince Leopold, Duke of Albany, 2 June 1875
[Prince Leopold]
2306
Christ Church Studio, Oxford
Legend in violet ink, below center: *Prince Leopold,* written over pencil erasure
5⅛ x 4 in. (12.9 x 10.1 cm)
Prince Leopold, duke of Albany (1853–1884), Queen Victoria's youngest son, as undergraduate at Oxford. "The Prince came alone about 11½, and was joined afterwards by Collins [his tutor]. He staid till nearly 1, and I took two photographs of him, but neither was quite free from moving," wrote Dodgson on 2 June 1875.

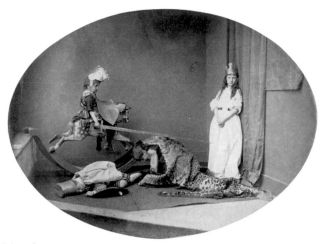

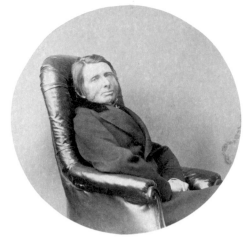

P(3): 108

Xie, Herbert, Hugh, and Brook Kitchin in "St. George and the Dragon," 26 June 1875

["St. George & the Dragon"]

2316

Christ Church Studio, Oxford

Legend in violet ink, below center: *S. George and the Dragon / (children of Rev. G. W. Kitchin),* written over pencil erasure

4⅛ x 5½ in. (10.5 x 14 cm)

All four Kitchin children—Brook Taylor (1869–1940) as St. George on the rocking-horse, George Herbert (b. 1865) and Hugh Bridges (1867–1945) as the defeated soldier and the Dragon (draped with leopard skin), and Xie as the damsel—play their part in this mythological scene.

P(3): 109

John Ruskin, 3 June 1875

[J. Ruskin, Esq.]

2309

Christ Church Studio, Oxford

Legend in violet ink, below center: *John Ruskin,* written over partial pencil erasure: *Mr. Ruskin (Author)*

5⅝ x 3⅞ in. (14.1 x 10 cm)

"With some difficulty persuaded Ruskin to come and be photographed, and to stay luncheon with us," wrote Dodgson on 3 June 1874. John Ruskin (1819–1900), M.A., Christ Church, Oxford, became Slade Professor of Fine Art in 1869. As an art critic he was a strong supporter of the Pre-Raphaelites.

P(3): 110

BLANK PAGE

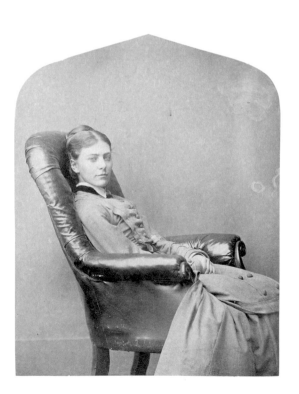

P(3): 111

Amy Walters, June 1875

[Amy Walters]

2310

Christ Church Studio, Oxford

Legend in violet ink, below center: *Miss Walters,* written over partial pencil erasure: *Miss Walters Guildford*

5⅛ x 3⅞ in. (13 x 10 cm)

Amy S. Walters (b. 1856?) was one of five daughters of Henry Littlejohn Master Walters (1821–1898) and his wife, Harriet (b. 1825). The family lived at Guildford and Dodgson often visited them. Here, on a visit to Oxford, she sits in the same chair as Ruskin in Dodgson's studio at Christ Church; see P(3): 109.

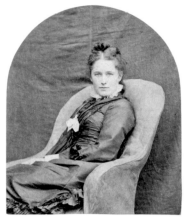

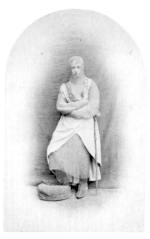

HH: 1
Rose Lawrie, 7 July 1875
[Miss Lawrie]
2351–2357
Oak Tree House, Hampstead
Inscribed in violet ink, below center of print: *"A Rose once grew within / A garden April-green, / In her loneness, in her loneness, / And the fairer for that oneness."*
4¾ x 3⅞ in. (12.2 x 10 cm)
Dodgson was at Oak Tree House, Hampstead, the London home of Henry Holiday (1839–1927), from 5 July until 14 July 1875, with the specific purpose of taking a series of photographs of Holiday's family and friends, Rose Lawrie (b. 1860?) being one of them.

HH: 2
Evelyn Dubourg as "Joan of Arc," 12 July 1875
["Joan of Arc" (Evelyn Dubourg)]
2361–2400
Oak Tree House, Hampstead
Inscribed in violet ink, below center of print: *"Dulce et decorum est pro patria mori"* [it is sweet and glorious to die for one's country]
5⅝ x 3⅜ in. (14.1 x 8.7 cm)
Evelyn Sophia Dubourg (1861–1917) was the daughter of Augustus William Dubourg (1830–1910), dramatist and clerk to the House of Lords, and his wife, Ellen. Later (in 1885) Evelyn married Robert Gustavus Alexander, a captain in the 3rd Hussars. Dodgson, who first met the Dubourgs at a party at the home of Arthur and Kate (Terry) Lewis in January 1869, included two distinct poses of Evelyn as Joan of Arc in this album; see HH: 7.

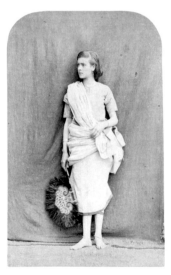

HH: 3
"An Ayah," 10 July 1875
["An Ayah"]
2354–2369
Oak Tree House, Hampstead
Inscribed in violet ink, below center of print: *"Tiffin's not ready yet."*
5⅝ x 3½ in. (14.5 x 9 cm)
This young female dressed as an East Indies native lady's maid is not identified by Dodgson, but she may be either Daisy Whiteside (dates unknown) or Honor Brooke (b. 1862), both of whom appear elsewhere in this album.

HH: 4
Mrs. Lawrie, 7 July 1875
[Mrs. Lawrie]
2351–2357
Oak Tree House, Hampstead
No inscription
4⅜ x 3⅜ in. (11.3 x 8.7 cm)
Mrs. Lawrie (dates unknown), mother of the sitter in the first portrait of this album. The connection between the Holidays and the Lawries is not known.

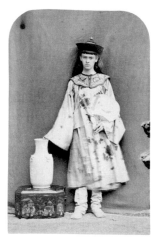

HH: 5

Daisy Whiteside in "A Chinese Bazaar," 10 July 1875

["A Chinese Bazaar"]

2354–2369

Oak Tree House, Hampstead

Inscribed in violet ink, below left of center: *"Me givee you good piecey bargain."*

6 x 3¾ in. (15.3 x 9.6 cm)

Dodgson does not identify the female in Chinese costume, but it is possibly Daisy Whiteside. She was the daughter of William Whiteside, whom Henry Holiday met in India in 1871. Whiteside was a merchant and farmer in India.

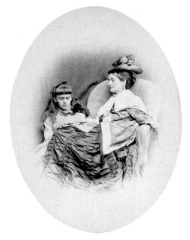

HH: 6

Mrs. Whiteside and Daisy, 10 July 1875

[Mrs. Whiteside and Daisy]

2354–2369

Oak Tree House, Hampstead

Inscribed in violet ink, below left of center: *"Sweet, all sweets above, / Is a Mother's love, / Deep as death her love / Even for a Daisy."*

5½ x 4⅛ in. (14 x 10.4 cm)

A feature of this photographic album is the number of mother and daughter photographs taken, either separately, or, as in this case, with Maria Whiteside (b. 1838) together with her daughter, Daisy (see HH: 5).

HH: 7

Evelyn Dubourg as "Joan of Arc," 12 July 1875

["Joan of Arc" (larger)]

2361–2400

Oak Tree House, Hampstead

Inscribed in violet ink, below center of print: *"My good blade carves the casques of men."* [from Tennyson's "Sir Galahad"]

6⅜ x 3¾ in. (16 x 9.6 cm)

Evelyn Dubourg in a larger version of "Joan of Arc" (see HH: 2).

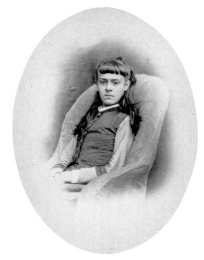

HH: 8

Daisy Whiteside, 10 July 1875

[Daisy]

2354–2369

Oak Tree House, Hampstead

Inscribed in violet ink, below center of print: *"No sooner does the sun appear / From out the vapours hazy, / Than, first bright offering to the year, / Expands the little Daisy."* [possibly an original poem by Dodgson]

5½ x 4⅛ in. (14 x 10.5 cm)

Daisy Whiteside (see HH: 5). Dodgson wrote on 10 July 1875: "Did photos of Daisy, Lady E. Cecil, etc."

HH: 9
Rose Lawrie in "The Birthday Wreath," 13 July 1875
["The Birthday Wreath" (Miss Lawrie)]
2374 2400
Oak Tree House, Hampstead
Inscribed in violet ink, below center of print: *"Because the birthday of my life, / Is come, my love is come to me."* [from Christina Rossetti's "A Birthday"]
5⅞ x 3⅜ in. (15 x 8.7 cm)
Dodgson presented Rose Lawrie with a copy of *The Hunting of the Snark* personally inscribed in March 1876.

HH: 10
Evelyn Dubourg and Kathleen O'Reilly as "Fairy Cooks," 10 July 1875
["Fairy Cooks" (Evelyn Dubourg & Kathleen O'Reilly)]
2354–2369
Oak Tree House, Hampstead
Inscribed in violet ink, below center of print: *"Fairy Cooks."*
5 x 3¾ in. (12.6 x 9.5 cm)
Evelyn Dubourg (HH: 2 and 7) and Kathleen O'Reilly (b. 1865) as "Fairy Cooks." Dodgson's interest in fairies became a feature of his last major literary works, the *Sylvie and Bruno* books (1889 and 1893), which he was working on at this time.

HH: 11
Honor Brooke as "A Modern Greek," 13 July 1875
["A modern Greek" (Honor Brooke)]
2374–2400
Oak Tree House, Hampstead
Greek quotation inscribed in violet ink, below center of print: ["Ζωη μ̂ου, δᾶς ἀγαπῶ."] [My life, I love you.]
5½ x 4⅛ in. (14 x 10.4 cm)
In a letter to Dodgson's sister dated 12 November 1900 (MS. Dodgson Family Collection), Honor Brooke wrote: "The day when Mr. Dodgson took me is as fresh in my memory as yesterday. It was up at Mr. Holiday's house in Hampstead: and Winifred and I climbed a tree and discussed how I should like to be taken with naked toes."

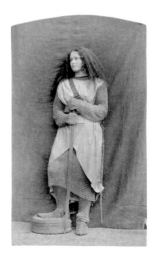

HH: 12
Rose Lawrie in "Waiting for the Trumpet," 7 July 1875
["Waiting for the trumpet"]
2351–2357
Oak Tree House, Hampstead
Inscribed in violet ink, below center of print: *"A maiden knight; to me is given / Such bliss, I know not fear."* [from Tennyson's "Sir Galahad"]
5⅝ x 3⅜ in. (14.4 x 8.4 cm)
Rose Lawrie is seen wearing Henry Holiday's specially made chain-mail costume, the same one used by Evelyn Dubourg in her poses as Joan of Arc (HH: 2 and 7).

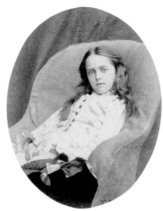

HH: 13
Amy Raikes, 8 July 1875
[Amy Raikes]
2352–2357
Oak Tree House, Hampstead
No inscription
4½ x 3⅜ in. (11.5 x 8.6 cm)
Dodgson wrote on 8 July 1875: "Mrs. Cecil Raikes brought Amy and Edith, who are much grown." Blanche Amabel "Amy" Raikes (1865?–1904) was the second daughter of the Rt. Hon. Henry Cecil Raikes M.P., and his wife, Charlotte. Dodgson was distantly related to the Raikes family, Henry Cecil having a common great-grandfather with Dodgson's Uncle Thomas and Aunt Elizabeth née Lutwidge.

HH: 14
Edith Morley in "The Castle Builder," 9 July 1875
["The Castle Builder" (Edith Morley)]
2353–2357
Oak Tree House, Hampstead
Inscribed in violet ink, below center of print: *We are building little homes on the sands; / We are making little rooms very gay; / We are busy with our hearts and our hands; / We are sorry that the time flits away.*" [possibly an original poem by Dodgson]
6⅛ x 3½ in. (15.6 x 9 cm)
Edith Caroline Morley (1864–1945) was the youngest daughter of Henry Morley (1822–1894), professor of literature at University College, London, and his wife, Mary. Dodgson drew Edith on the beach at Sandown, Isle of Wight (1874), enjoying her favorite pastime of digging in the sand. He wrote on 9 July 1875: "Very rainy, copied pictures in studio, and did Edith Morley."

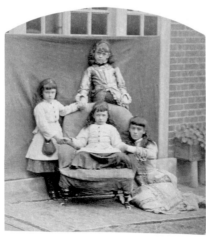

HH: 15
Daisy Whiteside with Beatrix, May, and Sylvia Du Maurier, 12 July 1875
[Daisy and 3 du Mauriers]
2361–2400
Oak Tree House, Hampstead
Inscribed in violet ink, below center of print: *Linked sweetness long drawn out.*" [from Milton's "L'Allegro" (1632)]
5⅝ x 5 in. (14.1 x 12.6 cm)
Daisy Whiteside joins hands with three Du Maurier sisters, Marie "May" (b. 1869), Sylvia (b. 1867), and Beatrix (1864–1913), forming a chain of friendship. The sisters were daughters of the writer and actor George Du Maurier (1834–1896) and his wife, Emma (b. 1841). Dodgson first met the Du Mauriers in January 1868. He consulted Du Maurier about the French translation of *Alice*.

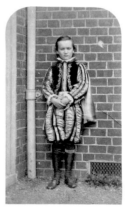

HH: 16
Hon. Evelyn Cecil as "Shakspere," 10 July 1875
["Shakspere" (Hon^blc. Evelyn Cecil)]
2354–2369
Oak Tree House, Hampstead
Inscribed in violet ink, below center of print: *Sweetest Shakspere, Fancy's child.*" [from Milton's "L'Allegro" (1632)]
6⅛ x 3⅝ in. (15.5 x 9.2 cm)
The Hon. Evelyn Cecil (1865–1941) was the eldest son of Lord Eustace Cecil (1834–1921) and his wife, Lady Gertrude. Evelyn later became Baron Rockley, M.P. for East Hertfordshire, and private secretary to the prime minister. He was a cousin to Lord Salisbury's children.

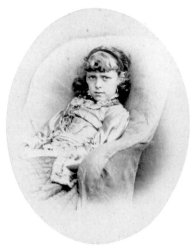

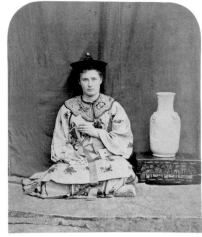

HH: 17
Beatrix Du Maurier, 12 July 1875
[Beatrix du Maurier]
2361–2400
Oak Tree House, Hampstead
Inscribed in violet ink, below center of print: *"My Tricksy Sprite!"*
4⅜ x 3⅜ in. (11.3 x 8.7 cm)
Beatrix was the eldest daughter of George and Emma Du Maurier. Dodgson wrote on 12 July 1875: "A grand day of photos, did the Du Maurier children, and the Terrys; Polly in armour, and as 'Dora,' and Florence as a Turk"; see HH: 15.

HH: 18
Rose Lawrie as "The Heathen Chinee," 13 July 1875
["The Heathen Chinee" (Miss Lawrie)]
2374–2400
Oak Tree House, Hampstead
Inscribed in violet ink, below center of print: *"Which we had a small game, / And Ah-Sin took a hand; / It was euchre—the same / He did not understand; / But he smiled as he sat by the table / A smile that was child-like and bland."*
[from Bret Harte's *Plain Language from Truthful James* (1870)]
5½ x 4⅝ in. (14 x 11.6 cm)
The title of this photograph of Rose Lawrie also comes from the same book by Bret Harte (1836–1902), "The heathen Chinee is peculiar, Which the same I would rise to explain."

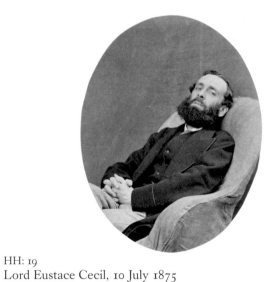

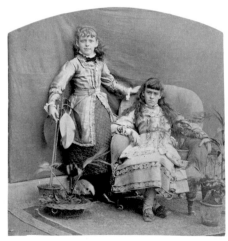

HH: 19
Lord Eustace Cecil, 10 July 1875
[Lord Eustace Cecil]
2354–2369
Oak Tree House, Hampstead
No inscription
4⅜ x 3⅜ in. (11.3 x 8.7 cm)
Lord Eustace Brownlow Henry Cecil (1834–1921), younger brother of Robert Cecil, the 3rd marquis of Salisbury, was a lieutenant colonel in the Coldstream Guards and M.P. for West Essex (1868–85). He married Lady Gertrude in 1860, and they had two sons and a daughter, Evelyn, Algernon, and Blanche.

HH: 20
Beatrix Du Maurier and Daisy Whiteside, 10 July 1875
[Daisy and Beatrix]
2354–2369
Oak Tree House, Hampstead
No inscription
5⅞ x 5⅝ in. (15 x 14.2 cm)
Beatrix Du Maurier (left) and Daisy Whiteside (right); see HH: 5 and 15.

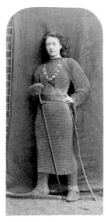

HH: 21
Marion Terry as "Fitz-James," 12 July 1875
["Fitz-James" (Miss M. Terry)]
2370
Oak Tree House, Hampstead
Inscribed in violet ink, below center of print: *"Come one, come all! This rock shall fly / From its firm base as soon as I!"*
5⅝ x 2⅝ in. (14.2 x 6.6 cm)
Holiday wrote: "Among others he [Dodgson] photographed Miss Marion Terry in my chain-mail, and I drew her lying on the lawn in the same" (*Reminiscences of My Life* [William Heinemann, 1914], p. 244, which includes Holiday's sketch of Marion "Polly" Terry [1854–1930]).

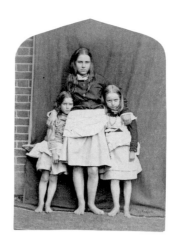

HH: 22
Honor, Evelyn, and Olive Brooke in "Going-a-Shrimping,"
13 July 1875
["Going-a-shrimping" (Honor, Evelyn, & Olive Brooke)]
2374–2400
Oak Tree House, Hampstead
Inscribed in violet ink, below center of print: *"Pretty little legs / Paddling in the waters, / Knees, as smooth as eggs, / Belonging to my daughters."*
5⅝ x 4 in. (14.6 x 10.2 cm)
Honor Brooke (b. 1862), the tallest and oldest girl, with her sisters Evelyn (b. 1867) and Olive (b. 1869). Dodgson wrote on 13 July 1875: "Did Miss Lawrie as 'Heathen Chinee,' etc., also Honor, Evelyn, and Olive Brooke"; see HH: 11. The children were daughters of Augustus Stopford Brooke (1832–1916), an independent minister in London.

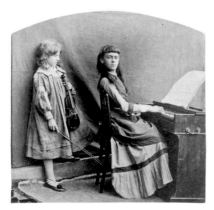

HH: 23
Winifred Holiday and Daisy Whiteside in "The Lost Tune,"
10 July 1875
["The lost tune"]
2360
Oak Tree House, Hampstead
Inscribed in violet ink, below center of print: *"Amid the notes his fingers strayed, / And an uncertain warbling made, / And oft he shook his hoary head"*; [from Adelaide Proctor's "A Lost Chord" (1858)]
5½ x 5⅝ in. (14 x 14.1 cm)
Winifred Holiday (violin) and Daisy Whiteside (harmonium) searching for a "lost tune." Winifred (1864–1949) was the only daughter of Henry and Kate Holiday; she won a scholarship in 1883 to study at the Royal College of Music.

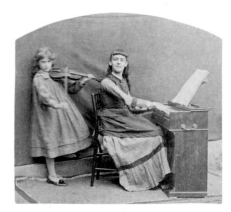

HH: 24
Winifred Holiday and Daisy Whiteside in "Caught It at Last!"
10 July 1875
["Caught it at last!"]
2359
Oak Tree House, Hampstead
Inscribed in violet ink, below center of print: *"But when he caught the measure wild, / The Old Man raised his face and smiled."* [from Adelaide Proctor's "A Lost Chord" (1858)]
4⅝ x 5 in. (11.7 x 12.7 cm)
Winifred Holiday and Daisy Whiteside in the complementary photograph (see HH: 23) revealing their success in finding the "lost tune." Winifred and her other friend Xie Kitchin were both accomplished violinists. In 1912 Winifred spent six weeks in Berlin studying music. She was competent in ensemble playing and once played a Mozart quartet with Professor Max Müller at the piano.

The photographic albums compiled by Reginald Southey contain a number of identified photographs taken by Dodgson for which image numbers are known. There may be others taken by Dodgson in these albums that have not yet been fully identified as his; supporting evidence has not come to light. For example, a number of photographs taken at Twyford School, Hampshire, appear in the first album. Some of these are known to be by Dodgson; he records them in his *List of Photographs* (1860). Whether all the Twyford School photographs in this album were taken by Dodgson is not known. Southey visited the school in February 1858 and may have taken some of these photographs himself. Southey and Dodgson shared photographs they had taken for inclusion in each other's albums, adding to the problem of definitively identifying the photographer. The inscriptions, probably by a later hand, contain a number of errors in identification.

ALBUM I

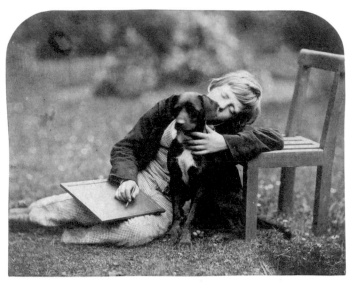

RS1: 1
Edwin Dodgson as "The Young Mathematician,"
July/August 1857
251
Croft Rectory, Yorkshire
Inscribed below center: *Dodgson*
5¼ x 4⅛ in. (13.1 x 10.4 cm)
Duplicate of A(I): 6

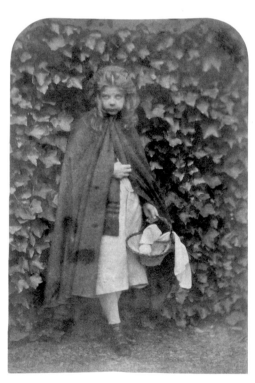

RS1: 2
Agnes Weld as "Little Red Riding-Hood," 18 August 1857
275
Croft Rectory, Yorkshire
Inscribed below center: *Alice Liddell* [sic]
5⅝ x 3¾ in. (14.1 x 9.6 cm)
Duplicate of A(I): 24

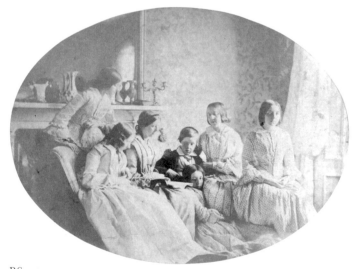

RS1: 5
Edwin Dodgson and "The New Book," July/August 1857
248
Croft Rectory, Yorkshire
Inscribed below center: *The / Miss Dodgsons*
4¾ x 6½ in. (12.3 x 16.4 cm)
Duplicate of A(I): 2

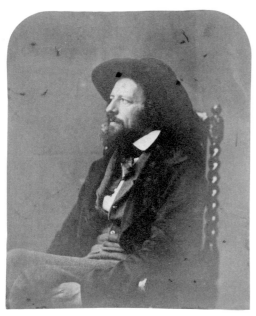

RS1: 7
Alfred Tennyson, 28 September 1857
306
Monk Coniston Park, Ambleside
Inscribed: *Alfred Tennyson*
4⅞ x 4 in. (12.5 x 10.3 cm)
Duplicate of A(I): 26

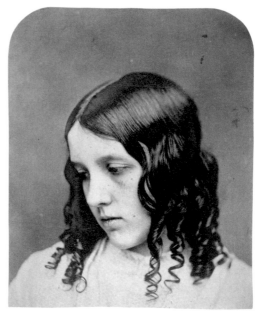

RS1: 11
Margaret Dodgson, summer 1859
427–439
Croft Rectory, Yorkshire
Inscribed: *Miss Dodgson*
4¾ x 4 in. (12.1 x 10.2 cm)
Duplicate of A(I): 27

RS1: 12
Fanny, Maria, and Anne Smith with Their Pony, 4 August 1857
255
Dinsdale Rectory, Yorkshire
Inscribed below center: *The / Miss Longleys* [sic]
5⅝ x 6¼ in. (14.3 x 15.7 cm)
Duplicate of A(I): 23

RS1: 17
Alice Liddell, summer 1858
355
Deanery garden, Christ Church, Oxford
Inscribed below center: *Edith Liddell* [sic]
2⅞ x 2¼ in. (7.3 x 5.5 cm)
Duplicate of A(I): 75

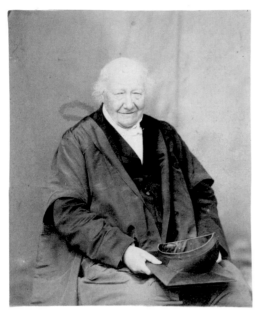

RS1: 20
Rev. Herbert Randolph, 3 July 1860
589
Christ Church, Oxford
Inscribed: *Revd. Thomas Randolph* [sic]
5¼ x 4⅜ in. (13.3 x 10.9 cm)
Duplicate of A(II): 42

RS1: 25
Edwin Dodgson and C. Turner, summer 1859
380
Twyford School, Hampshire
No inscription
5⅜ x 4½ in. (13.7 x 11.4 cm)
Duplicate of A(I): 45

RS1: 27
Earl of Enniskillen, 3 July 1860
587?
Christ Church, Oxford
Inscribed: *Lord Enniskillen*
4⅞ x 3⅞ in. (12.4 x 10 cm)
This photograph was taken at the same time as image number 588
(A[II]: 41).

RS1: 28
Osborne Gordon, spring 1857
175
Christ Church, Oxford
Inscribed: *Revd. Osborne Gordon*
5 x 4 in. (12.6 x 10.3 cm)
Rev. Osborne Gordon (1813–1883)—senior censor as well as reader in
Greek and rhetoric—was a brilliant scholar and a prominent member of
the teaching staff at Christ Church.

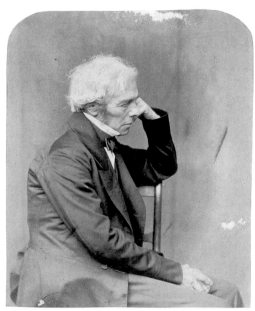

RS1: 29
Professor Michael Faraday, 30 June 1860
574
Christ Church, Oxford
Inscribed: *Michael Faraday*
5 x 4 in. (12.6 x 10.3 cm)
Duplicate of A(II): 18

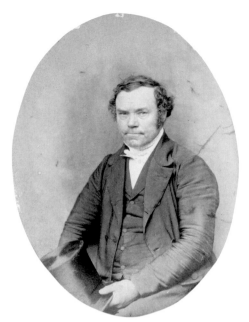

RS1: 30
Rev. Henry Gough, autumn 1860
668
Christ Church, Oxford
Inscribed: *Gough*
5 ⅝ x 4 ⅛ in. (14.1 x 10.4 cm)
Duplicate of A(II): 32

RS1: 40
Skeleton of an Anteater, June 1857
203
Anatomical Museum, Christ Church, Oxford
No inscription
4 ¼ x 6 ⅝ in. (10.6 x 16.7 cm)
Duplicate of A(I): 28

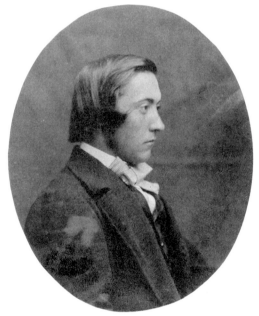

RS1: 50a
Reginald Southey, spring 1860
519
Christ Church, Oxford
Inscribed: *Regd. Southey–1856* [sic]
3 ½ x 2 ¾ in. (8.9 x 7.1 cm)
Dodgson's profile portrait of Southey also appears in two photographic
albums now at Christ Church. The date given in the legend is incorrect.

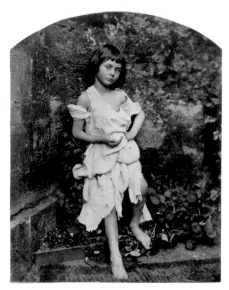

RS2: 15
Alice Liddell as "The Beggar-Maid," summer 1858
354
Deanery garden, Christ Church, Oxford
Inscribed: *The Beggar*
6⅝ x 5⅛ in. (16.8 x 13 cm)
Duplicate of A(II): 65. This print was made before the subsequent damage
to the glass-plate negative that reveals a gap by Alice's left knee in later
prints of this photograph.

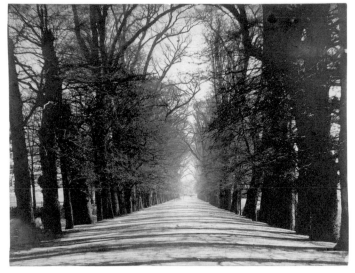

RS2: 21
Broad Walk, Christ Church, spring 1857
173
Oxford
Inscribed: *Broad Walk Ch: Ch:*
5½ x 6¾ in. (13.9 x 17.2 cm)
Duplicate of A(I): 3

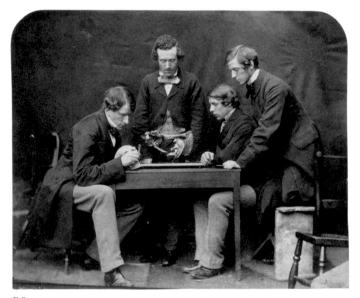

RS2: 22
Anatomy Lesson with Dr. George Rolleston, June 1857
205
Anatomical Museum, Christ Church, Oxford
Inscribed: *Professor Rolleston & pupils*
5⅜ x 6⅝ in. (13.7 x 16.8 cm)
Duplicate of A(I): 39

ALBUM 3

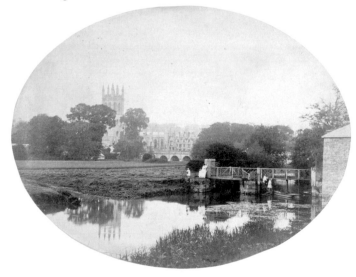

RS3: 33
Magdalen Tower, summer 1861
721
Oxford
Inscribed: *Magdalen, Oxford*
6¾ x 8¾ in. (17.3 x 22.4 cm)
Duplicate of A(II): 24

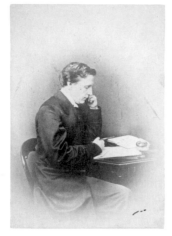

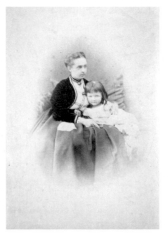

Leigh Album: Charles L. Dodgson, 13 March 1874?
2212
Christ Church Studio, Oxford
No inscription
5¾ x 4 in. (14.8 x 10.2 cm)
This assisted self-portrait shows Dodgson sitting at his hexagonal table, pen in hand, clearly indicating that he was right-handed. He noted in his diary on this day: "A little more photographing, visited the New Museum etc., and dined quietly."

L: 1
Mrs. Alice M. Kitchin and Xie, 12 June 1869
1676
Badcock's Yard, Oxford
Inscribed in pencil, verso: *A. M. K. & Xie* and *Mrs. Alice Maud Kitchin and Alexandra,* and in violet ink, verso: *1676*
6 x 5⅛ in. (15.3 x 12.9 cm)
Alice Maud Kitchin née Taylor (1844?–1930), with her daughter, Alexandra "Xie" Rhoda (1864–1925).

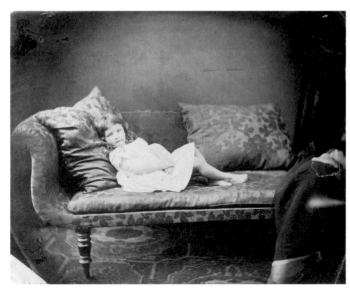

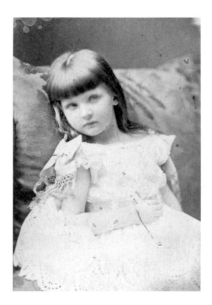

L: 2
Xie Kitchin, 12 June 1869
1677
Badcock's Yard, Oxford
Inscribed in pencil, verso: *Alexandra R. Kitchin by Mr. C. Dodgson, Oxford / one like this was painted & sent to Queen Alexandria* and in violet ink, verso: *1676*
5 x 6 in. (12.6 x 15.3 cm)
Dodgson recorded on 12 June 1869: "Mrs. Kitchin brought over Xie, of whom I did three photos."

L: 3
Xie Kitchin, June – August 1869
1707
Badcock's Yard, Oxford
Inscribed in pencil, verso: *Kitchin* and in violet ink, verso: *1707*
3⅜ x 2⅜ in. (8.6 x 5.9 cm)
An early photograph of Xie Kitchin, here aged five years.

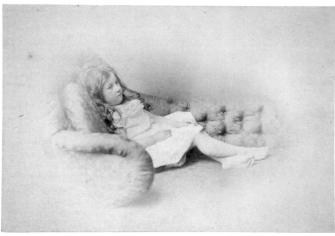

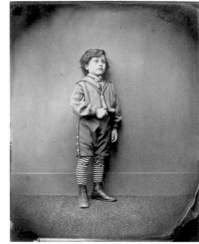

L: 4
Beatrice Hatch, 19–30 April 1872
1985–2031
Christ Church Studio, Oxford
Inscribed in violet ink, verso: *201* and in blue ink, verso: *B. H. (7) 15 Return to Miss Beatrice Hatch / 9 Frenchay Rd. Oxford*
4 x 5⅞ in. (10.1 x 14.9 cm)
Dodgson wrote on 30 April 1872: "During the month (beginning on the 19th) I have photographed the Hatches . . ." and this picture of Beatrice Sheward Hatch (1866–1947) is undoubtedly one of those photographs. Beatrice was the third child and first daughter of Edwin Hatch (1835–1889), vice principal of St. Mary Hall, Oxford, and his wife, Bessie Cartwright née Thomas (1839–1891).

L: 5
Wilfred Hatch, 19–30 April 1872
2000
Christ Church Studio, Oxford
Inscribed in pencil, verso: *Hatch* and in violet ink, verso: *2000*
6⅛ x 5⅛ in. (15.5 x 12.9 cm)
Wilfred Stanley Hatch (1865–1956), with striped stockings, looking slightly naval in appearance. He was the second son of Edwin and Bessie Hatch (see L: 4).

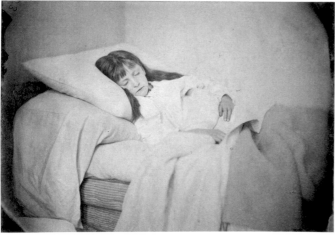

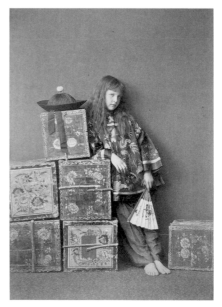

L: 6
Xie Kitchin in "Where Dreamful Fancies Dwell," 12 June 1873
2144
Christ Church Studio, Oxford
Inscribed in violet ink, recto: *A*(19) "Where dreamful fancies dwell.";*
in black ink, verso: *2144*; and in violet ink, verso: *A**
4 x 5⅞ in. (10.1 x 14.9 cm)
Dodgson wrote on 12 June 1873: "Photographed Xie with spade and bucket, in bed, and in Greek dress."

L: 7
Xie Kitchin as "Tea-Merchant" (Off Duty), 14 July 1873
2156
Christ Church Studio, Oxford
Inscribed in violet ink, verso: *2156*
5⅞ x 4⅛ in. (15 x 10.4 cm)
Duplicate of P(3): 106

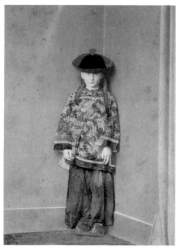

L: 8
Helen Standen, 23 July 1873
2161–2181
Christ Church Studio, Oxford
Inscribed verso: *Helen Melville Standen, a photo by Lewis Carroll at Oxford, July 23, 1873*
5⅞ x 4⅛ in. (14.9 x 10.5 cm)
Helen Melville Standen (1864–1937) was the daughter of Douglas Standen (1830–1903), an army staff officer, later lieutenant general, and his wife, Annie Aston née Liddell (b. 1833). Dodgson wrote on 23 July 1873: "Miss Brewer brought over Maud, Isabel, and Helen, of whom I did five pictures."

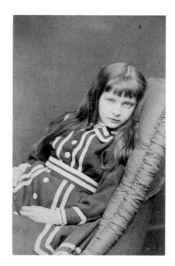

L: 9
Xie Kitchin, 23 March 1874
2222
Christ Church Studio, Oxford
Inscribed in violet ink, verso: *2222*
3¾ x 2⅜ in. (9.5 x 5.9 cm)
Dodgson took at least fifty photographs of Xie Kitchin. This is one of the first photographs of her to be taken in 1874.

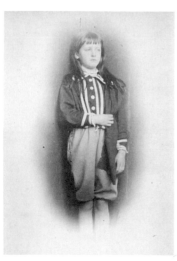

L: 10
Xie Kitchin as Viola, 23 March 1874
2223
Christ Church Studio, Oxford
Inscribed in violet ink, recto: *A**(1) Viola "My father had a daughter loved a man, / As it might be, perhaps, were I a woman, / I should your lordship."* and in violet ink, verso: *A*** and *2223*
5⅝ x 4 in. (14.2 x 10.2 cm)
Xie Kitchin dressed as Viola from *Twelfth Night*. This was one of three photographs taken during March 1874 that Dodgson noted were the first of Xie for the current year.

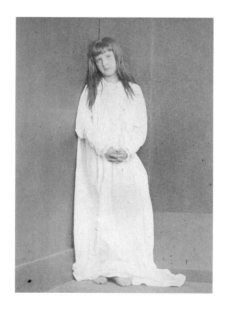

L: 11
Xie Kitchin in "Penitence," 23 March 1874
2224
Christ Church Studio, Oxford
Inscribed in violet ink, recto: *A*(11) Penitence,* in violet ink, verso: *A*,* and in black ink, recto: *2224.* With envelope, inscribed in violet ink: *Miss Alexandra Kitchin.*
5⅝ x 4 in. (14.1 x 10.3 cm)
The title is a biblical reference, possibly coming from the title of a sermon by Dodgson's friend, Richard St. John Tyrwhitt, published in 1859.

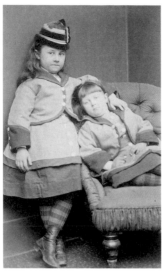

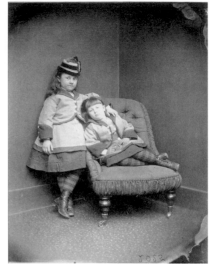

L: 12
Beatrice and Ethel Hatch, 24 March 1874
2225
Christ Church Studio, Oxford
Inscribed in pencil, verso: *Hatch* and in violet ink, verso: *2225*
3⅞ x 2⅜ in. (9.9 x 5.9 cm)
Beatrice Hatch (see L: 4), standing, and her sister Ethel Charlotte
(1869–1975), seated, daughters of Edwin and Bessie Hatch.

L: 13
Beatrice and Ethel Hatch, 24 March 1874
2225
Christ Church Studio, Oxford
Inscribed in pencil, verso: *Hatch* and in violet ink, verso: *2225*
6⅜ x 4⅝ in. (16.9 x 11.7 cm)
Beatrice Hatch, standing, and Ethel Hatch, seated; see L: 12.

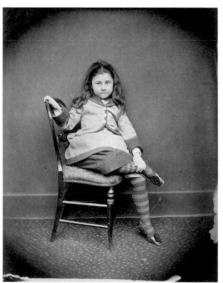

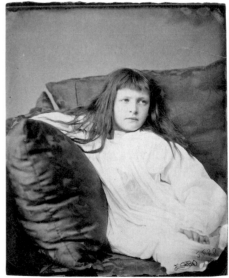

L: 14
Beatrice Hatch, 24 March 1874
2226
Christ Church Studio, Oxford
Inscribed in pencil, verso: *Hatch* and in violet ink, verso: *2226*
6½ x 4¾ in. (16.6 x 12.3 cm)
Beatrice Hatch recalled that she stood by Dodgson "in the tiny dark room,
and watch[ed] him while he poured the contents of several little, strong-
smelling bottles on to the glass picture of yourself that looked so funny
with its black face . . . " (*Strand Magazine*, April 1898, 413–23).

L: 15
Xie Kitchin in "Sleepless," 18 May 1874
2250
Christ Church Studio, Oxford
Inscribed in violet ink, verso: *2250* and in pencil, verso: *2250 Xie Kitchin
(A. R. Cardew) by Mr. C. Dodgson*
5⅞ x 5⅛ in. (14.9 x 13 cm)
On 22 June 1874, some days after this photograph was taken, Dodgson
noted: "On the 16th (Sat) Holiday arrived on a visit to me. On the 18th
[May] he fetched Xie Kitchin to be photographed, and I did a large one,
full length lying on the sofa in a long night-gown, which Holiday arranged,
about the best I have ever done of her."

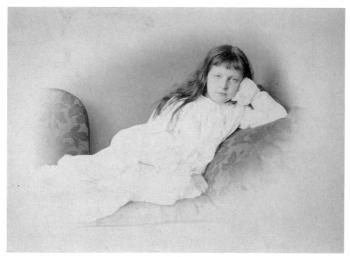

L: 16
Xie Kitchin in "A Summer Night," 18 May 1874
2251
Christ Church Studio, Oxford
Inscribed in violet ink, recto: *A*(12) A Summer Night,* in violet ink, verso: *A*,* and in black ink, verso: *2251*
4 x 5⅝ in. (10.2 x 14.2 cm)
For the relevant diary entry, see L: 15.

L: 17
Charles L. Dodgson, May 1875?
2285
Christ Church Studio, Oxford
Inscribed in black ink, verso: *Rev: C. L. Dodgson, "Lewis Carroll" from Mr. Dodgson* and in violet ink, verso: *L.1511 / #B127. Plate 4 x 5¼* and *2285*
5⅝ x 4 in. (14.3 x 10.3 cm)
Dodgson is seated in the same chair in which he took John Ruskin on 3 June 1875 (L: 18). He took this assisted self-portrait probably to check that his camera and chemicals were in good working order after being stored during the winter months. The first photograph of the year was taken on 15 May 1875.

L: 18
John Ruskin, 3 June 1875
2309
Christ Church Studio, Oxford
Inscribed in pencil, recto: *Photo by Lewis Carroll,* in pencil, verso: *PATY,* and in violet ink, verso: *2309*
5⅝ x 4 in. (14.1 x 10.3 cm)
Duplicate of P(3): 109

L: 19
Xie, Herbert, Hugh, and Brook Kitchin in "St. George and the Dragon," 26 June 1875
2316
Christ Church Studio, Oxford
Inscribed in violet ink, recto: *B*(1) St. George and the Dragon* and in violet and black ink, verso: *B** and a list of all the other photographs in his set labeled *B**, image numbers and titles, and *2316*
4¼ x 5⅞ in. (10.6 x 15 cm)
Duplicate of P(3): 108

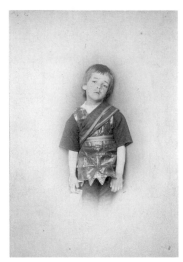

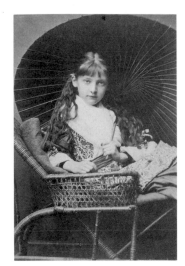

L: 20

Brook Kitchin in "Achilles in His Tent," 26 June 1875

2318

Christ Church Studio, Oxford

Inscribed in violet ink, recto: *B*(3) Achilles in his tent* and in violet ink, verso: *B** and *2318*

5⅞ x 4⅛ in. (14.9 x 10.5 cm)

Dodgson noted: "Photographed the Kitchins in the morning." This is Brook Taylor Kitchin (1869–1940) as St. George, standing in soldier's costume with false moustache. Dodgson also described the photograph as "Achilles in his tent"; see also P(3): 108, taken at the same time.

L: 21

Xie Kitchin, 1 July 1876

2422

Christ Church Studio, Oxford

Inscribed in violet ink, verso: *2422*

3⅝ x 2⅜ in. (9.2 x 6.1 cm)

See L: 23 for the diary entry associated with this photograph.

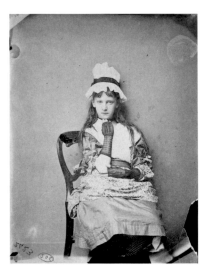

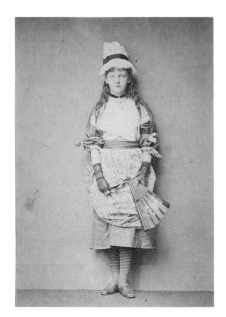

L: 22

Xie Kitchin as "Penelope Boothby," 1 July 1876

2423

Christ Church Studio, Oxford

Inscribed in pencil, verso: *Xie Kitchin as "Dolly Varden" / by Mr. C. Dodgson / Oxford* and in violet ink, verso: *2423*

6 x 4⅞ in. (15.3 x 12.4 cm)

This is one of two photographs (see L: 23) of Xie Kitchin taken as "Penelope Boothby." The portrait is also referred to as "Dolly Varden." Penelope Boothby's portrait was painted by Sir Joshua Reynolds; it was subsequently made into a mezzotint by Samuel Cousins and published in 1796.

L: 23

Xie Kitchin as "Penelope Boothby," 1 July 1876

2424

Christ Church Studio, Oxford

Inscribed in violet ink, recto: *D*(5) "Penelope Boothby" [Xie]* and in violet ink, verso: *D** and *2424*

5⅞ x 4 in. (15.1 x 10.3 cm)

Dodgson wrote in his diary for this day: "Mrs. Kitchin brought Xie to be photographed, and I got 4 good ones, two being as 'Penelope Boothby,' and one playing her violin."

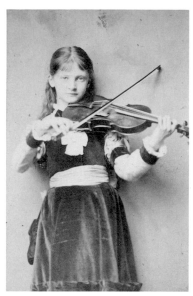

L: 24
Xie Kitchin in "Tuning," 1 July 1876
2425
Christ Church Studio, Oxford
Inscribed in violet ink, verso: *2425*
3⅝ x 2⅜ in. (9.4 x 6.1 cm)
Dodgson entitled this photograph "Tuning."

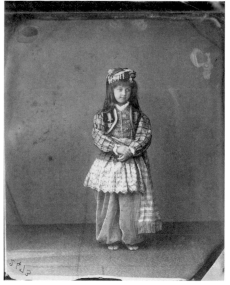

L: 25
Ethel Hatch in Turkish Dress (Standing), 16 June 1877
2473
Christ Church Studio, Oxford
Inscribed in pencil, verso: *Ethel Hatch* and in violet ink, verso: *2473*
6⅜ x 5¼ in. (16.7 x 13.1 cm)
Dodgson wrote on 16 June 1877: "Mrs. Hatch brought Beatrice and Ethel, and I photographed both, the latter in Turkish dress."

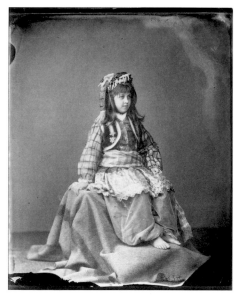

L: 26
Ethel Hatch in Turkish Dress (Seated), 16 June 1877
2474
Christ Church Studio, Oxford
Inscribed in pencil, verso: *Ethel Hatch* and in violet ink, verso: *2474*
6⅛ x 5⅛ in. (15.6 x 12.9 cm)
For the relevant diary entry, see L: 25.

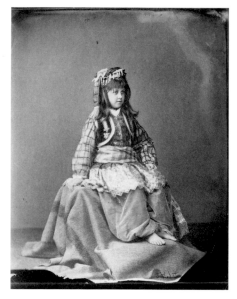

L: 27
Ethel Hatch in Turkish Dress (Seated), 16 June 1877
2474
Christ Church Studio, Oxford
Inscribed in pencil, verso: *Ethel Hatch* and in violet ink, verso: *2474*
6⅛ x 4⅞ in. (15.5 x 12.5 cm)
Duplicate of L: 26. See also L: 25.

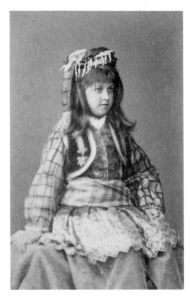

L: 28
Ethel Hatch in Turkish Dress (Seated), 16 June 1877
2474
Christ Church Studio, Oxford
Inscribed in pencil, verso: *Ethel Hatch* and in violet ink, verso: *2474*
3⅝ x 2¼ in. (9.3 x 5.7 cm)
See L: 25.

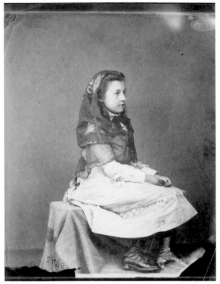

L: 29
Beatrice Hatch, 16 June 1877
2475
Christ Church Studio, Oxford
Inscribed in pencil, verso: *Beatrice Hatch* and in violet ink, verso: *2475*
6¼ x 5 in. (15.8 x 12.8 cm)
This photograph shows Beatrice Hatch in a white costume with a shawl (possibly Turkish) on her head.

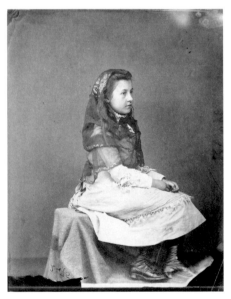

L: 30
Beatrice Hatch, 16 June 1877
2475
Christ Church Studio, Oxford
Inscribed in pencil, verso: *Beatrice Hatch* and in violet ink, verso: *2475*
6¼ x 5 in. (15.7 x 12.8 cm)
Duplicate of L: 29.

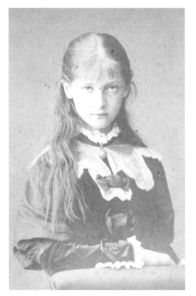

L: 31
Xie Kitchin, 20 June 1877
2477
Christ Church Studio, Oxford
Inscribed in violet ink, verso: *2477*
3⅝ x 2⅜ in. (9.3 x 5.8 cm)
Dodgson noted that he took two photographs of Xie Kitchin on this day. In one, she leans on the back of a chair with a downward gaze, but here she is looking straight ahead.

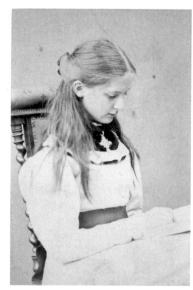

L: 32
Xie Kitchin, 17 July 1878
2541
Christ Church Studio, Oxford
Inscribed in violet ink, verso: *2541*
3 ⅝ x 2 ⅜ in. (9.1 x 5.8 cm)
"Xie was left with me about 11. I took four photos of her, and escorted her back about 2," wrote Dodgson on 17 July 1878. This is one of those photographs.

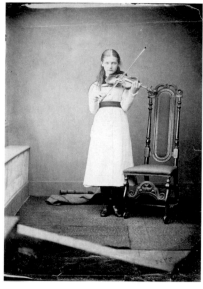

L: 33
Xie Kitchin in "Most Musical, Most Melancholy," 17 July 1878
2542
Christ Church Studio, Oxford
Inscribed in pencil, verso: *Kitchin / Xie Kitchin* and in violet ink and pencil, verso: *2542*
8 ½ x 6 ⅝ in. (21.6 x 17 cm)
Xie Kitchin in a photograph that Dodgson entitled "Most Musical, Most Melancholy."

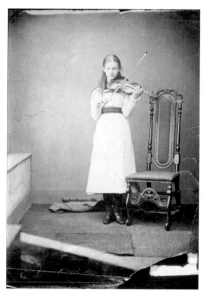

L: 34
Xie Kitchin in "Most Musical, Most Melancholy," 17 July 1878
2542
Christ Church Studio, Oxford
Inscribed in pencil, verso: *Alexandra Rhoda Kitchin "Xie" / by Mr. Charles Dodgson* and in violet ink, verso: *2542*
8 ½ x 6 ⅝ in. (21.6 x 16.9 cm)
Duplicate of L: 33.

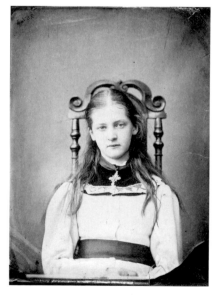

L: 35
Xie Kitchin, 17 July 1878
2543
Christ Church Studio, Oxford
Inscribed in pencil, verso: *2543* and in violet ink, verso: *2543*
8 ½ x 6 ⅝ in. (21.5 x 16.8 cm)

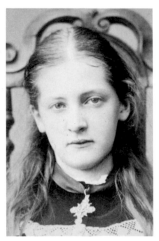

L: 36
Xie Kitchin, 17 July 1878
2543
Christ Church Studio, Oxford
Inscribed in violet ink, verso: *2543*
3 ½ x 2 ⅜ in. (8.8 x 5.8 cm)
Trimmed to look like a close-up of photograph L: 35.

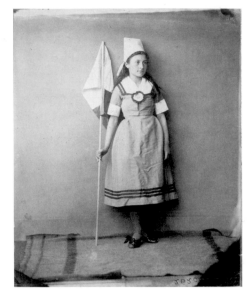

L: 37
Beatrice Hatch in "Vive la France!" 29 July 1879
2620
Christ Church Studio, Oxford
Inscribed in pencil, verso: *Beatrice Hatch* and in violet ink, verso: *2620*
6 ⅝ x 5 ⅜ in. (16.8 x 13.6 cm)
Beatrice Hatch in nurse's costume holding a flag in a photograph Dodgson entitled "Vive la France!" for reasons not now apparent.

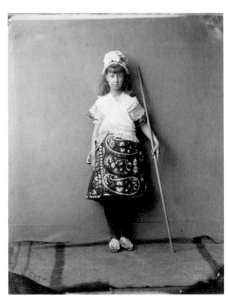

L: 38
Ethel Hatch in "The Beast Is Near!" 29 July 1879
2624
Christ Church Studio, Oxford
Inscribed in pencil, verso: *Ethel Hatch* and in violet ink, verso: *2624*
6 ⅜ x 5 ⅜ in. (16 x 13.7 cm)
On 29 July 1879 Dodgson wrote: "In the afternoon Mrs. Hatch came with Beatrice, Ethel, and Evelyn. I photographed all three. . . ." Ethel Hatch, dressed in a foreign costume (possibly Dutch) with patterned shoes, holds a pole to fend off a ferocious animal in a photograph that Dodgson entitled "The Beast is near!"

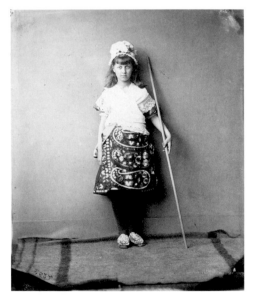

L: 39
Ethel Hatch in "The Beast Is Near!" 29 July 1879
2624
Christ Church Studio, Oxford
Inscribed in pencil, verso: *Ethel Hatch*
6 ½ x 5 ¼ in. (16.6 x 13.3 cm)
Duplicate of L: 38.

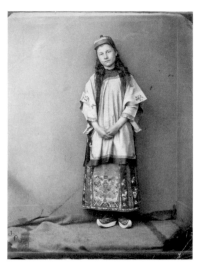

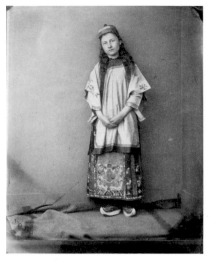

L: 40
Beatrice Hatch in "Apis Japanensis," 29 July 1879
2627
Christ Church Studio, Oxford
Inscribed in black ink, recto: *Beatrice Hatch,* in black ink, verso: *(6) B. S. Hatch. Aetat. [aged] 12,* and in blue ink, verso: *Return to Miss Beatrice Hatch, 9 Frenchay Rd. Oxford*
5⅝ x 4 in. (14.6 x 10.1 cm)
Beatrice Hatch in Japanese dress in a photograph that Dodgson entitled "Apis Japanensis," a Latin translation of "Japanese Bee" (he called Beatrice "Bee" or "B" for short).

L: 41
Beatrice Hatch in "Apis Japanensis," 29 July 1879
2627
Christ Church Studio, Oxford
Inscribed in pencil, verso: *Beatrice Hatch* and in violet ink, verso: *2627*
6⅜ x 4¾ in. (15.9 x 12.2 cm)
Duplicate of L: 40.

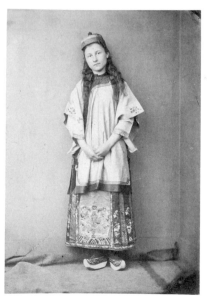

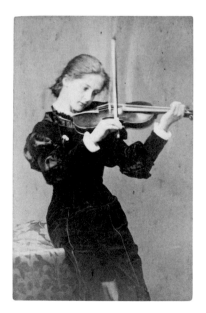

L: 42
Beatrice Hatch in "Apis Japanensis," 29 July 1879
2627
Christ Church Studio, Oxford
Inscribed in pencil, verso: *Beatrice Hatch* and in violet ink, verso: *2627*
5⅝ x 4¾ in. (14.6 x 12.2 cm)
Duplicate of L: 40.

L: 43
Xie Kitchin, 25 May 1880
2642
Christ Church Studio, Oxford
Inscribed in violet ink, verso: *2642*
3⅝ x 2⅜ in. (9.4 x 6 cm)
Xie was a competent musician and played in small ensembles at the homes of friends. On the day this photograph was taken, Dodgson recorded: "Mrs. Kitchin brought Xie and Dorothy, and I did several photos."

REGISTER OF ALL KNOWN PHOTOGRAPHS
BY CHARLES LUTWIDGE DODGSON

EDWARD WAKELING

This is the first time that a list of Dodgson's photographic output has been compiled for publication and it is, without doubt, incomplete. The information has been collected from a variety of sources, including catalogues of photograph collections, auction records, details supplied by private collectors, and references to photographs in Dodgson's diaries and letters. This list reveals that just over fifty percent are portraits of children, thirty percent are photographs of adults or families, six percent are Dodgson family pictures (including his extended family of aunts, uncles, and cousins), and four percent are topographical. The remaining photographs are assisted self-portraits, still lifes and skeletons, photographs of drawings and works of art, and a number of subjects best described as miscellaneous (such as the Dodgson family doll called Tim).

The individual image numbers given in this list were assigned by Dodgson. He probably used halves and thirds when he found additional photographs after he had assigned the original image numbers. A range of image numbers is given when the actual image number is unknown, and this is my own construction. This range is based upon the date when the photograph was taken. In some cases, neither date nor image number is known. The maximum number of 2700 is an estimate that I have made based on current information. If a photograph is listed as "Not located," this means that the current whereabouts of the photograph is unknown but either evidence from Dodgson's letters and diaries indicates that it was taken or it has appeared at auction. Some photographs exist in multiple copies; the location of only one print is given, usually from a principal source (i.e., an album or major collection). In the date range, "/" means "or" and "−" means "to" using information from diary entries. The use of "?" indicates that I have been unable to verify the information. A few images were destroyed according to Dodgson's instructions to his executors and are indicated here as "ERASED."

This list probably suffers from omissions, duplications, and errors. I take full responsibility for the lack of completeness, and I would be most pleased to hear from people who can add to the list or identify any errors; please contact me at the following e-mail address: *edward@wakeling.demon.co.uk*.

This register contains the following information, according to the criteria given on pages 129–32:

1. Image Number (or range of image numbers)
2. Subject. The subject of the photograph is, wherever possible, more detailed than the title given in the catalogue, to compensate for the absence of photographs and captions here.
3. Date Taken
4. Place
5. Current Owner. The current owner of the principal image is provided (either an institutional archive or private collection), using the following abbreviated forms:

AIC	The Art Institute of Chicago
Bickersteth	Collection of Justin Bickersteth
Christ Church	Christ Church Library, Oxford
DLI	Durham Light Infantry Museum
Getty	The J. Paul Getty Museum, Los Angeles
Gilman	The Gilman Paper Company Collection, New York
Hartland Mahon	Collection of Margaret Hartland Mahon
Harvard	Harcourt Amory Collection, Harvard College Library, Cambridge, Massachusetts
Hatfield House	Collection of the Marquess of Salisbury, Hatfield House, Hertfordshire
Hillelson	Collection of John Hillelson
Lindseth	Collection of Jon Lindseth
Morgan	Arthur A. Houghton Collection, The Pierpont Morgan Library, New York
Musée d'Orsay	Musée d'Orsay, Paris
NMPFT	National Museum of Photography, Film and Television, Bradford
NPG	National Portrait Gallery, London
NYU	Alfred C. Berol Collection, Fales Library, New York University
Ovenden	Collection of Graham Ovenden
Owen	Collection of Zoë Owen

Preston	Collection of John Preston		SNPG	Scottish National Portrait Gallery, Edinburgh
Princeton (Cotsen)	Cotsen Children's Library, Princeton University Library		Texas (Gernsheim)	Helmut Gernsheim Collection, Harry Ransom Humanities Research Center, University of Texas, Austin
Princeton (Parrish)	Morris L. Parrish Collection of Victorian Novelists, Princeton University Library		Texas (Hanley)	T. E. Hanley Collection, Harry Ransom Humanities Research Center, University of Texas, Austin
Rogers	Collection of Maurice Rogers			
Rosenbach	The Rosenbach Museum and Library, Philadelphia		V&A	Victoria and Albert Museum, London
RPS	Royal Photographic Society Collection, Bath		Wakeling	Collection of Edward Wakeling
Salisbury Jones	Collection of Celia Salisbury Jones		Woking	Dodgson Family Collection, Surrey History Centre, Woking
SF MoMA	San Francisco Museum of Modern Art			

IMAGE NUMBER	SUBJECT	DATE TAKEN	PLACE	CURRENT OWNER
15	Dodgson, Charles Lutwidge (1832–1898), standing by table, looking down	c. 1856	Christ Church, Oxford	Woking (Dodgson)
16?	Dodgson, Charles Lutwidge (1832–1898), standing by table, looking up	c. 1856	Christ Church, Oxford	Morgan (Houghton)
17–40	Liddell children	3 June 1856	Deanery garden,	Not located Christ Church, Oxford
17–170	Portrait of a seated man	c. 1856	Unknown	Texas (Gernsheim)
17–170	Two women	c. 1856	Unknown	Texas (Gernsheim)
17–170	Young woman with braid in hair	c. 1856	Unknown	Texas (Gernsheim)
17–1675	Mr. Deacon	pre-1868	Croft Rectory, Yorkshire	NMPFT
17–1675	Dodgson family in front of Croft Rectory	pre-1868	Croft Rectory, Yorkshire	Not located
17–1675	Young couple reading from large book	pre-1868	Unknown	Owen
17–1675	Woman with little boy in kilt on her knee	pre-1868	Unknown	Owen
17–1675	Old woman in bonnet with checked shawl, walking stick, and flower basket	pre-1868	Unknown	NPG
17–2280	Litton, Edward Arthur (1813–1897), and daughter, Edith Alice (1849–1919)	pre-1874	Unknown	Not located
17–2700	Dodgson, Charles Lutwidge (1832–1898), seated	Unknown	Christ Church, Oxford	Not located
17–2700	Unknown girl, seated on high-backed chair	Unknown	Unknown	Ovenden
40–58	Portrait of a woman (possibly Lucy Caroline Dodgson)	June 1856?	Putney?	Texas (Gernsheim)
40–58	Portrait of a woman (possibly Charlotte Mary Dodgson)	June 1856?	Putney?	Texas (Gernsheim)
40–58	Seated woman (possibly a Dodgson relative)	June 1856?	Putney?	Texas (Gernsheim)
40–58	Seated man (possibly a Dodgson relative)	June 1856?	Putney?	Texas (Gernsheim)
40–58	Four women on the stoop (possibly daughters of Hassard Dodgson)	June 1856?	Putney?	Texas (Gernsheim)
41	Dodgson, Francis "Frank" Hume (1834–1917)	June 1856	Park Lodge, Putney	Texas (Gernsheim)
44	Dodgson, Hassard Hume (1803–1884)	June 1856	Park Lodge, Putney	Texas (Gernsheim)
45	Dodgson, Caroline, née Hume (1809–1875)	June 1856	Park Lodge, Putney	Texas (Gernsheim)
46	Dodgson, Lucy Caroline (b. 1836), and Laura Elizabeth (b. 1853)	June 1856	Park Lodge, Putney	Texas (Gernsheim)
47	Dodgson, Charlotte Mary (b. 1839)	June 1856	Park Lodge, Putney	Texas (Gernsheim)
48	Dodgson, Charlotte Mary (b. 1839), and Louis Henry "Hal" (b. 1850)	June 1856	Park Lodge, Putney	Texas (Gernsheim)
49	Dodgson, Amy Menella (1842–1922), and Menella Frances (b. 1848)	June 1856	Park Lodge, Putney	Texas (Gernsheim)
50	Dodgson, Percy (1838–1886)	June 1856	Park Lodge, Putney	Texas (Gernsheim)

IMAGE NUMBER	SUBJECT	DATE TAKEN	PLACE	CURRENT OWNER
51	Murdoch, Katherine Frederica (d. 1926)	19 June 1856	Park Lodge, Putney	Texas (Gernsheim)
52	Murdoch, Millicent (dates unknown)	19 June 1856	Park Lodge, Putney	Texas (Gernsheim)
53	Murdoch, Alice Maria (1852–1881)	19 June 1856	Park Lodge, Putney	Texas (Gernsheim)
54	Murdoch, Katherine, Millicent, and Alice	19 June 1856	Park Lodge, Putney	Texas (Gernsheim)
55	Dodgsons and Murdochs	19 June 1856	Park Lodge, Putney	Texas (Gernsheim)
56–93	Smith family of Dinsdale	4 July 1856	Croft Rectory, Yorkshire	Not located
59	Dodgson, Skeffington Hume (1836–1919)	July 1856	Croft Rectory, Yorkshire	Texas (Gernsheim)
61	Barry, John "Johnnie" Warren (1851–1920)	July 1856	Croft Rectory, Yorkshire	Texas (Gernsheim)
63	Dodgson, Charles (1800–1868)	July 1856	Croft Rectory, Yorkshire	Texas (Gernsheim)
64	Croft Rectory	July 1856	Croft Rectory, Yorkshire	Princeton (Parrish)
66?	Croft National School with staff	July 1856	Croft, Yorkshire	NYU
67	Croft National School	July 1856	Croft, Yorkshire	Texas (Gernsheim)
68	Dodgson's sisters	July 1856	Croft Rectory, Yorkshire	Texas (Gernsheim)
69	Nichol, Frances, née Tweed (dates unknown)	July 1856	Croft Rectory, Yorkshire	Texas (Gernsheim)
70	Nichol, Frances, née Tweed (dates unknown), and her son, Iltyd (b. 1856)	July 1856	Croft Rectory, Yorkshire	Texas (Gernsheim)
71?	Nichol, Iltyd (b. 1856), and unknown woman	July 1856	Croft Rectory, Yorkshire	Texas (Gernsheim)
72–101	Wilcox, boy (possibly Herbert Francis Wilcox)	7–12 July 1856	Whitburn, Tyne and Wear	Texas (Gernsheim)
72–101	Wilcox, Mary Anne, née Marwood (1813–1870)	7–12 July 1856	Whitburn, Tyne and Wear	Texas (Gernsheim)
72–101	*The Lady of the Ganges,* sculpture by Henry Timbrell	7–12 July 1856	Whitburn, Tyne and Wear	Texas (Gernshein)
76	Wilcox, William (1801–1872)	7–12 July 1856	Whitburn, Tyne and Wear	Texas (Gernsheim)
77	Wilcox, Mary Anne, née Marwood (1813–1870)	7–12 July 1856	Whitburn, Tyne and Wear	Texas (Gernsheim)
79	Wilcox, Katherine Anne (1842–1868), and Elizabeth Georgina (1848–1934)	7–12 July 1856	Whitburn, Tyne and Wear	Texas (Gernsheim)
80	Wilcox, Henry "Harry" George (1839–1907)	7–12 July 1856	Whitburn, Tyne and Wear	Texas (Gernsheim)
81?	Wilcox, Henry "Harry" George (1839–1907), close-up	7–12 July 1856	Whitburn, Tyne and Wear	Texas (Gernsheim)
84	*Madonna,* painting	7 12 July 1856	Whitburn, Tyne and Wear	Texas (Gernsheim)
85	*S. Sebastian,* painting	7–12 July 1856	Whitburn, Tyne and Wear	Texas (Gernsheim)
86	*Fisherman's Wife,* drawing	7–12 July 1856	Whitburn, Tyne and Wear	Texas (Gernsheim)
88	Harrison, Charles Augustus (b. 1848)	7–12 July 1856	Whitburn, Tyne and Wear	Texas (Gernsheim)
90	Lorraine group	7–12 July 1856	Whitburn, Tyne and Wear	Texas (Gernsheim)
91–95	Tate family	11 July 1856	Whitburn, Tyne and Wear	Not located
94	Tate, Lucy Hutchinson (1842–1873)	11 July 1856	Whitburn, Tyne and Wear	Texas (Gernsheim)
96	*Princess Amelia,* engraving	7–12 July 1856	Whitburn, Tyne and Wear	Texas (Gernsheim)
97	*Ariel,* engraving	7–12 July 1856	Whitburn, Tyne and Wear	Texas (Gernsheim)
98	*Undine,* engraving	7–12 July 1856	Whitburn, Tyne and Wear	Texas (Gernsheim)
99–125	Keswick scenes	13 Aug. 1856	Keswick, Lake District	Not located
102	Dodgson, Skeffington Hume (1836–1919)	13 Aug. 1856	Crosthwaite, near Keswick	Texas (Gernsheim)
109	Webster, Charlotte Augusta (b. 1847)	13/16 Aug. 1856	Crosthwaite, near Keswick	Texas (Gernsheim)
111½	Webster, Charlotte Augusta (b. 1847), and Mary Elizabeth (b. 1849)	13/16 Aug. 1856	Crosthwaite, near Keswick	Texas (Gernsheim)
113	Webster, Alexander Rhind (1816–?1890)	13/16 Aug. 1856	Crosthwaite, near Keswick	Not located
114	Favell, Anne Elizabeth, née Cayley (1789–1871)	16 Aug. 1856	Crosthwaite, near Keswick	Texas (Gernsheim)
115	Favell, Rosellen (b. 1816), Elizabeth (b. 1818), and one other sister	16 Aug. 1856	Crosthwaite, near Keswick	Texas (Gernsheim)
116	Benn, Joseph (b. 1836)	12–26 Aug. 1856	Crosthwaite, near Keswick	Texas (Gernsheim)
117	Collyns, John Martyn (1827–1912)	12–26 Aug. 1856	Crosthwaite, near Keswick	Texas (Gernsheim)
118	Bather group	12–26 Aug. 1856	Crosthwaite, near Keswick	Texas (Gernsheim)
119	Portinscale Parsonage	12–26 Aug. 1856	Portinscale, near Keswick	Texas (Gernsheim)
120	Skiddaw, from the south	12 26 Aug. 1856	Lake District	Texas (Gernsheim)
121	Walker, John (1775–1860?)	12–26 Aug. 1856	Lake District	Texas (Gernsheim)
123	Profile of man reading	Aug.–Oct. 1856	Lake District or Whitby	Texas (Gernsheim)
124–130	Longley, Caroline Georgiana (1843–1867)	Oct. 1856	Hilda Terrace, Whitby	Texas (Gernsheim)
124–130	Longley, Rosamond Esther Harriet (1844–1936)	Oct. 1856	Hilda Terrace, Whitby	Texas (Gernsheim)

IMAGE NUMBER	SUBJECT	DATE TAKEN	PLACE	CURRENT OWNER
126	Longley, Charles Thomas (1794–1868)	Oct. 1856	Hilda Terrace, Whitby	Texas (Gernsheim)
127	Longley, Charles Thomas (1794–1868)	Oct. 1856	Hilda Terrace, Whitby	Texas (Gernsheim)
128	Longley, Charles Thomas (1794–1868)	Oct. 1856	Hilda Terrace, Whitby	Princeton (Parrish)
129?	*Bishop Longley*, painting	Oct. 1856	Hilda Terrace, Whitby	Texas (Gernsheim)
131	Bainbridge, Florence Hilda (b. 1847)	1 Oct. 1856	Hilda Terrace, Whitby	Texas (Gernsheim)
131½	Bainbridge, Florence Hilda (b. 1847)	1 Oct. 1856	Hilda Terrace, Whitby	Texas (Gernsheim)
132	Bainbridge, Henry (1816–1877)	1 Oct. 1856	Hilda Terrace, Whitby	Texas (Gernsheim)
136	Longley, Caroline Georgiana (1843–1867)	2/3 Oct. 1856	Hilda Terrace, Whitby	Texas (Gernsheim)
137	Longley, Rosamond Esther Harriet (1844–1936)	2/3 Oct. 1856	Hilda Terrace, Whitby	Texas (Gernsheim)
142	Pickard, Adelaide "Ada" (dates unknown)	1–4 Oct. 1856	Hilda Terrace, Whitby	Texas (Gernsheim)
144	Whitby, from Hilda Terrace	4 Oct. 1856	Hilda Terrace, Whitby	Texas (Gernsheim)
145–157	Sherwit, William (dates unknown)	9 Oct. 1856	Alvaston	Not located
145–157	Sherwit, Mary (dates unknown)	9 Oct. 1856	Alvaston	Not located
145–157	Poole, Henry (1808–1878), and family	9 Oct. 1856	Alvaston	Not located
147	Poole, Catherine Lucy (b. 1846)	9 Oct. 1856	Alvaston	Texas (Gernsheim)
148	Poole, Margaret Ellen (b. 1848)	9 Oct. 1856	Alvaston	Texas (Gernsheim)
150	Poole, Henry (1808–1878)	9 Oct. 1856	Alvaston	Texas (Gernsheim)
155	Alvaston House	9 Oct. 1856	Alvaston	Texas (Gernsheim)
158	Faussett, Robert Godfrey (1827–1908)	Oct./Nov. 1856	Deanery garden, Christ Church, Oxford	Christ Church
159	Longley, Henry (1832–1899), Richard Harington (1835–1911), Sidney Joyce (1834–1911), and Charlton George Lane (1836–1892)	Oct./Nov. 1856	Deanery garden, Christ Church, Oxford	Christ Church
160–170	Acland children	6–14 Nov. 1856	Deanery garden, Christ Church, Oxford	Not located
161	Liddell, Edward Henry "Harry" (1847–1911)	10 Nov. 1856	Deanery garden, Christ Church, Oxford	Texas (Gernsheim)
162 170	Liddell children	14 Nov. 1856	Deanery garden, Christ Church, Oxford	Not located
163–320	Dodgson, Charles Lutwidge (1832–1898)	c. 1857	Christ Church, Oxford	Christ Church
163–320	Old woman with hairnet	c. 1857	Unknown	Texas (Gernsheim)
163–320	Kitten	c. 1857	Unknown	Texas (Gernsheim)
163–320	Heurtley, Charles Abel (1806–1895)	c. 1857	Christ Church, Oxford	Christ Church
171	Lott, Mary Elizabeth (b. 1855?)	Spring 1857	Christ Church, Oxford	Princeton (Parrish)
173	Broad Walk, Christ Church	Spring 1857	Christ Church, Oxford	Princeton (Parrish)
174	Johnson, Frederick Pigott (1826–1882)	Spring 1857	Christ Church, Oxford	Christ Church
175	Gordon, Osborne (1813–1883)	Spring 1857	Christ Church, Oxford	Christ Church
177?	Jacobson, William (1804–1884)	Spring 1857	Christ Church, Oxford	Christ Church
178	Spencer Stanhope, John Roddam (1829–1908)	Spring 1857	Christ Church, Oxford	Christ Church
180	Clerke, Charles Carr (1799–1877)	Spring 1857	Christ Church, Oxford	Christ Church
181	Bayne, Thomas Vere (1829–1908)	Spring 1857	Christ Church, Oxford	Christ Church
182	Tyrwhitt, Richard St. John (1827–1895), facing forward	Spring 1857	Christ Church, Oxford	Christ Church
183?	Tyrwhitt, Richard St. John (1827–1895), facing left	Spring 1857	Christ Church, Oxford	NPG
184	Joyce, Francis Hayward (1829–1906)	Spring 1857	Christ Church, Oxford	Christ Church
194	Liddell, Lorina Charlotte (1849–1930)	2 June 1857	Deanery garden, Christ Church, Oxford	Princeton (Parrish)
195	Liddell, Alice Pleasance (1852–1934), facing forward	2 June 1857	Deanery garden, Christ Church, Oxford	Princeton (Parrish)
196?	Liddell, Alice Pleasance (1852–1934), facing left	2 June 1857	Deanery garden, Christ Church, Oxford	Ovenden
197?	Liddell, Alice Pleasance (1852–1934), as beggar child	2 June 1857	Deanery garden, Christ Church, Oxford	Christ Church
198	Max Müller, Friedrich (1823–1900)	June 1857	Christ Church, Oxford	Christ Church

IMAGE NUMBER	SUBJECT	DATE TAKEN	PLACE	CURRENT OWNER
199	Faussett, Robert Godfrey (1827–1908)	June 1857	Christ Church, Oxford	Christ Church
200–227	Skeleton of nylghau (antelope)	June 1857	Anatomical Museum, Christ Church, Oxford	Not located
200–227	Rolleston, George (1829–1881)	June 1857	Anatomical Museum, Christ Church, Oxford	Not located
200–227	Skeletons of a group of Australian animals	June 1857	Anatomical Museum, Christ Church, Oxford	Not located
200–227	Skeletons of a human and a monkey	June 1857	Anatomical Museum, Christ Church, Oxford	Not located
203	Skeleton of an anteater	June 1857	Anatomical Museum, Christ Church, Oxford	Princeton (Parrish)
205	Rolleston, George (1829–1881), with William Robertson (dates unknown), Augustus George Vernon Harcourt (1835–1919), and Heywood Smith (b. 1838)	June 1857	Anatomical Museum, Christ Church, Oxford	Princeton (Parrish)
206	Skeleton of tunny fish, side view	June 1857	Anatomical Museum, Christ Church, Oxford	Princeton (Parrish)
207?	Skeleton of tunny fish, full side view	June 1857	Anatomical Museum, Christ Church, Oxford	Christ Church
208	Skeleton of tunny fish, foreshortened	June 1857	Anatomical Museum, Christ Church, Oxford	Princeton (Parrish)
210	Skeleton of cod's head and shoulders with human skull	June 1857	Anatomical Museum, Christ Church, Oxford	Princeton (Parrish)
212	Broad Walk, Christ Church, from Fell's buildings	June 1857	Christ Church, Oxford	Princeton (Parrish)
213	Broad Walk, Christ Church, with figures	June 1857	Christ Church, Oxford	Princeton (Parrish)
215	Skeleton of sunfish	June 1857	Anatomical Museum, Christ Church, Oxford	Princeton (Parrish)
216	Marshall, George (1817–1897)	June 1857	Christ Church, Oxford	Christ Church
217	Stokes, Edward (1823–1863)	June 1857	Christ Church, Oxford	Christ Church
218	Skeleton of *apteryx australis*, the brown Kiwi bird	June 1857	Anatomical Museum, Christ Church, Oxford	Princeton (Parrish)
219	Southey, Reginald (1835–1899), and skeletons	June 1857	Anatomical Museum, Christ Church, Oxford	Princeton (Parrish)
221	Skeletons of fish, etc.	June 1857	Anatomical Museum, Christ Church, Oxford	Princeton (Parrish)
228	Liddon, Henry Parry (1829–1890)	June 1857	Christ Church, Oxford	Christ Church
229	Twiss, Quintin William Francis (1835–1900)	15 June 1857	Christ Church, Oxford	Princeton (Parrish)
230	Twiss, Quintin William Francis (1835–1900)	15 June 1857	Christ Church, Oxford	Christ Church
231	Twiss, Quintin William Francis (1835–1900), as sailor	15 June 1857	Christ Church, Oxford	Christ Church
232	Hill, Edward (1809–1900)	June 1857	Christ Church, Oxford	Christ Church
233	Rowley, Richard (1832–1864)	June 1857	Christ Church, Oxford	Christ Church
235	Dodgson, Charles Lutwidge (1832–1898)	2 June 1857	Deanery garden, Christ Church, Oxford	Princeton (Parrish)
236	Webster, Alexander Rhind (1816–1890?)	June 1857	Christ Church, Oxford	Princeton (Parrish)
238	Prout, Thomas Jones (1823–1909)	June 1857	Christ Church, Oxford	Christ Church
239	Jacobson, William (1804–1884)	June 1857	Christ Church, Oxford	Princeton (Parrish)
242	Harington, Charles (1838–1868)	June 1857	Christ Church, Oxford	Christ Church
243–292	Dodgson, Charles (1800–1868), silhouette dated 1840	July/Aug. 1857	Croft Rectory, Yorkshire	Owen
243–292	Dodgson, Frances Jane (1803–1851), silhouette dated 1840	July/Aug. 1857	Croft Rectory, Yorkshire	Salisbury Jones
243–292	Dodgson, Edwin Heron (1846–1918)	July/Aug. 1857	Croft Rectory, Yorkshire	Texas (Gernsheim)
243–292	Dodgson, Louisa, Margaret, Caroline, and Edwin (in tree)	July/Aug. 1857	Croft Rectory, Yorkshire	Texas (Gernsheim)

IMAGE NUMBER	SUBJECT	DATE TAKEN	PLACE	CURRENT OWNER
243–254	Dodgson, Louisa, Margaret, and Henrietta	July/Aug. 1857	Croft Rectory, Yorkshire	Texas (Gernsheim)
243–292	Three Dodgson sisters in Croft Rectory drawing room	July/Aug. 1857	Croft Rectory, Yorkshire	Texas (Gernsheim)
243–292	Dodgson, Charles Lutwidge (1832–1898)	July/Aug. 1857	Croft Rectory, Yorkshire	Morgan
243–292	Croft Rectory, the study	July/Aug. 1857	Croft Rectory, Yorkshire	NYU
243–292	Croft Rectory, the drawing room	July/Aug. 1857	Croft Rectory, Yorkshire	NYU
243–292	Croft Church (interior, nave)	July/Aug. 1857	Croft Church, Yorkshire	NYU
243–292	Croft Church (interior, sanctuary)	July/Aug. 1857	Croft Church, Yorkshire	NYU
243–292	Lutwidge, Lucy (1805–1880)	July/Aug. 1857	Croft Rectory, Yorkshire	Salisbury Jones
243–292	House at Croft	July/Aug. 1857	Croft, Yorkshire	NMPFT
243–292	Croft Rectory, from front garden	July/Aug. 1857	Croft Rectory, Yorkshire	Wakeling
243–292	Croft Rectory, from back garden	July/Aug. 1857	Croft Rectory, Yorkshire	NMPFT
243–292	Croft Churchyard, from front	July/Aug. 1857	Croft Church, Yorkshire	NMPFT
243–292	Croft Churchyard, from front near sanctuary	July/Aug. 1857	Croft Church, Yorkshire	NYU
243–292	Croft Churchyard (Dodgson grave)	July/Aug. 1857	Croft Church, Yorkshire	NYU
243–292	Croft Church, from the road (person in gateway)	July/Aug. 1857	Croft Church, Yorkshire	NYU
243–292	Croft Church, from the road	July/Aug. 1857	Croft Church, Yorkshire	NYU
243–292	Old man in checked suit	July/Aug. 1857	Croft Rectory, Yorkshire	NMPFT
248	Dodgson, Edwin Heron (1846–1918), and "The New Book"	July/Aug. 1857	Croft Rectory, Yorkshire	Princeton (Parrish)
251	Dodgson, Edwin Heron (1846–1918), as "The Young Mathematician"	July/Aug. 1857	Croft Rectory, Yorkshire	Princeton (Parrish)
255	Smith, Fanny (1847–1874), Maria (b. 1843), and Anne (b. 1848), with pony	4 Aug. 1857	Dinsdale Rectory, Yorkshire	Princeton (Parrish)
256	Smith, John William (1811–1897)	4 Aug. 1857	Dinsdale Rectory, Yorkshire	Princeton (Parrish)
264	Smith, Maria Grey (b. 1843)	4 Aug. 1857	Dinsdale Rectory, Yorkshire	Princeton (Parrish)
265	Smith, William Arthur Grey (b. 1850)	4 Aug. 1857	Dinsdale Rectory, Yorkshire	Princeton (Parrish)
269	Smith, Anne Grey (b. 1848)	4 Aug. 1857	Dinsdale Rectory, Yorkshire	Princeton (Parrish)
269½	Smith, Fanny Grey (1847–1874)	4 Aug. 1857	Dinsdale Rectory, Yorkshire	Princeton (Parrish)
270	Smith, Maria, Joanna, Fanny, and Anne	4 Aug. 1857	Dinsdale Rectory, Yorkshire	Princeton (Parrish)
271	Wood, Theresa "Lisa" Henrietta Charlotte (b. 1844?)	Aug. 1857	Croft Rectory, Yorkshire?	Princeton (Parrish)
272?	Weld, Anne, née Sellwood (1814–1894)	18 Aug. 1857	Croft Rectory, Yorkshire	Not located
273	Weld, Agnes Grace (1849–1915)	18 Aug. 1857	Croft Rectory, Yorkshire	Princeton (Parrish)
274?	Weld, Agnes Grace (1849–1915)	18 Aug. 1857	Croft Rectory, Yorkshire	Princeton (Parrish)
275	Weld, Agnes Grace (1849–1915), as Little Red Riding-Hood	18 Aug. 1857	Croft Rectory, Yorkshire	Princeton (Parrish)
276?	Chaytor, William Richard Carter (1805–1871)	18 Aug. 1857	Croft Rectory, Yorkshire	Not located
277?	Otter, Mrs. (dates unknown)	18 Aug. 1857	Croft Rectory, Yorkshire	Not located
278	Dodgson, Wilfred Longley (1838–1914), and Dido, the family dog	Aug. 1857	Croft Rectory, Yorkshire	Princeton (Parrish)
279?	Dido, the family dog	Aug. 1857	Croft Rectory, Yorkshire	Texas (Gernsheim)
280*	Hobson, Henry (1819–1873)	Summer 1860	Croft Rectory, Yorkshire	Owen
280⅓?	A mother and child with three girls in checked dresses	Aug. 1857	Croft Rectory, Yorkshire	NMPFT
280⅔*	Hobson, Sarah (b. 1852)	Summer 1860	Croft Rectory, Yorkshire	NMPFT
281*	Hobson, Eliza (b. 1855)	Summer 1860	Croft Rectory, Yorkshire	Texas (Gernsheim)
281½*	Hobson, Henry, and Sarah (1823–1877), and their daughters, Sarah, Eliza, and Lydia (b. 1858)	Summer 1860	Croft Rectory, Yorkshire	Princeton (Parrish)
282	Baker, James (1825–1897)	Aug. 1857	Croft Rectory, Yorkshire	Princeton (Parrish)
283?	Woman in dark hat	Aug. 1857	Croft Rectory, Yorkshire	Texas (Gernsheim)
284	Foster, Robert (1798–1877), half-length	Aug. 1857	Croft Rectory, Yorkshire	Princeton (Parrish)
285	Foster, Robert (1798–1877), full-length	Aug. 1857	Croft Rectory, Yorkshire	Princeton (Parrish)
286	Foster, Mary (1798–1871)	Aug. 1857	Croft Rectory, Yorkshire	Princeton (Parrish)

*Dodgson's error in assigning this image number.

IMAGE NUMBER	SUBJECT	DATE TAKEN	PLACE	CURRENT OWNER
287	Coates, Annie (dates unknown), hair forward	Aug. 1857	Croft Rectory, Yorkshire	Princeton (Parrish)
287½?	Coates, Annie (dates unknown), hair back	Aug. 1857	Croft Rectory, Yorkshire	Texas (Gernsheim)
288	Unknown man and dog	Aug. 1857	Croft Rectory, Yorkshire	Owen
289–297	Lutwidge, Henrietta Mary (1811–1872)	21 Sept. 1857	Ambleside, Lake District	Not located
289–297	Lutwidge, Henry Thomas (1786–1861)	21 Sept. 1857	Ambleside, Lake District	Not located
289–297?	Old man with sideburns (possibly Capt. Henry Lutwidge)	21 Sept. 1857?	Ambleside, Lake District?	Texas (Gernsheim)
289–297?	Woman with lace gloves and bonnet (possibly Henrietta Lutwidge)	21 Sept. 1857?	Ambleside, Lake District?	Texas (Gernsheim)
293	Ambleside, The Cottage	Sept. 1857	Ambleside, Lake District	Texas (Gernsheim)
294	Ambleside, New Church	Sept. 1857	Ambleside, Lake District	Texas (Gernsheim)
295–297	Webster, Mrs. (dates unknown)	25 Sept. 1857	Crosthwaite, near Keswick	Not located
298	Gatey, Margaret (dates unknown)	25 Sept. 1857	Crosthwaite, near Keswick	Princeton (Parrish)
299	Gatey, Margaret (dates unknown)	25 Sept. 1857	Crosthwaite, near Keswick	Princeton (Parrish)
300	Webster, Mary Elizabeth (b. 1849), and Charlotte Augusta (b. 1847), with Margaret Gatey (dates unknown)	25 Sept. 1857	Crosthwaite, near Keswick	Princeton (Parrish)
301	Webster, Alexander Rhind (1816–?1890)	25 Sept. 1857	Crosthwaite, near Keswick	Texas (Gernsheim)
302?	Tennyson, Emily, née Sellwood (1813–1896)	28 Sept. 1857	Monk Coniston Park, Ambleside	Not located
303?	Marshall, James Garth (1802–1873), and his wife, Mary (1812–1875)	28 Sept. 1857	Monk Coniston Park, Ambleside	Not located
304?	Tennyson, Hallam (1852–1928), and Lionel (1854–1886)	28 Sept. 1857	Monk Coniston Park, Ambleside	Lindseth
305	Tennyson, Hallam (1852–1928)	28 Sept. 1857	Monk Coniston Park, Ambleside	Princeton (Parrish)
306	Tennyson, Alfred, Lord (1809–1892)	28 Sept. 1857	Monk Coniston Park, Ambleside	Princeton (Parrish)
307	Lushington, Franklin (1823–1901)	28 Sept. 1857	Monk Coniston Park, Ambleside	Princeton (Parrish)
308	Marshall, James Garth (1802–1873), and his daughter, Julia Mary Garth (1845–1907)	28 Sept. 1857	Monk Coniston Park, Ambleside	Princeton (Parrish)
309	Tennyson, Hallam (1852–1928), and Lionel (1854–1886), with Julia Marshall (1845–1907)	28 Sept. 1857	Monk Coniston Park, Ambleside	Princeton (Parrish)
309½?	Tennyson, Hallam (1852–1928), seated	29 Sept. 1857	Monk Coniston Park, Ambleside	Not located
310	Tennysons and Marshalls	29 Sept. 1857	Monk Coniston Park, Ambleside	Princeton (Parrish)
311	Venetian drawing at Christ Church Library	Nov. 1857?	Christ Church Library, Oxford	Princeton (Parrish)
321	Magdalen Tower, Magdalen College, Oxford	Mar. 1858	Oxford	Princeton (Parrish)
323	Harington, Beatrice Cecilia (b. 1852?)	26 Mar. 1858	Christ Church, Oxford	Princeton (Parrish)
324	Harington, Alice Margaret (1854?–1901)	26 Mar. 1858	Christ Church, Oxford	Princeton (Parrish)
325	Harington, Mary (dates unknown), with daughters, Beatrice and Alice	26 Mar. 1858	Christ Church, Oxford	Princeton (Parrish)
326	Harington, Alice Margaret (1854?–1901)	26 Mar. 1858	Christ Church, Oxford	Princeton (Parrish)
328	Bust of Robert Hussey (1801–1856) by Alexander Munro	Mar. 1858	Christ Church, Oxford	Princeton (Parrish)
329	Ley, Jacob (1803–1881)	Mar. 1858	Christ Church, Oxford	Christ Church
333	Erskine, Henry David (1786–1859)	30 Mar. 1858	Ripon, Yorkshire	Princeton (Parrish)
335	Erskine, either Harriet (b. 1814), Caroline (b. 1818), or Anne (b. 1825)	30 Mar. 1858	Ripon, Yorkshire	Princeton (Parrish)
337	Smith, William Slayter (1792–1865)	31 Mar. 1858	Ripon, Yorkshire	Princeton (Parrish)
341	Tidy, Kathleen (b. 1851)	1 Apr. 1858?	Ripon, Yorkshire	Princeton (Parrish)
344	Tim, the Dodgson family doll	Apr. 1858	Ripon, Yorkshire	Princeton (Parrish)

IMAGE NUMBER	SUBJECT	DATE TAKEN	PLACE	CURRENT OWNER
347	Twiss, Quintin (1835–1900), Charlton George Lane (1836–1892), and Walter Vere Vaughan Williams (1839–1890)	Summer 1858	Deanery garden, Christ Church, Oxford	Christ Church
350	Twiss, Quintin William Francis (1835–1900), as the "Artful Dodger"	Summer 1858	Deanery garden, Christ Church, Oxford	Princeton (Parrish)
351	Twiss, Quintin William Francis (1835–1900), in "The Rat-catcher's Daughter"	Summer 1858	Deanery garden, Christ Church, Oxford	Princeton (Parrish)
352	Twiss, Quintin William Francis (1835–1900), in "The Two Bonnycastles"	Summer 1858	Deanery garden, Christ Church, Oxford	Princeton (Parrish)
353	Twiss, Quintin William Francis (1835–1900), in "The Country Fair"	Summer 1858	Deanery garden, Christ Church, Oxford	Princeton (Parrish)
354	Liddell, Alice Pleasance (1852–1934), as "The Beggar-Maid"	Summer 1858	Deanery garden, Christ Church, Oxford	Princeton (Parrish)
355	Liddell, Alice Pleasance (1852–1934), in profile	Summer 1858	Deanery garden, Christ Church, Oxford	Princeton (Parrish)
356?	Liddell, Alice Pleasance (1852–1934), in best dress	Summer 1858	Deanery garden, Christ Church, Oxford	Christ Church
357–377	Liddell, Alice, and Lorina and Edith, with guitars	Summer 1858	Deanery garden, Christ Church, Oxford	Ovenden
371	Liddell, Lorina Charlotte (1849–1930), with black doll	Summer 1858	Deanery garden, Christ Church, Oxford	Princeton (Parrish)
372	Liddell, Edith Mary (1854–1876), on sofa	Summer 1858	Deanery garden, Christ Church, Oxford	Princeton (Parrish)
374	Liddell, Lorina (1849–1930), Alice (1852–1934), and Edith (1854–1876)	Summer 1858	Deanery garden, Christ Church, Oxford	Princeton (Parrish)
378	Collyns, Henry Martyn (b. 1833)	Summer 1859	Twyford School, Hampshire	Christ Church
379?	Smith, Heywood (b. 1838)	Summer 1859	Twyford School, Hampshire	Not located
380	Dodgson, Edwin Heron (1846–1918), and C. Turner (dates unknown)	Summer 1859	Twyford School, Hampshire	Princeton (Parrish)
381	Smith, Alfred Fowler (1831–1891)	Summer 1859	Twyford School, Hampshire	Princeton (Parrish)
382	Hart, John (dates unknown)	Summer 1859	Twyford School, Hampshire	Princeton (Parrish)
383	Liddell, Edward Henry "Harry" (1847–1911)	Summer 1859	Twyford School, Hampshire	Princeton (Parrish)
384	Twyford School Cricket Eleven	Summer 1859	Twyford School, Hampshire	Princeton (Parrish)
385?	Twyford Eleven in tent	Summer 1859	Twyford School, Hampshire	Not located
386?	Twyford Eleven in field	Summer 1859	Twyford School, Hampshire	Not located
387	Twyford Church, near Winchester, Hampshire	Summer 1859	Twyford, Hampshire	Princeton (Parrish)
388?	Twyford School House and Boys (near)	Summer 1859	Twyford School, Hampshire	Not located
389	Twyford Schoolhouse	Summer 1859	Twyford School, Hampshire	Princeton (Parrish)
390?	Twyford, second schoolhouse	Summer 1859	Twyford School, Hampshire	Not located
391?	Twyford, new schoolroom	Summer 1859	Twyford School, Hampshire	Not located
392	Five Twyford Schoolboys	Summer 1859	Twyford School, Hampshire	Princeton (Parrish)
393	Seven Twyford Schoolboys	Summer 1859	Twyford School, Hampshire	Princeton (Parrish)
394	Kitchin, George William (1827–1912), and the Twyford School first class	Summer 1859	Twyford School, Hampshire	Princeton (Parrish)
395	Kitchin, George William (1827–1912)	Summer 1859	Twyford School, Hampshire	Princeton (Parrish)
396?	Kitchin, George William (1827–1912), and the Sixth Form	Summer 1859	Twyford School, Hampshire	Not located
398	Dodgson, James Hume (1845–1912)	Summer 1859	Twyford School, Hampshire	Princeton (Parrish)
399	Dicken, George Alldersey (1843–1867)	Summer 1859	Twyford School, Hampshire	Princeton (Parrish)
400	Malet, Clement Drake Elton (1845–1930)	Summer 1859	Twyford School, Hampshire	Princeton (Parrish)
405	Munro, Alexander (1825–1871)	Summer 1859	6 Upper Belgrave Place, Pimlico	Princeton (Parrish)
406–430	Mrs. V. Smith, sculpture by Alexander Munro	Summer 1859	6 Upper Belgrave Place, Pimlico	Not located

IMAGE NUMBER	SUBJECT	DATE TAKEN	PLACE	CURRENT OWNER
409	Bust of Ida Wilson by Alexander Munro	Summer 1859	6 Upper Belgrave Place, Pimlico	Princeton (Parrish)
410	*Measurement by Foxglove* (Edith and Emily Hardy) by Alexander Munro	Summer 1859	6 Upper Belgrave Place, Pimlico	Princeton (Parrish)
411	*The Sisters* (Ida Wilson and her sister) by Alexander Munro	Summer 1859	6 Upper Belgrave Place, Pimlico	Princeton (Parrish)
412	Bust of Dante by Alexander Munro	Summer 1859	6 Upper Belgrave Place, Pimlico	Princeton (Parrish)
413	*Lovers' Walk* (back view) by Alexander Munro	Summer 1859	6 Upper Belgrave Place, Pimlico	Princeton (Parrish)
414	*Lovers' Walk* (front view) by Alexander Munro	Summer 1859	6 Upper Belgrave Place, Pimlico	Princeton (Parrish)
417	Bust of Saffi by Alexander Munro	Summer 1859	6 Upper Belgrave Place, Pimlico	Princeton (Parrish)
418	Bust of Giuseppe Mazzini by Alexander Munro	Summer 1859	6 Upper Belgrave Place, Pimlico	Princeton (Parrish)
420	Bust of Madame Ristori by Alexander Munro	Summer 1859	6 Upper Belgrave Place, Pimlico	Princeton (Parrish)
424	*Hope* by Alexander Munro	Summer 1859	6 Upper Belgrave Place, Pimlico	Princeton (Parrish)
425	Head of Agnes Gladstone (1842–1931) by Alexander Munro	Summer 1859	6 Upper Belgrave Place, Pimlico	Princeton (Parrish)
426	Bust of Bianca by Alexander Munro	Summer 1859	6 Upper Belgrave Place, Pimlico	Princeton (Parrish)
427–439	Dodgson, Henrietta Harington (1843–1922)	Summer 1859	Croft Rectory, Yorkshire	Princeton (Parrish)
427–439	Dodgson, Margaret "Maggie" Anne Ashley (1841–1915)	Summer 1859	Croft Rectory, Yorkshire	Princeton (Parrish)
427–439	Dodgson, Margaret "Maggie" Anne Ashley (1841–1915), close-up	Summer 1859	Croft Rectory, Yorkshire	Texas (Gernsheim)
427–439	Dodgson, Wilfred Longley (1838–1914)	Summer 1859	Croft Rectory, Yorkshire	Princeton (Parrish)
427–439	Dodgson, Edwin Heron (1846–1918)	Summer 1859	Croft Rectory, Yorkshire	Princeton (Parrish)
427–439	Dodgson, Charles (1800–1868)	Summer 1859	Croft Rectory, Yorkshire	Princeton (Parrish)
431	Orde, C. (dates unknown)	Summer 1859	Croft Rectory, Yorkshire?	Princeton (Parrish)
432–439	Carr, James Haslewood (b. 1831), Gordon Salmon (b. 1833), Robert Ingham Salmon (b. 1835), Henry Charles Hardinge (1830–1873), and either Henry Paulett Shafto Orde (b. 1838) or William Jocelyn Shafto Orde (1836–1871)	Summer 1859	Croft Rectory, Yorkshire	Not located
432–439	Hardinge, Henry Charles (1830–1873)	Summer 1859	Croft Rectory, Yorkshire?	Not located
440	Lutwidge, Henrietta Mary (1811–1872), and Margaret Anne (1809–1869)	Summer 1859	Croft Rectory, Yorkshire	NMPFT
441	Smith, Fanny Grey (1847–1874), and dog	Summer 1859	Dinsdale Rectory, Yorkshire	Princeton (Parrish)
441⅔	Smith, Fanny Grey (1847–1874)	Summer 1859	Dinsdale Rectory, Yorkshire	Princeton (Parrish)
442	Smith, Maria, Joanna, Fanny, and Anne	Summer 1859	Dinsdale Rectory, Yorkshire	Princeton (Parrish)
442½	Smith, Joanna Grey (1845–1932)	Summer 1859	Dinsdale Rectory, Yorkshire	Princeton (Parrish)
443	Salmon-leap, River Tees at Dinsdale weir and mill, near Darlington	Summer 1859	Dinsdale weir, Yorkshire	Princeton (Parrish)
443½?	Salmon-leap, River Tees at Dinsdale weir and mill, near Darlington	Summer 1859	Dinsdale weir, Yorkshire	NMPFT
444	Dinsdale Church, Dinsdale, near Darlington	Summer 1859	Dinsdale Church, Yorkshire	Princeton (Parrish)
444½	Dinsdale Rectory Garden	Summer 1859	Dinsdale Rectory, Yorkshire	Princeton (Parrish)
445	Salmon, Robert Ingham (b. 1835)	Summer 1859	Croft Rectory, Yorkshire	Princeton (Parrish)
446	Lutwidge, Lucy (1805–1880)	Summer 1859	Croft Rectory, Yorkshire	NMPFT
450	Bamlett, Robert (1772–1863)	Summer 1859	Croft Rectory, Yorkshire	Princeton (Parrish)
451	Longley, Charles Thomas (1794–1868)	Sum./Aut. 1859	Auckland Castle, Durham	Princeton (Parrish)

IMAGE NUMBER	SUBJECT	DATE TAKEN	PLACE	CURRENT OWNER
451½	Longley, Charles Thomas (1794–1868)	Sum./Aut. 1859	Auckland Castle, Durham	Texas (Gernsheim)
452	Longley, Caroline (1843–1867), and Rosamond (1844–1936)	Sum./Aut. 1859	Auckland Castle, Durham	Princeton (Parrish)
454	Cole, Miss (dates unknown)	Sum./Aut. 1859	Auckland Castle, Durham	Princeton (Parrish)
455	Chapel, Auckland Castle, Durham	Sum./Aut. 1859	Auckland Castle, Durham	Princeton (Parrish)
456?	Auckland Castle, Durham	Sum./Aut. 1859	Auckland Castle, Durham	Not located
457	Longley, Rosamond Esther Harriet (1844–1936), from an oil painting	Sum./Aut. 1859	Auckland Castle, Durham	Princeton (Parrish)
458–474	Man in front of a trellised door	Sum./Aut. 1859	Whitburn, Tyne and Wear?	Texas (Gernsheim)
460	Wilcox, Mary (1813–1870), with five sons, four daughters, a niece, and nephew	Sum./Aut. 1859	Whitburn, Tyne and Wear	Princeton (Parrish)
461?	Family with drum and ladder (Wilcoxes)	Sum./Aut. 1859	Whitburn, Tyne and Wear?	Texas (Gernsheim)
462	*Medora,* engraving of a painting	Sum./Aut. 1859	Whitburn, Tyne and Wear?	Princeton (Parrish)
463–474	Robertson, William (1840–1885)	1859	Christ Church, Oxford	Not located
463–474	Pitchin, Alice (dates unknown)	c. 1859	Unknown	Ovenden
475	Ottley group: five children of Lawrence Ottley (1808–1861) and his wife, Elizabeth	Spring 1860	Richmond, Yorkshire	Princeton (Parrish)
478	Richmond Church, Yorkshire	Spring 1860	Richmond, Yorkshire	Princeton (Parrish)
479	Richmond Friary, Yorkshire	Spring 1860	Richmond, Yorkshire	Princeton (Parrish)
480	Richmond Friary, Yorkshire	Spring 1860	Richmond, Yorkshire	Princeton (Parrish)
486	Daresbury Parsonage, front	Spring 1860	Daresbury, Cheshire	Princeton (Parrish)
487	Daresbury Parsonage, side	Spring 1860	Daresbury, Cheshire	NMPFT
488	Daresbury Parsonage, distant	Spring 1860	Daresbury, Cheshire	Princeton (Parrish)
490	Houghton, Mary, née Cliff (b. 1822)	Spring 1860	Daresbury, Cheshire	Princeton (Parrish)
491	Irwin, Phoebe, née Thomas (b. 1812), Bostock by first marriage	Spring 1860	Daresbury, Cheshire	Princeton (Parrish)
492	Greenall, Richard (b. 1830), and his wife, Mary, née Burnett (b. 1835)	Spring 1860	Daresbury, Cheshire	Princeton (Parrish)
493	Walton Hall, near Warrington	Spring 1860	Walton Hall, near Warrington, Cheshire	Princeton (Parrish)
494–568	Anderson, C. (dates unknown)	Spring 1860	Christ Church, Oxford	Not located
494–568	Barnes, Ralph (1810–1884)	Spring 1860	Christ Church, Oxford	Not located
494–568	Choristers at Christ Church	Spring 1860	Christ Church, Oxford	Princeton (Parrish)
494–568	Codrington, Robert Henry (b. 1831)	Spring 1860	Christ Church, Oxford	V&A
494–568	Colley, Richard Henry (1832–1902)	Spring 1860	Christ Church, Oxford	Not located
494–568	Corfe, Charles William (1814–1883)	Spring 1860	Christ Church, Oxford	NPG
494–568	Hussey, William Law (1813–1893)	Spring 1860	Christ Church, Oxford	Not located
494–568	Huxley, Thomas Henry (1825–1895)	Spring 1860	Christ Church, Oxford	Christ Church
494–568	Ingram, Hugh (1827–1872)	Spring 1860	Christ Church, Oxford	Not located
494–568	Lipscomb, Cyril William (b. 1831)	Spring 1860	Christ Church, Oxford	Not located
494–568	Melhuish, George Edward (1834?–1874)	Spring 1860	Christ Church, Oxford	Not located
494–568	Oswald, Henry Murray (b. 1833)	Spring 1860	Christ Church, Oxford	Not located
494–568	Oxford man in degree robes, wearing mortarboard	Spring 1860	Christ Church, Oxford	NPG
494–568	Oxford man looking down, reading	Spring 1860	Christ Church, Oxford	NPG
494–568	Oxford man looking at photo album	Spring 1860	Christ Church, Oxford	NPG
494–568	Oxford man sitting on sofa, looking left	Spring 1860	Christ Church, Oxford	NPG
494–568	Oxford man with mortarboard in hand	Spring 1860	Christ Church, Oxford	Christ Church
494–568	Price, Bartholomew "Bat" (1818–1898)	Spring 1860	Christ Church, Oxford	Not located
494–568	Pickard, Henry Adair (b. 1832)	Spring 1860	Christ Church, Oxford	Not located
494–568	Ramsay, James Henry (b. 1832)	Spring 1860	Christ Church, Oxford	Not located
494–568	Robertson, William (1840–1885)	Spring 1860	Christ Church, Oxford	Not located
494–568	Salmon, J. (dates unknown)	Spring 1860	Christ Church, Oxford	Not located
494–568	Salwey, Henry (1837–1913)	Spring 1860	Christ Church, Oxford	Not located
494–568	Sedgwick, Adam (1785–1873)	Spring 1860	Christ Church, Oxford	Christ Church
494–568	Tyrwhitt, Richard St. John (1827–1895)	Spring 1860	Christ Church, Oxford	Not located

IMAGE NUMBER	SUBJECT	DATE TAKEN	PLACE	CURRENT OWNER
494–568	Unknown clergyman	Spring 1860	Christ Church, Oxford	V&A
495–697	Celia Hutchinson (dates unknown)	Spring 1860	Location unknown	Getty
495–697	Celia Hutchinson (dates unknown), as "Little Red Riding-Hood"	Spring 1860	Location unknown	Getty
495–697	Unknown man seated with open book on his lap	Spring 1860	Location unknown	Getty
501	Rich, John (1826–1913)	Spring 1860	Christ Church, Oxford	Christ Church
502	Bosanquet, Samuel Courthope (1832–1925)	Spring 1860	Christ Church, Oxford	Not located
505	Benson, Richard Meux (1824–1915)	Spring 1860	Christ Church, Oxford	NPG
507	Jelf, George Edward (1834–1908)	Spring 1860	Christ Church, Oxford	Not located
508	Jelf, Richard William (1798–1871), and his wife, Emmy, and family	Spring 1860	Christ Church, Oxford	Princeton (Parrish)
509	Ouseley, Frederick Gore (1825–1889)	Spring 1860	Christ Church, Oxford	Christ Church
511	Andrews, Septimus (1832–1914)	Spring 1860	Christ Church, Oxford	Not located
512	Chamberlain, Thomas (1810–1892)	Spring 1860	Christ Church, Oxford	Christ Church
513	Saunders, Augustus Page (1801–1878)	Spring 1860	Christ Church, Oxford	Christ Church
515	Marsham, Charles (1841–1905)	Spring 1860	Christ Church, Oxford	Not located
519	Southey, Reginald (1835–1899)	Spring 1860	Christ Church, Oxford	Princeton (Cotsen)
523	Benson, F. and M. (dates unknown)	Spring 1860	Oxford?	Princeton (Parrish)
526	Price, Amy Eliza, née Cole (b. 1836), and her daughter, Amy Maud (1858–1923)	Spring 1860	Christ Church, Oxford	Not located
537	Liddell, Alice Pleasance (1852–1934), asleep	Spring 1860	Deanery garden, Christ Church, Oxford	Princeton (Parrish)
538	Liddell, Alice Pleasance (1852–1934), walking	Spring 1860	Deanery garden, Christ Church, Oxford	Not located
539	Liddell, Lorina Charlotte (1849–1930), in Chinese dress	Spring 1860	Deanery garden, Christ Church, Oxford	Princeton (Parrish)
540	Liddell, Lorina Charlotte (1849–1930), and Alice Pleasance (1852–1934), in Chinese dress	Spring 1860	Deanery garden, Christ Church, Oxford	Princeton (Parrish)
543	Liddell, Edith Mary (1854–1876), on sofa	Spring 1860	Deanery garden, Christ Church, Oxford	Princeton (Parrish)
546	Liddell, Lorina Charlotte (1849–1930), with guitar	Spring 1860	Deanery garden, Christ Church, Oxford	Princeton (Parrish)
547	Liddell, Alice, Lorina, Harry, and Edith	Spring 1860	Deanery garden, Christ Church, Oxford	Ovenden
548	Donkin, Alice, with Sarah Acland and Lorina Liddell	Spring 1860	Deanery garden, Christ Church, Oxford	Princeton (Parrish)
549	Harington, Alice Margaret (1854?–1901)	Spring 1860	Christ Church, Oxford	Princeton (Parrish)
550–551	Acland, Sarah Angelina (1849–1930), and unknown woman (H.D.T.)	Spring 1860	Deanery garden, Christ Church, Oxford	Not located
552	Sandford, Charles Waldegrave (1828–1903)	Spring 1860	Christ Church, Oxford	Christ Church
554	Dodgson, Charles (1800–1868), reading	May 1860	Croft Rectory, Yorkshire	Princeton (Parrish)
556–568	Liddell, Alice Pleasance (1852–1934), and Lorina Charlotte (1849–1930)	May/June 1860	Deanery garden, Christ Church, Oxford	Ovenden
556–568	Liddell, Lorina Charlotte (1849–1930)	May/June 1860	Deanery garden, Christ Church, Oxford	Ovenden
561	Liddell, Alice Pleasance (1852–1934), in wreath	May/June 1860	Deanery garden, Christ Church, Oxford	Princeton (Parrish)
562	Fellowes, possibly Pleasance Susan (b. 1846?)	May/June 1860	Deanery garden, Christ Church, Oxford	Princeton (Parrish)
563	Liddell, Alice Pleasance (1852–1934), and Lorina Charlotte (1849–1930) and see-saw	May/June 1860	Deanery garden, Christ Church, Oxford	Princeton (Parrish)
564	Deanery garden, Christ Church	May/June 1860	Deanery garden, Christ Church, Oxford	Princeton (Parrish)
565?	Christ Church Library from Deanery garden	May/June 1860	Deanery garden, Christ Church, Oxford	Christ Church

IMAGE NUMBER	SUBJECT	DATE TAKEN	PLACE	CURRENT OWNER
569	Dindorf, Karl Wilhelm (1802–1883)	26 June 1860	Christ Church, Oxford	Princeton (Parrish)
571	Wilberforce, Samuel (1805–1873)	28 June 1860	Christ Church, Oxford	Princeton (Parrish)
572	Jackson, John (1811–1885)	28 June 1860	Christ Church, Oxford	Princeton (Parrish)
573	Randall, James (1790–?1878)	28 June 1860	Christ Church, Oxford	Princeton (Parrish)
574	Faraday, Michael (1791–1867)	30 June 1860	Christ Church, Oxford	Princeton (Parrish)
576	Hunt, William Holman (1827–1910)	30 June 1860	Christ Church, Oxford	Princeton (Parrish)
577	Petherick, John (d. 1882)	29 June 1860	Christ Church, Oxford	Princeton (Parrish)
578	Bolster, John Abraham (dates unknown)	30 June 1860	Christ Church, Oxford	Princeton (Parrish)
579	Mayor, Robert Bickersteth (1820–1898)	30 June 1860	Christ Church, Oxford	Princeton (Parrish)
580	Tristram, Henry Baker (1822–1906)	2 July 1860	Christ Church, Oxford	Princeton (Parrish)
582	Slatter, John (1817–1899)	2 July 1860	Christ Church, Oxford	Princeton (Parrish)
583	Slatter, Elizabeth "Bessie" Ann (b. 1854)	2 July 1860	Christ Church, Oxford	Princeton (Parrish)
584	Woolner, Thomas (1825–1892)	2 July 1860	Christ Church, Oxford	Princeton (Parrish)
585	Ranken, William Henry (1832–1920)	2/3 July 1860	Christ Church, Oxford	Princeton (Parrish)
587?	Cole, William Willoughby, Earl of Enniskillen (1807–1886)	3 July 1860	Christ Church, Oxford	Christ Church
588	Cole, William Willoughby, Earl of Enniskillen (1807–1886)	3 July 1860	Christ Church, Oxford	Princeton (Parrish)
589	Randolph, Herbert (1789–1875)	3 July 1860	Christ Church, Oxford	Princeton (Parrish)
592	Hill, Edward (1809–1900)	3 July 1860	Christ Church, Oxford	Christ Church
595	Gordon, Osborne (1813–1883)	3/4 July 1860	Christ Church, Oxford	Christ Church
596	Murchison, Roderick Impey (1792–1871)	4 July 1860	Christ Church, Oxford	Princeton (Parrish)
597	Stanley, Arthur Penrhyn (1815–1881)	4 July 1860	Christ Church, Oxford	Princeton (Parrish)
598	Woodward, Benjamin (1816–1861)	4 July 1860	Christ Church, Oxford	Princeton (Parrish)
599	Woodward, Benjamin (1816–1861)	4 July 1860	Christ Church, Oxford	Princeton (Parrish)
601	Harrison, James Park (1817–1901), and his son, Matthew J. (b. 1847), R.N.	5 July 1860	Christ Church, Oxford	Princeton (Parrish)
604	Brooks, Blencoe (dates unknown)	July 1860	Christ Church, Oxford	Princeton (Parrish)
606	Combe, Thomas (1797–1872)	30 June 1860?	Christ Church, Oxford	Princeton (Parrish)
608	Acland, Sarah (1849–1930), Henry (1850–1936), and Theodore (1851–1931)	July 1860	Deanery garden, Christ Church, Oxford	Princeton (Parrish)
609	Bowlby, Mary (b. 1854)	July 1860	Deanery garden, Christ Church, Oxford	Princeton (Parrish)
610	Salmon, Robert Ingham (b. 1835), and Frances Bowlby (b. 1858)	July 1860	Deanery garden, Christ Church, Oxford	Princeton (Parrish)
611	Liddell, Edith, Lorina, and Alice, in "Open your mouth and shut your eyes"	July 1860	Deanery garden, Christ Church, Oxford	Princeton (Parrish)
613	Liddell, Alice Pleasance (1852–1934), and fern	July 1860	Deanery garden, Christ Church, Oxford	Princeton (Parrish)
616	Liddell, Edith Mary (1854–1876), and foxgloves	July 1860	Deanery garden, Christ Church, Oxford	Princeton (Parrish)
622	Barry, Louisa "Loui" Dorothy (b. 1852)	Summer 1860	Whitby, Yorkshire	Princeton (Parrish)
623	Barry, Letitia Anna (1824–1911), and her daughter, Louisa (b. 1852)	Summer 1860	Whitby, Yorkshire	Princeton (Parrish)
624	Keane, William (1818–1873)	Summer 1860	Whitby, Yorkshire	Princeton (Parrish)
626	Keane, William (1818–1873), in Indian hat	Summer 1860	Whitby, Yorkshire	Princeton (Parrish)
627	Bainbridge, Florence Hilda (b. 1847)	Summer 1860	Whitby, Yorkshire	Princeton (Parrish)
628	Bainbridge, Florence (b. 1847), Agnes (b. 1850), and Laura (b. 1854)	Summer 1860	Whitby, Yorkshire	Princeton (Parrish)
630	Hunton, Mrs. (dates unknown)	Summer 1860	Whitby, Yorkshire	Princeton (Parrish)
630½	Whitby	Summer 1860	Whitby, Yorkshire	Princeton (Parrish)
641	Lutwidge, Lucy (1805–1880)	Summer 1860	Croft Rectory, Yorkshire	Woking
642	Dodgson, Henrietta Harington (1843–1922)	Summer 1860	Croft Rectory, Yorkshire	Woking
643–697	Wilcox, William Edward (1835–1876)	Autumn 1860	Whitburn, Tyne and Wear	DLI

IMAGE NUMBER	SUBJECT	DATE TAKEN	PLACE	CURRENT OWNER
663	Erskine, Henry David (1786–1859) [re-photographed]	Autumn 1860	Croft Rectory, Yorkshire	Princeton (Parrish)
667	Harington, Beatrice Cecilia (b. 1852?), and Alice Margaret (1854?–1901)	Autumn 1860	Christ Church, Oxford	Princeton (Parrish)
668	Gough, Henry (1812–1862)	Autumn 1860	Christ Church, Oxford	Princeton (Parrish)
676	Brodie, Margaret Anne (b. 1850), and Lilian (1853–1916)	Autumn 1860	Oxford	Princeton (Parrish)
678–733	Rogers, Annie Mary Ann Henley (1856–1937)	June 1861	Oxford	Rogers
678–733	Rogers, Mrs., and Annie Mary Ann Henley (1856–1937)	June 1861	Oxford	Rogers
678–733	Rogers, Bertram Mitford Heron (b. 1860)	June 1861	Oxford	Rogers
678–733	Rogers, James Edwin Thorold (1822–1890), and his son, Henry Reynolds Knatchbull (1858–1876)	June 1861	Oxford	Rogers
678–733	Rogers, James Edwin Thorold (1822–1890), and his daughter, Annie	June 1861	Oxford	Rogers
678–733	Statuette of Annie Rogers	June 1861?	Oxford	Not located
698	Rogers, Annie Mary Ann Henley (1856–1937)	June 1861	Oxford	Princeton (Parrish)
704	Brodie, Benjamin Collins (1817–1880)	21 June 1861	Oxford	Princeton (Parrish)
709	Brodie, Ethel (1856–1926), and Lilian (1853–1916)	21 June 1861	Oxford	Princeton (Parrish)
710	Brodie, Margaret (b. 1850), Lilian (1853–1916), Ethel (1856–1926), and Mary (b. 1858)	21 June 1861	Oxford	Princeton (Parrish)
715	Brodie, Margaret Anne (b. 1850)	21 June 1861	Oxford	Princeton (Parrish)
716	Brodie, Margaret Anne (b. 1850), and Lilian (1853–1916)	21 June 1861	Oxford	Princeton (Parrish)
718	Brodie, Lilian (1853–1916), Margaret (b. 1850), Ida (1852–1917), and Ethel (1856–1926)	21 June 1861	Oxford	Princeton (Parrish)
719	Brodie, Lilian (1853–1916), Margaret (b. 1850), Ida (1852–1917), and Ethel (1856–1926)	21 June 1861	Oxford	Princeton (Parrish)
721	Magdalen Tower, Magdalen College, Oxford	Summer 1861	Oxford	Princeton (Parrish)
722–745	Cameron, Julia Margaret (1815–1879), and two sons	Apr. 1862?	Isle of Wight?	Ovenden
722–745	Two boys, possibly sons of Julia Margaret Cameron	Apr. 1862?	Isle of Wight?	Texas (Gernsheim)
722–745	Boy, possibly son of Julia Margaret Cameron	Apr. 1862?	Isle of Wight?	Texas (Gernsheim)
734*	Rogers, Annie Mary Ann Henley (1856–1937)	June 1861	Christ Church, Oxford	Princeton (Parrish)
736	Slatter, Elizabeth "Bessie" Ann (b. 1854)	Spring 1862	Christ Church, Oxford	Princeton (Parrish)
737–745	Hoskyns, Emma (dates unknown)	2 June 1862	Christ Church, Oxford	Not located
738–760	Joyce, Francis Hayward (1829–1906)	27–30 June 1862	Christ Church, Oxford	Not located
738–760	Golding, Alice (dates unknown)	27–30 June 1862	Christ Church, Oxford	Not located
738–760	Golding, Mrs. (dates unknown)	27–30 June 1862	Christ Church, Oxford	Not located
738–760	Barnes, Miss (dates unknown)	27–30 June 1862	Christ Church, Oxford	Not located
746	Lott, Mary Elizabeth (b. 1855?)	27 June 1862	Christ Church, Oxford	Princeton (Parrish)
750	Mayo, Robert (b. 1832?)	27–30 June 1862	Christ Church, Oxford	Not located
751	Atkinson, Francis Home (1840–1901)	29 June 1862	Christ Church, Oxford	Princeton (Parrish)
752	Conybeare, Charles Ranken (1821–1885)	30 June 1862	Christ Church, Oxford	Princeton (Parrish)
761	Hicks Beach, Michael Edward (1837–1916)	3 July 1862	Christ Church, Oxford	Princeton (Parrish)
762–765	Peters, Mrs. (dates unknown)	4 July 1862	Christ Church, Oxford	Not located
762–765	Peters, Miss (dates unknown)	4 July 1862	Christ Church, Oxford	Not located
763–791	Collyns, John Martyn (1827–1912)	10 July 1862	Christ Church, Oxford	Not located
763–791	Gandell, Shomberg (b. 1859)	10 July 1862	Iffley Rectory, Oxford	Not located
766	Gandell, Florence (dates unknown)	10 July 1862	Iffley Rectory, Oxford	Princeton (Parrish)
769	Gandell, Robert (1818–1887), and his daughter, Florence	10 July 1862	Iffley Rectory, Oxford	Princeton (Parrish)

*Dodgson's error in assigning this image number.

IMAGE NUMBER	SUBJECT	DATE TAKEN	PLACE	CURRENT OWNER
785	Rumsey, Elizabeth (b. 1826), and daughter, Elizabeth "Leila" (b. 1859)	10–14 July 1862	Iffley Rectory, Oxford	Princeton (Parrish)
786?	Rumsey, Elizabeth "Leila" (b. 1859)	10–14 July 1862	Iffley Rectory, Oxford	Not located
787–791	Edwards, James George (1836–1903)	14 July 1862	Christ Church, Oxford	Not located
788–791	Harington, Beatrice Cecilia (b. 1852?)	21 July 1862	Christ Church, Oxford	Not located
788–791	Harington, Alice Margaret (1854?–1901)	21 July 1862	Christ Church, Oxford	Not located
789–791	Ranken, William Henry (1832–1920)	22 July 1862	Christ Church, Oxford	Not located
792	Brodie, Margaret Anne (b. 1850), and Ida Philothea (1852–1917)	2 Aug. 1862	Christ Church, Oxford	Princeton (Parrish)
793	Brodie, Lilian (1853–1916)	2 Aug. 1862	Christ Church, Oxford	Princeton (Parrish)
794–816	Goff, William (b. 1842)	8 Aug. 1862	Christ Church, Oxford	Not located
794–816	Goff, John Crosbie (b. 1840)	8 Aug. 1862	Christ Church, Oxford	Not located
795–849	Ellison, Gerald Francis (b. 1861)	23 Aug. 1862	South Bank, Malvern	Not located
795–849	Ellison, Mary Beatrice (b. 1857)	23 Aug. 1862	South Bank, Malvern	Not located
795–849	Ellison, Dorothy Frances (b. 1859)	23 Aug. 1862	South Bank, Malvern	Not located
817	Ellison, John "Johnnie" Henry Joshua (b. 1855)	23 Aug. 1862	South Bank, Malvern	Princeton (Parrish)
824	Ellison, Constance Margaret (b. 1856)	23 Aug. 1862	South Bank, Malvern	Princeton (Parrish)
830	Ellison, Constance Margaret (b. 1856), and Mary Beatrice (b. 1857) in "Tired of Play"	23 Aug. 1862	South Bank, Malvern	Princeton (Parrish)
833	Ellison, Henry John (1813–1899)	23 Aug. 1862	South Bank, Malvern	Princeton (Parrish)
835	Ellison, Mary Dorothy, née Jebb (1832–1870)	23 Aug. 1862	South Bank, Malvern	Princeton (Parrish)
850	Dodgson, Charlotte Mary (b. 1839)	1–11 Sept. 1862	Park Lodge, Putney	Princeton (Parrish)
859	Dodgson, Laura Elizabeth (1853–1882)	1–11 Sept. 1862	Park Lodge, Putney	Princeton (Parrish)
863	Dodgson, Hassard Hume (1803–1884), and family	1–11 Sept. 1862	Park Lodge, Putney	Princeton (Parrish)
864	Poole, Alice Henrietta (b. 1844), and Margaret "Meta" Frances (b. 1842)	1–11 Sept. 1862	Park Lodge, Putney	Princeton (Parrish)
865	Poole, Skeffington (1803–1876), and one of his daughters	1–11 Sept. 1862	Park Lodge, Putney	Princeton (Parrish)
866	Poole, Skeffington (1803–1876)	1–11 Sept. 1862	Park Lodge, Putney	Princeton (Parrish)
867	Poole, Skeffington (1803–1876)	1–11 Sept. 1862	Park Lodge, Putney	Hartland Mahon
868	Old House, Park Lodge, Putney	1–11 Sept. 1862	Park Lodge, Putney	Princeton (Parrish)
876	Taylor, Aubrey Ashworth (1845–1876)	5 Sept. 1862	East Sheen, London	Princeton (Parrish)
878	Taylor, Eleanor Emma Ashworth (1847–1911)	5 Sept. 1862	East Sheen, London	Princeton (Parrish)
879	Taylor, Ida Alice Ashworth (1850–1929)	5 Sept. 1862	East Sheen, London	Princeton (Parrish)
880	De Vere, Aubrey Thomas (1814–1902)	5 Sept. 1862	East Sheen, London	Princeton (Parrish)
881	Taylor, Henry (1800–1886)	5 Sept. 1862	East Sheen, London	Princeton (Parrish)
883	Taylor, Harry Ashworth (1854–1907)	5 Sept. 1862	East Sheen, London	Princeton (Parrish)
884	Taylor, Harry, and Una	5 Sept. 1862	East Sheen, London	Princeton (Parrish)
885–890	Prescott, Emily (dates unknown)	6 Sept. 1862	East Sheen, London	Not located
886	Taylor, Una Mary Ashworth (1857–1922)	6 Sept. 1862	East Sheen, London	Princeton (Parrish)
888	Cameron, Ewen Wrottesley Hay (1843–1888)	6 Sept. 1862	East Sheen, London	Princeton (Parrish)
889–896	"Sleeping Beauty"	8 Sept. 1862	Park Lodge, Putney	Not located
891	Family group, Putney	1–11 Sept. 1862	Park Lodge, Putney	RPS
892	Dodgsons and Pooles in "I Zingari"	8 Sept. 1862	Park Lodge, Putney	Princeton (Parrish)
897	Dodgson, Margaret "Maggie" Anne Ashley (1841–1915), in "Reflection"	Sept. 1862	Croft Rectory, Yorkshire	Princeton (Parrish)
900	Dodgson's sisters	Sept. 1862	Croft Rectory, Yorkshire	NMPFT
902	Dykes, Gertrude Kingston (b. 1854)	Sept. 1862	Croft Rectory, Yorkshire	Princeton (Parrish)
904	Dykes, Gertrude Kingston (b. 1854)	Sept. 1862	Croft Rectory, Yorkshire	Princeton (Parrish)
907	Dykes, Gertrude (b. 1854), Mary E. (b. 1852), and Caroline Sybil (b. 1856)	Sept. 1862	Croft Rectory, Yorkshire	Princeton (Parrish)
907½	Dykes, Mary, Gertrude, and Caroline	Sept. 1862	Croft Rectory, Yorkshire	Owen
912	Bickersteth, Robert (1816–1884)	24 Sept. 1862	Croft Rectory, Yorkshire	Princeton (Parrish)
918	Four unknown children at Croft Rectory	Sept. 1862	Croft Rectory, Yorkshire	NMPFT
919–952	Donkin children	8 Oct. 1862	Barmby Moor, Yorkshire	Not located

IMAGE NUMBER	SUBJECT	DATE TAKEN	PLACE	CURRENT OWNER
929	Donkin, Alice Jane (1851–1929), in "The Elopement"	9 Oct. 1862	Barmby Moor, Yorkshire	Princeton (Parrish)
930–952	Donkin, Alice Jane (1851–1929), and Mary "Polly" (dates unknown)	9 Oct. 1862	Barmby Moor, Yorkshire	Not located
933	Barmby Moor	8 Oct. 1862	Barmby Moor, Yorkshire	Princeton (Parrish)
934–952	Wethered, Mrs. (dates unknown)	18 June 1863	Badcock's Yard, Oxford	Not located
935–952	Harington, Beatrice Cecilia (b. 1852?), and Alice Margaret (1854?–1901)	22 June 1863	Badcock's Yard, Oxford	Not located
935–952	Harington, Alice Margaret (1854?–1901)	22 June 1863	Badcock's Yard, Oxford	Not located
935–952	Harington, Beatrice Cecilia (b. 1852?)	22 June 1863	Badcock's Yard, Oxford	Not located
936–952	Christ Church Deanery and Cathedral	23 June 1863	Christ Church, Oxford	Not located
936–952	Royal bedstead at Christ Church Deanery	23 June 1963	Deanery, Christ Church	Not located
953	Owen, Sidney, Junior (dates unknown)	27 June 1863	Badcock's Yard, Oxford	Texas (Gernsheim)
954–956	Allen, Charlotte (dates unknown)	30 June 1863	Badcock's Yard, Oxford	Not located
955	Allen, Misses, possibly Mary (b. 1843), and her sister, in "News from Home"	30 June 1863	Badcock's Yard, Oxford	Texas (Gernsheim)
956–968	Jacobson, William (1804–1884)	1 July 1863	Badcock's Yard, Oxford	Not located
957	Acland, Henry Wentworth (1815–1900)	1–20 July 1863	Badcock's Yard, Oxford	Princeton (Parrish)
958–973	Rogers, Annie, and Henry Reynolds Knatchbull (1858–1876)	July 1863	Badcock's Yard, Oxford	Rogers
958–973	Rogers, Annie, and Henry Reynolds Knatchbull (1858–1876)	July 1863	Badcock's Yard, Oxford	Rogers
958–973	Rogers, Annie Mary Ann Henley (1856–1937), seated	3 July 1863	Badcock's Yard, Oxford	Rogers
958–973	Rogers, Annie Mary Ann Henley (1856–1937), standing	3 July 1863	Badcock's Yard, Oxford	Rogers
958–973	Rogers, Annie Mary Ann Henley (1856–1937)	3 July 1863	Badcock's Yard, Oxford	Rogers
966	Donkin, Alice Emily (b. 1850)	3 July 1863	Badcock's Yard, Oxford	Princeton (Parrish)
969	Jackson, Mary (b. 1854?)	3 July 1863	Badcock's Yard, Oxford	Princeton (Parrish)
972?	Rogers, Annie, and Mary Jackson	3 July 1863	Badcock's Yard, Oxford	Rogers
974	Rogers, Annie, and Mary Jackson, in "Fair Rosamond"	3 July 1863	Badcock's Yard, Oxford	Princeton (Parrish)
975–994	Donkin family	4–13 July 1863	Badcock's Yard, Oxford	Not located
975–994	Brodies and Donkins	4–13 July 1863	Badcock's Yard, Oxford	Not located
975–994	Brodie family	4–13 July 1863	Badcock's Yard, Oxford	Not located
975–994	Brodie, Benjamin Vincent Sellons (1862–1938), asleep on couch	4–13 July 1863	Badcock's Yard, Oxford	Not located
975–994	Rowden family	4–13 July 1863	Badcock's Yard, Oxford	Not located
980	Donkin, William Fishburn (1814–1869)	4–13 July 1863	Badcock's Yard, Oxford	Princeton (Parrish)
981–994	Kitchin, George William (1827–1912), and Snub, the dog	4–13 July 1863	Badcock's Yard, Oxford	Lindseth
981–994	Snub, the Kitchin family dog	4–13 July 1863	Badcock's Yard, Oxford	Lindseth
981–994	Snub, the Kitchin family dog, asleep	4–13 July 1863	Badcock's Yard, Oxford	Lindseth
982–1049	Campbell, Margaret (dates unknown)	25–31 July 1863	Elm Lodge, Hampstead	Not located
982–1049	Rankin, Mary (dates unknown)	25–31 July 1863	Elm Lodge, Hampstead	Not located
982–1049	MacDonald, Winifred Louisa (1858–1946)	25–31 July 1863	Elm Lodge, Hampstead	Not located
982–1049	MacDonald, Mrs. L., Greville, Mary, Irene, and Caroline with Dodgson	25–31 July 1863	Elm Lodge, Hampstead	Lindseth
982–1049	Three women with book (Powells?)	25–31 July 1863?	Elm Lodge, Hampstead?	Texas (Gernsheim)
982–1049	MacDonald, Irene, and Mary, with Flora Rankin	25–31 July 1863	Elm Lodge, Hampstead	Gilman
982–1049	MacDonald, Irene, and Mary, with Flora Rankin, slightly different pose	25–31 July 1863	Elm Lodge, Hampstead	Not located
982–1195	MacDonald, George (1824–1905), and his wife, Louisa (1822–1902)	July/Oct. 1863	Elm Lodge, Hampstead	Lindseth
982–1195	MacDonald, Mary Josephine (1853–1878)	July/Oct. 1863	Elm Lodge, Hampstead	Lindseth

IMAGE NUMBER	SUBJECT	DATE TAKEN	PLACE	CURRENT OWNER
982–1195	Noyle, Mrs. Crawford, and her youngest son	July/Oct. 1863	Elm Lodge, Hampstead?	SNPG
982–1195	Noyle, Mrs. Crawford (dates unknown)	July/Oct. 1863	Elm Lodge, Hampstead?	SNPG
995	MacDonald, Caroline Grace (1854–1884)	25–31 July 1863	Elm Lodge, Hampstead	SNPG
996	MacDonald, Irene (b. 1857)	25–31 July 1863	Elm Lodge, Hampstead	Texas (Gernsheim)
997?	MacDonald, Irene (b. 1857)	25–31 July 1863	Elm Lodge, Hampstead	Not located
1002	Maurice, Frederick Denison (1805–1872)	27 July 1863	Elm Lodge, Hampstead	Princeton (Parrish)
1003	MacDonald, George (1824–1905)	27 July 1863	Elm Lodge, Hampstead	Princeton (Parrish)
1005	MacDonald, Nelly (dates unknown)	25–31 July 1863	Elm Lodge, Hampstead	Princeton (Parrish)
1008	MacDonald, Irene (b. 1857)	25–31 July 1863	Elm Lodge, Hampstead	Texas (Gernsheim)
1016	Rankin, Flora (dates unknown)	25–31 July 1863	Elm Lodge, Hampstead	Princeton (Parrish)
1017	Rankin, Flora (dates unknown), in "No Lessons Today"	25–31 July 1863	Elm Lodge, Hampstead	Princeton (Parrish)
1025	MacDonald, Mary Josephine (1853–1878)	25–31 July 1863	Elm Lodge, Hampstead	Princeton (Parrish)
1026?	MacDonald, George (1824–1905), with Mary and Ronald	25–31 July 1863	Elm Lodge, Hampstead	SNPG
1027	MacDonald, Irene (b. 1857), in "It Won't Come Smooth"	25–31 July 1863	Elm Lodge, Hampstead	Texas (Gernsheim)
1028?	MacDonald, Irene (b. 1857)	25–31 July 1863	Elm Lodge, Hampstead	Not located
1029	MacDonald, Greville Matheson (1856–1944)	25–31 July 1863	Elm Lodge, Hampstead	Princeton (Parrish)
1050	Tate, Lucy Hutchinson (1842–1873)	20 Aug. 1863	Croft Rectory, Yorkshire	Princeton (Parrish)
1054	Anderson, Marie "Minnie" Katherine (1846–1889)	20–25 Aug. 1863	Croft Rectory, Yorkshire	Princeton (Parrish)
1058	Dodgson's sisters	20–25 Aug. 1863	Croft Rectory, Yorkshire	Princeton (Parrish)
1059–1082	Barry children, in "The Dream"	26–29 Aug. 1863	Whitby, Yorkshire	RPS
1059–1082	Barry, John "Johnnie" Warren (1851–1920)	26–29 Aug. 1863	Whitby, Yorkshire	RPS
1059–1082	Barry, Emily Eupatoria "Mimie" (b. 1854)	26–29 Aug. 1863	Whitby, Yorkshire	Not located
1059–1082	Goode, Miss (dates unknown)	26–29 Aug. 1863	Whitby, Yorkshire	Not located
1059–1082	Keane, Elizabeth Fryer, née Thomas (dates unknown)	26–29 Aug. 1863	Whitby, Yorkshire	Not located
1059–1082	Keane, William (1818–1873)	26–29 Aug. 1863	Whitby, Yorkshire	Not located
1067	Keane, Marcus (dates unknown)	26–29 Aug. 1863	Whitby, Yorkshire	Texas (Gernsheim)
1072	Barry, Louisa "Loui" Dorothy (b. 1852), hand on arm of chair	26–29 Aug. 1863	Whitby, Yorkshire	Princeton (Parrish)
1073?	Barry, Louisa "Loui" Dorothy (b. 1852), hands clasped	26–29 Aug. 1863	Whitby, Yorkshire	RPS
1075	Powell, Anna Catherine (1841–1911)	26–29 Aug. 1863	Whitby, Yorkshire	Texas (Gernsheim)
1076	Powell, Constance Mary (dates unknown)	26–29 Aug. 1863	Whitby, Yorkshire	Princeton (Parrish)
1077–1082	Read, Thomas Frederick Rudston (1811–1892)	7 Sept. 1863	Winteringham, Lincolnshire	Not located
1077–1082	Mitchell, Mr. (dates unknown)	7 Sept. 1863	Winteringham, Lincolnshire	Not located
1078–1082	Schoolchildren	8–11 Sept. 1863	Winteringham, Lincolnshire	Not located
1078–1082	Winteringham Rectory	8–11 Sept. 1863	Winteringham, Lincolnshire	Not located
1083	Read, Louisa Lucy Rudston, née Erskine (1816–1865)	8–11 Sept. 1863	Winteringham, Lincolnshire	Princeton (Parrish)
1087	Winteringham Church	8–11 Sept. 1863	Winteringham, Lincolnshire	Princeton (Parrish)
1088–1104	Watkin, Mrs. (dates unknown)	1 Oct. 1863	6 Upper Belgrave Place, Pimlico	Not located
1088–1104	Watkin, Harriet (dates unknown)	1 Oct. 1863	6 Upper Belgrave Place, Pimlico	Not located
1088–1104	Edward "Teddy" Wilson (b. 1857), as Henry VIII	1 Oct. 1863	6 Upper Belgrave Place, Pimlico	Not located
1105	Clay bust by Alexander Munro	2 Oct. 1863	6 Upper Belgrave Place, Pimlico	Texas (Gernsheim)
1106	*Children's Play,* sculpture by Alexander Munro	2 Oct. 1863	6 Upper Belgrave Place, Pimlico	Texas (Gernsheim)
1107	Bust of Joan of Arc by Alexander Munro	2 Oct. 1863	6 Upper Belgrave Place, Pimlico	Texas (Gernsheim)

IMAGE NUMBER	SUBJECT	DATE TAKEN	PLACE	CURRENT OWNER
1108–1125	Taylor, Wickliffe (dates unknown)	3 Oct. 1863	Wandsworth, London	Not located
1111	Taylor, Tom (1817–1880)	3 Oct. 1863	Wandsworth, London	Texas (Gernsheim)
1116	Taylor, Wickliffe (dates unknown)	3 Oct. 1863	Wandsworth, London	Texas (Gernsheim)
1122	Taylor, Wickliffe (dates unknown)	3 Oct. 1863	Wandsworth, London	Texas (Gernsheim)
1123?	Taylor, Henry (1800–1886)	5 Oct. 1863?	Wandsworth, London	Wakeling
1124?	Servants of Tom Taylor	5 Oct. 1863	Wandsworth, London	Not located
1125?	Rossetti, Dante Gabriel (1828–1882)	6 Oct. 1863	16 Cheyne Walk, Chelsea	Texas (Gernsheim)
1126	Rossetti, Dante Gabriel (1828–1882)	6 Oct. 1863	16 Cheyne Walk, Chelsea	Texas (Gernsheim)
1128	Legros, Alphonse (1837–1911)	6 Oct. 1863	16 Cheyne Walk, Chelsea	Texas (Gernsheim)
1129	Cayley, Charles Bagot (1823–1883)	6 Oct. 1863	16 Cheyne Walk, Chelsea	Texas (Gernsheim)
1130	Rossetti, Christina Georgina (1830–1894), and her mother, Frances	7 Oct. 1863	16 Cheyne Walk, Chelsea	Texas (Gernsheim)
1131?	Rossetti, Christina, Maria, Frances, and Dante Gabriel	7 Oct. 1863	16 Cheyne Walk, Chelsea	Hillelson
1132	Rossetti, Dante Gabriel, Christina, Frances, and William Michael (1829–1919)	7 Oct. 1863	16 Cheyne Walk, Chelsea	Texas (Gernsheim)
1134	Rossetti, Christina Georgina (1830–1894)	6 Oct. 1863	16 Cheyne Walk, Chelsea	Texas (Gernsheim)
1136	Munro, Alexander (1825–1871), and his wife, Mary, née Carruthers (d. 1872)	7 Oct. 1863	16 Cheyne Walk, Chelsea	Texas (Gernsheim)
1137	Douglas, Angus (dates unknown)	7 Oct. 1863	16 Cheyne Walk, Chelsea	Princeton (Parrish)
1139	Beyer, Helene (dates unknown)	9 Oct. 1863	16 Cheyne Walk, Chelsea	Texas (Gernsheim)
1146	Drawings of (a) Irish girl, and (b) the late Mrs. D. G. Rossetti, by Rossetti	8 Oct. 1863	16 Cheyne Walk, Chelsea	Not located
1147	Drawing of the late Mrs. D. G. Rossetti (profile), by Rossetti	8 Oct. 1863	16 Cheyne Walk, Chelsea	Not located
1149	Drawing of "Miss Miller" (Annie Miller), by Rossetti	8 Oct. 1863	16 Cheyne Walk, Chelsea	Texas (Gernsheim)
1150	Drawing of female head (profile), by Rossetti	8 Oct. 1863	16 Cheyne Walk, Chelsea	Not located
1151	Drawing of the late Mrs. D. G. Rossetti, by Rossetti	8 Oct. 1863	16 Cheyne Walk, Chelsea	Not located
1152	Drawing of head only, by Rossetti	8 Oct. 1863	16 Cheyne Walk, Chelsea	Texas (Gernsheim)
1153	Watercolor sketch of Miss Herbert, by Rossetti	8 Oct. 1863	16 Cheyne Walk, Chelsea	Not located
1154	Drawing of girl and grapes, by Rossetti	8 Oct. 1863	16 Cheyne Walk, Chelsea	Not located
1155	*Woven Gold*, drawing by Rossetti	8 Oct. 1863	16 Cheyne Walk, Chelsea	Not located
1156–1170	MacDonald, Irene (b. 1857)	10 Oct. 1863	12 Earl's Terrace, Kensington	Lindseth
1156–1170	Strong, Clement Erskine (b. 1855)	10 Oct. 1863	12 Earl's Terrace, Kensington	Not located
1156–1170	Strong, Alice (b. 1852)	10 Oct. 1863	12 Earl's Terrace, Kensington	Not located
1161	MacDonald, Mary Josephine (1853–1878)	10 Oct. 1863	12 Earl's Terrace, Kensington	Texas (Gernsheim)
1162?	MacDonald, Mary Josephine (1853–1878)	10 Oct. 1863	12 Earl's Terrace, Kensington	Lindseth
1163?	MacDonald, Mary Josephine (1853–1878)	10 Oct. 1863	12 Earl's Terrace, Kensington	Not located
1164	MacDonald, Lily "Lilia" Scott (1852–1891)	10 Oct. 1863	12 Earl's Terrace, Kensington	Texas (Gernsheim)
1165	MacDonald, Greville Matheson (1856–1944)	10 Oct. 1863	12 Earl's Terrace, Kensington	Texas (Gernsheim)
1167	Strong, Zoë Sophia (b. 1854)	10 Oct. 1863	12 Earl's Terrace, Kensington	Texas (Gernsheim)
1168	Strong, Fanny Louisa, née Erskine (1822–1908)	10 Oct. 1863	12 Earl's Terrace, Kensington	Texas (Gernsheim)
1169–1178	Hughes, Agnes (1859–1945), asleep on sofa	12 Oct. 1863	12 Earl's Terrace, Kensington	Ovenden
1169–1178	Hughes, Agnes (1859–1945), standing	12 Oct. 1863	12 Earl's Terrace, Kensington	Ovenden
1171	Hughes, Arthur Foord (1856–1934)	12 Oct. 1863	12 Earl's Terrace, Kensington	Texas (Gernsheim)
1172	Hughes, Amy (1857–1915)	12 Oct. 1863	12 Earl's Terrace, Kensington	Texas (Gernsheim)
1173	Hughes, Agnes (1859–1945)	12 Oct. 1863	12 Earl's Terrace, Kensington	Princeton (Parrish)
1174?	Hughes, Agnes (1859–1945), and Amy (1857–1915)	12 Oct. 1863	12 Earl's Terrace, Kensington	Not located
1177	Hughes, Arthur (1830–1915), and his daughter, Agnes (1859–1945)	12 Oct. 1863	12 Earl's Terrace, Kensington	Texas (Gernsheim)
1179	Smart, Antoinette "Netty" A. (dates unknown)	13 Oct. 1863	12 Earl's Terrace, Kensington	Texas (Gernsheim)
1183	MacDonald, George (1824–1905), and his daughter, Lily "Lilia" Scott	14 Oct. 1863	12 Earl's Terrace, Kensington	Texas (Gernsheim)
1192?	Reynolds, Edith Mary (b. 1848)	20 July 1864	Lambeth Palace, London	Texas (Gernsheim)

IMAGE NUMBER	SUBJECT	DATE TAKEN	PLACE	CURRENT OWNER
1193?	Reynolds, Edith Mary (b. 1848), in veil	20 July 1864	Lambeth Palace, London	Texas (Gernsheim)
1196?	Frederick, Crown Prince of Denmark (1843–1912), seated	18 Nov. 1863	Badcock's Yard, Oxford	Christ Church
1197	Frederick, Crown Prince of Denmark (1843–1912), standing	18 Nov. 1863	Badcock's Yard, Oxford	Princeton (Parrish)
1198–1211	Price, Maud (b. 1857?)	24 Mar. 1864	Badcock's Yard, Oxford	Not located
1199–1211	Shirley, Mary (b. 1859?)	19 Apr. 1864	Badcock's Yard, Oxford	Not located
1199–1211	Shirley, Alice (b. 1858?)	19 Apr. 1864	Badcock's Yard, Oxford	Not located
1199–1211	Claude, nephew of Shirley (dates unknown)	19 Apr. 1864	Badcock's Yard, Oxford	Not located
1202?	Price, Agnes Florence (dates unknown)	2 May 1864	Badcock's Yard, Oxford	Not located
1203	Price, Agnes Florence (dates unknown)	2 May 1864	Badcock's Yard, Oxford	Texas (Gernsheim)
1204–1216	Hussey, Elizabeth, née Ley (d. 1896)	26 Apr. 1864	Badcock's Yard, Oxford	Not located
1212	Hussey, Elizabeth "Bessie" Ley (b. 1852?)	26 Apr. 1864	Badcock's Yard, Oxford	Texas (Gernsheim)
1213–1231	Rowden, Mary (dates unknown)	29 Apr. 1864	Badcock's Yard, Oxford	Not located
1217	White, Mrs. (dates unknown)	30 Apr. 1864	Badcock's Yard, Oxford	Texas (Gernsheim)
1218–1231	Shirley, Loeta (dates unknown)	3 May 1864	Badcock's Yard, Oxford	Not located
1218–1231	Shirley, Walter Waddington (1829–1866)	3 May 1864	Badcock's Yard, Oxford	Not located
1219–1231	Granville, Ellen Evelyn (b. 1857)	6 May 1864	Badcock's Yard, Oxford	Not located
1219–1231	Granville, Emma Violet (b. 1855)	6 May 1864	Badcock's Yard, Oxford	NMPFT
1220–1231	Hackman, Alfred (1811–1874)	12 May 1864	Badcock's Yard, Oxford	Not located
1232	Barker, May (b. 1857)	6 June 1864	Badcock's Yard, Oxford	Texas (Gernsheim)
1233	Barker, Thomas Childe (b. 1827), and his daughter, May	6 June 1864	Badcock's Yard, Oxford	Texas (Gernsheim)
1234–1267	Vicars, Misses	6 June 1864	Badcock's Yard, Oxford	Not located
1234–1267	Vicars, Hedley (1797–1864)	6 June 1864	Badcock's Yard, Oxford	Not located
1235–1267	Granville, Ellen Evelyn (b. 1857)	9 June 1864	Badcock's Yard, Oxford	Not located
1235–1267	Granville, Mary "May" Elizabeth (b. 1849)	9 June 1864	Badcock's Yard, Oxford	Not located
1236–1267	Latham, Mrs. (dates unknown)	10 June 1864	Badcock's Yard, Oxford	Not located
1236–1267	Latham, Beatrice (b. 1861?)	10 June 1864	Badcock's Yard, Oxford	Not located
1237–1267	Latham, Mr. and Mrs. (dates unknown)	11 June 1864	Badcock's Yard, Oxford	Not located
1237–1267	Latham, Beatrice (b. 1861?)	11 June 1864	Badcock's Yard, Oxford	Not located
1238–1267	Hunt, William Holman (1827–1910)	16 June 1864	Badcock's Yard, Oxford	Not located
1239–1272	Cole, Alice (dates unknown), and Edith Stogden (dates unknown)	17 June 1864?	Badcock's Yard, Oxford	Not located
1268	Stogden, Edith (dates unknown)	17 June 1864	Badcock's Yard, Oxford	Texas (Gernsheim)
1273	Goundry, Elizabeth "Bessie" S. (b. 1852)	June 1864	Badcock's Yard, Oxford	Texas (Gernsheim)
1274–1283	Longley, Rosamond Esther Harriet (1844–1936)	4 July 1864	Lambeth Palace, London	Not located
1274–P36	Willatson, Emma, and her brother (dates unknown)	4–21 July 1864	Lambeth Palace, London	Not located
1275–1292	Balfour, Georgina Mary (1851–1929), and Ella Sophia Anna (1854–1935)	5 July 1864	Lambeth Palace, London	Not located
1275–1292	Balfour, Georgina Mary "Gina" or "Georgie" (1851–1929), profile	5 July 1864	Lambeth Palace, London	Texas (Gernsheim)
1275–1292	Longley, Mrs. Henry (dates unknown)	5 July 1864	Lambeth Palace, London	Not located
1275–1292	Gatty, Alfred (1813–1903)	5 July 1864	Lambeth Palace, London	Not located
1284	Balfour, Georgina Mary "Gina" or "Georgie" (1851–1929), facing front	5 July 1864	Lambeth Palace, London	Texas (Gernsheim)
1285	Balfour, Ella Sophia Anna (1854–1935)	5 July 1864	Lambeth Palace, London	Texas (Gernsheim)
1291	Bourke, Walter Longley (1859–1939)	5 July 1864	Lambeth Palace, London	Princeton (Parrish)
1292?	Longley party	6 July 1864	Lambeth Palace, London	Not located
1293	Bligh, Ivo Francis Walter (1859–1927)	7 July 1864	Lambeth Palace, London	Texas (Gernsheim)
1294?	Bligh, Alice Isabella Harriet (1860–1943), and Ivo Francis Walter (1859–1927)	7 July 1864	Lambeth Palace, London	Private collection
1295	Parnell, Madeline Caroline (1855–1925)	7 July 1864	Lambeth Palace, London	Texas (Gernsheim)
1296	Parnell, Louisa "Loui" Anna Maria (1857–1933)	7 July 1864	Lambeth Palace, London	Texas (Gernsheim)
1297	Parnell, Elizabeth "Leila" Mary Emily (1859–1936)	7 July 1864	Lambeth Palace, London	Not located

IMAGE NUMBER	SUBJECT	DATE TAKEN	PLACE	CURRENT OWNER
1298?	Parnell, Mabel Frances Letitia (1862–1947)	7 July 1864	Lambeth Palace, London	Not located
1299	Parnell, Victor Alexander Lionel Dawson (1852–1936)	7 July 1864	Lambeth Palace, London	Texas (Gernsheim)
1300	Parnell, Victor Alexander Lionel Dawson (1852–1936)	7 July 1864	Lambeth Palace, London	Not located
1304	Longley, Charles Thomas (1794–1868)	7 July 1864	Lambeth Palace, London	Princeton (Parrish)
1305–1311	Johnson, Master (dates unknown)	8 July 1864	Lambeth Palace, London	Not located
1305–1311	Johnson, Edith (dates unknown)	8 July 1864	Lambeth Palace, London	Not located
1305–1311	Denman, Charlotte Edith (1855–1884), and Arthur (b. 1857)	8 July 1864	Lambeth Palace, London	Not located
1307	Denman, Charlotte Edith (1855–1884)	8 July 1864	Lambeth Palace, London	Texas (Gernsheim)
1309	Denman, Arthur (b. 1857)	8 July 1864	Lambeth Palace, London	Texas (Gernsheim)
1310	Denman, Grace (1858–1935)	8 July 1864	Lambeth Palace, London	Texas (Gernsheim)
1311–P8	Longley, Henry (1833–1899), and his wife, Diana, née Davenport	9 July 1864	Lambeth Palace, London	Not located
1312	Westmacott, Emily Beatrice (dates unknown)	9 July 1864	Lambeth Palace, London	Not located
1313–P8	Westmacott, Antoinette (dates unknown)	9 July 1864	Lambeth Palace, London	Not located
1313–P8	Westmacott, Amy (b. 1856)	9 July 1864	Lambeth Palace, London	Not located
1316	Westmacott, Alice Constance (b. 1859)	9 July 1864	Lambeth Palace, London	Texas (Gernsheim)
1317	Westmacott, Alice Constance (b. 1859)	9 July 1864	Lambeth Palace, London	Not located
P1–P8	Randall, Mrs. (dates unknown)	11 July 1864	Lambeth Palace, London	Not located
P1–P8	Gilliat, Louisa Anne Fanny, née Babington (dates unknown)	11 July 1864	Lambeth Palace, London	Not located
P1–P8	Gilliat children	11 July 1864	Lambeth Palace, London	Not located
P9	White, Maria (dates unknown)	11 July 1864	Lambeth Palace, London	Texas (Gernsheim)
P10	Westmacott, James Sherwood (1823–1900)	12 July 1864	Lambeth Palace, London	Texas (Gernsheim)
P11–P22	MacDonald, Irene (b. 1857), and Mary Josephine (1853–1878)	12 July 1864	Lambeth Palace, London	Not located
P11–P22	MacDonald, Irene (b. 1857)	12 July 1864	Lambeth Palace, London	Not located
P13	Darvall, Henry (dates unknown)	12 July 1864	Lambeth Palace, London	Texas (Gernsheim)
P14–P22	Houses of Parliament	15 July 1864	London	Not located
P14–P22	Andrews, Septimus (1832–1914)	15 July 1864	Lambeth Palace, London	Not located
P15–P27	Munro, Miss (dates unknown)	19 July 1864	Lambeth Palace, London	Not located
P23	Hughes, Tryphena, née Foord, and Arthur (1856–1934), Amy (1857–1915), and Agnes (1859–1945)	19 July 1864	Lambeth Palace, London	Texas (Gernsheim)
P28	Reynolds, Edith Mary (b. 1848), and Amy Beatrice (b. 1854)	20 July 1864	Lambeth Palace, London	Texas (Gernsheim)
P31	Henley, Constance Laura (1857–1930)	20 July 1864	Lambeth Palace, London	Texas (Gernsheim)
P32	Henley, Beatrice Mary (1859–1941)	20 July 1864	Lambeth Palace, London	Texas (Gernsheim)
P33–P40	Franklin, Vernon (dates unknown)	13 Aug. 1864	Farringford, Isle of Wight	Not located
P33–P40	Franklin, Rose Lucy (1857?–1934)	13 Aug. 1864	Farringford, Isle of Wight	Not located
P33–P40	Franklin children	13 Aug. 1864	Farringford, Isle of Wight	Not located
P37	Parkes, Annie (b. 1855)	13 Aug. 1864	Farringford, Isle of Wight	Texas (Gernsheim)
P41	Farringford, from field	15 Aug. 1864	Farringford, Isle of Wight	Texas (Gernsheim)
P42	Franklin, Lucy, née Haywood (1828?–1922), and daughter, Rose	15 Aug. 1864	Farringford, Isle of Wight	Texas (Gernsheim)
P43–P78	Tennyson's servants at Farringford	16 Aug. 1864	Farringford, Isle of Wight	Not located
P47	Burnett, Mary (b. 1853)	16 Aug. 1864	Farringford, Isle of Wight	Texas (Gernsheim)
P48–P78	Weld, Charles Richard (1813–1869)	17 Aug. 1864	Farringford, Isle of Wight	Texas (Gernsheim)
P48–P78	Farringford	17 Aug. 1864	Farringford, Isle of Wight	Not located
P48–P78	Burnett, Frank (1852–1896)	17 Aug. 1864	Farringford, Isle of Wight	Not located
P49–P78	Franklin, Rose Lucy (1857?–1934)	18 Aug. 1864	Farringford, Isle of Wight	Not located
P49–P78	Hurd, Mr. (dates unknown)	18 Aug. 1864	Farringford, Isle of Wight	Not located
P49–P78	Lambert, Mr. (dates unknown)	18 Aug. 1864	Farringford, Isle of Wight	Not located

IMAGE NUMBER	SUBJECT	DATE TAKEN	PLACE	CURRENT OWNER
P49–P78	Lambert, Master (dates unknown)	18 Aug. 1864	Farringford, Isle of Wight	Not located
P50–P100	Langton Clarke, Charles Langton "Robin" (b. 1858?)	19–29 Sept. 1864	Whitburn, Tyne and Wear	AIC
P50–P100	Langton Clarke, James (1833–1916), and his son, Charles "Robin" (b. 1858?)	19–29 Sept. 1864	Whitburn, Tyne and Wear	AIC
P50–P100	Langton Clarke, Margaret Frances (b. 1860)	19–29 Sept. 1864	Whitburn, Tyne and Wear	AIC
P50–P100	Langton Clarke, Margaret Frances (b. 1860), with doll	19–29 Sept. 1864	Whitburn, Tyne and Wear	AIC
P50–P100	Wilcox family	19–29 Sept. 1864	Whitburn, Tyne and Wear	Not located
P50–P100	Balfour children	19–29 Sept. 1864	Whitburn, Tyne and Wear	Not located
P50–P100	Balfour, Ella Sophia Anna (1854–1935)	19–29 Sept. 1864	Whitburn, Tyne and Wear	Not located
P50–P100	Balfour, Georgina Mary "Gina" or "Georgie" (1851–1929), full-length	19–29 Sept. 1864	Whitburn, Tyne and Wear	Not located
P50–P100	Balfour, Georgina Mary "Gina" or "Georgie" (1851–1929), half-length	19–29 Sept. 1864	Whitburn, Tyne and Wear	Not located
P50–P100	Balfour, Sophia, née Cathcart (1830–1902)	19–29 Sept. 1864	Whitburn, Tyne and Wear	Not located
P79	Langton Clarke, Alice Gertrude (b. 1863) ?	19–29 Sept. 1864	Whitburn, Tyne and Wear	AIC
P91	Wilcox, William Edward (1835–1876), and Fanny (1832–1919)	19–29 Sept. 1864	Whitburn, Tyne and Wear	Princeton (Parrish)
P92–P100	Metcalfe, Frances (b. 1860?)	6 June 1865	Badcock's Yard, Oxford	Not located
P92–P100	Metcalfe, Rosamond (b. 1859?)	6 June 1865	Badcock's Yard, Oxford	Not located
P93–P100	Godfrey, Georgina "Georgie" F. (b. 1855)	1 July 1865	Badcock's Yard, Oxford	Not located
P93–P100	Stone, Edith (b. 1857?)	1 July 1865	Badcock's Yard, Oxford	Not located
1329	Terry, Marion "Polly" (1854–1930)	13 July 1865	92 Stanhope Street, London	Musée d'Orsay
1330	Terry, Ellen Alice (Mrs. Watts) (1847–1928)	13 July 1865	92 Stanhope Street, London	Texas (Gernsheim)
1331	Terry, Ellen Alice (1847–1928), and Florence "Flo" Maude (1856–1896)	13 July 1865	92 Stanhope Street, London	Texas (Gernsheim)
1332	Terry, Charles "Charlie" or "Charley" John Arthur (1858–1933)	14 July 1865	92 Stanhope Street, London	Musée d'Orsay
1333–1343	Terry, Marion "Polly" (1854–1930)	14 July 1865	92 Stanhope Street, London	Ovenden
1334	Terry, Ellen Alice (1847–1928), and Sarah, née Ballard (1819–1892)	14 July 1865	92 Stanhope Street, London	Musée d'Orsay
1336	Terry, Charles "Charlie" or "Charley" John Arthur (1858–1933)	14 July 1865	92 Stanhope Street, London	Texas (Gernsheim)
1337	Terry, Elizabeth "Kate" Murray (1844–1924)	14 July 1865	92 Stanhope Street, London	Texas (Gernsheim)
1339	Terry, Ellen Alice (Mrs. Watts) (1847–1928)	14 July 1865	92 Stanhope Street, London	Texas (Gernsheim)
1340	Terry, Florence "Flo" Maude (1856–1896)	14 July 1865	92 Stanhope Street, London	Texas (Gernsheim)
1341	Terry, "Polly," and "Flo"	14 July 1865	92 Stanhope Street, London	Texas (Gernsheim)
1342	Terry, Benjamin (1818–1896), and Sarah, née Ballard (1819–1892)	14 July 1865	92 Stanhope Street, London	Texas (Gernsheim)
1343–1350	Martin, Miss (dates unknown)	15 July 1865	92 Stanhope Street, London	Not located
1344	Terry, Thomas "Tom" Walter Alfred (1860–1932)	15 July 1865	92 Stanhope Street, London	Not located
1346?	Terry, Elizabeth "Kate" Murray, and Ellen Alice	15 July 1865	92 Stanhope Street, London	NYU
1347	Terry, Elizabeth "Kate" Murray (1844–1924), as "Andromeda"	15 July 1865	92 Stanhope Street, London	Musée d'Orsay
1348	Terry, Benjamin, and Sarah, with six of their children	15 July 1865	92 Stanhope Street, London	Musée d'Orsay
1351	Terry, Florence "Flo" Maude (1856–1896), as "Cinderella"	17 July 1865	92 Stanhope Street, London	Musée d'Orsay
1353	Terry, Florence "Flo" Maude (1856–1896)	17 July 1865	92 Stanhope Street, London	Musée d'Orsay
1357?	Millais, Euphemia "Effie," née Gray (1828–1897)	19 July 1865	7 Cromwell Place, London	Not located
1358?	Millais, Mary Hunt (1860–1944)	19 July 1865	7 Cromwell Place, London	Not located
1359	Millais, Effie Gray (1858–1912)	21 July 1865	7 Cromwell Place, London	Texas (Gernsheim)
1360–1376	Turnbull, Elizabeth (dates unknown)	21 July 1865	7 Cromwell Place, London	Not located
1363	Millais, John Everett, and his wife, Euphemia, with Effie and Mary	21 July 1865	7 Cromwell Place, London	Texas (Gernsheim)

IMAGE NUMBER	SUBJECT	DATE TAKEN	PLACE	CURRENT OWNER
1366	Millais, John Everett (1829–1896)	21 July 1865	7 Cromwell Place, London	Princeton (Parrish)
1369	Millais, Mary Hunt (1860–1944), in "Waking"	21 July 1865	7 Cromwell Place, London	Princeton (Parrish)
1377	Ellis, Bertha S. (b. 1858)	26/27 July 1865	Cranbourne, near Windsor	Texas (Gernsheim)
1378	Ellis, Frances Dymphna Harriet (1854–1930)	25 July 1865	Cranbourne, near Windsor	Texas (Gernsheim)
1379–1404	Ellis children	26/27 July 1865	Cranbourne, near Windsor	Ovenden
1381	Ellis, Katherine "Kate" (b. 1860)	26/27 July 1865	Cranbourne, near Windsor	Texas (Gernsheim)
1390	Ellis, Mary (b. 1856)	26/27 July 1865	Cranbourne, near Windsor	Texas (Gernsheim)
1405	Fawcett, Eliza Rose, née Wood (b. 1843), as "Jeannie Campbell"	Sept. 1865	Croft Rectory, Yorkshire	Princeton (Parrish)
1408⅔	Whitaker, Edward Wright (1840–1881)	Sept. 1865	Croft Rectory, Yorkshire	Princeton (Parrish)
1413	Wilson Todd, William Pierrepont (1857–1925)	4 Sept. 1865	Croft Rectory, Yorkshire	Texas (Gernsheim)
1415	Wilson Todd, Elizabeth "Lizzie" Jane (1856–1931)	4 Sept. 1865	Croft Rectory, Yorkshire	Texas (Gernsheim)
1416	Wilson Todd, Aileen Frances Mary (1859?–1937)	4 Sept. 1865	Croft Rectory, Yorkshire	Texas (Gernsheim)
1418	Wilson Todd, Evelyn Frideswide (b. 1860)	4 Sept. 1865	Croft Rectory, Yorkshire	Texas (Gernsheim)
1419–1431	Bickersteth, Robert "Robin" (b. 1847), and Florence Elizabeth (1852–1923)	7 Sept. 1865	Bishop's Palace, Ripon	Not located
1419–1431	Bickersteth, Florence Elizabeth (1852–1923), Edward Ernest (1853–1872), and Montague Cyril (1858–1937)	7 Sept. 1865	Bishop's Palace, Ripon	Not located
1419–1431	Bickersteth, Florence Elizabeth (1852–1923)	7 Sept. 1865	Bishop's Palace, Ripon	Not located
1419–1451	Bickersteth, Edward (1814–1892)	7–9 Sept. 1865	Bishop's Palace, Ripon	Not located
1419–1451	Bickersteth, Elizabeth, née Garde (dates unknown)	7–9 Sept. 1865	Bishop's Palace, Ripon	Bickersteth
1419–1451	Bickersteth, Henry "Harry" Cecil (1848–1896)	7–9 Sept. 1865	Bishop's Palace, Ripon	Texas (Gernsheim)
1419–1451	Bickersteth, Florence Elizabeth (1852–1923)	7–9 Sept. 1865	Bishop's Palace, Ripon	Bickersteth
1426	Bickersteth, Robert (1816–1884)	7 Sept. 1865	Bishop's Palace, Ripon	Princeton (Parrish)
1427	Bickersteth, Montague Cyril (1858–1937)	7 Sept. 1865	Bishop's Palace, Ripon	Texas (Gernsheim)
1432	Bickersteth, Edward (1814–1892)	8 Sept. 1865	Bishop's Palace, Ripon	Texas (Gernsheim)
1434	Bickersteth, Edward Ernest (1853–1872)	8 Sept. 1865	Bishop's Palace, Ripon	Not located
1437	Bickersteth, Robert "Robin" (b. 1847)	8 Sept. 1865	Bishop's Palace, Ripon	Texas (Gernsheim)
1440	Bickersteth, Florence Elizabeth (1852–1923)	8 Sept. 1865	Bishop's Palace, Ripon	Texas (Gernsheim)
1444?	Bishop's Palace, Ripon	9 Sept. 1865	Bishop's Palace, Ripon	NYU
1445	Bishop's Palace, Ripon	9 Sept. 1865	Bishop's Palace, Ripon	Princeton (Parrish)
1446–1451	St. John's Chapel, Ripon	Sept. 1865	Ripon, Yorkshire	NYU
1446–1451	The Residence, Ripon	Sept. 1865	Ripon, Yorkshire	NYU
1452	Yonge, Charlotte Mary (1823–1901)	4 May 1866	Badcock's Yard, Oxford	Princeton (Parrish)
1453	Yonge, Charlotte Mary, and her mother, Frances Mary (dates unknown)	4 May 1866	Badcock's Yard, Oxford	Texas (Gernsheim)
1454–1458	Donkin, William Fishburn (1814–1869)	14 May 1866	Badcock's Yard, Oxford	Not located
1455	Donkin, Alice Emily (b. 1850), and Alice Jane (1851–1929)	14 May 1866	Badcock's Yard, Oxford	Princeton (Parrish)
1457?	Langton Clarke, James (1833–1916)	30 May 1866	Badcock's Yard, Oxford	Texas (Gernsheim)
1459	Wall, Mary (dates unknown)	15 May 1866	Badcock's Yard, Oxford	Texas (Gernsheim)
1460	Wall, Henry (1810–1873)	15 May 1866	Badcock's Yard, Oxford	Texas (Gernsheim)
1461–1483	Monier-Williams, Ella Chlora Faithfull (1859–1954), standing	24/28 May 1866	Badcock's Yard, Oxford	Texas (Gernsheim)
1461–1483	Monier-Williams, Ella Chlora Faithfull (1859–1954), on sofa	24/28 May 1866	Badcock's Yard, Oxford	Texas (Gernsheim)
1461–1483	Monier-Williams, Ella Chlora Faithfull (1859–1954), on sofa	24/28 May 1866	Badcock's Yard, Oxford	Private collection
1461–1483	Monier-Williams, Ella Chlora Faithfull (1859–1954), on sofa with book	24/28 May 1866	Badcock's Yard, Oxford	Private collection
1461 1483	Monier-Williams, Ella Chlora Faithfull (1859–1954), leaning on sofa	24/28 May 1866	Badcock's Yard, Oxford	Private collection
1461–1483	Monier-Williams, Ella Chlora Faithfull (1859–1954), asleep	24/28 May 1866	Badcock's Yard, Oxford	Texas (Gernsheim)

IMAGE NUMBER	SUBJECT	DATE TAKEN	PLACE	CURRENT OWNER
1461–1483	Monier-Williams, Ella Chlora Faithfull (1859–1954), close-up	24/28 May 1866	Badcock's Yard, Oxford	Lindseth
1461–1483	Monier-Williams, Ella, and one of her brothers	24/28 May 1866	Badcock's Yard, Oxford	SF MoMA
1462–1483	Rogers, Bertram Mitford Heron (b. 1860), and Leonard James (b. 1862)	15 June 1866	Badcock's Yard, Oxford	Rogers
1484	Brine, Catherine "Katie" Gram (b. 1860)	16 June 1866	Badcock's Yard, Oxford	Texas (Gernsheim)
1485–1493	Brine, Mary Amelia, née Pusey (1833–1910)	16 June 1866	Badcock's Yard, Oxford	Not located
1487	Lloyd, Catharine Eliza (1824–1898), and "Katie" Brine (b. 1860)	16 June 1866	Badcock's Yard, Oxford	Princeton (Parrish)
1490	Allen, Mary (b. 1843)	June 1866	Badcock's Yard, Oxford	Princeton (Parrish)
1491–1500	Monier-Williams, either Clive, Stanley, or Outram (dates unknown)	1–8 July 1866	Badcock's Yard, Oxford	Lindseth
1491–1500	Monier-Williams, Outram (dates unknown)	1–8 July 1866	Badcock's Yard, Oxford	Not located
1491–1500	Treacher, Joseph Skipper (b. 1816)	1–8 July 1866	Badcock's Yard, Oxford	Not located
1491–1500	Treacher sisters	1–8 July 1866	Badcock's Yard, Oxford	Not located
1491–1500	Monier-Williams, Ella Chlora Faithfull (1859–1954), New Zealand dress	1–8 July 1866	Badcock's Yard, Oxford	Private collection
1491–1500	Monier-Williams, Julia, née Faithfull, and her daughter, Ella	1–8 July 1866	Badcock's Yard, Oxford	Lindseth
1491–1500	Monier-Williams, Sir Monier (1819–1899)	1–8 July 1866	Badcock's Yard, Oxford	Lindseth
1491–1500	Monier-Williams, Julia, née Faithfull (dates unknown)	1–8 July 1866	Badcock's Yard, Oxford	Lindseth
1491–1500	Monier-Williams, Stanley (dates unknown)	1–8 July 1866	Badcock's Yard, Oxford	Not located
1491–1500	Monier-Williams, Clive (dates unknown)	1–8 July 1866	Badcock's Yard, Oxford	Not located
1494	Jenkins, John David (1828–1876)	1–8 July 1866	Badcock's Yard, Oxford	Texas (Gernsheim)
1495	Jelf, George Edward (1834–1908)	July 1866	Badcock's Yard, Oxford	Princeton (Parrish)
1496	Wilcox, Henry "Harry" George (1839–1907)	7 July 1866	Badcock's Yard, Oxford	Princeton (Parrish)
1497–1500	Bayne, Thomas Vere (1829–1908)	1–8 July 1866	Badcock's Yard, Oxford	Not located
1498–1500	Gandell party	9 July 1866	Badcock's Yard, Oxford	Not located
1501	Phillips, John (1800–1874)	11 July 1866	Badcock's Yard, Oxford	Texas (Gernsheim)
1503	"Minnie Morton," from a painting by Sophie Anderson	11–23 July 1866	Badcock's Yard, Oxford	Princeton (Parrish)
1505	Liddon, Henry Parry (1829–1890)	11–23 July 1866	Badcock's Yard, Oxford	Christ Church
1506–1514	Sant, Eliza, née Thomson (1833–1907)	24 July 1866	2 Fitzroy Square, London	Not located
1513	Sant, James (1820–1916)	24 July 1866	2 Fitzroy Square, London	Princeton (Parrish)
1515	Ward, Flora Emma Sarah (dates unknown)	25 July 1866	2 Fitzroy Square, London	Texas (Gernsheim)
1516–1519	Sant, Mary Edith (b. 1852), and Sarah Fanny Constance (b. 1856)	25 July 1866	2 Fitzroy Square, London	Not located
1516–1519	Ward, Flora Emma Sarah (dates unknown)	25 July 1866	2 Fitzroy Square, London	Not located
1516–1519	Desanges, Eleanor "Nelly" Fanny (b. 1858)	25 July 1866	2 Fitzroy Square, London	Not located
1516–1519	Sant, Mary Edith (b. 1852)	25 July 1866	2 Fitzroy Square, London	Not located
1516–1519	Sant, Ada G (b. 1859)	25 July 1866	2 Fitzroy Square, London	Not located
1516–1519	Sant, Sarah Fanny Constance (b. 1856)	25 July 1866	2 Fitzroy Square, London	Not located
1516–1519	Ward, Eva Mariana (dates unknown)	25 July 1866	2 Fitzroy Square, London	Not located
1516–1519	Sant, Minnie Lilla (b. 1854)	25 July 1866	2 Fitzroy Square, London	Not located
1516–1519	Ward, Wriothesley "Russell" (b. 1858)	25 July 1866	2 Fitzroy Square, London	Not located
1517–1527	Sant, Mary Edith, Minnie Lilla, Sarah Fanny Constance, and Ada	26 July 1866	2 Fitzroy Square, London	Not located
1517–1527	Sant, James (1820–1916), and daughter, Sarah Fanny Constance (b. 1856)	26 July 1866	2 Fitzroy Square, London	Not located
1517–1527	Sant, Mowbray Lees (b. 1863)	26 July 1866	2 Fitzroy Square, London	Not located
1520	Sant, Ada G. (b. 1859)	26 July 1866	2 Fitzroy Square, London	Not located
1523	Sant, James "Jemmy" (b. 1862)	26 July 1866	2 Fitzroy Square, London	Princeton (Parrish)
1524–1536	Ward, Beatrice (b. 1860)	27 July 1866	2 Fitzroy Square, London	Not located
1524–1536	Ward, Beatrice (b. 1860), full-length	27 July 1866	2 Fitzroy Square, London	Not located

IMAGE NUMBER	SUBJECT	DATE TAKEN	PLACE	CURRENT OWNER
1528	Ward, Eva Mariana (dates unknown)	27 July 1866	2 Fitzroy Square, London	Texas (Gernsheim)
1530	Ward, Wriothesley "Russell" (b. 1858)	27 July 1866	2 Fitzroy Square, London	Not located
1531–1543	Cockburn, Edith Mary (dates unknown)	28 July 1866	2 Fitzroy Square, London	Not located
1531–1543	Cockburn, Julia Sant (dates unknown)	28 July 1866	2 Fitzroy Square, London	Not located
1531–1543	Cockburn, Ruth (dates unknown)	28 July 1866	2 Fitzroy Square, London	Not located
1531–1543	Sant, Mary Edith (b. 1852)	28 July 1866	2 Fitzroy Square, London	Not located
1537	Cockburn, Edith, Julia, and Ruth (dates unknown)	28 July 1866	2 Fitzroy Square, London	Not located
1544	Pollock, Joanna de Morlôt (1863–1949)	30 July 1866	2 Fitzroy Square, London	Princeton (Parrish)
1545	Ward, Alice (b. 1850), and Beatrice (b. 1860)	30 July 1866	2 Fitzroy Square, London	Texas (Gernsheim)
1546–1557	Ward, Beatrice (b. 1860)	30 July 1866	2 Fitzroy Square, London	Not located
1547–1575	Jebb, Florence Emma Dorothy (1854–1925)	25 Sept. 1866	Whitby, Yorkshire	Not located
1547–1575	Jebb, Edith Fanny Maud (1858–1942)	25 Sept. 1866	Whitby, Yorkshire	Not located
1547–1575	Russell, Mr. (dates unknown), and his dog, Shot	25 Sept. 1866	Whitby, Yorkshire	Not located
1547–1575	Jebb, Alvery Frederick Richard (1860–1871)	25 Sept. 1866	Whitby, Yorkshire	Not located
1547–1610	Barry, Emily Eupatoria "Mimie" (b. 1854)	25–30 Sept. 1866	Whitby, Yorkshire	Not located
1547–1610	Barry, Louisa "Loui" Dorothy (b. 1852)	25–30 Sept. 1866	Whitby, Yorkshire	Not located
1558	Dodgson, Charles Lutwidge (1832–1898)	Autumn 1866	Badcock's Yard, Oxford	Woking
1578	Seymour, Isobel Fortescue (1856?–1916)	Autumn 1866	Unknown	Not located
1579?	Seymour, Mary Maud (d. 1896)	Autumn 1866	Unknown	Not located
1582	Barker, Thomas Childe (b. 1827)	Autumn 1866	Badcock's Yard, Oxford	Not located
1583–1624	Thompson, John Barclay (b. 1845) or Henry Lewis (1840–1905)	3 May 1867	Badcock's Yard, Oxford	Not located
1584–1624	Hulme, Catherine "Kate" (b. 1859)	7 May 1867	Badcock's Yard, Oxford	Not located
1584–1624	Hulme, Alice (b. 1862)	7 May 1867	Badcock's Yard, Oxford	Not located
1584–1624	Hulme, Elizabeth "Bessie" (b. 1852)	7 May 1867	Badcock's Yard, Oxford	Not located
1585–1624	Bayne, Thomas Vere (1829–1908)	11–18 May 1867	Badcock's Yard, Oxford	Not located
1586–1624	Latham, Beatrice (b. 1861?)	21 May 1867	Badcock's Yard, Oxford	Not located
1586–1624	Latham, Mrs., and Beatrice (b. 1861?)	21 May 1867	Badcock's Yard, Oxford	Not located
1587–1624	Max Müller, Mary (b. 1862)	30 May 1867	Badcock's Yard, Oxford	Not located
1587–1624	Max Müller, Mrs. Georgina (b. 1835)	30 May 1867	Badcock's Yard, Oxford	Not located
1587–1624	Max Müller, Ada (b. 1861)	30 May 1867	Badcock's Yard, Oxford	Not located
1587–1624	Max Müller, Friedrich (1823–1900)	30 May 1867	Badcock's Yard, Oxford	Not located
1588–1624	Hardy, Gathorne (1814–1906)	10 June 1867	Badcock's Yard, Oxford	Not located
1589–1624	Keyser, Marion Charlotte (b. 1846)	25 June 1867	Badcock's Yard, Oxford	Not located
1611	Drawing by Nasmyth	June 1867	Unknown	Texas (Gernsheim)
1629	Peabody, George (1795–1869)	26 June 1867	Badcock's Yard, Oxford	Not located
1630–1639	Max Müller's children	July 1867	Badcock's Yard, Oxford	Not located
1630–1639	Sidney Owen's children	July 1867	Badcock's Yard, Oxford	Not located
1631–1675	Evans, Mrs. Mary Sophia (b. 1843)	4–11 May 1868	Badcock's Yard, Oxford	Not located
1631–1675	Evans, Evan (1813–1891)	4–11 May 1868	Badcock's Yard, Oxford	Not located
1631–1675	Owen, Lucy (b. 1862)	4–11 May 1868	Badcock's Yard, Oxford	Not located
1632–1675	Beresford, Selina Mary Emily (1861–1880)	11 May 1868	Badcock's Yard, Oxford	Not located
1632–1675	Chambers, Mrs. (dates unknown)	11 May 1868	Badcock's Yard, Oxford	Not located
1632–1675	Chambers, Rose (dates unknown)	11 May 1868	Badcock's Yard, Oxford	Not located
1633–1675	Shirley, Walter Knight (b. 1864)	21 May 1868	Badcock's Yard, Oxford	Not located
1633–1675	Shirley, Ralph (b. 1865)	21 May 1868	Badcock's Yard, Oxford	Not located
1634–1675	Villiers, Gwendolen Mary (1865–1941)	23 May 1868	Badcock's Yard, Oxford	Not located
1634–1675	Villiers, Victoria, formerly Lady Russell (1838–1880)	23 May 1868	Badcock's Yard, Oxford	Not located
1634–1675	Villiers, Henry Montagu (b. 1863)	23 May 1868	Badcock's Yard, Oxford	Not located
1634–1675	Villiers, Henry Montagu (1837–1908)	23 May 1868	Badcock's Yard, Oxford	Not located
1634–1675	Villiers, Frances Adelaide "Ada" (1862–1934)	23 May 1868	Badcock's Yard, Oxford	Not located
1635–1675	Villiers, Frances Adelaide "Ada" (1862–1934)	26 May 1868	Badcock's Yard, Oxford	Not located
1640	Unknown young girl	May 1868	Badcock's Yard, Oxford	Lindseth
1641–1675	Adair, Alexander William (1830–1889)	10 June 1868	Badcock's Yard, Oxford	Not located

IMAGE NUMBER	SUBJECT	DATE TAKEN	PLACE	CURRENT OWNER
1642–1675	Rumsey, Elizabeth (b. 1826?), and daughter, Leila (b. 1859)	10/12 June 1868	Badcock's Yard, Oxford	Not located
1643–1675	Rumsey, Leila (b. 1859)	21 June 1868	Badcock's Yard, Oxford	Not located
1644–1675	Bennie, Mary "Minnie" (b. 1856)	5 Sept. 1868	Whitby, Yorkshire	Not located
1644–1675	Bray, Theresa "Tiny" (dates unknown)	5 Sept. 1868	Whitby, Yorkshire	Not located
1644–1675	Bennie, Elizabeth "Doe" (b. 1856)	5 Sept. 1868	Whitby, Yorkshire	Not located
1645–1748	Lloyd, Catharine Eliza (1824–1898)	Apr.–June 1869	Badcock's Yard, Oxford	Not located
1645–1748	Bode, Edith (dates unknown)	Apr.–June 1869	Badcock's Yard, Oxford	Not located
1645–1748	Metcalfe, Frederick (1815–1885)	Apr.–June 1869	Badcock's Yard, Oxford	Not located
1645–1748	Metcalfe, Frances (b. 1860?)	Apr.–June 1869	Badcock's Yard, Oxford	Not located
1645–1748	Metcalfe, Rosamond (b. 1859?)	Apr.–June 1869	Badcock's Yard, Oxford	Not located
1676	Kitchin, Alice Maud, née Taylor (1844?–1930), and Alexandra "Xie" Rhoda (1864–1925)	12 June 1869	Badcock's Yard, Oxford	Princeton (Parrish)
1677	Kitchin, Alexandra "Xie" Rhoda (1864–1925)	12 June 1869	Badcock's Yard, Oxford	Princeton (Parrish)
1678?	Kitchin, Alexandra "Xie" Rhoda (1864–1925)	12 June 1869	Badcock's Yard, Oxford	Lindseth
1679?	Kitchin, Alexandra "Xie" Rhoda (1864–1925)	12 June 1869	Badcock's Yard, Oxford	Not located
1680–1748	Kitchin, Alexandra "Xie" Rhoda (1864–1925)	June–Aug. 1869	Badcock's Yard, Oxford	Lindseth
1680–1748	Tolhurst, Mary Beatrix (1863–1915)	June–Aug. 1869	Badcock's Yard, Oxford	Not located
1707	Kitchin, Alexandra "Xie" Rhoda (1864–1925)	June–Aug. 1869	Badcock's Yard, Oxford	Princeton (Parrish)
1710	Kitchin, Alexandra "Xie" Rhoda (1864–1925)	June–Aug. 1869	Badcock's Yard, Oxford	Not located
1727	Kitchin, Alexandra "Xie" Rhoda (1864–1925)	June–Aug. 1869	Badcock's Yard, Oxford	Texas (Gernsheim)
1727⅓	Kitchin, Alexandra "Xie" Rhoda (1864–1925)	June–Aug. 1869	Badcock's Yard, Oxford	Not located
1727⅔	Kitchin, Alexandra "Xie" Rhoda (1864–1925)	June–Aug. 1869	Badcock's Yard, Oxford	Lindseth
1728–1748	Wilcox, Elizabeth "Lizzie," née Pittar (b. 1848)	1–3 Sept. 1869	Chestnuts, Guildford, Surrey	Not located
1728–1748	Blagrave, Alice (dates unknown)	1–3 Sept. 1869	Chestnuts, Guildford, Surrey	Not located
1728–1748	Taylor, Sophia Christiana "Christie" (b. 1859)	1–3 Sept. 1869	Guildford, Surrey	Not located
1728–1748	Furnivall, Alice Eveline (b. 1859)	1–3 Sept. 1869	Guildford, Surrey	Not located
1729–1748	Furnivall, Alice Eveline (b. 1859), and her horse, Spectacles	4 Sept. 1869	Guildford, Surrey	Private collection
1730–1753	Taylor, Sophia Christiana "Christie" (b. 1859)	4–17 Sept. 1869	Guildford, Surrey	Not located
1730–1753	Cragie, Isabel C. (b. 1857)	4–17 Sept. 1869	Chestnuts, Guildford, Surrey	Not located
1749	Drury, Isabella "Ella" Maude (1862–1884)	4–17 Sept. 1869	Chestnuts, Guildford, Surrey	Texas (Gernsheim)
1751	Drury, Isabella "Ella" Maude (1862–1884)	4–17 Sept. 1869	Chestnuts, Guildford, Surrey	Not located
1752	Drury, Emily "Emmie" Henrietta (1864–1930), Isabella "Ella" Maude (1862–1884), and Mary "Minnie" Frances (1859–1935)	4–17 Sept. 1869	Chestnuts, Guildford, Surrey	Lindseth
1754	Dodgson, Wilfred Longley (1838–1914)	4–17 Sept. 1869	Chestnuts, Guildford, Surrey	Princeton (Parrish)
1755	Dodgson, Louisa Fletcher (1840–1930)	4–17 Sept. 1869	Chestnuts, Guildford, Surrey	Woking
1762	Merriman, Janet Gertrude (1859–1907)	4–17 Sept. 1869	Guildford, Surrey	Texas (Hanley)
1764	Merriman, Harry Moubray (b. 1857)	4–17 Sept. 1869	Guildford, Surrey	Texas (Hanley)
1765	Merriman, Henry Gordon (1823–1887)	4–17 Sept. 1869	Guildford, Surrey	Texas (Hanley)
1766	Merriman, Janet Gertrude (1859–1907)	4–17 Sept. 1869	Guildford, Surrey	Rosenbach
1767–1811	Smith, Laura (b. 1861)	22–29 Sept. 1869	Babbacombe, Torquay	Not located
1767–1811	Argles children	22–29 Sept. 1869	Babbacombe, Torquay	Not located
1812	Standen, Henrietta Maud (1857?–1938), and Isabel Julia (1859–1941)	4 Oct. 1869	Chestnuts, Guildford, Surrey	NYU
1813	Standen, Isabel Julia (1859–1941)	4 Oct. 1869	Chestnuts, Guildford, Surrey	NYU
1814?	Standen, Henrietta Maud (1857?–1938)	4 Oct. 1869	Chestnuts, Guildford, Surrey	Not located
1815–1851	Craigie, Isabel C. (b. 1857), as Ophelia	5 Oct. 1869	Chestnuts, Guildford, Surrey	Not located
1815–1851	Synge, Madeline (dates unknown)	5 Oct. 1869	Chestnuts, Guildford, Surrey	Not located
1815–1851	Craigie, Josephine (b. 1854)	5 Oct. 1869	Chestnuts, Guildford, Surrey	Not located
1815–1851	Keates, Gertrude W. (b. 1859)	5 Oct. 1869	Chestnuts, Guildford, Surrey	Not located
1815–1851	Keates, Lucia F. (b. 1862)	5 Oct. 1869	Chestnuts, Guildford, Surrey	Not located
1815–1851	Haydon, Mary "May" Eleanor (1862–1944), seaside dress	5 Oct. 1869	Chestnuts, Guildford, Surrey	Not located

IMAGE NUMBER	SUBJECT	DATE TAKEN	PLACE	CURRENT OWNER
1815–1851	Haydon, Edith Georgiana (b. 1863), seaside dress	5 Oct. 1869	Chestnuts, Guildford, Surrey	Not located
1816–1851	Watson, Mary Emma (1861?–1928)	5 Oct. 1869	Guildford, Surrey	Not located
1816–1851	Watson, Harriet "Hartie" (b. 1860)	5 Oct. 1869	Guildford, Surrey	Not located
1816–1851	Watson, Georgina "Ina" Janet (b. 1862)	5 Oct. 1869	Guildford, Surrey	Not located
1852	Haydon, Mary "May" Eleanor (1862–1944)	6 Oct. 1869	Guildford, Surrey	Princeton (Parrish)
1854	Haydon, Edith Georgiana (b. 1863)	6 Oct. 1869	Guildford, Surrey	Princeton (Parrish)
1855–1869	Synge, William Makepeace Thackeray (b. 1861), as a sailor	7 Oct. 1869	Guildford, Surrey	Not located
1855–1869	Craigie, Reginald W. (b. 1859)	7 Oct. 1869	Guildford, Surrey	Not located
1856–1869	Hulme, Helen A. (b. 1859)	8 Oct. 1869	Guildford, Surrey	Not located
1856–1869	Hulme, Edith B. (b. 1862)	8 Oct. 1869	Guildford, Surrey	Ovenden
1856–1869	Hulme, Mary Florence (b. 1863)	8 Oct. 1869	Guildford, Surrey	Ovenden
1856–1869	Hulme, Annie E. (b. 1857)	8 Oct. 1869	Guildford, Surrey	Ovenden
1856–1869	Watson, Harriet "Hartie" (b. 1860), Mary Emma (1861?–1928), and Georgina "Ina" Janet (b. 1862)	8 Oct. 1869	Guildford, Surrey	Not located
1856–1869	Watson, Georgina "Ina" Janet (b. 1862), and Edith Georgiana Haydon (b. 1863)	8 Oct. 1869	Guildford, Surrey	Not located
1857–1869	Haydon, Thomas "Tommy" Horatio (b. 1865)	9 Oct. 1869	Guildford, Surrey	Not located
1857–1869	Haydons, Watsons, Trimmers, and Sells	9 Oct. 1869	Guildford, Surrey	Not located
1857–1869	Watson, Mary Emma (1861?–1928)	9 Oct. 1869	Guildford, Surrey	Not located
1857–1869	Haydon, Ethel Dodsworth (b. 1867)	9 Oct. 1869	Guildford, Surrey	Not located
1858–1952	Moberly, Robert Campbell (1845–1903)	1870	Badcock's Yard, Oxford	Christ Church
1858–1952	Prout, Thomas Jones (1823–1909)	1870	Badcock's Yard, Oxford	Christ Church
1859–1874	Cecil, Robert, Lord Salisbury (1830–1903)	23 June 1870	Badcock's Yard, Oxford	Hatfield House
1859–1874	Cecil, Lord William (1863–1936)	23 June 1870	Badcock's Yard, Oxford	Hatfield House
1859–1874	Cecil, Maud, Gwendolen, James, and William	23 June 1870	Badcock's Yard, Oxford	Hatfield House
1870	Cecil, Robert, Lord Salisbury (1830–1903), with James (1861–1947) and William (1863–1936)	23 June 1870	Badcock's Yard, Oxford	Princeton (Parrish)
1871	Cecil, Maud (1858–1950), and Gwendolen (1860–1945)	23 June 1870	Badcock's Yard, Oxford	Not located
1875	Liddell, Lorina Charlotte (1849–1930)	25 June 1870	Badcock's Yard, Oxford	Morgan
1876	Liddell, Alice Pleasance (1852–1934)	25 June 1870	Badcock's Yard, Oxford	Morgan
1877–1890	Harington, Alice Margaret (1854?–1901)	29–30 June 1870	Badcock's Yard, Oxford	Not located
1877–1890	Harington, Beatrice Cecilia (b. 1852?)	29–30 June 1870	Badcock's Yard, Oxford	Not located
1877–1890	Owen, Lucy (b. 1862), and Henrietta "Atty" O'Brien (b. 1862)	29–30 June 1870	Badcock's Yard, Oxford	Not located
1877–1890	Max Müller, Beatrice (b. 1865)	29–30 June 1870	Badcock's Yard, Oxford	Not located
1877–1890	Max Müller, Mary (b. 1862)	29–30 June 1870	Badcock's Yard, Oxford	Not located
1878–1896	Max Müller, Ada (b. 1861), Beatrice (b. 1865), and Mary (b. 1862)	5 July 1870	Badcock's Yard, Oxford	Not located
1878–1896	Max Müller, Ada (b. 1861)	5 July 1870	Badcock's Yard, Oxford	Not located
1878–1896	Kitchin, George Herbert (b. 1865)	5 July 1870	Badcock's Yard, Oxford	Not located
1878–1896	Kitchin, Alexandra "Xie" Rhoda (1864–1925), and George Herbert (b. 1865)	5 July 1870?	Badcock's Yard, Oxford	Lindseth
1891	Kitchin, Alexandra "Xie" Rhoda (1864–1925)	5 July 1870	Badcock's Yard, Oxford	Private collection
1893	Kitchin, Alexandra "Xie" Rhoda (1864–1925), in "The Prettiest Doll in the World"	5 July 1870	Badcock's Yard, Oxford	Lindseth
1894	Kitchin, Alexandra "Xie" Rhoda (1864–1925), in "Waiting for the Verdict"	5 July 1870	Badcock's Yard, Oxford	Lindseth
1895–1906	Cecil, Lady Maud (1858–1950)	7 July 1870	5 Marlborough Road, St. John's Wood	Hatfield House
1895–1906	Cecil, Lord William (1863–1936)	7 July 1870	5 Marlborough Road, St. John's Wood	Hatfield House
1895–1906	Cecil, Lady Gwendolen (1860–1945)	7 July 1870	5 Marlborough Road, St. John's Wood	Hatfield House

IMAGE NUMBER	SUBJECT	DATE TAKEN	PLACE	CURRENT OWNER
1897	Cecil, James (1861–1947), Lord Cranborne	7 July 1870	5 Marlborough Road, St. John's Wood	Hatfield House
1899	Cecil, James, Maud, William, and Gwendolen	7 July 1870	5 Marlborough Road, St. John's Wood	Hatfield House
1900–1952	Hughes, Amy (1857–1915)	8–11 July 1870	5 Marlborough Road, St. John's Wood	Not located
1900–1952	Hughes, Agnes (1859–1945)	8–11 July 1870	5 Marlborough Road, St. John's Wood	Not located
1901–1952	Heaphy, Theodosia "Theo" Laura (1858–1920)	8–11 July 1870	5 Marlborough Road, St. John's Wood	Not located
1901–1952	Heaphy, Leonora "Leo" (b. 1862)	8–11 July 1870	5 Marlborough Road, St. John's Wood	Not located
1902–1952	Sant, Ada G. (b. 1859)	8–11 July 1870	5 Marlborough Road, St. John's Wood	Not located
1902–1952	Sant, Minnie Lilla (b. 1854)	8–11 July 1870	5 Marlborough Road, St. John's Wood	Not located
1903–1952	Desanges, Beatrice Laura (b. 1864)	8–11 July 1870	5 Marlborough Road, St. John's Wood	Not located
1907	Holiday, Henry (1839–1927)	8–11 July 1870	5 Marlborough Road, St. John's Wood	Lindseth
1908	Holiday, Winifred (1865–1949)	8–11 July 1870	5 Marlborough Road, St. John's Wood	Not located
1909–1952	Holiday, Catherine "Kate," née Raven (1840–1924)	8–11 July 1870	5 Marlborough Road, St. John's Wood	Not located
1910	Terry, Florence "Flo" Maude (1856–1896)	8–11 July 1870	5 Marlborough Road, St. John's Wood	Musée d'Orsay
1915	Kay, Phyllis Annie (dates unknown)	8–11 July 1870	5 Marlborough Road, St. John's Wood	Not located
1917	Holiday, Lily, née Atchison, and her daughter, Dora (dates unknown)	8 11 July 1870	5 Marlborough Road, St. John's Wood	Lindseth
1918	Holiday, Winifred (1865–1949)	8–11 July 1870	5 Marlborough Road, St. John's Wood	Lindseth
1920?	Drury, Mary "Minnie" Frances (1859–1935)	8–11 July 1870	5 Marlborough Road, St. John's Wood	Not located
1921?	Drury, Isabella "Ella" Maude (1862–1884)	8–11 July 1870	5 Marlborough Road, St. John's Wood	Not located
1922	Drury, Emily "Emmie" Henrietta (1864–1930)	8–11 July 1870	5 Marlborough Road, St. John's Wood	Preston
1923	Drury, Emily, Isabella, and Mary	8–11 July 1870	5 Marlborough Road, St. John's Wood	Preston
1924–1952	MacDonald, Ronald (1860–1933)	14–16 July 1870	The Retreat, Hammersmith	SNPG
1924–1952	MacDonald, Robert Falconer (1862–1913)	14–16 July 1870	The Retreat, Hammersmith	SNPG
1924–1952	MacDonald, Maurice (b. 1864)	14–16 July 1870	The Retreat, Hammersmith	SNPG
1924–1952	MacDonald family	14–16 July 1870	The Retreat, Hammersmith	SNPG
1925–1979	Holland, Henry Scott (1847–1920)	1871?	Christ Church, Oxford?	Not located
1953	Arnold, Julia Frances (1862–1908)	5 June 1871	Badcock's Yard, Oxford	Private collection
1954–1979	Arnold, Julia Frances (1862–1908), in Chinese dress, sitting	5 June 1871	Badcock's Yard, Oxford	Ovenden
1954–1979	Arnold, Julia Frances (1862–1908), in Chinese dress, standing	5 June 1871	Badcock's Yard, Oxford	Morgan
1954–1979	Arnold, Julia Frances (1862–1908), and Ethel Margaret (1866–1930)	5 June 1871	Badcock's Yard, Oxford	Not located
1955	Arnold, Julia Frances (1862–1908), and Ethel Margaret (1866–1930)	5 June 1871	Badcock's Yard, Oxford	Private collection
1957	Kitchin, George Herbert (b. 1865)?	5 June 1871	Badcock's Yard, Oxford	Rosenbach

IMAGE NUMBER	SUBJECT	DATE TAKEN	PLACE	CURRENT OWNER
1958–1979	Bradley, Mabel (b. 1861?)	7 June 1871	Badcock's Yard, Oxford	Not located
1958–1979	Bradley, Emily Tennyson (1862–1946)	7 June 1871	Badcock's Yard, Oxford	Not located
1958–1979	Bradley, Rose Marian (b. 1868)	7 June 1871	Badcock's Yard, Oxford	Not located
1958–1979	Bradley, Hugh Vachell (1865–1907)	7 June 1871	Badcock's Yard, Oxford	Not located
1959–1979	Fane, Agnes (dates unknown)	16 June 1871	Badcock's Yard, Oxford	Not located
1959–1979	Fane, Isabel (dates unknown)	16 June 1871	Badcock's Yard, Oxford	Not located
1959–1979	Hussey, Elizabeth "Bessie" (b. 1852?)	16 June 1871	Badcock's Yard, Oxford	Not located
1960–1979	Sampson, Edward Francis (1848–1918)	17 June 1871	Badcock's Yard, Oxford	Not located
1961–1979	Cecil group	3 July 1871	Hatfield House	Hatfield House
1980?	Arnold, Julia Frances (1862–1908)	17 Mar. 1872	Christ Church Studio, Oxford	Not located
1981	Arnold, Julia Frances (1862–1908)	17 Mar. 1872	Christ Church Studio, Oxford	Not located
1982–1989	Bradley, Margaret "Daisy" (dates unknown)	20 Mar. 1872	Christ Church Studio, Oxford	Not located
1983–1989	Bradley, Mabel (b. 1861?)	22 Mar. 1872	Christ Church Studio, Oxford	Not located
1984–2700	Price, A. (Amy Maud, Alice Margaret, or Agnes Florence), as "The Sibyl"	after Mar. 1872	Christ Church Studio, Oxford	Not located
1985–2031	Price, Amy Eliza, née Cole (b. 1836), and her daughter, Amy Maud (1858–1923)	19–30 Apr. 1872	Christ Church Studio, Oxford	Not located
1985–2031	Hatch, Arthur Herbert (1864–1910), and Wilfred Stanley (1865–1956)	19–30 Apr. 1872	Christ Church Studio, Oxford	Not located
1985–2031	Hatch, Beatrice Sheward (1866–1947), on sofa	19–30 Apr. 1872	Christ Church Studio, Oxford	Princeton (Parrish)
1985–2031	Fearon, Beatrice (dates unknown)	19–30 Apr. 1872	Christ Church Studio, Oxford	Not located
1985–2031	Fearon, Maud (dates unknown)	19–30 Apr. 1872	Christ Church Studio, Oxford	Not located
1985–2031	Thompson, John Barclay (b. 1845)	19–30 Apr. 1872	Christ Church Studio, Oxford	Not located
1989?	Arnold, Mary Augusta (1851–1920), Mrs. Humphry Ward	19–30 Apr. 1872	Christ Church Studio, Oxford	Not located
1990	Arnold, Ethel Margaret (1866–1930)	19–30 Apr. 1872	Christ Church Studio, Oxford	Not located
1991	Arnold, Mary Augusta (1851–1920), Lucy Ada (1858–1894), Julia Frances (1862–1908), and Ethel Margaret (1866–1930)	19–30 Apr. 1872	Christ Church Studio, Oxford	Not located
2000	Hatch, Wilfred Stanley (1865–1956)	19–30 Apr. 1872	Christ Church Studio, Oxford	Princeton (Parrish)
2002	Hatch, Arthur Herbert (1864–1910), as Cupid	19–30 Apr. 1872	Christ Church Studio, Oxford	Not located
2012	Kitchin, Alexandra "Xie" Rhoda (1864–1925)	19–30 Apr. 1872	Christ Church Studio, Oxford	Princeton (Parrish)
2013	Kitchin, Alexandra "Xie" Rhoda (1864–1925)	19–30 Apr. 1872	Christ Church Studio, Oxford	Lindseth
2021	Kitchin, Alexandra "Xie" Rhoda (1864–1925)	19–30 Apr. 1872	Christ Church Studio, Oxford	Not located
2025	Hatch, Beatrice Sheward (1866–1947), and Ethel Charlotte (1869–1975)	19–30 Apr. 1872	Christ Church Studio, Oxford	Texas (Gernsheim)
2026–2031	Fearon, Mrs., and her daughter, Beatrice (dates unknown)	2 May 1872	Christ Church Studio, Oxford	Not located
2026–2031	Fearon, Maud (dates unknown)	2 May 1872	Christ Church Studio, Oxford	Not located
2027–2031	Fearon, Beatrice (dates unknown)	3 May 1872	Christ Church Studio, Oxford	Not located
2027–2031	Bayne, Thomas Vere (1829–1908)	3 May 1872	Christ Church Studio, Oxford	Not located
2028–2031	West family	7 May 1872	Christ Church Studio, Oxford	Not located
2029–2031	Max Müller, Ada (b. 1861)	8 May 1872	Christ Church Studio, Oxford	Not located
2029–2031	Max Müller, Mary (b. 1862)	8 May 1872	Christ Church Studio, Oxford	Not located
2032	Kitchin, Alexandra "Xie" Rhoda (1864–1925)	8–20 May 1872	Christ Church Studio, Oxford	NYU
2033	Kitchin, Alexandra "Xie" Rhoda (1864–1925)	8–20 May 1872	Christ Church Studio, Oxford	Lindseth
2034–2043	Arnold, Julia Frances (1862–1908), in Greek dress	20 May 1872	Christ Church Studio, Oxford	Not located
2035–2043	Brown, Charles Abbott (b. 1838)	24 May 1872	Christ Church Studio, Oxford	Not located
2036–2043	Shaw Stewart, John Archibald (1829–1900)	25 May 1872	Christ Church Studio, Oxford	Not located
2036–2043	Tyrwhitt, Mary Frances "Polly" (b. 1867)	25 May 1872	Christ Church Studio, Oxford	Not located
2036–2043	Tyrwhitt, Alice Katherine "Kittie" (dates unknown)	25 May 1872	Christ Church Studio, Oxford	Not located
2037 2043	The New Belfry, Tom Quad, Christ Church	31 May 1872	Christ Church, Oxford	Not located
2037–2043	Longley, Henry (1832–1899)	31 May 1872	Christ Church Studio, Oxford	Not located
2038–2053	Arnold, Julia Frances (1862–1908)	15 June 1872	Christ Church Studio, Oxford	Lindseth

IMAGE NUMBER	SUBJECT	DATE TAKEN	PLACE	CURRENT OWNER
2038–2053	Arnold, Julia Frances (1862–1908), with rocking-horse	15 June 1872	Christ Church Studio, Oxford	Not located
2038–2053	Arnold, Julia, and Ethel, with buckets and spades	15 June 1872	Christ Church Studio, Oxford	Not located
2038–2053	Lutwidge, Robert Wilfred Skeffington (1802–1873)	15 June 1872	Christ Church Studio, Oxford	Woking
2044	Kitchin, Alexandra "Xie" Rhoda (1864–1925)	May/June 1872	Christ Church Studio, Oxford	Not located
2045	Arnold, Julia Frances (1862–1908), and Ethel Margaret (1866–1930)	15 June 1872	Christ Church Studio, Oxford	Lindseth
2046	Arnold, Julia Frances (1862–1908)	15 June 1872	Christ Church Studio, Oxford	Not located
2047–2053	Simpson, Gaynor Anne (1862–1954), and Henrietta Mary Amy (1866–1957)	18 June 1872	Christ Church Studio, Oxford	Not located
2047–2053	Simpson, Honor (dates unknown)	18 June 1872?	Christ Church Studio, Oxford	Not located
2047–2053	Simpson, Henrietta Mary Amy (1866–1957), in "Minuet"	18 June 1872	Christ Church Studio, Oxford	Not located
2054	Kitchin, George William (1827–1912)	19 June 1872	Christ Church Studio, Oxford	Lindseth
2055–2091	Hunt, William Holman (1827–1910), and his son, Cyril	24 July 1872	Christ Church Studio, Oxford	Not located
2056–2091	Combe, Thomas (1797–1872)	25 July 1872	Christ Church Studio, Oxford	Not located
2056–2091	Hunt, Cyril Holman (dates unknown)	25 July 1872	Christ Church Studio, Oxford	Not located
2057–2091	Arnold, Julia Frances (1862–1908)	25 July 1872	Christ Church Studio, Oxford	Not located
2057–2091	Arnold, Julia, née Sorrell (1826–1888)	25 July 1872	Christ Church Studio, Oxford	Not located
2065	Kitchin, Brook Taylor (1869–1940)	July 1872	Christ Church Studio, Oxford	Not located
2067?	MacDonald, George (1824–1905), and one of his daughters	Summer 1872	The Retreat, Hammersmith	RPS
2068–2091	Feilden, Helen Arbuthnot (1859–1947)	30 Jan. 1873	Christ Church Studio, Oxford	Not located
2069–2091	March-Phillipps, Geraldine (b. 1865)	7 Feb. 1873	Christ Church Studio, Oxford	Not located
2070–2091	Christ Church from Tom Quad	Mar. 1873?	Christ Church, Oxford	Christ Church
2070–2091	Mason, Ida F. (b. 1868)	25 Mar. 1873	Christ Church Studio, Oxford	Not located
2070–2091	Mason, Alice E. (b. 1866)	25 Mar. 1873	Christ Church Studio, Oxford	Not located
2071–2091	Mason, Alice E. (b. 1866), full-length	27 Mar. 1873	Christ Church Studio, Oxford	Not located
2071–2091	Mason, Isabel (b. 1833), and her daughter, Alice (b. 1866)	27 Mar. 1873	Christ Church Studio, Oxford	Not located
2072–2091	Mason, Alice (b. 1866), seated on box	28 Mar. 1873	Christ Church Studio, Oxford	Not located
2072–2091	Mason, Caroline "Carry" J. (b. 1863)	28 Mar. 1873	Christ Church Studio, Oxford	Not located
2072–2091	Mason, Alice (b. 1866), lying on sofa	28 Mar. 1873	Christ Church Studio, Oxford	Not located
2073–2091	Jones, Miss (dates unknown)	29 Mar. 1873	Christ Church Studio, Oxford	Not located
2074–2091	Kitchin, George Herbert (b. 1865)	19 Apr. 1873	Christ Church Studio, Oxford	Not located
2092	Kitchin, Alexandra "Xie" Rhoda (1864–1925), in "High Caste"	19 Apr. 1873	Christ Church Studio, Oxford	Lindseth
2093	Kitchin, Alexandra "Xie" Rhoda (1864–1925), and George Herbert (b. 1865)	19 Apr. 1873	Christ Church Studio, Oxford	Private collection
2094	Arnold, Julia Frances (1862–1908)	22 Apr. 1873	Christ Church Studio, Oxford	Not located
2095–2100	Arnold, Julia Frances (1862–1908), in Indian shawls	22 Apr. 1873	Christ Church Studio, Oxford	Not located
2096–2100	Bruce, Lily (dates unknown)	23 Apr. 1873	Christ Church Studio, Oxford	Not located
2097–2100	Parker family	25 Apr. 1873	Christ Church Studio, Oxford	Not located
2097–2100	Ward, Miss (dates unknown), as "Roman Girl"	25 Apr. 1873	Christ Church Studio, Oxford	Not located
2101	Price, Alice Margaret (1863–1945)	Apr. 1873	Christ Church Studio, Oxford	Lindseth
2102	Price, William Arthur (1860–1954)	Apr. 1873	Christ Church Studio, Oxford	Lindseth
2120	The New Belfry, Tom Quad, Christ Church	Apr. 1873	Christ Church, Oxford	Princeton (Parrish)
2122	Arnold, Julia Frances (1862–1908), as an "Allegory of Spring"	3 May 1873?	Christ Church Studio, Oxford	Not located
2123	Morrell, Margaret "Margie" Cecil Louisa (b. 1868)	3 May 1873	Christ Church Studio, Oxford	Not located
2124–2131	Mason, Alice (b. 1866), and Ida (b. 1868)	7 May 1873	Christ Church Studio, Oxford	Not located
2132	Kitchin, Alexandra "Xie" Rhoda (1864–1925), as Dane	14 May 1873	Christ Church Studio, Oxford	Princeton (Parrish)

IMAGE NUMBER	SUBJECT	DATE TAKEN	PLACE	CURRENT OWNER
2133	Kitchin, Alexandra "Xie" Rhoda (1864–1925), in petticoat	14 May 1873	Christ Church Studio, Oxford	Lindseth
2135	Kitchin, Alexandra "Xie" Rhoda (1864–1925), in Greek dress	14 May 1873	Christ Church Studio, Oxford	Ovenden
2136–2140	Fane, Isabel (dates unknown)	17 May 1873	Christ Church Studio, Oxford	Not located
2141	Kitchin, George Herbert (b. 1865)	May/June 1873	Christ Church Studio, Oxford	Rosenbach
2142	Kitchin, George Herbert (b. 1865)	May/June 1873	Christ Church Studio, Oxford	Lindseth
2143	Kitchin, Alexandra "Xie" Rhoda (1864–1925), with bucket and spade	12 June 1873	Christ Church Studio, Oxford	NYU
2144	Kitchin, Alexandra "Xie" Rhoda (1864–1925), in "Where Dreamful Fancies Dwell"	12 June 1873	Christ Church Studio, Oxford	Princeton (Parrish)
2144½	Kitchin, Alexandra "Xie" Rhoda (1864–1925), in Greek dress	12 June 1873	Christ Church Studio, Oxford	Texas (Gernsheim)
2153	Kitchin, Alexandra "Xie" Rhoda (1864–1925), in "Rosy Dreams and Slumbers Light"	12 June 1873	Christ Church Studio, Oxford	Musée d'Orsay
2154	Morrell, Margaret "Margie" Cecil Louisa (b. 1868), asleep	11 July 1873?	Christ Church Studio, Oxford	Lindseth
2155	Kitchin, Alexandra "Xie" Rhoda (1864–1925), Chinese Tea-merchant (on duty)	14 July 1873	Christ Church Studio, Oxford	Princeton (Parrish)
2156	Kitchin, Alexandra "Xie" Rhoda (1864–1925), Chinese Tea-merchant (off duty)	14 July 1873	Christ Church Studio, Oxford	Princeton (Parrish)
2157	Kitchin, Alexandra "Xie" Rhoda (1864–1925), asleep on sofa	14 July 1873	Christ Church Studio, Oxford	Texas (Gernsheim)
2158	Morrell, Harriette Anne, née Wynter (1843–1924)	11 July 1873?	Christ Church Studio, Oxford	Not located
2159–2181	Morrell, Margaret (b. 1868), and Frederica Harriette (b. 1869)	11 July 1873?	Christ Church Studio, Oxford	Not located
2160–2181	Arnold, Julia Frances (1862–1908), as Chinese	16 July 1873	Christ Church Studio, Oxford	Not located
2160–2181	Denman, George (1819–1896)	16 July 1873	Christ Church Studio, Oxford	Not located
2161–2181	Standen, Henrietta Maud (1857?–1938)	23 July 1873	Christ Church Studio, Oxford	Not located
2161–2181	Standen, Isabel Julia (1859–1941), seated	23 July 1873	Christ Church Studio, Oxford	Morgan
2161–2181	Standen, Isabel Julia (1859–1941)	23 July 1873	Christ Church Studio, Oxford	Not located
2161–2181	Standen, Helen Melville (1864–1937)	23 July 1873	Christ Church Studio, Oxford	Princeton (Parrish)
2162–2181	Arnold, Julia Frances (1862–1908)	25 July 1873	Christ Church Studio, Oxford	Not located
2163–2211	Hatch, Beatrice Sheward (1866–1947), in rags	29 July 1873	Christ Church Studio, Oxford	Not located
2163–2211	Hatch, Beatrice Sheward (1866–1947), nude study	29 July 1873	Christ Church Studio, Oxford	Rosenbach
2175	ERASED	1873	Unknown	No copy survives
2176	ERASED	1873	Unknown	No copy survives
2180	ERASED	1873	Unknown	No copy survives
2181–2211	Hatch, Beatrice Sheward (1866–1947), nude study	30 July 1873	Christ Church Studio, Oxford	Rosenbach
2181–2211	Hatch, Beatrice Sheward (1866–1947), further studies	30 July 1873	Christ Church Studio, Oxford	Not located
2182–2211	Dubourg, Evelyn Sophia (1861–1917)	13 Aug. 1873	Christ Church Studio, Oxford	Private collection
2183–2211	Harcourt, Edith (1855–1944)	14 Aug. 1873	Christ Church Studio, Oxford	Not located
2184–2211	Christie, Edith (dates unknown)	15 Aug. 1873	Christ Church Studio, Oxford	Not located
2184–2211	Christie, Margaret (dates unknown)	15 Aug. 1873	Christ Church Studio, Oxford	Not located
2184–2211	Christie, May (dates unknown)	15 Aug. 1873	Christ Church Studio, Oxford	Not located
2187–2290	Hicks Beach, Michael Edward (1837–1916)	c. 1874	Christ Church, Oxford	Not located
2187–2290	Paget, Francis (1851–1911)	c. 1874	Christ Church, Oxford	Not located
2187–2290	Brodie, Robert (b. 1841)	1874	Christ Church Studio, Oxford	Christ Church
2187–2700	Warner, William (1851–1921)	post-1873	Christ Church, Oxford	Not located
2187–2700	Chapman, Elizabeth B. (b. 1842)	post-1873	Unknown	Not located
2187–2215	Howard, Lydia (b. 1864)	28 Feb. 1874	Christ Church Studio, Oxford	Not located
2188–2215	Jebb, Edith Fanny Maud (1858–1942)	12 Mar. 1874	Christ Church Studio, Oxford	Not located
2212	Dodgson, Charles Lutwidge (1832–1898)	13 Mar. 1874?	Christ Church Studio, Oxford	Princeton (Parrish)
2216	Arnold, Julia Frances (1862–1908), in "Little Vanity"	14 Mar. 1874	Christ Church Studio, Oxford	Morgan

IMAGE NUMBER	SUBJECT	DATE TAKEN	PLACE	CURRENT OWNER
2217–2221	Mowbray, John Robert (1815–1899)	23 Mar. 1874	Christ Church Studio, Oxford	Not located
2217–2221	Conybeare, Charles Ranken (1821–1885)	23 Mar. 1874	Christ Church Studio, Oxford	Not located
2217–2221	Kitchin, Alexandra "Xie" Rhoda (1864–1925)	23 Mar. 1874	Christ Church Studio, Oxford	Not located
2222	Kitchin, Alexandra "Xie" Rhoda (1864–1925)	23 Mar. 1874	Christ Church Studio, Oxford	Princeton (Parrish)
2223	Kitchin, Alexandra "Xie" Rhoda (1864–1925), as Viola	23 Mar. 1874	Christ Church Studio, Oxford	Princeton (Parrish)
2224	Kitchin, Alexandra "Xie" Rhoda (1864–1925), in "Penitence"	23 Mar. 1874	Christ Church Studio, Oxford	Princeton (Parrish)
2225	Hatch, Beatrice Sheward (1866–1947), and Ethel Charlotte (1869–1975)	24 Mar. 1874	Christ Church Studio, Oxford	Princeton (Parrish)
2226	Hatch, Beatrice Sheward (1866–1947)	24 Mar. 1874	Christ Church Studio, Oxford	Princeton (Parrish)
2227–2249	Hatch, Ethel Charlotte (1869–1975)	24 Mar. 1874	Christ Church Studio, Oxford	Not located
2227–2249	Hatch, Beatrice Sheward (1866–1947)	24 Mar. 1874	Christ Church Studio, Oxford	Rosenbach
2227–2249	Evans, Mary "Molly" Beatrice (b. 1870)	24 Mar. 1874	Christ Church Studio, Oxford	Not located
2227–2249	Evans, Mary Sophia (b. 1843)	24 Mar. 1874	Christ Church Studio, Oxford	Not located
2228–2249	Craik, Dorothy Mulock (b. 1868)	23 Apr. 1874	Christ Church Studio, Oxford	Not located
2228–2249	Paton, Mona Margaret Noël (1860–1928)	23 Apr. 1874	Christ Church Studio, Oxford	Not located
2228–2249	Craik, Dinah Maria, née Mulock (1826–1887)	23 Apr. 1874	Christ Church Studio, Oxford	Not located
2229–2249	Spencer, Lady Sarah Isabella (1838–1919)	7 May 1874	Christ Church Studio, Oxford	Not located
2229–2249	Talbot, Eleanora Julia, née Coventry (b. 1825)	7 May 1874	Christ Church Studio, Oxford	Not located
2250	Kitchin, Alexandra "Xie" Rhoda (1864–1925), in "Sleepless"	18 May 1874	Christ Church Studio, Oxford	Princeton (Parrish)
2251	Kitchin, Alexandra "Xie" Rhoda (1864–1925), in "A Summer Night"	18 May 1874	Christ Church Studio, Oxford	Princeton (Parrish)
2252–2271	Smith, Goldwin (1823–1910)	27 May 1874	Christ Church Studio, Oxford	Not located
2252–2271	Faussett, Maud Isabel (b. 1862)	27 May 1874	Christ Church Studio, Oxford	Not located
2253–2284	Sampson, Miss (dates unknown)	16 June 1874	Christ Church Studio, Oxford	Not located
2272	Drury, Isabella "Ella" Maude (1862–1884)	16 June 1874	Christ Church Studio, Oxford	Texas (Gernsheim)
2273?	Drury, Mary "Minnie" Frances (1859–1935)	16 June 1874	Christ Church Studio, Oxford	Not located
2274	Drury, Sophia Louisa, née Bousfield (1830–1886)	16 June 1874	Christ Church Studio, Oxford	Not located
2275	Drury, Emily "Emmie" Henrietta (1864–1930)	16 June 1874	Christ Church Studio, Oxford	Texas (Gernsheim)
2276–2304	Arnold, Julia Frances (1862–1908)	15 May 1875	Christ Church Studio, Oxford	Not located
2276–2400	Baynes, Robert Edward (b. 1849)	1875?	Christ Church Studio, Oxford	Not located
2276–2400	Grave of Agnes Mary Collingwood (b. & d. 1875)	1875?	Southwick Churchyard, near Sunderland	NYU
2277–2304	Conybeare, Linda (dates unknown)	25 May 1875	Christ Church Studio, Oxford	Not located
2278–2304	Dodgson, Charles Lutwidge (1832–1898)	May 1875?	Christ Church Studio, Oxford	Texas (Gernsheim)
2285	Dodgson, Charles Lutwidge (1832–1898)	May 1875?	Christ Church Studio, Oxford	Princeton (Parrish)
2291	Dodgson, Charles Lutwidge (1832–1898)	May 1875?	Christ Church Studio, Oxford	Christ Church
2292	Dodgson, Charles Lutwidge (1832–1898)	May 1875?	Christ Church Studio, Oxford	Texas (Gernsheim)
2293–2357	King, Edward (1830–1910)	June 1875?	Christ Church Studio, Oxford	Not located
2305	Prince Leopold, Duke of Albany (1853–1884), standing	2 June 1875	Christ Church Studio, Oxford	Texas (Gernsheim)
2306	Prince Leopold, Duke of Albany (1853–1884), seated	2 June 1875	Christ Church Studio, Oxford	Princeton (Parrish)
2309	Ruskin, John (1819–1900)	3 June 1875	Christ Church Studio, Oxford	Princeton (Parrish)
2310	Walters, Amy S. (b. 1856?)	June 1875	Christ Church Studio, Oxford	Princeton (Parrish)
2311–2357	Arnold, Julia Frances (1862–1908)	26 June 1875	Christ Church Studio, Oxford	Not located
2311–2357	Arnold, Julia, née Sorrell (1826–1888)	26 June 1875	Christ Church Studio, Oxford	Wakeling
2314	Sampson, Edward Francis (1848–1918)	June 1875	Christ Church Studio, Oxford	Princeton (Parrish)
2316	Kitchin, "Xie," Herbert, Hugh, and Brook, in "St. George & the Dragon"	26 June 1875	Christ Church Studio, Oxford	Princeton (Parrish)
2317	Kitchin, Brook Taylor (1869–1940), as "St. George"	26 June 1875	Christ Church Studio, Oxford	Texas (Gernsheim)
2318	Kitchin, Brook Taylor (1869–1940), in "Achilles in His Tent"	26 June 1875	Christ Church Studio, Oxford	Princeton (Parrish)

IMAGE NUMBER	SUBJECT	DATE TAKEN	PLACE	CURRENT OWNER
2319	Kitchin, Alexandra "Xie" Rhoda (1864–1925), as the "Captive Princess"	26 June 1875	Christ Church Studio, Oxford	Texas (Gernsheim)
2331	Price, Rose Emelyn (1866–1894)	June 1875	Christ Church Studio, Oxford	Not located
2334	Kitchin, George Herbert (b. 1865)	26 June 1875	Christ Church Studio, Oxford	Not located
2336	Kitchin, Hugh Bridges (1867–1945), and Brook Taylor (1869–1940)	26 June 1875	Christ Church Studio, Oxford	NYU
2350	Kitchin, Alexandra "Xie" Rhoda (1864–1925)	26 June 1875	Christ Church Studio, Oxford	Not located
2351–2357	Lawrie, Rose (b. 1860?)	7 July 1875	Oak Tree House, Hampstead	Princeton (Parrish)
2351–2357	Lawrie, Rose (b. 1860?), in "Waiting for the Trumpet"	7 July 1875	Oak Tree House, Hampstead	Princeton (Parrish)
2351–2357	Lawrie, Mrs. (dates unknown)	7 July 1875	Oak Tree House, Hampstead	Princeton (Parrish)
2352–2357	Samuels, Gertrude (dates unknown)	8 July 1875	Oak Tree House, Hampstead	Not located
2352–2357	Raikes, Edith Gertrude (1866?–1949)	8 July 1875	Oak Tree House, Hampstead	Not located
2352–2357	Raikes, Blanche Amabel "Amy" (1865?–1904)	8 July 1875	Oak Tree House, Hampstead	Princeton (Parrish)
2353–2357	Morley, Edith Caroline (1864–1945)	9 July 1875	Oak Tree House, Hampstead	Princeton (Parrish)
2354–2369	Du Maurier, Beatrix (1864–1913), and Daisy Whiteside (dates unknown)	10 July 1875	Oak Tree House, Hampstead	Princeton (Parrish)
2354–2369	Unknown female in "An Ayah"	10 July 1875	Oak Tree House, Hampstead	Princeton (Parrish)
2354–2369	Whiteside, Mrs. (dates unknown), and her daughter, Daisy	10 July 1875	Oak Tree House, Hampstead	Princeton (Parrish)
2354–2369	Whiteside, Daisy (dates unknown)	10 July 1875	Oak Tree House, Hampstead	Princeton (Parrish)
2354–2369	Whiteside, Daisy (dates unknown), in "A Chinese Bazaar"	10 July 1875	Oak Tree House, Hampstead	Princeton (Parrish)
2354–2369	Dubourg, Evelyn Sophia (1861–1917), and O'Reilly, Kathleen, as "Fairy Cooks"	10 July 1875	Oak Tree House, Hampstead	Princeton (Parrish)
2354–2369	Cecil, Hon. Evelyn (1865–1941), as "Shakspere"	10 July 1875	Oak Tree House, Hampstead	Princeton (Parrish)
2354–2369	Cecil, Lord Eustace Brownlow Henry (1834–1921)	10 July 1875	Oak Tree House, Hampstead	Princeton (Parrish)
2358	Holiday, Winifred (1865–1949)	10 July 1875	Oak Tree House, Hampstead	Lindseth
2359	Holiday, Winifred (1864–1949), and Daisy Whiteside (dates unknown), in "Caught It at Last!"	10 July 1875	Oak Tree House, Hampstead	Princeton (Parrish)
2360	Holiday, Winifred (1864–1949), and Daisy Whiteside (dates unknown), in "The Lost Tune"	10 July 1875	Oak Tree House, Hampstead	Princeton (Parrish)
2361–2400	Whiteside, Daisy, and Beatrix, May, and Sylvia Du Maurier	12 July 1875	Oak Tree House, Hampstead	Princeton (Parrish)
2361–2400	Dubourg, Evelyn Sophia (1861–1917), as "Joan of Arc"	12 July 1875	Oak Tree House, Hampstead	Princeton (Parrish)
2361–2400	Du Maurier children	12 July 1875	Oak Tree House, Hampstead	Not located
2361–2400	Dubourg, Evelyn Sophia (1861–1917), as "Joan of Arc"	12 July 1875	Oak Tree House, Hampstead	Princeton (Parrish)
2361–2400	Du Maurier, Beatrix (1864–1913)	12 July 1875	Oak Tree House, Hampstead	Princeton (Parrish)
2369?	Terry, Marion "Polly" (1854–1930), as "Dora"	12 July 1875	Oak Tree House, Hampstead	Not located

IMAGE NUMBER	SUBJECT	DATE TAKEN	PLACE	CURRENT OWNER
2370	Terry, Marion "Polly" (1854–1930), as "Fitz-James"	12 July 1875	Oak Tree House, Hampstead	Princeton (Parrish)
2371	Terry, Florence "Flo" Maude (1856–1896), as Turk	12 July 1875	Oak Tree House, Hampstead	Musée d'Orsay
2372	Terry, Florence "Flo" Maude (1856–1896), and Marion "Polly" (1854–1930)	12 July 1875	Oak Tree House, Hampstead	Musée d'Orsay
2373	Terry, Florence "Flo" Maude (1856–1896)	12 July 1875	Oak Tree House, Hampstead	Musée d'Orsay
2374–2400	Lawrie, Rose (b. 1860?), in "The Birthday Wreath"	13 July 1875	Oak Tree House, Hampstead	Princeton (Parrish)
2374–2400	Lawrie, Rose (b. 1860?), in "The Heathen Chinee"	13 July 1875	Oak Tree House, Hampstead	Princeton (Parrish)
2374–2400	Brooke, Honor (b. 1862), Evelyn (b. 1867), and Olive (b. 1869), in "Going-a-Shrimping"	13 July 1875	Oak Tree House, Hampstead	Princeton (Parrish)
2374–2400	Brooke, Honor (b. 1862), as "A Modern Greek"	13 July 1875	Oak Tree House, Hampstead	Princeton (Parrish)
2375–2400	Thresher, Elizabeth "Beta" Annie (b. 1868), in Spanish dress	9–10 Sept. 1875	29 Tewry Street, Winchester	Lindseth
2375–2400	Thresher, Elizabeth "Beta" Annie (b. 1868), seated on doorstep	9–10 Sept. 1875	29 Tewry Street, Winchester	Lindseth
2375–2400	Thresher, Elizabeth "Beta" Annie (b. 1868), reclining on sofa	9–10 Sept. 1875	29 Tewry Street, Winchester	Lindseth
2375–2400	Thresher, Lucy Mabel (b. 1870)	9–10 Sept. 1875	29 Tewry Street, Winchester	Not located
2375–2400	Thresher, Lucy Mabel (b. 1870), as page-boy	9–10 Sept. 1875	29 Tewry Street, Winchester	Lindseth
2375–2400	Thresher, Mary (b. 1869), in Spanish dress	9–10 Sept. 1875	29 Tewry Street, Winchester	Lindseth
2375–2400	Thresher, Mary (b. 1869)	9–10 Sept. 1875	29 Tewry Street, Winchester	Lindseth
2375–2400	Thresher, Mrs. Sarah Anne (b. 1845)	9–10 Sept. 1875	29 Tewry Street, Winchester	Lindseth
2375–2400	Thresher, James Henville (b. 1843)	9 10 Sept. 1875	29 Tewry Street, Winchester	Lindseth
2375–2400	Thresher, Elizabeth "Beta" Annie (b. 1868), in swimming costume	9–10 Sept. 1875	29 Tewry Street, Winchester	Lindseth
2375–2400	Thresher, Elizabeth "Beta" Annie, Mary, and Lucy Mabel	9–10 Sept. 1875	29 Tewry Street, Winchester	Lindseth
2375–2400	Thresher, James Henville (b. 1843), seated in profile	9–10 Sept. 1875	29 Tewry Street, Winchester	Lindseth
2401	Morrell, Rachel Emilia Louisa (b. 1869)	4 May 1876	Christ Church Studio, Oxford	Private collection
2404	Morrell, Edith Frances, née Brett, and her daughter, Rachel	4 May 1876	Christ Church Studio, Oxford	Not located
2405	Dodgson, Skeffington Hume (1836–1919)	June 1876?	Christ Church Studio, Oxford	NMPFT
2407	Liddon, Henry Parry (1829–1890)	5 June 1876	Christ Church Studio, Oxford	Hatfield House
2408	Liddon, Henry Parry (1829–1890)	5 June 1876	Christ Church Studio, Oxford	Hatfield House
2409	Ambrose, Mary (b. 1863)	13 June 1876	Christ Church Studio, Oxford	Hatfield House
2410?	Ambrose, Mrs. Louisa (b. 1836)	13 June 1876	Christ Church Studio, Oxford	Not located
2411–2420	Harvey, Herbert (1835–1899)	13 June 1876	Christ Church Studio, Oxford	Not located
2411–2420	Harvey, Mrs. Gertrude (b. 1836)	13 June 1876	Christ Church Studio, Oxford	Not located
2412–2420	Duckworth, Robinson (1834–1911)	17 June 1876	Christ Church Studio, Oxford	Not located
2413–2420	Wilcoxes	27 June 1876	Christ Church Studio, Oxford	Not located
2414–2420	Wilcox, Frances Menella "Nella" (1869–1932)	28 June 1876	Christ Church Studio, Oxford	Not located
2414–2420	Evans, Mary "Molly" Beatrice (b. 1870)	28 June 1876	Christ Church Studio, Oxford	Not located
2415–2420	Arnold, Ethel Margaret (1866–1930)	29 June 1876	Christ Church Studio, Oxford	Not located

IMAGE NUMBER	SUBJECT	DATE TAKEN	PLACE	CURRENT OWNER
2421?	Arnold, Julia Frances (1862–1908)	29 June 1876	Christ Church Studio, Oxford	Not located
2421 ½	Arnold, Julia Frances (1862–1908)	29 June 1876	Christ Church Studio, Oxford	Wakeling
2422	Kitchin, Alexandra "Xie" Rhoda (1864–1925)	1 July 1876	Christ Church Studio, Oxford	Princeton (Parrish)
2423	Kitchin, Alexandra "Xie" Rhoda (1864–1925), as "Penelope Boothby," seated	1 July 1876	Christ Church Studio, Oxford	Princeton (Parrish)
2424	Kitchin, Alexandra "Xie" Rhoda (1864–1925), as "Penelope Boothby," standing	1 July 1876	Christ Church Studio, Oxford	Princeton (Parrish)
2425	Kitchin, Alexandra "Xie" Rhoda (1864–1925), in "Tuning"	1 July 1876	Christ Church Studio, Oxford	Princeton (Parrish)
2426	Kitchin, Brook Taylor (1869–1940)	5 July 1876	Christ Church Studio, Oxford	Lindseth
2427	Kitchin, Hugh Bridges (1867–1945)	5 July 1876	Christ Church Studio, Oxford	Not located
2428	Kitchin, Brook Taylor (1869–1940), and Hugh Bridges (1867–1945)	5 July 1876	Christ Church Studio, Oxford	Musée d'Orsay
2429–2444	Kitchin, Hugh Bridges (1867–1945)	5 July 1876	Christ Church Studio, Oxford	Lindseth
2429–2444	Kitchin, Brook Taylor (1869–1940), in shawls	5 July 1876	Christ Church Studio, Oxford	Not located
2430–2444	Todd, Laura Emma (1864?–1948)	18 July 1876	Christ Church Studio, Oxford	Not located
2430–2444	Todd, Ada Drummond (1866?–1953)	18 July 1876	Christ Church Studio, Oxford	Not located
2437	Dodgson, Charles Lutwidge (1832–1898)	July 1876?	Christ Church Studio, Oxford	Texas (Gernsheim)
2438	Dodgson, Charles Lutwidge (1832–1898)	July 1876?	Christ Church Studio, Oxford	Texas (Gernsheim)
2439	Dodgson, Charles Lutwidge (1832–1898)	July 1876?	Christ Church Studio, Oxford	Texas (Gernsheim)
2440–2452	Gray, Lilian "Lily" Amelia (1871–1924), with wand	20 Oct. 1876	Christ Church Studio, Oxford	Not located
2440–2452	Gray, Lilian "Lily" Amelia (1871–1924), on low chair	20 Oct. 1876	Christ Church Studio, Oxford	Not located
2440–2472	Gray, Lilian "Lily" Amelia (1871–1924), as Gretchen	20/28 Oct. 1876	Christ Church Studio, Oxford	Not located
2440–2472	Gray, Lilian "Lily" Amelia (1871–1924), in "Entering the Tower"	20/28 Oct. 1876	Christ Church Studio, Oxford	Not located
2440–2472	Gray, Lilian "Lily" Amelia (1871–1924), in "My Lady Passes"	20/28 Oct. 1876	Christ Church Studio, Oxford	Not located
2440–2472	Gray, Lilian "Lily" Amelia (1871–1924), in "My Lady Is Passed"	20/28 Oct. 1876	Christ Church Studio, Oxford	Not located
2440–2472	Gray, Lilian "Lily" Amelia (1871–1924), as acrobat	20/28 Oct. 1876	Christ Church Studio, Oxford	Not located
2440–2472	Gray, Lilian "Lily" Amelia (1871–1924), as bride	20/28 Oct. 1876	Christ Church Studio, Oxford	Not located
2440–2472	Gray, Lilian "Lily" Amelia (1871–1924), as Turk	20/28 Oct. 1876	Christ Church Studio, Oxford	Not located
2441	ERASED	Oct. 1876	Unknown	No copy survives
2444	ERASED	Oct. 1876	Unknown	No copy survives
2445	Gray, Lilian "Lily" Amelia (1871–1924), with seaside spade	20 Oct. 1876	Christ Church Studio, Oxford	Lindseth
2446–2452	Gray, Lilian "Lily" Amelia (1871–1924)	21 Oct. 1876	Christ Church Studio, Oxford	Not located
2447	ERASED	Oct. 1876	Unknown	No copy survives
2448–2472	Chataway, Elizabeth Ann, née Drinkwater (1833–1893)	26 Oct. 1876	Christ Church Studio, Oxford	Not located
2448–2472	Chataway, Annie Gertrude (1866–1951), in full dress, standing	26 Oct. 1876	Christ Church Studio, Oxford	Not located
2448–2472	Chataway, Annie Gertrude (1866–1951), in bathing drawers	26 Oct. 1876	Christ Church Studio, Oxford	Not located
2448–2472	Chataway, Annie Gertrude (1866–1951), in nightgown	26 Oct. 1876	Christ Church Studio, Oxford	Not located
2453	Chataway, Annie Gertrude (1866–1951), in Swanage costume	26 Oct. 1876	Christ Church Studio, Oxford	NYU
2455	Barker, May (b. 1857)	26 Oct. 1876	Christ Church Studio, Oxford	Not located

IMAGE NUMBER	SUBJECT	DATE TAKEN	PLACE	CURRENT OWNER
2457	ERASED	Oct. 1876	Unknown	No copy survives
2458	Chataway, Annie Gertrude (1866–1951), asleep	26 Oct. 1876	Christ Church Studio, Oxford	Texas (Gernsheim)
2459–2472	Gray, Lilian "Lily" Amelia (1871–1924)	28 Oct. 1876	Christ Church Studio, Oxford	Not located
2460–2472	Majendie, Dulcie (b. 1868)	27 Nov. 1876	Christ Church Studio, Oxford	Not located
2461–2472	Hermon, Mrs. Mary, née Newson (b. 1854)	30 Nov. 1876	Christ Church Studio, Oxford	Not located
2462	ERASED	Nov./Dec. 1876	Unknown	No copy survives
2463	*The Sisters,* painting by William Blake Richmond	Dec. 1876?	Christ Church Studio, Oxford	Morgan
2464–2503	"Buy a Broom"	c. 1877	Christ Church Studio, Oxford	Not located
2464–2472	Gilchrist, Constance "Connie" MacDonald (1865–1946)?	Apr. 1877?	Christ Church Studio, Oxford	AIC
2465–2472	Hatch, Beatrice Sheward (1866–1947)	16 June 1877	Christ Church Studio, Oxford	Not located
2473	Hatch, Ethel Charlotte (1869–1975), as Turk, standing	16 June 1877	Christ Church Studio, Oxford	Princeton (Parrish)
2474	Hatch, Ethel Charlotte (1869–1975), as Turk, seated	16 June 1877	Christ Church Studio, Oxford	Princeton (Parrish)
2475	Hatch, Beatrice Sheward (1866–1947)	16 June 1877	Christ Church Studio, Oxford	Princeton (Parrish)
2476	Kitchin, Alexandra "Xie" Rhoda (1864–1925)	20 June 1877	Christ Church Studio, Oxford	Lindseth
2477	Kitchin, Alexandra "Xie" Rhoda (1864–1925)	20 June 1877	Christ Church Studio, Oxford	Princeton (Parrish)
2478–2503	Forshall, Frances Mary "May" (1867–1937)	1 Dec. 1877	Christ Church Studio, Oxford	Not located
2479–2503	Forshall, Frances Mary "May" (1867–1937)	3 Dec. 1877	Christ Church Studio, Oxford	Not located
2480–2503	Arnold, Lucy Ada (1858–1894)	12 Dec. 1877	Christ Church Studio, Oxford	Not located
2481	Arnold, Julia Frances (1862–1908)	Dec. 1877?	Christ Church Studio, Oxford	Lindseth
2482–2540	Dodgson, Charles Lutwidge (1832–1898)	Apr. 1878?	Christ Church Studio, Oxford	Rosenbach
2483–2540	Coote, Lizzie (1862–1886)	1 May 1878	Christ Church Studio, Oxford	Not located
2484–2540	Milman, Susan Augusta Carter, née Hanbury (b. 1847)	4 May 1878	Christ Church Studio, Oxford	Not located
2485–2540	Wilcox, Mary "May" Anne, née Allen (1848–1904)	8 May 1878	Christ Church Studio, Oxford	Not located
2486–2540	Wilcox, Arthur Marwood (1840–1901)	9 May 1878	Christ Church Studio, Oxford	Not located
2486–2540	Arnold, Julia Frances (1862–1908), as Compte (*sic*) de Brissac	9 May 1878	Christ Church Studio, Oxford	Not located
2486–2540	Arnold, Ethel Margaret (1866–1930), as Compte (*sic*) de Brissac	9 May 1878	Christ Church Studio, Oxford	Not located
2487–2540	Beadon, Frederick (1778–1879)	15 May 1878	Christ Church Studio, Oxford	Not located
2488–2540	Coote, Caroline "Carrie" Eva (1870–1907)	3 June 1878	Christ Church Studio, Oxford	Not located
2489–2540	Gray, Lilian "Lily" Amelia (1871–1924)	17 June 1878	Christ Church Studio, Oxford	Not located
2490–2540	Dodgson, Henrietta Harington (1843–1922)	19 June 1878	Christ Church Studio, Oxford	Not located
2490–2540	Drewitt, Miss (dates unknown), as Eastern bride	19 June 1878	Christ Church Studio, Oxford	Not located
2490–2540	Drewitt, Miss (dates unknown)	19 June 1878	Christ Church Studio, Oxford	Not located
2491–2540	Thompson, John Barclay (b. 1845)	20 June 1878	Christ Church Studio, Oxford	Not located
2492–2540	Monier-Williams, Ella Chlora Faithfull (1859–1954)	29 June 1878	Christ Church Studio, Oxford	Not located
2492–2540	Williams, Mrs. (Junior) (dates unknown)	29 June 1878	Christ Church Studio, Oxford	Not located
2493–2540	Gray, Lilian "Lily" Amelia (1871–1924), as "Lily of the Ganges"	2 July 1878	Christ Church Studio, Oxford	Not located
2493–2540	Gray, Lilian "Lily" Amelia (1871–1924)	2 July 1878	Christ Church Studio, Oxford	Not located
2494–2540	Pollock, Sir Charles Edward (1823–1897)	6 July 1878	Christ Church Studio, Oxford	Not located
2495–2540	Gray, Lilian "Lily" Amelia (1871–1924)	15 July 1878	Christ Church Studio, Oxford	Not located
2504	Kitchin, Alexandra "Xie" Rhoda (1864–1925)	July 1878	Christ Church Studio, Oxford	Morgan
2519	Price, Alice Margaret (1863–1945)	July 1878	Christ Church Studio, Oxford	Not located
2536	Gray, Lilian "Lily" Amelia (1871–1924), in pantomime dress	15 July 1878	Christ Church Studio, Oxford	Not located
2541	Kitchin, Alexandra "Xie" Rhoda (1864–1925)	17 July 1878	Christ Church Studio, Oxford	Princeton (Parrish)
2542	Kitchin, Alexandra "Xie" Rhoda (1864–1925), in "Most Musical, Most Melancholy"	17 July 1878	Christ Church Studio, Oxford	Princeton (Parrish)
2543	Kitchin, Alexandra "Xie" Rhoda (1864–1925)	17 July 1878	Christ Church Studio, Oxford	Princeton (Parrish)

IMAGE NUMBER	SUBJECT	DATE TAKEN	PLACE	CURRENT OWNER
2544	Kitchin, Alexandra "Xie" Rhoda (1864–1925), as "An Eastern Gem"	17 July 1878	Christ Church Studio, Oxford	NYU
2545–2605	Heaphy, Leonora "Leo" (b. 1862)	18 July 1878	Christ Church Studio, Oxford	Not located
2546–2605	McDermott, Miss (dates unknown)	30 July 1878	Christ Church Studio, Oxford	Not located
2547–2605	Hull, Agnes Georgina (1867–1936)	15 Oct. 1878	Christ Church Studio, Oxford	Not located
2547–2605	Hull, Alice Frances (1863–1952)	15 Oct. 1878	Christ Church Studio, Oxford	Not located
2548–2605	Feilden, Helen Arbuthnot (1859–1947)	23 Oct. 1878	Christ Church Studio, Oxford	Not located
2549–2605	Woodroffe, Clara (b. 1868?)	26 Oct. 1878	Christ Church Studio, Oxford	Not located
2549–2605	Woodroffe, Alice Maud, née Townshend (1847–1907)	26 Oct. 1878	Christ Church Studio, Oxford	Not located
2550–2605	Henderson, Annie Gray Wright (1871–1951)	1 Nov. 1878	Christ Church Studio, Oxford	Not located
2551–2605	Smith, F. A. (dates unknown)	12 Nov. 1878	Christ Church Studio, Oxford	Not located
2552–2605	Thompson, Mrs. Barclay (dates unknown)	20 Nov. 1878	Christ Church Studio, Oxford	Not located
2553–2605	Pember, Edward Henry (b. 1833)	22 Nov. 1878	Christ Church Studio, Oxford	Not located
2554–2605	Drewitt, Frederick George Dawtrey (1848–1942)	13 Dec. 1878	Christ Church Studio, Oxford	Not located
2555–2605	Drawing by E. Gertrude Thomson	7 Feb. 1879	Christ Church Studio, Oxford	Not located
2556–2605	Mayhew, Ethel Innes (1867–1919), as Compte (sic) de Brissac	15 Feb. 1879	Christ Church Studio, Oxford	Not located
2556–2605	Mayhew, Janet (1873–1891)	15 Feb. 1879	Christ Church Studio, Oxford	Not located
2557–2605	Willets, Miss (dates unknown), in Japanese dress	15 Feb. 1879	Christ Church Studio, Oxford	Not located
2558–2605	Bowles, Thomas Gibson (1841–1922)	4 Mar. 1879	Christ Church Studio, Oxford	Not located
2559–2605	Craik, Dorothy Mulock (b. 1868)	17 Mar. 1879	Christ Church Studio, Oxford	Not located
2560–2605	Mayhew, Ethel Innes (1867–1919)	24 May 1879	Christ Church Studio, Oxford	Not located
2560–2605	Mayhew children	24 May 1879	Christ Church Studio, Oxford	Not located
2560–2605	Mayhew, Mary Ruth (1866–1939), as Compte (sic) de Brissac	24 May 1879	Christ Church Studio, Oxford	Not located
2561–2605	Drage, Gerida (b. 1865), as Compte (sic) de Brissac	15 July 1879	Christ Church Studio, Oxford	Not located
2561–2605	Drage, Gerida (b. 1865)	15 July 1879	Christ Church Studio, Oxford	Not located
2562–2605	Smith, Ada (b. 1868)	17 July 1879	Christ Church Studio, Oxford	Not located
2563–2605	Henderson, Annie Gray Wright (1871–1951)	18 July 1879	Christ Church Studio, Oxford	Not located
2563–2605	Henderson, Annie, and Frances, nude study	18 July 1879	Christ Church Studio, Oxford	Rosenbach
2606	Taylor, Leila Campbell (b. 1868)	19 July 1879	Christ Church Studio, Oxford	NMPFT
2607	Taylor, May Campbell (b. 1871)	19 July 1879	Christ Church Studio, Oxford	NMPFT
2608	Taylor, Leila Campbell (b. 1868), as Compte (sic) de Brissac	19 July 1879	Christ Church Studio, Oxford	NMPFT
2610	Taylor, Leila Campbell (b. 1868)	19 July 1879	Christ Church Studio, Oxford	NMPFT
2611–2619	Henderson, Hamilton Frances (b. 1872), nude study	21 July 1879	Christ Church Studio, Oxford	Not located
2612–2619	Taylor, Leila Campbell (b. 1868), in bathing costume	22 July 1879	Christ Church Studio, Oxford	Not located
2612–2619	Taylor, Leila Campbell (b. 1868)	22 July 1879	Christ Church Studio, Oxford	Not located
2613–2619	Henderson, Annie, and Frances, nude study	25 July 1879	Christ Church Studio, Oxford	Not located
2614–2637	Hatch, Evelyn Maud (1871–1951), nude study	29 July 1879	Christ Church Studio, Oxford	Rosenbach
2614–2637	Hatch, Beatrice Sheward (1866–1947)	29 July 1879	Christ Church Studio, Oxford	Not located
2614–2637	Hatch, Evelyn Maud (1871–1951), nude study	29 July 1879	Christ Church Studio, Oxford	Not located
2614–2637	Hatch, Ethel Charlotte (1869–1975)	29 July 1879	Christ Church Studio, Oxford	Not located
2614–2637	Henderson, Annie Gray Wright (1871–1951), nude study	29 July 1879	Christ Church Studio, Oxford	Not located
2620	Hatch, Beatrice Sheward (1866–1947), in "Vive la France!"	29 July 1879	Christ Church Studio, Oxford	Princeton (Parrish)
2624	Hatch, Ethel Charlotte (1869–1975), in "The Beast Is Near!"	29 July 1879	Christ Church Studio, Oxford	Princeton (Parrish)
2627	Hatch, Beatrice Sheward (1866–1947), in "Apis Japanensis"	29 July 1879	Christ Church Studio, Oxford	Princeton (Parrish)
2628–2637	Woodhouse, Henry M. (b. 1840), and his wife, Mary (b. 1849)	15 May 1880	Christ Church Studio, Oxford	Not located

IMAGE NUMBER	SUBJECT	DATE TAKEN	PLACE	CURRENT OWNER
2629–2637	Henderson, Annie Gray Wright (1871–1951), and Hamilton Frances (b. 1872), as princes	22 May 1880	Christ Church Studio, Oxford	Not located
2629–2637	Henderson, Annie Gray Wright (1871–1951), nude study	22 May 1880	Christ Church Studio, Oxford	Not located
2638	Kitchin, Alexandra "Xie" Rhoda (1864–1925)	25 May 1880	Christ Church Studio, Oxford	Private collection
2639	Kitchin, Dorothy Maud Mary (1874–1953)	25 May 1880	Christ Church Studio, Oxford	Ovenden
2640	Kitchin, Dorothy Maud Mary (1874–1953)	25 May 1880	Christ Church Studio, Oxford	Lindseth
2641	Kitchin, Alexandra "Xie" Rhoda (1864–1925), and Dorothy Maud Mary (1874–1953)	25 May 1880	Christ Church Studio, Oxford	Texas (Gernsheim)
2642	Kitchin, Alexandra "Xie" Rhoda (1864–1925)	25 May 1880	Christ Church Studio, Oxford	Princeton (Parrish)
2643–2700	Henderson, Annie Gray Wright (1871–1951), and Hamilton Frances (b. 1872), nude study	29 May 1880	Christ Church Studio, Oxford	Not located
2644–2700	Tait, Archibald Campbell (1811–1882)	31 May 1880	Christ Church Studio, Oxford	Not located
2645–2700	Blucher, Gustav (dates unknown)	1 June 1880	Christ Church Studio, Oxford	Not located
2645–2700	Blucher, Alice (dates unknown)	1 June 1880	Christ Church Studio, Oxford	Not located
2646–2700	Hatch, Evelyn Maud (1871–1951)	15 June 1880	Christ Church Studio, Oxford	Not located
2662	Hatch, Evelyn Maud (1871–1951)	15 June 1880	Christ Church Studio, Oxford	Private collection
2663–2700	Henderson, Annie Gray Wright (1871–1951), and Hamilton Frances (b. 1872)	18 June 1880	Christ Church Studio, Oxford	Not located
2664–2700	Drage, Gertrude (b. 1864)	15 July 1880	Christ Church Studio, Oxford	Not located
2665–2700	Drage, Gerida (b. 1865)	15 July 1880	Christ Church Studio, Oxford	Not located

ACKNOWLEDGMENTS

A book of this complexity would not be possible without the support, guidance, and encouragement of a number of friends and colleagues. We are particularly indebted to the current and former staff and students at Princeton University, especially John Bidwell, Peter C. Bunnell, Charles Greene, Scott Husby, William L. Joyce, Toby Jurovics, Kevin Moore, Doug Nickel, AnnaLee Pauls, Ben Primer, the late Alexander Wainwright, and all the other people who made our research trips so productive. We would also like to thank John Blazejewski for his careful and attentive photography of the albums. The Friends of the Princeton University provided a Fellowship that allowed Edward Wakeling to undertake research into the collection. The Publication Fund of the Department of Rare Books and Special Collections, Princeton University Library, the Publications Fund of the Department of Art and Archaeology, Princeton University, and Lloyd E. Cotsen contributed generously to this publication. Lloyd E. Cotsen's gift of the Reginald Southey albums to the Princeton University Library allowed us to glean valuable new evidence about Southey's role as Dodgson's photographic mentor, and for this we are especially grateful. Our thanks also go to our colleagues (past and present) at Princeton University Press—Patricia Fidler, Nancy Grubb, Sarah Henry, Devra K. Nelson, Ken Wong, and Kate Zanzucchi—and to the designers, Celia Fuller and Laura Lindgren; the copyeditor, Sharon Herson; the proofreader, June Cuffner; and the indexer, Kathleen Friello.

Our book has received strong support from members of the Charles L. Dodgson (Lewis Carroll) Family, and we thank Philip Dodgson Jaques, Caroline Luke, Beth Mead, Zoë Owen, and Margaret Hartland-Mahon for providing valuable information and assistance. We have also received support from the descendants of Alice Liddell, especially Mary Jean St. Clair, to whom we are also grateful.

The curators and library staff at other institutions holding albums and photographs by Lewis Carroll went out of their way to help us, and we extend our thanks to these people:

Janet McMullin and Judith Curthoys at Christ Church Library, Oxford; Roy Flukinger, David Coleman, and Linda Briscoe at the Harry Ransom Humanities Research Center, University of Texas, Austin; Mark Haworth-Booth, Julia Bigham, and Charlotte Cotton at the Victoria and Albert Museum, London; Pierre Apraxine and Maria Umali at the Gilman Paper Company Collection, New York; Julian Cox at the J. Paul Getty Museum, Los Angeles; Elizabeth Fuller, Jason A. Staloff, and Diane Waggoner at the Rosenbach Museum and Library, Philadelphia; Pam Roberts at the Royal Photographic Society, Bath; Amanda Nevill, Brian Liddy, and Russell Roberts at the National Museum of Photography, Film, and Television, Bradford; Anna Lou Ashby at the Pierpont Morgan Library, New York; Juliet Hacking and Terence Pepper at the National Portrait Gallery, London; and Mary Mackey at the Surrey History Centre, Woking. The Mellon Foundation generously provided Edward Wakeling with a fellowship in November 2000 to continue his photographic research at the Harry Ransom Humanities Research Center, University of Texas, Austin.

We are grateful to some private collectors for sharing their photographic information with us: the late Joseph Brabant, Celia Salisbury Jones, Jon Lindseth, Katherine MacDonald, Graham Ovenden, David Preston, Mark and Catherine Richards, and Bernard Symonds.

Other friends have shared their expertise, in particular, Brett Rogers and Sean Williams from the British Council; Mavis Batey, Stanley Chapman, Morton N. Cohen, Matt Demakos, Selwyn Goodacre, August and Clare Imholtz, Hugues Lebailly, Charlie Lovett, Yoshiyuki Momma, Brian Partridge, David Schaefer, Bea Sidaway, and Jeffrey Stern from the Lewis Carroll Society; Sam Abell from the National Geographic Society; and Keith Scott from Warrington Museum.

We have also been helped by these people, to whom we offer our gratitude: John Cass, Ann Fell, Colin Ford, Ann Hurst, Brian Mills, Richard Morris, Michael Pritchard, Phillip Prodger, Benedict Read, Justin Schiller, and Dominic Winter.

Finally, we would like to thank Brian May for his friendship and interest in our project. He provided us with the opportunity to see the actor Kevin Moore perform his one-man show, *Crocodiles in Cream,* about the life and work of Lewis Carroll, and the memory of that performance proved essential when putting this book together.

SELECTED BIBLIOGRAPHY

ROGER TAYLOR

Charles Lutwidge Dodgson

PRIMARY SOURCES
Dodgson, Charles Lutwidge. *Manuscript Diaries.* 9 vols. London: British Library, 1855–98.

SECONDARY SOURCES
Bakewell, Michael. *Lewis Carroll: A Biography.* London: Heinemann, 1996.
Carroll, Lewis. "Hiawatha's Photographing." *Phantasmagoria,* 1869. Reprint in *The Complete Works of Lewis Carroll.* London: Nonesuch Press, 1939.
———. "Photography Extraordinary." In *Comic Times,* 1855. Reprint in *The Complete Works of Lewis Carroll.* London: Nonesuch Press, 1939.
Cohen, Morton N. *Lewis Carroll and the Kitchins.* New York: Argosy Bookstore, 1980.
———. *Lewis Carroll.* London: Macmillan, 1995.
———. *Reflections in a Looking Glass.* New York: Aperture, 1999.
Cohen, Morton N., and Roger L. Green, eds. *The Letters of Lewis Carroll.* 2 vols. London: Macmillan, 1979.
Collingwood, Stuart Dodgson. *The Life and Letters of Lewis Carroll.* London: T. Fisher Unwin, 1898.
Crutch, Denis, ed. *Mr Dodgson: Nine Lewis Carroll Studies with a Companion-Guide to the Alice at Longleaf.* Exh. cat. London: Lewis Carroll Society, 1973.
Exhibition from the Jon A. Lindseth Collection of C. L. Dodgson and Lewis Carroll. Exh. cat. New York: The Grolier Club, 1998.
Fisher, John. *The Magic of Lewis Carroll.* London: Nelson, 1973.
Ford, Colin. *Lewis Carroll: Photographer.* Exh. cat. Bradford, UK: National Museum of Photography, Film, and Television, 1987.
Gattégno, Jean. *Lewis Carroll: Fragments of a Looking Glass.* Trans. Rosemary Sheed. New York: Thomas Y. Crowell Co., 1976.
Gernsheim, Helmut. *Lewis Carroll, Photographer.* London: Max Parrish and Co., 1949.
Guiliano, Edward, ed. *Lewis Carroll: A Celebration.* New York: Clarkson N. Potter, Inc., 1982.
Hatch, Beatrice. "Lewis Carroll." *Strand Magazine,* April 1898, 412–23.
Hudson, Derek. *Lewis Carroll.* London: Constable, 1954.
Leach, Karoline. *In the Shadow of the Dreamchild.* London: Peter Owen, 1999.
Lebailly, Hugues. "C. L. Dodgson and the Victorian Cult of the Child." *The Carrollian,* Autumn 1999, 3–31.
Lennon, Florence Becker. *Victoria through the Looking-Glass.* New York: Simon and Schuster, 1945.

Lewis Carroll at Christ Church. Exh. cat. London: National Portrait Gallery, 1974.
Liddell, Alice. "Alice's Recollections of Carrollian Days." *Cornhill Magazine,* July 1932, 6.
Moore, Kevin, "Charles Dodgson's Anatomical Photographs: Their Creation and Reception." Unpublished paper. Princeton University, 1996.
Shute, Edith Letitia. "Lewis Carroll as Artist." *Cornhill Magazine,* November 1932, 559–62.
Steinorth, Karl, ed. *Lewis Carroll: Photographs.* Schaffhausen, Switzerland: Edition Stemmle, 1991.
Stern, Jeffrey. *Lewis Carroll Bibliophile.* Luton, UK: White Stone Publishing, 1997.
Taylor, Robert N. *Lewis Carroll at Texas.* Austin: University of Texas at Austin, 1985.
Wakeling, Edward. "What I Tell You Forty-Two Times Is True." *Jabberwocky: The Journal of the Lewis Carroll Society* 6 (Autumn 1977): 101–6.
———. "Lewis Carroll's Rooms at Christ Church, Oxford." *Jabberwocky: The Journal of the Lewis Carroll Society* 12, no. 3 (Summer 1983): 51–61.
———. "Further Findings about the Number Forty-Two." *Jabberwocky: The Journal of the Lewis Carroll Society* 17 (Winter/Spring 1988): 11–13.
———. *The Oxford Pamphlets, Leaflets and Circulars of Charles Lutwidge Dodgson.* Charlottesville: University Press of Virginia, 1993.
———. *Lewis Carroll's Diaries.* 5 vols. Luton, UK: Lewis Carroll Society, 1993–99.
Weaver, Warren. "Ink (and Pen) Used by Lewis Carroll." *Jabberwocky: The Journal of the Lewis Carroll Society* 4 (Winter 1975): 3–4.

Victorian Photography

PRIMARY SOURCES
Abney, W. W. *Instruction in Photography.* 5th ed. London: Piper & Carter, 1882.
Bede, Cuthbert [pseud. Rev. E Bradley]. *Photographic Pleasures.* London: T. Mc'Lean, 1855.
Blanchard, Valentine. "Cabinet Portraits." *British Journal of Photography* 15 (11 September 1868): 437.
Catalogue of an Exhibition of Recent Specimens of Photography. Exh. cat. London: Society of Arts, 1852.
Catalogue of the First Annual Exhibition. Exh. cat. Birmingham, UK: Birmingham Photographic Society, 1857.

Eastlake, Lady Elizabeth. "Photography," *Quarterly Review* 101 (1857): 442–68.

Exhibition of Photographs and Daguerreotypes, Second Year. Exh. cat. London: Photographic Society, 1855.

Exhibition of Photographs and Daguerreotypes, Third Year. Exh. cat. London: Photographic Society, 1856.

Exhibition of Photographs at the Mechanic's Institution. Exh. cat. Manchester: Manchester Photographic Society, 1857.

Exhibition of Photographs and Daguerreotypes at the South Kensington Museum, Fifth Year. Exh. cat. London: Photographic Society, 1858.

Journal of The Photographic Society. London, 1853–present.

Minutes of Council. Papers of Society of Arts, 17 November 1852, 127.

Photographic Notes. London, 1856–65.

Price, William Lake. *A Manual of Photographic Manipulation.* London: John Churchill, 1858.

Talbot, William Henry Fox. Letter to Robert Hunt, 24 March 1852. Royal Photographic Society.

Wynter, Andrew. "Cartes-de-Visite." *British Journal of Photography* 16 (12 March 1869): 125–26 and (25 March 1869): 148–50.

SECONDARY SOURCES

After Daguerre: Masterworks of French Photography (1848–1900) from the Bibliothèque Nationale. Exh. cat. New York: Metropolitan Museum of Art, 1980.

Anninger, Anne, and Julie Melby. *Salts of Silver, Toned with Gold.* Exh. cat. Cambridge, Mass.: Harvard University, 1999.

Bartram, Michael. *The Pre-Raphaelite Camera.* London: Weidenfeld and Nicolson, 1985.

Dimond, Frances. "Prince Albert and the Application of Photography." In Frances Dimond and Roger Taylor, *Crown and Camera: The Royal Family and Photography, 1842–1910.* London: Viking, 1987.

Dodier, Virginia. *Lady Hawarden: Studies from Life, 1857–1864.* London: V&A Publications, 1999.

Ford, Colin. *The Cameron Collection.* London: Van Nostrand Reinhold, 1975.

Ford, Colin, and Roy Strong. *An Early Victorian Album.* New York: Alfred A. Knopf, 1976.

Gernsheim, Helmut. *Incunabula of British Photographic Literature.* London: Scolar Press, 1984.

Green-Lewis, Jennifer. *Framing the Victorians.* Ithaca, N.Y., and London: Cornell University Press, 1996.

Harker, Margaret F. *Henry Peach Robinson.* Oxford: Basil Blackwell, 1988.

Heathcote, Bernard V., and Pauline F. Heathcote. "Richard Beard: An Ingenious and Enterprising Patentee." *History of Photography* 3, no. 4 (October 1979): 313–29.

Heathcote, Pauline F. "The First Ten Years of the Daguerreotype in Nottingham." *History of Photography* 2, no. 4 (October 1978): 315–24.

Jaeger, Jens. "Photographic Societies in Britain in the 19th Century." In *Darkness and Light,* 133–40. Proceedings of the ESHP Symposium. Oslo, 1994.

Mavor, Carol. *Pleasures Taken.* Durham, N.C., and London: Duke University Press, 1995.

McCauley, Elizabeth Anne. *A. A. E. Disdéri and the Carte-de-Visite Portrait Photograph.* New Haven, Conn., and London: Yale University Press, 1985.

Morris, Richard. *Penllergare: A Victorian Paradise.* Llandeilo, UK: The Friends of Penllergare, 1999.

Morton, Vanda. *Oxford Rebels: The Life and Friends of Nevil Story Maskelyne, 1823–1911.* Gloucester: Alan Sutton, 1987.

Pritchard, Michael. *A Directory of London Photographers 1841–1908.* Watford: PhotoResearch, 1994.

Schaaf, Larry. *Out of the Shadows.* New Haven, Conn., and London: Yale University Press, 1992.

——. *The Photographic Art of William Henry Fox Talbot.* Princeton, N.J.: Princeton University Press, 2000.

Scharf, Aaron. *Art and Photography.* London: Allen Lane, 1968.

Seiberling, Grace, and Caroline Bloor. *Amateurs, Photography, and the Mid-Victorian Imagination.* Chicago: University of Chicago Press, 1986.

Taylor, Roger. *George Washington Wilson.* Aberdeen, UK: Aberdeen University Press, 1981.

Wolf, Sylvia. *Julia Cameron's Women.* New Haven, Conn., and London: Yale University Press, 1998.

Wood, R. Derek. "The Daguerreotype in England: Some Primary Material Relating to Beard's Lawsuits." *History of Photography* 3, no. 4 (October 1979): 305–9.

INDEX

Page numbers in italics indicate
illustrations.

Acland: children, 114n.73, 243;
 Henry Dyke (1850–1936), *167*,
 251; Henry Wentworth (1815–
 1900), 34, 39–41, 56, 77, 114n.73,
 136, 160, 162, 167, *183*, 254;
 Sarah, 57, 114n.73, 167; Sarah
 Angelina (1849–1930), *160, 167*,
 250–51; Theodore Dyke (1851–
 1931), *167*, 251
Adair, Alexander William (1830–
 1889), 262
Adamson, Robert, 84
Aesthetic Movement, 57, 104–5
Albert Augustus Charles, Prince, 25,
 46, 60–61, 103, 119n.240
Albert Edward, Prince of Wales, 70,
 76, 96, 117n.157, 160, 183, 194
albums, Dodgson's, general, 1, 16,
 22–24, 66–72, 110, 123–32; con-
 tents, 66–68, 123, 131; family
 albums, viii, 50, 66, 118n.188,
 124–25, 128, 131, 141; page com-
 position, 68–69; presentation
 albums, viii, 66–67, 124–25, 131;
 shape of photographs, 68, 131;
 show albums, viii, 66, 72,
 118n.188, 123–24, 126, 131; signa-
 tures in, 69–72, 76, 81, 125,
 131–32
albums, Dodgson's, individual: A(I),
 xi, 67–68, 124, 129, 131, 133–59;
 A(II), xi–xii, 67, 70, 124, 131;
 A(III), xii, 67, 70, 76–77, 124;
 A(VI), 67, 124, 126–27; A(VII),
 124; A(X), xi, 124; Bosworth
 Album, 124; Canon Rich Album,
 xi, 124; Common Room Album,
 xi, 124; Henry B. Crichton
 Album, 124; Dodgson Family
 Album (P[3]), Princeton, 124,
 128–29, 131; Dodgson Family
 Album, Texas, 124; Hassard
 Dodgson Albums, xi, 124; Miss

Dodgson Album, xi, 124; Henry
 Holiday Album, xi, xiii, xvn.20,
 67, 124, 126, 129, 131–32, 218–23;
 Kitchin Family Album, 125;
 Leigh Album, 229; Liddell
 Albums, xi, xvn.19, 124; Arthur
 C. Madan Album, 124; Salisbury
 Albums, 125; Reginald Southey
 Albums, xiii, 125, 129, 224–28;
 Weld Album, 124
Alexander, Robert Gustavus, 218
Alexandra, Princess of Wales,
 96–97, 215
Allen: Charlotte, 254; Mary (b.
 1843), *204*, 254, 261; Misses, 254;
 Thomas, 204
Ambrose: Louisa (b. 1836), 271;
 Mary (b. 1863), 271
Anderson: C., 249; Maria "Minnie"
 Katherine (1846–1889), *202, 255*;
 Richard, 202; Sophie (1823–
 1903), 214, 261
Andrews, Septimus (1832–1914), 81,
 250, 258
Archer, Frederick Scott, 8
Argles children, 263
Arnold: Ethel Margaret (1866–
 1930), 92, 265–67, 271; Julia, née
 Sorrell (1826–1888), 267, 269;
 Julia Frances (1862–1908), 92,
 265–69, 272–73; Lucy Ada
 (1858–1894), 266, 273; Mary
 Augusta (1851–1920), 266;
 Thomas, 3
Atkinson, Francis Home (1840–
 1901), *178*, 252

Badcock, Richard, 75, 114n.76. *See
 also* photographic studios, Dodg-
 son's: Badcock's Yard
Bainbridge: Agnes Constance (b.
 1850), *165*, 251; Florence Hilda
 (b. 1847), 70, *71* (pl. 51), *165, 185*,
 243, 251; Henry (1816–1877),
 165, 185, 243; Laura (b. 1854),
 165, 185, 251; Mary, *165, 185*

Baker, James (1825–1897), *204, 245*
Balfour: children, 259; Ella Sophia
 Anna (1854–1935), 80, 257, 259;
 Georgina "Gina" or "Georgie"
 Mary (1851–1929), 80, 257, 259;
 Sophia, née Cathcart (1830–
 1902), 80, 259
Bamlett: Jane, née Barker (d. 1820),
 198; Robert (1772–1863), *198,
 248*
Barker: May (b. 1857), 77, *78* (pl.
 54), 79, 257, 272; Thomas Childe
 (b. 1827), 77, *78* (pl. 54), 79, 257,
 262
Barnes: Miss, 252; Ralph (1810–
 1884), 249
Barry: children, 255; Emily Eupato-
 ria "Mimie" (b. 1854), 201, 255,
 262; John (1819–1856), 163; John
 "Johnnie" Warren (1851–1920),
 201, 242, 255; Letitia Anna
 (1824–1911), 163, *200*, 201, 251;
 Louisa "Loui" Dorothy (b. 1852),
 163, *171, 197, 200–201*, 251, 255,
 262
Bayne, Thomas Vere (1829–1908),
 243, 261–62, 266
Baynes, Robert Edward (b. 1849),
 269
Beadon, Frederick (1778–1879), 273
Beatrice Mary Victoria, Princess,
 81–82
Benn, Joseph (b. 1836), 242
Bennie: Elizabeth "Doe" (b. 1856),
 263; Mary "Minnie" (b. 1856),
 263
Benson: F., *161*, 250; M., *161*, 250;
 Richard Meux (1824–1915), *161*,
 250
Beresford, Selina Mary Emily
 (1861–1880), 262
Berger, Frederick, 8
Beyer, Helene, 256
Bickersteth: Edward (1814–1892),
 260; Edward Ernest (1853–1872),
 260; Elizabeth, née Garde, 260;

Florence Elizabeth (1852–1923),
 260; Henry "Harry" Cecil
 (1848–1896), 260; Montague
 Cyril (1858–1937), 260; Robert
 (1816–1884), *193, 201, 213, 253*, 260;
 Robert "Robin" (b. 1847), 260
Blagrave, Alice, 263
Bligh: Alice Isabella Harriet (1860–
 1943), 80, 257; Ivo Francis Walter
 (1859–1927), 80, 257
Blore, George John (1835–1916),
 204
Blucher: Alice, 275; Gustav, 275
Bode, Edith, 263
Bolster, John Abraham, *166*, 251
Bond, Anne Lydia (1822–1881),
 120n.275
Bosanquet, Samuel Courthope
 (1832–1925), 250
Bourke: George Wingfield (1829–
 1903), 207; Mary Henrietta, née
 Longley (1837?–1906), 207;
 Walter Longley (1859–1939), 80,
 207, 257
Bowlby: Eleanora Frances (b. 1858),
 175, 251; Henry Bond (d. 1824),
 169, 175; Mary (b. 1854), *169*,
 175, 251
Bowles, Thomas Gibson (1841–
 1922), 274
Bradley: Emily Tennyson (1862–
 1946), 266; Hugh Vachell (1865–
 1907), 266; Mabel (b. 1861?), 266;
 Margaret "Daisy," 266; Rose
 Marian (b. 1868), 266
Braithwaite, Florence (b. 1852), 214
Bray, Theresa "Tiny," 263
Brine: Catherine "Katie" Gram (b.
 1860), *213*, 261; James Gram
 (1819–1901), 213; Mary Amelia,
 née Pusey (1833–1910), 213, 261
British Association for the Ad-
 vancement of Science, 24, 41,
 164, 170–71; Oxford meeting,
 Dodgson's portraits from, 41–46,
 161, 164–66, 170–71

LEWIS CARROLL, PHOTOGRAPHER
THE PRINCETON UNIVERSITY LIBRARY ALBUMS

ROGER TAYLOR AND EDWARD WAKELING
INTRODUCTION BY PETER C. BUNNELL

Long before he published *Alice's Adventures in Wonderland,* Charles Lutwidge Dodgson ("Lewis Carroll" to the world) took up photography as a hobby. Unlike most of the other amateurs in his circle, he persevered to become a dedicated, prolific, and remarkably gifted photographer, creating approximately 3,000 images during his twenty-five years of photographic activity. This handsomely designed volume makes clear the remarkable extent and complexity of Carroll's photographic art. It publishes for the first time the world's finest and most extensive collection of Carroll photographs, many of which have never been reproduced before and are unknown even to committed Carroll enthusiasts.

Roger Taylor's thorough and sophisticated discussion of Carroll as a photographic artist and as a prominent member of Victorian society reveals the man as never before, illuminating his relationships with the children he photographed in light of the idealism and social conventions of the day. This text, illustrated with exquisite tritone plates, is followed by Edward Wakeling's fully illustrated and thoroughly annotated catalogue of the entire Princeton University Library collection. It features, in addition to a trove of loose prints, four rare albums made by Carroll himself to showcase his work to friends, family, and potential sitters. Reproduced in album order, these images offer new insight into how Carroll thought about his work—and how he wanted it to be seen.

Compelling portraits of Alice Liddell and other children are presented alongside those of eminent Victorians such as Alfred Tennyson and William Holman Hunt, as well as evocative landscapes, narrative tableaux, and wonderfully strange studies of anatomical skeletons. The catalogue is followed by a chronological register of every known Carroll photograph—a remarkable resource for anyone studying his career as a photographer.

This sumptuous volume is the definitive work on Carroll's photography. All who admire Carroll and his writing, as well as everyone interested in Victorian England or the history of photography, will find it both essential and irresistible.

ABOUT THE AUTHORS

ROGER TAYLOR is an independent British photographic historian specializing in the mid-Victorian period. His publications include *Crown and Camera: The Royal Family and Photography.*

EDWARD WAKELING has compiled and edited several volumes of the writings of Lewis Carroll, including the first unabridged edition of *Lewis Carroll's Diaries* (six of nine volumes are already in print).

PETER C. BUNNELL is the David Hunter McAlpin Professor of the History of Photography and Modern Art and Faculty Curator of Photography in The Art Museum at Princeton University.

Designed by Lindgren/Fuller Design, New York
Typefaces in this book are Berthold Caslon Book and Big Caslon, based on designs by
William Caslon, and Highway Gothic, designed by Roger Vershen
Composed by Duke & Company, Devon, Pennsylvania

Printed on 135 gsm Gardapat
Bound with Cialux and 170 gsm Woodstock
Separations, printing, and binding by Trifolio, Verona, Italy